GARDNER'S
ART
THROUGH THE
AGES

TWELFTH EDITION

Volume II

FRED S. KLEINER

CHRISTIN J. MAMIYA

THOMSON

WADSWORTH

AUSTRALIA • CANADA • MEXICO • SINGAPORE • SPAIN
UNITED KINGDOM • UNITED STATES

Acquisitions Editor
JOHN R. SWANSON

Senior Development Editor
STACEY SIMS

Assistant Editor
AMY MCGAUGHEY

Editorial Assistant
BRIANNA BRINKLEY

Technology Project Manager
MELINDA NEWFARMER

Marketing Manager
MARK ORR

Marketing Assistant
ANNABELLE YANG

Advertising Project Manager
VICKY WAN

Project Manager, Editorial Production
KATHRYN M. STEWART

Print/Media Buyer
BARBARA BRITTON

Permissions Editor
JOOHEE LEE

Production Service
JOAN KEYES, DOVETAIL PUBLISHING SERVICES

Text Designer
JOHN WALKER

Photo Researchers
LILI WEINER, IMAGE SELECT INTERNATIONAL

Copy Editors
MICHELE JONES, GAIL NELSON-BONEBRAKE

Illustrator
DARTMOUTH PUBLISHING

Cover Designer
BRIAN SALISBURY

Cover Image
**MORRIS LOUIS, *SARABAND*, 1959.
ACRYLIC RESIN ON CANVAS, 8′ 5⅛″ × 12′ 5″.
© SOLOMON R. GUGGENHEIM MUSEUM, NEW YORK.
PHOTOGRAPH: DAVID HEALD.**

Cover Printer
THE LEHIGH PRESS, INC.

Compositor
PROGRESSIVE INFORMATION TECHNOLOGIES

Printer
R.R. DONNELLEY/WILLARD

Printed in the United States of America
1 2 3 4 5 6 7 08 07 06 05 04

For more information about our products, contact us at:
Thomson Learning Academic Resource Center
1-800-423-0563

For permission to use material from this text or product, submit a request online at http://www.thomsonrights.com. Any additional questions about permissions can be submitted by e-mail to thomsonrights@thomson.com

Wadsworth/Thomson Learning
10 Davis Drive, Belmont, CA 94002-3098
USA

Asia
Thomson Learning
5 Shenton Way #01-01, UIC Building
Singapore 068808

Australia
Nelson Thomson Learning
102 Dodds Street, South Melbourne, Victoria 3205
Australia

Canada
Nelson Thomson Learning
1120 Birchmount Road, Toronto, Ontario M1K 5G4
Canada

Europe/Middle East/Africa
Thomson Learning
High Holborn House, 50/51 Bedford Row, London WC1R 4LR
United Kingdom

Library of Congress Control Number
2003111627

ISBN 0-534-64091-5

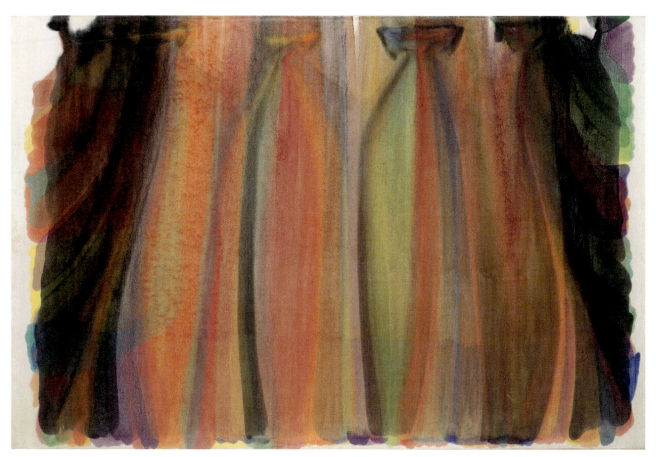

Morris Louis, *Saraband*, 1959. Acrylic resin on canvas, 8' 5$\frac{1}{8}$" × 12' 5". Solomon R. Guggenheim Museum, New York.

About the Cover Art

Saraband (FIG. 34-13), painted in 1959 by American artist Morris Louis, exemplifies a trend towards increased abstraction that developed in the 20th century. This trend culminated in images such as *Saraband,* which is wholly abstract and makes no reference to objects or external realities. This painting, from Louis's Veils series, exists purely as a visual image; there is no subject matter per se. Louis created this work by pouring diluted acrylic resin onto the surface of a canvas that he held vertically. The pigment running down the canvas produced these billowy, transparent veils of color. As representative of the dominance of abstraction in the later 20th century and as a captivating image whose meaning is totally embedded in the visual, *Saraband* is an appropriate cover image for Volume II of the Twelfth Edition of *Gardner's Art through the Ages.*

CONTENTS IN BRIEF

CONTENTS

Chapter 21

HUMANISM AND THE ALLURE OF ANTIQUITY:
15TH-CENTURY ITALIAN ART 573

Chapter 22

BEAUTY, SCIENCE, AND SPIRIT
IN ITALIAN ART: THE HIGH RENAISSANCE
AND MANNERISM 613

Chapter 23

THE AGE OF REFORMATION: 16TH-CENTURY
ART IN NORTHERN EUROPE AND SPAIN 663

Chapter 24

POPES, PEASANTS, MONARCHS,
AND MERCHANTS: BAROQUE ART 689

Chapter 30

Chapter 31

Chapter 32

Chapter 33

Chapter 34

FROM THE MODERN TO THE POSTMODERN AND BEYOND: ART OF THE LATER 20TH CENTURY 1031

PREFACE

We take great pleasure in presenting the Twelfth Edition of *Gardner's Art through the Ages*, the most widely read introduction to the history of art in the English language. When Helen Gardner published the first edition of her classic global survey of art and architecture in 1926, she could not have imagined that eight decades later instructors all over the world would still be using her textbook in their classrooms. She would no doubt have been especially proud that the Eleventh Edition of *Art through the Ages* was awarded both the 2001 Texty and McGuffey Book Prizes of the Text and Academic Authors Association as the best college textbook in the humanities and social sciences—the first art history book to win either award and the only title ever to win both prizes in the same year.

The fundamental belief that guided Helen Gardner—that the history of art is essential to a liberal education—is one that we also embrace. The study of art history has as its aim the appreciation and understanding of works of high aesthetic quality and historical significance produced throughout the world and across thousands of years of human history. We think, as she did, that the most effective way to tell the story of art through the ages, especially for those who are studying art history for the first time, is to organize the vast array of artistic monuments according to the civilizations that produced them and to consider each work in roughly chronological order. This approach has not only stood the test of time; it is the most appropriate for narrating the *history* of art. We believe that the enormous variation in the form and meaning of paintings, sculptures, buildings, and other artworks is largely the result of the constantly changing historical, social, economic, religious, and cultural context in which artists and architects worked. A historically based narrative is therefore best suited for a global history of art.

Yet, in other ways, Helen Gardner would not recognize the Twelfth Edition of *Art through the Ages* as her book. Most obvious, perhaps, Pablo Picasso and Arthur B. Davies are no longer treated in a chapter entitled "Contemporary Art in Europe and America." More significantly, however, the discipline of art history has changed markedly in recent decades, and so too has this book. The Twelfth Edition fully reflects the latest art historical research emphases, while maintaining the traditional strengths that have made all the previous editions of *Art through the Ages* so successful. While sustaining attention to style, chronology, iconography, and technique, we pay greater attention than ever before to function and context. We consider artworks with a view toward their purpose and meaning in the society that produced them at the time at which they were produced. We also address the very important role of patronage in the production of art and examine the role of the individuals or groups who paid the artists and influenced the shape the monuments took. We devote more space to the role of women and women artists in societies worldwide over time. Throughout, we have aimed to integrate the historical, political, and social context of art and architecture with the artistic and intellectual aspects. Consequently, we often treat painting, sculpture, architecture, and the so-called minor arts together, highlighting how they all reflect the conventions and aspirations of a common culture, rather than treating them as separate and distinct media. And we feature many works that until recently art historians would not have considered to be "art" at all. In every chapter, we have tried in our choice of artworks and buildings to reflect the increasingly wide range of interests of scholars today, while not rejecting the traditional list of "great" works or the very notion of a "canon." The selection of works encompasses every artistic medium and almost every era and culture.

The changes we have made even with respect to the Eleventh Edition are notable and will be immediately apparent to anyone who examines the Eleventh and Twelfth Editions side by side. Both editions feature more than 1400 photographs, plans, and drawings, but in the new edition nearly every photograph is in color. The only exceptions are works that were created in black-and-white, such as prints or photographs, and a small number of other monuments of which we were unable to obtain a color view that met our very high standards for reproduction.

Every edition of *Art through the Ages* has gone through a rigorous process of review, and the Twelfth Edition is no exception. Each of its 34 chapters has been read by experts in the respective fields. Some chapters were reviewed by as many as six scholars in order to ensure that the text lived up to the Gardner reputation for accuracy as well as readability. Every chapter has been revised. Some have been rewritten almost in their entirety. All feature superb new color illustrations, including a full-page, chapter-opening image reproducing a characteristic work of each period.

The rich illustration program is not, however, confined to the printed page. Every copy of the Twelfth Edition of *Art through the Ages* comes with a complimentary copy of *ArtStudy 2.0*, a CD-ROM that contains hundreds of high-quality digital images of the works discussed in the text. To facilitate the coordinated use of the CD-ROM and the book itself, every monument illustrated on the CD-ROM has an identifying icon appended to the caption of the corresponding figure in the text.

In response to student requests, every chapter of the new edition of *Art through the Ages* now ends with a short Conclusion summarizing the major themes discussed. These summaries face a full-page Chronological Overview of the material presented in

the chapter, organized as a vertical timeline, with four "thumbnail" illustrations of characteristic works in a variety of media, generally including at least one painting, sculpture, and building. Each thumbnail is numbered; the corresponding number appears on the time rule to the left so that the chronological sequence of production is clear.

The most popular features of previous editions of *Art through the Ages* have, of course, been retained. Especially noteworthy are the boxed essays that we introduced in the Eleventh Edition and which were so enthusiastically received by students and instructors alike. As before, these essays are presented in six broad categories.

Architectural Basics provide students with a sound foundation for the understanding of architecture. These discussions are concise primers, with drawings and diagrams of the major aspects of design and construction. The information included is essential to an understanding of architectural technology and terminology. The boxes address questions of how and why various forms developed, the problems architects confronted, and the solutions they used to resolve them. Topics discussed include how the Egyptians built the pyramids, the orders of classical architecture, Roman concrete construction, and the design and terminology of mosques, stupas, and Gothic cathedrals.

Materials and Techniques essays explain the various media artists employed from prehistoric to modern times. Since materials and techniques often influence the character of works of art, these discussions also contain essential information on why many monuments look the way they do. Hollow-casting bronze statues, fresco painting, Chinese silk, Andean weaving, Islamic tilework, embroidery and tapestry, woodblock prints, and perspective are among the many subjects treated.

Written Sources present and discuss key historical documents illuminating important monuments of art and architecture and the careers of some of the world's leading artists, architects, and patrons. The passages we quote permit voices from the past to speak directly to the reader, providing vivid and unique insights into the creation of artworks in all media. Examples include Bernard of Clairvaux's treatise on sculpture in medieval churches, Sinan the Great's commentary on the mosque he built for Selim II, Jean François Marmontel's account of 18th-century salon culture, as well as texts that bring the past to life, such as eyewitness accounts of the volcanic eruption that buried Roman Pompeii and of the fire that destroyed Canterbury Cathedral in medieval England.

Religion and Mythology boxes introduce students to the principal elements of the world's great religions, past and present, and to the representation of religious and mythological themes in painting and sculpture of all periods and places. These discussions of belief systems and iconography give readers a richer understanding of some of the greatest artworks ever created. The topics include the gods and goddesses of Egypt, Mesopotamia, Greece, and Rome; the life of Jesus in art; Buddha and Buddhism; Muhammad and Islam; and Aztec religion.

Art and Society essays treat the historical, social, political, cultural, and religious context of art and architecture. In some instances, specific monuments are the basis for a discussion of broader themes, as when we use the Hegeso stele to serve as the springboard for an exploration of the role of women in ancient Greek society. In other cases, we discuss how people's evaluation today of artworks can differ from those of the society that produced them, as when we examine the problems created by the contemporary market for undocumented archaeological finds. Other subjects include Egyptian mummification, the art of freed Roman slaves, the Mesoamerican ball game, the shifting fortunes

of Vincent van Gogh, Japanese court culture, and Native American artists.

Art in the News boxes present accounts of the latest archaeological finds and discussions of current controversies in the history of art. Among the discoveries and issues we highlight are the excavation of the tomb of the sons of the pharaoh Ramses and the restoration of Michelangelo's frescoes in the Sistine Chapel.

As in the past, the Twelfth Edition of *Art through the Ages* is published in a single hardcover version and as two paperbound volumes. Because many students taking the second half of a year-long introductory art history survey course will only have the second volume of the paperbound edition, we have again provided a feature not found in any other textbook currently available: a special set of Volume II boxes on religion, mythology, and architecture entitled *Before 1300*. These discussions immediately follow the Preface to Volume II and provide concise primers on religion and mythology and on architectural terminology and construction methods in the ancient and medieval worlds—information that is essential for understanding the history of art after 1300, both in the West and in the East. The subjects of these special boxes are The Gods and Goddesses of Mount Olympus; Buddhism and Hinduism; The Life of Jesus in Art; Greco-Roman Temple Design and the Classical Orders; Arches and Vaults; The Basilican Church; and The Central-Plan Church.

Full-color maps also remain an important element of every chapter of *Art through the Ages*. As in previous editions, we have taken great care to make sure that every site discussed in the text appears on our maps. These maps vary widely in both geographical and chronological scope. Some focus on a small region or even a single city, while others encompass a vast territory and occasionally bridge two or more continents. Several maps plot the art-producing sites of a given area over hundreds, even thousands, of years. In every instance, our aim has been to provide readers with maps that will easily allow them to locate the places where works of art originated or were found and where buildings were erected. To this end we have regularly placed the names of modern nations on maps of the territories of past civilizations. The maps, therefore, are pedagogical tools and do not constitute a historical atlas.

In addition, in order to aid our readers in mastering the vocabulary of art history, we have italicized and defined all art historical terms and other unfamiliar words at their first occurrence in the text—and at later occurrences too, whenever the term has not been used again for several chapters. Definitions of all terms introduced in the text appear once more in the Glossary at the back of the book, which includes pronunciations, a feature introduced in the Eleventh Edition. *Art through the Ages* also has a comprehensive bibliography of books in English, including both general works and a chapter-by-chapter list of more focused studies.

The captions to our more than 1400 illustrations contain a wealth of information, including the name of the artist or architect, if known; the formal title (printed in italics), if assigned, description of the work, or name of the building; the findspot or place of production of the object or location of the building; the date; the material or materials used; the size; and the present location if the work is in a museum or private collection. We urge readers to pay attention to the scales provided on all plans and to all dimensions given in the captions. The objects we illustrate vary enormously in size, from colossal sculptures carved into mountain cliffs and paintings that cover entire walls or ceilings to tiny figurines, coins, and jewelry that one can hold in the hand. Note too the location of the monuments discussed. Although many buildings and museums may be in cities or countries that a

reader may never visit, others are likely to be close to home. Nothing can substitute for walking through a building, standing in the presence of a statue, or inspecting the brushwork of a painting close up. Consequently, we have made a special effort to illustrate artworks in geographically wide-ranging public collections.

A work as extensive as a global history of art could not be undertaken or completed without the counsel of experts in all areas of world art. We are especially grateful to Herbert Cole of the University of California, Santa Barbara, for contributing the two chapters on African art, reprising a role he played in the Tenth Edition of *Art through the Ages*. And we remain grateful to Robert L. Brown (University of California, Los Angeles), George Corbin (Lehman College of the City University of New York), Virginia E. Miller (University of Illinois, Chicago), and Quitman Eugene Phillips (University of Wisconsin, Madison) for their contributions to the Eleventh Edition on India and Southeast Asia; Africa and Oceania; the native arts of the Americas; and China, Korea, and Japan, respectively, which laid the foundation for much of the treatment of non-Western art in the Twelfth Edition.

For contributions in the form of extended critiques of the Eleventh Edition or of the penultimate drafts of the Twelfth Edition chapters, as well as other assistance of various sorts, we wish to thank Stanley K. Abe, Duke University; C. Edson Armi, University of California, Santa Barbara; Frederick M. Asher, University of Minnesota; Cynthia Atherton, Middlebury College; Paul G. Bahn, Hull, England; Janis Bergman-Carton, Southern Methodist University; Janet Berlo, University of Rochester; Anne Bertrand, Bard College; Jonathan M. Bloom, Boston College; Kendall H. Brown, California State University, Long Beach; Andrew L. Cohen, University of Central Arkansas; Harry A. Cooper, Fogg Art Museum, Harvard University; Roger J. Crum, University of Dayton; LouAnn Faris Culley, Kansas State University; Thomas E. A. Dale, University of Wisconsin, Madison; Anne D'Alleva, University of Connecticut; Eve D'Ambra, Vassar College; Cindy Bailey Damschroder, University of Cincinnati; Abraham A. Davidson, Temple University; Carolyn Dean, University of California, Santa Cruz; William Diebold, Reed College; Erika Doss, University of Colorado; Daniel Ehnbom, University of Virginia; David Ehrenpreis, James Madison University; Jerome Feldman, Hawaii Pacific University; Peter Fergusson, Wellesley College; Barbara Frank, State University of New York, Stony Brook; Rita E. Freed, Museum of Fine Arts, Boston; Eric G. Garbersen, Virginia Commonwealth University; Clive F. Getty, Miami University; Paula Girshick, Indiana University; Carma R. Gorman, Southern Illinois University, Carbondale; Elizabeth ten Grotenhuis, Boston University; Melinda K. Hartwig, Georgia State University; Marsha Haufler, University of Kansas; Mary Beth Heston, College of Charleston; Hannah Higgins, University of Illinois, Chicago; Charlotte Houghton, The Pennsylvania State University; Aldona Jonaitis, University of Alaska Museum; Adrienne Kaeppler, Smithsonian Institution; Padma Kaimal, Colgate University; Stacy L. Kamehiro, University of Redlands; Thomas DaCosta Kaufmann, Princeton University; Dale Kinney, Bryn Mawr College; Sandy Kita, University of Maryland, College Park; Cecelia F. Klein, University of California, Los Angeles; James Kornwolf, College of William and Mary; Andrew Ladis, University of Georgia, Athens; Ellen Johnston Laing, University of Michigan; Joseph Lamb, Ohio University; Dana Leibsohn, Smith College; Janice Leoshko, University of Texas at Austin; Henry Maguire, Johns Hopkins University; Joan Marter, Rutgers University; Michael Meister, University of Pennsylvania; Samuel C. Morse, Amherst College; Susan E. Nelson, Indiana University; Irene Nero, Southeastern Louisiana University; Esther Pasztory, Columbia University; Jeanette F. Peterson, University of California, Santa Barbara; Elizabeth Piliod, Oregon State University; Martin Powers, University of Michigan; Ingrida Raudzens, Salem State College; Paul Rehak, University of Kansas; Margaret Cool Root, University of Michigan; Lisa Rosenthal, University of Illinois, Urbana-Champaign; Jonathan M. Reynolds, University of Southern California; Conrad Rudolph, University of California, Riverside; Denise Schmandt-Besserat, University of Texas at Austin; Ellen C. Schwartz, Eastern Michigan University; Michael Schwartz, Augusta State University; Raymond A. Silverman, Michigan State University; Jeffrey Chipps Smith, University of Texas at Austin; Anne Rudloff Stanton, University of Missouri, Columbia; Rebecca Stone-Miller, Emory University; Mary C. Sturgeon, University of North Carolina at Chapel Hill; Peter C. Sturman, University of California, Santa Barbara; Melinda Takeuchi, Stanford University; Woodman Taylor, University of Illinois at Chicago; Jehanne Teilhet-Fisk, Florida State University; Dorothy Verkerk, University of North Carolina at Chapel Hill; Monica Blackmun Visonà, Metro State College; Gerald Walker, Clemson University; Martha Ward, University of Chicago; Gregory Warden, Southern Methodist University; Kent R. Weeks, American University in Cairo; Victoria Weston, University of Massachusetts, Boston; Deborah B. Waite, University of Hawaii; Catherine Wilkinson Zerner, Brown University. Innumerable other instructors and students have also sent us helpful reactions, comments, and suggestions for ways to improve the book. We are grateful for their interest and their insights.

Among those at Thomson Wadsworth who worked with us to make the new edition of *Art through the Ages* the best ever are the CEO and president, Susan Badger; senior vice president, editorial, Sean Wakely; vice president and editor-in-chief, Marcus Boggs; publisher, Clark Baxter; executive editor, David Tatom; acquisitions editor, John Swanson; technology project manager, Melinda Newfarmer; our development editors, Helen Triller and Stacey Sims; assistant editor, Amy McGaughey; and editorial assistants, Rebecca Jackson and Brianna Brinkley. This edition of *Art through the Ages* is the most ambitious ever, and the production schedule was the tightest ever. We therefore want to acknowledge the extraordinary efforts of our editorial production manager, Kathryn Stewart, and her team of dedicated professionals: Joan Keyes of Dovetail Publishing Services, our production service; our copy editors, Michele Jones and Gail Nelson-Bonebrake; interior designer, John Walker; cover designer, Brian Salisbury; and photo researchers Carrie Ward, Lili Weiner, and Image Select International. We are also grateful to the marketing staff for their dedication to making this edition a success: senior vice president, marketing, Jonathan Hulbert; director of marketing, Elana Dolberg; executive marketing manager, Diane Wenckebach; executive director of advertising and marketing communications, Margaret Parks; senior channel manager, school, Wadsworth Group, Pat Murphree; marketing manager, Mark Orr; and marketing assistant, Annabelle Yang. Recognition and thanks are also due to our proofreaders, Katherine Hyde and Pete Shanks, and our indexer, Nancy Ball.

We also owe a deep debt of gratitude to our colleagues at Boston University and the University of Nebraska, Lincoln, and to the thousands of students and the scores of teaching fellows in our art history courses over many years in Boston and Lincoln, and at the University of Virginia and Yale University. From them we have learned much that has helped determine the form and content of *Art through the Ages*.

FRED S. KLEINER
CHRISTIN J. MAMIYA

The Gods and Goddesses of Mount Olympus

The names of scores of Greek gods and goddesses were recorded as early as the eighth century BCE in Homer's epic tales of the war against Troy (*Iliad*) and of the adventures of the Greek hero Odysseus on his long and tortuous journey home (*Odyssey*). Even more are enumerated in the poems of Hesiod, especially his *Theogony (Geneaology of the Gods)* composed around 700 BCE.

The Greek deities most often represented in art are all ultimately the offspring of the two key elements of the Greek universe, Earth (*Gaia/Ge*; we give the names in Greek/Latin form) and Heaven (*Ouranos/Uranus*). Earth and Heaven mated to produce 12 Titans, including Ocean (*Okeanos/Oceanus*) and his youngest brother *Kronos (Saturn)*. Kronos castrated his father in order to rule in his place, married his sister *Rhea*, and then swallowed all his children as they were born, lest one of them seek in turn to usurp him. When *Zeus (Jupiter)* was born, Rhea deceived Kronos by feeding him a stone wrapped in clothes in place of the infant. After growing to manhood, Zeus forced Kronos to vomit up Zeus's siblings. Together they overthrew their father and the other Titans and ruled the world from their home on Mount Olympus, Greece's highest peak.

This cruel and bloody tale of the origin of the Greek gods has parallels in Near Eastern mythology and is clearly pre-Greek in origin, one of many Greek borrowings from the East. The Greek version of the creation myth, however, appears infrequently in painting and sculpture. Instead, the later 12 Olympian gods and goddesses, the chief deities of Greece, figure most prominently in art—not only in Greek, Etruscan, and Roman times but also in the Middle Ages, the Renaissance, and up to the present.

THE OLYMPIAN GODS
(AND THEIR ROMAN EQUIVALENTS)

ZEUS (JUPITER) King of the gods, Zeus ruled the sky and allotted the sea to his brother Poseidon and the Underworld to his other brother Hades. His weapon was the thunderbolt, and with it he led the other gods to victory over the Giants, who had challenged the Olympians for control of the world.

HERA (JUNO) Wife and sister of Zeus, Hera was the goddess of marriage, and Zeus's many love affairs often angered her. Her favorite cities were Mycenae, Sparta, and Argos, and she aided the Greeks in their war against the Trojans.

POSEIDON (NEPTUNE) Poseidon was one of the three sons of Kronos and Rhea and was lord of the sea. He controlled waves, storms, and earthquakes with his three-pronged pitchfork (trident).

HESTIA (VESTA) Daughter of Kronos and Rhea and sister of Zeus, Poseidon, and Hera, Hestia was goddess of the hearth. In Rome, Vesta had an ancient shrine with a sacred fire in the Roman Forum. Her six Vestal Virgins were the most important priestesses of the state, drawn only from aristocratic families.

DEMETER (CERES) Third sister of Zeus, Demeter was the goddess of grain and agriculture. She taught humans how to sow and plow. The English word *cereal* derives from Ceres.

ARES (MARS) God of war, Ares was the son of Zeus and Hera and the lover of Aphrodite. In the *Iliad* he took the side of the Trojans. Mars, father of the twin founders of Rome, *Romulus* and *Remus*, looms much larger in Roman mythology and religion than Ares does in Greek.

ATHENA (MINERVA) Goddess of wisdom and warfare, Athena was a virgin (*parthenos* in Greek), born not from a woman's womb but from the head of her father, Zeus. Her city was Athens, and her greatest temple was the Parthenon.

HEPHAISTOS (VULCAN) God of fire and of metalworking, Hephaistos fashioned the armor Achilles wore in battle against Troy. He also provided Zeus his scepter and Poseidon his trident, and was the "surgeon" who split open Zeus's head when Athena was born. In some accounts, Hephaistos is the son of Hera without a male partner. In others, he is the son of Hera and Zeus. He was born lame and, uncharacteristically for a god, ugly. His wife Aphrodite was unfaithful to him.

APOLLO (APOLLO) God of light and music, and a great archer, Apollo was the son of Zeus with *Leto/Latona*, daughter of one of the Titans. His epithet *Phoibos* means "radiant," and the young, beautiful Apollo is sometimes identified with the sun (*Helios/Sol*).

ARTEMIS (DIANA) Sister of Apollo, Artemis was goddess of the hunt and of wild animals. As Apollo's twin, she was occasionally regarded as the moon (*Selene/Luna*).

APHRODITE (VENUS) Daughter of Zeus and *Dione* (daughter of Okeanos and one of the *nymphs*—the goddesses of springs, caves, and woods), Aphrodite was the goddess of love and beauty. In one version of her myth, she was born from the foam (*aphros* in Greek) of the sea. She was the mother of Eros by Ares and of the Trojan hero *Aeneas* by *Anchises*. Julius Caesar and Augustus traced their lineage to Venus through Aeneas.

HERMES (MERCURY) Son of Zeus and another nymph, Hermes was the fleet-footed messenger of the gods and possessed winged sandals. He was also the guide of travelers, including the dead journeying to the Underworld. He carried the *caduceus*, a magical herald's rod, and wore a traveler's hat, often also shown with wings.

Equal in stature to the Olympians was *Hades (Pluto)*, one of the children of Kronos who fought with his brothers against the Titans but who never resided on Mount Olympus. Hades was the lord of the Underworld and god of the dead.

Other important Greek gods and goddesses were *Dionysos (Bacchus)*, the god of wine and the son of Zeus and a mortal woman; *Eros (Amor or Cupid)*, the winged child god of love and the son of Aphrodite and Ares; and *Asklepios (Aesculapius)*, son of Apollo and a mortal woman, the Greek god of healing, whose serpent-entwined staff is the emblem of modern medicine.

Buddhism and Hinduism

THE BUDDHA AND THE EIGHTFOLD PATH

The Buddha (Enlightened One) was born around 563 BCE as Prince Siddhartha Gautama, the eldest son of the king of the Shakya Clan. A prophecy foretold that he would grow up to be either a world conqueror or a great religious leader. His father preferred the secular role for young Siddhartha and groomed him for kingship by shielding the boy from the hardships of the world. When he was 29, however, the prince rode out of the palace, abandoned his wife and family, and encountered firsthand the pain of old age, sickness, and death. Siddhartha responded to the suffering he witnessed by renouncing his opulent life and becoming a wandering ascetic searching for knowledge through meditation. Six years later, he achieved complete enlightenment, or buddhahood, while meditating beneath a pipal tree (the Bodhi tree) at Bodh Gaya ("place of enlightenment") in eastern India. Known from that day on as Shakyamuni (Wise Man of the Shakya Clan), the Buddha preached his first sermon in the Deer Park at Sarnath. There he set in motion the Wheel (chakra) of the Law (dharma) and expounded the Four Noble Truths that are the core insights of Buddhism: (1) life is suffering; (2) the cause of suffering is desire; (3) one can overcome and extinguish desire; (4) the way to conquer desire and end suffering is to follow the Buddha's Eightfold Path of right understanding, right thought, right speech, right action, right livelihood, right effort, right mindfulness, and right concentration. The Buddha's path leads to nirvana, the cessation of the endless cycle of painful life,

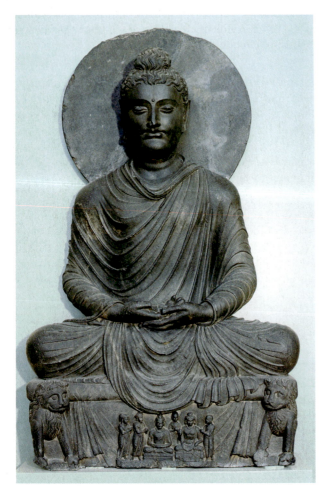

Meditating Buddha, second century CE
(The National museums of Scotland).

XIV

death, and rebirth. The Buddha continued to preach until his death at 80 at Kushinagara. His disciples carried on his teaching and established monasteries where others could follow the Buddha's path to enlightenment and nirvana.

THE SPREAD OF BUDDHISM

This earliest form of Buddhism is called *Theravada* (the Path of the Elders) Buddhism. The new religion developed and changed over time as the Buddha's teachings spread from India throughout Asia. The second major school of Buddhist thought, *Mahayana* (Great Path) Buddhism, emerged around the beginning of the Christian era. Mahayana Buddhists refer to Theravada Buddhism as *Hinayana* (Lesser Path) Buddhism and believe in a larger goal than nirvana for an individual—namely, buddhahood for all. Mahayana Buddhists also revere *bodhisattvas* ("Buddhas-to-be"), exemplars of compassion who, holding back at the threshold of nirvana, aid others in earning merit and achieving buddhahood. Theravada Buddhism became the dominant sect in southern India, Sri Lanka, and mainland Southeast Asia, whereas Mahayana Buddhism took root in northern India and spread to China, Korea, Japan, and Nepal.

A third important Buddhist sect, especially popular in East Asia, venerates the *Amitabha* Buddha (*Amida* in Japanese), the Buddha of Infinite Light and Life. The devotees of this Buddha hope to be reborn in the Pure Land Paradise of the West, where the Amitabha resides and can grant them salvation. Pure Land teachings maintain that people have no possibility of attaining enlightenment on their own, but can achieve paradise by faith alone.

THE BUDDHA IN ART

When artists began depicting the Buddha in human form, probably in the first century CE, it was as a robed monk. They distinguished the Enlightened One from monks and bodhisattvas by *lakshanas*, body attributes or characteristics indicating the Buddha's superhuman nature. These distinguishing marks include an *urna*, or curl of hair between the eyebrows, shown as a dot; an *ushnisha*, a cranial bump shown as hair on the earliest images but later as an actual part of the head; and, less frequently, palms of hands and soles of feet imprinted with a wheel. The Buddha is also recognizable by his elongated ears, the result of wearing heavy royal jewelry in his youth, but the enlightened Shakyamuni is rarely bejeweled, as are many bodhisattvas. Sometimes the Buddha appears with a halo, or sun disk, behind his head.

Representations of the Buddha also feature a repertory of *mudras*, or hand gestures, conveying fixed meanings. These include the *dhyana* (meditation) mudra, with hands overlapping in the lap, palms upward; the *bhumisparsha* (earth touching) mudra, right hand down reaching to the ground, calling the earth to witness the Buddha's enlightenment; the *dharmachakra* (Wheel of the Law, or teaching) mudra, a two-handed gesture with right thumb and index finger forming a circle; and the *abhaya* (do not fear) mudra, right hand up, palm outward, a gesture of protection or blessing.

Episodes from the Buddha's life are among the most popular subjects in all Buddhist artistic traditions. No single text provides the complete or authoritative narrative of his life and death. Thus, numerous versions and variations exist, allowing for a rich artistic repertory. Four of the most important events are his birth at

Buddhism and Hinduism (continued)

Lumbini from the side of his mother, Queen Maya; the achievement of buddhahood while meditating beneath the Bodhi tree at Bodh Gaya; the Buddha's first sermon at Sarnath; and his attainment of nirvana when he died (*parinirvana*) at Kushinagara. Buddhists erected monasteries and monuments at the four sites where these key events occurred. Monks and lay pilgrims from throughout the world continue to visit these places today.

HINDUISM

Unlike Buddhism (and Christianity, Islam, and other religions), Hinduism recognizes no founder or great prophet. Hinduism also has no simple definition, but means "the religion of the Indians." Both "India" and "Hindu" have a common root in the name of the Indus River. The actual practices and beliefs of Hindus vary tremendously, but the literary origins of Hinduism can be traced to the second half of the second millennium BCE, and some aspects of Hindu practice seem already to have been present in the Indus Civilization of the third millennium BCE. Ritual sacrifice is central to Hinduism. The goal of sacrifice is to please a deity in order to achieve release (*moksha*, liberation) from the endless cycle of birth, death, and rebirth (*samsara*) and become one with the universal spirit.

Not only is Hinduism a religion of many gods, but the Hindu deities have various natures and take many forms. This multiplicity suggests the all-pervasive nature of the Hindu gods. The three most important deities are the gods Shiva and Vishnu and the goddess Devi. Each of the three major sects of Hinduism today considers one of these three to be supreme—Shiva in Shaivism, Vishnu in Vaishnavism, and Devi in Shaktism. (*Shakti* is the female creative force.)

Shiva is the Destroyer, but, consistent with the multiplicity of Hindu belief, he is also a regenerative force and, in the latter role, can be represented in the form of a *linga* (a phallus or cosmic pillar). When Shiva appears in human form in Hindu art, he frequently has multiple limbs and heads, signs of his superhuman nature. He often has matted locks piled on top of his head, crowned by a crescent moon. Sometimes he wears a serpent scarf and has a third eye on his forehead (the emblem of his all-seeing nature). Shiva rides the bull *Nandi* and often carries a trident. His son is the elephant-headed Ganesha.

Vishnu is the Preserver of the Universe. Artists frequently portray him with four arms holding various attributes, including a conch-shell trumpet and discus. He sometimes reclines on a serpent floating on the waters of the cosmic sea. When the evil forces of the universe become too strong, he descends to earth to restore balance and assumes different forms (*avatars*, or incarnations), including a boar, fish, and tortoise, as well as *Krishna*, the divine lover, and even the Buddha himself.

Devi is the Great Goddess who takes many forms and has many names. Hindus worship her alone or as a consort of male gods (*Parvati* or *Uma*, wife of Shiva; *Lakshmi*, wife of Vishnu), as well as *Radha*, lover of Krishna. She has both benign and horrific forms; she both creates and destroys. In one manifestation, she is *Durga*, a multiarmed goddess who rides or is accompanied by a lion.

The stationary images of deities in Hindu temples are often made of stone. Hindus periodically remove portable images of their gods, often of bronze, from the temple, particularly during festivals to enable many worshipers to take *darshan* (seeing the deity and being seen by the deity) at one time. In temples dedicated to Shiva, the stationary form is the linga.

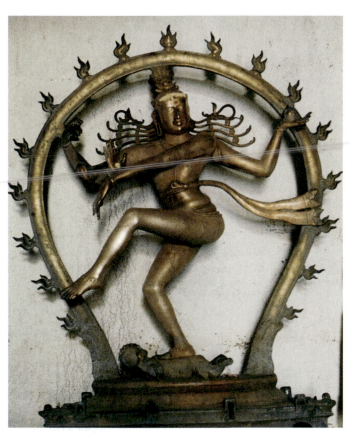

Dancing Shiva, ca. 1000 (Naltunai Ishvaram Temple, Punjai)

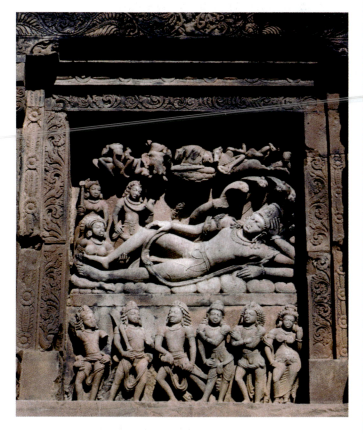

Vishnu on a serpent, early sixth century (Vishnu Temple, Deogarh)

The Life of Jesus in Art

Christians believe that Jesus of Nazareth is the son of God, the Messiah (Savior, *Christ*) of the Jews prophesied in the Old Testament. His life—his miraculous birth from the womb of a virgin mother, his preaching and miracle working, his execution by the Romans and subsequent ascent to heaven—has been the subject of countless artworks from Roman times through the present day. The primary literary sources for these representations are the Gospels of the New Testament attributed to the Four Evangelists, Saints Matthew, Mark, Luke, and John; later apocryphal works; and commentaries on these texts by medieval theologians.

The life of Jesus dominated the subject matter of Christian art to a far greater extent than Greco-Roman religion and mythology ever did classical art. Whereas images of athletes, portraits of statesmen and philosophers, narratives of war and peace, genre scenes, and other secular subjects were staples of the classical tradition, Christian iconography held a near monopoly in the art of the Western world in the Middle Ages.

Although many of the events of Jesus' life were rarely or never depicted during certain periods, the cycle as a whole has been one of the most frequent subjects of Western art, even after the revival of classical and secular themes in the Renaissance. We describe the events as they usually appear in the artworks.

INCARNATION AND CHILDHOOD

The first "cycle" of the life of Jesus consists of the events of his conception, birth, infancy, and childhood.

ANNUNCIATION TO MARY The archangel Gabriel announces to the Virgin Mary that she will miraculously conceive and give birth to God's son Jesus. God's presence at the *Incarnation* is sometimes indicated by a dove, the symbol of the Holy Spirit, the third "person" of the Trinity with God the Father and Jesus.

VISITATION The pregnant Mary visits Elizabeth, her older cousin, who is pregnant with the future Saint John the Baptist. Elizabeth is the first to recognize that the baby Mary is bearing is the Son of God, and they rejoice.

NATIVITY, ANNUNCIATION TO THE SHEPHERDS, AND ADORATION OF THE SHEPHERDS Jesus is born at night in Bethlehem and placed in a basket. Mary and her husband Joseph marvel at the newborn in a stable or, in Byzantine art, in a cave. An angel announces the birth of the Savior to shepherds in the field, who rush to Bethlehem to adore the child.

ADORATION OF THE MAGI A bright star alerts three wise men (*magi*) in the East that the King of the Jews has been born. They travel 12 days to find the Holy Family and present precious gifts to the infant Jesus.

PRESENTATION IN THE TEMPLE In accordance with Jewish tradition, Mary and Joseph bring their firstborn son to the temple in Jerusalem, where the aged Simeon, whom God said would not die until he had seen the Messiah, recognizes Jesus as the prophesied Savior of humankind.

MASSACRE OF THE INNOCENTS AND FLIGHT INTO EGYPT King Herod, fearful that a rival king has been born, orders the massacre of all infants in Bethlehem, but an angel warns the Holy Family, and they escape to Egypt.

DISPUTE IN THE TEMPLE Joseph and Mary travel to Jerusalem for the feast of Passover (the celebration of the release of the Jews from bondage to the pharaohs of Egypt). Jesus, only 12 years old at the time, engages in learned debate with astonished Jewish scholars in the temple, foretelling his ministry.

PUBLIC MINISTRY

The public ministry cycle comprises the teachings of Jesus and the miracles he performed.

BAPTISM The beginning of Jesus' public ministry is marked by his baptism at age 30 by John the Baptist in the Jordan River, where the dove of the Holy Spirit appears and God's voice is heard proclaiming Jesus as his son.

CALLING OF MATTHEW Jesus summons Matthew, a tax collector, to follow him, and Matthew becomes one of his 12 disciples, or *apostles* (from the Greek for "messenger"), and later the author of one of the four Gospels.

MIRACLES In the course of his teaching and travels, Jesus performs many miracles, revealing his divine nature. These include acts of healing and the raising of the dead, the turning of water into wine, walking on water and calming storms, and the creation of wondrous quantities of food. In the miracle of loaves and fishes, for example, Jesus transforms a few loaves of bread and a handful of fishes into enough food to feed several thousand people.

DELIVERY OF THE KEYS TO PETER The fisherman Peter was one of the first Jesus summoned as a disciple. Jesus chooses Peter (whose name means "rock") as his successor. He declares that Peter is the rock on which his church will be built, and symbolically delivers to Peter the keys to the kingdom of heaven.

TRANSFIGURATION Jesus scales a high mountain and, in the presence of Peter and two other disciples, James and John the Evangelist, is transformed into radiant light. God, speaking from a cloud, discloses that Jesus is his son.

CLEANSING OF THE TEMPLE Jesus returns to Jerusalem, where he finds money changers and merchants conducting business in

The Life of Jesus in Art (continued)

the temple. He rebukes them and drives them out of the sacred precinct.

PASSION

The Passion (from Latin *passio*, "suffering") cycle includes the episodes leading to Jesus' death, Resurrection, and ascent to heaven.

ENTRY INTO JERUSALEM On the Sunday before his Crucifixion (Palm Sunday), Jesus rides triumphantly into Jerusalem on a donkey, accompanied by disciples. Crowds of people enthusiastically greet Jesus and place palm fronds in his path.

LAST SUPPER AND WASHING OF THE DISCIPLES' FEET In Jerusalem, Jesus celebrates Passover with his disciples. During this Last Supper, Jesus foretells his imminent betrayal, arrest, and death and invites the disciples to remember him when they eat bread (symbol of his body) and drink wine (his blood). This ritual became the celebration of Mass *(Eucharist)* in the Christian Church. At the same meal, Jesus sets an example of humility for his apostles by washing their feet.

AGONY IN THE GARDEN Jesus goes to the Mount of Olives in the Garden of Gethsemane, where he struggles to overcome his human fear of death by praying for divine strength. The apostles who accompanied him there fall asleep despite his request that they stay awake with him while he prays.

BETRAYAL AND ARREST One of the disciples, Judas Iscariot, agrees to betray Jesus to the Jewish authorities in return for 30 pieces of silver. Judas identifies Jesus to the soldiers by kissing him, and Jesus is arrested. Later, a remorseful Judas hangs himself from a tree.

TRIALS OF JESUS AND DENIAL OF PETER Jesus is brought before Caiaphas, the Jewish high priest, and is interrogated about his claim to be the Messiah. Meanwhile, the disciple Peter thrice denies knowing Jesus, as Jesus predicted he would. Jesus is then brought before the Roman governor of Judaea, Pontius Pilate, on the charge of treason because he had proclaimed himself as King of the Jews. Pilate asks the crowd to choose between freeing Jesus or Barabbas, a murderer. The people choose Barabbas, and the judge condemns Jesus to death. Pilate washes his hands, symbolically relieving himself of responsibility for the mob's decision.

FLAGELLATION AND MOCKING The Roman soldiers who hold Jesus captive whip (flagellate) him and mock him by dressing him as King of the Jews and placing a crown of thorns on his head.

CARRYING OF THE CROSS, RAISING OF THE CROSS, AND CRUCIFIXION The Romans force Jesus to carry the cross on which he will be crucified from Jerusalem to Mount Calvary (Golgotha, the "place of the skull," where Adam was buried). He falls three times and gets stripped along the way. Soldiers erect the cross and nail his hands and feet to it. Jesus' mother, John the Evangelist, and Mary Magdalene mourn at the foot of the cross, while soldiers torment Jesus. One of them (the centurion Longinus) stabs his side with a spear. After suffering great pain, Jesus dies. The Crucifixion occurred on a Friday, and Christians celebrate the day each year as Good Friday.

DEPOSITION, LAMENTATION, AND ENTOMBMENT Two disciples, Joseph of Arimathea and Nicodemus, remove Jesus' body from the cross (the Deposition); sometimes those present at the Crucifixion look on. They take Jesus to the tomb Joseph had purchased for himself, and Joseph, Nicodemus, the Virgin Mary, Saint John the Evangelist, and Mary Magdalene mourn over the dead Jesus (the Lamentation). (When in art the isolated figure of the Virgin Mary cradles her dead son in her lap, it is called a *Pietà* [Italian for "pity"]). In portrayals of the Entombment, his followers lower Jesus into a sarcophagus in the tomb.

DESCENT INTO LIMBO During the three days he spends in the tomb, Jesus (after death, Christ) descends into Hell, or Limbo, and triumphantly frees the souls of the righteous, including Adam, Eve, Moses, David, Solomon, and John the Baptist. In Byzantine art, this episode is often labeled *Anastasis* (Greek, "resurrection"), although it refers to events preceding Christ's emergence from the tomb and reappearance on earth.

RESURRECTION AND THREE MARYS AT THE TOMB On the third day (Easter Sunday), Christ rises from the dead and leaves the tomb while the guards outside are sleeping. The Virgin Mary, Mary Magdalene, and Mary, the mother of James, visit the tomb, find it empty, and learn from an angel that Christ has been resurrected.

NOLI ME TANGERE, SUPPER AT EMMAUS, AND DOUBTING OF THOMAS During the 40 days between Christ's Resurrection and his ascent to heaven, he appears on several occasions to his followers. Christ warns Mary Magdalene, weeping at his tomb, with the words "Don't touch me" (*Noli me tangere* in Latin), but he tells her to inform the apostles of his return. At Emmaus he eats supper with two of his astonished disciples. Later, Thomas, who cannot believe that Christ has risen, is invited to touch the wound in his side that he received at his Crucifixion.

ASCENSION On the 40th day, on the Mount of Olives, with his mother and apostles as witnesses, Christ gloriously ascends to heaven in a cloud.

Greco-Roman Temple Design and the Classical Orders

The gable-roofed columnar stone temples of the Greeks and Romans have had more influence on the later history of architecture in the Western world than any other building type ever devised. Many of the elements of classical temple architecture are present in buildings from the Renaissance to the present day. We outline here the basic design principles of Greek and Roman temples and the most important components of the classical orders.

TEMPLE DESIGN The core of a Greco-Roman temple was the *cella,* a room with no windows that usually housed the statue of the god or goddess to whom the shrine was dedicated. Generally, only the priests, priestesses, and chosen few would enter the cella.

Worshipers gathered in front of the building, where sacrifices occurred at open-air altars. In most Greek temples, a *colonnade* was erected all around the cella to form a *peristyle*. In contrast, Roman temples usually have freestanding columns only in a porch at the front of the building. Sometimes, as in our example, *engaged* (attached) half-columns adorn three sides of the cella to give the building the appearance of a *peripteral* temple.

CLASSICAL ORDERS The Greeks developed two basic architectural orders, or design systems: the *Doric* and the *Ionic*. The forms of the columns and *entablature* (superstructure) generally differentiate the orders. Classical columns have two or three parts,

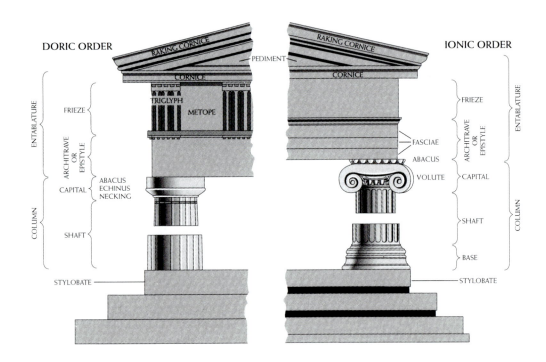

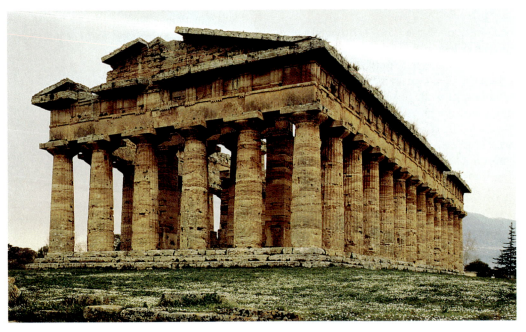

Greek Doric temple (Temple of Hera II, Paestum, Italy, ca. 460 BCE)

Greco-Roman Temple Design and the Classical Orders *(continued)*

depending on the order: the shaft, which is usually marked with vertical channels *(flutes)*; the *capital*; and, in the Ionic order, the *base*. The Doric capital consists of a round *echinus* beneath a square abacus block. Spiral *volutes* constitute the distinctive feature of the Ionic capital. Classical entablatures have three parts: the *architrave,* the *frieze,* and the triangular *pediment* of the gabled roof. In the Doric order, the frieze is subdivided into *triglyphs* and *metopes,* whereas in the Ionic, the frieze is left open.

The *Corinthian capital,* a later Greek invention very popular in Roman times, is more ornate than either the Doric or Ionic. It consists of a double row of acanthus leaves, from which tendrils and flowers emerge. Although this capital often is cited as the distinguishing element of the Corinthian order, strictly speaking no Corinthian order exists. Architects simply substituted the new capital type for the volute capital in the Ionic order.

Sculpture played a major role on the exterior of classical temples, partly to embellish the deity's shrine and partly to tell something about the deity to those gathered outside. Sculptural ornament was concentrated on the upper part of the building, in the pediment and frieze.

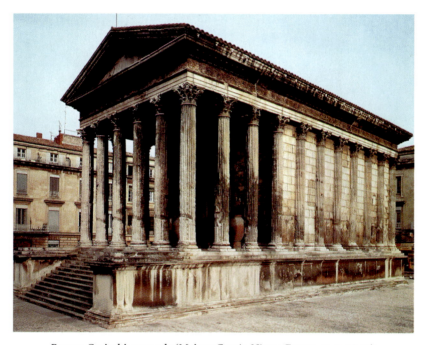

Roman Corinthian temple (Maison Carrée, Nîmes, France, ca. 1–10 CE)

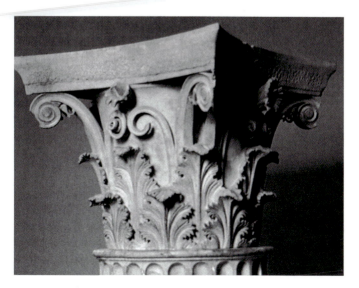

Corinthian capital (Tholos, Epidauros, Greece, ca. 350 BCE)

Arches and Vaults

Although earlier architects used both arches and vaults, the Romans employed them more extensively and effectively than any other ancient civilization. The Roman forms became staples of architectural design from the Middle Ages until today.

ARCH The arch is an alternate way of spanning a passageway. The Romans preferred it to the *post-and-lintel* (column-and-architrave) system used in the Greek orders. Arches are constructed using wedge-shaped stone blocks called *voussoirs*. The central voussoir is the arch's *keystone*.

BARREL VAULT Also called the *tunnel vault*, the barrel vault is an extension of a simple arch, creating a semicylindrical ceiling over parallel walls.

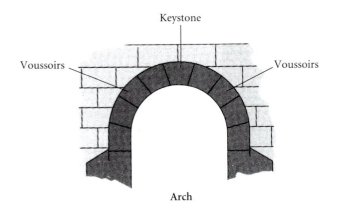

Arch

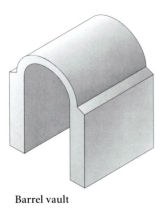

Barrel vault

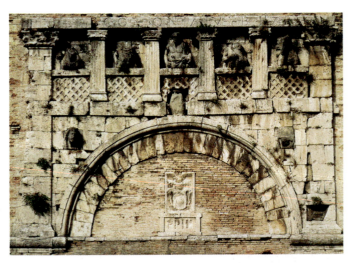

Etruscan gate (Porta Marzia, Perugia, Italy, second century BCE)

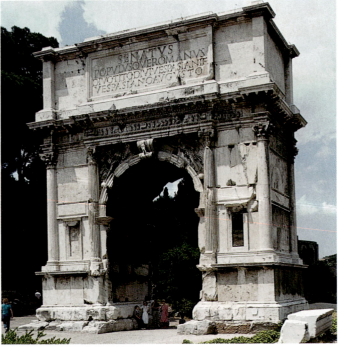

Roman arch (Arch of Titus, Rome, Italy, 81 CE)

Arches and Vaults (continued)

GROIN VAULT The groin or *cross vault* is formed by the intersection at right angles of two barrel vaults of equal size. When a series of groin vaults covers an interior hall, the open lateral arches of the vaults function as windows admitting light to the building.

DOME The hemispherical dome may be described as a round arch rotated around the full circumference of a circle, usually resting on a cylindrical *drum*. The Romans usually constructed domes using *concrete*, a mix of lime mortar, volcanic sand, water,

and small stones, instead of with large stone blocks. Concrete dries to form a solid mass of great strength, which allowed the Romans to puncture the apex of a concrete dome with an *oculus* (eye), so that much-needed light could reach the often vast spaces beneath.

Barrel vaults, as noted, resemble tunnels, and groin vaults are usually found in a series covering a similar *longitudinally* oriented interior space. Domes, in contrast, crown *centrally* planned buildings, so named because the structure's parts are of equal or almost equal dimensions around the center.

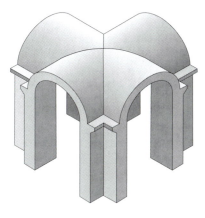

Groin vault

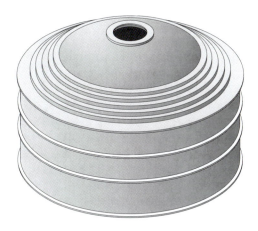

Hemispherical dome with oculus

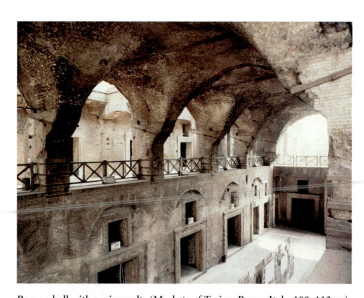

Roman hall with groin vaults (Markets of Trajan, Rome, Italy, 100–112 CE)

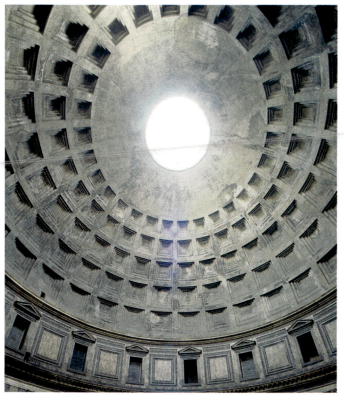

Roman dome with oculus (Pantheon, Rome, Italy, 118–125 CE)

The Basilican Church

Church design during the Middle Ages set the stage for eccle-siastical architecture from the Renaissance to the present. Both the longitudinal and central-plan building types of antiquity had a long postclassical history.

In Western Christendom, the typical church had a *basilican* plan, which evolved from the Roman columnar hall, or *basilica*. One of the earliest and most famous of these churches was Saint Peter's in Rome, begun ca. 320. It was typical of Early Christian church design. Covered by a simple timber roof, the basilican church had a wide central columnar *nave* flanked by *aisles* (four

in the case of Saint Peter's) and ending in an apse. Saint Peter's also had a *transept*, an area perpendicular to the nave. The nave and transept intersect at the *crossing*.

The original Saint Peter's was entirely rebuilt beginning in the 15th century, but one can get some idea of its character from our photograph of the interior of the more modestly propor-tioned fifth-century church of Santa Sabina, which has a nave and two aisles. Light entered the church through *clerestory* win-dows situated between the timber roof and the columnar *nave arcade*.

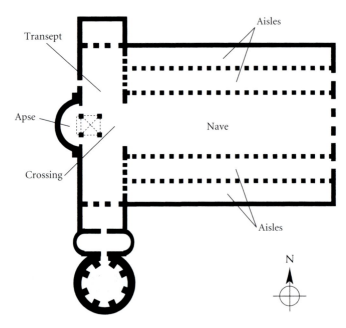

Old Saint Peter's, Rome, Italy, begun ca. 320

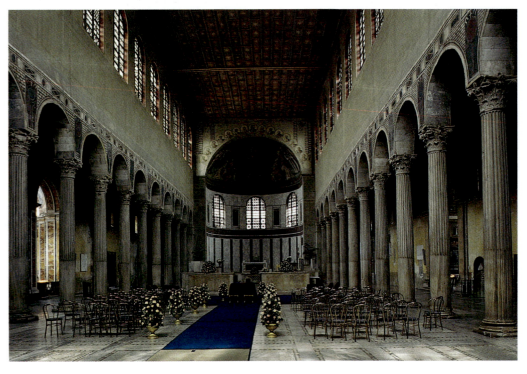

Santa Sabina, Rome, Italy, 422–432

The Basilican Church (continued)

The basilican church underwent many changes during the millennium following the construction of Old Saint Peter's, but its essential form endured. The great European cathedrals of the Gothic age, which were the immediate predecessors of the churches of the Renaissance and Baroque eras, shared many elements of the Early Christian basilica, including the nave, aisles, apse, transept, and crossing, but also had many new features. To illustrate the key components of Gothic design, we illustrate an "exploded" view of a typical Gothic cathedral and the plan of Chartres Cathedral.

In late medieval basilican churches, architects frequently extended the aisles around the apse to form an *ambulatory*, onto which opened *radiating chapels* housing sacred relics. Groin vaults formed the ceiling of the nave, aisles, ambulatory, and transept alike. These vaults rested on *diagonal* and *transverse ribs* in the form of pointed arches. On the exterior, *flying buttresses* held the nave vaults in place. These masonry struts transferred the thrust of the nave vaults across the roofs of the aisles to tall piers frequently capped by pointed ornamental *pinnacles*. This structural system made it possible to open up the walls above the nave arcade more fully than ever before, with huge *stained-glass* clerestory windows beneath the nave vaults.

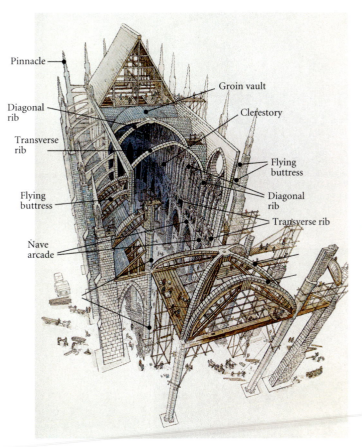

Typical Gothic cathedral

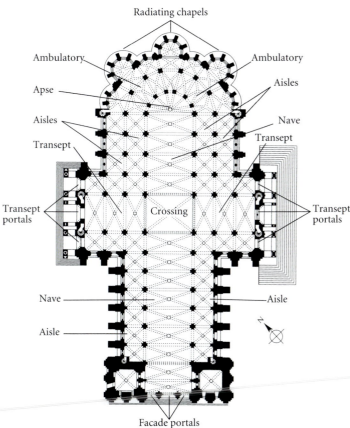

Chartres Cathedral, Chartres, France, rebuilt after 1194

The Central-Plan Church

The domed central plan of classical antiquity dominated the architecture of the Byzantine Empire, but with important modifications. Because the dome covered the crossing of a Byzantine church, architects had to find a way to erect domes on square bases instead of on the circular bases (cylindrical drums) of Roman buildings. The solution was *pendentive* construction in which the dome rests on what is in effect a second, larger dome. The top portion and four segments around the rim of the larger dome are omitted, creating four curved triangles, or pendentives. The pendentives join to form a ring and four arches whose planes bound a square. The first use of pendentives on a grand scale occurred in the sixth-century church of Hagia Sophia (Holy Wisdom) in Constantinople.

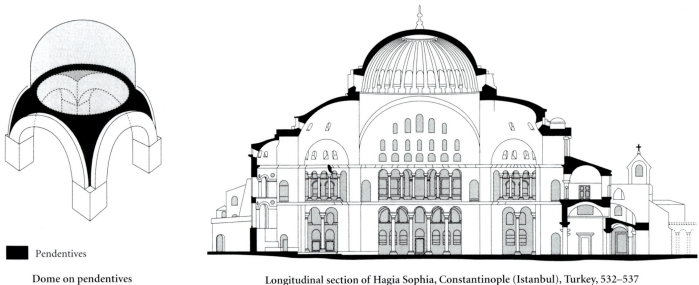

■ Pendentives

Dome on pendentives

Longitudinal section of Hagia Sophia, Constantinople (Istanbul), Turkey, 532–537

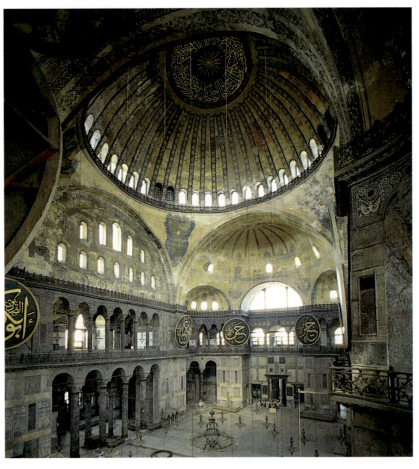

Hagia Sophia, Constantinople (Istanbul), Turkey, 532–537

The Central-Plan Church (continued)

In later Byzantine architecture, the typical church plan took the form of a cross with arms of almost equal length. Sometimes, as in the 11th-century church of Saint Mark's in Venice, a dome on pendentives crowned all four arms of the structure as well as the crossing.

The interiors of Byzantine churches differed from those of basilican churches in the West not only in plan but also in the manner in which they were adorned. The mosaic decoration of Hagia Sophia is lost, but at Saint Mark's some 40,000 square feet of mosaics cover all the walls, arches, vaults, and domes.

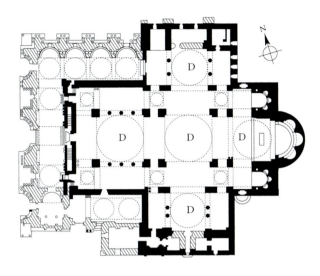

\\\\\ Additions to original structure D = Dome

Saint Mark's, Venice, Italy, begun 1063

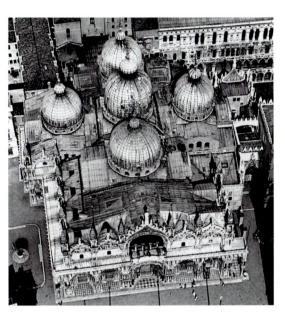

Aerial view of Saint Mark's

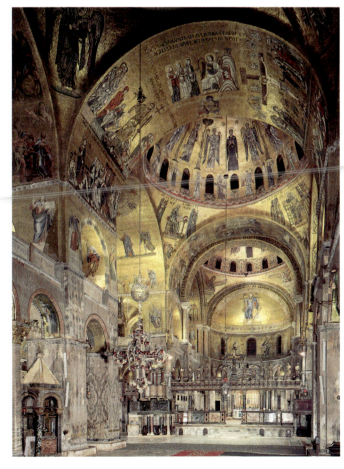

Interior of Saint Mark's

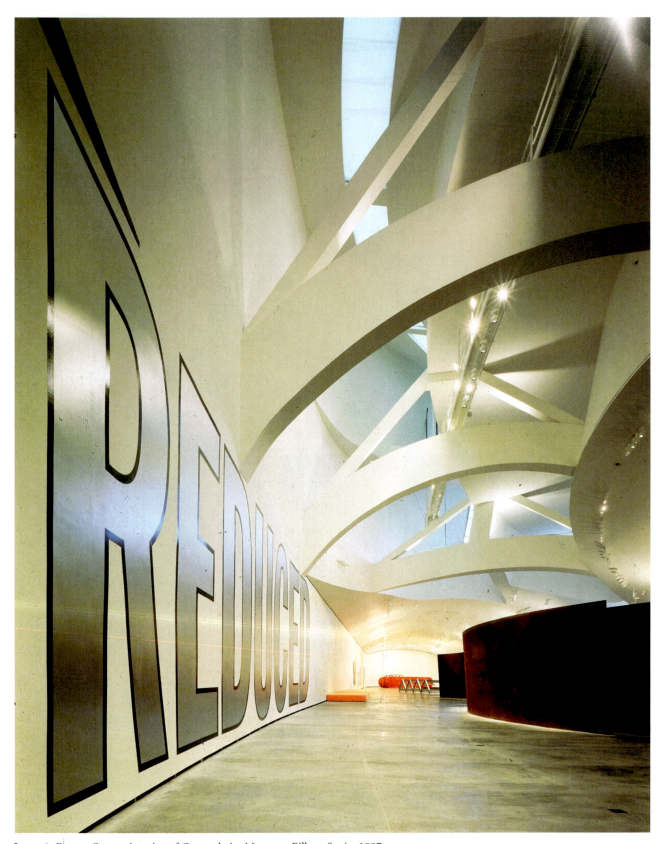

Intro-1 Frank Gehry, interior of Guggenheim Museum, Bilbao, Spain, 1997.

INTRODUCTION

THE SUBJECTS AND VOCABULARY OF ART HISTORY

People do not often juxtapose the terms *art* and *history*. They tend to think of history as the record and interpretation of past human actions, particularly social and political actions. Most think of art, quite correctly, as part of the present—as something people can see and touch. People cannot, of course, see or touch history's vanished human events. But a visible and tangible artwork is a kind of persisting event. One or more artists made it at a certain time and in a specific place, even if no one now knows just who, when, where, or why. Although created in the past, an artwork continues to exist in the present, long surviving its times. The first painters and sculptors died 30,000 years ago, but their works remain, some of them exhibited in glass cases in museums built only a few years ago.

Modern museum visitors can admire these relics of the remote past and the countless other objects humankind has produced over the millennia without any knowledge of the circumstances that led to the creation of those works. The beauty or sheer size of an object can impress people, the artist's virtuosity in the handling of ordinary or costly materials can dazzle them, or the subject depicted can move them. Viewers can react to what they see, interpret the work in the light of their own experience, and judge it a success or a failure. These are all valid responses to a work of art. But the enjoyment and appreciation of artworks in museum settings (FIG. **Intro-1**) are relatively recent phenomena, as is the creation of artworks solely for museum-going audiences to view.

Today, it is common for artists to work in private studios and to create paintings, sculptures, and other objects commercial art galleries will offer for sale. Usually, someone the artist has never met will purchase the artwork and display it in a setting the artist has never seen. But although this is not a new phenomenon in the history of art—an ancient potter decorating a vase for sale at a village market stall also probably did not know who would buy the pot or where it would be housed—it is not at all typical. In fact, it is exceptional. Throughout history, most artists created the paintings, sculptures, and other objects exhibited in museums today for specific patrons and settings and to fulfill a specific purpose. Often, no one knows the original contexts of those artworks.

Although people may appreciate the visual and tactile qualities of these objects, they cannot understand why they were made or why they look the way they do without knowing the circumstances of their creation. *Art appreciation* does not require knowledge of the historical context of an artwork (or a building). *Art history* does.

Thus, a central aim of art history is to determine the original context of artworks. Art historians seek to achieve a full understanding not only of why these "persisting events" of human history look the way they do but also of why the artistic events happened at all. What unique set of circumstances gave rise to the erection of a particular building or led a specific patron to commission an individual artist to fashion a singular artwork for a certain place? The study of history is therefore vital to art history. And art history is often very important to the study of history. Art objects and buildings are historical documents that can shed light on the peoples who made them and on the times of their creation in a way other historical documents cannot. Furthermore, artists and architects can affect history by reinforcing or challenging cultural values and practices through the objects they create and the structures they build. Thus, the history of art and architecture is inseparable from the study of history, although the two disciplines are not the same. In the following pages, we outline some of the distinctive subjects art historians address and the kinds of questions they ask, and explain some of the basic terminology art historians use when answering their questions. Armed with this arsenal of questions and terms, you will be ready to explore the multifaceted world of art through the ages.

ART HISTORY IN THE 21ST CENTURY

Art historians study the visual and tangible objects humans make and the structures humans build. Scholars traditionally have classified such works as architecture, sculpture, the pictorial arts (painting, drawing, printmaking, and photography), and the craft arts, or arts of design. The craft arts comprise utilitarian objects, such as ceramics, metalwares, textiles, jewelry, and similar accessories of ordinary living. Artists of every age have blurred the boundaries between these categories, but this is especially true today, when *multimedia* works abound.

From the earliest Greco-Roman art critics on, scholars have studied objects that their makers consciously manufactured as "art" and to which the artists assigned formal titles. But today's art historians also study a vast number of objects that their creators and owners almost certainly did not consider to be "works of art." Few ancient Romans, for example, would have regarded a coin bearing their emperor's portrait as anything but money. Today, an art museum may exhibit that coin in a locked case in a climate-controlled room, and scholars may subject it to the same kind of art historical analysis as a portrait by an acclaimed Renaissance or modern sculptor or painter.

The range of objects art historians study is constantly expanding and now includes, for example, computer-generated images, whereas in the past almost anything produced using a machine would not have been regarded as art. Most people still consider the performing arts—music, drama, and dance—as outside art history's realm because these arts are fleeting, impermanent media. But recently even this distinction between "fine art" and performance art has become blurred. Art historians, however, generally ask the same kinds of questions about what they study, whether they employ a restrictive or expansive definition of art.

The Questions Art Historians Ask

HOW OLD IS IT? Before art historians can construct a history of art, they must be sure they know the date of each work they study. Thus, an indispensable subject of art historical inquiry is *chronology*, the dating of art objects and buildings. If researchers cannot determine a monument's age, they cannot place the work in its historical context. Art historians have developed many ways to establish, or at least approximate, the date of an artwork.

Physical evidence often reliably indicates an object's age. The material used for a statue or painting—bronze, plastic, or oil-based pigment, to name only a few—may not have been invented before a certain time, indicating the earliest possible date someone could have fashioned the work. Or artists may have ceased using certain materials—such as specific kinds of inks and papers for drawings and prints—at a known time, providing the latest possible dates for objects made of such materials. Sometimes the material (or the manufacturing technique) of an object or a building can establish a very precise date of production or construction. Studying tree rings, for instance, usually can determine within a narrow range the date of a wood statue or a timber roof beam.

Documentary evidence also can help pinpoint the date of an object or building when a dated written document mentions the work. For example, official records may note when church officials commissioned a new altarpiece—and how much they paid to which artist.

Visual evidence, too, can play a significant role in dating an artwork. A painter might have depicted an identifiable person or a kind of hairstyle, clothing, or furniture fashionable only at a certain time. If so, the art historian can assign a more accurate date to that painting.

Stylistic evidence is also very important. The analysis of *style*—an artist's distinctive manner of producing an object, the way a work looks—is the art historian's special sphere. Unfortunately, because it is a subjective assessment, stylistic evidence is by far the most unreliable chronological criterion. Still, art historians sometimes find style a very useful tool for establishing chronology.

WHAT IS ITS STYLE? Defining artistic style is one of the key elements of art historical inquiry, although the analysis of artworks solely in terms of style no longer dominates the field the way it once did. Art historians speak of several different kinds of artistic styles.

Period style refers to the characteristic artistic manner of a specific time, usually within a distinct culture, such as "Archaic Greek" or "Late Byzantine." But many periods do not display any stylistic unity at all. How would someone define the artistic style of the opening decade of the new millennium in North America? Far too many crosscurrents exist in contemporary art for anyone to describe a period style of the early 21st century—even in a single city such as New York.

Regional style is the term art historians use to describe variations in style tied to geography. Like an object's date, its *provenance*, or place of origin, can significantly determine its character. Very often two artworks from the same place made centuries apart are more similar than contemporaneous works from two different regions. To cite one example, usually only an expert can distinguish between an Egyptian statue carved in 2500 BCE and one made in 500 BCE. But no one would mistake an Egyptian statue of 500 BCE for one of the same date made in Greece or Mexico.

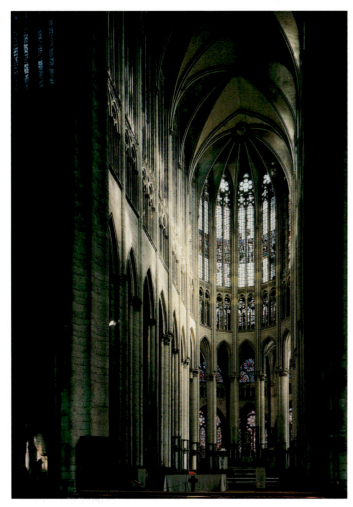

Intro-2 Choir of Beauvais Cathedral, Beauvais, France, rebuilt after 1284.

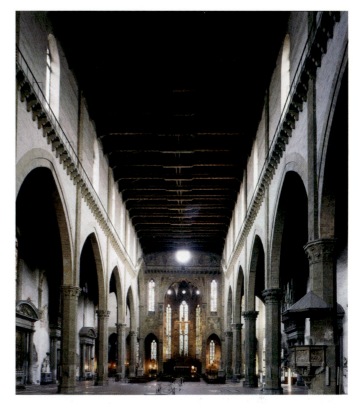

Intro-3 Interior of Santa Croce, Florence, Italy, begun 1294.

Intro-4 GEORGIA O'KEEFFE, *Jack-in-the-Pulpit No. 4*, 1930. Oil on canvas, 3′ 4″ × 2′ 6″. National Gallery of Art, Washington (Alfred Stieglitz Collection, bequest of Georgia O'Keeffe).

Considerable variations in a given area's style are possible, however, even during a single historical period. In late medieval Europe during the so-called Gothic age, French architecture differed significantly from Italian architecture. The interiors of Beauvais Cathedral (FIG. **Intro-2**) and Santa Croce in Florence (FIG. **Intro-3**) typify the architectural styles of France and Italy, respectively, at the end of the 13th century. The rebuilding of the choir of Beauvais Cathedral began in 1284. Construction commenced on Santa Croce only 10 years later. Both structures employ the characteristic Gothic pointed arch, yet they contrast strikingly. The French church has towering stone vaults and large expanses of stained-glass windows, whereas the Italian building has a low timber roof and small, widely separated windows. Because the two contemporaneous churches served similar purposes, regional style mainly explains their differing appearance.

Personal style, the distinctive manner of individual artists or architects, often decisively explains stylistic discrepancies among monuments of the same time and place. In 1930 the American painter GEORGIA O'KEEFFE produced a series of paintings of flowering plants. One of them was *Jack-in-the-Pulpit No. 4* (FIG. **Intro-4**), a sharply focused close-up view of petals and leaves. O'Keeffe captured the growing plant's slow, controlled motion while converting the plant into a powerful abstract composition of lines, forms, and colors (see the discussion of art historical vocabulary in the next section). Only a year later, another American artist, BEN SHAHN, painted *The Passion of Sacco and Vanzetti*

The different kinds of artistic styles are not mutually exclusive. For example, an artist's personal style may change dramatically during a long career. Art historians then must distinguish among the different period styles of a particular artist, such as the "Blue Period" and the "Cubist Period" of the prolific 20th-century artist Pablo Picasso.

WHAT IS ITS SUBJECT? Another major concern of art historians is, of course, subject matter, encompassing the story, or *narrative;* the scene presented; the action's time and place; the persons involved; and the environment and its details. Some artworks, such as modern abstract paintings, have no subject, not even a setting. But when artists represent people, places, or actions, viewers must identify these aspects to achieve complete understanding of the work. Art historians traditionally separate pictorial subjects into various categories, such as religious, historical, mythological, *genre* (daily life), portraiture, *landscape* (a depiction of a place), *still life* (an arrangement of inanimate objects), and their numerous subdivisions and combinations.

Iconography—literally, the "writing of images"—refers both to the *content,* or subject of an artwork, and to the study of content in art. By extension, it also includes the study of *symbols,* images that stand for other images or encapsulate ideas. In Christian art, two intersecting lines of unequal length or a simple geometric cross can serve as an emblem of the religion as a whole, symbolizing the cross of Jesus Christ's crucifixion. A symbol also can be a familiar object the artist imbued with greater meaning. A balance or scale, for example, may symbolize justice or the weighing of souls on Judgment Day (FIG. **Intro-6**).

Artists also may depict figures with unique *attributes* identifying them. In Christian art, for example, each of the authors of the New Testament Gospels, the Four Evangelists (FIG. **Intro-7**), has a

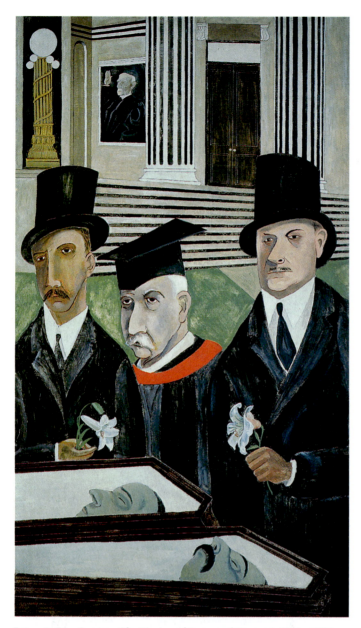

Intro-5 BEN SHAHN, *The Passion of Sacco and Vanzetti,* 1931–1932. Tempera on canvas, 7' $\frac{1}{2}$" × 4'. Whitney Museum of American Art, New York (gift of Edith and Milton Lowenthal in memory of Juliana Force).

(FIG. **Intro-5**), a stinging commentary on social injustice inspired by the trial and execution of two Italian anarchists, Nicola Sacco and Bartolomeo Vanzetti. Many people believed Sacco and Vanzetti had been unjustly convicted of killing two men in a holdup in 1920. Shahn's painting compresses time in a symbolic representation of the trial and its aftermath. The two executed men lie in their coffins. Presiding over them are the three members of the commission (headed by a college president wearing academic cap and gown) that declared the original trial fair and cleared the way for the executions. Behind, on the wall of a columned government building, hangs the framed portrait of the judge who pronounced the initial sentence. Personal style, not period or regional style, sets Shahn's canvas apart from O'Keeffe's. The contrast is extreme here because of the very different subjects the artists chose. But even when two artists depict the same subject, the results can vary widely. The *way* O'Keeffe painted flowers and the *way* Shahn painted faces are distinctive and unlike the styles of their contemporaries. (See the "Who Made It?" discussion on page xxxi.)

Intro-6 GISLEBERTUS, The weighing of souls, detail of Last Judgment, west tympanum of Saint-Lazare, Autun, France, ca. 1120–1135.

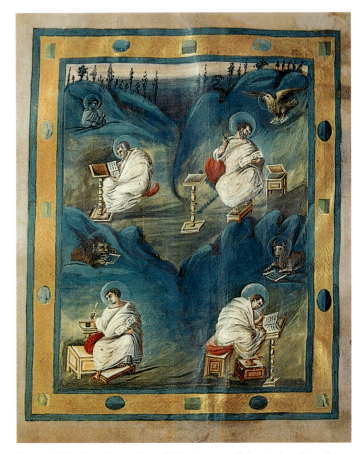

Intro-7 The Four Evangelists, folio 14 verso of the *Aachen Gospels,* ca. 810. Ink and tempera on vellum, $1' \times 9\frac{1}{2}''$. Cathedral Treasury, Aachen.

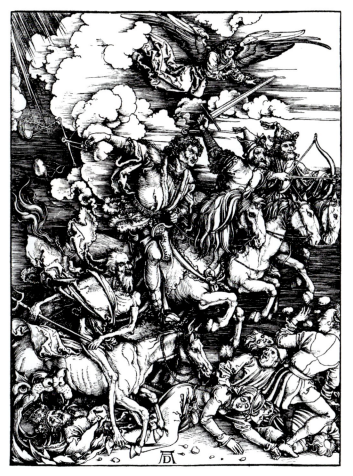

Intro-8 ALBRECHT DÜRER, *The Four Horsemen of the Apocalypse,* ca. 1498. Woodcut, approx. $1' \ 3\frac{1}{4}'' \times 11''$. Metropolitan Museum of Art, New York (gift of Junius S. Morgan, 1919).

distinctive attribute. Saint John is known by his eagle, Luke by an ox, Mark by a lion, and Matthew by a winged man.

Throughout the history of art, artists also used *personifications*—abstract ideas codified in bodily form. Worldwide, people visualize Liberty as a robed woman with a torch because of the fame of the colossal statue set up in New York City's harbor in the 19th century. *The Four Horsemen of the Apocalypse* (FIG. **Intro-8**) is a terrifying late-15th-century depiction of the fateful day at the end of time when, according to the Bible's last book, Death, Famine, War, and Pestilence will cut down the human race. The artist, ALBRECHT DÜRER, personified Death as an emaciated old man with a pitchfork. Dürer's Famine swings the scales that will weigh human souls (compare FIG. Intro-6), War wields a sword, and Pestilence draws a bow.

Even without considering style and without knowing a work's maker, informed viewers can determine much about the work's period and provenance by iconographical and subject analysis alone. In *The Passion of Sacco and Vanzetti* (FIG. Intro-5), for example, the two coffins, the trio headed by an academic, and the robed judge in the background are all pictorial clues revealing the painting's subject. The work's date must be after the trial and execution, probably while the event was still newsworthy. And because the two men's deaths caused the greatest outrage in the United States, the painter–social critic was probably American.

WHO MADE IT? If Ben Shahn had not signed his painting of Sacco and Vanzetti, an art historian could still assign, or *attribute,*

the work to him based on knowledge of the artist's personal style. Although signing (and dating) works is quite common (but by no means universal) today, in the history of art countless works exist whose artists remain unknown. Because personal style can play a large role in determining the character of an artwork, art historians often try to attribute anonymous works to known artists. Sometimes they attempt to assemble a group of works all thought to be by the same person, even though none of the objects in the group is the known work of an artist with a recorded name. Art historians thus reconstruct the careers of people such as "the Andokides Painter," the anonymous ancient Greek artist who painted the vases produced by the potter Andokides. Scholars base their attributions on internal evidence, such as the distinctive way an artist draws or carves drapery folds, earlobes, or flowers. It requires a keen, highly trained eye and long experience to become a *connoisseur,* an expert in assigning artworks to "the hand" of one artist rather than another. Attribution is, of course, subjective and ever open to doubt. At present, for example, international debate rages over attributions to the famous Dutch painter Rembrandt.

Sometimes a group of artists works in the same style at the same time and place. Art historians designate such a group as a *school.* "School" does not mean an educational institution. The term connotes only chronological, stylistic, and geographic similarity. Art historians speak, for example, of the Dutch school of the 17th century and, within it, of subschools such as those of the cities of Haarlem, Utrecht, and Leyden.

Intro-11 CLAUDE LORRAIN, *Embarkation of the Queen of Sheba,* 1648. Oil on canvas, approx. 4′ 10″ × 6′ 4″. National Gallery, London.

as sculpture, pottery, or furniture. Volume and mass describe both the exterior and interior forms of a work of art—the forms of the matter of which it is composed and the spaces immediately around the work and interacting with it.

PERSPECTIVE AND FORESHORTENING *Perspective* is one of the most important pictorial devices for organizing forms in space. Throughout history, artists have used various types of perspective to create an illusion of depth or space on a two-dimensional surface. The French painter CLAUDE LORRAIN employed several perspectival devices in *Embarkation of the Queen of Sheba* (FIG. **Intro-11**), a painting of a biblical episode set in a 17th-century European harbor with a Roman ruin in the left foreground. For example, the figures and boats on the shoreline are much larger than those in the distance. Decreasing the size of an object makes it appear farther away from viewers. Also, the top and bottom of the port building at the painting's right side are not parallel horizontal lines, as they are in an actual building. Instead, the lines converge beyond the structure, leading viewers' eyes toward the hazy, indistinct sun on the horizon. These perspectival devices—the reduction of figure size, the convergence of diagonal lines, and the blurring of distant forms—have been familiar features of Western art since the ancient Greeks. But it is important to note at the outset that all kinds of perspective

are only pictorial conventions, even when one or more types of perspective may be so common in a given culture that they are accepted as "natural" or as "true" means of representing the natural world.

In *White and Red Plum Blossoms* (FIG. **Intro-12**), a Japanese landscape painting on two folding screens, OGATA KORIN used none of these Western perspective conventions. He showed the two plum trees as seen from a position on the ground, while viewers look down on the stream between them from above. Less concerned with locating the trees and stream in space than with composing shapes on a surface, the painter played the water's gently swelling curves against the jagged contours of the branches and trunks. Neither the French nor the Japanese painting can be said to project "correctly" what viewers "in fact" see. One painting is not a "better" picture of the world than the other. The European and Asian artists simply approached the problem of picture-making differently.

Artists also represent single figures in space in varying ways. When PETER PAUL RUBENS painted *Lion Hunt* (FIG. **Intro-13**) in the early 17th century, he used *foreshortening* for all the hunters and animals—that is, he represented their bodies at angles to the picture plane. When in life one views a figure at an angle, the body appears to contract as it extends back in space. Foreshortening is a kind of perspective. It produces the illusion that one part of the

Intro-12 OGATA KORIN, *White and Red Plum Blossoms,* Edo period, ca. 1710–1716. Pair of twofold screens. Ink, color, and gold leaf on paper, each screen 5′ 1$\frac{5}{8}$″ × 5′ 7$\frac{7}{8}$″. MOA Art Museum, Shizuoka-ken, Japan.

body is farther away than another, even though all the forms are on the same surface. Especially noteworthy in *Lion Hunt* are the gray horse at the left, seen from behind with the bottom of its left rear hoof facing viewers and most of its head hidden by its rider's shield, and the fallen hunter at the painting's lower right corner, whose barely visible legs and feet recede into the distance.

The artist who carved the portrait of the ancient Egyptian official Hesire (FIG. **Intro-14**) did not employ foreshortening. That artist's purpose was to present the various human body parts as clearly as possible, without overlapping. The lower part of Hesire's body is in profile to give the most complete view of the legs, with both the heels and toes of the foot visible. The frontal torso, however, allows viewers to see its full shape, including both shoulders, equal in size, as in nature. (Compare the shoulders of the hunter

on the gray horse or those of the fallen hunter in *Lion Hunt*'s left foreground.) The result, an "unnatural" 90-degree twist at the waist, provides a precise picture of human body parts. Rubens and the Egyptian sculptor used very different means of depicting forms in space. Once again, neither is the "correct" manner.

PROPORTION AND SCALE *Proportion* concerns the relationships (in terms of size) of the parts of persons, buildings, or objects. "Correct proportions" may be judged intuitively ("that statue's head seems the right size for the body"). Or proportion may be formalized as a mathematical relationship between the size of one part of an artwork or building and the other parts within the work. Proportion in art implies using a *module,* or basic unit of measure. When an artist or architect uses a formal

Intro-13 PETER PAUL RUBENS, *Lion Hunt,* 1617–1618. Oil on canvas, approx. 8′ 2″ × 12′ 5″. Alte Pinakothek, Munich.

Intro-14 Hesire, from his tomb at Saqqara, Egypt, Dynasty III, ca. 2650 BCE. Wood, approx. 3′ 9″ high. Egyptian Museum, Cairo.

Intro-15 MICHELANGELO, unfinished captive, 1527–1528. Marble, 8′ 7½″ high. Accademia, Florence.

system of proportions, all parts of a building, body, or other entity will be fractions or multiples of the module. A module might be a column's diameter, the height of a human head, or any other component whose dimensions can be multiplied or divided to determine the size of the work's other parts.

In certain times and places, artists have formulated *canons,* or systems, of "correct" or "ideal" proportions for representing human figures, constituent parts of buildings, and so forth. In ancient Greece, many sculptors formulated canons of proportions so strict and all-encompassing that they calculated the size of every body part in advance, even the fingers and toes, according to mathematical ratios. The ideal of human beauty the Greeks created based on "correct" proportions influenced the work of countless later artists in the Western world (for example, FIG. **Intro-15**) and endures to this day. Proportional systems can differ sharply from period to period, culture to culture, and artist to artist. Part of the task art history students face is to perceive and adjust to these differences.

In fact, many artists have used *disproportion* and distortion deliberately for expressive effect. In the medieval French depiction of the weighing of souls on Judgment Day (FIG. Intro-6), the devilish figure yanking down on the scale has distorted facial features and stretched, lined limbs with animal-like paws for feet. Disproportion and distortion make him appear "inhuman," precisely as the sculptor intended.

In other cases, artists have used disproportion to focus attention on one body part (often the head) or to single out a group member (usually the leader). These intentional "unnatural" discrepancies in proportion constitute what art historians call *hierarchy of scale,* the enlarging of elements considered the most important. On a bronze plaque from Benin, Nigeria (FIG. **Intro-16**), the sculptor enlarged all the heads for emphasis and also varied the size of each figure according to its social status. Central, largest, and therefore most important is the Benin king, mounted on horseback. The horse has been a symbol of power and wealth in many societies from prehistory to the present. That the Benin king is disproportionately larger than his horse, contrary to nature, further aggrandizes him. Two large attendants fan the king. Other figures of smaller size and status at the Benin court stand on the king's left and right and in the plaque's upper corners. One tiny figure next to the horse is almost hidden from view beneath the king's feet.

CARVING AND CASTING Sculptural technique falls into two basic categories, *subtractive* and *additive. Carving* is a subtractive technique. The final form is a reduction of the original mass of a

Intro-16 King on horseback with attendants, from Benin, Nigeria, ca. 1550–1680. Bronze, 1′ 7½″ high. Metropolitan Museum of Art, New York (Michael C. Rockefeller Memorial Collection, gift of Nelson A. Rockefeller).

Intro-17 Head of a warrior, detail of a statue from the sea off Riace, Italy, ca. 460–450 BCE. Bronze, statue approx. 6′ 6″ high. Archaeological Museum, Reggio Calabria.

block of stone, a piece of wood, or another material. Wooden statues were once tree trunks, and stone statues began as blocks pried from mountains. In an unfinished 16th-century marble statue of a bound slave (FIG. Intro-15) by MICHELANGELO, the original shape of the stone block is still visible. Michelangelo thought of sculpture as a process of "liberating" the statue within the block. All sculptors of stone or wood cut away (subtract) "excess material." When they finish, they "leave behind" the statue—in our example, a twisting nude male form whose head Michelangelo never freed from the stone block.

In additive sculpture, the artist builds up the forms, usually in clay around a framework, or *armature.* Or a sculptor may fashion a *mold,* a hollow form for shaping, or *casting,* a fluid substance such as bronze. The ancient Greek sculptor who made the bronze statue of a warrior found in the sea near Riace, Italy, cast the head (FIG. **Intro-17**), limbs, torso, hands, and feet in separate molds and then *welded* them (joined them by heating). Finally, the artist added features, such as the pupils of the eyes (now missing), in other materials. The warrior's teeth are silver, and his lower lip is copper.

RELIEF SCULPTURE Statues or busts that exist independent of any architectural frame or setting and that viewers can walk around are *freestanding* sculptures, or *sculptures in the round,* whether the piece was carved (FIG. Intro-9) or cast (FIG. Intro-17). In *relief sculptures,* the subjects project from the background but remain part of it. In *high relief* sculpture, the images project boldly. In some cases, such as the weighing-of-souls relief at Autun (FIG. Intro-6), the relief is so high that not only do the forms

cast shadows on the background, but some parts are actually in the round. The arms of the scale are fully detached from the background in places—which explains why some pieces broke off centuries ago. In *low relief,* or *bas-relief,* such as the wooden relief of Hesire (FIG. Intro-14), the projection is slight. In a variation of both techniques, *sunken relief,* the sculptor cuts the design into the surface so that the image's highest projecting parts are no higher than the surface itself. Relief sculpture, like sculpture in the round, can be produced either by carving or casting. The plaque from Benin (FIG. Intro-16) is an example of bronze casting in high relief. Artists also can make reliefs by hammering a sheet of metal from behind, pushing the subject out from the background in a technique called *repoussé.*

ARCHITECTURAL DRAWINGS Buildings are groupings of enclosed spaces and enclosing masses. People experience architecture both visually and by moving through and around it, so they perceive architectural space and mass together. These spaces and masses can be represented graphically in several ways, including as plans, sections, elevations, and cutaway drawings.

A *plan,* essentially a map of a floor, shows the placement of a structure's masses and, therefore, the spaces they bound and

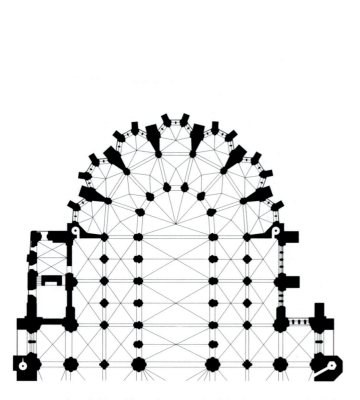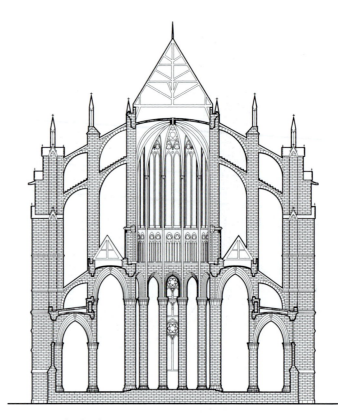

Intro-18 Plan *(left)* and lateral section *(right)* of Beauvais Cathedral, Beauvais, France, rebuilt after 1284.

enclose. A *section*, like a vertical plan, depicts the placement of the masses as if the building were cut through along a plane. Drawings showing a theoretical slice across a structure's width are *lateral sections*. Those cutting through a building's length are *longitudinal sections*. Illustrated here are the plan and lateral section of Beauvais Cathedral (FIG. **Intro-18**), which may be compared to the photograph of the church's choir (FIG. Intro-2). The plan shows not only the choir's shape and the location of the piers dividing the aisles and supporting the vaults above but also the pattern of the crisscrossing vault *ribs*. The lateral section shows not only the interior of the choir with its vaults and tall stained-glass windows but also the structure of the roof and the form of the exterior *buttresses* that hold the vaults in place.

Other types of architectural drawings appear throughout this book. An *elevation* drawing is a head-on view of an external or internal wall. A *cutaway* combines an exterior view with an interior view of part of a building in a single drawing.

This overview of the art historian's vocabulary is not exhaustive, nor have artists used only painting, drawing, sculpture, and architecture as media over the millennia. Ceramics, jewelry, textiles, photography, and computer art are just some of the numerous other arts. All of them involve highly specialized techniques described in distinct vocabularies. These are considered and defined where they arise in the text.

Art History and Other Disciplines

By its very nature, the work of art historians intersects with that of others in many fields of knowledge, not only in the humanities but also in the social and natural sciences. To "do their job" well

today, art historians regularly must go beyond the boundaries of what the public and even professional art historians of previous generations traditionally have considered the specialized discipline of art history. Art historical research in the 21st century is frequently *interdisciplinary* in nature. To cite one example, in an effort to unlock the secrets of a particular statue, an art historian might conduct archival research hoping to uncover new documents shedding light on who paid for the work and why, who made it and when, where it originally stood, how its contemporaries viewed it, and a host of other questions. Realizing, however, that the authors of the written documents often were not objective recorders of fact but observers with their own biases and agendas, the art historian may also use methodologies developed in such fields as literary criticism, philosophy, sociology, and gender studies to weigh the evidence the documents provide.

At other times, rather than attempting to master many disciplines at once, art historians band together with other specialists in *multidisciplinary* inquiries. Art historians might call in chemists to date an artwork based on the composition of the materials used or might ask geologists to determine which quarry furnished the stone for a particular statue. X-ray technicians might be enlisted in an attempt to establish whether or not a painting is a forgery. Of course, art historians often contribute their expertise to the solution of problems in other disciplines. A historian, for example, might ask an art historian to determine—based on style, material, iconography, and other criteria—if any of the portraits of a certain king were made after his death. That would help establish the ruler's continuing prestige during the reigns of his successors. (Some portraits of Augustus, FIG. Intro-9, the founder of the Roman Empire, postdate his death by decades, even centuries.)

Intro-19 JOHN SYLVESTER *(left)* and TE PEHI KUPE *(right),* portraits of Maori chief Te Pehi Kupe, 1826. From *The Childhood of Man,* by Leo Frobenius (New York: J. B. Lippincott, 1909).

DIFFERENT WAYS OF SEEING

The history of art can be a history of artists and their works, of styles and stylistic change, of materials and techniques, of images and themes and their meanings, and of contexts and cultures and patrons. The best art historians analyze artworks from many viewpoints. But no art historian (or scholar in any other field), no matter how broad-minded in approach and no matter how experienced, can be truly objective. Like artists, art historians are members of a society, participants in its culture. How can scholars (and museum visitors and travelers to foreign locales) comprehend cultures unlike their own? They can try to reconstruct the original cultural contexts of artworks, but they are bound to be limited by their distance from the thought patterns of the cultures they study and by the obstructions to understanding—the assumptions, presuppositions, and prejudices peculiar to their own culture—their own thought patterns raise. Art historians may reconstruct a distorted picture of the past because of culture-bound blindness.

A single instance underscores how differently people of diverse cultures view the world and how various ways of seeing can cause sharp differences in how artists depict the world. We illustrate two contemporaneous portraits of a 19th-century Maori chieftain side by side (FIG. **Intro-19**)—one by an Englishman, JOHN SYLVESTER, and the other by the New Zealand chieftain himself, TE PEHI KUPE. Both reproduce the chieftain's facial tattooing. The European artist included the head and shoulders and underplayed the tattooing. The tattoo pattern is one aspect of the likeness among many, no more or less important than the chieftain's dressing like a European. Sylvester also recorded his subject's momentary glance toward the right and the play of light on his hair, fleeting aspects that have nothing to do with the figure's identity.

In contrast, Te Pehi Kupe's self-portrait—made during a trip to Liverpool, England, to obtain European arms to take back to New Zealand—is not a picture of a man situated in space and bathed in light. Rather, it is the chieftain's statement of the supreme importance of the tattoo design that symbolizes his rank among his people. Remarkably, Te Pehi Kupe created the tattoo patterns from memory, without the aid of a mirror. The splendidly composed insignia, presented as a flat design separated from the body and even from the head, is Te Pehi Kupe's image of himself. Only by understanding the cultural context of each portrait can viewers hope to understand why either looks the way it does.

As noted at the outset, the study of the context of artworks and buildings is one of the central aims of art history. Our purpose in writing *Art through the Ages* is to present a history of art and architecture that will help you understand not only the subjects, styles, and techniques of paintings, sculptures, buildings, and other art forms created in all parts of the world for 30 millennia but also their cultural and historical contexts. That story now begins.

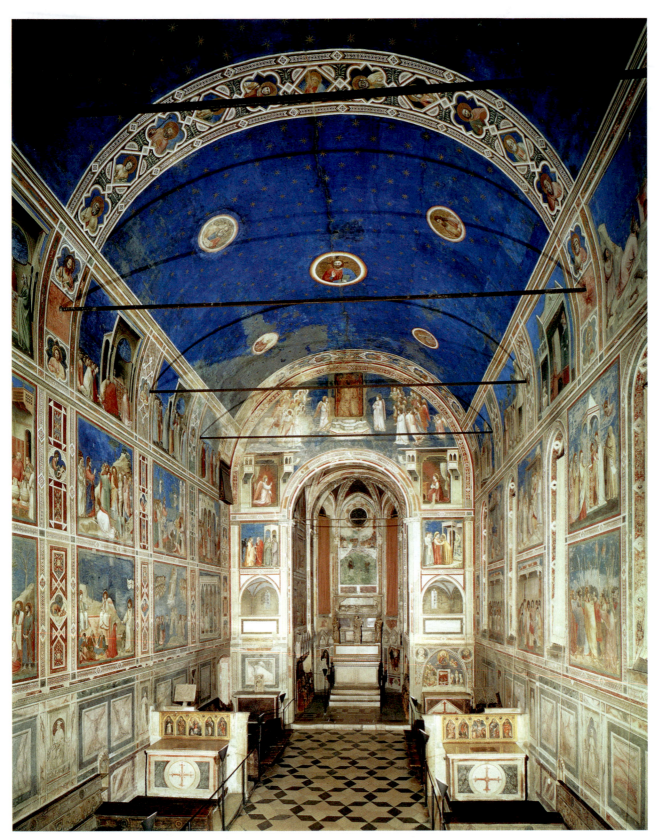

Interior of the Arena Chapel (Cappella Scrovegni), Padua, Italy, 1305–1306.

19

FROM GOTHIC TO RENAISSANCE

14TH-CENTURY ITALIAN ART

The essentially religious view of the world that dominated medieval Europe began to change dramatically in what we call the European Renaissance. Although religion continued to occupy a primary position in the lives of Europeans, a growing concern with the natural world, the individual, and humanity's worldly existence characterized the Renaissance period. Derived from the French word *renaissance* and the Italian word *rinascita*, both meaning "rebirth," the Renaissance extends roughly from the 14th through the 16th centuries. In the 14th century, scholars and artists began to cultivate what they believed to be a rebirth of art and culture. A revived interest in classical* cultures— indeed, the veneration of classical antiquity as a model—was central to this rebirth, hence the notion of the Middle Ages, or medieval period, as the age in between antiquity and the Renaissance. The transition from the medieval to the Renaissance, though dramatic, did not come about abruptly. The Renaissance had its roots in epochs that even preceded the Middle Ages, and much that is medieval persisted in the Renaissance and in later periods. The Renaissance eventually gave way to the modern era; the continuous nature of this development is revealed in the use of the term "early modern" by many scholars to describe the Renaissance. We begin our examination of the Renaissance in Italy.

THE CITY-STATES: POLITICS AND ECONOMICS

In the 14th century, Italy (MAP **19-1**) consisted of numerous city-states, each functioning independently. Each city-state consisted of a geographic region, varying in size, dominated by a major city. Most of the city-states, such as Venice, Florence, Lucca, and Siena, were republics. These republics were constitutional oligarchies—governed by executive bodies, advisory councils, and special commissions. Other powerful city-states included the Papal States, the Kingdom of Naples, and the Duchies of Milan, Modena, Ferrara, and Savoy. As their names indicate, these city-states were politically distinct from the republics.

*Note: In *Art through the Ages* the adjective "Classical," with uppercase *C*, refers specifically to the Classical period of ancient Greece, 480–323 BCE. Lowercase "classical" refers to Greco-Roman antiquity in general, that is, the period treated in Chapters 5, 9, and 10.

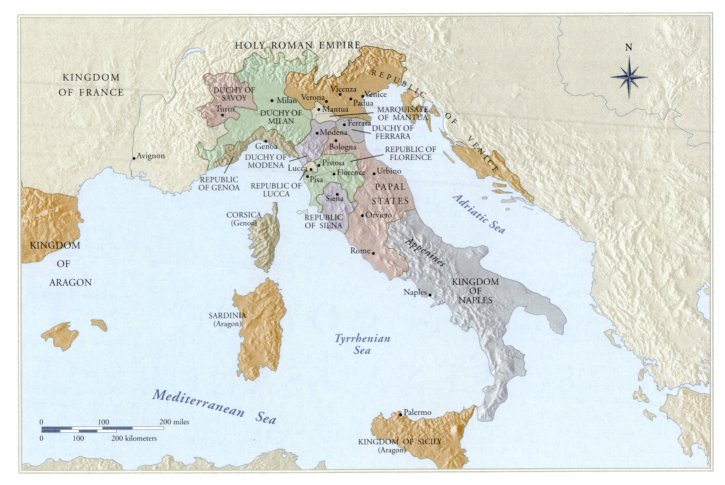

MAP 19-1 Italy around 1400.

The uniqueness and independence of each city-state were underscored by their separate economies; for example, Italy's port cities expanded maritime trade, whereas the economies of other cities centered on such flourishing industries as arms, banking, or textiles.

As a result of this economic prosperity, Italy had established a thriving international trade and held a commanding position in the Mediterranean world by the beginning of the 14th century. The structured organization of economic activity extended to the many trades and professions. Guilds (associations of master craftspeople, apprentices, and tradespeople), which had emerged during the 12th century, became prominent. These associations not only protected members' common economic interests against external pressures, such as taxation, but also provided them with the means to regulate their internal operations (for example, work quality and membership training). Although members' personal security and welfare were the guilds' primary concerns, these organizations dominated city governments as well.

DISRUPTION AND CHANGE

THE BLACK DEATH Despite the relative stability and prosperity established throughout the Italian peninsula, the eruption of the Black Death (bubonic plague) in the late 1340s threw this delicate balance into chaos. Originating in China, the Black Death swept across the entire European continent. The most devastating natural disaster in European history, the Black Death eliminated between 25 and 50 percent of Europe's population in about five years. Italy was particularly hard hit. In large cities, where people lived in relatively close proximity, the death tolls climbed as high as 50 or 60 percent of the population.

The Black Death had a significant effect on art. It stimulated religious bequests and encouraged the commissioning of devotional images. The focus on sickness and death also led to a burgeoning in hospital construction.

THE GREAT SCHISM Disruptions in the religious realm also contributed to the societal upheaval. In 1305, the College of Cardinals (the collective body of all cardinals) elected a French pope, Clement V, who settled in Avignon. Subsequent French popes remained in Avignon, despite their announced intentions to return to Rome. Understandably, this did not sit well with Italians, who saw Rome as the rightful capital of the universal church. The conflict between the French and Italians resulted in the election in 1378 of two popes—Clement VII, who resided in Avignon (and who does not appear on historical lists of popes compiled by the Catholic Church), and Urban VI (r. 1378–1389), who remained in Rome. Thus began what became known as the Great Schism. After 40 years, a council convened by the Holy Roman Emperor Sigismund managed to resolve this crisis in the church by electing a new Roman pope, Martin V (r. 1417–1431), who was acceptable to all.

LETTERS AND LEARNING

A VERNACULAR LITERATURE Concurrent with these momentous shifts in the economic, social, and religious realms was the development of a vernacular (commonly spoken) literature,

which dramatically affected Italy's intellectual and cultural life. Latin remained the official language of church liturgy and state documents. However, the creation of an Italian vernacular literature (based on the Tuscan dialect common in Florence) expanded the audience for philosophical and intellectual concepts because of its greater accessibility. Dante Alighieri (1265–1321; the author of *The Divine Comedy*), the poet and scholar Francesco Petrarch (1304–1374), and Giovanni Boccaccio (1313–1375; the author of *Decameron*) were among those most responsible for establishing this vernacular literature.

REVIVING CLASSICAL VALUES Fundamental to the development of the Italian Renaissance was humanism, which emerged during the 14th century and became a central component of much of Italian art and culture in the 15th and 16th centuries. Humanism was more a code of civil conduct, a theory of education, and a scholarly discipline than a philosophical system. As the word *humanism* suggests, the chief concerns of its proponents were human values and interests as distinct from—but not opposed to—religion's otherworldly values. Humanists held up classical cultures as particularly laudatory. This enthusiasm for antiquity, represented by Cicero's elegant Latin and the Augustan age, involved study of Latin classics and a conscious emulation of what proponents thought were the Roman civic virtues. These included self-sacrificing service to the state, participation in government, defense of state institutions (especially the administration of justice), and stoic indifference to personal misfortune in the performance of duty. With the help of a new interest in and knowledge of Greek, the humanists of the late 14th and 15th centuries recovered a large part of the Greek as well as the Roman literature and philosophy that had been lost, left unnoticed, or cast aside in the Middle Ages. What classical cultures provided to humanists was a model for living in this world, a model primarily of human focus that derived not from an authoritative and traditional religious dogma but from reason.

Ideally, humanists sought no material reward for services rendered. The sole reward for heroes of civic virtue was fame, just as the reward for leaders of the holy life was sainthood. For the educated, the lives of heroes and heroines of the past became as edifying as the lives of the saints. Petrarch wrote a book on illustrious men, and his colleague Boccaccio complemented it with biographies of famous women—from Eve to his contemporary, Joanna, queen of Naples. Both Petrarch and Boccaccio were famous in their own day as poets, scholars, and men of letters—their achievements equivalent in honor to those of the heroes of civic virtue. In 1341, Petrarch was crowned in Rome with the laurel wreath, the ancient symbol of victory and merit. The humanist cult of fame emphasized the importance of creative individuals and their role in contributing to the renown of the city-state and of all Italy.

Yet humanism, with its revival of interest in antiquity's secular culture, was only part of the general humanizing tendency in life and art that began in the 14th century and became dominant in subsequent centuries. Italy, crowded with classical monuments and memorials, was the natural setting for receiving humanistic values recovered from antiquity's omnipresent influence.

AN ARTISTIC TRANSITION Humanism—particularly the renewed interest in the classical—was an essential component of Italian Renaissance art and culture that developed in the 14th century and reached its zenith in the 15th and 16th centuries.

Although some scholars refer to late-13th- and 14th-century Italian art as Late Gothic, connecting it with the medieval culture that preceded it, other scholars describe it as Early Renaissance. Both of these characterizations have merit. Medieval conventions dominated late-13th- and 14th-century art and architecture, but artists more assertively attempted to break away from these conventions.

THE MOVEMENT AWAY FROM MEDIEVALISM IN ART

MANIERA GRECA The fundamentally medieval nature of much of Italian art of this period is evident in a panel of the *Saint Francis Altarpiece* (FIG. **19-1**) by BONAVENTURA BERLINGHIERI (active ca. 1235–1244). Throughout the Middle Ages, the Byzantine style dominated Italian painting. This Italo-Byzantine style, or *maniera greca* (Greek style), surfaced in Berlinghieri's altarpiece. Painted in tempera on wood panel, Saint Francis wears the belted clerical garb of the order he founded. He holds a large book and displays the *stigmata*—marks like Christ's wounds—that appeared on his hands and feet. The saint is flanked by two angels, whose presentation—the frontality of their poses, prominent halos, and lack of modeling—indicates that Berlinghieri borrowed from Byzantine models. The painter enhanced this connection to earlier art forms with gold leaf (gold beaten into tissue-paper-thin sheets that then can be applied to surfaces), which emphasizes the image's flatness and spiritual nature. Other scenes from Francis's life depicted on the panel strongly suggest that their source is Byzantine illuminated manuscripts (compare FIG. 12-15). The central scene on the saint's right depicts Saint Francis preaching to the birds. The saint and his two attendants are aligned carefully against a shallow tower and wall, from Early Christian times a stylized symbol of a town or city. In front of the saint is another stage-scenery image of nested birds and twinkling plants. The composition's strict formality (relieved somewhat by the lively stippling—applied small dots or paint flecks—of the plants), the shallow space, and the linear flatness in the rendering of the forms are all familiar traits of a long and venerated tradition, soon suddenly and dramatically replaced. Despite the limited means of pictorial illusion at his disposal, Berlinghieri imbued this painting with an emotional resonance. The narrative scenes that run along the sides of the *Saint Francis Altarpiece* contribute to this resonance by providing an active contrast to the stiff formality of the large central image of Francis. For example, the scene on the upper left depicts Francis receiving the stigmata from a seraph and reveals the emotion of the Stigmatization.

Berlinghieri's depiction of Saint Francis sheds light on more than aspects of style—it also highlights the increasingly prominent role of religious orders in Italy (see "Mendicant Orders and Confraternities," page 524). The Franciscan order, named after its founder, Saint Francis of Assisi (ca. 1181–1226), worked diligently to impress on the public the saint's valuable example and to demonstrate its commitment to teaching and to alleviating suffering. Berlinghieri's altarpiece, commissioned for the church of San Francesco (Saint Francis) in Pescia, was created nine years after the saint's death and is the earliest known signed and dated representation of Saint Francis. Appropriately, this image focuses on the aspects of the saint's life that the Franciscans wanted to promote, thereby making visible (and thus more credible) the

Mendicant Orders and Confraternities

The pope's absence from Italy during much of the 14th century (the Avignon papacy) contributed to an increase in prominence of monastic orders and confraternities. Such orders as the Augustinians, Carmelites, and Servites became very active, ensuring a constant religious presence in the daily life of Italians. Of the monastic orders, the largest and most influential were the *mendicants* (begging friars)—the Franciscans, founded by Francis of Assisi (FIG. 19-1), and the Dominicans, founded by the Spaniard Dominic de Guzman (ca. 1170–1221). These mendicants renounced all worldly goods and committed themselves to spreading God's word, performing good deeds, and ministering to the sick and dying. The Dominicans, in particular, contributed significantly to establishing urban educational institutions. The Franciscans and Dominicans became very popular among Italian citizens because of their devotion to their faith and the more personal relationship with God they encouraged.

Although both mendicant orders were working for the same purpose—the glory of God—a degree of rivalry nevertheless existed between the two. They established their churches on opposite sides of Florence—Santa Croce (see FIG. Intro-3), the Franciscan church, on the eastern side, and the Dominicans' Santa Maria Novella (FIGS. 19-19 and 21-34) on the western.

Confraternities, organizations consisting of laypersons who dedicated themselves to strict religious observance, also grew in popularity during the 14th and 15th centuries. The mission of confraternities included tending the sick, burying the dead, singing hymns, and performing other good works.

The mendicant orders and confraternities continued to play an important role in Italian religious life through the 16th century. Further, the numerous artworks and monastic churches they commissioned ensured their enduring legacy.

19-1 BONAVENTURA BERLINGHIERI, panel from the *Saint Francis Altarpiece,* San Francesco, Pescia, Italy, 1235. Tempera on wood, approx. 5′ × 3′× 6″.

Artists' Names in Renaissance Italy

In contemporary societies, people have become accustomed to a standardized method of identifying individuals. Given names are coupled with family names, although the order of the two (or more) names sometimes varies. This standardization has been necessitated by increased reliance on "official" documentation such as birth certificates, driver's licenses, and wills.

However, such regularity in names was not the norm in Italy during the 14th and 15th centuries. Often, individuals adopted their hometowns as one of their names. For example, sculptor Nicola Pisano (FIGS. 19-2 and 19-3) was from Pisa, Giulio Romano (see FIG. 22-49) was from Rome, and painter Domenico Veneziano was from Venice. Leonardo da Vinci (see FIGS. 22-1 to 22-5) hailed from the small town of Vinci, Andrea del Castagno (see FIG. 21-37) from Castagno. This information was particularly valuable when meeting someone for the first time, especially once mobility and travel increased in the 14th century. Such artists are often referred to by their given names, such as *Leonardo.*

Nicknames were also common. Masaccio (see FIGS. 21-10, 21-11, and 21-12) was "Big Thomas," and his fellow artist, Masolino, was "Small Thomas." Guido di Pietro is better known today as Fra Angelico (the Angelic Friar; FIG. 21-36), and Cenni di Pepo (FIG. 19-6) is remembered as Cimabue, meaning "bull's head." Artists sometimes derived their names from their renowned works. Jacopo della Quercia was familiar to early-15th-century Italians as Jacopo del Fonte (Jacopo of the Fountain) for his impressive Fonte Gaia (Gay Fountain) in the public square in front of the Palazzo Pubblico in Siena.

Names were not only nonstandardized but also impermanent and could be changed at will. This flexibility has resulted in significant challenges for historians, who often must deal with archival documents and records.

legendary life of this holy man. Saint Francis believed he could get closer to God by rejecting worldly goods, and to achieve this he stripped himself bare in a public square and committed himself to a strict life of fasting, prayer, and meditation. The appearance of stigmata on his hands and feet (visible in Berlinghieri's painting) was perceived as God's blessing and led some followers to see Francis as a second Christ. Fittingly, four of the six scenes that surround the central figure of Saint Francis depict miraculous healings, connecting him more emphatically to Christ. The coarse habit he wears, tied at the waist with a rope, became the garb of the Franciscans.

THE INFLUENCE OF CLASSICAL ART Interest in the art of classical antiquity was not unheard of during the medieval period. For example, the Visitation group statues on the west facade of Reims Cathedral (see FIG. 18-22) show an unmistakable interest in Roman sculpture, even though the facial modeling reveals their Gothic origin. However, the 13th-century sculpture of NICOLA PISANO (active ca. 1258–1278), contemporary with the Reims statues, exhibits an interest in classical forms unlike that found in the works of his predecessors. This interest was perhaps due in part to the influence of the humanistic culture of Sicily under its king, Holy Roman Emperor Frederick II. The king was known in his own time as "the wonder of the world" for his many intellectual gifts and other talents. Frederick's nostalgia for the past grandeur of Rome fostered a revival of Roman sculpture and decoration in Sicily and southern Italy before the mid-13th century. Because Nicola Pisano (see "Artists' Names in Renaissance Italy," above) may have received his early training in this environment, he may have been influenced by Roman artworks. After Frederick's death in 1250, Nicola Pisano traveled northward and eventually settled in Pisa. Then at the height of its political and economic power, Pisa was recognized by artists as a locale for lucrative commissions (see "Art to Order: Commissions and Patronage," page 526).

Nicola Pisano's sculpture, unlike the French sculpture of the period, was not part of the extensive decoration of great portals. He carved marble reliefs and ornament for large pulpits, completing the first in 1260 for the baptistery of Pisa Cathedral (FIG. **19-2**). Some elements of the pulpit's design carried on medieval

19-2 NICOLA PISANO, pulpit of Pisa Cathedral baptistery, Pisa, Italy, 1259–1260. Marble, approx. 15′ high.

Art to Order
Commissions and Patronage

Because of today's international open art market, the general public tends to see art as the creative expression of an individual—the artist. However, artists did not always enjoy this degree of freedom. Historically, artists rarely undertook major artworks without a patron's concrete commission.

The patron could be a civic group, religious entity, or private individual. Guilds, although primarily economic commercial organizations, contributed to their city's religious and artistic life by subsidizing the building and decoration of numerous churches and hospitals. For example, the Arte della Lana (wool manufacturers' guild) oversaw the start of the Florence Cathedral (FIGS. 19-17 and 19-18) in 1296, and the Arte di Calimala (wool merchants' guild) supervised the completion of its dome (see FIG. 21-13).

Religious groups, such as the monastic orders, were also major art patrons. Of course, the papacy had long been an important patron, and artists vied for the pope's prestigious commissions. The papacy's patronage became even more visible during the 16th and 17th centuries, and today the Vatican Museums hold one of the world's most spectacular art collections.

Wealthy families and individuals commissioned artworks for a wide variety of reasons. Besides the aesthetic pleasure these patrons derived from art, the images often also served as testaments to the patron's wealth, status, power, and knowledge. Art was commissioned for propagandistic, philanthropic, or commemorative purposes as well.

Because artworks during this period were the product of what was, in effect, a service contract, viewers must consider the patrons' needs or wishes when looking at commissioned art and architecture. From the few extant contracts, it appears that artists normally were asked to submit drawings or models to their patrons for approval. Patrons expected artists to adhere to the approved designs fairly closely. Surviving contracts do not have the detail one might expect from a legal document. These contracts usually stipulate certain conditions, such as the insistence on the artist's own hand in the production of the work, the pigment quality and amount of gold or other precious items to be used, completion date, payment terms, and penalties for failure to meet the contract's terms. Although it is clear that patrons could have been very specific about the details of projects and often made many decisions about the works, those expectations are often absent from the written contracts. Regardless, the patron's role looms large in any discussion of art created before the 17th century, when an open art market developed.

traditions (for example, the trilobed arches and the lions supporting some of the columns), but Nicola Pisano also incorporated classical elements into this medieval type of structure. The large, bushy capitals are a Gothic variation of the Corinthian capital; the arches are round rather than pointed *(ogival);* and the large rectangular relief panels, if their proportions were altered slightly, could have come from the sides of Roman sarcophagi. The densely packed large-scale figures of the individual panels also seem to derive from the compositions found on Roman sarcophagi. In one of these panels, *The Annunciation and the Nativity* (FIG. **19-3**), the Virgin reclines in a manner reminiscent of the lid figures on Etruscan (see FIGS. 9-4 and 9-14) and Roman (see

FIG. 10-62) sarcophagi, and the face types, beards, coiffures, and draperies, as well as the bulk and weight of the figures, were clearly inspired by classical relief sculpture. (For information on the Annunciation and the Nativity, see "The Life of Jesus in Art," Chapter 11, pages 308–309 or xvi–xvii in Volume II.) Scholars have even been able to pinpoint the models of some of Nicola's figures on Roman sarcophagi the sculptor would have known.

A SON'S SCULPTURAL RESPONSE Nicola Pisano's classicizing manner was countered by his son GIOVANNI PISANO (ca. 1250–1320). Giovanni's version of *The Annunciation and the Nativity* (FIG. **19-4**), from the pulpit in Sant'Andrea at Pistoia, was

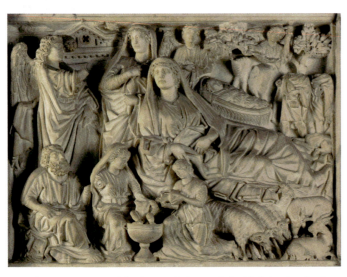

19-3 NICOLA PISANO, *The Annunciation and the Nativity,* detail of pulpit of Pisa Cathedral baptistery, Pisa, Italy, 1259–1260. Marble relief, approx. 2' 10" × 3' 9".

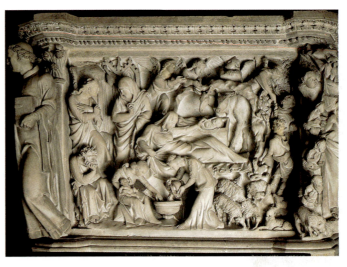

19-4 GIOVANNI PISANO, *The Annunciation and the Nativity,* detail of the pulpit of Sant'Andrea, Pistoia, Italy, 1297–1301. Marble relief, approx. 2' 10" × 3' 4".

finished some 40 years after the one by his father in the Pisa baptistery. It offers a striking contrast to Nicola Pisano's thick carving and placid, almost stolid, presentation of the theme. Giovanni Pisano arranged the figures loosely and dynamically. An excited animation twists and bends them, and their motion is suggested by spaces that open deeply between them. In the Annunciation episode, which is combined with the Nativity (as in the older version), the Virgin shrinks from the angel's sudden appearance in a posture of alarm touched with humility. The same spasm of apprehension contracts her supple body as she reclines in the Nativity scene. The drama's principals share in a peculiar nervous agitation, as if they all suddenly are moved by spiritual passion. Only the shepherds and the sheep, appropriately, do not yet share in the miraculous event. The swiftly turning, sinuous draperies; the slender figures they enfold; and the general emotionalism of the scene are features not found in Nicola Pisano's interpretation. Thus, the father's and son's works show, successively, two novel trends of great significance for subsequent art — a new interest in classical antiquity and a burgeoning naturalism.

SCULPTURAL FORM IN PAINTING The art of PIETRO CAVALLINI (active ca. 1273–1308) represented one style of the Roman school of painting. A great interest in the sculptural rendering of form characterized the style, as evidenced in a detail (FIG. **19-5**) from Cavallini's badly damaged fresco, *Last Judgment*, in the church of Santa Cecilia in Trastevere in Rome. Cavallini, perhaps under the influence of Roman paintings now lost, abandoned Byzantine stylized dignity and replaced it with a long-lost impression of solidity and strength in *Seated Apostles*. He achieved this effect through careful depiction of light that illuminates the figures, throwing them into relief, along with his presentation of drapery, which envelops the figures and enhances their three-dimensionality.

A SUMMARY OF BYZANTINE STYLE Like Cavallini, Cenni di Pepo, better known as CIMABUE (ca. 1240–1302; see "Artists' Names in Renaissance Italy," page 525), moved beyond the limits of the Italo-Byzantine style. Although his works reveal the unmistakable influence of Gothic sculpture, Cimabue was inspired by the same impulse toward naturalism as Giovanni Pisano, and challenged the conventions that dominated earlier art. The formality evident in Cimabue's *Madonna Enthroned with Angels and Prophets* (FIG. **19-6**) is appropriate to the dignity of the theme represented. The artist modeled his large image on Byzantine examples (see FIG. 12-16), revealed in the painting's careful structure and symmetry.

He also used the gold embellishments common to Byzantine art to enhance the folds and three-dimensionality of the drapery. However, Cimabue constructed a deeper space for the Madonna and the surrounding figures to inhabit. Despite such departures from Byzantine convention, this vast altarpiece is a final summary of centuries of Byzantine art before its utter transformation.

AN EMPIRICAL ART A naturalistic approach based on observation was the major contribution of GIOTTO DI BONDONE (ca. 1266–1337), who made a much more radical break with the past. Scholars still debate the sources of Giotto's style, although one source must have been the style of the Roman school of painting Cavallini represented. Another formative influence on Giotto may have been the work of the man presumed to be his teacher, Cimabue. The art of the French Gothic sculptors (perhaps seen by Giotto himself but certainly familiar to him from the sculpture of Giovanni Pisano, who had spent time in Paris) and ancient Roman art, both sculpture and painting, must have contributed to Giotto's artistic education. Some believe that new developments in contemporaneous Byzantine art further influenced him.

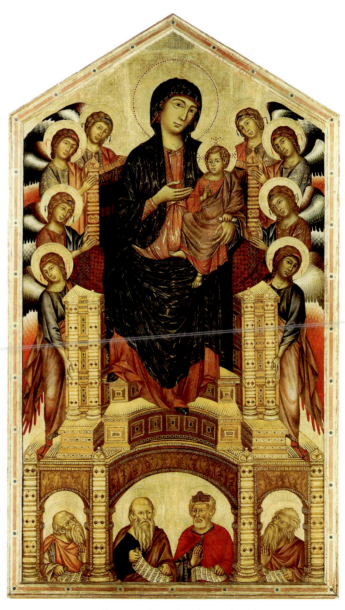

19-6 CIMABUE, *Madonna Enthroned with Angels and Prophets*, ca. 1280–1290. Tempera on wood, 12′ 7″ × 7′ 4″. Galleria degli Uffizi, Florence.

19-5 PIETRO CAVALLINI, *Seated Apostles*, detail of the *Last Judgment*, Santa Cecilia in Trastevere, Rome, Italy, ca. 1291. Fresco.

Yet no mere synthesis of these varied influences could have produced the significant shift in artistic approach that has led some scholars to describe Giotto as the father of Western pictorial art. Renowned in his own day, his reputation has never faltered. Regardless of the other influences on his artistic style, his true teacher was nature—the world of visible things.

Giotto's revolution in painting did not consist only of displacing the Byzantine style, establishing painting as a major art form for the next seven centuries, and restoring the naturalistic approach developed by the ancients and largely abandoned in the Middle Ages. He also inaugurated a method of pictorial expression based on observation and initiated an age that might be called "early scientific." By stressing the preeminence of sight for gaining knowledge of the world, Giotto and his successors contributed to the foundation of empirical science. They recognized that the visual world must be observed before it can be analyzed and understood. Praised in his own and later times for his fidelity to nature, Giotto was more than a mere imitator of it. He revealed nature while observing it and divining its visible order. In fact, he

showed his generation a new way of seeing. With Giotto, Western artists turned resolutely toward the visible world as their source of knowledge of nature.

On nearly the same great scale as the Madonna painted by Cimabue, Giotto depicted her (FIG. 19-7) in a work that offers an opportunity to appreciate his perhaps most telling contribution to representational art—sculptural solidity and weight. The Madonna, enthroned with angels, rests within her Gothic throne with the unshakable stability of an ancient marble goddess (see FIG. 10-28). Giotto replaced Cimabue's slender Virgin, fragile beneath the thin ripplings of her drapery, with a sturdy, queenly mother, bodily of this world, even to the swelling of her bosom. Her body is not lost; it is asserted. The new art aimed, before all else, to construct a figure that has substance, dimensionality, and bulk. Works painted in the new style portray figures, like those in sculpture, that project into the light and give the illusion that they could throw shadows. In Giotto's *Madonna Enthroned*, the throne is deep enough to contain the monumental figure and breaks away from the flat ground to project and enclose her.

19-7 GIOTTO DI BONDONE, *Madonna Enthroned,* ca. 1310. Tempera on wood, 10′ 8″ × 6′ 8″. Galleria degli Uffizi, Florence.

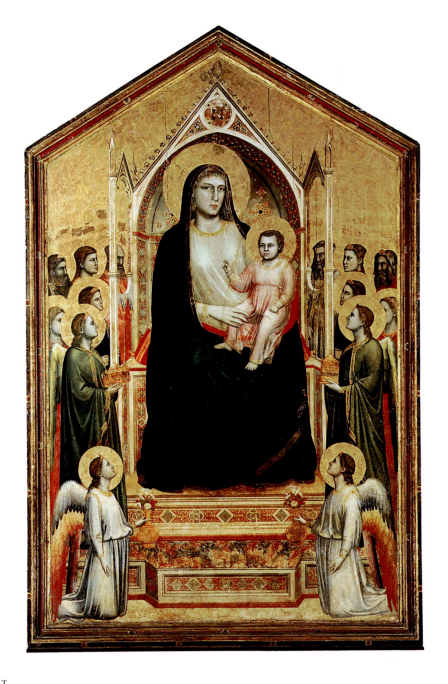

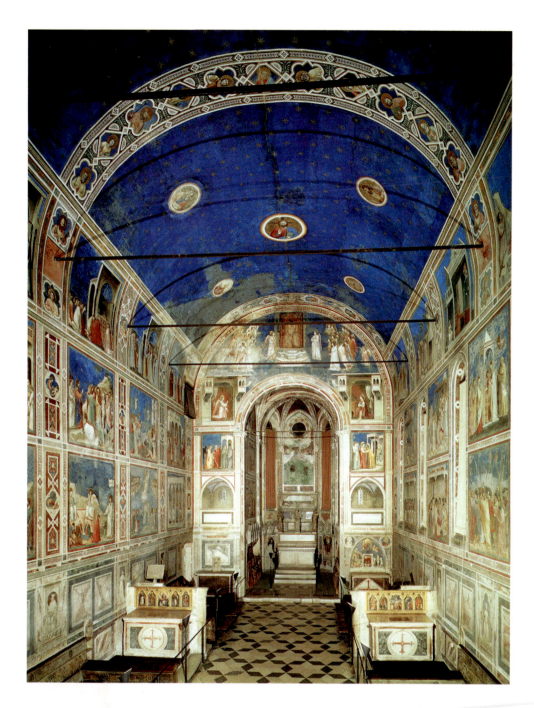

CHRONICLING THE LIVES OF THE VIRGIN AND CHRIST

Projecting on a flat surface the illusion of solid bodies moving through space presents a double challenge. Constructing the illusion of a body also requires constructing the illusion of a space sufficiently ample to contain that body. In Giotto's fresco cycles (he was primarily a muralist), he constantly strove to reconcile these two aspects of illusionistic painting. His frescoes (paintings on wet plaster; see "Fresco Painting," page 530) in the Arena Chapel (Cappella Scrovegni) at Padua (FIG. **19-8**) show his art at its finest. The Arena Chapel, which takes its name from an ancient Roman amphitheater nearby, was built for Enrico Scrovegni, a wealthy Paduan merchant, on a site adjacent to his now razed palace. This building, intended for the Scrovegni family's private use, was consecrated in 1305, and its design is so perfectly suited to its interior decoration that some scholars have suggested that Giotto himself may have been its architect.

The rectangular barrel-vaulted hall has six narrow windows in its south wall only, which left the entire north wall an unbroken and well-illuminated surface for painting. The entire building seems to

have been designed to provide Giotto with as much flat surface as possible for presenting one of the most impressive and complete pictorial cycles of Christian Redemption ever rendered. With 38 framed pictures, arranged on three levels, the artist related the most poignant incidents from the lives of the Virgin and her parents, Joachim and Anna (top level); the life and mission of Christ (middle level); and his Passion, Crucifixion, and Resurrection (bottom level). These three pictorial levels rest on a coloristically neutral base. Imitation marble veneer—reminiscent of ancient Roman decoration (see FIG. 10-50), which Giotto may have seen—alternates with the Virtues and Vices painted in *grisaille* (monochrome grays, often used for modeling in paintings) to resemble sculpture. The climactic event of the cycle of human salvation, the Last Judgment, covers most of the west wall above the chapel's entrance.

The hall's vaulted ceiling is blue, an azure sky symbolic of Heaven. It is dotted with golden stars and medallions bearing images of Christ, Mary, and various prophets. Giotto painted the same blue in the backgrounds of the narrative panels on the walls below (some now faded or flaked). The color thereby functions as

Fresco Painting

Fresco has a long history, particularly in the Mediterranean region (see FIGS. 4-6 to 4-9), where the Minoans used it as early as 1650 BCE. Fresco (Italian for "fresh") is a mural-painting technique that involves applying permanent limeproof pigments, diluted in water, on freshly laid lime plaster. Because the pigments are absorbed into the surface of the wall as the plaster dries, fresco is one of the most permanent painting techniques. The stable condition of frescoes such as those in the Arena Chapel (FIGS. 19-8 and 19-9) and in the Sistine Chapel (see FIGS. 22-12, 22-13, and 22-14), now hundreds of years old, testify to the longevity of this painting method. The colors have remained vivid (although dirt and soot have necessitated cleaning) because of the chemically inert pigments the artists used. In addition to this *buon fresco* ("true" fresco) technique, artists used *fresco secco* (dry fresco). Fresco secco involves painting on dried lime plaster. Although the finished product visually approximates buon fresco, the pigments are not absorbed into the wall and simply adhere to the surface, so fresco secco does not have buon fresco's longevity. Compare, for example, the current condition of Michelangelo's buon fresco Sistine Ceiling (see FIG. 22-13) with Leonardo da Vinci's *Last Supper* (see FIG. 22-3), executed largely in fresco secco (with experimental techniques and pigments).

The buon fresco process is time-consuming and demanding and requires several layers of plaster. Although buon fresco methods vary, generally the artist prepares the wall with a rough layer of lime plaster called the *arriccio* (brown coat). The artist then transfers the composition to the wall, usually by drawing directly on the arriccio with a burnt-orange pigment called *sinopia* (most popular during the 14th century), or by transferring a *cartoon* (a full-sized preparatory drawing). Cartoons increased in usage in the 15th and 16th centuries, largely replacing sinopia underdrawings. Finally, the *intonaco* (painting coat) is laid smoothly over the drawing in sections (called *giornate*, Italian for "days") only as large as the artist expects to complete in that session. The artist must paint fairly quickly, because once the plaster is dry, it will no longer absorb the pigment. Any areas of the intonaco that remain unpainted after a session must be cut away so that fresh plaster can be applied for the next giornata.

In areas of high humidity, such as Venice, fresco was less appropriate because of the obstacle the moisture presented to the drying process. Over the centuries, fresco became less popular, although it did experience a revival in the 1930s with the Mexican muralists (see FIGS. 33-80 and 33-81). Many of the older frescoes have been transferred from their original walls by lifting off the intonaco layer of plaster and readhering the images to other supports.

a unifying agent for the entire decorative scheme and renders the scenes more realistic.

The individual panels are framed with decorative borders, which, with their delicate tracery, offer a striking contrast to the sparse simplicity of the images they surround. Subtly scaled to the chapel's space (only about half life-size), Giotto's stately and slow-moving actors present their dramas convincingly and with great restraint. *Lamentation* (FIG. 19-9) reveals the essentials of his style. In the presence of angels darting about in hysterical grief, a congregation mourns over the dead body of the Savior just before its entombment. Mary cradles her son's body, while Mary Magdalene looks solemnly at the wounds in Christ's feet and Saint John the Evangelist throws his arms back dramatically. Giotto arranged a shallow stage for the figures, bounded by a thick diagonal rock incline that defines a horizontal ledge in the foreground. Though rather narrow, the ledge provides firm visual support for the figures, and the steep slope indicates the picture's dramatic focal point at the lower left. The rocky landscape also links this scene with the adjoining one. Giotto connected the framed scenes throughout the fresco cycle with such formal elements. The figures are sculpturesque, simple, and weighty, but this mass did not preclude motion and emotion. Postures and gestures that might have been only rhetorical and mechanical convey, in *Lamentation,* a broad spectrum of grief. They range from Mary's almost fierce despair to the passionate outbursts of Mary Magdalene and John to the philosophical resignation of the two disciples at the right and the mute sorrow of the two hooded mourners in the foreground (compare FIG. 12-27). Giotto constructed a kind of stage that served as a model for artists who depicted human dramas in many subsequent paintings. His style was far removed from the isolated episodes and figures seen in art until the late 13th century. In *Lamentation,* a single event provokes an intense response. This combination of compositional complexity and emotional resonance was rarely attempted, let alone achieved, in art before Giotto.

The formal design of the *Lamentation* fresco, the way the figures are grouped within the constructed space, is worth close study. Each group has its own definition, and each contributes to the rhythmic order of the composition. The strong diagonal of the rocky ledge, with its single dead tree (the tree of knowledge of good and evil, which withered at the Fall of Adam), concentrates the viewer's attention on the group around the head of Christ, whose positioning is dynamically off center. All movement beyond this group is contained, or arrested, by the massive bulk of the seated mourner in the painting's left corner. The seated mourner to the right establishes a relation with the center group, who, by their gazes and gestures, draw the viewer's attention back to Christ's head. Figures seen from the back, which are frequent in Giotto's compositions, represent an innovation in the development away from the formal Italo-Byzantine style. These figures emphasize the foreground, aiding the visual placement of the intermediate figures farther back in space. This device, the very contradiction of the old frontality, in effect puts viewers behind the "observer" figures, who, facing the action as spectators, reinforce the sense of stagecraft as a model for painting.

Giotto's new devices for depicting spatial depth and bodily mass could not, of course, have been possible without his management of light and shade. He shaded his figures to indicate both the direction of the light that illuminates them and the shadows (the diminished light), giving the figures volume. In *Lamentation,* light falls upon the upper surfaces of the figures (especially the two central bending figures) and passes down to dark in their

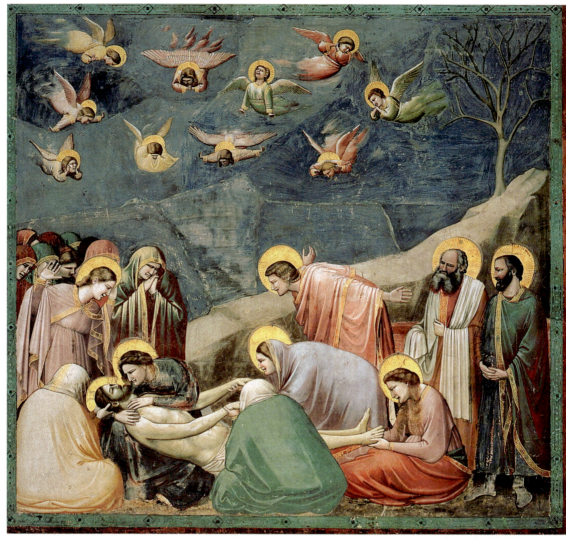

19-9 Giotto di Bondone, *Lamentation*, Arena Chapel (Cappella Scrovegni), Padua, Italy, ca. 1305. Fresco, 6' 6¾" × 6'¾".

draperies, separating the volumes one from the other and pushing one to the fore, the other to the rear. The graded continuum of light and shade, directed by an even neutral light from a single steady source—not shown in the picture—was the first step toward the development of *chiaroscuro* (the use of dramatic contrasts of dark and light to produce modeling).

The stagelike settings made possible by Giotto's innovations in *perspective* (the depiction of three-dimensional objects in space on a two-dimensional surface) and lighting suited perfectly the dramatic narrative the Franciscans emphasized then as a principal method for educating the faithful in their religion. In the humanizing age, the old stylized presentations of the holy mysteries had evolved into what were called the "mystery" plays. The drama of the Mass was extended into one- and two-act tableaus and scenes and then into simple narratives offered at church portals and in city squares. (Eventually, confraternities also presented more elaborate religious dramas called *sacre rappresentazioni*—sacred representations.) The great increase in popular sermons to huge city audiences prompted a public taste for narrative, recited as dramatically as possible. The arts of illusionistic painting, of drama, and of sermon rhetoric with all their theatrical flourishes were developing simultaneously and were mutually influential. Giotto's art masterfully—perhaps uniquely—synthesized dramatic narrative, holy lesson, and truth to human experience in a visual idiom of his own inven-

tion, accessible to all. Not surprisingly, Giotto's frescoes served as textbooks for generations of Renaissance painters from Masaccio to Michelangelo and beyond.

The Republic of Siena

Among 14th-century Italian city-states, the Republics of Siena and Florence were notable for their strong commitment to art. Both Siena and Florence (the major cities of these two republics) were urban centers of bankers and merchants with widespread international contacts. Chroniclers and historians recognized early on the importance of these two cities for the development of art; discussions comparing their artistic contributions extend back into the 14th century.

MARY IN MAJESTY Siena was a commanding presence in 14th-century Italy. Particularly proud of their victory over the Florentines at the battle of Monteperti in 1260, the Sienese believed that the Virgin Mary had sponsored their victory. This belief reinforced Sienese devotion to the Virgin, which was paramount in the religious life of the city. Sienese citizens could boast of Siena's dedication to the Queen of Heaven as more ancient and venerable than that of all others. It is important that loyalty to the secular republican city-state was linked with devotion to its favorite saint. The Virgin became protector not only of every citizen but also of the city itself.

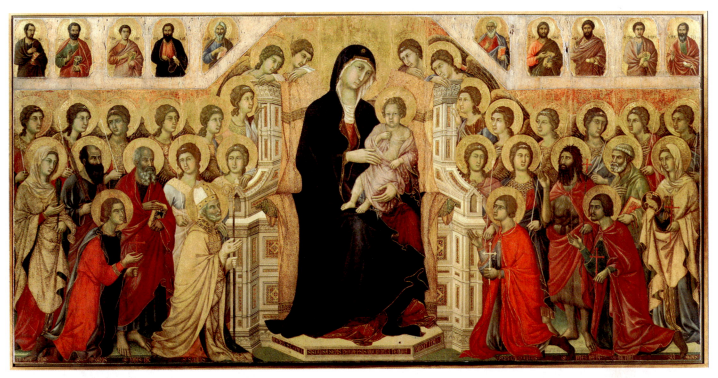

19-10 Duccio di Buoninsegna, *Virgin and Child Enthroned with Saints,* principal panel of the *Maestà* altarpiece, from the Siena Cathedral, Siena, Italy, 1308–1311. Tempera on wood, 7′ × 13′ (center panel). Museo dell'Opera del Duomo, Siena.

The works of Duccio di Buoninsegna (active ca. 1278–1318) represent Sienese art in its supreme achievement. His immense altarpiece, the *Maestà,* was designed to replace a much smaller painting of the Virgin Mary. Duccio's inscription of his name at the base of the Virgin's throne in the *Maestà* is part of a prayer for himself and for the city of Siena, its cathedral, and its churches.

The *Maestà,* painted in tempera front and back and composed of many panels, was commissioned for the high altar of the Siena Cathedral in 1308 and completed by Duccio and his assistants in 1311. As originally executed, it consisted of a seven-foot-high central panel (FIG. **19-10**), surmounted by seven pinnacles above, and a *predella,* or raised shelf, of panels at the base, altogether some 13 feet high. Unfortunately, the work no longer can be seen in its entirety. It was dismantled in subsequent centuries, and many of its panels are now scattered as single masterpieces among the world's museums.

The main panel of the front side represents the Virgin enthroned in majesty (maestà) as Queen of Heaven amid choruses of angels and saints. Duccio derived the composition's formality and symmetry, along with the figures and facial types of the principal angels and saints, from Byzantine tradition. But the artist relaxed the strict frontality and rigidity of the figures in the typical Byzantine icon and iconostasis, or apse mosaic; they turn to each other in quiet conversation. Further, Duccio individualized the faces of the four saints kneeling in the foreground, who perform their ceremonial gestures without stiffness. Similarly, Duccio softened the usual Byzantine hard body outlines and drapery patterning. The drapery, particularly that of the female saints at both ends of the panel, falls and curves loosely. This is a feature familiar in northern Gothic works (see FIG. 18-35) and is a mark of the artistic dialogue that occurred between Italy and the north in the 14th century.

Despite these changes that reveal Duccio's interest in the new naturalism, he respected the age-old requirement that as an altarpiece, the *Maestà* would occupy the very center of the sanctuary as the focus of worship. As such, he knew it should be an object holy in itself—a work of splendor to the eyes, precious in its message and its materials. Duccio thus recognized that the function of this work naturally limited experimentation with depicting narrative action and producing illusionistic effects (such as Giotto's) by modeling forms and adjusting their placement in pictorial space.

Instead, the Queen of Heaven panel is a miracle of color composition and texture manipulation, unfortunately not apparent in a photo. Close inspection of the original reveals what the Sienese artists learned from other sources. In the 13th and 14th centuries, Italy was the distribution center for the great silk trade from China and the Middle East (see "Silk and the Silk Road," Chapter 7, page 201). After processing in city-states such as Lucca and Florence, the silk was exported throughout Europe to satisfy an immense market for sumptuous dress. (Dante, Petrarch, and many of the humanists decried the appetite for luxury in costume, which to them represented a decline in civic and moral virtue.) People throughout Europe (Duccio and other artists among them) prized fabrics from China, Persia, Byzantium, and the Islamic realms. In the *Maestà* panel, Duccio created the glistening and shimmering effects of textiles, adapting the motifs and design patterns of exotic materials.

On the front panel of the *Maestà* Duccio showed himself as the great master of the formal altarpiece. However, he allowed himself greater latitude for experimentation in the small accompanying panels, front and back. It is these images that reveal his powers as a narrative painter. In the numerous panels on the back, he illustrated the later life of Christ—his ministry (on the predella), his Passion (on the main panel), and his Resurrection

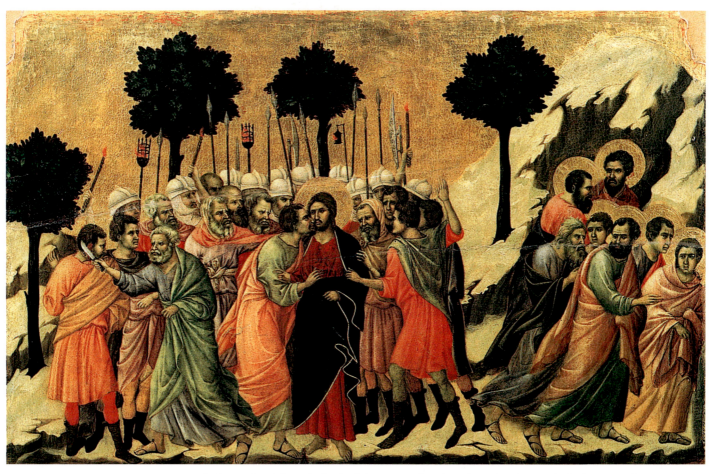

19-11 DUCCIO DI BUONINSEGNA, *Betrayal of Jesus*, detail from the back of the *Maestà* altarpiece, from the Siena Cathedral, Siena, Italy, 1309–1311. Tempera on wood, detail approx. 1′ 10½″ × 3′ 4″. Museo dell'Opera del Duomo, Siena.

and appearances to the disciples (on the pinnacles). In the small narrative pictures, Duccio relaxed the formalism appropriate to the iconic, symbolic representation of the maestà and displayed his ability not only as a narrator but also as an experimenter with new pictorial ideas. In a synoptic sequence on one of the small panels, *Betrayal of Jesus* (FIG. **19-11**), the artist represented several episodes of the event—the betrayal of Jesus by Judas's false kiss, the disciples fleeing in terror, and Peter cutting off the ear of the high priest's servant. Although the background, with its golden sky and rock formations, remains traditional, the style of the figures before it has changed quite radically. The bodies are not the flat frontal shapes of earlier Byzantine art. Duccio imbued them with mass, modeled them with a range from light to dark, and arranged their draperies around them convincingly. Even more novel and striking is how the figures seem to react to the central event. Through posture, gesture, and even facial expression, they display a variety of emotions. Duccio carefully differentiated among the anger of Peter, the malice of Judas (echoed in the faces of the throng about Jesus), and the apprehension and timidity of the fleeing disciples. These figures are actors in a religious drama that the artist interpreted in terms of thoroughly human actions and reactions. In this and similar narrative panels, Duccio took another decisive step toward the humanization of religious subject matter. The greatness of the *Maestà* did not have to wait for modern acclaim. A Sienese chronicler noted that nothing like it had been done anywhere else in Italy (see "A Majestic Altarpiece: Duccio's *Maestà*," page 534).

AN "INTERNATIONAL STYLE" Duccio's successors in the Sienese school displayed even greater originality and assurance than Duccio. SIMONE MARTINI (ca. 1285–1344) was a pupil of Duccio and a close friend of Petrarch, who praised him highly for his portrait of "Laura" (the woman to whom Petrarch dedicated his sonnets). Martini worked for the French kings in Naples and Sicily and, in his last years, produced paintings for the papal court at Avignon, where he came in contact with northern painters. By adapting the insubstantial but luxuriant patterns of the French Gothic manner to Sienese art and, in turn, by acquainting northern painters with the Sienese style, Martini was instrumental in forming the so-called *International Style*. This new style swept Europe during the late 14th and early 15th centuries because it appealed to the aristocratic taste for brilliant colors, lavish costumes, intricate ornamentation, and themes involving splendid processions.

Martini's own style did not quite reach the full exuberance of the developed International Style, but his famous *Annunciation* altarpiece (FIG. **19-12**) provides a counterpoint to Giotto's style. Elegant shapes and radiant color; flowing, fluttering line; and weightless figures in a spaceless setting characterize the *Annunciation.* The complex etiquette of the European chivalric courts dictated the presentation. The angel Gabriel has just alighted, the breeze of his passage lifting his mantle, his iridescent wings still beating. The gold of his sumptuous gown heraldically represents the celestial realm whence he bears his message. The Virgin, putting down her book of devotions, shrinks demurely from

A Majestic Altarpiece
Duccio's Maestà

Agnolo di Tura del Grasso provided one of the most complete records of the completion and installation of the *Maestà* in the Siena Cathedral. Scholars consider his account reliable, as he was the keeper of the record books of Siena's chief financial magistracy. He described the pomp and ceremony that accompanied the transport of the altarpiece to the cathedral:

This [*Maestà*] was painted by master Duccio di Niccolò, painter of Siena, who was in his time the most skillful painter one could find in these lands. The panel was painted outside the Porta a Stalloreggi in the Borgo a Laterino, in the house of the Muciatti. The Sienese took the panel to the Cathedral at noontime on the ninth of June [1311], with great devotions and processions, with the bishop of Siena, Ruggero da Casole, with all of the clergy of the Cathedral, and with all the monks and nuns of Siena, and the Nove [the ruling council of Siena], with the city officials, the Podestà and the Captain, and all the citizens with coats of arms and those with more

distinguished coats of arms, with lighted lamps in hand. And thus, the women and children went through Siena with much devotion and around the Campo in procession, ringing all the bells for joy, and this entire day the shops stayed closed for devotions, and throughout Siena they gave many alms to the poor people, with many speeches and prayers to God and to his mother, Madonna ever Virgin Mary, who helps, preserves and increases in peace the good state of the city of Siena and its territory, as advocate and protectress of that city, and who defends the city from all danger and all evil. And so, this panel was placed in the Cathedral on the high altar. The panel is painted on the back with the Old Testament [sic], with the Passion of Jesus Christ, and on the front is the Virgin Mary with her son in her arms and many saints at the side. Everything is ornamented with fine gold; it cost three thousand gold florins.[1]

[1] Quoted in James H. Stubblebine, *Duccio di Buoninsegna and His School* (Princeton, N.J.: Princeton University Press, 1979), 1: 33–34.

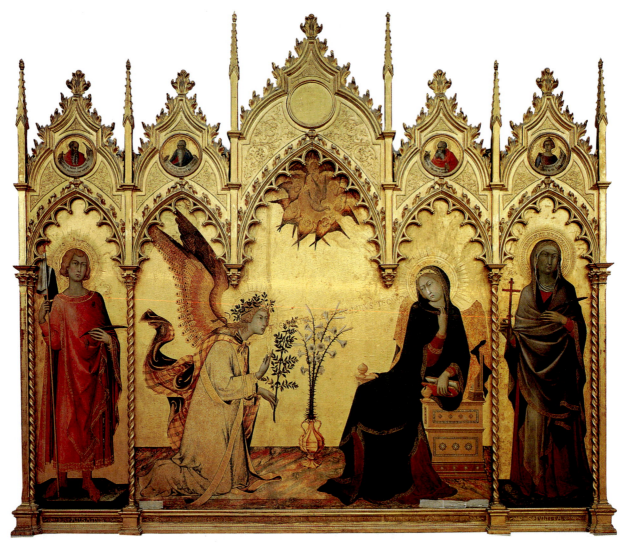

19-12 Simone Martini and Lippo Memmi(?), *Annunciation*, 1333 (frame reconstructed in the 19th century). Tempera and gold leaf on wood, approx. 10′ 1″ × 8′ 8¾″ *(center panel)*. Galleria degli Uffizi, Florence.

Mastering a Craft
Artistic Training in the Renaissance

In 14th- through 16th-century Italy, training to become a professional artist (earning membership in the appropriate guild) was a laborious and lengthy process. Because Italians perceived art as a trade, they expected artists to be trained as they would in any other profession. Accordingly, aspiring artists started their training at an early age, anywhere from 7 to 15 years old. Their fathers would negotiate arrangements with specific master artists, whereby each youth lived with a master for a specified number of years, usually five or six. During that time, they served as apprentices to the masters in the workshop, learning the trade. This living arrangement served as a major obstacle for aspiring female artists, as it was considered inappropriate for young girls to live in a master's household.

The skills apprentices learned varied with the type of studio they joined. Those apprenticed to painters learned to grind pigments, draw, prepare wood panels for painting, gild, and lay plaster for fresco. Sculptors in training learned to manipulate different materials (for example, wood, stone, terracotta, wax, bronze, or stucco), although many sculpture workshops specialized in only one or two of these materials. For stone carving, apprentices learned their craft by blocking out the master's designed sculpture.

The guilds supervised this rigorous training. They wanted not only to ensure their professional reputations by admitting only the most talented members but also to control the number of artists (to limit undue competition). Toward this end they frequently tried to regulate the number of apprentices working under a single master. Surely the quality of the apprentices a master trained reflected the master's competence. When encouraging a prospective apprentice to join his studio, the Paduan painter Francesco Squarcione boasted he could teach "the true art of perspective and everything necessary to the art of painting. . . . I made a man of Andrea Mantegna [see FIGS. 21-45, 21-46, 21-47, and 21-48] who stayed with me and I will also do the same to you."[1]

As their skills developed, apprentices took on increasingly difficult tasks. After completing their apprenticeships, artists entered the appropriate guilds. For example, painters, who ground pigments, joined the guild of apothecaries; sculptors were members of the guild of stoneworkers; and goldsmiths entered the silk guild, because gold often was stretched into threads wound around silk for weaving. Such memberships served as certification of the artists' competence. Once "certified," artists often affiliated themselves with established workshops, as assistants to master artists. This was largely for practical reasons. New artists could not expect to receive many commissions, and the cost of establishing their own workshops was high. In any case, this arrangement was not permanent, and workshops were not necessarily static enterprises. Although well-established and respected studios existed, workshops could be organized around individual masters (with no set studio locations) or organized for a specific project, especially an extensive decoration program.

Generally, assistants were charged with gilding frames and backgrounds, completing decorative work, and, occasionally, rendering architectural settings. Artists regarded figures, especially those central to the represented subject, as the most important and difficult parts of a painting, and the master retained responsibility for such figures. Assistants were allowed to paint some of the less important or marginal figures, but only under the master's close supervision.

Eventually, of course, artists hoped to attract patrons and establish themselves as masters. Artists, who were largely anonymous during the medieval period, began to enjoy greater emancipation during the 15th and 16th centuries, when they rose in rank from artisan to artist-scientist. The value of their individual skills—and their reputations—became increasingly important to their patrons and clients. This apprentice system—the passing of knowledge from one generation to the next—accounts for the sense of continuity people experience when reviewing Italian Renaissance art.

[1] Quoted in Giuseppe Fiocco, *Mantegna: La cappella Ovetari nella chiesa degli Eremitani* (Milan: A. Pizzi, 1974), 7.

Gabriel's reverent genuflection, an appropriate gesture in the presence of royalty. She draws about her the deep blue, golden-hemmed mantle, the heraldic colors she wears as Queen of Heaven. Despite the Virgin's modesty and diffidence and the tremendous import of the angel's message, the scene subordinates drama to court ritual, and structural experimentation to surface splendor. The intricate tracery of the richly tooled Late Gothic frame enhances the painted magnificence. Of French inspiration, it replaced the more sober, clean-cut shapes traditional in Italy, and its appearance here is eloquent testimony to the two-way flow of transalpine influences that fashioned the International Style.

Simone Martini and his student and assistant, LIPPO MEMMI, signed the altarpiece and dated it (1333). Lippo's contribution to the *Annunciation* is still a matter of debate, but historians now generally agree he painted the two lateral saints, Saint Ansanus and Saint Margaret(?). Lippo drew these figures, which are reminiscent of the jamb statues of Gothic church portals, with greater solidity and without the linear elegance of Martini's central pair. Given the nature of medieval and Renaissance workshop practices, it is often next to impossible to distinguish the master's hand from those of assistants, especially if the master corrected or redid part of the latter's work (see "Mastering a Craft: Artistic Training in the Renaissance," above). This uncertainty is exacerbated by the fact that *Annunciation*'s current architectural enframements are dated much later than the central panel.

CONCERN FOR SPATIAL ILLUSION The Lorenzetti brothers, also Duccio's students, shared in the general experiments in pictorial realism that characterized the 14th century, especially in their search for convincing spatial illusions. Going well beyond his master, PIETRO LORENZETTI (active 1320–1348) achieved remarkable success in a large panel, *The Birth of the Virgin*

19-13 PIETRO LORENZETTI, *The Birth of the Virgin,* from Altar of Saint Savinus, Siena Cathedral, Siena, Italy, 1342. Tempera on wood, approx. 6′ 1″ × 5′ 11″. Museo dell'Opera del Duomo, Siena.

(FIG. **19-13**). Like Duccio's *Maestà* and Simone Martini's *Annunciation,* the panel was painted for the Siena Cathedral as part of a program honoring the Virgin Mary, heavenly Queen of the Republic. Pietro Lorenzetti painted the wooden architectural members that divide the panel as though they extend back into the painted space, as if viewers were looking through the wooden frame (apparently added later) into a boxlike stage, where the event takes place. That one of the vertical members cuts across one of the figures, blocking part of it from view, strengthens the illusion. In subsequent centuries, artists exploited this use of architectural elements to enhance pictorial illusion. A long, successful history of such visual illusions produced by unifying both real and simulated architecture with painted figures evolved from these experiments.

Pietro Lorenzetti did not make just a structural advance here; his very subject represents a marked step in the advance of worldly realism. Saint Anne, reclining wearily as the midwives wash the child and the women bring gifts, is the center of an episode that occurs in an upper-class Italian house of the period. A number of carefully observed domestic details and the scene at the left, where Joachim eagerly awaits the news of the delivery, place the event in an actual household, as if viewers had moved the panels of the walls back and peered inside. Pietro Lorenzetti joined structural innovation in illusionistic space with the new curiosity that led to careful inspection and recording of what lay directly before the artist's eye in the everyday world.

19-14 Palazzo Pubblico, Siena, Italy, 1288–1309.

most buildings of its type and period, it abuts a lofty tower, which (along with Giotto's campanile in Florence; see FIG. 19-17, left of image) is one of the finest in Italy. This tall structure served as lookout over the city and the countryside around it and as a bell tower for ringing signals of all sorts to the populace. The city, a self-contained political unit, had to defend itself against neighboring cities and often against kings and emperors. In addition, it had to be secure against internal upheavals common in the history of the Italian city-republics. Class struggle, feuds between rich and powerful families, even uprisings of the whole populace against the city governors were constant threats. The heavy walls and battlements of the Italian town hall eloquently express how frequently the city governors needed to defend themselves against their own citizens. The high tower, out of reach of most missiles, includes machicolated galleries (galleries with holes in their floors to allow stones or hot liquids to be dumped on enemies below). These were built out on corbels around the top of the structures to provide openings for a vertical (downward) defense of the tower's base.

A BASTION OF POWER The Sienese were concerned about matters of both church and state. The city-state was a proud commercial and political rival of Florence. The secular center of the community, the town hall, was almost as great an object of civic pride as the cathedral. A building such as the Palazzo Pubblico of Siena (FIG. **19-14**) must have earned the admiration of Siena's citizens as well as of visiting strangers, inspiring in them respect for the city's power and success. More symmetrical in its design than

DEPICTING GOVERNMENTAL EFFECTS Pietro Lorenzetti's brother AMBROGIO LORENZETTI (active 1319–1348) both elaborated the advances in illusionistic representation in spectacular fashion and gave visual form to Sienese civic concerns in a vast fresco program in the Palazzo Pubblico. Ambrogio Lorenzetti produced three frescoes: *Allegory of Good Government, Bad Government and the Effects of Bad Government in the City,* and *Effects of Good Government in the City and in the Country.* The turbulent politics of the Italian cities—the violent party struggles, the overthrow and reinstatement of governments—certainly would have called for solemn reminders of fair and just administration. And the city hall was just the place for paintings such as Ambrogio Lorenzetti's. Indeed, the leaders of the Sienese government who commissioned this fresco series had undertaken the "ordering and reformation of the whole city and *contado* ('countryside') of Siena."

In *Effects of Good Government in the City and in the Country,* the artist depicted the urban and rural effects of good government. *Peaceful City* (FIG. **19-15**) is a panoramic view of Siena, with its clustering palaces, markets, towers, churches, streets, and walls.

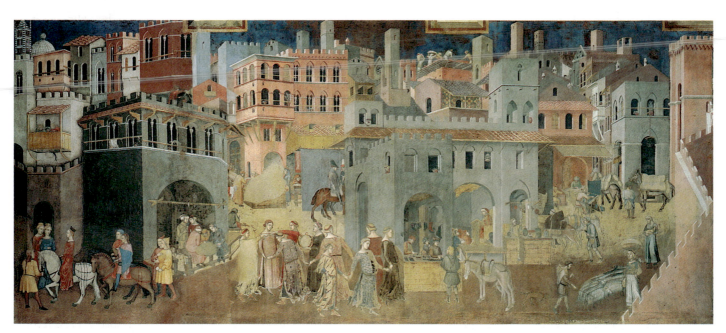

19-15 AMBROGIO LORENZETTI, *Peaceful City,* detail from *Effects of Good Government in the City and in the Country,* Sala della Pace, Palazzo Pubblico, Siena, Italy, 1338–1339. Fresco.

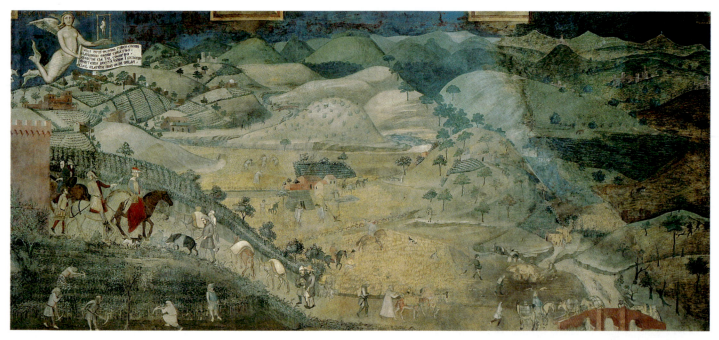

19-16 AMBROGIO LORENZETTI, *Peaceful Country,* detail from *Effects of Good Government in the City and in the Country,* Sala della Pace, Palazzo Pubblico, Siena, Italy, 1338–1339. Fresco.

The city's traffic moves peacefully, guild members ply their trades and crafts, and a cluster of radiant maidens, hand in hand, performs a graceful circling dance. Such dancers were part of festive springtime rituals; here, their presence also serves as a metaphor for a peaceful commonwealth. The artist fondly observed the life of his city, and its architecture gave him an opportunity to apply Sienese artists' rapidly growing knowledge of perspective. Passing through the city gate to the countryside beyond its walls, Ambrogio Lorenzetti's *Peaceful Country* (FIG. **19-16**) presents a bird's-eye view of the undulating Tuscan countryside—its villas, castles, plowed farmlands, and peasants going about their seasonal occupations. An allegorical figure of Security hovers above the landscape, unfurling a scroll that promises safety to all who live under the rule of the law. In this sweeping view of an actual countryside, *Peaceful Country* represents one of the first appearances of landscape in Western art since antiquity. Whereas earlier ancient depictions were fairly generic, Lorenzetti particularized the landscape—as well as the city view—by careful observation and endowed the painting with the character of a portrait of a specific place and environment. By combining some of Giotto's analytical powers with Duccio's narrative talent, Ambrogio Lorenzetti achieved more spectacular results than those of either of his two great predecessors.

The Black Death may have ended the careers of both Lorenzettis. They disappear from historical records in 1348, the year that brought so much horror to defenseless Europe.

The Republic of Florence

THE "MOST BEAUTIFUL" TUSCAN CHURCH Like Siena, the Republic of Florence was a dominant city-state during the 14th century, as evidenced by such statements as one by the early historian Giovanni Villani (ca. 1270–1348). Villani wrote that Florence was "the daughter and the creature of Rome," suggesting a preeminence inherited from the Roman Empire. Florentines prided themselves on what they perceived as economic and cultural superiority. The city-state assured its centrality to banking operations by making its gold florin the standard coin of exchange everywhere, and its economic prosperity was further enhanced by its control of the textile industry. Florentines translated their pride in their predominance into such landmark buildings as Florence Cathedral (FIG. **19-17**). Recognized as the center for the most important religious observances in the city, the cathedral was begun in 1296 by ARNOLFO DI CAMBIO. Intended as the "most beautiful and honorable church in Tuscany," this structure reveals the competitiveness Florentines felt with such cities as Siena and Pisa. Cathedral authorities planned for the church to hold the city's entire population, and although it holds only about 30,000 (Florence's population at the time was slightly less than 100,000), it seemed so large that even the noted architect Leon Battista Alberti commented that it seemed to cover "all of Tuscany with its shade." The architects ornamented the building's surfaces, in the old Tuscan fashion, with marble-encrusted geometric designs. This matched it to the 11th-century Romanesque baptistery of San Giovanni nearby (see FIG. 17-18). The vast gulf that separates this Italian church from its northern European counterparts is strikingly evident when the former is compared with a full-blown German representative of the High Gothic style, such as Cologne Cathedral (see FIG. 18-44).

Cologne Cathedral's emphatic stress on the vertical produces an awe-inspiring upward rush of almost unmatched vigor and intensity. The building has the character of an organic growth shooting heavenward, its toothed upper portions engaging the sky. The pierced, translucent stone tracery of the spires merges with the atmosphere.

Florence Cathedral, in contrast, clings to the ground and has no aspirations to flight. All emphasis is on the horizontal elements of the design, and the building rests firmly and massively on the ground. Simple geometric volumes are defined clearly and show no tendency to merge either into each other or into the sky. The dome, though it may seem to be rising because of its ogival section, has a crisp, closed silhouette that sets it off emphatically against the sky behind it. But because this dome is the monument with which

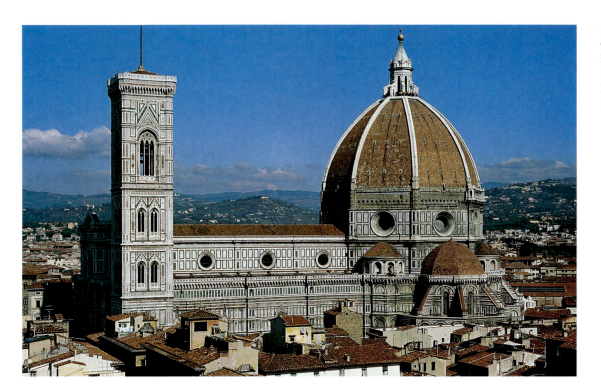

architectural historians usually introduce the Renaissance (it was built by Filippo Brunelleschi between 1420 and 1436), the following comparison of the campanile with the Cologne towers may be somewhat more appropriate in this discussion of 14th-century Italian art and architecture.

A TOWER OF BUILDING BLOCKS Designed by the painter Giotto di Bondone in 1334 (and completed with some minor modifications after his death), the Florence campanile (FIG. 19-17) stands apart from the cathedral, in keeping with Italian tradition. In fact, it could stand anywhere else in Florence without looking out of place; it is essentially self-sufficient. The same hardly can be said of the Cologne towers (see FIG. 18-44). They are essential elements of the building behind them, and it would be unthinkable to detach one of them and place it somewhere else. No individual element in the Cologne grouping seems capable of an independent existence. One form merges into the next in a series of rising movements that pull the eye upward and never permit it to rest until it reaches the sky. The beauty of this structure is formless rather than formal—a beauty that speaks to the heart rather than to the intellect.

The Italian tower is entirely different. Neatly subdivided into cubic sections, Giotto's tower is the sum of its clearly distinguished parts. Not only could this tower be removed from the building without adverse effects, but also each of the component parts—cleanly separated from each other by continuous moldings—seems capable of existing independently as an object of considerable aesthetic appeal. This compartmentalization is reminiscent of the Romanesque style, but it also forecasts the ideals of Renaissance architecture. Artists hoped to express structure in the clear, logical relationships of the component parts and to produce self-sufficient works that could exist in complete independence. Compared to Cologne's north towers, Giotto's campanile has a cool and rational quality that appeals more to the intellect than to the emotions.

In Florence Cathedral's plan, the nave appears almost to have been added to the crossing complex as an afterthought. In fact, the nave was built first, mostly according to Arnolfo's original plans (except for the vaulting), and the crossing was redesigned midway through the 14th century to increase the cathedral's interior space.

In its present form, the area beneath the dome is the design's focal point, and the nave leads to it. To visitors from the north, the nave may seem as strange as the plan; neither has a northern European counterpart. The Florence nave bays (FIG. **19-18**) are twice as deep as those of Amiens (see FIG. 18-17), and the wide arcades permit

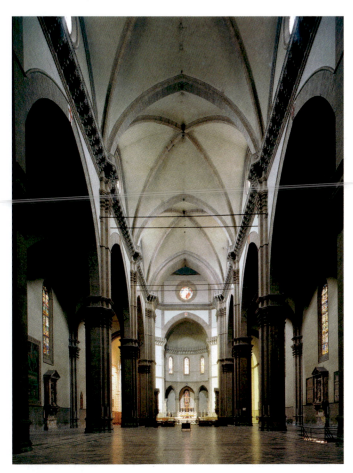

19-18 Nave of Florence Cathedral (view facing east), Florence, Italy, begun 1296.

the shallow aisles to become part of the central nave. The result is an interior of unmatched spaciousness. The accent here, as it is on the exterior, is on the horizontal elements. The substantial capitals of the piers prevent them from soaring into the vaults and emphasize their function as supports.

The facade of Florence Cathedral was not completed until the 19th century and then in a form much altered from its original design. In fact, until the 17th century, Italian builders exhibited little concern for the facades of their churches, and dozens remain unfinished to this day. One reason for this may be that the facades were not conceived as integral parts of the structures but as screens that could be added to the church exterior at any time.

ACCOMMODATING THE FAITHFUL The increased importance of the mendicant orders during the 14th century led to the construction of large churches by the Franciscans (Santa Croce; see FIG. Intro-3) and the Dominicans (see "Mendicant Orders and Confraternities," page 524) in Florence. The Florentine government and contributions from private citizens subsidized the commissioning of the Dominicans' Santa Maria Novella (FIG. 19-19) around 1246. The large congregations these orders attracted necessitated the expansive scale of this church. Small *oculi* (round openings) and marble striping along the ogival arches punctuate the nave. Originally, a screen *(tramezzo)* placed

across the nave separated the friars from the lay audience; the Mass was performed on separate altars on each side of the screen. Church officials removed this screen in the mid-16th century to encourage greater lay participation in the Mass. A powerful Florentine family, the Rucellai, commissioned the facade for Santa Maria Novella from architect Leon Battista Alberti in the mid-15th century.

A MEMORIAL TO THE BLACK DEATH The tabernacle of the Virgin Mary in Florence's Or San Michele (FIG. 19-20) is the work of two "Giotteschi" (followers of Giotto), Andrea di Cione, known as ORCAGNA (active 1343–1368), and BERNARDO DADDI (ca. 1290–1348). Orcagna produced the work's architecture and sculpture, and Bernardo Daddi painted the panel of the Madonna, which the tabernacle enshrines. Or San Michele was originally a grain market, a *loggia* (open-sided arcade) into the street; it was transformed into a church, confraternity building, and center for the city's guilds. Around mid-century, upper stories were added to house a granary. Or San Michele also functioned as a guild church, and each guild was assigned a niche on the building's exterior for a commissioned statue of its patron saint.

Construction of Orcagna's tabernacle was prompted by the plague, which decimated Europe in the late 1340s. Italy was particularly hard hit by this Black Death. With death tolls climbing as

19-19 Nave of Santa Maria Novella, Florence, Italy, ca. 1246–1470.

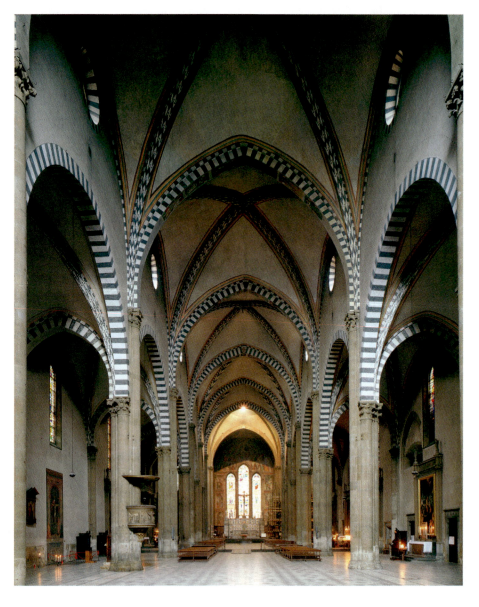

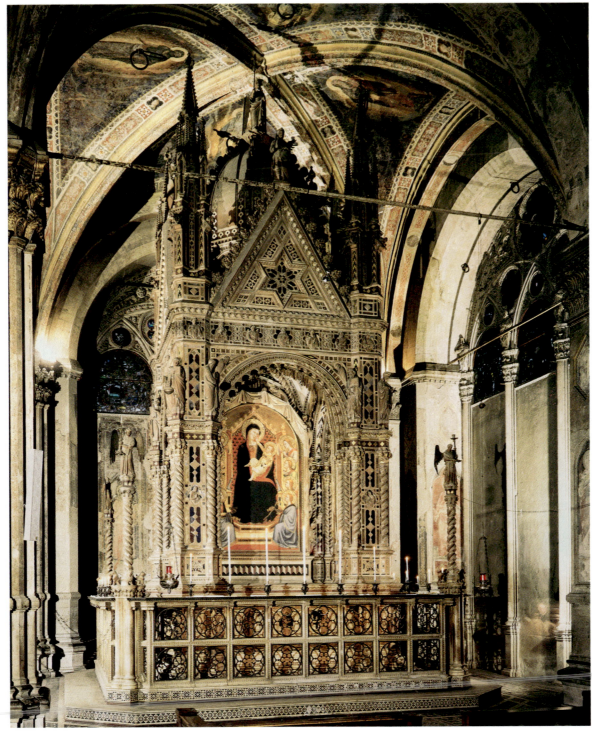

19-20 ORCAGNA, tabernacle, Or San Michele, Florence, Italy, begun 1349. Mosaic, gold, marble, lapis lazuli. BERNARDO DADDI, *Madonna and Child with Saints,* painted panel insert, 1346–1347.

high as 50 or 60 percent of the population in large cities, the plague wreaked havoc on all levels of society. This disaster prompted the commission of religious and devotional artworks. Such donations funded Orcagna's tabernacle, which donors no doubt perceived as a kind of memorial to both the dead and the survivors. Individuals made bequests to a supposed miraculous portrait of the Virgin, which later burned and was replaced with the image by BERNARDO DADDI. The entire tabernacle, started in 1349, took 10 years to complete, costing the vast sum of 87,000 gold florins.

Orcagna, an artistic virtuoso, was an architect, sculptor, and painter; he was familiar with the styles and practice of all the arts in post-Giotto Florence. The architectural enframement of the tabernacle recalls the polygonal piers and the slender spiral colonnettes of the Florence Cathedral and campanile (FIG. 19-17), as well as the triangular pediment, fenestration, and pinnacles of a typical Italian Gothic facade (see FIG. 18-55). The planar surfaces sparkle with gold, lapis lazuli, mosaic, and finely cut marble, all inlaid in geometric patterns called *Cosmato work* (from *Cosmati,* the name given to craftsmen who worked in marble and mosaic in the 12th to 14th centuries, many belonging to a family of that name). The effect is that of a gem-encrusted, scintillating shrine or reliquary, more the work of a jeweler than an architect.

The lavish ornamentation and costly materials recall the medieval association of precious material with holy things and

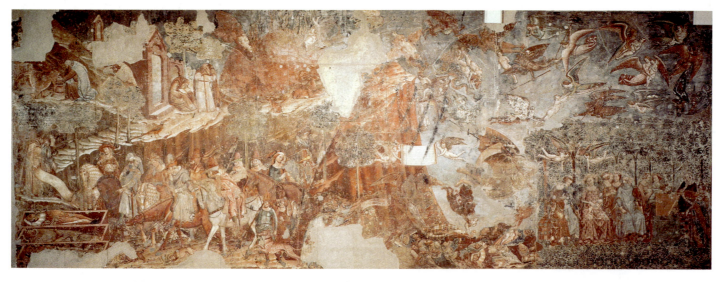

19-21 Francesco Traini(?) or Buonamico Buffalmacco(?), *Triumph of Death*, 1330s. Fresco, 18′ 6″ × 49′ 2″. Camposanto, Pisa.

themes, in this case with the original miracle-working image of the Virgin, which the new *Madonna and Child* replaced. Bernardo Daddi interpreted this most popular of Gothic subjects in a light, delicate manner appropriate to the humanizing of religion and to the emotional requirements of private devotion. Flanked by angels, two of whom swing censers filled with incense, the enthroned Virgin sits within a round arch with sculptured curtains. The Christ Child playfully touches his mother's face. The composition is conventional but softened by sentiment. The architectural enframement provides an illusionistic stage for the image, composing an ensemble of architecture, painting, and sculpture to serve devotion to the Virgin Mary. This tabernacle attests to the versatility of Florentine artists after Giotto as they followed the various paths suggested by his original inspiration. The ideas that gained momentum in the 14th century—humanism, direct observation, greater concern with the solidity of forms, and the interest in illusion—became prominent in the following centuries.

Pisa

Italy's port cities—Genoa, Pisa, and Venice—controlled the ever busier and more extended avenues of maritime commerce that connected the West with the lands of Islam, with Byzantium and Russia, and overland with China. As a port city, Pisa established itself as a major shipping power and thus as a dominant Italian city-state. Yet Pisa was not immune from the disruption that the Black Death wreaked across all of Italy and Europe in the late 1340s. Concern with death was a significant theme in art even before the onset of the plague and became more prominent in the years after mid-century.

DEALING WITH DEATH *Triumph of Death* (FIG. **19-21**) is a tour de force of death imagery. The creator of this large-scale (over 18 × 49 feet) fresco remains disputed; some attribute the work to FRANCESCO TRAINI (active c. 1321–1363), while others argue for BUONAMICO BUFFALMACCO (active 1320–1336). Painted on the wall of the Camposanto ("holy field"), the enclosed burial ground adjacent to the Pisa Cathedral, the fresco captures the horrors of death and forces viewers to confront their mortality.

In the left foreground, young aristocrats, mounted in a stylish cavalcade, encounter three coffin-encased corpses in differing stages of decomposition. As the horror of the confrontation with death strikes them, the ladies turn away with delicate and ladylike disgust, while a gentleman holds his nose (the animals, horses and dogs, sniff excitedly). At the far left, the hermit Saint Macarius unrolls a scroll whose inscription speaks of the folly of pleasure and the inevitability of death. In contrast with this mournful scene, hermits who have come to terms with their mortality exist peacefully in the background of the fresco. On the far right, ladies and gentlemen ignore dreadful realities, occupying themselves in an orange grove with music and amusements while all around them angels and demons struggle for the souls of the corpses heaped in the middle foreground.

As direct and straightforward as these scenes seem, more subtle messages are also embedded in the imagery. For example, those in *Triumph of Death* who appear unprepared for death and thus unlikely to see salvation after death are depicted as wealthy and reveling in luxury. Given that the Dominicans—an order committed to a life of poverty—participated in the design for this fresco program, this imagery surely was intended to warn against greed and lust.

Although *Triumph of Death* consists of a compilation of disparate scenes, the artist rendered each scene with naturalism and emotive power. It is an irony of history that, as Western humanity drew both itself and the world into ever sharper visual focus, it perceived ever more clearly that corporeal things are perishable.

CONCLUSION

In the early 14th century, people began to manifest a growing interest in the natural world. Accordingly, artists such as Giotto and Duccio, for example, began to abandon some of the conventions of medieval art and increasingly based their artworks on their worldly observations, resulting in a greater naturalism in art. Greater illusionism, more emphatic pictorial solidity and spatial depth, and stronger emotional demonstrations from depicted figures were among the developments. This changing worldview came to be known as the Renaissance. Instrumental in the germination of Renaissance art was the humanists' revived veneration of classical cultures. The subsequent maturation of Renaissance art and thought will be chronicled in Chapters 20, 21, 22, and 23.

SAINT DOMINIC, CA. 1170–1221

SAINT FRANCIS OF ASSISI, CA. 1181–1226

1200

FRANCISCAN ORDER FOUNDED, 1209

DOMINICAN ORDER FOUNDED, 1215

1225

SAINT THOMAS AQUINAS, CA. 1225–1274 (SCHOLASTICISM)

1

1 Bonaventura Berlinghieri, panel from Saint Francis Altarpiece, 1235

1250

DANTE ALIGHIERI, 1265–1321, *The Divine Comedy*

2
3

1300

2 Florence Cathedral, 1296–1436

FRANCESCO PETRARCH, 1304–1374, HUMANIST POET

1305

PAPACY MOVED TO AVIGNON, 1305

GIOVANNI BOCCACCIO, 1313–1375, HUMANIST SCHOLAR AND NOVELIST

1338

4

SAINT CATHERINE OF SIENA, 1347–1380

BLACK DEATH, 1348–MID 1350S

3 Giovanni Pisano, *The Annunciation and the Nativity*, Pistoia, Italy, 1297–1301

1378

BEGINNING OF GREAT SCHISM, 1378

ELECTION OF CLEMENT VII (AVIGNON), 1378

ELECTION OF URBAN VI (ROME), 1378

4 Ambrogio Lorenzetti, *Peaceful City*, Siena, Italy, 1338–1339

1400

FREDERICK II (HOLY ROMAN EMPEROR)

TRIUMPH OF THE PAPACY
FALL OF HOHENSTAUFEN HOLY ROMAN EMPERORS

AVIGNON PAPACY

HUNDRED YEARS' WAR BETWEEN FRANCE AND ENGLAND

GREAT SCHISM IN THE CHRISTIAN CHURCH

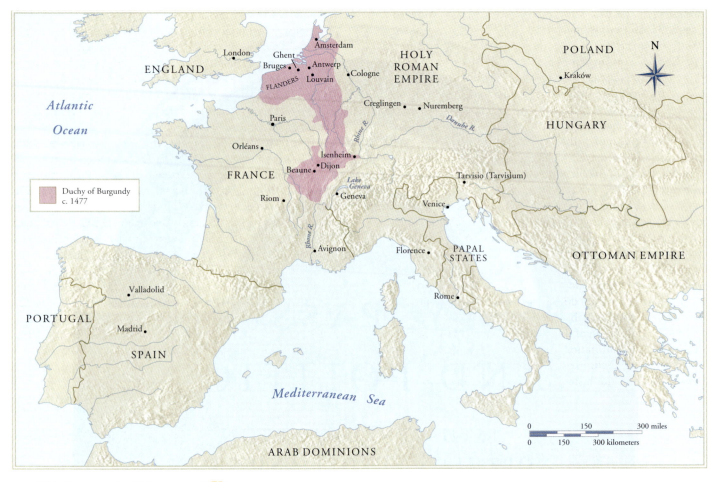

MAP 20-1 Europe in the 15th century.

origin of the French word for "stock market" demonstrates the importance of Flanders to Europe's economic development. *Bourse* came from the name of the van der Beurse family, whose residence in Bruges (now a Belgian city) was a center of economic activity. The first international commercial stock exchange, established in Antwerp in 1460, became pivotal for Europe's integrated economic activity. The thriving commerce, industry, and finance contributed to the evolution of cities, as did the migration of a significant portion of the rural population to urban centers.

FLOURISHING OF ART The widespread convulsions that swept across Europe did not impede artistic development; the 15th century witnessed the increased use of oil paints in Flanders, the maturation of manuscript illumination, and the invention of movable-type printing in Germany. These developments had a dramatic impact on artistic production worldwide. The art produced during this period in Northern Europe emphatically demonstrates the dynamic relationship between art and its historical context—the way art both reflects and contributes to historical developments. Northern European art of the 15th century, appropriately, focuses on the major aspects of life at that time—piety and political power, and the relationship between the two.

FRENCH MANUSCRIPT ILLUMINATION

A NEW VISION OF SPACE During the 15th century, French artists built on the expertise of earlier manuscript illuminators (see FIGS. 18-32 and 18-33) and produced exquisitely refined images. Knowledge of stained glass (see FIGS. 18-13 and 18-14),

with its profound luminosity and rich, jewel-like colors, no doubt contributed to the color mastery demonstrated by these illuminators.

Among the most significant developments in French manuscript illumination was a new conception and presentation of space. Illuminations took on more pronounced characteristics as illusionistic scenes; rather than appear simply as images on flat surfaces (the pages), illuminations increasingly were conceived by artists and perceived by viewers as illusory three-dimensional images. This interest in illusionism may have been influenced, in part, by increased contact with artists from Italy, where the development of humanism (Chapter 19, page 523) revived the principles and images of classical antiquity. What this illusionism cultivated was a new relationship between viewer and image. By presenting the illusion of a three-dimensional scene, the illuminated page became a liminal space between the viewer and that scene, thereby strengthening the connection between the two—not just in physical terms, but socially, politically, spiritually, and emotionally as well.

VERY SUMPTUOUS HOURS Among the early-15th-century artists who furthered the maturation of manuscript illumination were the three LIMBOURG BROTHERS—POL (PAUL?), HENNEQUIN (JEAN? JAN?), and HERMAN. Following in the footsteps of earlier illustrators such as Jean Pucelle (see FIG. 18-34), the Limbourg brothers expanded the illusionistic capabilities of illumination. They produced a gorgeously illustrated Book of Hours for Jean, the duke of Berry (1340–1416) and brother of King Charles V of France. The duke was an avid art patron and focused much of his collecting energy on manuscripts, jewels, and rare artifacts. An

inventory of the duke's libraries revealed that he owned more than 300 manuscripts, including the *Belleville Breviary* (see FIG. 18-34) and the *Hours of Jeanne d'Évreux*. The Limbourg brothers worked on the manuscript, *Les Très Riches Heures du Duc de Berry (The Very Sumptuous Hours of the Duke of Berry)*, until their deaths in 1416. A Book of Hours, like a breviary, was a book used for reciting prayers. As prayer books, they replaced the traditional psalters, which had been the only liturgical books in private hands until the mid-13th century. The centerpiece of a Book of Hours (see "Medieval Books," Chapter 16, page 425) was the "Office [prayer] of the Blessed Virgin," which contained liturgical passages to be read privately at set times during the day, from matins (dawn prayers) to compline (the last of the prayers recited daily). An illustrated calendar containing local religious feast days usually preceded the "Office of the Blessed Virgin." Penitential psalms, devotional prayers, litanies to the saints, and other prayers, including those of the dead and of the Holy Cross, followed the centerpiece. Such books became favorite possessions of the northern aristocracy during the 14th and 15th centuries. They eventually became available to affluent burghers and contributed to the decentralization of religious practice that was one factor in the Protestant Reformation in the early 16th century.

The calendar pictures of *Les Très Riches Heures* are perhaps the most famous in the history of manuscript illumination. They represent the 12 months in terms of the associated seasonal tasks, alternating scenes of nobility and peasantry. Above each picture is a lunette depicting the chariot of the sun as it makes its yearly cycle through the 12 months and zodiac signs. Beyond its function as a religious book, *Les Très Riches Heures* also visually captures the power of the duke and his relationship to the peasants. The colorful calendar picture for January (FIG. **20-1**) depicts a New Year's reception at court. The duke appears as magnanimous host, his head circled by the fire screen, almost halolike, behind him. His chamberlain stands next to him, urging the guests forward with the words "aproche, aproche." The richness and extravagance of the setting and the occasion are augmented by the lavish spread of food on the table and the large tapestry on the back wall. From their study of the few decipherable passages of poetry that appear at the top of the tapestry, scholars have concluded that the scene is most likely a representation of the Trojan War.

In contrast, the illustration for October (FIG. **20-2**) focuses on the peasantry. Here, the Limbourg brothers have depicted a sower, a harrower on horseback, and washerwomen, along with city dwellers, who promenade in front of the Louvre (the king's residence at the time). The peasants do not appear particularly disgruntled as they go about their tasks; surely such an image flattered

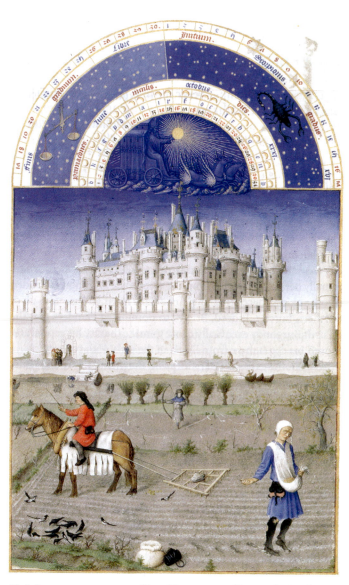

20-1 LIMBOURG BROTHERS (POL, HENNEQUIN, HERMAN), *January*, from *Les Très Riches Heures du Duc de Berry*, 1413–1416. Ink on vellum, approx. $8\frac{1}{2}'' \times 5\frac{1}{2}''$. Musée Condé, Chantilly.

20-2 LIMBOURG BROTHERS (POL, HENNEQUIN, HERMAN), *October*, from *Les Très Riches Heures du Duc de Berry*, 1413–1416. Ink on vellum, approx. $8\frac{1}{2}'' \times 5\frac{1}{2}''$. Musée Condé, Chantilly.

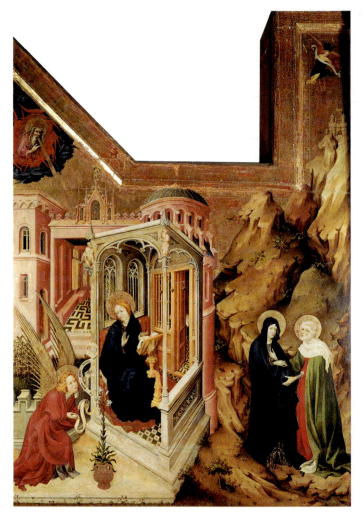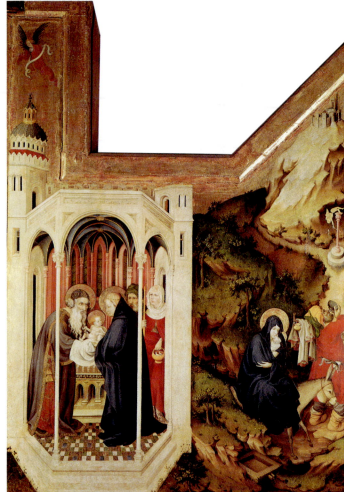

20-4 MELCHIOR BROEDERLAM, outer wings of the *Retable de Champmol*. *Annunciation and Visitation* (left) and *Presentation and Flight into Egypt* (right), from the chapel of the Chartreuse de Champmol, Dijon, France, installed 1399. Panels, each 5′ 5$\frac{3}{4}$″ × 4′ 1$\frac{1}{4}$″. Musée de la Ville, Dijon.

by Jean Malouel (uncle of the Limbourg brothers) and further augments the naturalism of the figures. This fascination with the specific and tangible in the visible world became one of the chief characteristics of 15th-century Flemish painting. Yet despite the realism of Sluter's figures, they do not evidence much physical movement or weight shift.

PANELS THAT PREFACE THE PASSION Philip the Bold also commissioned a major altarpiece for the main altar in the chapel of the Chartreuse. A collaborative project, this altarpiece consisted of a large sculptured shrine carved by JACQUES DE BAERZE and a pair of exterior panels (FIG. **20-4**) painted by MELCHIOR BROEDERLAM (active ca. 1387–1409). The artist depicted *Annunciation and Visitation* on the left panel and *Presentation and Flight into Egypt* on the right panel (see "The Life of Jesus in Art," Chapter 11, pages 308–309, or xx–xxi in Volume II). Dealing with Christ's birth and infancy, these painted images introduce the Passion scenes (from Christ's last days on earth) presented by de Baerze in the interior sculpture. The exterior panels are an unusual amalgam of different styles, locales, and religious symbolism. The two paintings include both landscape and interior scenes, and the architecture of the structures varies from Romanesque to Gothic. Scholars have suggested that the juxtaposition of different architectural styles in the left panel is symbolic. The *rotunda* (round building, usually with a dome) refers to the Old Testament, whereas the Gothic porch relates to the New Testament. Stylistically, Broederlam's representation of parts

of the landscape and architecture reveals an attempt to render three-dimensionality on the two-dimensional surface. Yet his staid treatment of the figures, their halos, and the flat gold background recall medieval pictorial conventions. Despite this interplay of various styles and diverse imagery, the altarpiece was a precursor of many of the artistic developments (such as the illusionistic depiction of three-dimensional objects and the representation of landscape) that preoccupied European artists throughout the 15th century.

Public Devotional Imagery: Altarpieces

Large-scale public altarpieces such as Broederlam's were among the most visible manifestations of piety. From their position behind the altar (the most common location for such altarpieces in the 15th century), these altarpieces served as backdrops for the Mass. The Mass represents a ritual celebration of the Holy Eucharist. At the Last Supper, Christ commanded that his act of giving to his apostles his body to eat and his blood to drink be repeated in memory of him. This act serves as the nucleus of the Mass. The ritual of the Mass involves prayer, contemplation of the Word of God, and the reenactment of the Eucharistic Sacrament. Because the Mass involves not only a memorial rite but complex Christian doctrinal tenets as well, art has traditionally played an important role in giving visual form to these often complex theological concepts for a wide public audience. These altarpieces

were thus didactic (especially for the illiterate). They also reinforced Church doctrines for viewers and stimulated devotion. Given their function as backdrops to the Mass, it is not surprising that many altarpieces depict scenes directly related to Christ's sacrifice (for example, FIG. 20-7). These public altarpieces most often took the form of *polyptychs* (hinged multipaneled paintings) or carved relief panels. The hinges allowed users to close the polyptych's side wings over the central panel(s). Artists decorated both the exterior and interior of the altarpieces. This multi-image format provided artists the opportunity to construct narratives through a sequence of images, somewhat like manuscript illustration. Although scholars do not have concrete information about

the specific circumstances in which these altarpieces were opened or closed, evidence suggests that they remained closed on regular days and were opened on Sundays and feast days. This schedule would have allowed viewers to see both the interior and exterior—diverse imagery at various times according to the liturgical calendar. As will be discussed in Chapter 23, differing Protestant conceptions of the Eucharist led, ultimately, to a decline of the altarpiece as a dominant art form in northern Europe.

REDEMPTION AND SALVATION The *Ghent Altarpiece* in Saint Bavo Cathedral in Ghent (FIG. 20-5) is one of the largest and most admired Flemish altarpieces of the 15th century. Jodocus

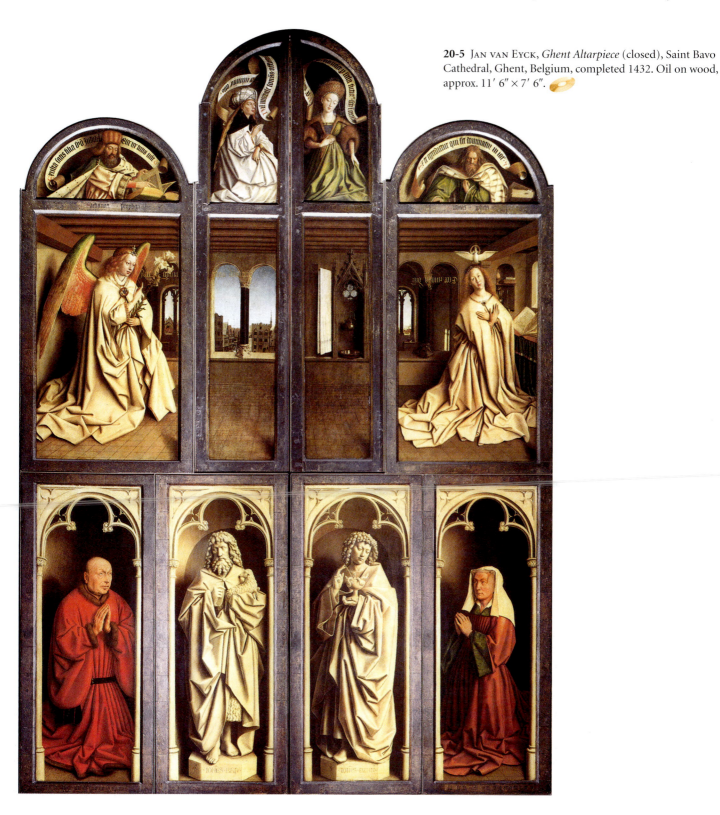

20-5 JAN VAN EYCK, *Ghent Altarpiece* (closed), Saint Bavo Cathedral, Ghent, Belgium, completed 1432. Oil on wood, approx. 11′ 6″ × 7′ 6″.

Vyd and his wife Isabel Borluut commissioned this polyptych from JAN VAN EYCK (ca. 1390–1441). That van Eyck was, at the time, Philip the Good's court painter reveals the powerful circles in which Vyd (diplomat-retainer of Philip the Good) traveled. Certainly, Vyd's largess and the political and social connections that this work revealed to its audience contributed to Vyd's appointment as burgomeister (chief magistrate) of Ghent shortly after this work was unveiled. Completed in 1432, the *Ghent Altarpiece* functioned as the liturgical centerpiece of the endowment established in the chapel that Vyd and Borluut built. This chapel is located in the local church dedicated to Saint John the Baptist (now Saint Bavo Cathedral).

Two of the exterior panels of the *Ghent Altarpiece* depict the donors at the bottom. The husband and wife, painted in illusionistically rendered niches, kneel with their hands clasped in prayer. They gaze piously at illusionistic stone sculptures of Ghent's patron saints, Saint John the Baptist and Saint John the Evangelist (who was probably also Vyd's patron saint). An Annunciation scene appears on the upper register, with a careful representation of a Flemish town outside the painted window of the center panel. In the uppermost arched panels, van Eyck depicted images of the Old Testament prophets Zachariah and Micah, along with sibyls, classical mythological prophetesses whose writings the Christian Church interpreted as prophecies of Christ.

When opened, the altarpiece (FIG. **20-6**) reveals a sumptuous, superbly colored painting of the medieval conception of humanity's Redemption. In the upper register, God the Father—wearing the pope's triple tiara, with a worldly crown at his feet, and resplendent in a deep-scarlet mantle—presides in majesty. To God's right is the Virgin, represented as the Queen of Heaven, with a crown of 12 stars upon her head. Saint John the Baptist sits to God's left. To either side is a choir of angels, on the right an angel playing an organ. Adam and Eve appear in the far panels. The inscriptions in the arches above Mary and Saint John extol the Virgin's virtue and purity and Saint John's greatness as the forerunner of Christ. The particularly significant inscription above the Lord's head translates as "This is God, all-powerful in his divine majesty; of all the best, by the gentleness of his goodness; the most liberal giver, because of his infinite generosity." The step behind the crown at the Lord's feet bears the inscription, "On his head, life without death. On his brow, youth without age. On his right, joy without sadness. On his left, security without fear." The entire altarpiece amplifies the central theme of salvation—even though humans, symbolized by Adam and Eve, are sinful, they will be saved because God, in his infinite love, will sacrifice his own son for this purpose.

The panels of the lower register extend the symbolism of the upper. In the central panel, the community of saints comes from the four corners of the earth through an opulent, flower-spangled landscape. They proceed toward the altar of the Lamb and toward the octagonal fountain of life. The Lamb symbolizes the sacrificed Son of God, whose heart bleeds into a chalice, while into the fountain spills the "pure river of water of life, clear as crystal, proceeding out of the throne of God and of the Lamb" (Rev. 22:1). On the right, the Twelve Apostles and a group of martyrs in red robes advance; on the left appear prophets. In the right background come the virgin martyrs, and in the left background the holy confessors approach. On the lower wings, other approaching groups symbolize the four cardinal virtues: the hermits, Temperance; the pilgrims, Prudence; the knights, Fortitude; and the

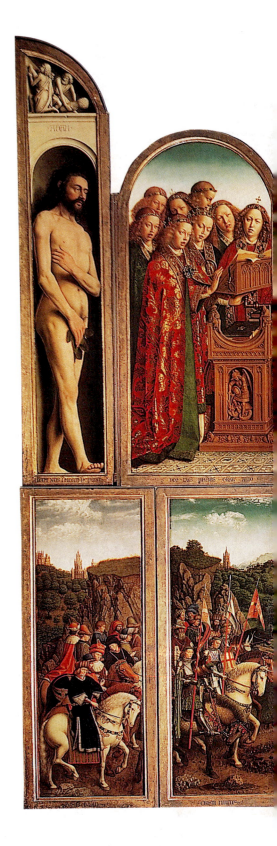

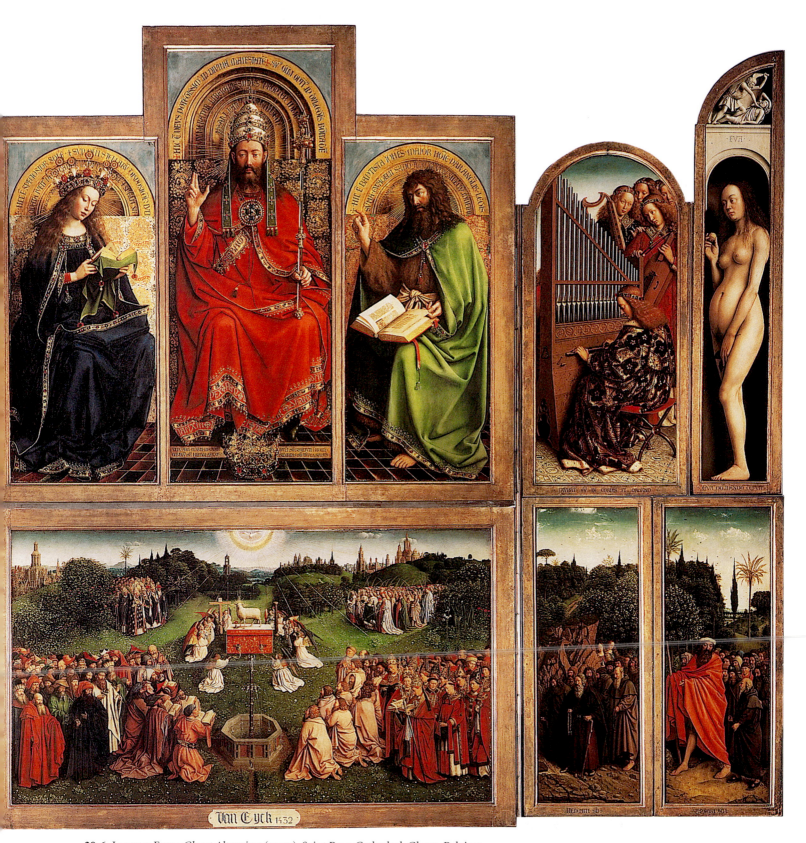

20-6 JAN VAN EYCK, *Ghent Altarpiece* (open), Saint Bavo Cathedral, Ghent, Belgium, completed 1432. Oil on wood, approx. 11′ 6″ × 15′.

judges, Justice. The altarpiece celebrates the whole Christian cycle from the Fall to the Redemption, presenting the Church triumphant in heavenly Jerusalem.

Van Eyck rendered the entire altarpiece in a shimmering splendor of color that defies reproduction. No small detail escaped van Eyck, trained as a miniaturist. With pristine specificity, he revealed the beauty of the most insignificant object as if it were a work of piety as much as a work of art. He depicted the soft texture of hair, the glitter of gold in the heavy brocades, the luster of pearls, and the flashing of gems, all with loving fidelity to appearance.

OIL PAINTS AND GLAZES Oil paints facilitated the exactitude found in the work of van Eyck and others. Although traditional scholarship credited Jan van Eyck with the invention of oil painting, recent evidence has revealed that oil paints had been known for some time and that Melchior Broederlam was using oils in the 1390s. Flemish painters built up their pictures by superimposing translucent paint layers, called *glazes*, on a layer of underpainting, which in turn had been built up from a carefully planned drawing made on a panel prepared with a white ground. With the rediscovered medium, painters created richer colors than previously had been possible. Thus, a deep, intense tonality; the illusion of glowing light; and hard, enamel-like surfaces characterized 15th-century Flemish painting. These traits differed significantly from the high-keyed color, sharp light, and rather matte surface of tempera (see "Painters, Pigments, and Panels," page 555). The brilliant and versatile oil medium suited perfectly the formal intentions of the Flemish painters, who aimed for sharply focused, hard-edged, and sparkling clarity of detail in their representation of thousands of objects ranging in scale from large to almost invisible.

The apprentice training system throughout the continent (see "The Artist's Profession in Flanders," page 556) ensured the transmission of information about surfaces and pigments from generation to generation, thereby guaranteeing the continued viability of the painting tradition.

THE DRAMA OF CHRIST'S DEATH Like the art of van Eyck, that of ROGIER VAN DER WEYDEN (ca. 1400–1464) had a great impact on northern painting during the 15th century. In particular, Rogier (as scholars refer to him) created fluid and dynamic compositions stressing human action and drama. He concentrated on such themes as the Crucifixion and the Pietà, moving observers emotionally by relating the sufferings of Christ.

Deposition (FIG. 20-7) was the center panel of a *triptych* (three-paneled painting) commissioned by the Archers' Guild of Louvain for the church of Notre-Dame hors-les-murs (Notre-Dame "outside the [town] walls") in Louvain. Rogier acknowledged the

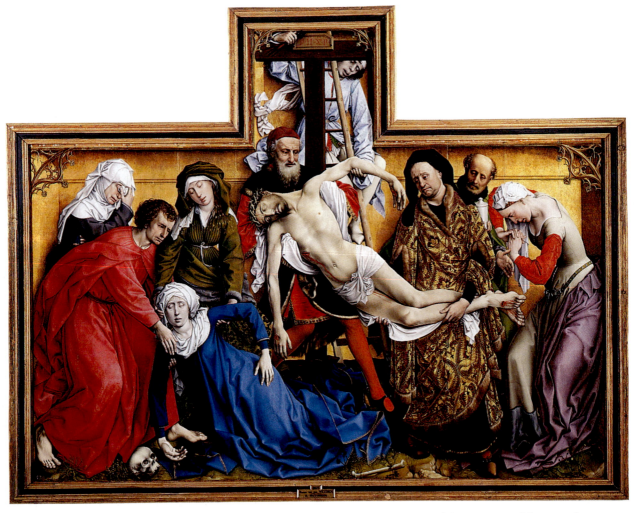

20-7 ROGIER VAN DER WEYDEN, *Deposition*, from Notre-Dame hors-les-murs, Louvain, Belgium, ca. 1435. Oil on wood, approx. 7′ 3″ × 8′ 7″. Museo del Prado, Madrid.

Painters, Pigments, and Panels

The generic word *paint* or *pigment* encompasses a wide range of substances artists have used over the years. Fresco aside (see "Fresco Painting," Chapter 19, page 530), during the 14th century, egg *tempera* was the material of choice for most painters, both in Italy and northern Europe. Tempera consists of egg combined with a wet paste of ground pigment. In his influential guidebook *Il Libro dell'Arte (The Craftsman's Handbook),* Cennino Cennini, a contemporaneous painter, mentioned that artists mixed only the egg yolk with the ground pigment, but analysis of paintings from this period has revealed that some artists chose to use the whole egg. Images painted with tempera have a velvety sheen to them and exhibit a lightness of artistic touch because thick application of the pigment mixture results in premature cracking and flaking.

Scholars have discovered that artists used oil paints as far back as the 8th century, but not until the early 15th century did painting with this material become widespread. Flemish artists were among the first to employ oils extensively (often mixing them with tempera), and Italian painters quickly followed suit. The discovery of better drying components in the early 15th century enhanced the setting capabilities of oils. Rather than apply these oils in the light, flecked brushstrokes that tempera encouraged, artists laid the oils down in transparent *glazes* over opaque or semiopaque underlayers. In this manner, painters could build up deep tones through repeated glazing. Unlike tempera, whose surface dries quickly due to water evaporation, oils dry more uniformly and slowly, providing the artist time to rework areas. This flexibility must have been particularly appealing to artists who worked very deliberately, such as Leonardo da Vinci (Chapter 22, pages 613–618). Leonardo also preferred oil paint because its gradual drying process and consistency permitted him to blend the pigments, thereby creating the impressive *sfumato* (smoky effect) that contributed to his fame.

Both tempera and oils can be applied to various surfaces. Through the early 16th century, wooden panels served as the foundation for most paintings. Italians painted on poplar; northern artists used oak, lime, beech, chestnut, cherry, pine, and silver fir. Availability of these timbers determined the choice of wood. Linen canvas became increasingly popular in the late 16th century. Although evidence suggests that artists did not intend permanency for their early images on canvas, the material proved particularly useful in areas such as Venice where high humidity warped wood panels and made fresco unfeasible. Further, until canvas paintings were stretched on wooden stretcher bars before framing or affixed to a surface, they were more portable than wood panels.

patrons of this large painting by incorporating the crossbow (the guild's symbol) into the decorative spandrels in the corners.

This altarpiece nicely sums up Rogier's early style and content. Instead of creating a deep landscape setting, as Jan van Eyck might have, he compressed the figures and action onto a shallow stage to concentrate the observer's attention. Here, Rogier imitated the large sculptured shrines so popular in the 15th century, especially in Germany, and the device admirably serves his purpose of expressing maximum action within a limited space. The painting, with the artist's crisp drawing and precise modeling of forms, resembles a stratified relief carving. A series of lateral undulating movements gives the group a compositional unity, a formal cohesion that Rogier strengthened by psychological means— by depicting the desolating anguish shared by many of the figures. The similar poses of Christ and the Virgin Mary further unify *Deposition*. Few painters have equaled Rogier in the rendering of passionate sorrow as it vibrates through a figure or distorts a tear-stained face. His depiction of the agony of loss is among the most authentic in religious art. The emotional impact on the viewer is immediate and direct.

SAVING LIVES AND SOULS Rogier further demonstrated his immense talent for producing compositionally complex and emotionally intense images in the *Last Judgment Altarpiece* (FIG. **20-8**). Nicholas Rolin, whom Philip the Good had appointed chancellor of the Burgundian territories, commissioned this polyptych. Created for the Hôtel-Dieu (hospital) in Beaune (also founded by Rolin), this image served an important function in the treatment of hospital patients. The public often attributed the horrific medical maladies affecting people of all walks of life to God's displeasure, and perceived such afflictions as divine punishment. Thus, the general populace embraced praying to patron saints as a viable component of treatment. On the altarpiece's exterior (not illustrated), Rogier depicted Saints Anthony and Sebastian, both considered plague saints—saints whose legends made them appropriate intercessors for warding off or curing the plague. Chancellor Rolin and his wife also appear on the exterior, in perpetual prayer to the two saints. This work served many purposes. It demonstrated Nicholas Rolin's devotion and generosity, aided in patient therapy, and warned of the potential fate of people's souls should they turn away from the Christian Church.

Rogier gave visual form to this warning on the altarpiece's interior (FIG. 20-8), where he depicted the Last Judgment, a reminder of larger issues beyond earthly life and death—everlasting life or consignment to Hell. A radiant Christ appears in the center panel, above the archangel Michael, who holds the scales to weigh souls. The panels on both sides include numerous saints above the dead. On the ends, the saved are ushered into Heaven on the left, and the damned tumble into the fires of Hell on the right. Because this altarpiece is largely horizontal, for the artist to rely solely on the common convention of distinguishing the spiritual from the mundane by placing the figures in a vertical hierarchy would not have been very effective. Therefore, Rogier used both hierarchy and scale to emphasize the relative importance of the figures. Christ appears as the largest and highest figure in the altarpiece, whereas the naked souls are minuscule.

The Artist's Profession in Flanders

As in Italy (see "Mastering a Craft," Chapter 19, page 534), guilds controlled the Flemish artist's profession. To pursue a craft, individuals had to belong to the guild controlling that craft. Painters, for example, sought admission to the Guild of Saint Luke, which included saddlers, glassworkers, and mirrorworkers as well. The path to eventual membership in the guild began, for men, at an early age, when the father apprenticed his son in boyhood to a master, with whom the young aspiring painter lived. The master taught the fundamentals of his craft—how to make implements; how to prepare panels with gesso (plaster mixed with a binding material); and how to mix colors, oils, and varnishes. Once the youth mastered these procedures and learned to work in the master's traditional manner, he usually spent several years working as a journeyman in various cities, observing and absorbing ideas from other masters. He then was eligible to become a master and applied for admission to the guild. Through the guild, he obtained commissions. The guild also inspected his paintings to ensure that he used quality materials and to evaluate workmanship. It also secured him adequate payment for his labor. As a result of this quality control,

Flemish artists soon gained a favorable reputation for their solid artisanship.

It is clear that women had many fewer opportunities than men to train as artists, in large part because of social and moral constraints that would have forbidden women's apprenticeship in the homes of male masters. Moreover, from the 16th century, when academic training courses supplemented and then replaced guild training, until the 20th century, women would not as a rule expect or be permitted instruction in figure painting, insofar as it involved dissection of cadavers and study of the nude male model. Flemish women interested in pursuing art as a career most often received tutoring from fathers and husbands who were professionals and whom the women assisted in all the technical procedures of the craft. Despite these obstacles, a substantial number of Flemish women in the 15th century were able to establish themselves as artists (revealed by membership records of the art guilds of cities such as Bruges). That these female artists were able to negotiate the difficult path to acceptance as professionals is a testament to both their tenacity and their artistic skill.

20-8 Rogier van der Weyden, *Last Judgment Altarpiece* (open), Hôtel-Dieu, Beaune, France, ca. 1444–1448. Oil on wood, 7′ 4$\frac{5}{8}$″ × 17′ 11″. Musée de l'Hôtel-Dieu, Beaune.

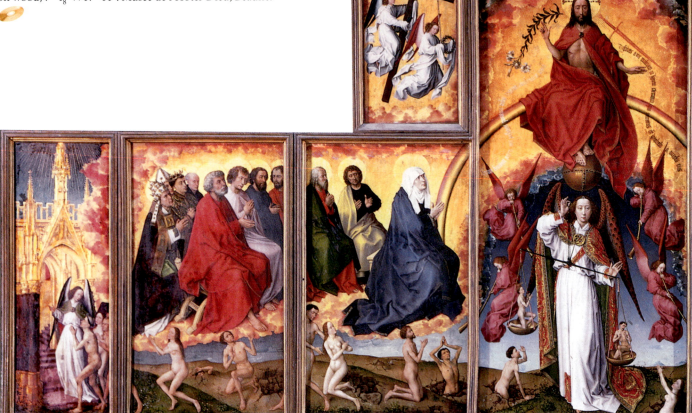

A FLEMISH LAST SUPPER Among the first northern paintings to demonstrate the use of a single vanishing point (see "Depicting Objects in Space," Chapter 21, page 578) is *Last Supper* (FIG. 20-9) by DIRK BOUTS (ca. 1415–1475). *Last Supper* is the central panel of *Altarpiece of the Holy Sacrament,* commissioned from Bouts by the Louvain Confraternity of the Holy Sacrament in 1464. All of the central room's *orthogonals* (lines imagined to be behind and perpendicular to the picture plane that converge at a vanishing point) lead to a single vanishing point in the center of the mantelpiece above Christ's head. However, the small side room has its own vanishing point, and neither it nor the vanishing point of the main room falls on the horizon of the landscape seen through the windows.

Scholars also have noted that Bouts's *Last Supper* was the first Flemish panel painting depicting this event. In this central panel, Bouts did not focus on the biblical narrative itself but instead presented Christ in the role of a priest performing a ritual from the liturgy of the Christian Church—the consecration of the Eucharistic wafer. This contrasts strongly with other Last Supper depictions, which often focused on Judas's betrayal or on Christ's comforting of John. Bouts also added to the complexity of this image by including four servants (two in the window and two standing), all dressed in Flemish attire. These servants are most likely portraits of the confraternity's members responsible for commissioning the altarpiece.

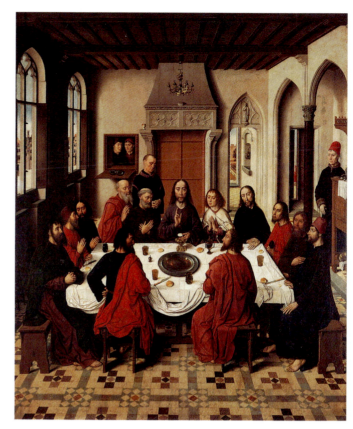

20-9 DIRK BOUTS, *Last Supper,* center panel of the *Altarpiece of the Holy Sacrament,* Saint Peter's, Louvain, Belgium, 1464–1468. Oil on wood, approx. 6′ × 5′.

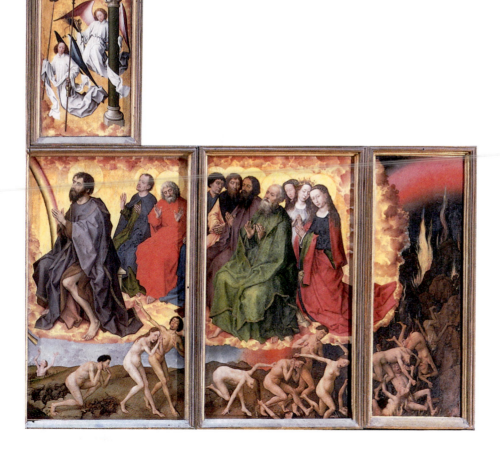

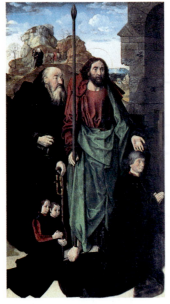
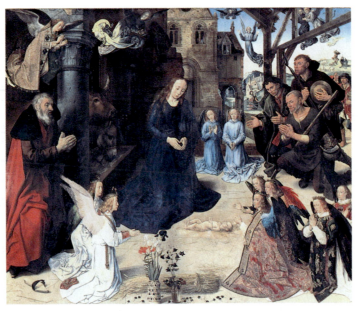
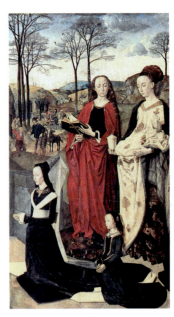

20-10 HUGO VAN DER GOES, *Portinari Altarpiece* (open), from Sant'Egidio, Florence, Italy, ca. 1476. Tempera and oil on wood, 8′ 3 ½″ × 10′ (center panel), 8′ 3 ½″ × 4′ 7 ½″ (each wing). Galleria degli Uffizi, Florence.

FROM FLANDERS TO FLORENCE Artists and patrons throughout Europe expressed great interest in Flemish art. Indeed, the *Portinari Altarpiece* (FIG. **20-10**) is just one example of a Flemish painting that made its way out of Flanders. A large-scale altarpiece installed in a family chapel in Florence, the *Portinari Altarpiece* was the creation of Flemish artist HUGO VAN DER GOES (ca. 1440–1482). As the dean of the painters' guild of Ghent from 1468 to 1475, Hugo was an extremely popular painter.

Hugo painted the triptych for Tommaso Portinari, an Italian shipowner and agent for the powerful Medici family of Florence. Portinari appears on the wings of the altarpiece with his family and their patron saints. The central panel is titled *Adoration of the Shepherds.* On this large surface, Hugo displayed a scene of solemn grandeur, muting the high drama of the joyous occasion. The Virgin, Joseph, and the angels seem to brood on the suffering to come rather than to meditate on the Nativity miracle. Mary kneels, somber and monumental, on a tilted ground that has the expressive function of centering the main actors. From the right rear enter three shepherds, represented with powerful realism in attitudes of wonder, piety, and gaping curiosity. Their lined plebeian faces, work-worn hands, and uncouth dress and manner seem immediately familiar. The symbolic architecture and a continuous wintry northern landscape unify the three panels. Symbols surface throughout the altarpiece. Iris and columbine flowers symbolize the Sorrows of the Virgin; the 15 angels represent the Fifteen Joys of Mary; a sheaf of wheat stands for Bethlehem (the "house of bread" in Hebrew), a reference to the Eucharist; and the harp of David, emblazoned over the building's portal in the middle distance (just to the right of the Virgin's head), signifies the ancestry of Christ.

To stress the meaning and significance of the depicted event, Hugo revived medieval pictorial devices. Small scenes shown in the background of the altarpiece represent (from left to right) the flight into Egypt, the Annunciation to the Shepherds, and the arrival of the Magi. Hugo's variation in the scale of his figures to differentiate them by their importance to the central event also reflects older traditions. Still, he put a vigorous, penetrating realism

to work in a new direction, characterizing human beings according to their social level while showing their common humanity.

After Portinari placed his altarpiece in the family chapel in the Florentine church of Sant'Egidio, it created a considerable stir among Italian artists. Although the painting as a whole may have seemed unstructured to them, Hugo's masterful technique and what they thought of as incredible realism in representing drapery, flowers, animals, and, above all, human character and emotion made a deep impression on them. At least one Florentine artist, Domenico Ghirlandaio, paid tribute to the northern master by using Hugo's most striking motif, the adoring shepherds, in one of his own Nativity paintings.

CELEBRATING A MYSTIC MARRIAGE The artistic community in Flanders held Hugo's contemporary, HANS MEMLING (ca. 1430–1494), in high esteem as well. Memling specialized in images of the Madonna; the many that survive are young, slight, pretty princesses, each holding a doll-like infant Christ. One such painting is the *Saint John Altarpiece,* the center panel of which is *Virgin with Saints and Angels* (FIG. **20-11**). The patrons of this altarpiece—two brothers and two sisters of the order of the Hospital of Saint John in Bruges—appear on the exterior side panels (not illustrated). In the central panel, two angels, one playing a musical instrument and the other holding a book, flank the Virgin. To the sides of Mary's throne stand Saint John the Baptist on the left and Saint John the Evangelist on the right, and in the foreground are Saints Catherine and Barbara. This gathering celebrates the Mystic Marriage of Saint Catherine of Alexandria; a number of virgin saints were believed to have entered into a special spiritual marriage (Mystic Marriage) with Christ. As one of the most revered virgins of Christ, Saint Catherine (and the celebration of her Mystic Marriage in paintings such as this) provided a model of devotion especially resonant with women viewers (particularly nuns). The altarpiece exudes an opulence that results from the rich colors, carefully depicted tapestries and brocades, and the serenity of the figures. The composition is balanced and serene; the color, sparkling and luminous; and the

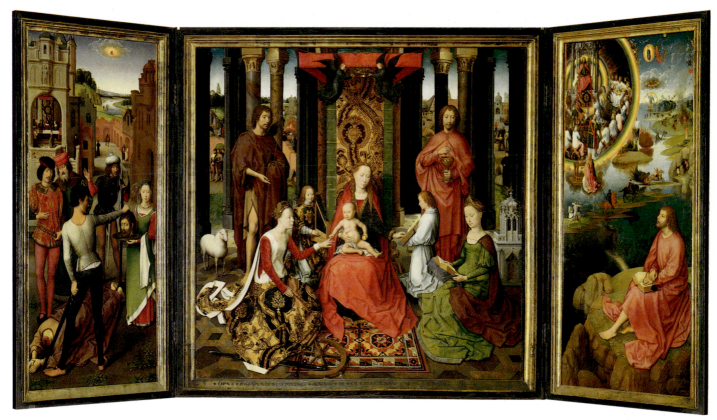

20-11 HANS MEMLING, *Virgin with Saints and Angels,* center panel of the *Saint John Altarpiece,* Hospitaal Sint Jan, Bruges, Belgium, 1479. Oil on wood, approx. 5′ 7¾″ × 5′ 7¾″ (center panel), 5′ 7¾″ × 2′ 7⅛″ (each wing).

execution, of the highest technical quality. Works such as this earned Memling the following tribute after his death: "Johannes Memlinc [Memling] was the most accomplished and excellent painter in the entire Christian world."[1] Fortunately for contemporary viewers, Memling's paintings are among the best preserved from the 15th century.

Private Devotional Imagery

IN THE PRIVACY OF THE HOME The Flemish did not limit their demonstrations of piety to the public realm, relying increasingly on private devotional practices. The expanding use of prayer books and Books of Hours (such as *Les Très Riches Heures;* FIGS. 20-1 and 20-2) was one manifestation of this commitment to private prayer. Individuals commissioned artworks for private devotional use in the home as well. So strong was the impetus for private devotional imagery that it seems, based on an accounting of extant Flemish religious paintings, that lay patrons outnumbered clerical patrons by a ratio of two to one. Dissatisfaction with the clergy accounted, in part, for this commitment to private prayer. In addition, popular reform movements advocated personal devotion, and in the years leading up to the Protestant Reformation in the early 16th century, private devotional exercises and prayer grew in popularity.

One of the more prominent features of these images commissioned for private use is the integration of religious and secular concerns. For example, biblical scenes were often presented as transpiring in a Flemish house. Although this may seem inappropriate or even sacrilegious, religion was such an integral part of Flemish life that separating the sacred from the secular became

virtually impossible. Further, the presentation in religious art of familiar settings and objects no doubt strengthened the direct bond the patron or viewer felt with biblical figures.

THE SYMBOLIC AND THE SECULAR The *Mérode Altarpiece* (FIG. **20-12**) is representative of triptychs commissioned for private use. Scholars generally agree that the artist, referred to as the "Master of Flémalle," is ROBERT CAMPIN (ca. 1378–1444), the leading painter of the city of Tournai. Similar in format to large-scale Flemish public altarpieces, the *Mérode Altarpiece* is considerably smaller (the central panel is roughly two feet square), which allowed the owners to close the wings and move the painting when necessary. The popular Annunciation theme (as prophesied in Isa. 7:14) occupies the triptych's central panel. The archangel Gabriel approaches Mary, who sits reading. The artist depicted a well-kept middle-class Flemish home as the site of the event. The carefully rendered architectural scene in the background of the right wing confirms this identification of the locale.

The depicted accessories, furniture, and utensils contribute to the identification of the setting as Flemish. However, the objects represented are not merely decorative. They also function as religious symbols, thereby reminding viewers of the event's miraculous nature. The book, extinguished candle, lilies, copper basin (in the corner niche), towels, fire screen, and bench symbolize, in different ways, the Virgin's purity and her divine mission. In the right panel, Joseph has made a mousetrap, symbolic of the theological tradition that Christ is bait set in the trap of the world to catch the Devil. The painter completely inventoried a carpenter's shop. The ax, saw, and rod in the foreground are not only tools of the carpenter's trade but also mentioned in Isaiah 10:15. In the left panel, the altarpiece's donor, Peter Inghelbrecht, and his wife

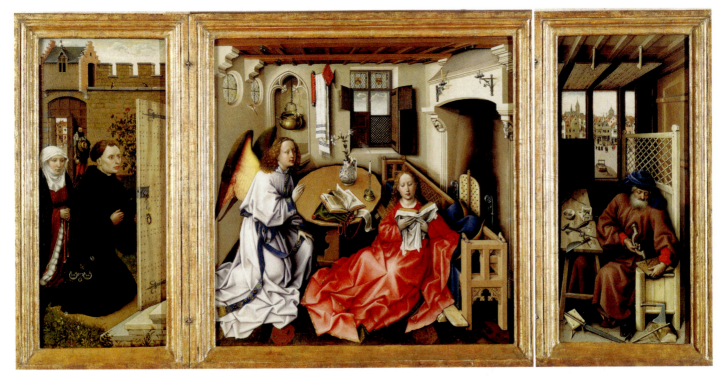

20-12 ROBERT CAMPIN (Master of Flémalle), *Mérode Altarpiece* (open), *The Annunciation* (center panel), ca. 1425–1428. Oil on wood, center panel approx. 2′ 1″ × 2′ 1″. Metropolitan Museum of Art, New York (The Cloisters Collection, 1956).

kneel and seem to be permitted to witness this momentous event through an open door. The Inghelbrechts, a devout, middle-class couple, appear in a closed garden, symbolic of Mary's purity, and the flowers depicted (such as strawberries and violets) all relate to Mary's virtues, especially humility.

The careful personalization of this entire altarpiece is further suggested by the fact that the Annunciation theme refers to the patron's name, Inghelbrecht (angel bringer), and the workshop scene in the right panel also refers to his wife's name, Schrin-mechers (shrine maker).

FOR BETTER, FOR WORSE References to both the secular and the religious in Flemish painting also surface in Jan van Eyck's double portrait *Giovanni Arnolfini and His Bride* (FIG. **20-13**). Van Eyck depicted the Lucca financier (who had established himself in Bruges as an agent of the Medici family) and his betrothed in a Flemish bedchamber that is simultaneously mundane and charged with the spiritual. As in the *Mérode Altarpiece,* almost every object portrayed conveys the sanctity of the event, specifi- cally, the holiness of matrimony. Arnolfini and his bride, Giovanna Cenami, hand in hand, take the marriage vows. The cast-aside clogs indicate that this event is taking place on holy ground. The little dog symbolizes fidelity (the common canine name Fido orig- inated from the Latin *fido,* "to trust"). Behind the pair, the curtains of the marriage bed have been opened. The bedpost's *finial* (crowning ornament) is a tiny statue of Saint Margaret, patron saint of childbirth. From the finial hangs a whisk broom, symbolic of domestic care. The oranges on the chest below the window may refer to fertility, and the all-seeing eye of God seems to be referred to twice. It is symbolized once by the single candle burning in the left rear holder of the ornate chandelier, and again by the mirror, in which the viewer sees the entire room reflected (FIG. **20-14**). The small medallions set into the mirror frame show tiny scenes

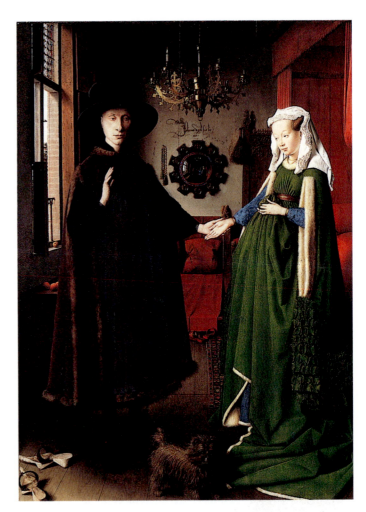

20-13 JAN VAN EYCK, *Giovanni Arnolfini and His Bride,* 1434. Oil on wood, approx. 2′ 8″ × 1′ 11½″. National Gallery, London.

from the Passion of Christ and represent God's promise of salvation for the figures reflected on the mirror's convex surface.

Flemish viewers would have been familiar with many of the objects included in *Giovanni Arnolfini and His Bride* because of traditional Flemish customs. Husbands traditionally presented brides with clogs, and the solitary lit candle in the chandelier was also part of Flemish marriage practices. Van Eyck's placement of the two figures suggests conventional gender roles—the woman stands near the bed and well into the room, whereas the man stands near the open window, symbolic of the outside world.

Van Eyck enhanced the documentary nature of this scene by exquisitely painting each object. He carefully distinguished textures and depicted the light from the window on the left reflecting off various surfaces. The artist augmented the scene's credibility by including the convex mirror (FIG. 20-14), because viewers can see not only the principals, Arnolfini and his wife, but also two persons who look into the room through the door. One of these must be the artist himself, as the florid inscription above the mirror, "Johannes de Eyck fuit hic" (Jan van Eyck was here), announces he was present. The picture's purpose, then, seems to have been to record and sanctify this marriage. Although this has been the traditional interpretation of the image, some scholars recently have taken issue with this reading, suggesting that Arnolfini is conferring legal privileges on his wife to conduct business in his absence. Despite the lingering questions about the precise purpose of *Giovanni Arnolfini and His Bride*, the painting provides viewers today with great insight into both van Eyck's remarkable skill and Flemish life in the 15th century.

SAINT OR GOLDSMITH? Like *Giovanni Arnolfini and His Bride, A Goldsmith in His Shop, Possibly Saint Eligius* (FIG. **20-15**) by PETRUS CHRISTUS (ca. 1410–1472) testifies to the incorporation of references to both the religious and the secular realms that characterizes much of 15th-century Flemish art. Traditional scholarship posited a religious interpretation of this painting. According to this interpretation, *A Goldsmith in His Shop, Possibly Saint Eligius* conveys the importance and sacredness of the sacrament of marriage. In the painting, Saint Eligius (initially a master goldsmith before committing his life to God) sits in his stall, showing an elegantly attired couple a selection of rings. The bride's betrothal girdle lies on the table as a symbol of chastity, and the woman reaches for the ring the goldsmith weighs. The artist's inclusion of a crystal container for Eucharistic wafers (on the lower shelf to the right of Saint Eligius) and the scales (a reference to the Last Judgment) supports a religious interpretation of this painting. A halo that at one time circled Saint Eligius's head seemingly emphasized the religious nature of this scene. However, scientific analysis revealed that the halo was added later by an artist other than Christus, and it has been removed.

Although not completely dismissing this religious reading of *A Goldsmith in His Shop, Possibly Saint Eligius*, more recent scholarship has argued that this painting was more likely commissioned as part of the tradition of vocational paintings produced for installation in guild chapels. Although the couple's presence suggests a marriage portrait, most scholars now believe that the goldsmiths' guild in Bruges commissioned this painting. Saint Eligius was the patron saint of gold- and silversmiths, blacksmiths, and metalworkers, all of whom shared a chapel in a building adjacent to their meetinghouse. Because we know that this chapel was reconsecrated in 1449, the same date as this painting, it seems probable that *A Goldsmith in His Shop, Possibly Saint*

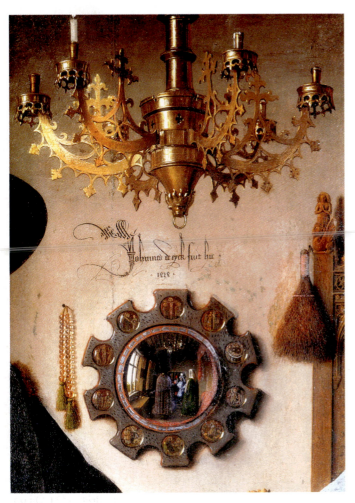

20-14 JAN VAN EYCK, detail of *Giovanni Arnolfini and His Bride*, 1434.

20-15 PETRUS CHRISTUS, *A Goldsmith in His Shop, Possibly Saint Eligius*, 1449. Oil on wood, approx. 3′ 3″ × 2′ 10″. Metropolitan Museum of Art, New York (the Robert Lehman Collection, 1975).

Eligius, which depicts an economic transaction and focuses on the goldsmith's profession, was commissioned for this chapel. Scrutiny of this painting reveals that Christus went to great lengths to produce a historically credible image. For example, the variety of objects depicted in the painting serves as advertisement for the goldsmiths' guild. The raw materials—precious stones, beads, crystal, coral, and seed pearls—are scattered among finished products, including rings, buckles, and brooches. The cast pewter vessels on the upper shelves were donation pitchers, given to distinguished guests by town leaders. All these objects attest to the centrality and importance of the goldsmiths to both the secular and sacred communities. The naturalism of this painting is enhanced by such elements as the meticulously painted convex mirror in the foreground, which extends the painting's space into that of the viewer, creating a greater sense of involvement.

Portraiture

MEETING THE VIEWER'S GAZE Emerging capitalism led to an urban prosperity that fueled the growing bourgeois market for art objects, particularly in Bruges, Antwerp, and, later, Amsterdam.

This prosperity contributed to a growing interest in secular art, such as landscapes and portraits, in addition to religious artworks. Two Flemish works shown so far, the *Ghent Altarpiece* (FIG. 20-5) and the *Mérode Altarpiece* (FIG. 20-12), include painted portraits of their donors. These paintings marked a significant revival of portraiture, a genre that had languished since antiquity. Jan van Eyck's *Man in a Red Turban* (FIG. **20-16**) is a completely secular portrait without the layer of religious interpretation common to Flemish painting. In this work (possibly a van Eyck self-portrait), the image of a living individual apparently required no religious purpose for being—only a personal one. These private portraits began to multiply as both artists and patrons became interested in the reality (both physical and psychological) such portraits revealed. As human beings confronted themselves in painted portraits, they objectified themselves as people. In this confrontation, the man van Eyck portrayed looks directly at the viewer or, perhaps, at himself in a mirror. So far as studies show, this was the first Western painted portrait in a thousand years to do so. The level, composed gaze, directed from a true three-quarter head pose, must have impressed observers deeply. The painter created the illusion that from whatever angle

20-16 JAN VAN EYCK, *Man in a Red Turban,* 1433. Oil on wood, approx. $10\frac{1}{4}'' \times 7\frac{1}{2}''$. National Gallery, London.

Edges and Borders
Framing Paintings

Until recent decades, when painters began to complete their works by simply affixing canvas to wooden stretcher bars, artists considered the frame an integral part of the painting. Frames served a number of functions, some visual, others conceptual. For paintings such as large-scale altarpieces that were part of a larger environment, frames were often used to integrate the painting with its surroundings. Frames could also be used to reinforce the illusionistic nature of the painted image. For example, Giovanni Bellini (see FIG. 22-31) and Andrea Mantegna (see Chapter 21, pages 605–608) duplicated the carved pilasters of their architectural frames in their paintings, thereby enhancing the illusion of space and rendering their painted images more "real." Or, conversely, a frame could be used specifically to distance the viewer from the (often otherworldly) scene by calling attention to the separation of the image from the viewer's space.

Most 15th- and 16th-century paintings included elaborate frames that artists helped design and construct. Frames were frequently polychromed (painted) or gilded, adding to the expense. Surviving contracts reveal that as much as half of an altarpiece's cost derived from the frame. For small works, artists sometimes affixed the frames to the panels before painting, creating an insistent visual presence as they worked. Occasionally, a single piece of wood served as both panel and frame, and the artist carved the painting surface from the wood, leaving the edges as a frame.

Larger images with elaborate frames, such as altarpieces, required the services of a woodcarver or stonemason. The painter worked closely with the individual constructing the frame to ensure its appropriateness for the image(s) produced.

Unfortunately, over time, many frames were removed from paintings. For instance, most scholars believe that individuals concerned with conserving the *Ghent Altarpiece* (FIG. 20-5) removed its elaborately carved frame and dismantled the altarpiece in 1566 to protect it from Protestant iconoclasts. As ill luck would have it, when the panels were reinstalled in 1587, no one could find the frame, which probably had been destroyed. Sadly, the absence of many of the original frames deprives viewers today of the complete artistic vision of painters and, sometimes, of their hired woodcarvers.

a viewer observes the face, the eyes return that gaze. Van Eyck, with his considerable observational skill and controlled painting style, injected a heightened sense of specificity into this portrait by including beard stubble, veins in the bloodshot left eye, and weathered and aged skin.

Although a definitive identification of the sitter has yet to be made, the possibility that *Man in a Red Turban* is a van Eyck self-portrait seems reinforced by the inscriptions on the frame (see "Edges and Borders: Framing Paintings," above). Across the top, van Eyck wrote "As I can" in Flemish using Greek letters, and across the bottom in Latin appears the statement "Jan van Eyck made me" and the date.

Admired artists, such as van Eyck, established portraiture among their principal tasks. For various reasons, great patrons embraced the opportunity to have their likenesses painted. They wanted to memorialize themselves in their dynastic lines; to establish their identities, ranks, and stations with images far more concrete than heraldic coats of arms; or to represent themselves at state occasions when they could not attend. They even used such paintings when arranging marriages. Royalty, nobility, and the very rich would send painters to "take" the likeness of a prospective bride or groom. Evidence reveals that when young King Charles VI of France sought a bride, a painter journeyed to three different royal courts to make portraits of the candidates for the king to use in making his choice.

CAPTURING CLASS AND CHARACTER The commission details for Rogier van der Weyden's portrait of an unknown young lady (FIG. **20-17**) remain unclear. Her dress and bearing imply noble rank. The artist created a portrait that not only presented a faithful likeness of her somewhat plain features but also revealed her individual character. Her lowered eyes, tightly locked thin fingers, and fragile physique bespeak a reserved and pious demeanor. This style contrasted with the formal Italian approach

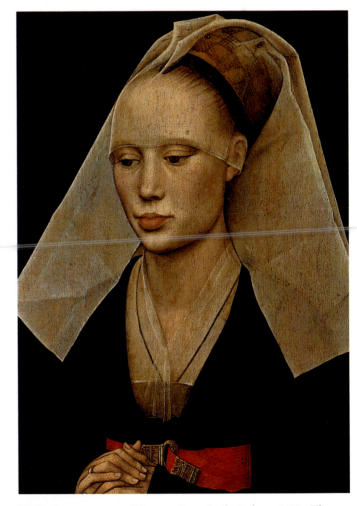

20-17 ROGIER VAN DER WEYDEN, *Portrait of a Lady,* ca. 1460. Oil on panel, 1′ 1⅜″ × 10 1/16″. National Gallery, Washington (Andrew W. Mellon Collection).

(see FIG. 21-31), derived from the profiles common to coins and medallions, which was sterner and conveyed little of the sitter's personality. Rogier was perhaps chief among the Flemish in his penetrating readings of his subjects, and, as a great pictorial composer, he made beautiful use here of flat, sharply pointed angular shapes that so powerfully suggest this subject's composure. Unlike Jan van Eyck, Rogier placed little emphasis on minute description of surface detail. Instead, he defined large, simple planes and volumes, achieving an almost "abstract" effect, in the modern sense, of dignity and elegance.

An Enigmatic Flemish Painter

LOVE AND MARRIAGE OR SEX AND SIN? Although certain genres and themes in painting emerged so frequently during the 15th century in Flanders as to qualify as conventions, this country also produced one of the most fascinating and puzzling painters in history, HIERONYMUS BOSCH (ca. 1450–1516). Interpretations of Bosch differ widely. Was he a satirist, an irreligious mocker, or a pornographer? Was he a heretic or an orthodox fanatic like Girolamo Savonarola, his Italian contemporary? Was he obsessed by guilt and the universal reign of sin and death?

Bosch's most famous work, the so-called *Garden of Earthly Delights* (FIG. **20-18**), is also his most enigmatic, and no interpretation of it is universally accepted. This large-scale work takes the familiar form of a triptych. More than 7 feet high, the painting extends to more than 12 feet wide when opened. This triptych format seems to indicate a religious function for this work, but documentation reveals that *Garden of Earthly Delights* resided in the palace of Henry III of Nassau, regent of the Netherlands, seven years after its completion. This suggests a secular commission for private use. Scholars have proposed that such a commission, in conjunction with the central themes of marriage, sex, and procreation, points to a wedding commemoration, which, as seen in *Giovanni Arnolfini and His Bride* (FIG. 20-13) and in *A Goldsmith in His Shop, Possibly Saint Eligius* (FIG. 20-15), was not uncommon. Any similarity to these paintings ends there, however. Whereas van Eyck and Christus grounded their depictions of betrothed couples in contemporary Flemish life and custom, Bosch's image portrays a visionary world of fantasy and intrigue.

In the left panel, God presents Eve to Adam in a landscape, presumably the Garden of Eden. Bosch complicated his straightforward presentation of this event by placing it in a wildly imaginative setting that includes an odd pink fountainlike structure in a body of water and an array of fanciful and unusual animals, which may hint at an interpretation involving alchemy—the medieval study of seemingly magical changes, especially chemical changes. The right panel, in contrast, bombards viewers with the horrors of Hell. Beastly creatures devour people, while others are impaled or strung on musical instruments, as if on a medieval rack. A gambler is nailed to his own table. A spidery monster embraces a girl while toads bite her. A sea of inky darkness envelops all of these horrific scenes. Observers must search through the hideous enclosure of Bosch's Hell to take in its fascinating though repulsive details.

Sandwiched between Paradise and Hell is the huge central panel, with nude people blithely cavorting in a landscape dotted with bizarre creatures and unidentifiable objects. The numerous fruits and birds (fertility symbols) in the scene suggest procreation, and, indeed, many of the figures are paired off as couples. The orgiastic overtones of *Garden of Earthly Delights,* in conjunction with the terrifying image of Hell, have led some scholars to interpret this triptych, like other Last Judgment images, as a warning to viewers of the fate awaiting the sinful, decadent, and immoral.

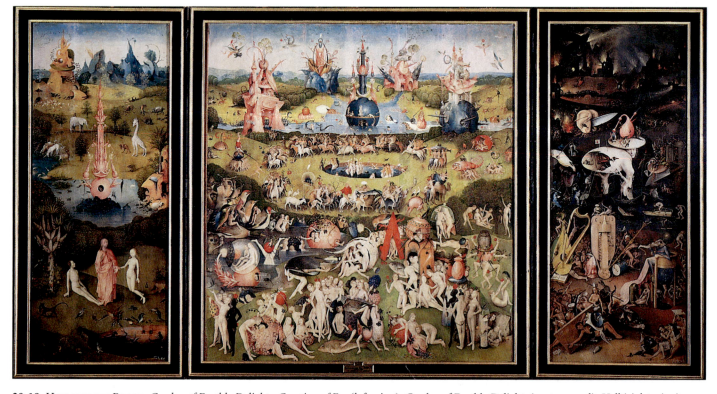

20-18 HIERONYMUS BOSCH, *Garden of Earthly Delights. Creation of Eve* (left wing), *Garden of Earthly Delights* (center panel), *Hell* (right wing), 1505–1510. Oil on wood, center panel 7′ 2⅝″ × 6′ 4¾″. Museo del Prado, Madrid.

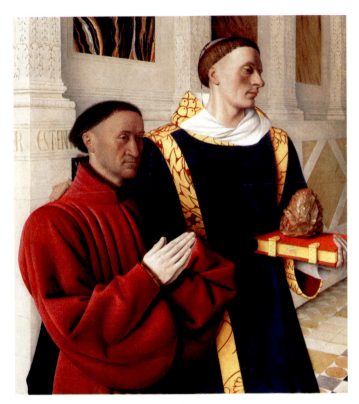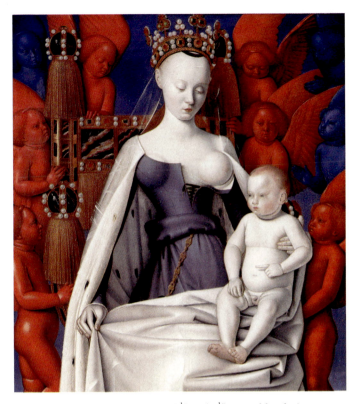

20-19 JEAN FOUQUET, *Melun Diptych. Étienne Chevalier and Saint Stephen* (left wing), ca. 1450. Oil on wood, 3′ $\frac{1}{2}$″ × 2′ 9$\frac{1}{2}$″. Gemäldegalerie, Staatliche Museen, Berlin. *Virgin and Child* (right wing), ca. 1451. Oil on wood, 3′ 1$\frac{1}{4}$″ × 2′ 9$\frac{1}{2}$″. Koninklijk Museum voor Schone Kunsten, Antwerp, Belgium.

15TH-CENTURY FRENCH ART

In France, the Hundred Years' War decimated economic enterprise and prevented political stability. The anarchy of war and the weakness of the kings gave rise to a group of duchies, each with significant power. The strongest of these, as mentioned earlier, was the Duchy of Burgundy. Despite this instability, French artists joined the retinues of the wealthiest nobility—the dukes of Berry, Bourbon, and Nemours and sometimes the royal court—where they could continue to develop their art.

PORTRAYING THE PIOUS Images for private devotional use were popular in France, as in Flanders. Among the French artists whose paintings were in demand was JEAN FOUQUET (ca. 1420–1481), who worked for King Charles VII (the patron and client of Jacques Coeur; see FIG. 18-28) and for the duke of Nemours. Fouquet painted a diptych (two-paneled painting; FIG. **20-19**) for Étienne Chevalier. Despite lowly origins, Chevalier elevated himself in French society, and in 1452 Charles VII named him treasurer of France. In the left panel, Chevalier appears with his patron saint, Saint Stephen (Étienne in French), in a format commonly referred to as a donor portrait because an individual commissioned (or "gave") the portrait as evidence of devotion. Appropriately, Fouquet depicted Chevalier as devout—kneeling, with hands clasped in prayer. The representation of the pious donor with his standing saint recalls Flemish art, as do the three-quarter stances and the sharp, clear focus of the portraits. The artist depicted Saint Stephen holding the stone of his martyrdom (death by stoning) atop a volume of the Scriptures, thereby ensuring that viewers properly identify the saint. Fouquet rendered the entire image in meticulous detail and included a highly ornamented architectural setting.

In its original diptych form (the two panels were separated some time ago and now reside in different museums), the viewer would follow the gaze of Chevalier and Saint Stephen over to the right panel, which depicts the Virgin Mary and Christ Child. The juxtaposition of these two images allowed the patron to bear witness to the sacred. However, other interpretations present themselves. The integration of sacred and secular (especially the political or personal) prevalent in other Northern European artworks also emerges here, complicating the reading of this diptych. The depiction of the Virgin Mary was modeled after Agnès Sorel, the mistress of King Charles VII. Sorel was respected as a pious individual, and, according to an inscription, Chevalier commissioned this painting to fulfill a vow he made after Sorel's death in 1450. Thus, in addition to the religious interpretation of this diptych, there is surely a personal narrative here as well.

15TH-CENTURY GERMAN ART

Whereas the exclusive authority of the monarchies in France, England, and Spain fostered cohesive and widespread developments in the arts of those countries, the lack of a strong centralized power in the Holy Roman Empire (whose core was Germany) led to provincial artistic styles that the strict guild structure perpetuated. Because the Holy Roman Empire did not participate in the long, drawn-out saga of the Hundred Years' War, its economy was stable and prosperous. Without a dominant court culture to commission artworks and with the flourishing of the middle class, wealthy merchants and clergy became the primary German patrons during the 15th century.

German Piety

A ROSE AMONG THORNS Most of the early years of STEPHAN LOCHNER (ca. 1400–1451) remain a mystery. Scholars have documented his artistic activity in Cologne in 1440, and by 1447 he had accrued sufficient respect to be named city councilor, representing the painters' guild. Lochner's painting from the 1430s, *Madonna in the Rose Garden* (FIG. **20-20**), presents an extremely popular theme in the Rhineland. The artist depicted the Virgin Mary and Christ Child in a rose arbor, a traditional reference to Mary's holiness ("a rose among thorns") and a symbol of her purity. Increasing interest in Rosary devotion no doubt contributed to the popularity of this theme. The Rosary, a devotional exercise in which one meditates on aspects of the lives of Christ and Mary while reciting prayers, particularly served the needs of the laity in a time of growing privatization of religion. Lochner presented this subject using stylized conventions. He established a symmetrical and very structured composition, and the exquisite gold background recalls Byzantine and medieval artworks. His use of established conventions can be attributed, in part, to the new patronage. Wealthy laypersons who desired such images for private devotional purposes or as status symbols relied on a familiar, recognizable iconography and presentation.

FISHING IN LAKE GENEVA As in Flanders, large-scale altarpieces were familiar sights in the Holy Roman Empire. Among the most notable of these is the *Altarpiece of Saint Peter* painted in 1444 for the chapel of Notre-Dame des Maccabées in the Cathedral of Saint Peter in Geneva. On one exterior wing of this triptych appears *Miraculous Draught of Fish* (FIG. **20-21**) by the Swiss

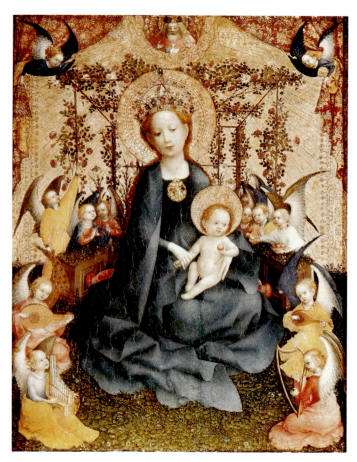

20-20 STEPHAN LOCHNER, *Madonna in the Rose Garden*, ca. 1430–1435. Tempera on wood, approx. 1′ 8″ × 1′ 4″. Wallraf-Richartz Museum, Cologne.

20-21 KONRAD WITZ, *Miraculous Draught of Fish*, from the *Altarpiece of Saint Peter*, from Chapel of Notre-Dame des Maccabées in the Cathedral of Saint Peter, Geneva, Switzerland, 1444. Oil on wood, approx. 4′ 3″ × 5′ 1″. Musée d'art et d'histoire, Geneva.

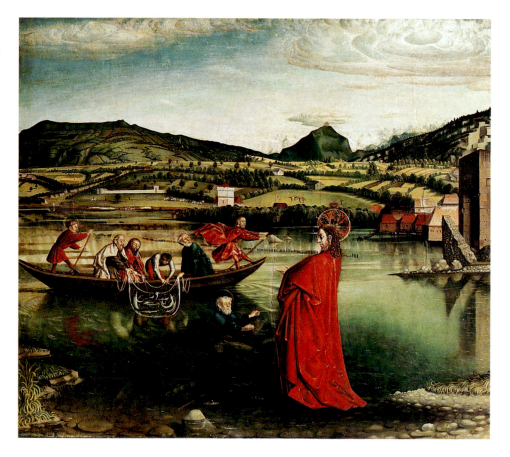

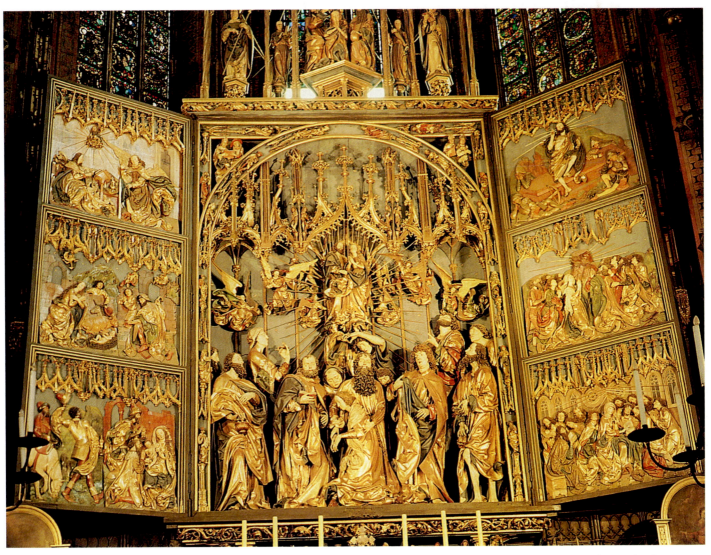

20-22 Veit Stoss, *The Death and Assumption of the Virgin* (wings open), altar of the Virgin Mary, church of Saint Mary, Kraków, Poland, 1477–1489. Painted and gilded wood, 43′ × 35′.

painter Konrad Witz (ca. 1400–1446). The other exterior wing (not illustrated) depicts the release of Saint Peter from prison. The central panel has been lost. On the interior wings, Witz painted scenes of the Adoration of the Magi and of Saint Peter's presentation of the donor (Bishop François de Mies) to the Virgin and Child. *Miraculous Draught of Fish* is particularly significant because of the landscape's prominence. Witz showed precocious skill in the study of water effects—the sky glaze on the slowly moving lake surface, the mirrored reflections of the figures in the boat, and the transparency of the shallow water in the foreground. He observed and depicted the landscape so carefully that art historians have determined the exact location shown. Witz presented a view of the shores of Lake Geneva, with the town of Geneva on the right and Le Môle Mountain in the distance behind Christ's head. This painting is one of the first 15th-century works depicting a specific site.

WITNESSING THE VIRGIN'S ASSUMPTION The works of German artists who specialized in carving large wooden *retables* (altarpieces) reveal most forcefully the power of the Late Gothic style. The sculptor Veit Stoss (1447–1533) carved a great altarpiece (FIG. **20-22**) for the church of Saint Mary in Kraków, Poland.

In the central boxlike shrine, huge figures (some are nine feet high) represent the Virgin's death and Assumption, and on the wings Stoss portrayed scenes from the lives of Christ and Mary. The altar expresses the intense piety of Gothic culture in its late phase, when artists used every figural and ornamental design resource from the vocabulary of Gothic art to heighten the emotion and to glorify the sacred event. In *The Death and Assumption of the Virgin*, the disciples of Christ congregate around the Virgin, who sinks down in death. One of them supports her, while another, just above her, wrings his hands in grief. Stoss posed others in attitudes of woe and psychic shock, striving for realism in every minute detail. Moreover, he engulfed the figures in restless, twisting, and curving swaths of drapery whose broken and writhing lines unite the whole tableau in a vision of agitated emotion. The artist's massing of sharp, broken, and pierced forms that dart flamelike through the composition—at once unifying and animating it—recalls the design principles of Late Gothic architecture (see FIG. 18-25). Indeed, in the Kraków altarpiece, Stoss merged sculpture and architecture, enhancing their union with paint and gilding.

AN ORNATE SPIRITUAL VISION Tilman Riemenschneider (ca. 1460–1531) depicted the Virgin's Assumption in the center

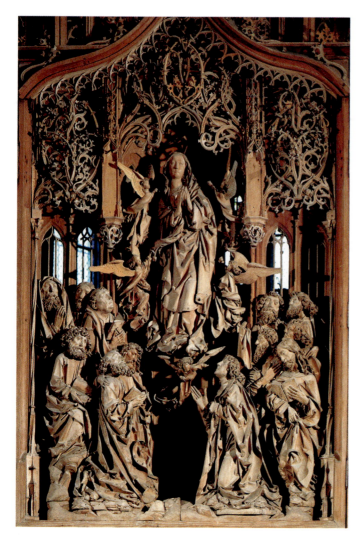

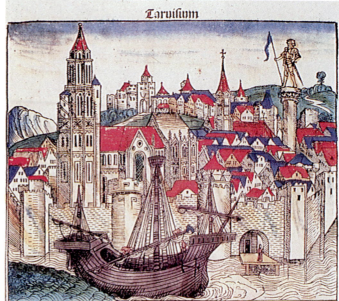

20-23 TILMAN RIEMENSCHNEIDER, *The Assumption of the Virgin,* center panel of the *Creglingen Altarpiece,* parish church, Creglingen, Germany, ca. 1495–1499. Carved lindenwood, 6′ 1″ wide.

20-24 MICHEL WOLGEMUT and Shop, "Tarvisium," page from the so-called *Nuremberg Chronicle,* 1493. Woodcut, approx. 1′ 2″ × 9″. Printed by Anton Koberger.

panel of the *Creglingen Altarpiece* (FIG. **20-23**), created for a parish church in Creglingen. He also incorporated intricate Gothic forms, especially in the altarpiece's elaborate canopy. By employing an endless and restless line that runs through the draperies of the figures in *The Assumption of the Virgin,* Riemenschneider succeeded in setting the whole design into fluid motion, and no individual element functions without the rest. The draperies float and flow around bodies lost within them, serving not as descriptions but as design elements that tie the figures to one another and to the framework. A look of psychic strain, a facial expression common to Riemenschneider's figures and consonant with the emerging age of disruption, heightens the spirituality of the figures, immaterial and weightless as they appear.

Graphic Art

GOING AGAINST THE GRAIN A new age blossomed in the 15th century with a sudden technological advance that had widespread effects—the German invention of the *letterpress,* printing with movable type. Printing had been known in China centuries before but had never developed, as it did in 15th-century Europe, into a revolution in written communication and in the generation and management of information. Printing provided new and challenging media for artists, and the earliest form was the *woodcut*

(see "Graphic Changes: The Development of Printmaking," page 569). Using a gouging instrument, artists remove sections of wood blocks, sawing along the grain. They ink the ridges that carry the designs, and the hollows remain dry of ink and do not print. Artists produced woodcuts well before the development of movable-type printing. But when a rise in literacy and the improved economy necessitated production of illustrated books on a grand scale, artists met the challenge of bringing the woodcut picture onto the same page as the letterpress.

The illustrations (more than 650 of them!) for the so-called *Nuremberg Chronicle,* a history of the world produced in the shop of the Nuremberg artist MICHEL WOLGEMUT (1434–1519), document this achievement. The hand-colored page illustrated (FIG. **20-24**) represents Tarvisium (modern Tarvisio), a town in the extreme northeast of Italy, as it was in the "fourth age of the world" (according to the Latin inscription at top). The blunt, simple lines of the woodcut technique give a detailed perspective of Tarvisium, its harbor and shipping, its walls and towers, its churches and municipal buildings, and the baronial castle on the hill. Despite the numerous architectural structures, historians cannot determine whether this illustration represents the artist's accurate depiction of the city or his fanciful imagination. Artists often reprinted the same image as illustrations of different cities; hence, this depiction of Tarvisium was likely fairly general. Regardless, the work is a monument to a new craft, which expanded in concert with the art of the printed book.

Graphic Changes
The Development of Printmaking

The popularity of prints over the centuries attests to the medium's enduring appeal. Generally speaking, a print is an artwork on paper, usually produced in multiple impressions. The set of prints an artist creates from a single print surface is often referred to as an *edition*. The printmaking process involves the transfer of ink from a printing surface to paper, which can be accomplished in several ways. During the 15th and 16th centuries, artists most commonly used the *relief* and *intaglio* methods of printmaking.

Artists produce relief prints by carving into a surface, usually wood. The oldest and simplest of the printing methods, relief printing requires artists to conceptualize their images negatively; that is, they remove the surface areas around the images. Thus, when the printmaker inks the surface, the carved-out areas remain clean, and a positive image results when the artist presses the printing block against paper. Because artists produce *woodcuts* through a subtractive process (removing parts of the material), it is difficult to create very thin, fluid, and closely spaced lines. As a result, woodcut prints tend to exhibit stark contrasts and sharp edges (see FIGS. Intro-8, 23-1, and 23-4).

In contrast to the production of relief prints, the intaglio method involves a positive process; the artist incises or scratches an image on a metal plate, often copper. The image can be created on the plate manually (*engraving* or *drypoint*) using a tool (a *burin* or *stylus*; see FIGS. 20-25, 21-26, 23-6, and 23-8) or chemically (*etching*). In the latter process, an acid bath eats into the exposed parts of the plate where the artist has drawn through an acid-resistant coating. When the artist inks the surface of the intaglio plate and wipes it clean, the ink is forced into the incisions. Then the artist runs the plate and paper through a roller press, and the paper absorbs the remaining ink, creating the print. Because the artist "draws" the image onto the plate, intaglio prints possess a character different from that of relief prints. Engravings, drypoints, and etchings generally present a wider variety of linear effects. They also often reveal to a greater extent evidence of the artist's touch, the result of the hand's changing pressure and shifting directions.

The paper and inks artists use also affect the finished look of the printed image. During the 15th and 16th centuries, European printmakers had papers produced from cotton and linen rags that papermakers mashed with water into a pulp. The papermakers then applied a thin layer of this pulp to a wire screen and allowed it to dry to create the paper. As contact with the Far East increased, printmakers made greater use of what was called Japan paper (of mulberry fibers) and China paper. Artists, then as now, could select from a wide variety of inks. The type and proportion of the ink ingredients affect the consistency, color, and oiliness of inks, which various papers absorb differently. The portability of prints—paper is lightweight, and, until recently, the size of presses precluded large prints—has appealed to artists over the years. Further, the opportunity to produce many impressions from the same print surface is an attractive option. Relatively speaking, prints can be sold at cheaper prices than paintings or sculptures, significantly expanding the buying audience. Recently, scholars have attempted to ascertain the audience for prints as well as their market value during the 15th and 16th centuries. The limited amount of extant documentation, however, has hindered these efforts. Regardless, the number and quality of existing prints, both from northern Europe and Italy, attest to the importance of the print medium during the Renaissance.

DRAWING ON METAL The woodcut medium hardly had matured when the technique of engraving (inscribing on a hard surface), begun in the 1430s and well developed by 1450, proved much more flexible (see "Graphic Changes," above). Predictably, in the second half of the century, engraving began to replace the woodcut process, for making both book illustrations and widely popular single prints. Metal engraving produces an intaglio (incised) surface for printing; the incised lines (hollows) of the design, rather than the ridges, take the ink. It is the reverse of the woodcut technique, which produces *rilievo* (relief).

MARTIN SCHONGAUER (ca. 1430–1491) was the most skilled and subtle northern master of metal engraving. His *Saint Anthony Tormented by Demons* (FIG. **20-25**) shows both the versatility of the medium and the artist's mastery of it. The stoic saint is caught in a revolving thornbush of spiky demons, who claw and tear at him furiously. With unsurpassed skill and subtlety, Schongauer created marvelous distinctions of tonal values and textures—from smooth skin to rough cloth, from the furry and feathery to the hairy and scaly. The use of *hatching* to describe forms, probably developed by Schongauer, became standard among German graphic artists. The Italians preferred parallel hatching (compare Antonio Pollaiuolo's engraving, FIG. 21-26) and rarely adopted the other method, which, in keeping with the general northern approach to art, tends to describe the surfaces of things rather than their underlying structures.

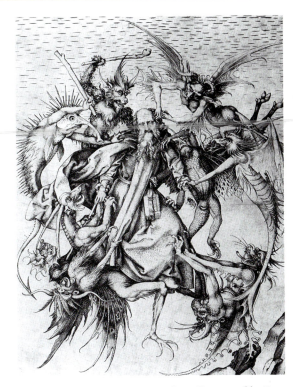

20-25 MARTIN SCHONGAUER, *Saint Anthony Tormented by Demons*, ca. 1480–1490. Engraving, approx. 1′ 1″ × 11″. Metropolitan Museum of Art, New York (Rogers Fund, 1920).

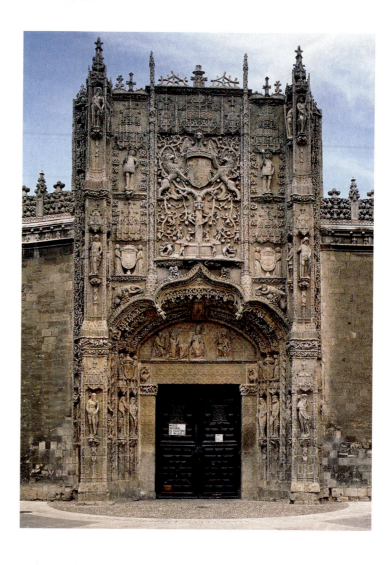

20-26 Portal, Colegio de San Gregorio, Valladolid, Spain, ca. 1498.

15TH-CENTURY SPANISH ART

Spain's ascent to power in Europe began in the mid-15th century with the marriage of Isabella of Castile (1451–1504) and Ferdinand of Aragon (1452–1516) in 1469. Together, Ferdinand and Isabella worked to strengthen royal control of the Spanish government. Eventually, their descendants became the most powerful monarchs in Europe.

SILVERWORK-INSPIRED ARCHITECTURE During the 15th century and well into the 16th, a Late Gothic style of architecture, the Plateresque, prevailed in Spain. *Plateresque* derives from the Spanish word *platero,* meaning silversmith, and relates to the style because of the delicate execution of its ornament. The Colegio de San Gregorio (Seminary of Saint Gregory; FIG. **20-26**) in the Castilian city of Valladolid handsomely exemplifies the Plateresque manner. Great carved retables, like the German altarpieces that influenced them (see FIGS. 20-22 and 20-23), appealed to church patrons and architects in Spain. They thus made such retables a conspicuous decorative feature of their exterior architecture, dramatizing a portal set into an otherwise blank wall. The Plateresque entrance of San Gregorio is a lofty sculptured stone screen that bears no functional relation to the architecture behind it. On the entrance level, lacelike tracery reminiscent of Moorish design hems the flamboyant ogival arches. A great screen, paneled into sculptured compartments, rises above the tracery. In the center, the branches of a huge pomegranate tree (symbolizing Granada, the Moorish capital of Spain captured by the Habsburgs

in 1492) wreathe the coat of arms of King Ferdinand and Queen Isabella. Cupids play among the tree branches, and, flanking the central panel, niches enframe armed pages of the court, heraldic wild men (wild men symbolized aggression, and here as heralds announce the royal intentions), and armored soldiers, attesting to Spain's proud new militancy. In typical Plateresque and Late Gothic fashion, the activity of a thousand intertwined motifs unifies the whole design, which, in sum, creates an exquisitely carved panel greatly expanded in scale from the retables that inspired it.

CONCLUSION

Northern and Spanish art in the 15th century was the product of political, religious, social, and economic changes. Among the notable transformations in art were the increased use of oil paints in Flanders, a greater illusionism in manuscript illumination, and the invention of movable-type printing in Germany. Flanders, in particular, was at the forefront of artistic developments, in part because of the power and patronage of the Burgundian dukes. This situation did not last long. Charles the Bold, who had assumed the title of duke of Burgundy in 1467, died in 1477, bringing to an end the dominance of the Burgundian Netherlands. France and the Holy Roman Empire divided the Burgundian territories. Eventually, through a series of fortuitous marriages, untimely deaths, and political shifts, Charles I, the grandson of Ferdinand and Isabella of Spain, united the three major dynastic lines—Habsburg, Burgundian, and Spanish.

HUNDRED YEARS' WAR BEGINS, 1337

THE PAPACY IN AVIGNON, 1305–1378

1375

THE GREAT SCHISM IN THE CHURCH, 1378–1417

THE NETHERLANDS UNDER THE DUKES OF BURGUNDY, 1384–1477

1 Claus Sluter, *Well of Moses*, 1395–1406

1425

HUNDRED YEARS' WAR ENDS, 1453

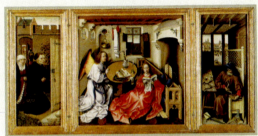

2 Robert Campin (Master of Flémalle), *Mérode Altarpiece*, ca. 1425–1428

1467

1477

BURGUNDY AND BURGUNDIAN NETHERLANDS PASS TO HOLY ROMAN EMPIRE; MAXIMILIAN I, HABSBURG EMPEROR, 1486

MOORISH KINGDOM OF GRANADA FALLS TO SPAIN, 1492

COLUMBUS ARRIVES IN WEST INDIES, 1492

FRENCH INVADE ITALY, 1494

3 Veit Stoss, *The Death and Assumption of the Virgin Mary*, 1477–1489

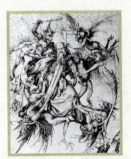

4 Martin Schongauer, *Saint Anthony Tormented by Demons*, ca. 1480–1490

1500

PHILIP THE BOLD (BURGUNDY)

JOHN THE FEARLESS

PHILIP THE GOOD

CHARLES THE BOLD

FERDINAND (ARAGON) AND ISABELLA (CASTILE), CATHOLIC RULERS OF SPAIN

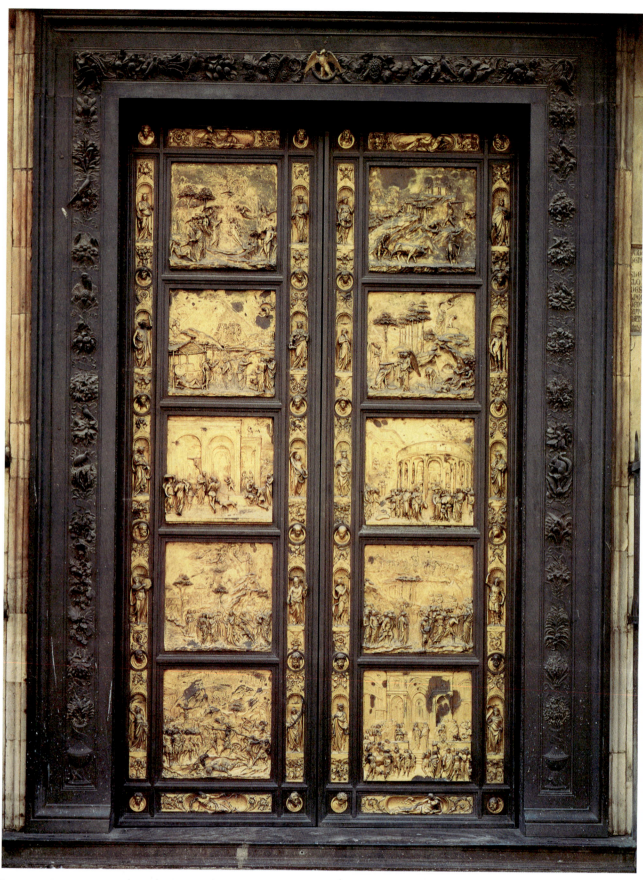

Lorenzo Ghiberti, east doors ("Gates of Paradise"), baptistery of Florence Cathedral, Florence, Italy, 1425–1452. Gilded bronze relief, approx. 17′ high. Modern copy, ca. 1980. Original panels in Museo dell'Opera del Duomo, Florence.

21

HUMANISM AND THE
ALLURE OF ANTIQUITY

15TH-CENTURY ITALIAN ART

The 15th century in Italy witnessed the flourishing of a significantly new and expanded artistic culture — the Renaissance — whose early development was chronicled in Chapter 19. The continued maturation of this culture was due to several factors, among them the spread of humanism, political and economic fluctuations throughout Italy, and a fortunate abundance of artistic talent.

THE SPREAD OF HUMANISM The humanism disseminated by Petrarch and Boccaccio during the 14th century had greater impact as the 15th century progressed. Increasingly, Italians in elite circles embraced the tenets underlying humanism — an emphasis on education and on expanding knowledge (especially of classical antiquity), the exploration of individual potential and a desire to excel, and a commitment to civic responsibility and moral duty.

For humanists, the quest for knowledge began with the legacy of the Greeks and Romans — the writings of Plato, Socrates, Aristotle, Ovid, and others. The development of a literature based on a vernacular (commonly spoken) Tuscan dialect expanded the audience for humanist writings. Further, the invention of movable metal type by the German Johann Gutenberg around 1445 facilitated the printing and wide distribution of books. Italians enthusiastically embraced this new printing process; by 1464 Subiaco (near Rome) boasted a press, and by 1469 Venice had established one as well. Among the first books printed in Italy using this new press was Dante's vernacular epic, *Divine Comedy*. The production of editions in Foligno (1472), Mantua (1472), Venice (1472), Naples (1477 and 1478–1479), and Milan (1478) testifies to the widespread popularity during the 15th century of Dante's epic poem about Heaven, Purgatory, and Hell.

The humanists did not restrict their learning to antique writings. They avidly acquired information in a wide range of fields, including science (such as botany, geology, geography, and optics), medicine, and engineering. Leonardo da Vinci's phenomenal expertise in many fields — from art and architecture to geology, aerodynamics, hydraulics, botany, and military science, among many others — serves to define the modern notion of a "Renaissance man."

on God's order to Abraham that he sacrifice his son Isaac as a demonstration of Abraham's devotion to God. Just as Abraham is about to comply, an angel intervenes and stops him from plunging the knife into his son's throat. Because of the parallel between Abraham's willingness to sacrifice Isaac and God's sacrifice of his Son, Jesus Christ, to redeem mankind, the sacrifice of Isaac was often linked to the Crucifixion. Both refer to covenants, and given that the sacrament of baptism initiates the neonate, or convert, into the possibilities of these covenants, Isaac's sacrifice was certainly appropriate for representation on a baptistery.

The selection of this theme may also have been influenced by historical developments. In the late 1390s, Giangaleazzo Visconti of Milan began a military campaign to take over the Italian peninsula. By 1401, when the directors of the cathedral's artworks initiated this competition, Visconti's troops had virtually surrounded Florence (MAP 21-1), and its independence was in serious jeopardy. Despite dwindling water and food supplies, Florentine officials exhorted the public to defend the city's freedom. For example, the humanist chancellor, Coluccio Salutati, whose Latin style of writing was widely influential, urged his fellow citizens to adopt the republican ideal of civil and political liberty associated with ancient Rome and to identify themselves with its spirit. To be Florentine was to be Roman; freedom was the distinguishing virtue of both. (Florentine faith and sacrifice were rewarded in 1402, when Visconti died suddenly, ending the invasion threat.) The story of Abraham and Isaac, with its theme of sacrifice, paralleled the message city officials had conveyed to inhabitants. It is certainly plausible that the Arte di Calimala, asserting both its preeminence among Florentine guilds and its civic duty, selected the subject with this in mind.

Those supervising this project selected as semifinalists seven artists from among the many who entered the widely advertised competition for the commission. Only the panels of the two finalists, LORENZO GHIBERTI (1378–1455) and FILIPPO BRUNELLESCHI (1377–1446), have survived. In 1402, the selection committee awarded the commission to Ghiberti. Both artists used the same French Gothic *quatrefoil* frames Andrea Pisano had used for the baptistery's south doors and depicted the same moment of the narrative — the angel's halting of the action. Examining these two panels provides insight into some stylistic indications of the direction Early Renaissance art was to take during the 15th century.

ABRAHAM'S SACRIFICE Brunelleschi's panel (FIG. **21-1**) shows a sturdy and vigorous interpretation of the theme, with something of the emotional agitation favored by Giovanni Pisano (see FIG. 19-4). Abraham seems suddenly to have summoned the dreadful courage needed to kill his son at God's command — he lunges forward, draperies flying, exposing Isaac's throat to the knife. Matching Abraham's energy, the saving angel darts in from the left, grabbing Abraham's arm to stop the killing. Brunelleschi's figures demonstrate his ability to observe carefully and represent faithfully all the elements in the biblical narrative.

EMULATING ANTIQUE MODELS Where Brunelleschi imbued his image with dramatic emotion, Ghiberti emphasized grace and smoothness. In Ghiberti's panel (FIG. **21-2**), Abraham appears in the familiar Gothic S-curve pose and seems to contemplate the act he is about to perform, even as he draws his arm back to strike. The figure of Isaac, beautifully posed and rendered, recalls Greco-Roman statuary and could be regarded as the first truly classicizing nude since antiquity. (Compare, for example, the torsion of Isaac's body and the dramatic turn of his head with those of the Hellenistic statue of a Gaul thrusting a sword into his own chest, FIG. 5-80). Unlike his medieval predecessors, Ghiberti revealed a genuine appreciation of the nude male form and a deep interest in how the muscular system and skeletal structure move the human body. Even the altar on which Isaac kneels displays Ghiberti's emulation of antique models. It is decorated with acanthus scrolls of a type that commonly adorned Roman temple friezes in Italy and throughout the former Roman Empire (see, for example, FIG. 10-30). These classical references reflect the increasing influence of humanism.

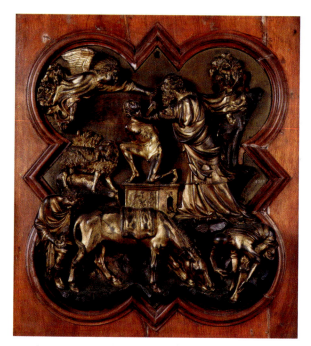

21-1 FILIPPO BRUNELLESCHI, *Sacrifice of Isaac,* competition panel for east doors, baptistery of Florence Cathedral, Florence, Italy, 1401–1402. Gilded bronze relief, 1′ 9″ × 1′ 5″. Museo Nazionale del Bargello, Florence.

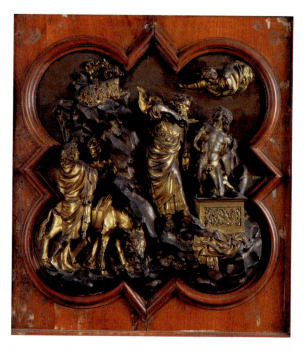

21-2 LORENZO GHIBERTI, *Sacrifice of Isaac,* competition panel for east doors, baptistery of Florence Cathedral, Florence, Italy, 1401–1402. Gilded bronze relief, 1′ 9″ × 1′ 5″. Museo Nazionale del Bargello, Florence.

Ghiberti's training included both painting and goldsmithery. His careful treatment of the gilded bronze surfaces, with their sharply and accurately incised detail, proves his skill as a goldsmith. As a painter, he was interested in spatial illusion. The rocky landscape seems to emerge from the blank panel toward the viewer, as does the strongly foreshortened angel. Brunelleschi's image, in contrast, emphasizes the planar orientation of the surface.

That Ghiberti cast his panel in only two pieces (thereby reducing the amount of bronze needed) no doubt impressed the selection committee. Ghiberti's construction method differed from that of Brunelleschi, who built his from several cast pieces. Thus, not only would Ghiberti's doors, as proposed, be lighter and more impervious to the elements, but they also represented a significant cost savings.

Ghiberti's submission clearly had much to recommend it, both stylistically and technically. Although Ghiberti's image was perhaps less overtly emotional than Brunelleschi's, it was more cohesive and presented a more convincing spatial illusion. Ghiberti further developed these pictorial effects, sometimes thought alien to sculpture, in his later work.

Ghiberti's pride in winning the commission is evident in his description of the award, which also reveals the fame and glory increasingly accorded to individual achievement during the Early Renaissance:

> To me was conceded the palm of the victory by all the experts and by all . . . who had competed with me. To me the honor was conceded universally and with no exception. To all it seemed that I had at that time surpassed the others without exception, as was recognized by a great council and an investigation of learned men. . . . The testimonial of the victory was given in my favor by all. . . . It was granted to me and determined that I should make the bronze door for this church.[1]

Ghiberti completed the 28 door panels depicting scenes from the New Testament in 1424. Church officials eventually decided to move the doors to the baptistery's north side.

A FEAST IN PERSPECTIVE Like Ghiberti, DONATELLO (ca. 1386–1466) was another sculptor who carried forward most dramatically the search for innovative forms capable of expressing the new ideas of the Early Renaissance. Donatello shared the humanist enthusiasm for Roman virtue and form. His greatness lies in an extraordinary versatility and a depth that led him through a spectrum of themes fundamental to human experience and through stylistic variations that express these themes with unprecedented profundity and force. Donatello understood the different aesthetic conventions artists routinely invoked at the time to distinguish their depictions of the real from those of the ideal and the earthly from the spiritual. His expansive knowledge and skill allowed him to portray this sweeping range with great facility. Further, as an astute observer of human life, Donatello could, with ease, depict figures of diverse ages, ranks, and human conditions. Few artists could match this range. That Donatello advanced both naturalistic illusion and classical idealism in sculpture remains a remarkable achievement.

This illusionism, like that Ghiberti pursued in his *Sacrifice of Isaac* panel, is evident in Donatello's bronze relief, *Feast of Herod* (FIG. **21-3**), on the baptismal font in the Siena baptistery. Salome (to the right) still dances even though she already has delivered the severed head of John the Baptist, which the kneeling executioner offers to King Herod. The other figures recoil in horror

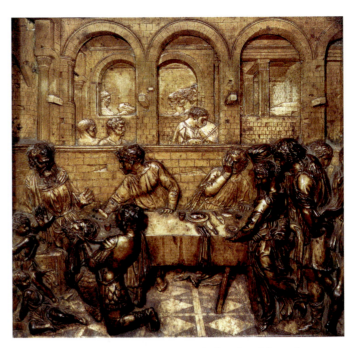

21-3 DONATELLO, *Feast of Herod*, from the baptismal font of Siena Cathedral, Siena, Italy, ca. 1425. Gilded bronze relief, approx. 1′ 11″ × 1′ 11″.

into two groups. At the right, one man covers his face with his hand; at the left, Herod and two terrified children shrink back in dismay. The psychic explosion drives the human elements apart, leaving a gap across which the emotional electricity crackles. This masterful stagecraft obscures another drama Donatello was playing out on the stage itself. The *Feast* marked the advent of rationalized perspective space, long prepared for in 14th-century Italian art and recognized by Donatello and his generation as a way to intensify the optical reality of the action and the characterization of the actors. Donatello, using pictorial perspective, opened the space of the action well into the distance, showing two arched courtyards and groups of attendants in the background. This penetration of the panel surface by spatial illusion replaced the flat grounds and backdrop areas of the medieval past. Ancient Roman illusionism (compare FIG. 10-16) had returned.

KEEPING PERSPECTIVE Fourteenth-century Italian artists, such as Duccio and the Lorenzetti brothers, had used several devices to indicate distance, but with the invention of "true" linear perspective (a discovery generally attributed to Brunelleschi), Early Renaissance artists acquired a way to make the illusion of distance mathematical and certain (see "Depicting Objects in Space: Perspectival Systems in the Early Renaissance," page 578). In effect, they thought of the picture plane as a transparent window through which the observer looks to see the constructed pictorial world. This discovery was enormously important, for it made possible what has been called the "rationalization of sight." It brought all our random and infinitely various visual sensations under a simple rule that could be expressed mathematically.

Indeed, the Renaissance artists' interest in perspective (based on principles already known to the ancient Greeks and Romans) reflects the emergence of science itself, which is, put simply, the mathematical ordering of our observations of the physical world. The observer's position of looking "through" a picture into the painted "world" is precisely that of scientific observers fixing their gaze on the carefully placed or located datum of their research. Of

Depicting Objects in Space
Perspectival Systems in the Early Renaissance

Scholars long have noted the Renaissance fascination with perspective. In essence, portraying perspective involves constructing a convincing illusion of space in two-dimensional imagery while unifying all objects within a single spatial system. Renaissance artists were not the first to focus on depicting illusionistic space; both the Greeks and the Romans were well versed in perspectival rendering. However, the perspectival systems developed during the Renaissance contrasted sharply with the portrayal of space during the preceding medieval period, when spiritual concerns superseded interest in the illusionistic presentation of objects.

Renaissance perspectival systems included both linear perspective and atmospheric perspective. Developed by Brunelleschi, *linear perspective* allows artists to determine mathematically the relative size of rendered objects to correlate them with the visual recession into space, and can be either one-point or two-point (see diagrams below). In one-point linear perspective, the artist first must identify a horizontal line that marks, in the image, the horizon in the distance (hence the term *horizon line*). The artist then selects a *vanishing point* on that horizon line (often located at the

exact center of the line). By drawing *orthogonals* (diagonal lines) from the edges of the picture to the vanishing point, the artist creates a structural grid that organizes the image and determines the size of objects within the image's illusionistic space. Under this system of linear perspective, artists often foreshorten a figure as the body recedes back into an illusionistic space, as seen in Andrea Mantegna's *Dead Christ* (FIG. 21-48). Among the works that provide clear examples of one-point linear perspective are Masaccio's *Holy Trinity* (FIG. 21-12), Leonardo da Vinci's *Last Supper* (see FIG. 22-3), and Raphael's *School of Athens* (see FIG. 22-17). Two-point linear perspective also involves the establishment of a horizon line. Rather than utilizing a single vanishing point along this horizon line, the artist identifies two of them. The orthogonals that result from drawing lines from an object to each of the vanishing points creates, as in one-point perspective, a grid that indicates the relative size of objects receding into space. An example of two-point perspective is Titian's *Madonna of the Pesaro Family* (see FIG. 22-36).

Rather than rely on a structured mathematical system (as does linear perspective), *atmospheric perspective* involves optical phenomena. Artists using atmospheric (sometimes called *aerial*) perspective exploit the principle that the farther back the object is in space, the blurrier, less detailed, and bluer it appears. Further, color saturation and value contrast diminish as the image recedes into the distance. Leonardo da Vinci used atmospheric perspective to great effect, as seen in works such as *Virgin of the Rocks* (see FIG. 22-1) and *Mona Lisa* (see FIG. 22-4).

These two methods of creating the illusion of space in pictures are not exclusive, and Renaissance artists often used both to heighten the sensation of three-dimensional space, as visible in Raphael's *Marriage of the Virgin* (see FIG. 22-18).

course, Early Renaissance artists were not primarily scientists; they simply found perspective an effective way to order and clarify their compositions.

Nonetheless, the art viewer cannot doubt that perspective, with its new mathematical certitude, conferred a kind of aesthetic legitimacy on painting by making the picture *measurable* and exact. According to Plato, measure is the basis of beauty. The art of Greece certainly was based on this belief. In the Renaissance, when humanists rediscovered Plato and eagerly read his works, artists once again exalted the principle of measure as the foundation of the beautiful in the fine arts. The projection of measurable objects on flat surfaces influenced the character of Renaissance paintings and made possible scale drawings, maps, charts, graphs, and diagrams—means of exact representation that laid the foundation

for modern science and technology. Mathematical truth and formal beauty conjoined in the minds of Renaissance artists.

THE "GATES OF PARADISE" Ghiberti was among the Italian artists in the 15th century who embraced a unified system for representing space; his enthusiasm for perspectival illusion is particularly evident in the famous east doors (FIG. **21-4**) commissioned from him by church officials in 1425 for the baptistery of Florence Cathedral. Michelangelo later declared these as "so beautiful that they would do well for the gates of Paradise."[2] Three sets of doors provide access to the baptistery (see FIG. 17-18). Andrea Pisano created the first set, on the south side, between 1330 and 1335. Ghiberti's first pair of doors (1403–1424), the result of the competition, was moved to the north doorway

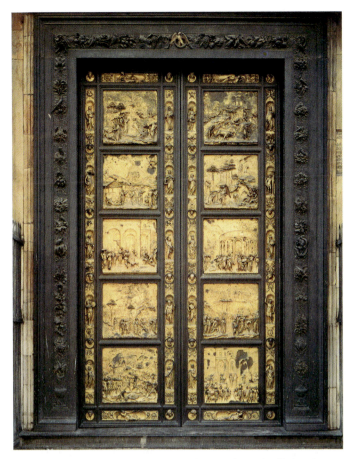

21-4 LORENZO GHIBERTI, east doors ("Gates of Paradise"), baptistery of Florence Cathedral, Florence, Italy, 1425–1452. Gilded bronze relief, approx. 17′ high. Modern copy, ca. 1980. Original panels in Museo dell'Opera del Duomo, Florence.

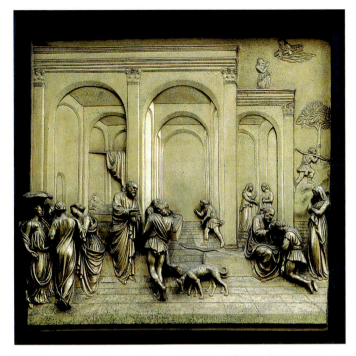

21-5 LORENZO GHIBERTI, *Isaac and His Sons* (detail of FIG. 21-4), east doors, baptistery of Florence Cathedral, Florence, Italy, 1425–1452. Gilded bronze relief, approx. 2′ 7½″ × 2′ 7½″. Museo dell'Opera del Duomo, Florence.

so that his second pair of doors (1425–1452) could be placed in the east doorway. In these "Gates of Paradise," Ghiberti abandoned the quatrefoil pattern that frames the reliefs on the south and north doors and reduced the number of panels from 28 to 10, possibly at the behest of his patrons. Each of the panels contains a relief set in plain moldings and depicts a scene from the Old Testament. The complete gilding of the reliefs creates an effect of great splendor and elegance.

The individual panels of Ghiberti's east doors, such as *Isaac and His Sons* (FIG. 21-5), clearly recall painting techniques in their depiction of space as well as in their treatment of the narrative. Some exemplify more fully than painting many of the principles formulated by the architect and theorist Leon Battista Alberti in his 1435 treatise, *On Painting*. In his relief, Ghiberti created the illusion of space partly through the use of pictorial perspective and partly by sculptural means. He represented buildings according to a painter's one-point perspective construction, but the figures (in the bottom section of the relief, which actually projects slightly toward the viewer) appear almost in the full round, some of their heads standing completely free. As the eye progresses upward, the relief increasingly flattens, concluding with the architecture in the background, which Ghiberti depicted in barely raised lines. In this manner, the artist created a sort of sculptor's aerial perspective, with forms appearing less distinct the deeper they are in space. Ghiberti described the east doors as follows:

I strove to imitate nature as closely as I could, and with all the perspective I could produce [to have] excellent compositions rich with many figures. In some scenes I placed about a hundred figures, in some less, and in some more. . . . There were ten stories, all [sunk] in frames because the eye from a distance measures and interprets the scenes in such a way that they appear round. The scenes are in the lowest relief and the figures are seen in the planes; those that are near appear large, those in the distance small, as they do in reality.[3]

In these panels, Ghiberti achieved a greater sense of depth than had seemed possible in a relief. His principal figures do not occupy the architectural space he created for them; rather, the artist arranged them along a parallel plane in front of the grandiose architecture. (According to Leon Battista Alberti, in his *De re aedificatoria*—*On the Art of Building*—the grandeur of the architecture reflects the dignity of the events shown in the foreground.) Ghiberti's figure style mixes a Gothic patterning of rhythmic line; classical poses and motifs; and a new realism in characterization, movement, and surface detail. The medieval narrative method of presenting several episodes within a single frame persisted. In *Isaac and His Sons* (FIG. 21-5), the group of women in the left foreground attends the birth of Esau and Jacob in the left background; in the central foreground, Isaac sends Esau and his dogs to hunt game; and, in the right foreground, Isaac blesses the kneeling Jacob as Rebecca looks on (Gen. 25–27). Yet viewers experience little confusion because of Ghiberti's careful and subtle placement of each scene. The figures, in varying degrees of projection, gracefully twist and turn, appearing to occupy and move through a convincing stage space, which Ghiberti deepened by showing some figures from behind. The classicism derives from the artist's close study of ancient art. According to his biography, he admired and collected classical sculpture, bronzes, and coins. Their influence is seen throughout the panel, particularly in the figure of Rebecca, which Ghiberti based on a popular Greco-Roman statuary type. The emerging practice of collecting classical art in the 15th century had much to do with the appearance of classicism in Renaissance humanistic art.

Exemplary Lives
The Path to Sainthood

Saints are a ubiquitous element in modern society, surfacing in the names of geographic locations and churches, as well as appearing in artworks. Why is this, and what purpose do saints serve? What is the history of saints, and how does one achieve sainthood?

The word *saint* derives from the Latin word *sanctus,* meaning "made holy to God," or *sacred.* Thus, saints are people who have demonstrated a dedication to God's service. The first saints were martyrs—individuals who suffered and died for Christianity—selected by public acclaim. The faithful called on these martyrs to intercede on their behalf. By the end of the fourth century CE, the group of saints expanded to include confessors, individuals who merited honor for the Christian devotion they demonstrated while alive.

A more formal process of canonization emerged in the 12th century (although the procedures in use today were established in 1634). The Roman Catholic Church derived the term *canonization* from the idea of a canon, or list, of approved saints. Canonization is a lengthy and involved process. Normally several years must pass before the Church will consider a deceased Catholic for sainthood. After a panel of theologians and cardinals of the Congregation for the Causes of Saints thoroughly evaluates the candidate's life, the pope proclaims an approved candidate "venerable" (worthy of reverence). Evidence of the performance of a miracle earns the candidate beatification (from the word *beatus,* meaning "blessed"). After proof of another miracle, the pope canonizes the candidate as a saint.

Despite the concept of a canon, no such thing as an authoritative register of all saints exists. Different groups have compiled various lists. For example, the Roman Martyrology, which is not comprehensive, contains more than 4,500 names. Indeed, during John Paul II's papacy alone (1978–), over 500 people have been canonized.

Saints provided inspiration to the faithful and were greatly respected for their teaching ability. For these reasons, representations of saints were popular in art, especially in eras when religion dominated the lives of the populace. This was not idolatry, because viewers did not worship the images. The images simply encouraged and facilitated personal devotion. The pious called on saints to intercede on behalf of sinners (themselves or others).

The faithful admired each saint for certain traits or qualities, often having to do with the particulars of the saint's life or death. For example, the devout remembered Saint Teresa (see FIG. 24-9) for her transverberation (the piercing of her heart by the arrow of Divine Love); they associated Saint Bartholomew (see FIGS. 22-25 and 24-28) with the manner of his martyrdom (he was flayed alive). Art viewers recognized saints by their attributes. For example, artists usually depicted Saint Sebastian—a Roman guard the emperor Diocletian ordered shot by archers for refusing to deny Christ—bound to a post or tree, his body pierced by numerous arrows. Other saints and their attributes follow:

SAINT	DEPICTED
Francis of Assisi (see FIG. 19-1)	In a long robe tied at waist with rope; with stigmata
Peter (see FIG. 23-5)	With keys signifying the power to "bind and loose" (Matt. 16:19)
Jerome (see FIG. 23-21)	As either a scholar at his desk or a hermit in the wilderness
Stephen (see FIGS. 20-19 and 23-26)	With a stone, referring to his death by stoning
Augustine (see FIG. 23-26)	In a mitre (tall pointed hat) and bishop's vestments

STATUE-FILLED NICHES Ghiberti was just one of numerous artists who acknowledged Donatello's prodigious talent. Donatello's enviable skill at creating visually credible and engaging relief sculptures extended to sculpture in the round. His artistry impressed those in a position to commission art, as demonstrated by his participation, along with other esteemed sculptors, such as Ghiberti, in another major civic art program of the early 1400s—the decoration of Or San Michele.

Or San Michele was an early-14th-century building that at various times housed a granary, the headquarters of the guilds, a church, and Orcagna's tabernacle (see FIG. 19-20). After construction of Or San Michele, city officials assigned each of the niches on the building's exterior to a specific guild for decoration with a sculpture of its patron saint (see "Exemplary Lives: The Path to Sainthood," above). Most of the niches languished empty. By 1406, guilds had placed statues in only 5 of the 14 niches. Between 1406 and 1423, however, guilds filled the 9 vacant niches with statues by Donatello, Ghiberti, and Nanni di Banco. How might historians account for this flurry of activity? First, city officials issued a dictum in 1406 requiring the guilds to comply with the original plan and fill their assigned niches. Second, Florence was once again under siege, this time by King

Ladislaus (r. 1399–1414) of Naples. Ladislaus had marched north, had occupied Rome and the Papal States by 1409, and then had threatened to overrun Florence. As they had previously, Florentine officials urged citizens to stand firm and defend their city-state from tyranny. As had Visconti a few years earlier, Ladislaus, on the verge of military success in 1414, fortuitously died, and Florence found itself spared yet again. The guilds may well have viewed this threat as an opportunity to perform their civic duty by rallying their fellow Florentines while also promoting their own importance and position in Florentine society. The early-15th-century niche sculptures thus served various purposes, and their public placement provided an ideal vehicle for presenting political, artistic, and economic messages to a wide audience. Examining a few of these Or San Michele sculptures will reveal the stylistic and historical significance of all these works.

FOUR MARTYRED SCULPTORS Among the niches filled in the early 15th century was that assigned to the Florentine guild of sculptors, architects, and masons, who chose NANNI DI BANCO (ca. 1380–1421) to create four life-size marble statues of the guild's martyred patron saints. These four Christian sculptors

had defied an order from the Roman emperor Diocletian to make a statue of a pagan deity. In response, the emperor ordered them put to death. Because they placed their faith above all else, these saints were perfect role models for the 15th-century Florentines whom city leaders exhorted to stand fast in the face of the invasion threat by Ladislaus.

Nanni's sculptural group, *Four Crowned Saints* (FIG. **21-6**), also represented an early attempt to solve the Renaissance problem of integrating figures and space on a monumental scale. The artist's positioning of the figures, which stand in a niche that is *in* but confers some separation *from* the architecture, furthered the gradual emergence of sculpture from its architectural setting. This process began with such works as the 13th-century statues of the west front of Reims Cathedral (see FIG. 18-22). The niche's spatial recess permitted a new and dramatic possibility for the interrelationship of the figures. By placing them in a semicircle within their deep niche and relating them to one another by their postures and gestures, as well as by the arrangement of draperies, Nanni arrived at a unified spatial composition. Further, a remarkable psychological unity connects these unyielding figures, whose bearing expresses the discipline and integrity necessary to face adversity. While the figure on the right speaks, pointing to his right, the two men opposite listen and the one next to him looks out into space, pondering the meaning of the words. Later Renaissance artists, particularly Leonardo, exploited this technique of reinforcing the formal unity of a figural group with psychological cross-references.

In *Four Crowned Saints,* Nanni also displayed a deep respect for and close study of Roman portrait statues. The emotional intensity of the faces of the two inner saints owes much to the extraordinarily moving portrayals in stone of Roman emperors of the third century CE (see FIG. 10-69), and the bearded heads of the outer saints reveal a familiarity with second-century CE imperial portraiture (see FIG. 10-60). Early Renaissance artists, such as Donatello and Nanni di Banco, sought to portray individual personalities and characteristics. Roman models served as inspiration, but Renaissance artists did not simply copy them. Rather, they strove to interpret or offer commentary on their classical models in the manner of humanist scholars dealing with classical texts.

SUGGESTING MOTION IN STONE Donatello's incorporation of Classical Greek and Roman principles surfaced in *Saint Mark* (FIG. **21-7**), commissioned for Or San Michele by the guild of linen drapers and completed in 1413. In this sculpture, Donatello took a fundamental step toward depicting motion in the human figure by recognizing the principle of weight shift. Earlier chapters have established the importance of weight shift in the ancient world; Greek sculptors grasped the essential principle that the human body is not rigid, as they demonstrated in works such as the *Kritios Boy* (see FIG. 5-33) and the *Doryphoros* (see FIG. 5-38). It is a flexible structure that moves by continuously shifting its weight from one supporting leg to the other, its main masses moving in consonance. Donatello reintroduced this concept (known as *contrapposto;* see Chapter 5, page 129).

As the saint's body "moves," its drapery "moves" with it, hanging and folding naturally from and around bodily points of support so that the viewer senses the figure as a draped nude, not simply as an integrated column with arbitrarily incised drapery. This separates Donatello's *Saint Mark* from all medieval portal statuary. It was the first Renaissance figure whose voluminous drapery (the pride of the Florentine guild that paid for the statue) did not conceal but accentuated the movement of the arms, legs, shoulders, and hips. This development further contributed to the sculpted figure's independence from its architectural setting. Saint Mark's stirring limbs, shifting weight, and mobile drapery suggest impending movement out of the niche.

ELEVATED FIGURES Between 1416 and 1435, the officials in charge of cathedral projects commissioned from Donatello five statues for niches on the *campanile* (bell tower) adjacent to Florence Cathedral—a project that, like the figures for Or San Michele, had originated in the preceding century. Unlike the Or San Michele figures, however, which were installed only slightly above eye level, these sculptures were designed for niches some 30 feet above the ground. At that distance, delicate descriptive details (hair, garments, and features) cannot be recognized readily.

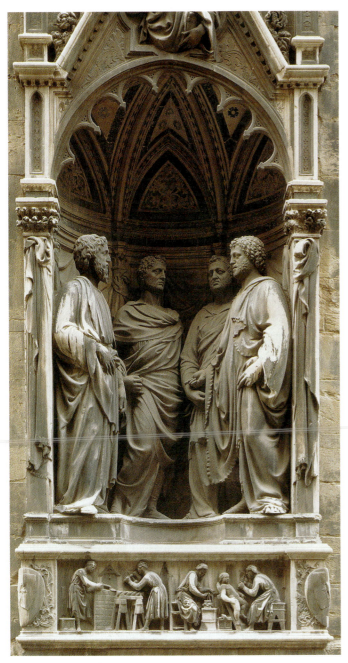

21-6 NANNI DI BANCO, *Four Crowned Saints,* Or San Michele, Florence, Italy, ca. 1408–1414. Marble, figures approx. life-size. Modern copy in exterior niche. Original sculpture in museum on second floor of Or San Michele.

The campanile figures thus required massive garment folds that could be read from afar and a much broader, summary treatment of facial and anatomical features, all of which Donatello used to great effect. In addition, he took into account the elevated position of his figures and, with subtly calculated distortions, created images that are at once realistic and dramatic when seen from below.

The most striking of the five figures is a prophet who is probably Habbakuk but is generally known by the nickname Zuccone, or "pumpkin-head" (FIG. 21-8). This figure shows Donatello's power of characterization at its most original. The artist represented all his prophets with a harsh, direct realism reminiscent of some ancient Roman portraits (compare FIGS. 10-7, 10-35, and 10-69). Their faces are bony, lined, and taut; Donatello carefully individualized each of them. The Zuccone is also bald, a departure from the conventional representation of the prophets but in keeping with many Roman portrait heads. Donatello's prophet wears an awkwardly draped and crumpled mantle with deeply undercut folds—a far cry from the majestic prophets of medieval portals. The head discloses a fierce personality; the deep-set eyes glare under furrowed brows, the nostrils flare, and the broad mouth is agape, as if the prophet were in the very presence of disasters that would prompt dire warnings.

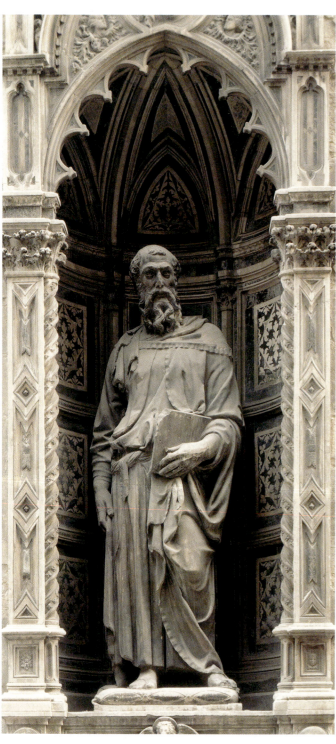

21-7 DONATELLO, *Saint Mark*, Or San Michele, Florence, Italy, 1411–1413. Marble, approx. 7′ 9″ high. Modern copy in exterior niche. Original sculpture in museum on second floor of Or San Michele.

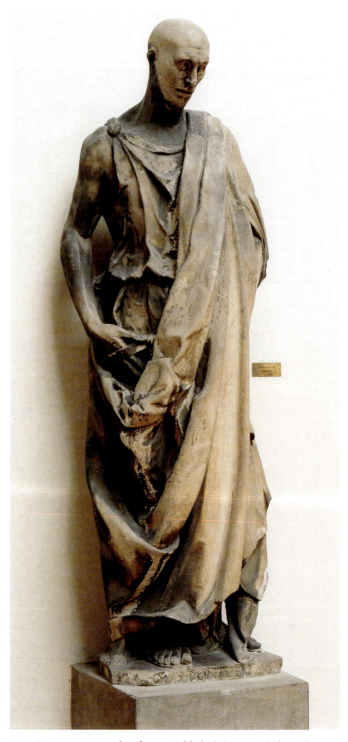

21-8 DONATELLO, prophet figure, Habbakuk (Zuccone), from the campanile of Florence Cathedral, Florence, Italy, 1423–1425. Marble, approx. 6′ 5″ high. Museo dell'Opera del Duomo, Florence.

Painting, Perspective, and Patronage

INSPIRED BY THE GOTHIC The International Style (see FIG. 19-12), the dominant style in painting around 1400 that persisted well into the 15th century, developed side by side with the new styles. GENTILE DA FABRIANO (ca. 1370–1427) produced a work representative of the International Style—*Adoration of the Magi* (FIG. 21-9), an altarpiece in the sacristy of the church of Santa Trinità in Florence. Gentile's patron was Palla Strozzi, the wealthiest Florentine of his day, and the altarpiece, with its elaborate gilded Gothic frame, is testimony to Strozzi's lavish tastes. So too is the painting itself, with its gorgeous surface and sumptuously costumed kings, courtiers, captains, and retainers accompanied by a menagerie of exotic and ornamental animals. Gentile portrayed all these elements in a rainbow of color with extensive use of gold. The painting presents all the pomp and ceremony of chivalric etiquette in a scene that sanctifies the aristocracy in the presence of the Madonna and Child. Although the style is fundamentally Late Gothic, Gentile inserted striking bits of radical naturalism. The artist depicted animals from a variety of angles, and he foreshortened their forms convincingly. He did the same with human figures, such as the man removing the spurs from the standing magus in the center foreground. On the right side of the predella (the ledge at the base of an altarpiece), Gentile placed the Presentation scene in a "modern" architectural setting. And on the left side of the predella, he painted what may have been the very first nighttime Nativity with the central light source—the radiant Christ Child—introduced into the picture itself. Although predominantly conservative, Gentile demonstrated that he was not oblivious to contemporary experimental trends and that he could blend naturalistic and inventive elements skillfully and subtly into a traditional composition without sacrificing Late Gothic coloristic splendor.

REVOLUTIONIZING REPRESENTATION A leading innovator in early-15th-century painting was Tommaso Guidi (or Tommaso di ser Giovanni), known as MASACCIO (1401–1428).

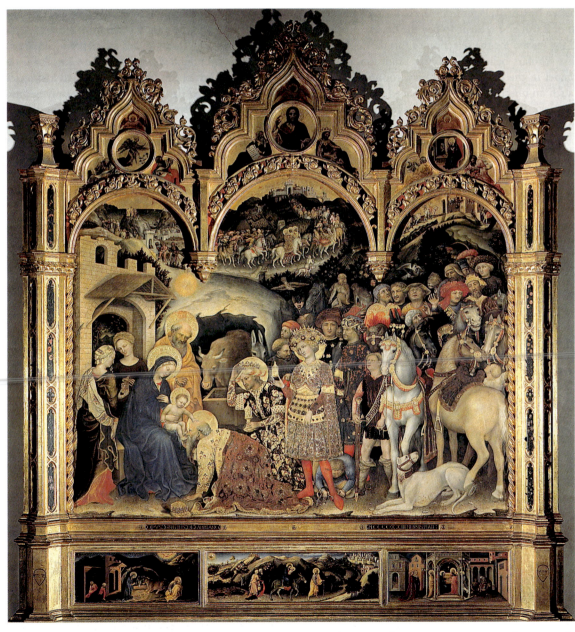

21-9 GENTILE DA FABRIANO, *Adoration of the Magi*, altarpiece from Santa Trinità, Florence, Italy, 1423. Tempera on wood, approx. 9′ 11″ × 9′ 3″. Galleria degli Uffizi, Florence.

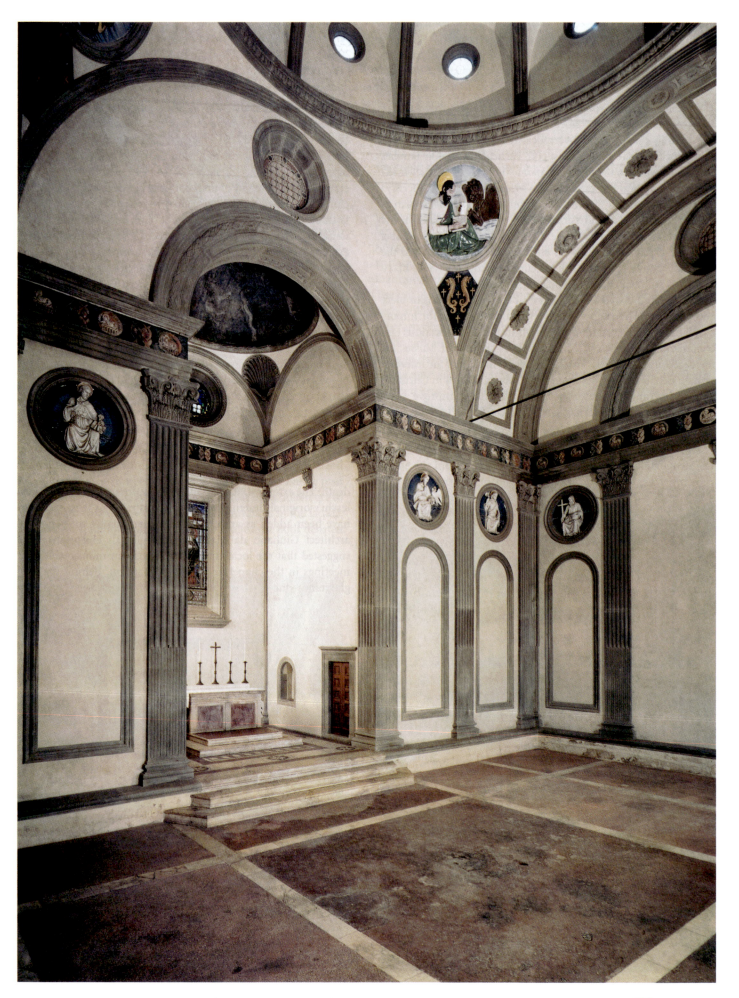

21-19 Filippo Brunelleschi, interior of the Pazzi Chapel (view facing northeast), Santa Croce, Florence, Italy, begun ca. 1440.

conceived basically as a central-plan structure. Although the plan (FIG. 21-18) is rectangular, rather than square or round, the architect placed all emphasis on the central dome-covered space. The short barrel-vault sections that brace the dome on two sides appear to be incidental appendages. The interior trim (FIG. 21-19) is done in gray stone, so-called *pietra serena* ("serene stone"), which stands out against the white stuccoed walls and crisply defines the modular relationships of plan and elevation. As he did in his design for Santo Spirito, Brunelleschi used a basic unit that allowed him to construct a balanced, harmonious, and regularly proportioned space. Medallions in the dome's *pendentives* consist of glazed terracotta reliefs representing the Four Evangelists. These medallions, together with the images of the Twelve Apostles on the pilaster-framed wall panels, add striking color accents to the tranquil interior.

The Medici as Patrons

A PALACE FIT FOR A MEDICI It seems curious that Brunelleschi, the most renowned architect of his time, did not participate in the upsurge of palace building that Florence experienced in the 1430s and 1440s. This proliferation of palazzi testified to the stability of the Florentine economy and to the affluence and confidence of the city's leading citizens. Brunelleschi, however, confined his efforts in this field to work on the Palazzo di Parte Guelfa (headquarters of Florence's then ruling "party") and to a rejected model for a new palace that Cosimo de' Medici intended to build.

Early in the 15th century, Giovanni de' Medici (ca. 1360–1429) had established the family fortune. Cosimo (1389–1464) expanded his family's financial control, which led to considerable political power as well. This consolidation of power in a city that prided itself on its republicanism did not go unchallenged. In the early 1430s, a power struggle with other wealthy families led to the Medici's expulsion from Florence. In 1434, the Medici returned, but Cosimo, aware of the importance of public perception, attempted to maintain a lower profile and to wield his power from behind the scenes. In all probability, this attitude accounted for his rejection of Brunelleschi's design for the Medici residence, which he evidently found too imposing and ostentatious to be politically wise. Cosimo eventually awarded the commission to MICHELOZZO DI BARTOLOMMEO (1396–1472), a young architect who had been Donatello's collaborator in several sculptural enterprises. Although Cosimo chose Michelozzo instead of Brunelleschi, Brunelleschi's architectural style in fact deeply influenced the young architect. To a limited extent, the Palazzo Medici-Riccardi (FIG. 21-20) reflects Brunelleschian principles.

Later bought by the Riccardi family (hence the name Palazzo Medici-Riccardi), who almost doubled the facade's length in the 18th century, the palace, both in its original and extended form, is a simple, massive structure. Heavy rustication on the ground floor accentuates its strength. Michelozzo divided the building block into stories of decreasing height by using long, unbroken stringcourses (horizontal bands), which give it coherence. Dressed stone on the upper levels produces a smoother surface with each successive story and modifies the severity of the ground floor. The building thus appears progressively lighter as the eye moves upward. The extremely heavy cornice, which Michelozzo related not to the top story but to the building as a whole, dramatically reverses this effect. Like the ancient Roman cornices that served as Michelozzo's models (compare, for example, FIGS. 10-30, 10-37, and 10-45), the Palazzo Medici-Riccardi cornice is a very effective lid for the structure, clearly and

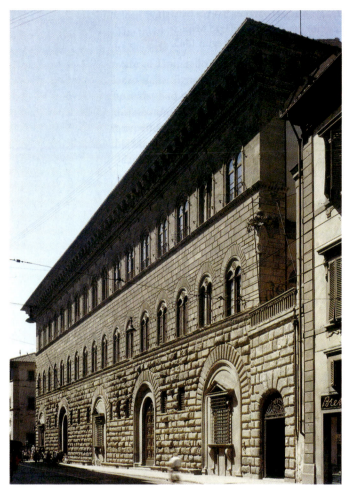

21-20 MICHELOZZO DI BARTOLOMMEO, facade of the Palazzo Medici-Riccardi, Florence, Italy, begun 1445.

emphatically defining its proportions. Michelozzo also may have been inspired by the many extant examples of Roman rusticated masonry, and Roman precedents even exist for the juxtaposition of rusticated and dressed stone masonry on the same facade (see FIG. 10-32). However, nothing in the ancient world precisely compares to Michelozzo's design. The Palazzo Medici-Riccardi is an excellent example of the simultaneous respect for and independence from the antique that characterize the Early Renaissance in Italy.

The Palazzo Medici-Riccardi is built around an open colonnaded court (FIG. 21-21) that clearly shows Michelozzo's debt to Brunelleschi. The round-arched colonnade, although more massive in its proportions, closely resembles other buildings by Brunelleschi. This internal court surrounded by an arcade was the first of its kind and influenced a long line of descendants in Renaissance domestic architecture.

THE MEDICI: CULTIVATED HUMANISTS The references to classical architecture in the Palazzo Medici-Riccardi's design were entirely appropriate for its patrons. The Medici were avid humanists. Cosimo began the first public library since the ancient world, and historians estimate that in some 30 years he and his descendants expended the equivalent of almost $20 million for manuscripts and books. Beyond their enthusiastic collecting of classical and Renaissance literature, the Medici eventually became voracious art collectors. Scarcely a great architect, painter, sculptor, philosopher, or humanist scholar escaped the Medici's notice.

Cosimo was the very model of the cultivated humanist. His grandson Lorenzo (1449–1492), called "the Magnificent," was a

David. Verrocchio's *David* is a sturdy, wiry young apprentice clad in a leathern doublet who stands with a jaunty pride. As in Donatello's version, Goliath's head lies at David's feet. He poses like a hunter with his kill. The easy balance of the weight and the lithe, still thinly adolescent musculature, with prominent veins, show how closely Verrocchio read the biblical text and how clearly he knew the psychology of brash and confident young men.

Lorenzo and Giuliano de' Medici eventually sold Verrocchio's bronze *David* to the Florentine *signoria* (a governing body) for placement in the Palazzo della Signoria. After the Medici were expelled from Florence, city officials appropriated Donatello's *David* for civic use and moved it to the Palazzo as well.

A MYTHIC WRESTLING MATCH Closely related in stylistic intent to Verrocchio's work is that of ANTONIO POLLAIUOLO (ca. 1431–1498). Pollaiuolo, who is also important as a painter and engraver, received a Medici commission in the 1470s to produce a small-scale sculpture, *Hercules and Antaeus* (FIG. 21-25). In contrast to the placid presentation of Donatello's *David, Hercules and Antaeus* exhibits the stress and strain of the human figure in violent action. This sculpture departs dramatically from the convention of frontality that had dominated statuary art during the Middle Ages and the Early Renaissance. Not quite 18 inches high, *Hercules and Antaeus* embodies the ferocity and vitality of elemental physical conflict. The group illustrates the Greek myth of a wrestling match between Antaeus (Antaios), a giant and son of Earth, and Hercules (Herakles). As seen earlier, Euphronios represented this story on an ancient Greek vase (see FIG. 5-21). Each time Hercules threw him down, Antaeus sprang up again, his strength renewed by contact with the earth. Finally, Hercules held him aloft, so that he could not touch the earth, and strangled him around the waist. Pollaiuolo strove to convey the final excruciating moments of the struggle—the straining and cracking of sinews, the clenched teeth of Hercules, and the kicking and screaming of Antaeus. The figures intertwine and interlock as they fight, and the flickering reflections of light on the dark gouged bronze surface contribute to a fluid play of planes and the effect of agitated movement. The subject matter, derived from Greek mythology, and the emphasis on human anatomy reflect the Medici preference for humanist imagery. Even more specifically, Hercules had been represented on Florence's state seal since the end of the 13th century. As was demonstrated by commissions such as the two *David* sculptures, the Medici clearly embraced every opportunity to associate themselves with the glory of the Florentine republic, surely claiming much of the credit for it.

BATTLING NUDES Although not commissioned by the Medici, Pollaiuolo's engraving *Battle of the Ten Nudes* (FIG. 21-26) further demonstrates the artist's sustained interest in the realistic presentation of human figures in action. Earlier artists, such as Donatello and Masaccio, had dealt effectively with the problem of rendering human anatomy, but they usually depicted their figures at rest or in restrained motion. As is evident in his *Hercules and Antaeus,* Pollaiuolo took delight in showing violent action and found his opportunity in subjects dealing with combat. He conceived the body as a powerful machine and liked to display its mechanisms, such as knotted muscles and taut sinews that activate the skeleton as ropes pull levers. To show this to best effect, Pollaiuolo developed a figure so lean and muscular that it appears *écorché* (as if without skin), with strongly accentuated delineations at the wrists, elbows, shoulders, and knees. His *Battle of the Ten Nudes* shows this figure type in a variety of poses and from numerous viewpoints, allowing Pollaiuolo to demonstrate his prowess in rendering the nude male figure. In this, he was a kindred spirit of late-sixth-century Greek vase painters, such as Euthymides (see FIG. 5-22), who had experimented with foreshortening for the first time in history. If Pollaiuolo's figures, even though they hack and slash at each other without mercy, seem somewhat stiff and frozen, it is because Pollaiuolo shows *all* the muscle groups at maximum tension. Not until several decades later did an even greater anatomist, Leonardo, observe that only part of the body's muscle groups are involved in any one action, while the others are relaxed.

The medium that Pollaiuolo used for *Battle of the Ten Nudes*—engraving—was probably developed by northern European artists around the middle of the 15th century. But whereas German graphic artists, such as Martin Schongauer (see FIG. 20-25), described their forms with hatching that follows the forms, Italian engravers, such as Pollaiuolo, preferred parallel hatching. The former method was in keeping with the general northern approach to art, which tended to describe surfaces of forms rather than their underlying structures, whereas the latter was better suited for the anatomical studies that preoccupied Pollaiuolo and his Italian contemporaries.

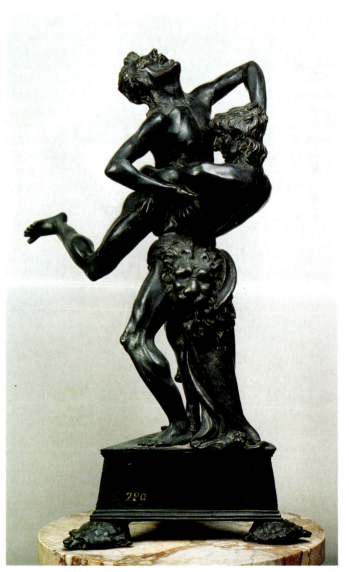

21-25 ANTONIO POLLAIUOLO, *Hercules and Antaeus,* ca. 1475. Bronze, approx. 1′ 6″ high with base. Museo Nazionale del Bargello, Florence.

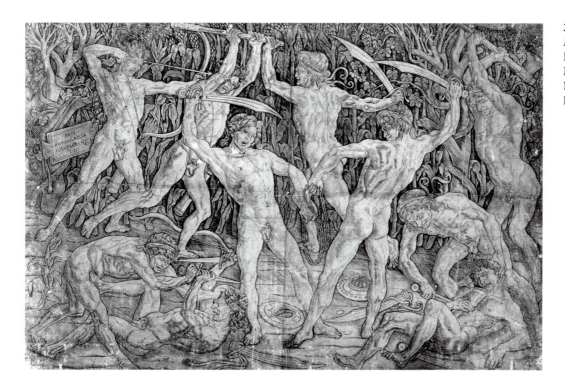

21-26 ANTONIO POLLAIUOLO, *Battle of the Ten Nudes,* ca. 1465. Engraving, approx. 1′ 3″ × 1′ 11″. Metropolitan Museum of Art, New York (bequest of Joseph Pulitzer, 1917).

VISUAL POETRY SANDRO BOTTICELLI (1444–1510) remains among the best known of the artists who produced works for the Medici. One of the works he painted in tempera on canvas for the Medici was his famous *Birth of Venus* (FIG. **21-27**). A poem on that theme by Angelo Poliziano, one of the leading humanists of the day, inspired Botticelli to create this lyrical image. Zephyrus (the west wind) blows Venus, born of the sea foam and carried on a cockle shell, to her sacred island, Cyprus. There, the nymph Pomona runs to meet her with a brocaded mantle. The lightness and bodilessness of the winds move all the figures without effort. Draperies undulate easily in the gentle gusts, perfumed by rose petals that fall on the whitecaps. Botticelli's nude presentation of

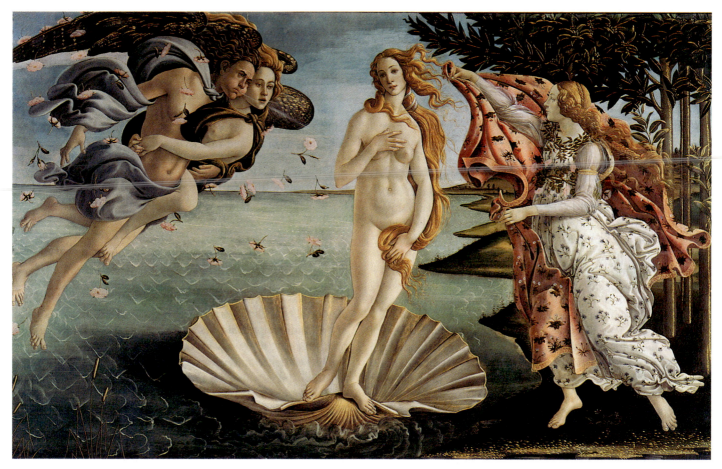

21-27 SANDRO BOTTICELLI, *Birth of Venus,* ca. 1482. Tempera on canvas, approx. 5′ 8″ × 9′ 1″. Galleria degli Uffizi, Florence.

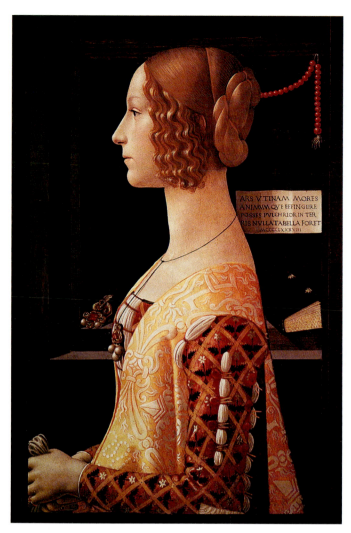

21-31 DOMENICO GHIRLANDAIO, *Giovanna Tornabuoni*(?), 1488. Oil and tempera on wood, approx. 2′ 6″ × 1′ 8″. Thyssen-Bornemisza Collection, Madrid, Spain.

Florentines of his day, commissioned Ghirlandaio's most representative pictures, a cycle of frescoes depicting scenes from the lives of the Virgin and Saint John the Baptist, for the choir of Santa Maria Novella. In the illustrated painting, *Birth of the Virgin* (FIG. **21-32**), Mary's mother, Saint Anne, reclines in a palace room embellished with fine *intarsia* (wood inlay) and sculpture, while midwives prepare the infant's bath. From the left comes a grave procession of women led by a young Tornabuoni family member, probably Ludovica, Giovanni's daughter. Ludovica holds as prominent a place in the composition (close to the central axis) as she must have held in Florentine society. Her appearance in the painting (a different female member of the house appears in each fresco) is conspicuous evidence of the secularization of sacred themes—commonplace in art by this time. Artists depicted living persons of high rank not only as present at biblical dramas but also, as here, often stealing the show from the saints. The display of patrician elegance tempers the biblical narrative and subordinates the tableau's devotional nature.

Ghirlandaio's composition epitomizes the achievements of Early Renaissance painting: clear spatial representation; statuesque, firmly constructed figures; and rational order and logical relations among these figures and objects. If anything of earlier traits remains here, it is the arrangement of the figures, which still cling somewhat rigidly to layers parallel to the picture plane.

FURTHER DEVELOPMENTS IN ARCHITECTURE

LEON BATTISTA ALBERTI (1404–1472) entered the profession of architecture rather late in life, but nevertheless made a remarkable contribution to architectural design. He was the first to study seriously the treatise of Vitruvius (*De architectura*), and his knowledge of it, combined with his own archaeological investigations, made him the first Renaissance architect to understand Roman

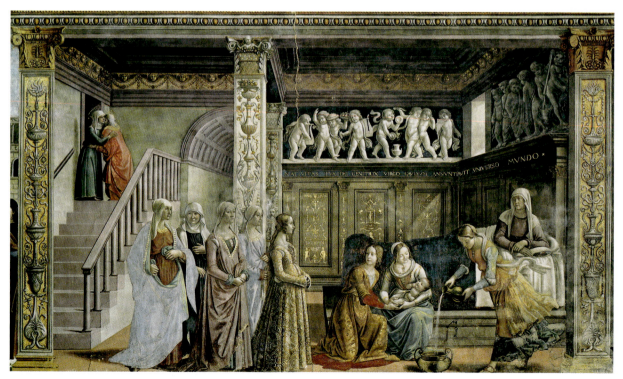

21-32 DOMENICO GHIRLANDAIO, *Birth of the Virgin*, Cappella Maggiore, Santa Maria Novella, Florence, Italy, 1485–1490. Fresco.

architecture in depth. Alberti's most important and influential theoretical work, *De re aedificatoria* (written about 1450, published 1486), although inspired by Vitruvius, contains much original material. Alberti advocated a system of ideal proportions and argued that the central plan was the ideal form for a Christian church. He also considered incongruous the combination of column and arch, which had persisted since Roman times (see FIG. 10-51). By arguing that the arch is a wall opening that should be supported only by a section of wall (a pier), not by an independent sculptural element (a column), Alberti (with a few exceptions) disposed of the medieval arcade used for centuries.

BUILDING ON CLASSICISM Alberti's own architectural style represents a scholarly application of classical elements to contemporary buildings. His Palazzo Rucellai in Florence (FIG. **21-33**) probably dates from the mid-1450s. Alberti organized the facade, built over a number of medieval houses, in a much more severe fashion than the Palazzo Medici-Riccardi facade (FIG. 21-20), another classically inspired building. Flat pilasters, which support full entablatures, define each story of the Palazzo Rucellai. A classical cornice crowns the palace. The rustication of the wall surfaces between the smooth pilasters is subdued and uniform. Alberti created the sense that the structure becomes lighter in weight toward its top by adapting the ancient Roman manner of using different capitals for each story. He chose Tuscan (the Etruscan variant of the Greek Doric order) for the ground floor, Composite (the Roman combination of Ionic volutes with the acanthus leaves of the Corinthian) for the second story, and Corinthian for the third floor. Alberti modeled his facade on the most imposing Roman ruin of all, the Colosseum (see FIG. 10-34), but he was no slavish copyist. On the Colosseum's facade the capitals employed are, from the bottom up, Tuscan, Ionic, and Corinthian. Moreover, Alberti adapted the Colosseum's varied surface to a flat facade, which does not allow the deep penetration of the building's mass that is so effective in the Roman structure. By converting his ancient model's *engaged columns* (half-round columns attached to a wall) into shallow pilasters that barely project from the wall, Alberti created a large-meshed linear net. Stretched tightly across the front of his building, it not only unifies the three levels but also emphasizes the wall's flat, two-dimensional qualities.

OF RATIOS AND RATIONALITY The Rucellai family also commissioned from Alberti the design for the facade of the 13th-century Gothic church of Santa Maria Novella in Florence (FIGS. **21-34** and **21-35**). Here, Alberti took his cue (just as Brunelleschi did occasionally) from a pre-Gothic medieval design—that of

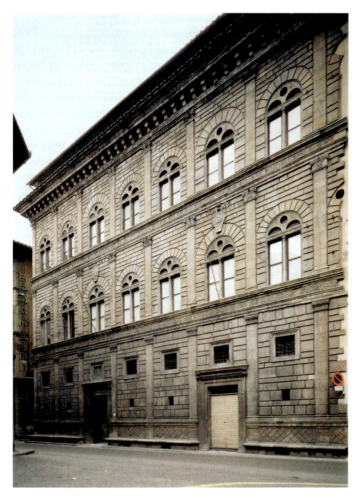

21-33 LEON BATTISTA ALBERTI, Palazzo Rucellai, Florence, Italy, ca. 1452–1470.

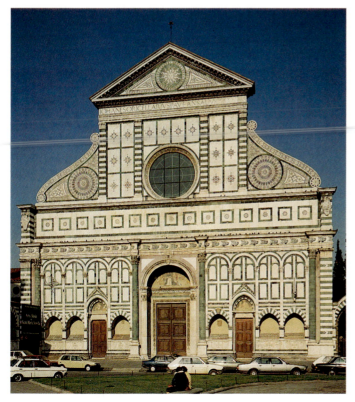

21-34 LEON BATTISTA ALBERTI, west facade of Santa Maria Novella, Florence, Italy, ca. 1458–1470.

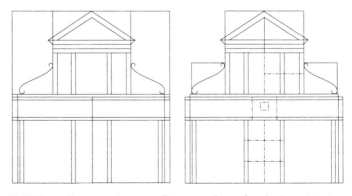

21-35 LEON BATTISTA ALBERTI, diagrams of west facade, Santa Maria Novella, Florence, Italy.

21-38 Fra Filippo Lippi, *Madonna and Child with Angels,* ca. 1455. Tempera on wood, approx. 3′ × 2′ 1″. Galleria degli Uffizi, Florence.

21-39 Luca della Robbia, *Madonna and Child,* Or San Michele, Florence, Italy, ca. 1455–1460. Terracotta with polychrome glaze, diameter approx. 6′.

RELIEF SCULPTURE FOR THE MASSES During the latter half of the 15th century, increasing demand for devotional images for private chapels and shrines (rather than for large public churches) contributed to a growing secularization of traditional religious subject matter. LUCA DELLA ROBBIA (1400–1482) discovered a way to produce Madonna images so that persons of modest means could buy them. His discovery (around 1430), involving the application of vitrified (heat-fused) potters' glazes to sculpture, led to his production, in quantity, of glazed terracotta reliefs. He is best known for these works. Inexpensive, durable, and decorative, they became extremely popular and provided the basis for a flourishing family business. Luca's nephew Andrea della Robbia (1435–1525) and Andrea's sons, Giovanni della Robbia (1469–1529) and Girolamo della Robbia (1488–1566), carried on this tradition well into the 16th century; people still refer to it as "della Robbia ware."

An example of Luca's specialty is the *Madonna and Child* (FIG. 21-39), commissioned by a guild and set into a wall of Or San Michele. The figures appear within a *tondo* (a circular painting or relief sculpture), a format that became popular with both sculptors and painters in the later part of the century. For example, Brunelleschi incorporated it into his design of the Pazzi Chapel's interior (FIG. 21-19), where most of the roundels are the work of Luca della Robbia himself. In his tondo for Or San Michele, Luca's introduction of high-key color into sculpture added a certain worldly gaiety to the Madonna and Child theme, and his customary light blue ground (and here the green and white of lilies and the white architecture) suggests in this work the festive Easter season and the freshness of May, the Virgin's month. The somber majesty of the old Byzantine style had long since disappeared. The young mothers who prayed before images in this new form could easily identify with the Madonna and doubtless did. The distance between the observed and observers had vanished.

21-40 PERUGINO, *Christ Delivering the Keys of the Kingdom to Saint Peter,* Sistine Chapel, Vatican, Rome, Italy, 1481–1483. Fresco, 11′ 5½″ × 18′ 8½″, Vatican Museums.

THE ESTABLISHMENT OF PAPAL AUTHORITY Of course, the production of religious art extended beyond Florence. The pope's presence in Rome ensured an active artistic scene there as well. Between 1481 and 1483, Pope Sixtus IV summoned a group of artists, including Botticelli, Ghirlandaio, and Luca Signorelli, to Rome to decorate with frescoes the walls of the newly completed Sistine Chapel. Pietro Vannucci, known as PERUGINO (ca. 1450–1523), was among this group and painted *Christ Delivering the Keys of the Kingdom to Saint Peter* (FIG. **21-40**). The papacy had, from the beginning, based its claim to infallible and total authority over the Roman Catholic Church on this biblical event. In Perugino's version, Christ hands the keys to Saint Peter, who stands amidst an imaginary gathering of the Twelve Apostles and Renaissance contemporaries. These figures occupy the apron of a great stage space that extends into the distance to a point of convergence in the doorway of a central-plan temple. (Perugino used parallel and converging lines in the pavement to mark off the intervening space.) Figures in the middle distance complement the near group, emphasizing its density and order by their scattered arrangement. At the corners of the great piazza, duplicate triumphal arches serve as the base angles of a distant compositional triangle whose apex is in the central building. Perugino modeled the arches very closely on the Arch of Constantine (see FIG. 10-76) in Rome. Although an anachronism in a painting depicting a scene from Christ's life, the arches remind viewers of the close ties between Constantine and Saint Peter and of the great basilica the first Christian emperor built over Saint Peter's tomb in Rome. Christ and Peter flank the triangle's central axis, which runs through the temple's doorway, the perspective's vanishing point. Thus, the composition interlocks both two-dimensional and three-dimensional space, and the placement of central actors emphasizes the axial center. This spatial science allowed the artist to organize the action systematically. Perugino, in this single picture, incorporated the learning of generations.

THE PRINCELY COURTS

Although virtually all the artworks discussed thus far in this chapter are Florentine, art production flourished throughout Italy in the 15th century. In particular, the princely courts that rulers established in such cities as Naples, Urbino, Milan, Ferrara, and Mantua deserve much credit for nurturing the arts. These princely courts consisted of the prince (lord of a territory), his consort and children, courtiers, household staff, and administrators (see "Cultivating Culture," page 575). The considerable wealth these princes possessed, coupled with their desire for recognition, fame, and power, resulted in major art commissions.

Mantua

Marquis Ludovico Gonzaga (1412–1478) ruled one of these princely courts, the marquisate of Mantua in northern Italy. A famed condottiere, Gonzaga established his reputation as a fierce military leader while general of the Milanese armies. A visit to Mantua by Pope Pius II in 1459 stimulated the Marquis's determination to transform Mantua into a spectacular city. After the pope's departure, Gonzaga set about building a city that would be the envy of all of Italy.

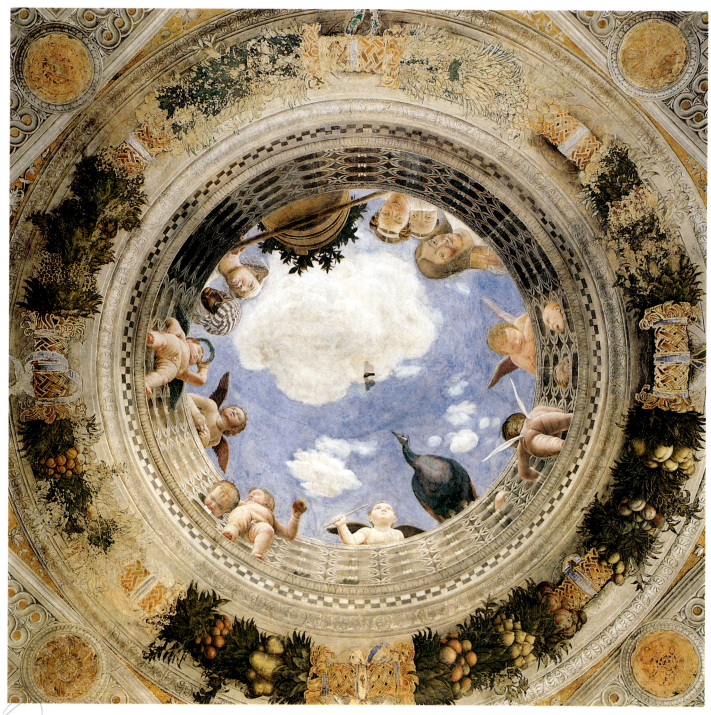

21-46 ANDREA MANTEGNA, ceiling of the Camera degli Sposi (Room of the Newlyweds), Palazzo Ducale, Mantua, Italy, 1474. Fresco, 8′ 9″ in diameter.

Mantegna's *trompe l'oeil* (French, "deceives the eye") design, however, went far beyond anything preserved from ancient Italy. The Renaissance painter's daring experimentalism led him to complete the room's decoration with the first *di sotto in sù* (from below upwards) perspective of a ceiling (FIG. **21-46**). Baroque ceiling decorators later broadly developed this technique. Inside the Room of the Newlyweds, the viewer becomes the viewed as figures look down into the room. The oculus is itself an "eye" looking down. Cupids (the sons of Venus), strongly foreshortened, set the amorous mood as the painted spectators (who are not identified) smile down on the scene. The peacock is an attribute of Juno, Jupiter's bride, who oversees lawful marriages. This tour de force of illusionism climaxes almost a century of experimentation with perspective.

A SAINT VIEWED FROM BELOW Whereas the Gonzaga frescoes showcase Mantegna's mature style, his earlier frescoes in the Ovetari Chapel in the Church of the Eremitani (largely destroyed in World War II) in Padua reveal Mantegna's early interest in illusionism and highlight the breadth of his literary, archaeological, and pictorial learning. *Saint James Led to Martyrdom* (FIG. **21-47**) depicts the condemned saint stopping, even on the way to his own death, to bless a man who has rushed from the crowd and kneels before him (while a Roman soldier restrains others from coming forward). Yet narrative does not seem to have been Mantegna's primary concern in this fresco. The painter strove for historical authenticity, much like the antiquarian scholars of the University of Padua. He excerpted the motifs (such as those that appear on the barrel-vaulted triumphal arch) from the classical

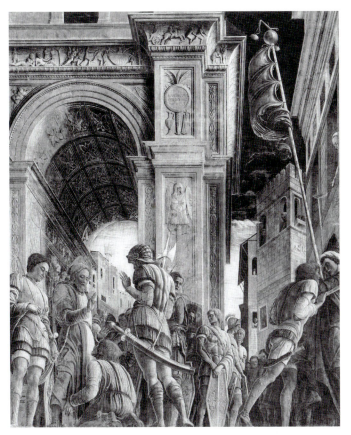

21-47 ANDREA MANTEGNA, *Saint James Led to Martyrdom,* Ovetari Chapel, Church of the Eremitani (largely destroyed, 1944), Padua, Italy, ca. 1455. Fresco, 10′ 9″ wide.

ornamental vocabulary. Antique attire served as the model for the soldiers' costumes.

Perspective also occupied Mantegna's attention. Indeed, he seemed to set up for himself difficult problems in perspective for the joy of solving them. Here, the observer views the scene from a very low point, almost as if looking up out of a basement window at the vast arch looming above. The lines of the building to the right plunge down dramatically. Several significant deviations from true perspective are apparent, however, and establish that Mantegna did not view the scientific organization of pictorial space as an end in itself. Using artistic license, he ignored the third vanishing point (seen from below, the buildings should converge toward the top). Disregarding perspectival facts, he preferred to work toward a unified, cohesive composition whose pictorial elements relate to the picture frame. Mantegna partly compensated for the lack of perspectival logic by inserting strong diagonals in the right foreground (the banner staff, for example).

EXAMINING CHRIST'S WOUNDS One of Mantegna's later paintings, *Dead Christ* (FIG. **21-48**), is a work of overwhelming power. At first glance, this painting seems to be a strikingly realistic study in foreshortening. Careful scrutiny, however, reveals that the artist reduced the size of the figure's feet, which, as he must have known, would cover much of the body if properly represented. Thus, tempering naturalism with artistic license, Mantegna presented both a harrowing study of a strongly foreshortened cadaver and an intensely poignant depiction of a biblical tragedy. The painter's harsh, sharp line seems to cut the surface as if it were metal and conveys, by its grinding edge, the theme's corrosive emotion. Remarkably, all the science of the 15th century here serves the purpose of devotion.

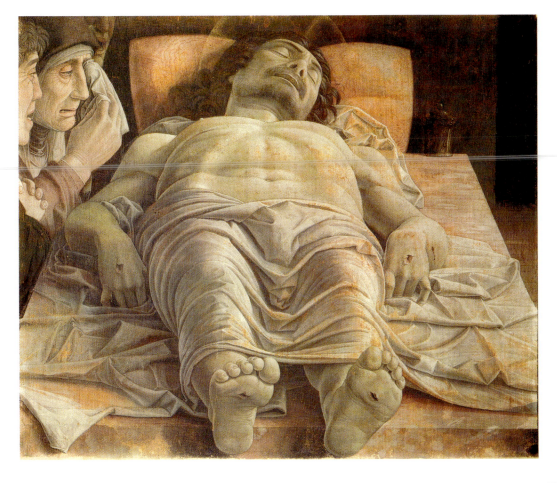

21-48 ANDREA MANTEGNA, *Dead Christ,* ca. 1501. Tempera on canvas, 2′ 2¾″ × 2′ 7⅞″. Pinacoteca di Brera, Milan.

Artists in northern Italy, not only in Mantua but in Ferrara and Venice as well, attempted to follow in Mantegna's footsteps. His influence went even further, however, for he was also a great engraver (the line in the *Dead Christ* certainly suggests engraving). His prints found their way across the Alps to Germany, where they influenced Albrecht Dürer (see FIGS. 23-4 to 23-8 and Intro-8), a leading figure in 16th-century art.

Urbino

Urbino, southeast of Florence across the Appenines, was another princely court; the patronage of Federico da Montefeltro (1422–1482) accounted for its status as a center of Renaissance art and culture. In fact, the humanist writer Paolo Cortese described Federico as one of the two greatest artistic patrons of the 15th century (the other was Cosimo de' Medici). Federico, like Ludovico Gonzaga, was a well-known condottiere. So renowned was Federico for his military skills that he was in demand by popes and kings across Europe, and soldiers came from across the continent to study with this military expert. One of the artists who received several commissions from Federico was PIERO DELLA FRANCESCA (ca. 1420–1492). His art projected a mind cultivated by mathematics. Piero believed that the highest beauty resides in forms that have the clarity and purity of geometric figures. Toward the end of his long career, Piero, a skilled geometrician, wrote the first theoretical treatise on systematic perspective, after having practiced the art with supreme mastery for almost a lifetime. His association with the architect Alberti at Ferrara and at Rimini around 1450–1451 probably turned his attention fully to perspective (a science in which Alberti was an influential pioneer) and helped determine his later, characteristically architectonic, compositions. This approach appealed to Federico, a patron fascinated by architectural space and its depiction. Observers can say fairly that Piero established his compositions almost entirely by his sense of the exact and lucid structures defined by mathematics.

A LEGENDARY FRESCO STYLE Piero produced many memorable works before he came to the attention of Federico da Montefeltro. One of these earlier works is the fresco cycle in the apse of the church of San Francesco in Arezzo, southeast of Florence on the Arno. Painted between 1452 and 1456, the cycle represents 10 episodes from the legend of the True Cross (the cross on which Christ died) and is based on a 13th-century popularization of the Scriptures, the *Golden Legend,* by Jacobus de Voragine. In the climactic scene of Piero's Arezzo cycle, the *Finding of the True Cross and Proving of the True Cross* (FIG. **21-49**), Saint Helena, mother of Constantine, accompanied by her retinue, oversees the unearthing of the buried crosses (at left), and witnesses (at right) how the True Cross miraculously restores a dead man (the nude figure) to life. The architectural background organizes and controls the grouping of the figures; its medallions, arches, and rectangular panels are the two-dimensional counterparts of the ovoid, cylindrical, and cubic forms placed in front of it. The careful delineation of architecture suggests an architect's vision, certainly that of a man entirely familiar with compass and straightedge. As the architectonic nature of the abstract shapes controls the grouping, so too does it impart a mood of solemn stillness to the figures.

Piero's work shows, in addition, an unflagging interest in the properties of light and color. In his effort to make the clearest possible distinction between forms, he flooded his pictures with light, imparting a silver-blue tonality. To avoid heavy shadows, he illuminated the dark sides of his forms with reflected light. By moving the darkest tones of his modeling toward the centers of his volumes, he separated them from their backgrounds. Because of this technique, Piero's paintings lack some of Masaccio's relief-like qualities but gain in spatial clarity, as each shape forms an independent unit surrounded by an atmospheric envelope and movable to any desired position, like a figure on a chessboard.

A PIOUS PATRON Piero deployed all his skills for the paintings commissioned by Federico da Montefeltro. One of those works is *Enthroned Madonna and Saints Adored by Federico da Montefeltro,* also called the *Brera Altarpiece* (FIG. **21-50**). The clarity of Piero's

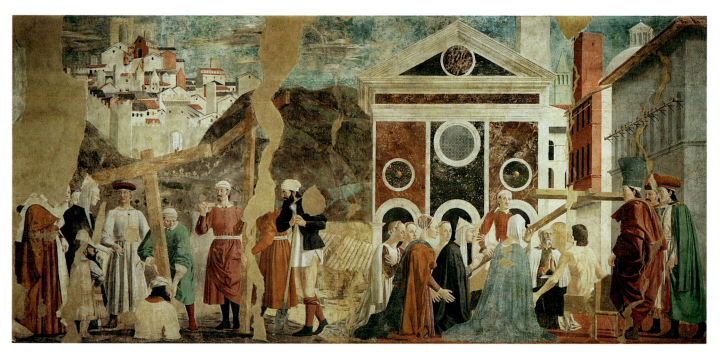

21-49 PIERO DELLA FRANCESCA, *Finding of the True Cross and Proving of the True Cross,* San Francesco, Arezzo, Italy, ca. 1455. Fresco, 6′ 4″ × 11′ 8⅜″.

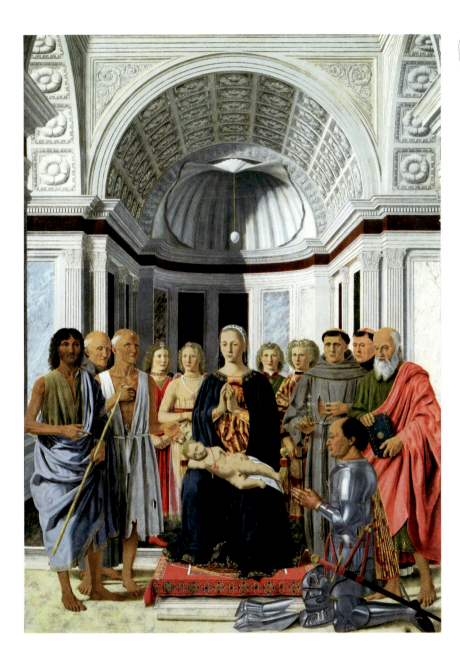

21-50 PIERO DELLA FRANCESCA, *Enthroned Madonna and Saints Adored by Federico da Montefeltro (Brera Altarpiece)*, ca. 1472–1474. Oil on panel, 8′ 2″ × 5′ 7″. Pinacoteca di Brera, Milan.

earlier works is in full view here, as Federico, clad in armor, kneels piously at the Virgin's feet. Directly behind him stands Saint John the Evangelist, his patron saint. Where the viewer would expect to see his wife, Battista Sforza (on the lower left, as a mirror image to Federico), no figure is present. Battista had died in 1472, shortly before Federico commissioned this painting. Thus, her absence clearly announces his loss. Piero further called attention to it by depicting Saint John the Baptist, Battista's patron saint, at the far left. The ostrich egg that hangs suspended from a shell over the Virgin's head was a common presence over altars dedicated to Mary. The figures appear in an illusionistically painted coffered barrel vault, which may have reflected the actual architecture of the painting's intended location, the church of San Bernadino degli Zoccolanti near Urbino. If such were the case, it would have enhanced the illusion, and the viewer would be compelled to believe in Federico's presence before the Virgin, Christ Child, and saints. That Piero depicted Federico in profile was undoubtedly a concession to the patron. The right side of Federico's face had been badly injured in a tournament, and the resulting deformity made him reluctant to show that side of his face. The number of works (including other portraits) that Piero executed for Federico reflects his success in accommodating his patron's wishes.

TURMOIL AT THE END OF THE CENTURY

In the 1490s, Florence underwent a political, cultural, and religious upheaval. Florentine artists and their fellow citizens responded then not only to humanist ideas but also to the incursion of French armies and especially to the preaching of the Dominican monk Girolamo Savonarola, the reforming priest-dictator who denounced the paganism of the Medici and their artists, philosophers, and poets. Savonarola exhorted the people of Florence to repent their sins, and, when Lorenzo de' Medici died in 1492 and the Medici fled, he prophesied the downfall of the city and of Italy and assumed absolute control of the state. Together with a large number of citizens, Savonarola believed that the Medici's political, social, and religious power had corrupted Florence and had invited the scourge of foreign invasion. Savonarola denounced humanism and encouraged "bonfires of the vanities" for citizens to burn their classical texts, scientific treatises, and philosophical publications. Modern scholars still debate the significance of Savonarola's brief span of power. Apologists for the undoubtedly sincere monk deny that his actions played a role in

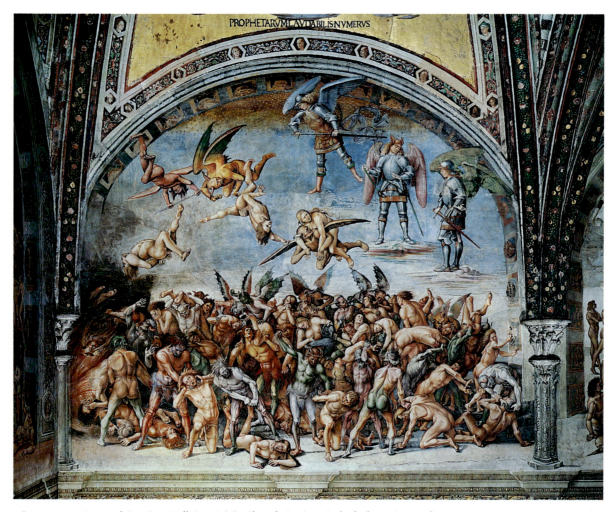

21-51 Luca Signorelli, *Damned Cast into Hell*, San Brizio Chapel, Orvieto Cathedral, Orvieto, Italy, 1499–1504. Fresco, approx. 23′ wide.

the decline of Florentine culture at the end of the 15th century. But he did condemn humanism as heretical nonsense, and his banishing of the Medici, Tornabuoni, and other wealthy families from Florence deprived local artists of some of their major patrons. Certainly, the puritanical spirit that moved Savonarola must have dampened considerably the neopagan enthusiasm of the Florentine Early Renaissance.

A VISION OF THE DAMNED Outside Florence, the fiery passion of the sermons of Savonarola found its pictorial equal in the work of the Umbrian painter LUCA SIGNORELLI (ca. 1445–1523). The artist further developed Antonio Pollaiuolo's interest in the depiction of muscular bodies in violent action in a wide variety of poses and foreshortenings. In the San Brizio Chapel in Orvieto Cathedral, Signorelli's painted scenes depicting the end of the world include *Damned Cast into Hell* (FIG. **21-51**). Few figure compositions of the 15th century have the same awesome psychic impact. Saint Michael and the hosts of Heaven hurl the damned into Hell, where, in a dense, writhing mass, they are vigorously tortured by demons. The horrible consequences of a sinful life had not been so graphically depicted since Gislebertus carved his vision of the Last Judgment in the west tympanum of Saint-Lazare at Autun (see FIGS. 17-25 and Intro-6) around 1130. The figures—nude, lean, and muscular—assume every conceivable posture of anguish. Signorelli's skill at foreshortening the human figure was one with his mastery of its action, and, although each figure is clearly a study from a model, he fit his theme to the figures in an entirely convincing manner. Terror and rage pass like storms through the wrenched and twisted bodies. The fiends, their hair flaming and their bodies the color of putrefying flesh, lunge at their victims in ferocious frenzy.

CONCLUSION

Expanding interest in humanism provided a foundation for much of the art produced in 15th-century Italy. The pronounced fascination with perspectival systems, along with the popularity of subjects derived from classical history and mythology, are evidence of the influence of humanism. Another factor in the development of 15th-century Italian art was the continuing political instability, which facilitated the consolidation of power by princely courts (such as those in Urbino and Mantua) and dominant families (such as the Medici). Such powerful individuals and families saw themselves not just as political and economic leaders but as cultural ones as well. For this reason, art patronage was a priority for many of them, and their commissions—in terms of quantity, scale, choice of subject and artist, and, often, visibility—affected the direction that art took in Italy. The flourishing of art during the 15th century continued the "rebirth" of Italian culture begun in the previous century, and the artworks produced served as important models for Leonardo, Michelangelo, Raphael, and the other masters of the 16th century.

EARLY RENAISSANCE

■ GIANGALEAZZO VISCONTI DIES; MILANESE ARMIES WITHDRAW FROM TUSCANY, 1402

■ KING LADISLAUS OF NAPLES DIES, 1414

■ END OF GREAT SCHISM IN CATHOLIC CHURCH, 1417

1420

1425

1 Donatello, *Saint Mark*, Or San Michele, Florence, Italy, 1411–1413

1430

■ BATTLE OF SAN ROMANO, 1432

■ MARSILIO FICINO, NEOPLATONIC PHILOSOPHER, 1433–1499

2 Filippo Brunelleschi, dome of Florence Cathedral, 1420–1436

1440

■ INVENTION OF MOVABLE METAL TYPE BY JOHANN GUTENBERG, CA. 1445

■ LORENZO DE' MEDICI, 1449–1492

■ CONQUEST OF CONSTANTINOPLE BY TURKS, 1453

3 Antonio Pol-laiuolo, *Hercules and Antaeus*, ca. 1475

1470

1475

1480

■ MEDICI EXPELLED FROM FLORENCE, 1494

■ GIROLAMO SAVONAROLA ASSUMES POWER, 1496; IS BURNED AT STAKE, 1498

■ FRANCE CAPTURES MILAN, 1499

4 Sandro Botticelli, *Birth of Venus*, ca. 1482

1500

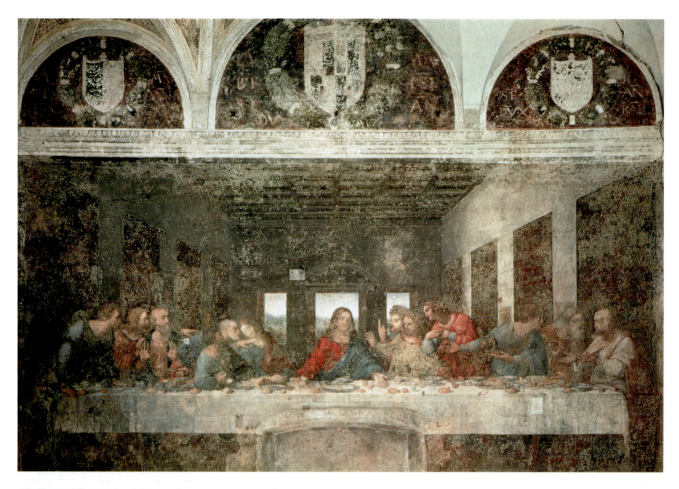

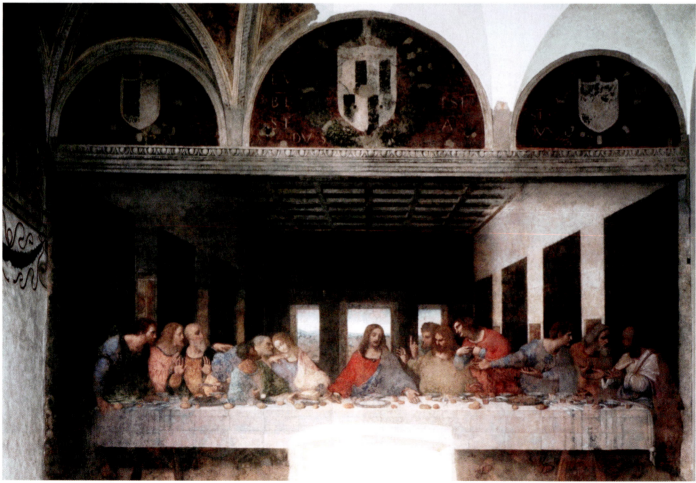

22-3 LEONARDO DA VINCI, *Last Supper* (*top*, uncleaned; *bottom*, cleaned), ca. 1495–1498. Fresco (oil and tempera on plaster), 13′ 9″ × 29′ 10″. Refectory, Santa Maria delle Grazie, Milan.

Disegno
Drawing on Design Fundamentals

In the 16th century in Italy, drawing (or *disegno*) assumed a position of greater prominence than ever before in artistic production. Until the late 15th century, the expense of drawing surfaces and their lack of availability limited the production of preparatory sketches. Most artists drew on parchment (prepared from the skins of calves, sheep, and goats) or on vellum (made from the skins of young animals and therefore very expensive). Because of the cost of these materials, drawings in the 14th and 15th centuries tended to be extremely detailed and meticulously executed. Artists often drew using *silverpoint* (a stylus made of silver) because of the fine line it produced and the sharp point it maintained. The introduction in the late 15th century of less expensive paper made of fibrous pulp, from the developing printing industry, allowed artists to experiment more and to draw with greater freedom. As a result, sketches abounded. Artists executed these drawings in pen and ink, chalk, charcoal, brush, and graphite or lead.

The importance of drawing extended beyond the mechanical or technical possibilities that drawing afforded artists, however. The term *disegno* also referred to design, an integral component of good art. Design was the foundation of art, and drawing was the fundamental element of design. A statement by the artist Federico Zuccaro that drawing is the external physical manifestation *(disegno esterno)* of an internal intellectual idea or design *(disegno interno)* confirms this connection.

The design dimension of art production became increasingly important as artists cultivated their own styles. The early stages of artistic training largely focused on imitation and emulation (see "Imitation and Emulation," Chapter 21, page 585), but, to achieve widespread recognition, artists were expected to move beyond this dependence on previous models and develop their own styles. Although the artistic community and public at large acknowledged technical skill, the conceptualization of the artwork—its theoretical and formal development—was paramount. *Disegno*, or *design* in this case, represented an artist's conceptualization and intention. In the literature of the period, the terms writers and critics often invoked to praise esteemed artists included *invenzione* (invention), *ingegno* (ingenuity), *fantasia* (imagination), and *capriccio* (originality).

(FIG. **22-3**). Despite its ruined state (in part from the painter's unfortunate experiments with his materials) and although it often has been restored ineptly (see "Restoring the Glory of Renaissance Art," page 628), the painting is both formally and emotionally his most impressive work. Christ and his 12 disciples are seated at a long table set parallel to the picture plane in a simple, spacious room. Leonardo amplified the painting's highly dramatic action by placing the group in an austere setting. Christ, with outstretched hands, has just said, "One of you is about to betray me" (Matt. 26:21). A wave of intense excitement passes through the group as each disciple asks himself and, in some cases, his neighbor, "Is it I?" (Matt. 26:22). Leonardo visualized a sophisticated conjunction of the dramatic "One of you is about to betray me" with the initiation of the ancient liturgical ceremony of the Eucharist, when Christ, blessing bread and wine, said, "This is my body, which is given for you. Do this for a commemoration of me. . . . This is the chalice, the new testament in my blood, which shall be shed for you" (Luke 22:19–20). The artist's careful conceptualization of the composition imbued this dramatic moment with force and lucidity.

In the center, Christ appears isolated from the disciples and in perfect repose, the still eye of the swirling emotion around him. The central window at the back, whose curved pediment arches above his head, frames his figure. The pediment is the only curve in the architectural framework, and it serves here, along with the diffused light, as a halo. Christ's head is the focal point of all converging perspective lines in the composition. Thus, the still, psychological focus and cause of the action is also the perspectival focus, as well as the center of the two-dimensional surface. One could say that the two-dimensional, the three-dimensional, and the psychodimensional focuses are the same. Leonardo presented the agitated disciples in four groups of three, united among and within themselves by the figures' gestures and postures. The artist sacrificed traditional iconography to pictorial and dramatic consistency by placing Judas on the same side of the table as Jesus and the other disciples. His face in shadow, Judas clutches a money bag in his right hand and reaches his left forward to fulfill the Master's declaration: "But yet behold, the hand of him that betrayeth me is with me on the table" (Luke 22:21). The two disciples at the table ends are more quiet than the others, as if to bracket the energy of the composition, which is more intense closer to Christ, whose calm both halts and intensifies it.

The disciples register a broad range of emotional responses, including fear, doubt, protestation, rage, and love. Leonardo's numerous preparatory studies suggest that he thought of each figure as carrying a particular charge and type of emotion. Like a skilled stage director (perhaps the first, in the modern sense), he read the Gospel story carefully, and scrupulously cast his actors as the New Testament described their roles. In this work, as in his other religious paintings, Leonardo revealed his extraordinary ability to apply his voluminous knowledge about the observable world to the pictorial representation of a religious scene, resulting in a psychologically complex and compelling painting.

A SMILE FOR THE AGES Leonardo's *Mona Lisa* (FIG. **22-4**) is probably the world's most famous portrait. The sitter's identity is still the subject of scholarly debate, but Renaissance biographer Giorgio Vasari asserted that she is Lisa di Antonio Maria Gherardini, the wife of Francesco del Giocondo, a wealthy Florentine—hence, "Mona (an Italian contraction of *ma donna*, "my lady") Lisa." Despite the uncertainty of this identification, this portrait is notable because it stands as a convincing representation of an individual, rather than serving as an icon of status. Mona Lisa appears in half-length view, her hands quietly folded and her gaze directed at observers, engaging them psychologically. The ambiguity of the famous "smile" is really the consequence of Leonardo's fascination and skill with chiaroscuro and atmospheric perspective, which he revealed in his *Virgin of the Rocks* (FIG. 22-1) and *Virgin and Child with Saint Anne and the Infant Saint John* (FIG. 22-2) groups. Here, they serve to disguise rather than reveal a human psyche. The

"THE GIANT" In 1501, the Florence Cathedral building committee asked Michelangelo to work a great block of marble left over from an earlier aborted commission. From this stone, Michelangelo crafted *David* (FIG. **22-9**), which assured his reputation then and now as an extraordinary talent. This early work reveals Michelangelo's fascination with the human form, and *David*'s formal references to classical antiquity surely appealed to Julius II, who associated himself with the humanists and with Roman emperors. Thus, this sculpture and the fame that accrued to Michelangelo on its completion called the artist to the pope's attention, leading to major papal commissions.

For *David*, Michelangelo took up the theme Donatello (see FIG. 21-23) and Andrea del Verrocchio (see FIG. 21-24) had used successfully. Like other David sculptures, Michelangelo's version had a political dimension. It seems certain that with the stability of the republic in some jeopardy, Florentines viewed David as the symbolic defiant hero of the Florentine republic, especially given the statue's placement near the west door of the Palazzo della Signoria. Michelangelo was surely cognizant of the political symbolism associated with the figure of David and other public sculptures in Florentine history. However, the degree to which the artist intended a specific political message is unknown. Regardless, only 40 years after *David*'s completion, biographer Giorgio Vasari extolled the political value of the colossal statue, claiming that "without any doubt the figure has put in the shade every other statue, ancient or modern, Greek or Roman—this was intended as a symbol of liberty for the Palace, signifying that just as David had protected his people and governed them justly, so whoever ruled Florence should vigorously defend the city and govern it with justice."[6]

Despite the traditional association of David with heroism, Michelangelo chose to represent David not after the victory, with Goliath's head at his feet, but turning his head to his left, sternly watchful of the approaching foe. His whole muscular body, as well as his face, is tense with gathering power. *David* exhibits the characteristic representation of energy in reserve that imbues Michelangelo's later figures with the tension of a coiled spring. The young hero's anatomy plays an important part in this prelude to action. His rugged torso, sturdy limbs, and large hands and feet alert viewers to the strength to come. Each swelling vein and tightening sinew amplifies the psychological energy of the monumental David's pose.

Michelangelo doubtless had the classical nude in mind. He, like many of his colleagues, greatly admired Greco-Roman statues, his knowledge limited mostly to Roman sculptures and Roman copies of Greek art. In particular, classical sculptors' skillful and precise rendering of heroic physique impressed Michelangelo. In his *David*, Michelangelo, without strictly imitating the antique style, captured the tension of Lysippan athletes (see FIG. 5-65) and the psychological insight and emotionalism of Hellenistic statuary (see FIGS. 5-80 and 5-81). This David differs from those of Donatello and Verrocchio in much the same way later Hellenistic statues departed from their Classical predecessors. Michelangelo abandoned the self-contained compositions of the 15th-century David statues by giving David's head the abrupt turn toward his gigantic adversary. Michelangelo's *David* is compositionally and emotionally connected to an unseen presence beyond the statue; this, too, is evident in Hellenistic sculpture (see FIG. 5-86). As early as *David*, then, Michelangelo invested his efforts in presenting towering pent-up emotion rather than calm ideal beauty. He transferred his own doubts, frustrations, and passions into the great figures he created or planned. And this resulted in works like *David*—a truly titanic sculpture (referred to as "the Giant" by Florentines) with immense physical and symbolic presence.

IN MEMORY OF A WARRIOR-POPE The first project Julius II commissioned from Michelangelo in 1505 was the pontiff's own tomb. The original design called for a freestanding two-story structure with some 28 statues. This colossal monument would have given Michelangelo the latitude to sculpt numerous human figures while providing the pope with a grandiose memorial (which Julius II intended to locate in Saint Peter's). Shortly after Michelangelo began work on this project, the pope, for unknown reasons, interrupted the commission, possibly because funds had to be diverted to Bramante's rebuilding of Saint Peter's. After

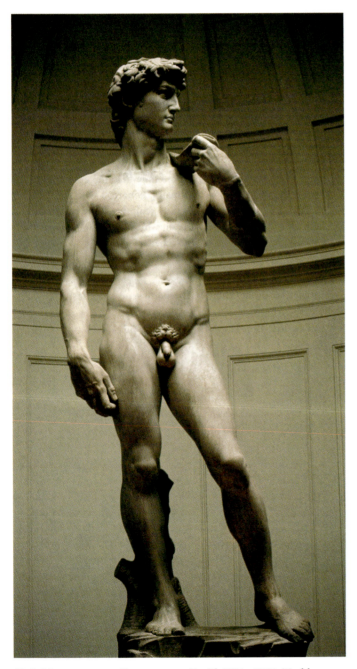

22-9 MICHELANGELO BUONARROTI, *David,* 1501–1504. Marble, 13′ 5″ high. Galleria dell'Accademia, Florence.

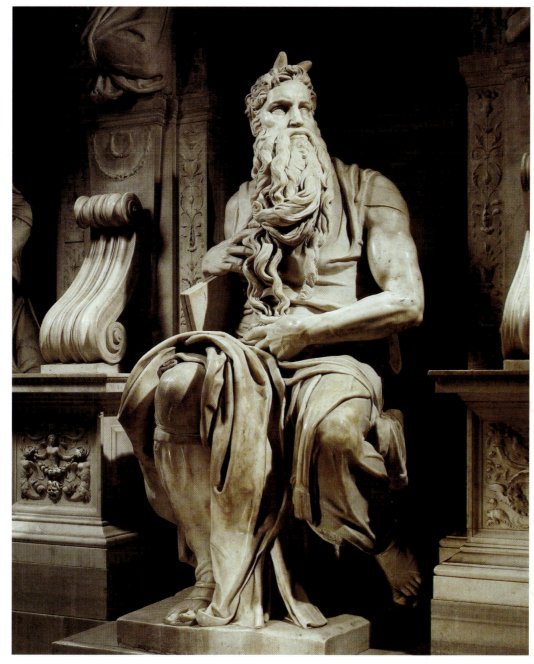

22-10 MICHELANGELO BUONARROTI, *Moses*, San Pietro in Vincoli, Rome, Italy, ca. 1513–1515. Marble, approx. 8′ 4″ high.

Julius II's death in 1513, Michelangelo was forced to reduce the scale of the project step-by-step until, in 1542, a final contract specified a simple wall tomb with fewer than one-third of the originally planned figures. Michelangelo completed the tomb in 1545 and saw it placed in San Pietro in Vincoli, Rome, where Julius II had served as a cardinal before his accession to the papacy. Given Julius's ambitions, it is safe to say that had he seen the final design of his tomb, or known where it was eventually located, he would have been bitterly disappointed.

The spirit of the tomb may be summed up in the figure *Moses* (FIG. **22-10**), which Michelangelo completed during one of his sporadic resumptions of the work in 1513. Meant to be seen from below and to be balanced with seven other massive forms related to it in spirit, the *Moses* now, in its comparatively paltry setting, does not have its originally intended impact. Michelangelo

depicted the Old Testament prophet seated, the Tablets of the Law under one arm and his hands gathering his voluminous beard. The horns that appear on Moses's head were a sculptural convention in Christian art and helped Renaissance viewers identify Moses (see FIG. 17-37). Here again, Michelangelo used the turned head, which concentrates the expression of awful wrath that stirs in the mighty frame and eyes. The muscles bulge, the veins swell, and the great legs seem to begin slowly to move. If this titan ever rose to his feet, one writer said, the world would fly apart. To find such pent-up energy—both emotional and physical—in a seated statue, historians must turn once again to Hellenistic statuary (see FIG. 5-86).

REPRESENTING OPPRESSION Originally, Michelangelo intended for some 20 sculptures of slaves, in various attitudes of

revolt and exhaustion, to appear on the tomb. One such figure is *Bound Slave* (FIG. **22-11**). (Another such figure is shown in FIG. Intro-15.) Considerable scholarly uncertainty about this sculpture (and three other "slave" figures) exists. Although conventional scholarship connected these statues with the Julius tomb, some art historians now doubt this. A lively debate also continues about the subject of these figures; many scholars reject their identification as "slaves" or "captives." Despite these unanswered questions, the "slaves," like *David* and *Moses,* represent definitive statements. Michelangelo created figures that do not so much represent an abstract concept, as in medieval allegory, but embody powerful emotional states associated with oppression. Indeed, Michelangelo communicated his expansive imagination through every plane and hollow of the stone. In *Bound Slave,* the defiant figure's violent contrapposto is the image of frantic but impotent struggle. Michelangelo based his whole art on his conviction that whatever can be said greatly through sculpture and painting must be said through the human figure.

A GRAND BIBLICAL DRAMA Julius II's artistic program continued unabated, despite the obstacles he encountered. With the suspension of the tomb project, Julius II gave the bitter and reluctant Michelangelo the commission to paint the ceiling of the Sistine Chapel (FIGS. **22-12** and **22-13**) in 1508. The artist, insisting that painting was not his profession (a protest that rings hollow after the fact, but Michelangelo's major works until then had been in sculpture, and painting was of secondary interest to him), assented in the hope that the tomb project could be revived. Michelangelo faced enormous difficulties in painting the Sistine ceiling. He had to address his relative inexperience in the fresco technique; the ceiling's dimensions (some 5,800 square feet); its height above the pavement (almost 70 feet); and the complicated perspective problems presented by the vault's height and curve. Yet, in less than four years, Michelangelo produced an unprecedented work—a monumental fresco incorporating the patron's agenda, Church doctrine, and the artist's interests. Depicting the

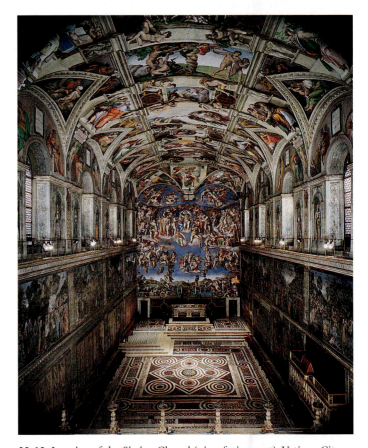

22-12 Interior of the Sistine Chapel (view facing east), Vatican City, Rome, Italy, built 1473. Copyright © Nippon Television Network Corporation, Tokyo.

22-11 MICHELANGELO BUONARROTI, *Bound Slave,* 1513–1516. Marble, approx. 6′ 10½″ high. Louvre, Paris.

22-13 Michelangelo Buonarroti, ceiling of the Sistine Chapel, Vatican City, Rome, Italy, 1508–1512. Fresco, approx. 128′ × 45′.

22-32 GIOVANNI BELLINI and TITIAN, *The Feast of the Gods*, 1529. Oil on canvas, approx. 5′ 7″ × 6′ 2″. National Gallery of Art, Washington (Widener Collection).

A MYTHOLOGICAL PICNIC In painting *The Feast of the Gods* (FIG. **22-32**), Bellini actually drew from the work of one of his own students, Giorgione da Castelfranco (FIGS. 22-33 and 22-34), who developed his master's landscape backgrounds into poetic Arcadian reveries. Derived from Arcadia, an ancient district of the central Peloponnesus (peninsula in southern Greece), the term *Arcadian* referred, by the Renaissance, to an idyllic place of rural, rustic peace and simplicity. After Giorgione's premature death, Bellini embraced his student's interests and, in *The Feast of the Gods,* developed a new kind of mythological painting. The duke of Ferrara, Alfonso d'Este, commissioned this work for a room in the Palazzo Ducale. Although Bellini drew some of the figures from the standard repertoire of Greco-Roman art—most notably, the nymph carrying a vase on her head and the sleeping nymph in the lower right corner—the Olympian gods appear as peasants enjoying a heavenly picnic in a shady northern glade.

Bellini's source was Ovid's *Fasti*, which describes a banquet of the gods. The artist spread the figures across the foreground. Satyrs attend the gods, nymphs bring jugs of wine, a child draws from a keg, couples engage in love play, and the sleeping nymph with exposed breast receives amorous attention. The mellow light of a long afternoon glows softly around the gathering, caressing the surfaces of colorful draperies, smooth flesh, and polished metal. Here, Bellini communicated the delight the Venetian school took in the beauty of texture revealed by the full resources of gently and subtly harmonized color. Behind the warm, lush tones of the figures, a background of cool green tree-filled glades extends into the distance; at the right, a screen of trees creates a verdant shelter. (Scholars believe that the background was modified by Titian, discussed shortly.) The atmosphere is idyllic, a lush countryside providing a setting for the never-ending pleasure of the immortal gods.

22-33 GIORGIONE DA CASTELFRANCO (and/or TITIAN?), *Pastoral Symphony,* ca. 1508. Oil on canvas, approx. 3′ 7″ × 4′ 6″. Louvre, Paris.

Thus, with Bellini, Venetian art became the great complement of the schools of Florence and Rome. The Venetians' instrument was color; that of the Florentines and Romans was sculpturesque form. Scholars often distill the contrast between these two approaches down to *colorito* (colored or painted) versus *disegno* (drawing and design—see *"Disegno,"* page 617). Whereas most central Italian artists emphasized careful design preparation based on preliminary drawing, Venetian artists focused on color and the process of paint application. In addition, the general thematic focus of their work differed. Venetian artists painted the poetry of the senses and delighted in nature's beauty and the pleasures of humanity. Artists in Florence and Rome gravitated toward more esoteric, intellectual themes—the epic of humanity, the masculine virtues, the grandeur of the ideal, and the lofty conceptions of religion involving the heroic and sublime. Much of the history of later Western art involved a dialogue between these two traditions.

Describing Venetian art as "poetic" is particularly appropriate, given the development of *poesia,* or painting meant to operate in a manner similar to poetry. Both classical and Renaissance poetry inspired Venetian artists, and their paintings focused on the lyrical and sensual. Thus, in many Venetian artworks, discerning concrete narratives or subjects (in the traditional sense) is virtually impossible.

POETRY IN MOTION A Venetian artist who deserves much of the credit for developing this poetic manner of painting was GIORGIONE DA CASTELFRANCO (ca. 1477–1510). Giorgione's so-called *Pastoral Symphony* (FIG. 22-33; some believe it an early work by his student Titian, discussed next) exemplifies poesia and surely inspired the late Arcadian scenes by Bellini, his teacher. Out of dense shadow emerge the soft forms of figures and landscape. The theme is as enigmatic as the lighting. Two nude women, accompanied by two clothed young men, occupy the rich, abundant landscape through which a shepherd passes. In the distance, a villa crowns a hill. The artist so eloquently evoked the pastoral mood that the viewer does not find the uncertainty about the picture's precise meaning distressing; the mood is enough. The shepherd symbolizes the poet; the pipes and lute symbolize his poetry. The two women accompanying the young men may be thought of as their invisible inspiration, their muses. One turns to lift water from the sacred well of poetic inspiration. The voluptuous bodies of the women, softly modulated by the smoky shadow, became the standard in Venetian art.

The fullness of their figures contributes to their effect as poetic personifications of nature's abundance.

As a pastoral poet in the pictorial medium and one of the greatest masters in the handling of light and color, Giorgione praised the beauty of nature, music, women, and pleasure. Vasari reported that Giorgione was an accomplished lutenist and singer, and adjectives from poetry and music seem best suited for describing the pastoral air and muted chords of his painting. He cast a mood of tranquil reverie and dreaminess over the entire scene, evoking the landscape of a lost but never forgotten paradise.

STORMY WEATHER Another Giorgione painting, *The Tempest* (FIG. **22-34**), manifests this same interest in the poetic qualities of the natural landscape inhabited by humans. Dominating the scene is a lush landscape, threatened by stormy skies and lightning in the middle background. Pushed off to both sides are the human figures—a young woman nursing a baby in the right foreground and a man carrying a halberd (a combination spear and battle-ax) on the left. Much scholarly debate has centered on this painting's

subject, fueled by the fact that X rays of the canvas revealed that a nude woman originally stood where Giorgione subsequently placed the man. This flexibility in subject has led many to believe that no definitive narrative exists, which is appropriate for a Venetian poetic rendering. Other scholars have suggested mythological narratives or historical events. This uncertainty about the subject contributes to the painting's enigmatic quality and intriguing air.

A MASTER OF COLOR Giorgione's Arcadianism passed not only to his much older yet constantly inquisitive master, Bellini, but also to Tiziano Vecelli, whose name has been anglicized into TITIAN (ca. 1490–1576). Titian was the most extraordinary and prolific of the great Venetian painters, a supreme colorist who cultivated numerous patrons. An important change occurring in Titian's time was the almost universal adoption of canvas, with its rough-textured surface, in place of wood panels for paintings. Titian's works established oil color on canvas as the typical medium of pictorial tradition thereafter. According to a contemporary of Titian, Palma il Giovane:

22-34 GIORGIONE DA CASTELFRANCO, *The Tempest*, ca. 1510. Oil on canvas, 2′ 7″ × 2′ 4¾″. Galleria dell' Accademia, Venice.

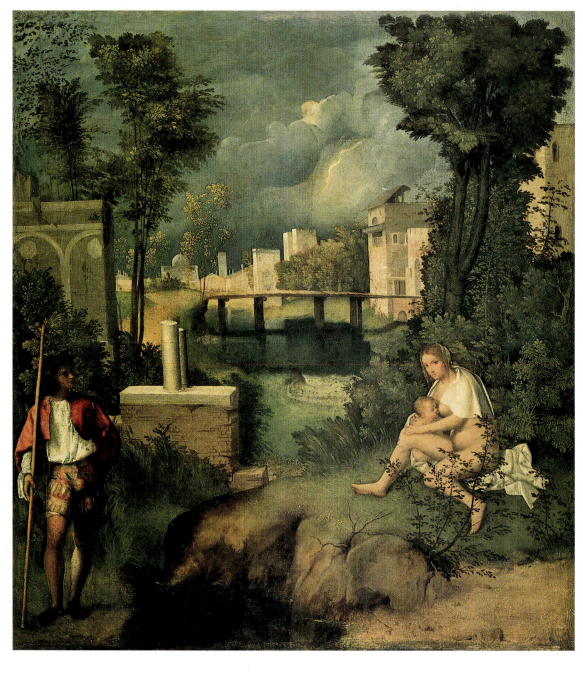

Titian [employed] a great mass of colors, which served . . . as a base for the compositions. . . . I too have seen some of these, formed with bold strokes made with brushes laden with colors, sometimes of a pure red earth, which he used, so to speak, for a middle tone, and at other times of white lead; and with the same brush tinted with red, black and yellow he formed a highlight; and observing these principles he made the promise of an exceptional figure appear in four brushstrokes. . . . Having constructed these precious foundations he used to turn his pictures to the wall and leave them there without looking at them, sometimes for several months. When he wanted to apply his brush again he would examine them with the utmost rigor . . . to see if he could find any faults. . . . In this way, working on the figures and revising them, he brought them to the most perfect symmetry that the beauty of art and nature can reveal. . . . [T]hus he gradually covered those quintessential forms with living flesh, bringing them by many stages to a state in which they lacked only the breath of life. He never painted a figure all at once and . . . in the last stages he painted more with his fingers than his brushes.[8]

THE GLORIOUS VIRGIN MARY Titian's remarkable coloristic sense and his ability to convey light through color emerge in a major altarpiece, *Assumption of the Virgin* (FIG. 22-35), painted for the main altar of Santa Maria Gloriosa dei Frari in Venice. Commissioned by the prior of this Franciscan basilica, the monumental altarpiece (close to 23 feet high) depicts the glorious ascent of the Virgin's body to Heaven. Visually, the painting is a stunning tour de force. Golden clouds so luminous they seem to glow, radiating light into the church interior, envelop the Virgin. God the Father appears above, awaiting her with open arms. Below, apostles gesticulate wildly as they witness this momentous event. Titian painted this large-scale altarpiece with exceptional clarity. Through vibrant color, he infused the image with a drama and intensity that assured his lofty reputation, then and now.

A DAZZLING DISPLAY OF COLOR Trained by both Bellini and Giorgione, Titian learned so well from them that even today scholars cannot agree about the degree of his participation in their later works. However, it is clear that Titian completed several of Bellini's and Giorgione's unfinished paintings. On Giovanni Bellini's death in 1516, the republic of Venice appointed Titian as its official painter. Shortly thereafter, Bishop Jacopo Pesaro commissioned Titian to paint *Madonna of the Pesaro Family* (FIG. 22-36), which the patron presented to the church of the Frari. This work furthered Titian's reputation and established his personal style. Pesaro, bishop of Paphos in Cyprus and commander of the papal fleet, had led a successful expedition in 1502 against the Turks during the Venetian-Turkish war and commissioned this painting in gratitude. In a stately sunlit setting, the Madonna receives the commander, who kneels dutifully at the foot of her throne. A soldier (Saint George?) behind the commander carries a banner with the *escutcheons* (shields with coats of arms) of the Borgia (Pope Alexander VI) and of Pesaro. Behind him is a turbaned Turk, a prisoner of war of the Christian forces. Saint Peter appears on the steps of the throne, and Saint Francis introduces other Pesaro family members (all male—Italian depictions of donors in this era typically excluded women and children), who kneel solemnly in the right foreground.

As already seen, the High Renaissance was characterized by the massing of monumental figures, singly and in groups, within a weighty and majestic architecture. But Titian did not compose a horizontal and symmetrical arrangement, as did Leonardo in *Last*

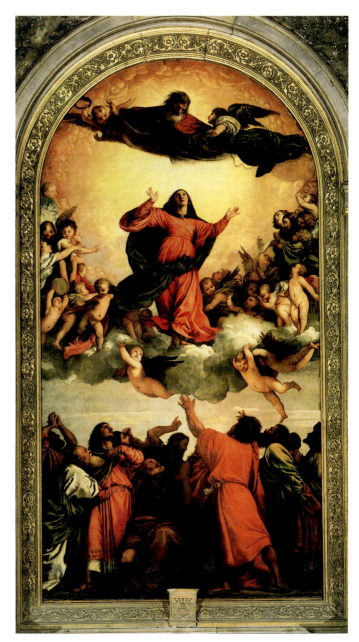

22-35 TITIAN, *Assumption of the Virgin*, Santa Maria Gloriosa dei Frari, Venice, Italy, ca. 1516–1518. Oil on wood, 22′ 6″ × 11′ 10″.

Supper (FIG. 22-3) and Raphael in *School of Athens* (FIG. 22-17). Rather, he placed the figures on a steep diagonal, positioning the Madonna, the focus of the composition, well off the central axis. Titian drew viewers' attention to her with the perspective lines, the inclination of the figures, and the directional lines of gaze and gesture. The banner inclining toward the left beautifully brings the design into equilibrium, balancing the rightward and upward tendencies of its main direction.

This kind of composition is more dynamic than those in the High Renaissance shown thus far and presaged a new kind of pictorial design—one built on movement rather than rest. In his rendering of the rich surface textures, Titian gave a dazzling display of color in all its nuances. He entwined the human scene with the heavenly, depicting the Madonna and saints honoring the achievements of a specific man in this particular world. A quite worldly transaction takes place (albeit beneath a heavenly cloud bearing angels) between a queen and her court and loyal servants. Titian constructed this tableau in terms of Renaissance protocol and courtly splendor.

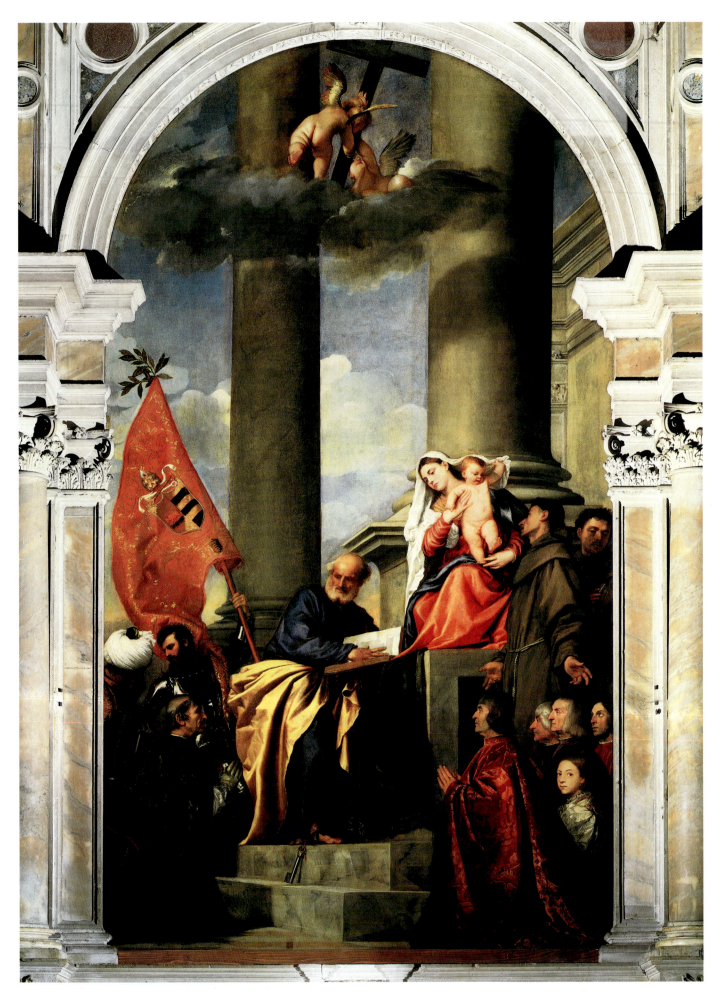

22-36 Titian, *Madonna of the Pesaro Family,* Santa Maria dei Frari, Venice, Italy, 1519–1526. Oil on canvas, approx. 16′ × 9′.

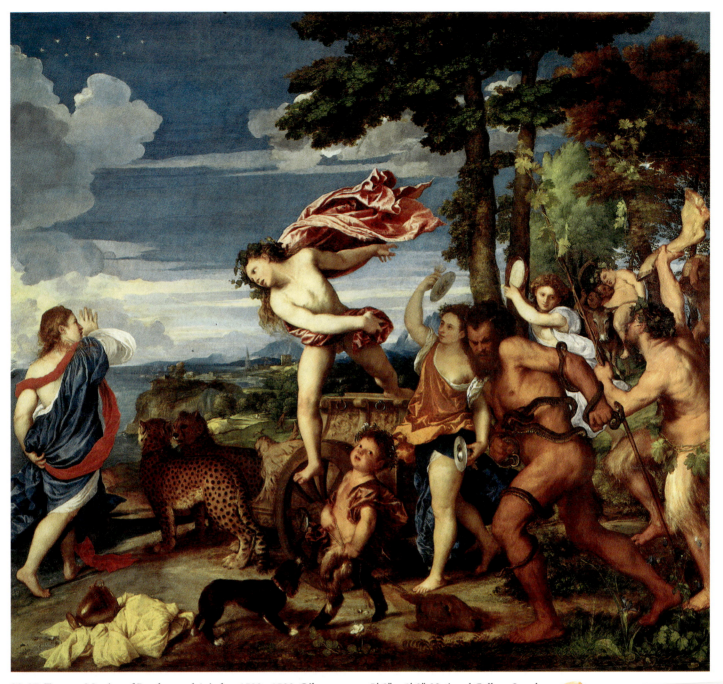

22-37 TITIAN, *Meeting of Bacchus and Ariadne*, 1522–1523. Oil on canvas, 5′ 9″ × 6′ 3″. National Gallery, London.

BACCHANALIAN REVELRY In 1511, Alfonso d'Este, duke of Ferrara, asked Titian to produce a painting for his Camerino d'Alabastro (small room of alabaster). The patron had requested one bacchanalian scene each from Titian, Bellini, Raphael, and Fra Bartolommeo. Both Raphael and Fra Bartolommeo died before fulfilling the commission, and Bellini painted only one scene (FIG. 22-32), leaving Titian to produce three. One of these three paintings is *Meeting of Bacchus and Ariadne* (FIG. **22-37**). Bacchus, accompanied by a boisterous and noisy group, arrives to save Ariadne, whom Theseus has abandoned on the island of Naxos. In this scene, Titian revealed his debt to classical art; he derived one of the figures, entwined with snakes, from the ancient sculpture of Laocoön (see FIG. 5-89). Titian's rich and luminous colors add greatly to the sensuous appeal of this painting, making it perfect for Alfonso's "pleasure chamber."

A VENETIAN VENUS In 1538, at the height of his powers, Titian painted the so-called *Venus of Urbino* (FIG. 22-38) for Guidobaldo II, duke of Urbino. The title (given to the painting later) elevates to the status of classical mythology what probably merely represents a courtesan in her bedchamber. Indeed, no evidence suggests that the duke intended the commission as anything more than a female nude for his private enjoyment. Whether the subject is divine or mortal, Titian based his version on an earlier (and pioneering) painting of Venus (not illustrated) by Giorgione. Here, Titian established the compositional elements and the standard for paintings of the reclining female nude, regardless of the many variations that ensued. This "Venus" reclines on the gentle slope of her luxurious pillowed couch, the linear play of the draperies contrasting with her body's sleek continuous volume. At her feet is a pendant (balancing) figure—in this case, a slumbering

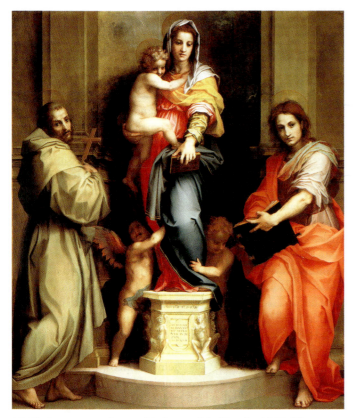

22-40 ANDREA DEL SARTO, *Madonna of the Harpies*, 1517. Oil on wood, approx. 6′ 9″ x 5′ 10″. Galleria degli Uffizi, Florence.

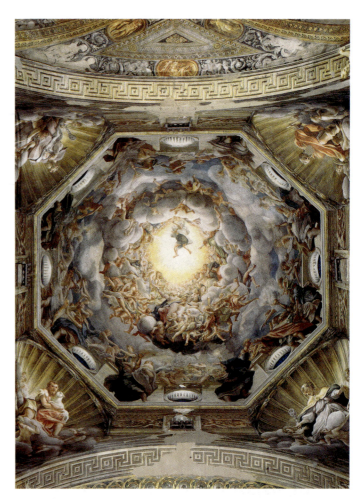

22-41 ANTONIO ALLEGRI DA CORREGGIO, *Assumption of the Virgin*, dome fresco of Parma Cathedral, Parma, Italy, 1526–1530.

leads from Saint Francis (on the left) to the Virgin, to Saint John the Evangelist, and downward from him toward the observer. This main movement is either echoed or countered by numerous secondary movements brought into perfect formal balance in a faultless compositional performance. The soft modeling of the forms is based on Leonardo but does not affect the colors, which are rich and warm. Andrea's sense of and ability to handle color set him apart from his contemporaries in central Italy. He is perhaps the only Renaissance artist to transpose his rich color schemes from panels into frescoes.

A VIEW OF THE SKY Andrea del Sarto may still be placed firmly in the High Renaissance, but his northern Italian contemporary, ANTONIO ALLEGRI DA CORREGGIO (ca. 1489–1534), of Parma, developed a unique personal style that is almost impossible to classify. A solitary genius, Correggio pulled together many stylistic trends, including those of Leonardo, Raphael, and the Venetians. Historically, his most enduring contribution was his development of illusionistic ceiling perspectives that his Baroque emulators seldom surpassed. At Mantua, Mantegna created the illusion of a hole in the ceiling of the Camera degli Sposi (see FIG. 21-46). Some 50 years later, Correggio painted away the entire dome of the Parma Cathedral in *Assumption of the Virgin* (FIG. 22-41). Opening up the cupola, the artist showed his audience a view of the sky, with concentric rings of clouds where hundreds of soaring figures perform a wildly pirouetting dance in celebration of the Assumption. Versions of these angelic creatures became permanent tenants of numerous Baroque churches in later centuries. Correggio was also an influential painter of religious panels, anticipating in them many other Baroque compositional devices. Correggio's contemporaries expressed little appreciation for his art. Later, during the 17th century, Baroque painters recognized him as a kindred spirit.

MANNERISM

Mannerism is a style that emerged in Italy during the 16th century. Over the years, scholars have refined their ideas about Mannerism, attempting to define the parameters of this style. It is difficult to identify specific dates for Mannerism—emerging in the 1520s, it overlapped considerably with High Renaissance art. The term is derived from the Italian word *maniera*, meaning style or manner. In the field of art history, the term *style* is usually used to refer to a characteristic or representative mode, especially of an artist or period (for example, Leonardo's style or Gothic style). Style can also refer to an absolute quality of fashion (for example, someone has "style"). Mannerism's style (or representative mode) is characterized by style (being stylish, cultured, elegant).

Among the features most closely associated with Mannerism is *artifice*. Actually, all art involves artifice, in the sense that art is not "natural"—it is a representation of a scene or idea. But many artists, including High Renaissance artists such as Leonardo and Raphael, chose to conceal that artifice by using such devices as perspective and shading to make their art look natural. In contrast, Mannerist artists consciously revealed the constructed nature of their art. In other words, High Renaissance artists generally strove to create art that appeared natural, whereas Mannerist artists were less inclined to disguise the contrived nature of art production. This is why artifice is a central feature of discussions about Mannerism, and why Mannerist works can seem, appropriately, "mannered." The conscious display of artifice in Mannerism often

reveals itself in imbalanced compositions and unusual complexities, both visual and conceptual. Ambiguous space, departures from expected conventions, and unique presentations of traditional themes also surface frequently in Mannerist art and architecture. And the stylishness of Mannerism often inspired artists to focus on themes of courtly grace and cultured sophistication.

Mannerist Painting

A PAINTING OF LOSS AND GRIEF *Descent from the Cross* (FIG. **22-42**) by JACOPO DA PONTORMO (1494–1557) exhibits almost all the stylistic features characteristic of Mannerism's early phase in painting. This subject had frequently been depicted in art, and Pontormo exploited the familiarity that viewers at the time would have had by playing off their expectations. For example, rather than presenting the action as taking place across the perpendicular picture plane, as artists such as Raphael and Rogier van der Weyden had done in their paintings (see FIG. 20-7) of this scene, Pontormo rotated the conventional figural groups along a vertical axis. As a result, the Virgin Mary falls back (away from the viewer) as she releases her dead Son's hand. In contrast with High Renaissance artists, who had concentrated their masses in the center of the painting, Pontormo here leaves a void. This accentuates the grouping of hands that fill that hole, calling attention to the void—symbolic of loss and grief.

The artist enhanced the painting's ambiguity with the curiously anxious glances the figures cast in all directions. Athletic bending and twisting characterize many of the figures, with distortions (for example, the torso of the foreground figure bends in an anatomically impossible way), elastic elongation of the limbs, and heads rendered as uniformly small and oval. The contrasting colors, primarily light blues and pinks, add to the dynamism and complexity of the work. The painting represents a departure from the balanced, harmoniously structured compositions of the earlier Renaissance.

MANNERISM'S ELEGANCE AND GRACE Correggio's pupil Girolamo Francesco Maria Mazzola, known as PARMIGIANINO (1503–1540), achieved in his best-known work, *Madonna with the Long Neck* (FIG. **22-43**), the elegance—stylishness—that was a principal aim of Mannerism. He smoothly combined the influences of Correggio and Raphael in a picture of exquisite grace and precious sweetness. The Madonna's small oval head; her long, slender neck; the unbelievable attenuation and delicacy of her hand; and the sinuous, swaying elongation of her frame—all are marks of the aristocratic, sumptuously courtly taste of a later phase of

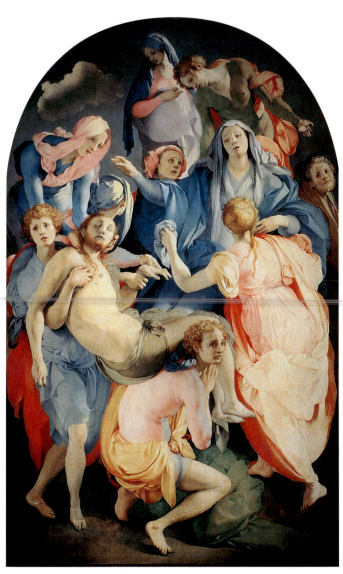

22-42 JACOPO DA PONTORMO, *Descent from the Cross,* Capponi Chapel, Santa Felicità, Florence, Italy, 1525–1528. Oil on wood, approx. 10′ 3″ × 6′ 6″.

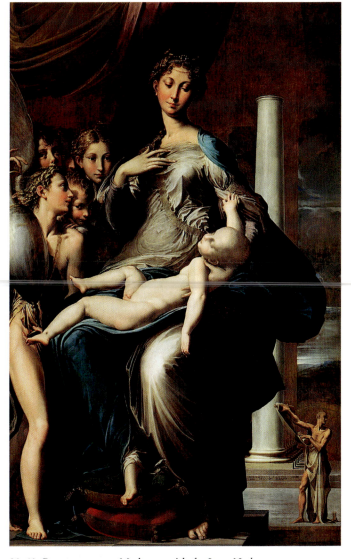

22-43 PARMIGIANINO, *Madonna with the Long Neck,* ca. 1535. Oil on wood, approx. 7′ 1″ × 4′ 4″. Galleria degli Uffizi, Florence.

Originally planned as a relatively modest country villa, Giulio's building so pleased the duke that he soon commissioned the architect to enlarge the structure. In a second building campaign, Giulio expanded the villa to a palatial scale by adding three wings, which he placed around a square central court. This once-paved court, which functions both as a passage and as the focal point of the design, has a nearly urban character. Its surrounding buildings form a self-enclosed unit with a large garden, flanked by a stable, attached to it on the east side.

Giulio exhibited his Mannerist style in the facades that face the palace's interior courtyard (FIG. 22-49), where the divergences from architectural convention are so pronounced that they constitute an enormous parody of Bramante's classical style, thereby announcing the artifice of the palace design. In a building laden with structural surprises and contradictions, the design of these facades is the most unconventional of all. The keystones (central voussoirs), for example, either have not fully settled or seem to be slipping from the arches—and, more eccentric still, Giulio even placed voussoirs in the pediments over the rectangular niches, where no arches exist. The massive Tuscan columns that flank these niches carry incongruously narrow architraves. That these architraves break midway between the columns stresses their apparent structural insufficiency, and they seem unable to support the weight of the triglyphs above, which threaten to crash down on the head of anyone foolish enough to stand below them. To be sure, appreciating Giulio's witticism requires a highly sophisticated audience, and recognizing some quite subtle departures from the norm presupposes a thorough familiarity with the established rules of classical architecture. It speaks well for the duke's sophistication that he accepted Giulio's form of architectural inventiveness.

In short, in his design for the Palazzo del Tè, Giulio Romano deliberately flouted most of the classical rules of order, stability, and symmetry. The resulting ambiguities and tensions are as typical of Mannerist architecture as they are of Mannerist painting, and many of the devices Giulio invented for the Palazzo del Tè became standard features in the formal repertoire of later Mannerist buildings.

LATER 16TH-CENTURY ARCHITECTURE

Acceptance of Mannerist style in architecture was by no means universal among either architects or patrons. Indeed, later 16th-century designs more in keeping with High Renaissance ideals proved to have a greater impact on 17th-century architecture in Italy than the more adventurous, yet eccentric, works by Giulio Romano and the other Mannerists.

ANTICIPATING THE BAROQUE Probably the most influential building of the second half of the 16th century was the mother church of the Jesuit order. The activity of the Society of Jesus, known as the Jesuits, was an important component of the Counter-Reformation (see page 634). Ignatius of Loyola (1491–1556), a Spanish nobleman who dedicated his life to the service of God, founded the Jesuit order. He attracted a group of followers, and in 1540 Pope Paul III formally recognized this group as a religious order. The Jesuits were the papacy's invaluable allies in its quest to reassert the supremacy of the Catholic Church. Particularly successful in the field of education, the order established numerous schools. Its commitment to education remains evident today in the many Jesuit colleges around the world. In addition, its members were effective missionaries and carried the message of Catholicism to the Americas, Asia, and Africa. The predominance of Catholicism in Latin America, the Philippines, and areas of Africa testifies to the Jesuit influence (as well as that of other Catholic orders, such as the Dominicans and the Franciscans).

As a major participant in the Counter-Reformation, the Jesuit order needed a church appropriate to its new prominence. Because Michelangelo was late in providing the plans for this church, called Il Gesù, or Church of Jesus (FIGS. **22-50** and **22-51**), the Jesuits turned to GIACOMO DA VIGNOLA (1507–1573), who designed the ground plan, and Giacomo della Porta, who was responsible for the facade. These two architects designed and built Il Gesù between 1568 and 1584. Chronologically and stylistically,

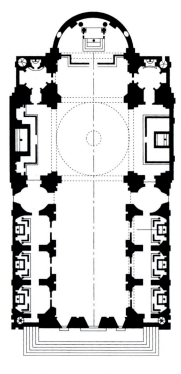

22-50 GIACOMO DELLA PORTA, facade of Il Gesù, Rome, Italy, ca. 1575–1584.

22-51 GIACOMO DA VIGNOLA, plan of Il Gesù, Rome, Italy, 1568.

the building belongs to the late Renaissance, but its enormous influence on later churches marks it as one of the significant monuments for the development of Baroque church architecture. Its facade (FIG. 22-50) was an important model and point of departure for the facades of Roman Baroque churches for two centuries. The facade's design was not entirely original. The union of the lower and upper stories, effected by scroll buttresses, harks back to Alberti's Santa Maria Novella in Florence (see FIG. 21-34). Its classical pediment is familiar in Alberti's work, as well as in the work of the Venetian architect Andrea Palladio, which is examined later. And its paired pilasters appear in Michelangelo's design for Saint Peter's (FIG. 22-30). Giacomo della Porta skillfully synthesized these already existing motifs. In his facade design, he unified the two stories. The horizontal march of the pilasters and columns builds to a dramatic climax at the central bay, and the bays of the facade snugly fit the nave-chapel system behind them. Many of the dramatic Roman Baroque facades of the 17th century were architectural variations on this facade.

The plan of Il Gesù (FIG. 22-51) reveals a monumental expansion of Alberti's scheme for Sant'Andrea in Mantua (see FIG. 21-42). Here, the nave takes over the main volume of space, making the structure a great hall with side chapels. A dome emphasizes the approach to the altar. The wide acceptance of the Gesù plan in the Catholic world, even until modern times, speaks to its ritual efficacy. The opening of the church building into a single great hall provides an almost theatrical setting for large promenades and processions (which seemed to combine social with priestly functions). Above all, the space is adequate to accommodate the great crowds that gathered to hear the eloquent preaching of the Jesuits.

LATER 16TH-CENTURY VENETIAN ART AND ARCHITECTURE

MANNERIST DRAMA AND DYNAMISM Venetian painting of the later 16th century built on established Venetian ideas. Jacopo Robusti, known as TINTORETTO (1518–1594), claimed to be a student of Titian and aspired to combine Titian's color with Michelangelo's drawing. Art historians often refer to Tintoretto as the outstanding Venetian representative of Mannerism. He adopted many Mannerist pictorial devices, which he employed to produce works imbued with dramatic power, depth of spiritual vision, and glowing Venetian color schemes.

A VISIONARY LAST SUPPER Toward the end of Tintoretto's life, his art became spiritual, even visionary, as solid forms melted away into swirling clouds of dark shot through with fitful light. In Tintoretto's *Last Supper* (FIG. **22-52**), painted for the interior of Andrea Palladio's church of San Giorgio Maggiore (FIG. 22-59), the figures appear in a dark interior illuminated by a single light in the upper left of the image. The shimmering halos clue viewers to the biblical nature of the scene. The ability of this dramatic scene to engage viewers was well in keeping with Counter-Reformation ideals (see "The Role of Religious Art in Counter-Reformation Italy," page 636) and the Catholic Church's belief in the didactic nature of religious art.

Last Supper incorporates many Mannerist devices, including an imbalanced composition and visual complexity. In terms of design, the contrast with Leonardo's *Last Supper* (FIG. 22-3) is both extreme and instructive. Leonardo's composition, balanced

22-52 TINTORETTO, *Last Supper*, Chancel, San Giorgio Maggiore, Venice, Italy, 1594. Oil on canvas, 12′ × 18′ 8″.

and symmetrical, parallels the picture plane in a geometrically organized and closed space. The figure of Christ is the tranquil center of the drama and the perspectival focus. In Tintoretto's painting, Christ is above and beyond the converging perspective lines that race diagonally away from the picture surface, creating disturbing effects of limitless depth and motion. The viewer locates Tintoretto's Christ via the light flaring, beaconlike, out of darkness. The contrast of the two reflects the direction Renaissance painting took in the 16th century, as it moved away from architectonic clarity of space and neutral lighting toward the dynamic perspectives and dramatic chiaroscuro of the coming Baroque.

A PROBLEMATIC PAINTING OF CHRIST Among the great Venetian masters was Paolo Cagliari of Verona, called PAOLO VERONESE (1528–1588). Whereas Tintoretto gloried in monumental drama and deep perspectives, Veronese specialized in splendid pageantry painted in superb color and set within majestic classical architecture. Like Tintoretto, Veronese painted on a huge scale, with canvases often as large as 20×30 feet or more. His usual subjects, painted for the refectories of wealthy monasteries, afforded him an opportunity to display magnificent companies at table.

Christ in the House of Levi (FIG. **22-53**), originally called *Last Supper,* is a good example. Here, in a great open loggia framed by three monumental arches (the architectural style closely resembles the upper arcades of Jacopo Sansovino's State Library, FIG. 22-55), Christ sits at the center of the splendidly garbed elite of Venice. In the foreground, with a courtly gesture, the very image of gracious grandeur, the chief steward welcomes guests. Robed lords, their colorful retainers, clowns, dogs, and dwarfs crowd into the spacious loggia.

Painted during the Counter-Reformation, this depiction prompted criticism from the Catholic Church. The Holy Office of the Inquisition accused Veronese of impiety for painting such creatures so close to the Lord, and it ordered him to make changes at his own expense. Reluctant to do so, he simply changed the painting's title, converting the subject to a less solemn one. As Andrea Palladio (whose work is discussed later) looked to the example of classically inspired High Renaissance architecture, so Veronese returned to High Renaissance composition, its symmetrical balance, and its ordered architectonics. His shimmering color is drawn from the whole spectrum, although he avoided solid colors for half shades (light blues, sea greens, lemon yellows, roses, and violets), creating veritable flower beds of tone.

VENICE TRIUMPHANT The Venetian Republic employed both Tintoretto and Veronese to decorate the grand chambers and council rooms of the Doge's Palace (see FIG. 18-56). A great and popular decorator, Veronese revealed himself a master of imposing illusionistic ceiling compositions, such as *Triumph of Venice* (FIG. **22-54**). Here, within an oval frame, he presented Venice, crowned by Fame, enthroned between two great twisted columns in a balustraded loggia, garlanded with clouds, and attended by figures symbolic of its glories. Unlike that of Mantegna or Correggio, Veronese's perspective is not projected directly up from below. Rather, it is a projection of the scene at a 45-degree angle to spectators, a technique many later Baroque decorators used, particularly the 18th-century Venetian Giambattista Tiepolo.

MONEY AND MANUSCRIPTS The Florentine Jacopo Tatti, called JACOPO SANSOVINO (1486–1570), introduced Venice to the High Renaissance style of architecture. Originally trained as a sculptor under Andrea Sansovino (ca. 1467–1529), whose name he adopted, Jacopo went to Rome in 1518, where, under the influence of Bramante's circle, he turned increasingly toward architecture. When he arrived in Venice as a refugee from the sack of Rome in 1527, he quickly established himself as that city's leading and most admired architect. His buildings frequently inspired the architectural settings of the most prominent Venetian painters, including Titian and Veronese.

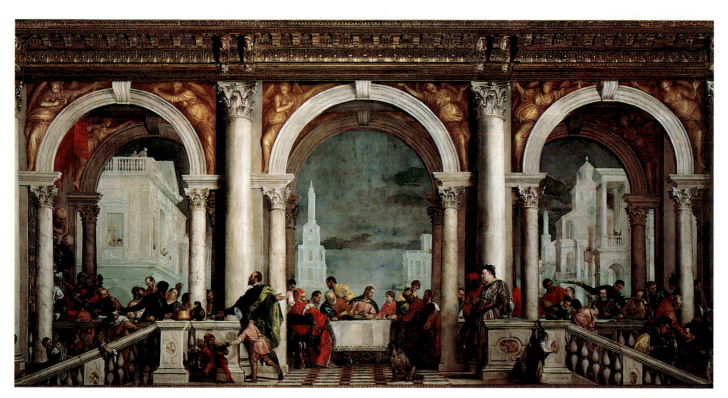

22-53 PAOLO VERONESE, *Christ in the House of Levi,* 1573. Oil on canvas, approx. 18′ 6″ × 42′ 6″. Galleria dell'Accademia, Venice.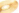

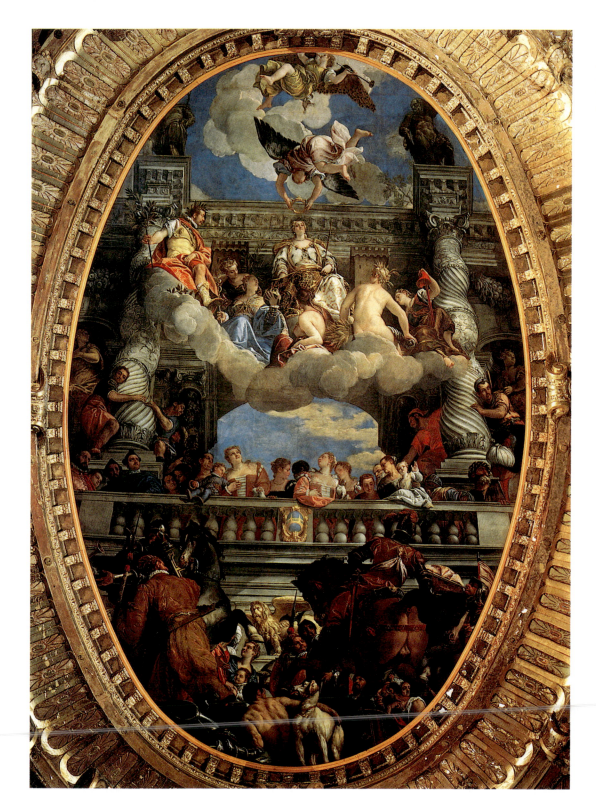

22-54 Paolo Veronese, *Triumph of Venice,* ceiling of the Hall of the Grand Council, Palazzo Ducale, Venice, Italy, ca. 1585. Oil on canvas, approx. 29′ 8″ × 19′.

Sansovino's largest and most rewarding public commissions were the Mint (la Zecca) and the adjoining State Library (FIG. **22-55**) in the heart of the island city. The Mint, begun in 1535, faces the Canale San Marco with a stern and forbidding three-story facade. Its heavy rustication imbues it with an intended air of strength and impregnability. A boldly projecting, bracket-supported cornice, reminiscent of the machicolated galleries of medieval castles, emphasizes this fortresslike look.

Begun a year after the Mint, the neighboring State Library of San Marco, which Andrea Palladio referred to as "perhaps the most sumptuous and the most beautiful edifice that has been erected since the time of the Ancients,"[9] exudes a very different spirit. With 21 bays (only 16 were completed during Sansovino's lifetime), the library faces the Gothic Doge's Palace (see FIG. 18-56) across the Piazzetta, a lateral extension of Venice's central Piazza San Marco. The relatively plain ground-story arcade has Tuscan-style columns attached to the arch-supporting piers in the manner of the Roman Colosseum (see FIG. 10-34). A Doric frieze of metopes and triglyphs caps it—none "slide" out of place as in the frieze of the contemporary Palazzo del Tè in Mantua (FIG. 22-49). The lower story sturdily supports the higher, lighter, and much more decorative Ionic second story, which housed the reading room with its

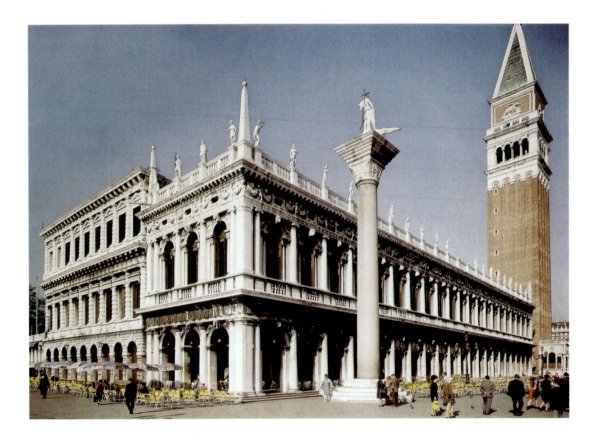

22-55 Jacopo Sansovino, the Mint (la Zecca), 1535–1545 *(left),* and the State Library, begun 1536 *(right),* Piazza San Marco, Venice.

treasure of manuscripts, keeping them safe from not-uncommon flooding. The main columns carry an entablature with a richly decorated frieze of putti, in strongly projecting relief, supporting garlands. The oval windows of an attic story punctuate this frieze, a favorite decorative motif of the ancient Romans. Perhaps the building's most striking feature is its roofline, where Sansovino replaced the traditional straight cornice with a balustrade (reminiscent of the one on Bramante's Tempietto, FIG. 22-8) interrupted by statue-bearing pedestals. The spacing of the latter corresponds to that of the orders below so that the sculptures are the sky-piercing finials of the building's vertical design elements. Sansovino's deft application of sculpture to the building's massive framework (with no visible walls) relieves the design's potential severity and gives its aspect an extraordinary sculptural richness.

One feature rarely mentioned is how subtly the library echoes the design of the lower two stories of the decorative Doge's Palace (see FIG. 18-56) opposite it. Although Sansovino used a vastly different architectural vocabulary, he managed admirably to adjust his building to the older one. Correspondences include the almost identical spacing of the lower arcades, the rich and ornamental treatment of the second stories (including their balustrades), and the dissolution of the rooflines (with decorative battlements in the palace and a statue-surmounted balustrade in the library). It is almost as if Sansovino set out to translate the Gothic architecture of the Doge's Palace into a "modern" Renaissance idiom. If so, he was eminently successful; the two buildings, although of different spiritual and stylistic worlds, mesh to make the Piazzetta one of the most elegantly framed urban units in Europe.

INSPIRED BY THE ANCIENTS After Jacopo Sansovino's death, ANDREA PALLADIO (1508–1580) succeeded him as chief architect of the Venetian Republic. Beginning as a stonemason and decorative sculptor, at age 30 Palladio turned to architecture, the ancient literature on architecture, engineering, topography, and military science. Unlike the universal scholar Alberti, Palladio

became more of a specialist. He made several trips to Rome to study the ancient buildings firsthand. He illustrated Daniele Barbaro's edition of *De architectura* by Vitruvius (1556), and he wrote his own treatise on architecture, *I quattro libri dell'architettura (The Four Books of Architecture),* originally published in 1570, which had a wide-ranging influence on succeeding generations of architects throughout Europe. Palladio's influence outside Italy, most significantly in England and in colonial America, was stronger and more lasting than that of any other architect.

Palladio accrued his significant reputation from his many designs for villas, built on the Venetian mainland. Nineteen still stand, and they especially influenced later architects. The same Arcadian spirit that prompted the ancient Romans to build villas in the countryside, and that the Venetian painter Giorgione expressed so eloquently in his art, motivated a similar villa-building boom in the 16th century. One can imagine that Venice, with its very limited space, must have been more congested than any ancient city. But a longing for the countryside was not the only motive; declining fortunes prompted the Venetians to develop their mainland possessions with new land investment and reclamation projects. Citizens who could afford it were encouraged to set themselves up as aristocratic farmers and to develop swamps into productive agricultural land. Wealthy families could look on their villas as providential investments. The villas were thus aristocratic farms (like the much later American plantations, which were influenced by Palladio's architecture) surrounded by service outbuildings. Palladio generally arranged the outbuildings in long, low wings branching out from the main building and enclosing a large rectangular court area.

Although it is the most famous, Villa Rotonda (FIG. **22-56**), near Vicenza, is not really typical of Palladio's villa style. He did not construct it for an aspiring gentleman farmer but for a retired monsignor who wanted a villa for social events. Palladio planned and designed Villa Rotonda, located on a hilltop, as a kind of belvedere (literally "beautiful view"; in architecture, a residence on a hill), without the usual wings of secondary buildings. Its

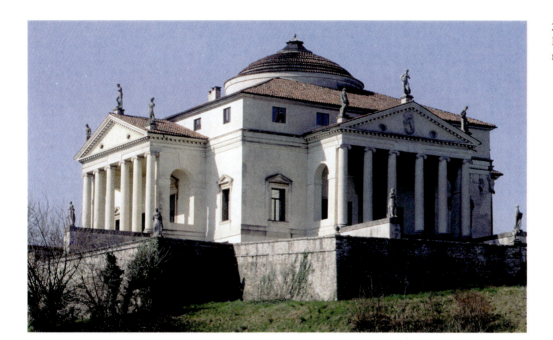

central plan (FIG. **22-57**), with four identical facades and project-ing porches, is therefore both sensible and functional. Each of the porches can be used as a platform for enjoying a different view of the surrounding landscape. In this design, the central dome-covered rotunda logically functions as a kind of circular platform from which visitors may turn in any direction for the preferred view. The result is a building with functional parts systemati-cally related to one another in terms of calculated mathematical relationships. Villa Rotonda embodies all the qualities of self-sufficiency and formal completeness sought by most Renaissance architects. The works of Alberti and Bramante and the remains

of classical architecture Palladio studied in Rome influenced the young architect in his formative years. Each facade of his Villa Rotonda resembles a Roman temple. In placing a traditional temple porch in front of a dome-covered interior, Palladio doubt-less had the Pantheon (see FIG. 10-48) in his mind as a model. By 1550, however, he had developed his personal style, which mixed elements of Mannerism with the clarity and lack of ambiguity that characterized classicism at its most "correct."

SHADOW AND SURFACE One of the most dramatically placed buildings in Venice is San Giorgio Maggiore (FIGS. **22-58**

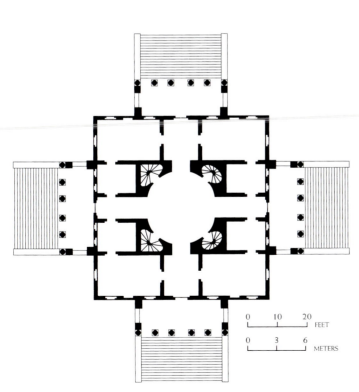

22-57 ANDREA PALLADIO, plan of the Villa Rotonda (formerly Villa Capra), near Vicenza, Italy, ca. 1566–1570.

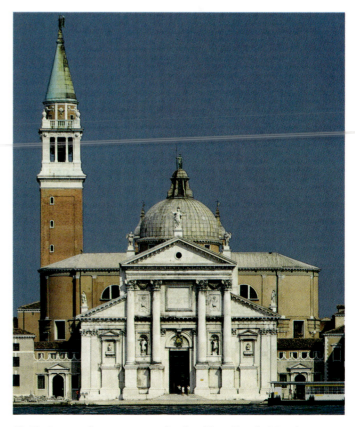

22-58 ANDREA PALLADIO, west facade of San Giorgio Maggiore, Venice, Italy, begun 1565.

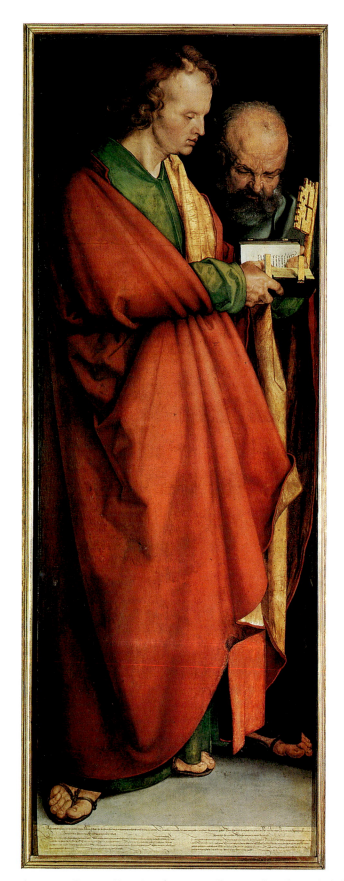
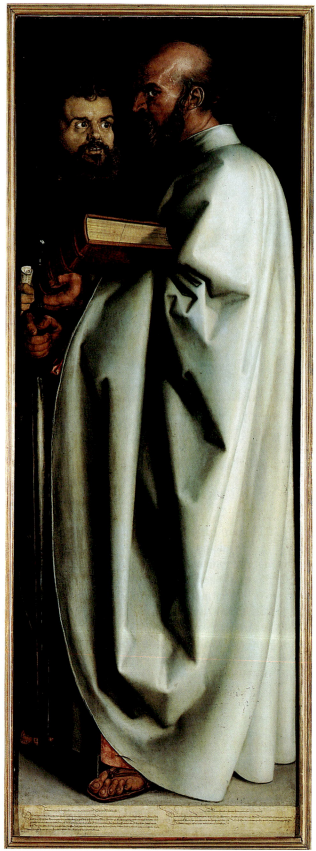

ALBRECHT DÜRER, *Four Apostles*, 1526. Oil on panel, each panel 7′ 1″ × 2′ 6″. Alte Pinakothek, Munich.

23

THE AGE OF REFORMATION

16TH-CENTURY ART IN NORTHERN EUROPE AND SPAIN

The dissolution of the Burgundian Netherlands in 1477 led to a realignment in the European geopolitical landscape (MAP **23-1**) in the early 16th century. France and the Holy Roman Empire (at the time consisting primarily of today's Germany) expanded their territories after this breakup of Flanders. Through calculated marriages, military exploits, and ambitious territorial expansion, Spain became the dominant power in Europe by the end of the 16th century. Monarchs increased their authority over their subjects and cultivated a stronger sense of cultural and political unity among the populace, thereby laying the foundation for the modern state or nation. Yet a momentous crisis in the Christian Church overshadowed these power shifts. As noted earlier (see Chapter 22, page 634), concerted attempts to reform the Church led to the Reformation and the establishment of Protestantism (as distinct from Catholicism), which in turn prompted the Catholic Church's response, the Counter-Reformation. Ultimately, the Reformation split Christendom in half and produced a hundred years of civil war between Protestants and Catholics.

THE PROTESTANT REFORMATION

Replacing Church Practices with Personal Faith

The Reformation, which came to fruition in the early 16th century, had its roots in long-term, growing dissatisfaction with Church leadership. The deteriorating relationship between the faithful and the Church hierarchy stood as an obstacle for the millions who sought a meaningful religious experience. Particularly damaging was the perception that popes concerned themselves more with temporal power and material wealth than with the salvation of Church members. The fact that many 15th-century popes and cardinals came from wealthy families, such as the Medici (for example, Clement VII, or Giulio de' Medici, and Leo X, or Giovanni de' Medici), intensified this perception. It was not only those at the highest levels who seemed to ignore their

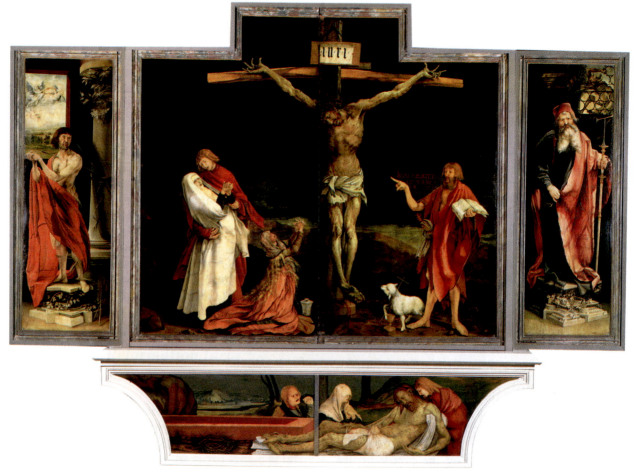

23-2 MATTHIAS GRÜNEWALD, *Isenheim Altarpiece* (closed), *Crucifixion* (center panel), from the chapel of the Hospital of Saint Anthony, Isenheim, Germany, ca. 1510–1515. Oil on panel, 9′ 9½″ × 10′ 9″ (center panel), 8′ 2½″ × 3′ ½″ (each wing), 2′ 5½″ × 11′ 2″ (predella). Musée d'Unterlinden, Colmar.

noted that the two movable halves of the altarpiece's predella, if slid apart, make it appear as if Christ's legs have been amputated. The same observation can be made with regard to the two main exterior panels. Due to the off-center placement of the cross, opening the left panel "severs" one arm from the crucified figure.

Thus, Grünewald carefully selected and presented his altarpiece's iconography to be particularly meaningful for viewers at this hospital. In the interior shrine, the artist balanced the horrors of the disease and the punishments that awaited those who did not repent with scenes such as the *Meeting of Saints Anthony and Paul,* depicting the two saints, healthy and aged, conversing peacefully. Even the exterior panels (the closed altarpiece) convey these same concerns. The *Crucifixion* emphasizes Christ's pain and suffering, but the knowledge that this act redeemed humanity tempers the misery. In addition, Saint Anthony appears in the right wing as a devout follower of Christ who, like Christ and for Christ, endured intense suffering for his faith. Saint Anthony's presence on the exterior thus reinforces the themes Grünewald intertwined throughout this entire altarpiece—themes of pain, illness, and death, as well as those of hope, comfort, and salvation.

The Protestant faith had not been formally established when Hagenauer and Grünewald produced the *Isenheim Altarpiece,* and the complexity and monumentality of the altarpiece must be viewed as Catholic in orientation. Further, Grünewald incorporated several references to Catholic doctrines, such as the lamb (symbol of the Son of God), whose wound spurts blood into a chalice in the exterior *Crucifixion* scene.

WIDELY ACCLAIMED TALENT In contrast, the Lutheran sympathies of Grünewald's contemporary, ALBRECHT DÜRER (1471–1528), are on display in many of his artworks. A dominant artist of the early 16th century in the Holy Roman Empire, Dürer was the first artist outside Italy to become an international art celebrity. He traveled extensively, visiting and studying in Colmar, Basel, Strasbourg, Venice, Antwerp, and Brussels, among other locales. As a result of these travels, Dürer was personally acquainted with many of the leading humanists and artists of his time, including Erasmus of Rotterdam and Giovanni Bellini. A man of exceptional talents and tremendous energy, Dürer achieved widespread fame in his own time and has enjoyed a lofty reputation ever since. Dürer was fervently committed to advancing his career and employed an agent to help sell his prints. His wife, who served as his manager, and his mother also sold his prints at markets. His business acumen is revealed by the lawsuit he brought against an Italian artist for copying his prints; scholars generally regard this lawsuit to be the first in history over artistic copyright. In part, his expansive reputation was due to the breadth of his talent. Although he was apprenticed at the age of 15 to a painter, Dürer quickly mastered the art of woodcut, engraving, and watercolor as well.

Like Leonardo da Vinci, Dürer wrote theoretical treatises on a variety of subjects, such as perspective, fortification, and the ideal in human proportions. Unlike Leonardo, he both finished and published his writings. Through his prints, he exerted strong influence throughout Europe, especially in Flanders but also in

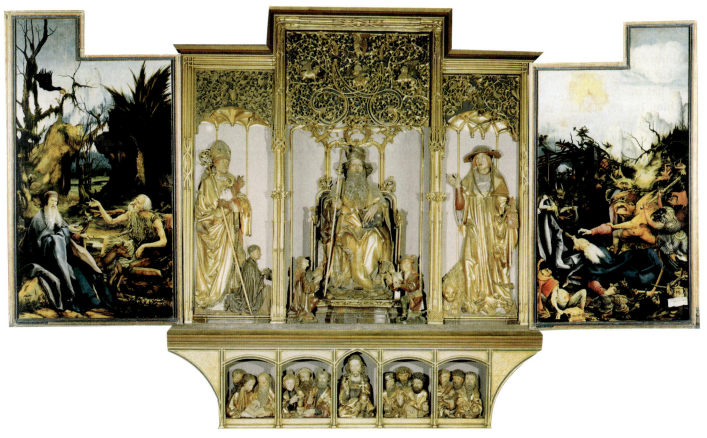

23-3 MATTHIAS GRÜNEWALD, *Isenheim Altarpiece* (open), center shrine carved by NIKOLAUS HAGENAUER in 1490, from the chapel of the Hospital of Saint Anthony, Isenheim, Germany, ca. 1510–1515. Shrine, painted and gilt limewood, 9′ 9½″ × 10′ 9″ (center), 2′ 5½″ × 11′ 2″ (predella). Each wing, oil on panel, 8′ 2½″ × 3′ ½″. Musée d'Unterlinden, Colmar.

Italy. Moreover, he was the first northern artist to leave a record of his life and career through several excellent self-portraits, through his correspondence, and through a carefully kept, quite detailed, and eminently readable diary.

A native of Nuremberg, one of the major cities in the Holy Roman Empire and a center of the Reformation, Dürer immersed himself in the religious debates of his day. *Last Supper* (FIG. **23-4**) is a woodcut Dürer produced six years after Luther's posting of his Ninety-five Theses. Dürer's treatment of this traditional subject (see FIGS. 21-37 and 22-3) alludes to Lutheran doctrine about Communion, one of the sacraments. Rather than promote the doctrine of transubstantiation, the Catholic belief that when consecrated by the

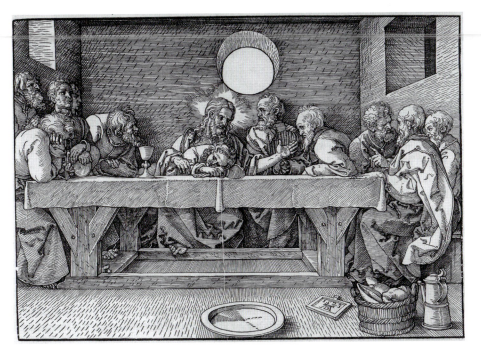

23-4 ALBRECHT DÜRER, *Last Supper*, 1523. Woodcut, 8⅜″ × 11¹³⁄₁₆″. British Museum, London.

23-7 ALBRECHT DÜRER, *The Great Piece of Turf*, 1503. Watercolor, approx. 1′ 4″ × 1′ 1½″. Graphische Sammlung Albertina, Vienna.

23-8 ALBRECHT DÜRER, *Knight, Death, and the Devil*, 1513. Engraving, $9\frac{5}{8}$″ × $7\frac{3}{8}$″. Metropolitan Museum of Art, New York.

Turf (FIG. 23-7) is as scientifically accurate as it is poetic. Botanists can distinguish each springing plant and grass variety—dandelions, great plantain, yarrow, meadow grass, and heath rush. "[D]epart not from nature according to your fancy," Dürer said, "imagining to find aught better by yourself; . . . For verily 'art' is embedded in nature; he who can extract it, has it."[2]

ELEVATING THE ART OF ENGRAVING This lifelong interest in both idealization and naturalism surfaces in *Knight, Death, and the Devil* (FIG. 23-8), one of three so-called Master Engravings Dürer made between 1513 and 1514. These works (the other two are *Melencolia I* and *Saint Jerome in His Study*) carry the art of engraving to the highest degree of excellence. Dürer used his burin to render differences in texture and tonal values that would be difficult to match even in the much more flexible medium of etching (corroding a design into metal), which artists developed later in the century. (Later in life Dürer also experimented with etching.)

Knight, Death, and the Devil depicts a mounted armored knight who rides fearlessly through a foreboding landscape. Accompanied by his faithful retriever, the knight represents a Christian knight—a soldier of God. Armed with his faith, this warrior can repel the threats of Death, who appears as a crowned decaying cadaver wreathed with snakes and shaking an hourglass as a reminder of time and mortality. The knight is equally impervious to the Devil, a pathetically hideous horned creature who follows him. The knight triumphs because he has "put on the whole armor of God that [he] may be able to stand against the wiles of the devil," as urged in Saint Paul's Epistle to the Ephesians (Eph. 6:11).

The monumental knight and his mount display the strength, movement, and proportions of the Renaissance equestrian statue. Dürer was familiar with Donatello's *Gattamelata* (see FIG. 21-29)

and Verrocchio's *Bartolommeo Colleoni* (see FIG. 21-30) and had copied a number of Leonardo's sketches of horses. His highly developed feeling for the real and his meticulous rendering of it surface in the myriad details—the knight's armor and weapons, the horse's anatomy, the textures of the loathsome features of Death and the Devil, the rock forms and rugged foliage. Dürer realized this great variety of imagery with the dense hatching of fluidly engraved lines that rivals the tonal range of painting. Erasmus could rightly compliment Dürer as the "Apelles [the ancient Greek master of painting] of black lines."[3]

Dürer's use of line, whether in oil, watercolor, woodcut, or engraving, was truly exceptional. He employed line not simply to describe but to evoke as well. This ability extended beyond his impressive technical facility with the different media. Dürer's art reveals an inspired, inquisitive mind and a phenomenally gifted talent. To this day, his work serves as a model for artists, and he deserves much of the credit for expanding the capability of the graphic arts to convey intellectually and emotionally complex themes. Further, in bringing a lawsuit against copyists in Italy in 1506, Dürer took the first step toward the modern concepts of copyright and intellectual property—a central feature of the modern world whose impact stretches far beyond the realm of art.

Commenting on History and Politics

INVOKING A HISTORICAL BATTLE Although the prominence of Reformation concerns in the Holy Roman Empire during the 16th century was reflected in the period's art, artists also addressed historical and political issues. *The Battle of Issus* (FIG. 23-9) by ALBRECHT ALTDORFER (ca. 1480–1538), for example,

23-9 Albrecht Altdorfer, *The Battle of Issus*, 1529. Oil on panel, 5′ 2⅓″ × 3′ 11¼″. Alte Pinakothek, Munich.

depicts the defeat of Darius in 333 BCE by Alexander the Great at a town called Issus on the Pinarus River (announced in the inscription that hangs in the sky). The duke of Bavaria, Wilhelm IV, commissioned *The Battle of Issus* in 1528, concurrent with his commencement of a military campaign against the invading Turks. The parallels between the historical and contemporary conflicts were no doubt significant to the duke. Both involved societies that deemed themselves progressive engaged in battles against infidels—the Persians in 333 BCE and the Turks in 1528. Altdorfer reinforced this connection by attiring the figures in contemporary armor and depicting them engaged in contemporary military alignments.

The scene reveals Altdorfer's love of landscape. The battle takes place in an almost cosmological setting. From a bird's-eye view, the clashing armies swarm in the foreground; in the distance, craggy mountain peaks rise next to still bodies of water. Amid swirling clouds, a blazing sun descends. Although the awesome spectacle of the topography may appear imaginary or invented, the artist actually used available historical information to produce this painting. Altdorfer derived his depiction of the landscape from maps. Specifically, he set the scene in the eastern Mediterranean with a view from Greece to the Nile in Egypt. In addition, Altdorfer may have acquired his information about this battle from an account written by Johannes Aventinus, a German scholar. In his text, Aventinus describes the bloody daylong battle and Alexander's ultimate victory. Appropriately, given Alexander's designation as the "sun god," the sun sets over the victorious Greeks on the right, while a small crescent moon (a symbol of the Near East) hovers in the upper left corner over the retreating Persians.

AN ELEGANT DIPLOMATIC PORTRAIT Choosing less dramatic scenes, HANS HOLBEIN THE YOUNGER (ca. 1497–1543) excelled as a portraitist. Trained by his father, Holbein produced portraits that reflected the northern tradition of close realism that had emerged in 15th-century Flemish art. Yet he also incorporated Italian ideas about monumental composition, bodily structure, and sculpturesque form. The color surfaces of his paintings are as lustrous as enamel, his detail is exact and exquisitely drawn, and his contrasts of light and dark are never heavy.

Holbein began his artistic career in Basel, where he knew Erasmus of Rotterdam. Because of the immediate threat of a religious civil war in Basel, Erasmus suggested that Holbein leave for England and gave him a recommendation to Thomas More,

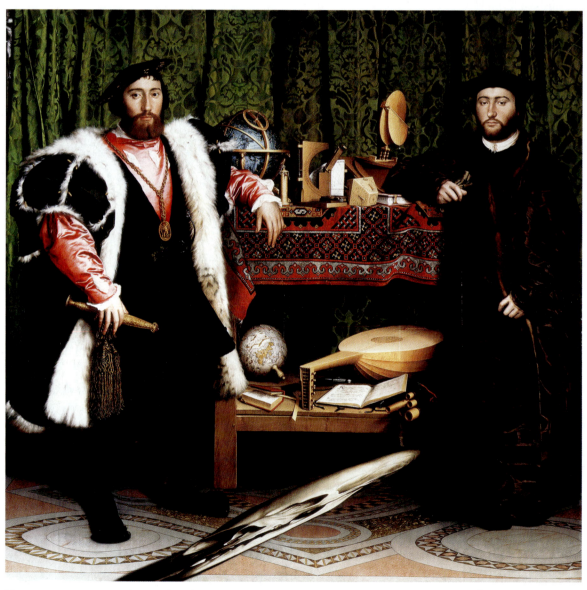

23-10 HANS HOLBEIN THE YOUNGER, *The French Ambassadors,* 1533. Oil and tempera on panel, approx. 6′ 8″ × 6′ 9½″. National Gallery, London.

chancellor of England under Henry VIII. Holbein did move and became painter to the English court. While there, he produced a superb double portrait of the French ambassadors to England, Jean de Dinteville and Georges de Selve. *The French Ambassadors* (FIG. 23-10) exhibits Holbein's considerable talents—his strong sense of composition, his subtle linear patterning, his gift for portraiture, his marvelous sensitivity to color, and his faultlessly firm technique. This painting may have been Holbein's favorite; it is the only one signed with his full name. The two men, both ardent humanists, stand at each end of a side table covered with an oriental rug and a collection of objects reflective of their worldliness and their interest in learning and the arts. These include mathematical and astronomical models and implements, a lute with a broken string, compasses, a sundial, flutes, globes, and an open hymnbook with Luther's translation of *Veni, Creator Spiritus* and of the Ten Commandments.

Of particular interest is the long gray shape that slashes diagonally across the picture plane and interrupts the stable, balanced, and serene composition. This form is an *anamorphic image,* a distorted image recognizable when viewed with a special device, such as a cylindrical mirror, or by viewing the painting at an acute angle. Viewing this painting while standing off to the right reveals that this gray slash is a skull. Although scholars do not agree on this skull's meaning, at the very least it certainly refers to death. Artists commonly incorporated skulls into paintings as reminders of mortality; indeed, Holbein depicted a skull on the metal medallion on Jean de Dinteville's hat. Holbein may have intended the skulls, in conjunction with the crucifix that appears half hidden behind the curtain in the upper left corner, to encourage viewers to ponder death and resurrection.

This painting may allude to the growing tension between secular and religious authorities; Jean de Dinteville was a titled landowner, Georges de Selve a bishop. The inclusion of Luther's translations next to the lute with the broken string (a symbol of discord) may also subtly refer to the religious strife. Despite scholars' uncertainty about the precise meaning of *The French Ambassadors,* it is a painting of supreme artistic achievement. Holbein rendered the still-life objects with the same meticulous care as the men themselves, as the woven design of the deep emerald curtain behind them, and as the floor tiles, constructed in faultless perspective. He surely hoped this painting's elegance and virtuosity of skill (produced shortly after Holbein arrived in England) would impress Henry VIII.

FRANCE

As *The French Ambassadors* illustrates, France in the early 16th century continued its efforts to secure widespread recognition as a political power. Under the rule of Francis I (r. 1515–1547), the French established a firm foothold in Milan and its environs. Francis waged a campaign (known as the Habsburg-Valois Wars) against Charles V (the Spanish king and Holy Roman Emperor), which occupied him from 1521 to 1544. These wars involved disputed territories—southern France, the Netherlands, the Rhinelands, northern Spain, and Italy—and reflect France's central role in the shifting geopolitical landscape. Despite these military preoccupations, Francis I also endeavored to elevate his country's cultural profile. To that end, he invited esteemed Italian artists such as Leonardo da Vinci and Andrea del Sarto to his court. Francis's attempt to glorify the state and himself meant that the

religious art dominating the Middle Ages no longer prevailed, for the king and not the Christian Church held the power.

A MAGNIFICENT FRENCH MONARCH The portrait *Francis I* (FIG. 23-11), painted by JEAN CLOUET (ca. 1485–1541), shows a worldly prince magnificently bedecked in silks and brocades, wearing a gold chain with a medallion of the Order of Saint Michael, a French order founded by Louis XI. Legend has it that the "merry monarch" was a great lover and the hero of hundreds of "gallant" deeds; appropriately, he appears suave and confident, with his hand resting on the pommel of a dagger. Despite the careful detail, the portrait also exhibits an elegantly formalized quality. This characteristic is due to Clouet's suppression of modeling, resulting in a flattening of features, seen particularly in Francis's neck. The disproportion between the small size of the king's head in relation to his broad body, swathed in heavy layers of fabric, adds to the formalized nature.

A PAINTED AND PLASTERED PALACE The personal tastes of Francis and his court must have run to an art at once elegant, erotic, and unorthodox. Appropriately, Mannerism (see Chapter 22, pages 648–654) appealed to them most. Among the Italian artists who had a strong impact on French art were the Mannerists Rosso Fiorentino and Benvenuto Cellini. Rosso became the court painter of Francis I shortly after 1530. The king put ROSSO FIORENTINO (1494–1540), along with fellow Florentine FRANCESCO PRIMATICCIO (1504–1570), in charge of decorating

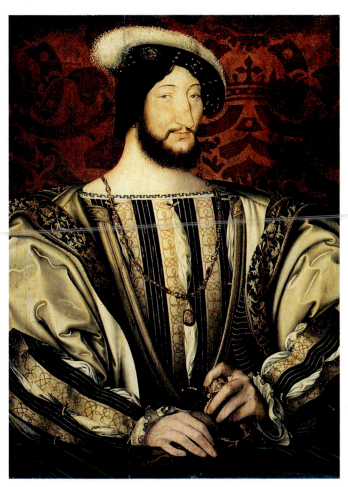

23-11 JEAN CLOUET, *Francis I,* ca. 1525–1530. Tempera and oil on panel, approx. 3′ 2″ × 2′ 5″. Louvre, Paris.

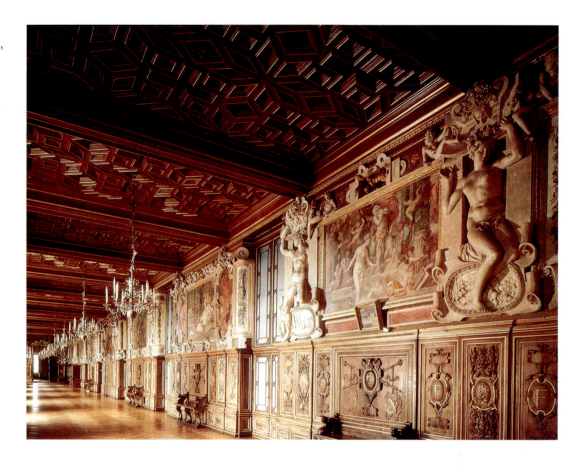

23-12 ROSSO FIORENTINO and FRANCESCO PRIMATICCIO, ensemble of architecture, sculpture, and painting, Gallery of King Francis I, Fontainebleau, France, ca. 1530–1540.

the new royal palace at Fontainebleau. Scholars refer to the sculptors and painters who worked together on this project as the school of Fontainebleau. When Rosso and Primaticcio decorated the Gallery of King Francis I at Fontainebleau (FIG. **23-12**), they combined painting, fresco, imitation mosaic, and stucco sculpture in low and high relief. The abrupt changes in scale and in the texture of the figurative elements are typically Mannerist, as are the compressed space, elongated grace, and stylized poses. The formalized elegance of the paintings also appears in the stucco relief figures and caryatids, and the shift in scale between the painted and the stucco figures adds tension. The combination of painted and stucco relief decorations became extremely popular from that time on and remained a favorite ornamental technique throughout the Baroque and Rococo periods of the 17th and early 18th centuries.

FROM CASTLES TO CHÂTEAUX During his reign, Francis I indulged a passion for building by commissioning several large-scale châteaux, among them the Château de Chambord (FIG. **23-13**). Reflecting more peaceful times, these châteaux, developed from the old castles, served as country houses for royalty, who usually built them near forests for use as hunting lodges. Construction on Chambord began in 1519, but Francis I never saw its completion. Chambord's plan, originally drawn by a pupil of Giuliano da Sangallo, includes a central square block with four corridors, in the shape of a cross, and a broad, central staircase that gives access to groups of rooms—ancestors of the modern suite of rooms or apartments. At each of the four corners, a round tower punctuates the square plan, and a moat surrounds the whole. From the exterior, Chambord presents a carefully contrived horizontal accent on three levels, its floors separated by continuous moldings. Windows align precisely, one exactly over another. The Italian palazzo served as the model for this matching

of horizontal and vertical features, but above the third level the structure's lines break chaotically into a jumble of high dormers, chimneys, and lanterns that recall soaring ragged Gothic silhouettes on the skyline.

REDESIGNING THE LOUVRE Chambord essentially retains French architectural characteristics. During the reign of Francis's successor, Henry II (r. 1547–1559), however, translations of Italian architectural treatises appeared, and Italian architects themselves came to work in France. Moreover, the French turned to Italy for study and travel. Such exchanges caused a more extensive revolution in style than earlier, although certain French elements derived from the Gothic tradition persisted. This incorporation of Italian architectural ideas can be seen in the redesigning of the Louvre in Paris, originally a medieval palace and fortress (see FIG. 20-2). Since Charles V's renovation of the Louvre in the mid-14th century, the castle had languished relatively empty and had thus fallen into a state of disrepair. Francis I initiated this project to update and expand the royal palace, but died before the work was well under way. His architect, PIERRE LESCOT (1510–1578), continued under Henry II and, with the aid of the sculptor JEAN GOUJON (ca. 1510–1565), produced the classical style later associated with 16th-century French architecture.

Although Chambord incorporated the formal vocabulary of the Early Renaissance, particularly from Lombardy, Lescot and his associates were familiar with the 16th-century Renaissance architecture of Bramante and his school. As the west facade of the Square Court (FIG. **23-14**) shows, each of the Louvre's stories forms a complete order, and the cornices project enough to furnish a strong horizontal accent. The arcading on the ground story reflects the ancient Roman use of arches and produces more shadow than in the upper stories due to its recessed placement, thereby strengthening the design's visual base. On the second story, the pilasters rising from bases and the

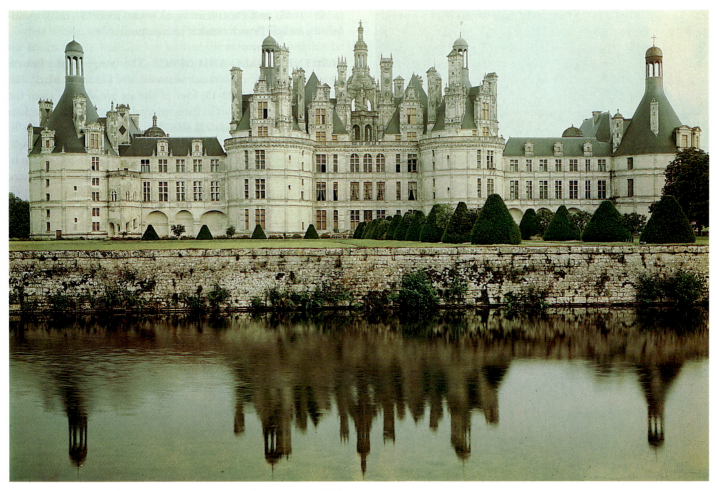

23-13 Château de Chambord, Chambord, France, begun 1519.

23-14 PIERRE LESCOT and JEAN GOUJON, west facade of the Square Court of the Louvre, Paris, France, begun 1546.

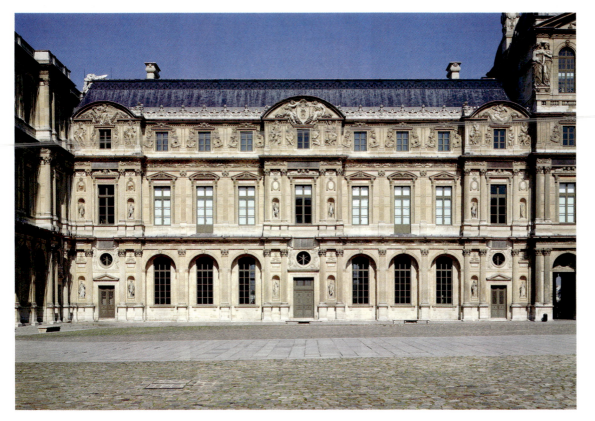

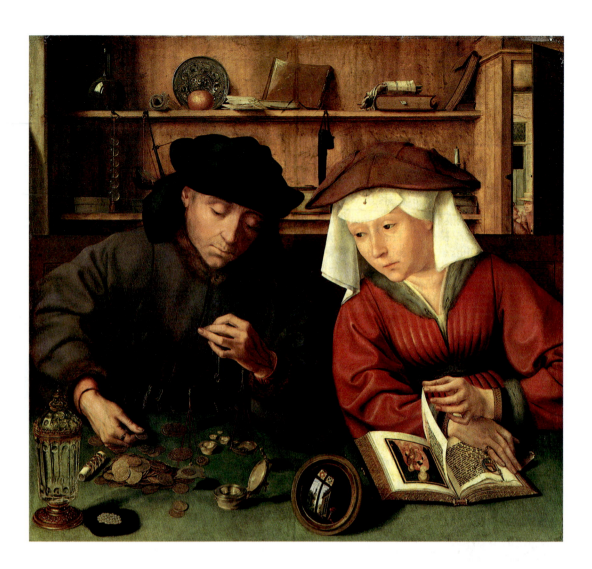

23-17 QUINTEN MASSYS, *Money-Changer and His Wife*, 1514. Oil on panel, 2′ 3¾″ × 2′ 2⅜″. Louvre, Paris.

In *Money-Changer and His Wife* (FIG. **23-17**), Massys presented a professional man transacting business. He holds scales, checking the weight of coins on the table. His wife interrupts her reading of a prayer book to watch him. The artist's detailed rendering of the figures, setting, and objects suggests a fidelity to observable fact. Thus, this work provides the viewer with insight into developing mercantilist practices. *Money-Changer and His Wife* also reveals Netherlandish values and mores. Although the painting highlights the financial transactions that were an increasingly prominent part of secular life in the 16th-century Netherlands, Massys tempered this focus on the material world with numerous references to the importance of a moral, righteous, and spiritual life. Not only does the wife hold a prayer book, but the artist also included other traditional religious symbols (for example, the carafe with water and candlestick). Massys included two small vignettes that refer to the balance this couple must establish between their worldly existence and their commitment to God's word. On the right, through a window, an old man talks with another man, suggesting idleness and gossip. The reflected image in the convex mirror on the counter offsets this image of sloth and foolish chatter. There, a man reads what is most likely a Bible or prayer book; behind him is a church steeple.

An inscription on the original frame (now lost) seems to have reinforced this message. According to a 17th-century scholar, this inscription read, "Let the balance be just and the weights equal" (Lev. 19:36), which applies both to the money-changer's professional conduct and the eventual Last Judgment.

MEETING SPIRITUAL OBLIGATIONS This tendency to inject reminders about spiritual well-being emerges in *Meat Still-Life* (FIG. **23-18**) by PIETER AERTSEN (ca. 1507–1575), who worked in Antwerp for more than three decades. At first glance, this painting appears to be a descriptive genre scene. On display is an array of meat products—a side of a hog, chickens, sausages, a stuffed intestine, pig's feet, meat pies, a cow's head, a hog's head, and hanging entrails. Also visible are fish, pretzels, cheese, and butter. Like Massys, Aertsen embedded strategically placed religious images as reminders to the viewer. In the background of *Meat Still-Life,* Joseph leads a donkey carrying Mary and the Christ Child. The Holy Family stops to offer alms to a beggar and his son, while the people behind the Holy Family wend their way toward a church. Furthermore, the crossed fishes on the platter and the pretzels and wine in the rafters on the upper left all refer to "spiritual food" (pretzels often served as bread during Lent). Aertsen accentuated these allusions to salvation through Christ by contrasting them to their opposite—a life of gluttony, lust, and sloth. He represented this degeneracy with the oyster and mussel shells (believed by Netherlanders to possess aphrodisiacal properties) scattered on the ground on the painting's right side, along with the people seen eating and carousing nearby under the roof.

AN ACCOMPLISHED WOMAN ARTIST With the accumulation of wealth in the Netherlands, portraits increased in popularity. The self-portrait (FIG. **23-19**) by CATERINA VAN HEMESSEN (1528–1587) is purportedly the first known northern European

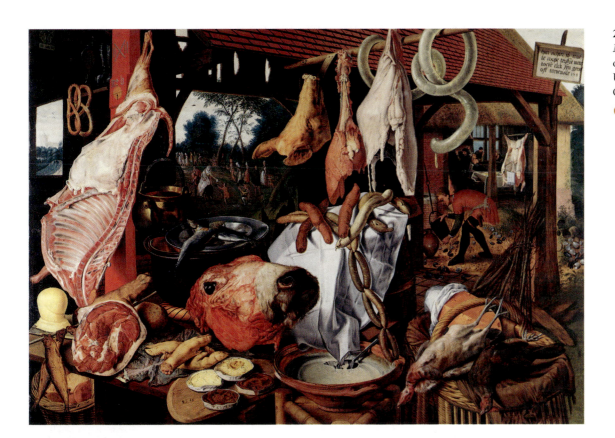

23-18 PIETER AERTSEN, *Meat Still-Life,* 1551. Oil on panel, 4' $\frac{3}{8}$" × 6' 5$\frac{3}{4}$". Uppsala University Art Collection, Uppsala.

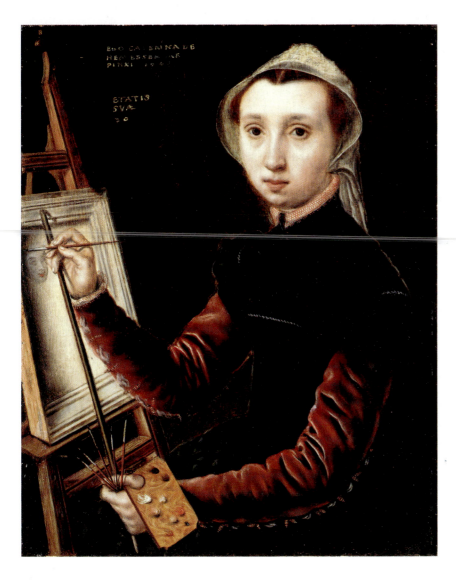

23-19 CATERINA VAN HEMESSEN, *Self-Portrait,* 1548. Oil on panel, 1' $\frac{3}{4}$" × 9$\frac{7}{8}$". Kunstmuseum, Öffentliche Kunstsammlung Basel.

self-portrait by a woman. Here, she confidently presented herself as an artist; she interrupts her painting to look toward the viewer. She holds brushes, a palette, and a *maulstick* (a stick used to steady the hand while painting) in her left hand, and delicately applies pigment to the canvas with her right hand. Van Hemessen's father, Jan Sanders van Hemessen, a well-known painter, trained her. Caterina ensured proper identification (and credit) through the inscription in the painting: "Caterina van Hemessen painted me / 1548 / her age 20."

A RENOWNED COURT PAINTER LEVINA TEERLINC (1515–1576) of Bruges established herself as such a respected artist that she was invited to England to paint miniatures for the courts of Henry VIII and his successors. There, she was a formidable rival of some of her male contemporaries at the court, such as Holbein, and received greater compensation for her work than they did for theirs. Teerlinc's considerable skill is evident in a life-size portrait attributed to her, which depicts Elizabeth I (FIG. **23-20**) as a composed, youthful princess. Daughter of Henry VIII and Anne Boleyn, Elizabeth was probably in her late twenties when she sat for this portrait. As presented by Teerlinc, Elizabeth is attired in an elegant brocaded gown. Appropriate to her station in life, she is adorned with extravagant jewelry and wears a headdress based on a style popularized by her mother.

That female artists like van Hemessen and Teerlinc were able to achieve such success is a testament to their determination and skill. Despite the difficulties for women in obtaining artistic training (see "The Artist's Profession in Flanders," Chapter 20, page 556), women artists contributed significantly to the lofty reputation enjoyed by Flemish artists. Beyond their participation as artists in the 16th-century art world, women also played an important role as patrons. Politically powerful women such as Margaret of Austria (regent of the Netherlands during the early 16th century; 1480–1530) and Mary of Hungary (queen consort of Hungary; 1505–1558) were avid collectors and patrons, and contributed significantly to the thriving state of the arts. Like other art patrons (see "Art to Order: Commissions and Patronage," Chapter 19, page 526), these women collected and commissioned art not only for the aesthetic pleasure it provided but also for the status it bestowed on them and the cultural sophistication it represented.

"A GOOD LANDSCAPE PAINTER" Landscape painting also flourished. Particularly well known for his landscapes was JOACHIM PATINIR (d. 1524). According to one scholar, the word *landscape (Landschaft)* first emerged in German literature as a characterization of an artistic genre when Dürer described Patinir as a "good landscape painter." In *Landscape with Saint Jerome* (FIG. **23-21**), Patinir subordinated the biblical scene to the exotic and detailed landscape. Saint Jerome, who removes a thorn from a lion's paw in the foreground, appears dwarfed by craggy rock formations, rolling fields, and expansive bodies of water in the background. Patinir amplified the sense of distance by masterfully using color to enhance the visual effect of recession and advance.

A WINTRY LANDSCAPE The early high-horizoned "cosmographical" landscapes of PIETER BRUEGEL THE ELDER (ca. 1528–1569) reveal both an interest in the interrelationship of human beings and nature and Patinir's influence. But in Bruegel's paintings, no matter how huge a slice of the world the artist shows, human activities remain the dominant theme. Like many of his contemporaries, Bruegel traveled to Italy, where he seems to have spent almost two years, going as far south as Sicily. Unlike other artists, however, Bruegel chose not to incorporate classical elements into his paintings. The impact of his Italian experiences emerges in his work most frequently in the Italian or Alpine landscape features, which he recorded in numerous drawings during his journey.

23-20 Attributed to LEVINA TEERLINC. *Elizabeth I as a Princess,* ca. 1559. Oil on oak panel, 3′ 6¾″ × 2′ 8¼″. The Royal Collection, Windsor Castle, Windsor, England.

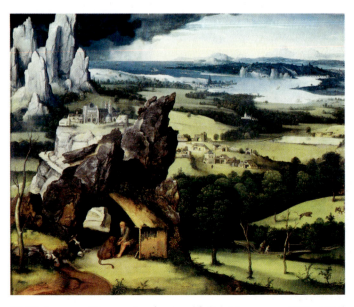

23-21 JOACHIM PATINIR, *Landscape with Saint Jerome,* ca. 1520–1524. Oil on panel, 2′ 5⅛″ × 2′ 11⅞″. Museo del Prado, Madrid.

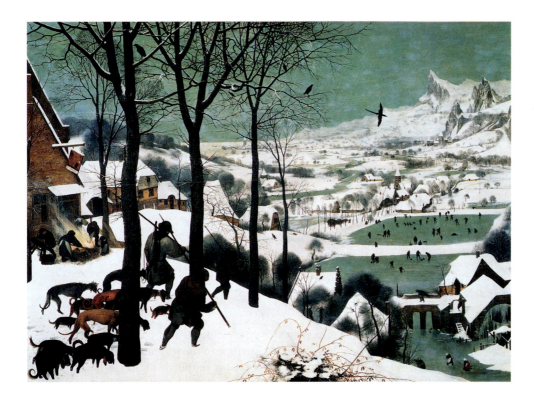

Hunters in the Snow (FIG. **23-22**) is one of five surviving paintings of a series of six illustrating seasonal changes in the year, and refers back to older Netherlandish traditions of depicting seasons and peasants found in Books of Hours. It shows human figures and landscape locked in winter cold; Bruegel's production of this painting in 1565 coincided with a particularly severe winter. The weary hunters return with their hounds, women build fires, skaters skim the frozen pond, and the town and its church huddle in their mantle of snow; beyond this typically Netherlandic winter scene lies a bit of Alpine landscape. Aside from this trace of fantasy, however, the artist rendered the landscape in an optically accurate manner. It develops smoothly from foreground to background and draws the viewer diagonally into its depths. Bruegel's consummate skill in using line and shape and his subtlety in tonal harmony make this one of the great landscape paintings and an occidental counterpart of the masterworks of classical Chinese landscape.

PROVERBIAL WISDOM Among the paintings that capture the Netherlandish obsession with proverbs during the 16th century is Bruegel's *Netherlandish Proverbs* (FIG. **23-23**). This

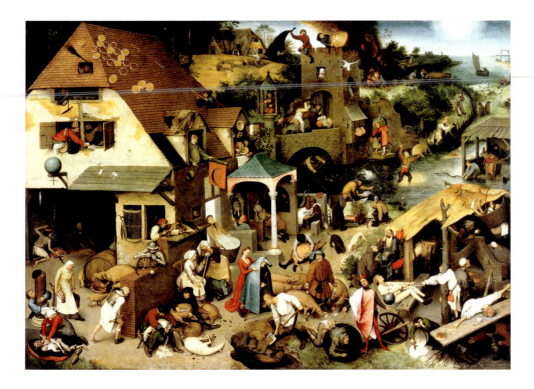

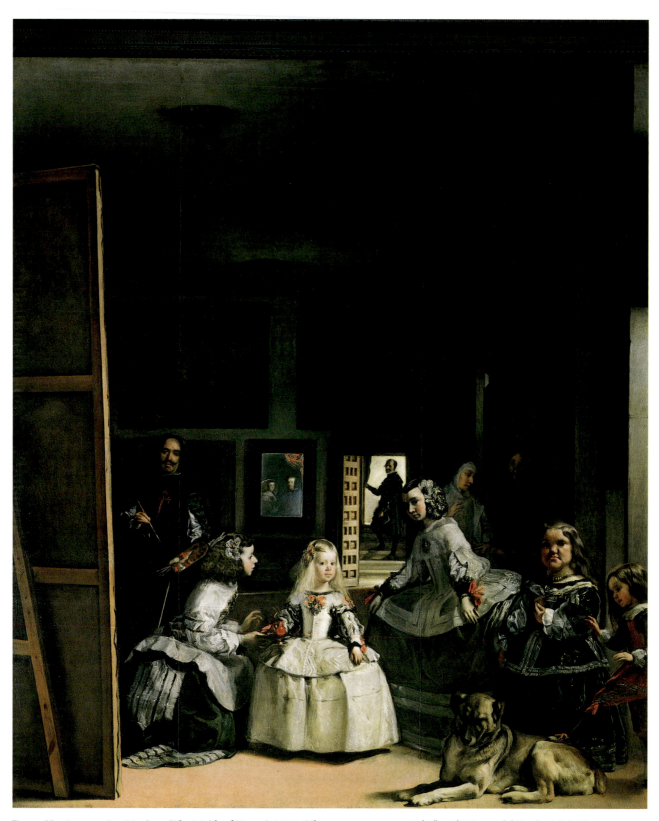

Diego Velázquez, *Las Meninas (The Maids of Honor),* 1656. Oil on canvas, approx. 10′ 5″ × 9′. Museo del Prado, Madrid.

24

POPES, PEASANTS, MONARCHS, AND MERCHANTS

BAROQUE ART

The cultural production of the 17th and early 18th centuries in the West is often described as "Baroque," a convenient blanket term. However, this term is problematic because the period encompasses a broad range of developments, both historical and artistic, across an expansive geographic area. Although its origin is unclear, the term may have come from the Portuguese word *barroco,* meaning an irregularly shaped pearl. Use of the term *baroque* emerged in the late 18th and early 19th centuries, when critics disparaged the Baroque period's artistic production, in large part because of perceived deficiencies in comparison to the art (especially Italian Renaissance) of the period preceding it. Over time, this negative connotation faded, and the term is now most often used as a general designation of the period. Some scholars use "Baroque" to describe a particular style that emerged during the 17th century—a style of complexity and drama that is usually associated with Italian art of this period. The dynamism and extravagance of this Baroque style contrast with the rational order of classicism. But as we shall see, not all artists adopted this style during the Baroque period.

Because of the problematic associations of the term and because no commonalities can be ascribed to all of the art and cultures of this period, we have limited use of the term in this book. Wherever it is used, we have described characteristics that anchor the term *Baroque* in particular cultures—for example, Italian Baroque as compared to Dutch Baroque.

17TH-CENTURY EUROPE

The Shifting Geopolitical Landscape

MORE THAN 30 YEARS OF WAR During the 17th and early 18th centuries, numerous geopolitical shifts occurred in Europe (MAP **24-1**) as the fortunes of the individual countries waxed and waned. Political and religious friction was prominent and

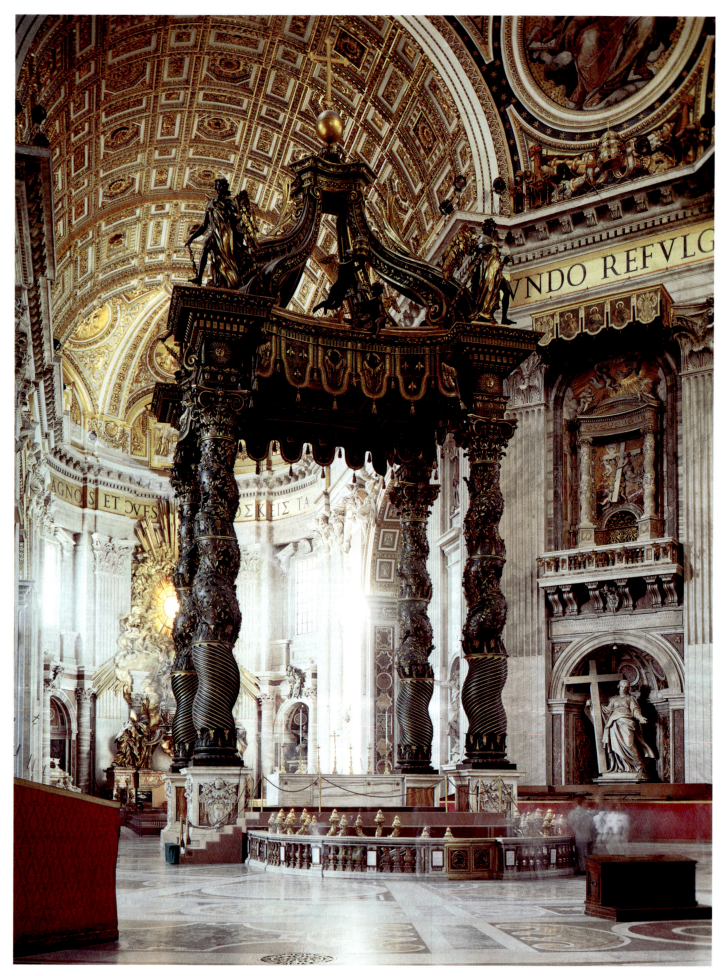

24-5 GIANLORENZO BERNINI, baldacchino, Saint Peter's, Vatican City, Rome, Italy, 1624–1633. Gilded bronze, approx. 100′ high.

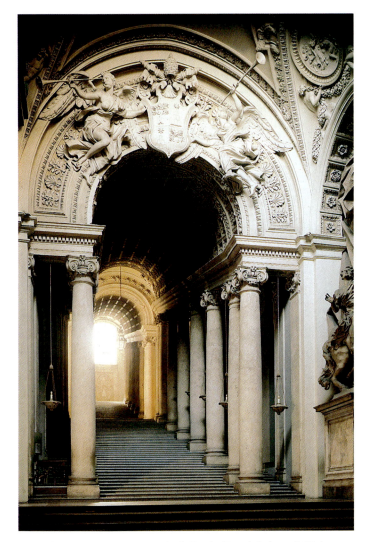

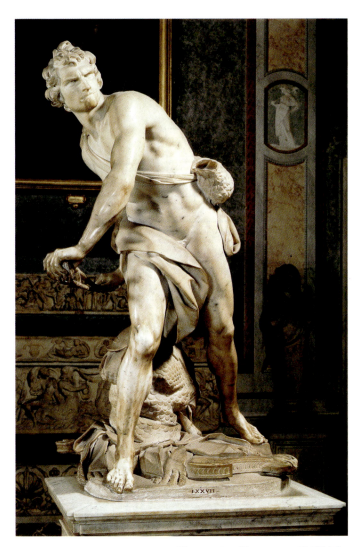

24-6 GIANLORENZO BERNINI, Scala Regia (Royal Stairway), Vatican City, Rome, Italy, 1663–1666.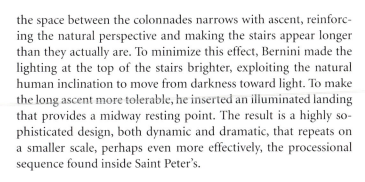

24-7 GIANLORENZO BERNINI, *David,* 1623. Marble, approx. 5′ 7″ high. Galleria Borghese, Rome.

the space between the colonnades narrows with ascent, reinforcing the natural perspective and making the stairs appear longer than they actually are. To minimize this effect, Bernini made the lighting at the top of the stairs brighter, exploiting the natural human inclination to move from darkness toward light. To make the long ascent more tolerable, he inserted an illuminated landing that provides a midway resting point. The result is a highly sophisticated design, both dynamic and dramatic, that repeats on a smaller scale, perhaps even more effectively, the processional sequence found inside Saint Peter's.

DECISIVE PHYSICAL ACTION Bernini devoted much of his prolific career to the adornment of Saint Peter's, where his works combine sculpture with architecture. Although Bernini was a great and influential architect, his fame rests primarily on his sculpture, which, like his architecture, energetically expresses the Italian Baroque spirit. Bernini's sculpture is expansive and theatrical, and the element of time usually plays an important role in it. A sculpture that predates his work on Saint Peter's is his *David* (FIG. 24-7), commissioned by Cardinal Scipione Borghese. This marble statue aims at catching the figure's split-second action and differs markedly from the restful figures of David

portrayed by Donatello (see FIG. 21-23), Verrocchio (see FIG. 21-24), and Michelangelo (see FIG. 22-9). Bernini's *David,* his muscular legs widely and firmly planted, is beginning the violent, pivoting motion that will launch the stone from his sling. Unlike Myron, the fifth-century BCE Greek sculptor whose *Diskobolos* (see FIG. 5-37) is frozen in inaction, Bernini selected the most dramatic of an implied sequence of poses, so observers have to think simultaneously of the continuum and of this tiny fraction of it. The suggested continuum imparts a dynamic quality to the statue that conveys a bursting forth of the energy seen confined in Michelangelo's figures (see FIGS. 22-9 and 22-10). Bernini's statue seems to be moving through time and through space. This is not the kind of sculpture that can be inscribed in a cylinder or confined in a niche; its indicated action demands space around it. Nor is it self-sufficient in the Renaissance sense, as its pose and attitude direct the observer's attention beyond it to its surroundings (in this case, toward an unseen Goliath). Bernini's sculpted figure moves out into and partakes of the physical space that surrounds it and the observer. Further, the expression of intense concentration on David's face is a far cry from the placid visages of previous Davids and augments the dramatic impact of this sculpture.

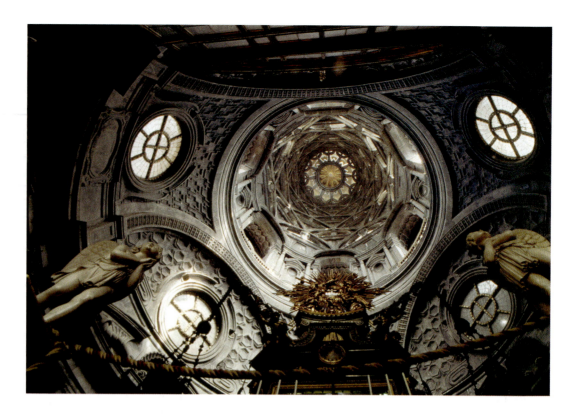

most noted Italian Baroque painters were Caravaggio and Annibale Carracci, whose styles, although different, were both thoroughly in accord with the period. Michelangelo Merisi, known as Caravaggio (1573–1610) after the northern Italian town he came from, developed a unique style that had tremendous influence throughout Europe. His outspoken disdain for the classical masters (probably more vocal than real) drew bitter criticism from many painters, one of whom denounced him as the "anti-Christ of painting." Giovanni Pietro Bellori, the most influential critic of the age and an admirer of Carracci, felt that Caravaggio's refusal to emulate the models of his distinguished predecessors threatened the whole classical tradition of Italian painting that had reached its zenith in Raphael's work. Yet despite this criticism and the problems in Caravaggio's troubled life (reconstructed from documents such as police records), Caravaggio received

many commissions, both public and private, and numerous artists paid him the supreme compliment of borrowing from his innovations. His influence on later artists, as much outside Italy as within, was immense. In his art, Caravaggio injected a naturalism into both religion and the classics, reducing them to human dramas played out in the harsh and dingy settings of his time and place. His unidealized figures selected from the fields and the streets were, however, effective precisely because of the Italian public's familiarity with such figures.

THE LIGHT OF DIVINE REVELATION Caravaggio painted *Conversion of Saint Paul* (FIG. **24-18**) for the Cerasi Chapel in the Roman church of Santa Maria del Popolo. It illustrates the conversion of the Pharisee Saul to Christianity, when he became the disciple Paul. The saint-to-be appears amid his conversion, flat on his back with his arms thrown up. In the background, an old hostler seems preoccupied with caring for the horse. At first inspection, little here suggests the momentous significance of the spiritual event taking place. The viewer of the painting seems to be witnessing a mere stable accident, not a man overcome by a great miracle. Although Caravaggio departed from traditional depictions of such religious scenes, the eloquence and humanity with which he imbued his paintings impressed many.

Caravaggio also employed other formal devices to compel the viewer's interest and involvement in the event. In *Conversion of Saint Paul*, he used a perspective and a chiaroscuro intended to bring viewers as close as possible to the scene's space and action, almost as if they were participating in them. The sense of inclusion is augmented by the low horizon line. Caravaggio designed *Conversion of Saint Paul* for presentation on the chapel wall, positioned at the viewers' line of sight as they stand at the chapel entrance. In addition, the sharply lit figures are meant to be seen as emerging from the dark of the background. The actual light from the chapel's windows functions as a kind of stage lighting for the production of a vision, analogous to the rays in Bernini's *Ecstasy of Saint Teresa* (FIG. 24-9).

24-17 Sant'Eligio degli Orefici (view into dome), Rome, Italy, attributed to Bramante and Raphael, ca. 1509; reconstructed ca. 1600.

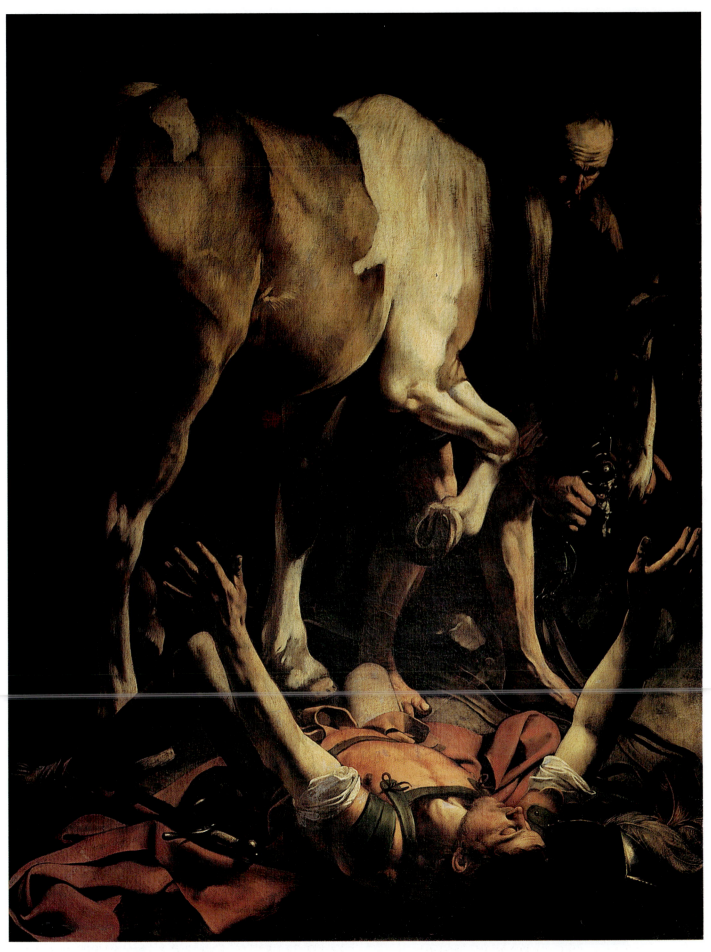

24-18 CARAVAGGIO, *Conversion of Saint Paul*, Cerasi Chapel, Santa Maria del Popolo, Rome, Italy, ca. 1601. Oil on canvas, approx. 7′ 6″ × 5′ 9″.

Caravaggio's use of light is certainly dramatic. The stark contrast of light and dark was a feature of Caravaggio's style that first shocked and then fascinated his contemporaries. Caravaggio's use of dark settings enveloping their occupants, which profoundly influenced European art, has been called *tenebrism,* from the Italian word *tenebroso,* or "shadowy" manner. Although tenebrism was widespread in 17th-century art, it made its most emphatic appearance in the art of Spain and of the Netherlands. In Caravaggio's work, tenebrism also contributed mightily to the essential meaning of his pictures. In *Conversion of Saint Paul,* the dramatic spotlight shining down upon the fallen Pharisee is the light of divine revelation converting Saul to Christianity.

FROM TAX COLLECTOR TO DISCIPLE A piercing ray of light illuminating a world of darkness and bearing a spiritual message is also a central feature of one of Caravaggio's early masterpieces, *Calling of Saint Matthew* (FIG. **24-19**). It is one of two large canvases honoring Saint Matthew that the artist painted for the side walls of the Contarelli Chapel in San Luigi dei Francesi in Rome. The commonplace setting is typical of Caravaggio—a bland street scene with a plain building wall serving as a backdrop. Into this mundane environment, cloaked in mysterious shadow and almost unseen, Christ, identifiable initially only by his indistinct halo,

enters from the right. With a commanding gesture that recalls that of the Lord in Michelangelo's *Creation of Adam* on the Sistine Chapel ceiling (see FIG. 22-14), he summons Levi, the Roman tax collector, to a higher calling. The astonished tax collector, whose face is highlighted for the viewer by the beam of light emanating from an unspecified source above Christ's head and outside the picture, points to himself in disbelief. Although Christ's extended arm is reminiscent of the Lord in *Creation of Adam,* the position of Christ's hand and wrist is similar to that of Adam. This reference is highly appropriate—theologically, Christ is the second Adam. Whereas Adam was responsible for the Fall of Man, Christ is responsible for human redemption. The conversion of Levi (who became Matthew) brought his salvation.

PRESENTING CHRIST'S BODY In 1603, Caravaggio produced a large-scale painting, *Entombment* (FIG. **24-20**), for the Chapel of Pietro Vittrice at Santa Maria in Vallicella in Rome. This work includes all the hallmarks of Caravaggio's distinctive style: the plebeian figure types (particularly visible in the scruffy, worn face of Nicodemus—a Pharisee whom Christ taught, and who here holds Christ's legs in the foreground), the stark use of darks and lights, and the invitation for the viewer to participate in the scene. As in *Conversion of Saint Paul,* the action takes place in the

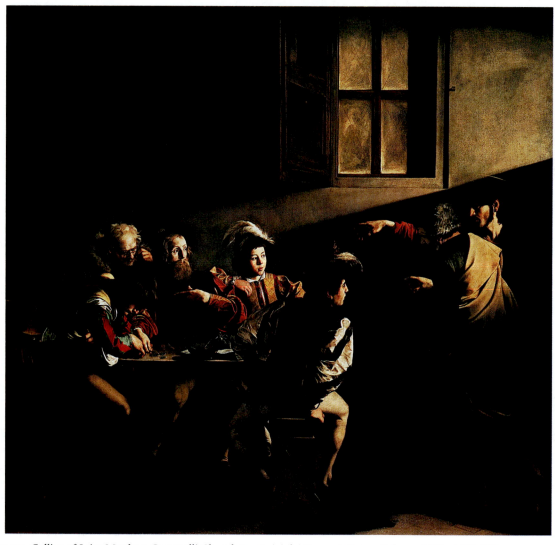

24-19 CARAVAGGIO, *Calling of Saint Matthew,* Contarelli Chapel, San Luigi dei Francesi, Rome, Italy, ca. 1597–1601. Oil on canvas, 11′ 1″ × 11′ 5″.

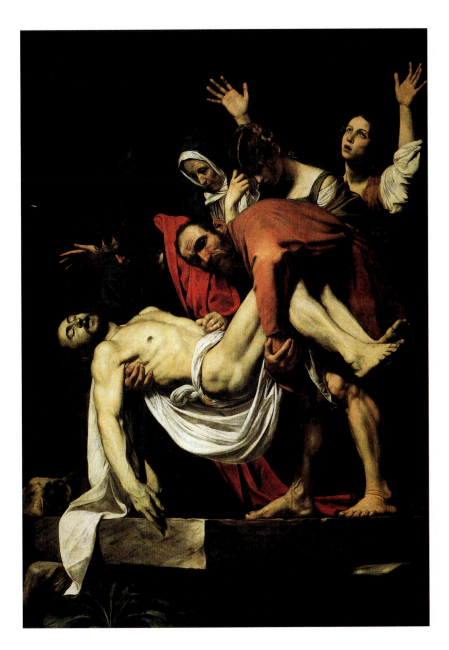

24-20 Caravaggio, *Entombment,* from the chapel of Pietro Vittrice, Santa Maria in Vallicella, Rome, Italy, ca. 1603. Oil on canvas, 9′ 10$\frac{1}{8}$″ × 6′ 7$\frac{15}{16}$″. Musei Vaticani, Pinacoteca, Rome.

foreground. The artist positioned the figures on a stone slab whose corner appears to extend into the viewer's space. This suggests that Christ's body will be laid directly in front of the viewer.

Beyond its ability to move its audience, such a composition also had theological implications. In light of the ongoing Counter-Reformation efforts at that time, such implications cannot be overlooked. To viewers in the chapel, it appeared as though the men were laying Christ's body onto the altar, which was in front of the painting. This served to give visual form to the doctrine of transubstantiation (the transformation of the Eucharistic bread and wine into the Body and Blood of Christ)—a doctrine central to Catholicism but rejected by Protestants. By depicting Christ's body as though it were physically present during the Mass, Caravaggio visually articulated an abstract theological precept. Unfortunately, because this painting has been moved to one of the Vatican Museums, viewers no longer can experience this effect.

IN CARAVAGGIO'S FOOTSTEPS Caravaggio's style became increasingly popular, and his combination of naturalism and drama appealed both to patrons and artists. A significant artist often discussed as a "Caravaggista" (a close follower of Caravaggio) is Artemisia Gentileschi (ca. 1593–1653). Gentileschi was instructed by her father, the artist Orazio, who was himself strongly influenced by Caravaggio. Her successful career, pursued in Florence, Venice, Naples, and Rome, helped disseminate Caravaggio's manner throughout the peninsula.

In her *Judith Slaying Holofernes* (FIG. **24-21**), Gentileschi used the tenebrism and what might be called the "dark" subject matter Caravaggio favored. Significantly, Gentileschi chose a narrative involving a heroic female, a favorite theme of hers. The story, from an Apocryphal work of the Old Testament, the Book of Judith, relates the delivery of Israel from its enemy, Holofernes. Having succumbed to Judith's charms, the Assyrian general Holofernes invited her to his tent for the night. When he fell asleep, Judith cut off his head. In this version of the scene (Gentileschi produced more than one image of Judith), Judith and her maidservant are beheading Holofernes. The drama of the event cannot be evaded—blood spurts everywhere, and the strength necessary to complete the task is evident as the two women struggle with the sword. The tension and strain are palpable. The controlled highlights on the action in the foreground recall Caravaggio's work and heighten the drama here as well.

24-21 ARTEMISIA GENTILESCHI, *Judith Slaying Holofernes*, ca. 1614–1620. Oil on canvas, 6′ 6⅓″ × 5′ 4″. Galleria degli Uffizi, Florence. 🔊

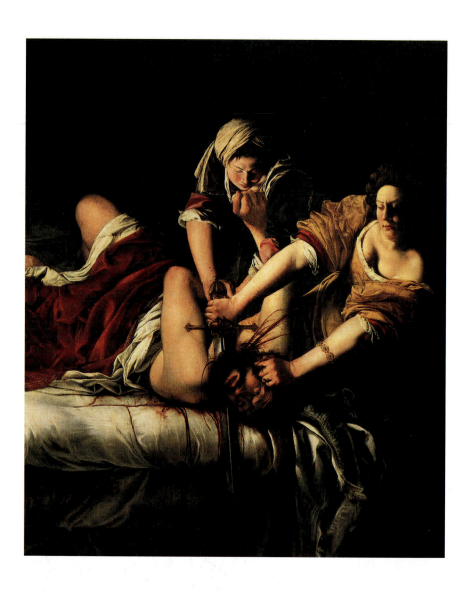

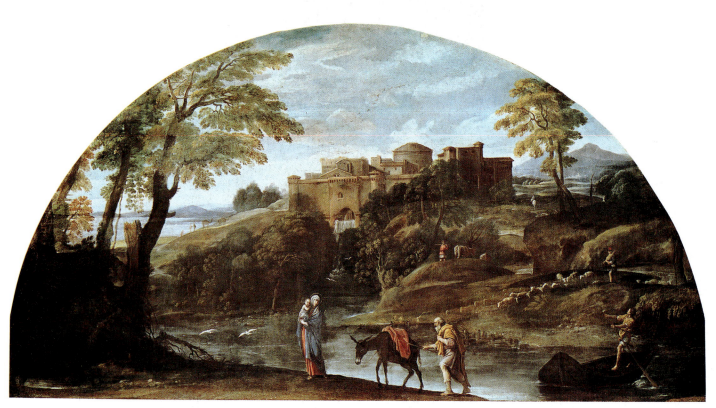

24-22 ANNIBALE CARRACCI, *Flight into Egypt*, 1603–1604. Oil on canvas, approx. 4′ × 7′ 6″. Galleria Doria Pamphili, Rome. 🔊

DRAWN TO THE CLASSICS In contrast to Caravaggio, ANNIBALE CARRACCI (1560–1609) not only studied but also emulated the Renaissance masters carefully. Carracci received much of his training at an academy of art in his native Bologna. Founded cooperatively by his family members, among them his cousin Ludovico Carracci (1555–1619) and brother Agostino Carracci (1557–1602), the Bolognese academy was the first significant institution of its kind in the history of Western art. It was founded on the premises that art can be taught—the basis of any academic philosophy of art—and that its instruction must include the classical and Renaissance traditions in addition to the study of anatomy and life drawing. Thus, in contrast to Caravaggio's more naturalistic style, Carracci embraced a more classically ordered style.

For example, in his *Flight into Egypt* (FIG. **24-22**), based on the biblical narrative from Matthew 2:13–14, Carracci created the "ideal" or "classical" landscape. Here he pictorially represented nature ordered by divine law and human reason. The roots of the style are in the landscape backgrounds of Venetian Renaissance paintings (compare FIG. 22-33). Tranquil hills and fields, quietly gliding streams, serene skies, unruffled foliage, shepherds with their flocks—all the props of the pastoral scene and mood—expand in such paintings to fill the picture space. Carracci regularly included screens of trees in the foreground, dark against the sky's even light. In this scene, streams or terraces, carefully placed one above the other and narrowed, zigzag through the terrain, leading the viewer's eye back to the middle ground. There, many Venetian Renaissance landscape artists depicted architectural structures (as Carracci did in *Flight into Egypt*)—walled towns or citadels, towers, temples, monumental tombs, villas. Such constructed environments captured idealized antiquity and the idyllic life. Although the artists often took the subjects for these classically rendered scenes from religious or heroic stories, they seem to have given precedence to the pastoral landscapes over the narratives. Here, Mary, with the Christ Child, and Saint Joseph are greatly diminished in size, simply becoming part of the landscape as they wend their way slowly to Egypt after having been ferried across a stream.

A CEILING FIT FOR THE GODS Among Carracci's most notable works is his decoration of the Palazzo Farnese gallery (FIG. **24-23**) in Rome. Cardinal Odoardo Farnese, a wealthy descendant of Pope Paul III, commissioned this ceiling fresco to celebrate the

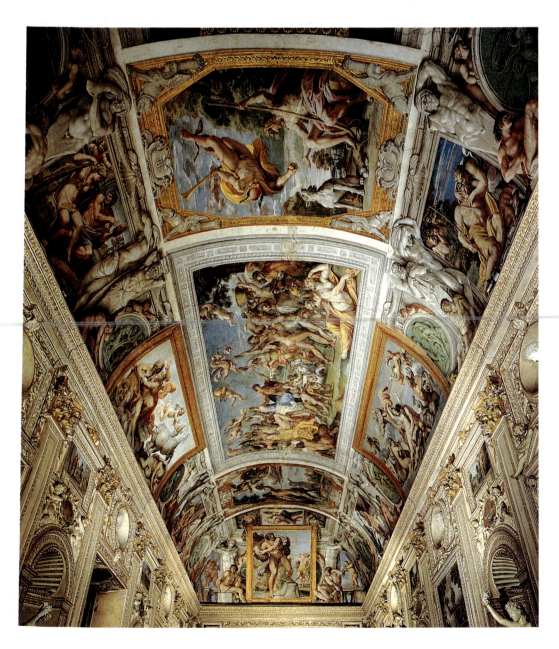

24-23 ANNIBALE CARRACCI, *Loves of the Gods,* ceiling frescoes in the gallery, Palazzo Farnese, Rome, Italy, 1597–1601.

portray the members of the surgeon's guild (who commissioned this group portrait) clustered together on the painting's left side. In the foreground appears the corpse that Dr. Tulp, a noted physician, is in the act of dissecting. Rembrandt diagonally placed and foreshortened the corpse, activating the space by disrupting the strict horizontal, planar orientation found in traditional portraiture. He depicted each of the "students" specifically, and although they wear virtually identical attire, their varying poses and facial expressions suggest unique individuals. In light of the fact that Rembrandt produced this painting when he was 26 and just beginning his career, his innovative approach to group portraiture is all the more remarkable.

AN ENERGETIC GROUP PORTRAIT Rembrandt amplified the complexity and energy of the group portrait in his famous painting of 1642, *The Company of Captain Frans Banning Cocq* (FIG. **24-45**), better known as *Night Watch.* This more commonly used title is, however, a misnomer—the painting is not of a nocturnal scene. Rembrandt used light in a masterful way, and dramatic lighting certainly enhances the image. However, the painting's darkness (which led to the commonly used title) is due more to the varnish the artist used, which has darkened considerably over time, than to the subject depicted.

This painting was one of many civic-guard group portraits produced during this period. From the limited information available about the commission, it appears that Rembrandt was asked to paint the two officers, Captain Frans Banning Cocq and his lieutenant Willem van Ruytenburch, along with 16 members of this militia group (each contributing to Rembrandt's fee). This work was one of six paintings commissioned from different artists around 1640 for the assembly and banquet hall of the new

Kloveniersdoelen (Musketeers' Hall) in Amsterdam. Some scholars have suggested that the occasion for these commissions was the visit of Queen Marie de' Medici to the Dutch city in 1638.

Rembrandt captured the excitement and frenetic activity of the men preparing for the parade. Comparing *The Company of Captain Frans Banning Cocq* to Hals's portrait of the *Archers of Saint Hadrian* (FIG. 24-42), another militia group, reveals Rembrandt's inventiveness in enlivening what was, by then, becoming a conventional portrait format. Rather than present assembled men, the artist chose to portray the company scurrying about in the act of organizing themselves, thereby animating the image considerably. Despite the prominence of the girl just to the left of center, scholars have yet to ascertain definitively her identity.

The large canvas was placed in the designated hall in 1642. Unfortunately, when the painting was subsequently moved in 1715 to the Amsterdam town hall, it was cropped on all sides, leaving viewers today with an incomplete record of the artist's final resolution of the challenge of portraying this group.

CELEBRATING CHRIST'S HUMILITY Rembrandt's interest in probing the states of the human soul was not limited to portraiture. The Calvinist injunctions against religious art did not prevent him from making a series of religious paintings and prints. These images, however, are not the opulent, overwhelming art of Baroque Italy. Rather, his art is that of a committed Christian who desired to interpret biblical narratives in human (as opposed to lofty theological) terms. The spiritual stillness of Rembrandt's religious paintings is that of inward-turning contemplation, far from the choirs and trumpets and the heavenly tumult of Bernini or Pozzo. Rembrandt gives the viewer not the celestial triumph of the Catholic Church but the humanity and humility of Jesus. His psychological insight and

24-45 REMBRANDT VAN RIJN, *The Company of Captain Frans Banning Cocq (Night Watch),* 1642. Oil on canvas (cropped from original size), 11′ 11″ × 14′ 4″. Rijksmuseum, Amsterdam.

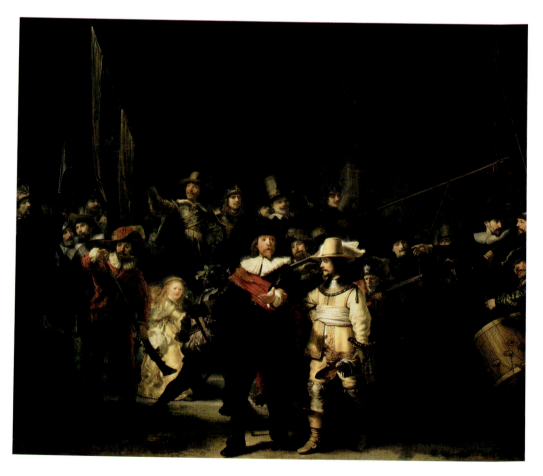

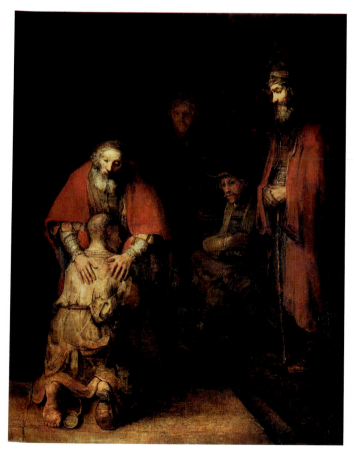

24-46 REMBRANDT VAN RIJN, *Return of the Prodigal Son*, ca. 1665. Oil on canvas, approx. 8′ 8″ × 6′ 9″. Hermitage Museum, Saint Petersburg.

his profound sympathy for human affliction produced, at the very end of his life, one of the most moving pictures in all religious art, *Return of the Prodigal Son* (FIG. **24-46**). Tenderly embraced by his forgiving father, the son crouches before him in weeping contrition, while three figures, immersed to varying degrees in the soft shadows, note the lesson of mercy. The light, everywhere mingled with shadow, directs the viewer's attention by illuminating the father and son and largely veiling the witnesses. Its focus is the beautiful, spiritual face of the old man; secondarily, it touches the contrasting stern face of the foremost witness. *Return* demonstrates the degree to which Rembrandt developed a personal style completely in tune with the simple eloquence of the biblical passage.

LIGHTING THE WAY From the few paintings by Rembrandt discussed thus far, it should be clear that the artist's use of light is among the hallmarks of his style. Rembrandt's pictorial method involved refining light and shade into finer and finer nuances until they blended with one another. Earlier painters' use of abrupt lights and darks gave way, in the work of artists such as Rembrandt and Velázquez, to gradation. Although these later artists may have sacrificed some of the dramatic effects of sharp chiaroscuro, a greater fidelity to actual appearances offset those sacrifices. This technique is closer to reality because the eyes perceive light and dark not as static but as always subtly changing.

Generally speaking, Renaissance artists represented forms and faces in a flat, neutral modeling light (even Leonardo's shading is of a standard kind). They represented the *idea* of light, rather than the actual look of it. Artists such as Rembrandt discovered degrees of light and dark, degrees of differences in pose, in the movements of facial features, and in psychic states. They arrived

at these differences optically, not conceptually or in terms of some ideal. Rembrandt found that by manipulating the direction, intensity, distance, and surface texture of light and shadow, he could render the most subtle nuances of character and mood, both in persons and whole scenes. He discovered for the modern world that variation of light and shade, subtly modulated, could be read as emotional differences. In the visible world, light, dark, and the wide spectrum of values between the two are charged with meanings and feelings that sometimes are independent of the shapes and figures they modify. The theater and the photographic arts have used these discoveries to great dramatic effect.

Rembrandt carried over the spiritual quality of his religious works into his later portraits by the same means—what could be called the "psychology of light." Light and dark are not in conflict in his portraits—they are reconciled, merging softly and subtly to produce the visual equivalent of quietness. Their prevailing mood is that of tranquil meditation, of philosophical resignation, of musing recollection—indeed, a whole cluster of emotional tones heard only in silence.

AN ILLUMINATING SELF-PORTRAIT In a self-portrait (FIG. **24-47**) produced late in Rembrandt's life, the light that shines from the upper left of the painting bathes the subject's face in soft light, leaving the lower part of his body in shadow. The artist depicted himself here as possessing dignity and strength, and the portrait can be seen as a summary of the many stylistic and professional concerns that occupied him throughout his career. Rembrandt's distinctive use of light is evident, as is the assertive brushwork that suggests a confidence and self-assurance. He presented himself as a working artist holding his brushes, palette,

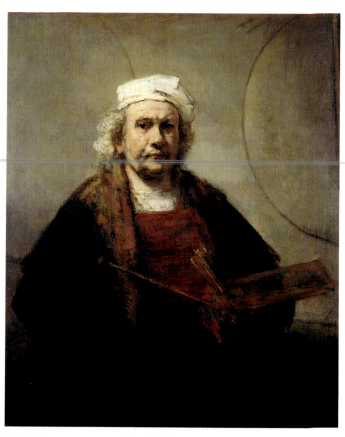

24-47 REMBRANDT VAN RIJN, *Self-Portrait*, ca. 1659–1660. Oil on canvas, approx. 3′ 8¾″ × 3′ 1″. The Iveagh Bequest, Kenwood House, London.

treason. Eventually, the state gave him a public funeral and memorialized him. In the foreground, the hero's body is being taken away, his burial on Athenian soil initially forbidden. The two massive bearers and the bier are starkly isolated in a great landscape that throws them into solitary relief, eloquently expressive of the hero abandoned in death. The landscape's interlocking planes slope upward to the lighted sky at the left. Its carefully arranged terraces bear slowly moving streams, shepherds and their flocks, and, in the distance, whole assemblies of solid geometric structures (temples, towers, walls, villas, and a central grand sarcophagus). The skies are untroubled, and the light is even and revealing of form. The trees are few and carefully arranged, like curtains lightly drawn back to reveal a natural setting carefully cultivated for a single human action. Unlike van Ruisdael's *View of Haarlem* (FIG. 24-51), this scene was not intended to represent a particular place and time. It was Poussin's construction of an idea of a noble landscape to frame a noble theme, much like Annibale Carracci's classical landscape (FIG. 24-22). The *Phocion* landscape is nature subordinated to a rational plan.

A LANDSCAPIST PAR EXCELLENCE Claude Gellée, called CLAUDE LORRAIN (1600–1682), modulated in a softer style the disciplined rational art of Poussin, with its sophisticated revelation of the geometry of landscape. Unlike the figures in Poussin's pictures, those in Claude's landscapes tell no dramatic story, point out no moral, and praise no hero. Indeed, they often appear to be added as mere excuses for the radiant landscape itself.

For Claude, painting involved essentially one theme—the beauty of a broad sky suffused with the golden light of dawn or sunset glowing through a hazy atmosphere and reflecting brilliantly off rippling water.

The subject of his work often remains grounded in classical antiquity, as seen in *Landscape with Cattle and Peasants* (FIG. **24-60**). The figures in the right foreground chat in animated fashion; in the left foreground, cattle relax contentedly; and in the middle ground, cattle amble slowly away. The well-defined foreground, distinct middle ground, and dim background recede in serene orderliness, until all form dissolves in a luminous mist. Atmospheric and linear perspective reinforce each other to turn a vista into a typical Claudian vision, an ideal classical world bathed in sunlight in infinite space.

Claude's formalizing of nature with balanced groups of architectural masses, screens of trees, and sheets of water followed the great tradition of classical landscape. It began with the backgrounds of Venetian painting (see FIGS. 22-32 and 22-33) and continued in the art of Annibale Carracci (FIG. 24-22) and Poussin (FIG. 24-59). Yet Claude, like the Dutch painters, studied the actual light and the atmospheric nuances of nature, making a unique contribution. He recorded carefully in hundreds of sketches the look of the Roman countryside, its gentle terrain accented by stone-pines, cypresses, and poplars and by the ever-present ruins of ancient aqueducts, tombs, and towers. He made these the fundamental elements of his compositions. Travelers could understand the picturesque beauties of the outskirts of Rome in Claude's landscapes.

24-60 CLAUDE LORRAIN, *Landscape with Cattle and Peasants,* 1629. Oil on canvas, 3′ 6″ × 4′ 10½″. Philadelphia Museum of Art, Philadelphia (the George W. Elkins Collection).

The artist achieved his marvelous effects of light by painstakingly placing tiny value gradations, which imitated, though on a very small scale, the actual range of values of outdoor light and shade. Avoiding the problem of high-noon sunlight overhead, Claude preferred, and convincingly represented, the sun's rays as they gradually illuminated the morning sky or, with their dying glow, set the pensive mood of evening. Thus, he matched the moods of nature with those of human subjects. Claude's infusion of nature with human feeling and his recomposition of nature in a calm equilibrium greatly appealed to the landscape painters of the 18th and early 19th centuries.

A DIGNIFIED AND ORDERED BUILDING In architecture, the classical bent asserted itself early in the work of FRANÇOIS MANSART (1598–1666), as seen in the Orléans wing of the Château de Blois (FIG. **24-61**), built in Blois between 1635 and 1638. The polished dignity evident here became the hallmark of French "Classical-Baroque," contrasting with the more daring and fanciful styles of the Baroque in Italy and elsewhere. The strong rectilinear organization and a tendency to design in repeated units suggest Italian Renaissance architecture (also permeated by the classical spirit), as do the insistence on the purity of line and the sharp relief of the wall joints. Yet the emphasis on focal points—achieved with the curving colonnades, the changing planes of the walls, and the concentration of ornament around the portal—is characteristic of French Baroque architectural thinking in general.

THE HARDSHIP OF PEASANT LIFE Although classicism was an important presence in French art during the 17th and early 18th centuries, not all artists pursued this direction. LOUIS LE NAIN (ca. 1593–1648) bears comparison to the Dutch. Subjects that in Dutch painting were opportunities for boisterous good humor were treated with somber stillness by the French. *Family of Country People* (FIG. **24-62**) expresses the grave dignity of a family close to the soil, one made stoic and resigned by hardship. These drab country folk surely had little reason for merriment. The peasant's lot, never easy, was miserable during the time Le Nain painted. The constant warfare (*Family* was painted during the Thirty Years' War) took its toll on France. The anguish and

frustration of the peasantry, suffering from the cruel depredations of unruly armies living off the country, often broke out in violent revolts that were savagely suppressed. This family, however, is pious, docile, and calm. Because Le Nain depicted peasants with dignity and subservience, despite their harsh living conditions, some scholars have suggested that he intended to please wealthy urban patrons with these paintings. Like Annibale Carracci, Le Nain worked cooperatively with family members—in Le Nain's case, his brothers Antoine (1588–1648) and Mathieu (1607–1677). They established a communal workshop and apparently collaborated on some paintings. For the most part, the Le Nain brothers focused on genre scenes.

A STARK ETCHING OF DEATH Although the Duchy of Lorraine was technically independent from the French monarchy during this period, artists from this region are often included in discussions of French art. Two prominent artists from Lorraine were Jacques Callot and Georges de La Tour. JACQUES CALLOT (ca. 1592–1635) conveyed a sense of military life of the times in a series

24-62 LOUIS LE NAIN, *Family of Country People*, ca. 1640. Oil on canvas, approx. 3′ 8″ × 5′ 2″. Louvre, Paris.

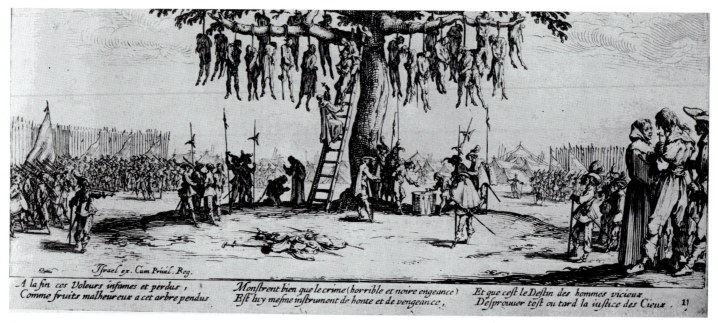

24-63 JACQUES CALLOT, *Hanging Tree,* from the *Large Miseries of War* series, 1633. Etching, 3¾″ × 7¼″. Bibiliothèque Nationale, Paris.

of etchings called *Large Miseries of War.* Callot confined himself almost exclusively to the art of etching and was widely influential in his own time and since; Rembrandt was among those who knew and learned from his work. Callot perfected the medium and the technique of etching, developing a very hard surface for the copper plate to permit fine and precise delineation with the needle. In one small print, he assembled as many as 1,200 figures, which the viewer can discern only through close scrutiny. His quick, vivid touch and faultless drawing produced panoramas sparkling with sharp details of life—and death. In the *Large Miseries of War* series, he observed these details coolly, presenting without comment images based on events he himself must have seen in the wars in Lorraine.

In one etching, he depicted a mass execution by hanging (FIG. **24-63**). The unfortunates in *Hanging Tree* are thieves (identified as such by the text added to the bottom of the print in its second state by Michel de Marolles and approved by Callot). The event takes place in the presence of a disciplined army, drawn up on parade with banners, muskets, and lances, their tents in the background. Hanged men sway in clusters from the branches of a huge cross-shaped tree. A monk climbs a ladder, holding up a crucifix to a man while the executioner adjusts the noose around the man's neck. At the foot of the ladder, another victim kneels to receive absolution. Under the crucifix tree, men roll dice on a drumhead for the belongings of the executed. (This may be an allusion to the soldiers who cast lots for the garments of the crucified Christ.) In the right foreground, a hooded priest consoles a bound man. Callot's *Large Miseries of War* were among the first realistic pictorial records of the human disaster of armed conflict.

REALISM, SPIRITUALISM, CLASSICISM Because of the prominence of religious issues and the value Catholics placed on the didactic capabilities of art (as in Baroque Italy), religious art did have a presence in France. Among the artists well known for their religious imagery was the painter GEORGES DE LA TOUR (1593–1652). His work, particularly his use of light, suggests a familiarity with Caravaggio's art. La Tour may have learned about Caravaggio from the Dutch school of Utrecht. Although La Tour used the devices of the northern Caravaggisti, his effects are strikingly different from theirs. His *Adoration of the Shepherds* (FIG. **24-64**) makes use of the night setting favored by that school, much as van Honthorst (FIG.

24-41) portrayed it. But here, the light, its source shaded by an old man's hand, falls upon a very different company in a very different mood. A group of humble men and women, coarsely clad, gather in prayerful vigil around a luminous baby Jesus. Without the aid of the title, this might be construed as a genre piece, a narrative of some event from peasant life. Nothing in the environment, placement, poses, dress, or attributes of the figures distinguishes them as the scriptural Virgin Mary, Joseph, Christ Child, or shepherds. The artist did not portray halos, choirs of angels, stately architecture, or resplendent grandees. The light is not spiritual but material; it comes from a candle. La Tour's scientific scrutiny of the effects of material light, as it throws precise shadows on surfaces that intercept it, nevertheless had religious intention and consequence. The light illuminates a group of ordinary people held in a mystic trance induced by their witnessing the miracle of the Incarnation. In this timeless tableau of simple people, La Tour eliminated the dogmatic significance and traditional iconography of the Incarnation. Still, these people reverently contemplate something they regard as holy. It is

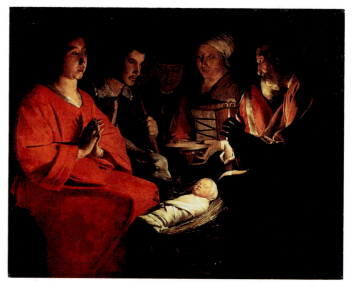

24-64 GEORGES DE LA TOUR, *Adoration of the Shepherds,* 1645–1650. Oil on canvas, approx. 3′ 6″ × 4′ 6″. Louvre, Paris.

clear that the painting is readable to the devout of any religious persuasion, whether or not they know of this central mystery of the Christian faith.

The supernatural calm that pervades this picture is characteristic of the mood of Georges de La Tour's art. He achieved this by eliminating motion and emotive gesture (only the light is dramatic), by suppressing surface detail, and by simplifying body volumes. These stylistic traits are among those associated with classical art and art based on classical principles—for example, that of Piero della Francesca (see FIGS. 21-49 and 21-50). Several apparently contrary elements meet in the work of La Tour: classical composure, fervent spirituality, and genre realism.

ART IN THE SERVICE OF ABSOLUTISM Perhaps the preeminent patron of the period was King Louis XIV. Determined to consolidate and expand his power, Louis XIV was a master of political strategy and propaganda. He ensured subservience by anchoring his rule in divine right (a belief in a king's absolute power as God's will), rendering Louis's authority incontestable. So convinced was he of his importance and centrality to the French kingdom that he eagerly adopted the nickname "le Roi Soleil" ("the Sun King"). Like the sun, Louis was the center of the universe. He also established a carefully crafted and nuanced relationship with the nobility. He allowed nobles sufficient benefits to keep them pacified but simultaneously maintained rigorous control to avoid insurrection or rebellion.

Louis's desire for control extended to all realms of French life, including art. Louis XIV and his principal adviser, Jean-Baptiste Colbert (1619–1683), were determined to organize art and architecture in the service of the state. The king understood well the power of art as propaganda and the value of visual imagery for cultivating a public persona, and no pains were spared to raise great symbols and monuments to the king's absolute power. The efforts of Louis XIV and Colbert to regularize taste were furthered by the foundation of the Royal Academy of Painting and Sculpture in 1648, which served to accelerate the establishment of the French classical style.

The portrait of Louis XIV (FIG. 24-65) by HYACINTHE RIGAUD (1659–1743) conveys the image of an absolute monarch in control. The king, 63 when this work was painted, looks out at the viewer with directness. The suggestion of haughtiness is perhaps

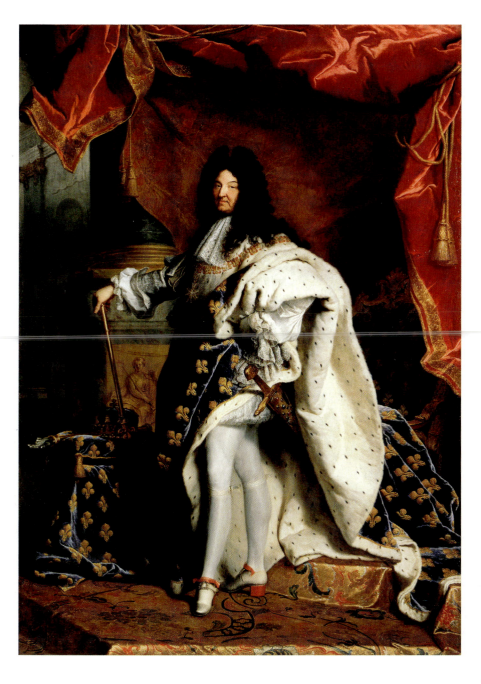

24-65 HYACINTHE RIGAUD, *Louis XIV*, 1701. Oil on canvas, approx. 9′ 2″ × 6′ 3″. Louvre, Paris.

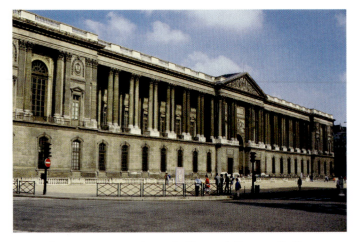

24-66 CLAUDE PERRAULT, LOUIS LE VAU, and CHARLES LE BRUN, east facade of the Louvre, Paris, France, 1667–1670.

due to the pose—Louis XIV stands with his left hand on his hip and with his elegant ermine-lined coronation robes thrown over his shoulder. This portrait's majesty is also derived from the composition. The king is the unmistakable focal point of the image, and the artist placed him so that he seems to look down on the viewer. Given that Louis XIV was very short in stature—only five feet, four inches, a fact that drove him to invent the red-heeled shoes he wears in the portrait—it seems the artist catered to his patron's wishes. The carefully detailed environment in which the king stands also contributes to the painting's stateliness and

grandiosity. So insistent was Louis XIV that the best artists serve his needs that he maintained a workshop of artists, each with a specialization—faces, fabric, architecture, landscapes, armor, or fur. Thus, many of the king's portraits were a group effort.

THE NEW OFFICIAL FRENCH TASTE Once young Louis XIV had formally ascended to power, the first project he and his adviser Colbert undertook was the closing of the east side of the Louvre court, left incomplete by Lescot in the 16th century. Bernini, as the most renowned architect of his day, was summoned from Rome to submit plans, but he envisioned an Italian palace on a monumental scale that would have involved the demolition of all previous work. His plan rejected, Bernini returned to Rome in high indignation. Instead, the Louvre's east facade (FIG. **24-66**) was a collaboration among CLAUDE PERRAULT (1613–1688), LOUIS LE VAU (1612–1670), and CHARLES LE BRUN (1619–1690). The design is a brilliant synthesis of French and Italian classical elements, culminating in a new and definitive formula. The French pavilion system was retained. The central pavilion is in the form of a classical temple front, and a giant colonnade of paired columns, resembling the columned flanks of a temple folded out like wings, is contained by the two salient pavilions at both ends. The whole is mounted on a stately basement, or podium. The designers favored an even roofline, balustraded and broken only by the central pediment, over the traditional French pyramidal roof. The emphatically horizontal sweep of this facade brushed aside all memory of Gothic verticality. Its stately proportions and monumentality were both an expression of the new official French taste and a symbol of centrally organized authority.

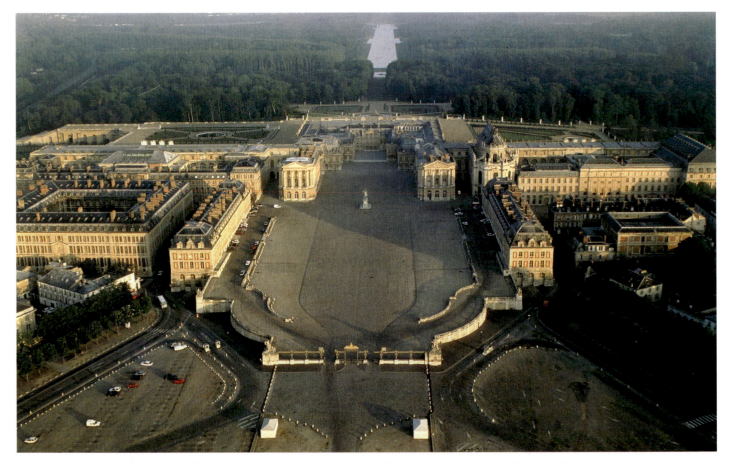

24-67 Aerial view of palace at Versailles, France, begun 1669, and a portion of the gardens and surrounding area. The white rectangle in the lower part of the plan (FIG. 24-68) outlines the area shown here.

FROM HUNTING LODGE TO PALACE Work on the Louvre hardly had begun when Louis XIV decided to convert a royal hunting lodge at Versailles, a few miles outside Paris, into a great palace. A veritable army of architects, decorators, sculptors, painters, and landscape architects was assembled under the general management of Charles Le Brun, a former student of Poussin. In their hands, the conversion of a simple lodge into the palace of Versailles (FIGS. **24-67** and **24-68**) became the greatest architectural project of the age—a defining statement of French Baroque style and an undeniable symbol of Louis XIV's power and ambition.

Planned on a gigantic scale, the project called not only for a large palace flanking a vast park but also for the construction of a satellite city to house court and government officials, military and guard detachments, courtiers, and servants (undoubtedly to keep them all under the king's close supervision). This town was laid out to the east of the palace along three radial avenues that converge on the palace structure itself; their axes, in a symbolic assertion of the ruler's absolute power over his domains, intersected in the king's bedroom. (As the site of the king's morning levee, this bedroom was actually an audience room, a state chamber.) The palace itself, more than a quarter of a mile long, was placed at right angles to the dominant east-west axis that runs through city and park.

Careful attention was paid to every detail of the extremely rich decoration of the palace's interior. The architects and decorators designed everything from wall paintings to doorknobs, to reinforce the splendor of Versailles and to exhibit the very finest sense of artisanship. Of the literally hundreds of rooms within the

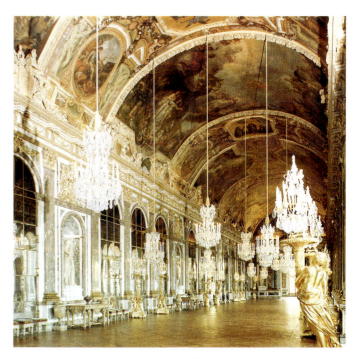

24-69 JULES HARDOUIN-MANSART and CHARLES LE BRUN, Galerie des Glaces (Hall of Mirrors), palace of Versailles, Versailles, France, ca. 1680.

palace, the most famous is the Galerie des Glaces, or Hall of Mirrors (FIG. **24-69**), designed by JULES HARDOUIN-MANSART (1646–1708) and Charles Le Brun. This hall overlooks the park from the second floor and extends along most of the width of the central block. Although deprived of its original sumptuous furniture, which included gold and silver chairs and bejeweled trees, the Galerie des Glaces retains much of its splendor today. Its tunnel-like quality is alleviated by hundreds of mirrors, set into the wall opposite the windows, that illusionistically extend the width of the room. The mirror, that ultimate source of illusion, was a favorite element of Baroque interior design; here, it also enhanced the dazzling extravagance of the great festivals Louis XIV was so fond of hosting.

CONTROLLING NATURE The enormous palace might appear unbearably ostentatious were it not for its extraordinary setting in the vast park that makes it almost an adjunct. The Galerie des Glaces is dwarfed by the sweeping vista (seen from its windows) down the park's tree-lined central axis and across terraces, lawns, pools, and lakes toward the horizon. The park of Versailles, designed by ANDRÉ LE NÔTRE (1613–1700), must rank among the world's greatest artworks in both size and concept. Here, an entire forest was transformed into a park. Although the geometric plan (FIG. 24-68) may appear stiff and formal, the park in fact offers an almost unlimited variety of vistas, as Le Nôtre used not only the multiplicity of natural forms but also the terrain's slightly rolling contours with stunning effectiveness.

The formal gardens near the palace provide a rational transition from the frozen architectural forms to the natural living ones. Here, the elegant forms of trimmed shrubs and hedges define the tightly designed geometric units. Each unit is different from its neighbor and has a focal point in the form of a sculptured group, a pavilion, a reflecting pool, or perhaps a fountain. Farther away from the palace, the design loosens as trees, in shadowy masses, screen or frame views of open countryside. Le Nôtre carefully composed all vistas for maximum effect. Dark

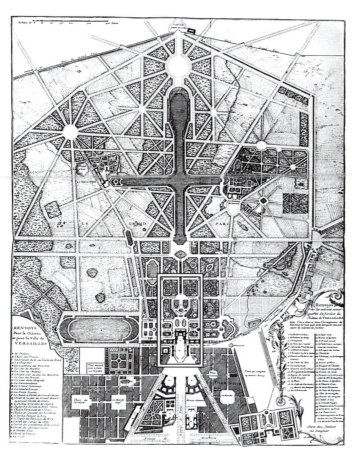

24-68 Plan of the park, palace, and town of Versailles, France (after a 17th-century engraving by FRANÇOIS BLONDEL). The area outlined in the white rectangle (lower center) is shown in FIG. 24-67.

24-73 Inigo Jones, Banqueting House at Whitehall, London, England, 1619–1622.

A TOWERING ARCHITECTURAL TALENT Until almost the present, the dominant feature of the London skyline was the majestic dome of Saint Paul's Cathedral (FIG. 24-74), the work of England's most renowned architect, CHRISTOPHER WREN (1632–1723). A mathematical genius and skilled engineer whose work won Isaac Newton's praise, Wren was appointed professor of astronomy in London at age 25. Mathematics led to architecture, and Charles II asked Wren to prepare a plan for restoring the old Gothic church of Saint Paul. Wren proposed to remodel the building based on Roman structures. Within a few months, the

24-74 SIR CHRISTOPHER WREN, new Saint Paul's Cathedral, London, England, 1675–1710.

Great Fire of London, which destroyed the old structure and many churches in the city in 1666, gave Wren his opportunity. He built not only the new Saint Paul's but numerous other churches as well.

Although Wren was strongly influenced by Jones's work, he also traveled in France, where he must have been much impressed by the splendid palaces and state buildings being created in and around Paris at the time of the competition for the Louvre design. Wren also must have closely studied prints illustrating Baroque architecture in Italy, for he harmonized Palladian, French, and Italian Baroque features in Saint Paul's.

In view of its size, the cathedral was built with remarkable speed—in a little more than 30 years—and Wren lived to see it completed. The building's form was constantly refined as it went up, and the final appearance of the towers was not determined until after 1700. In the splendid skyline composition, two foreground towers act effectively as foils to the great dome. This must have been suggested to Wren by similar schemes that Italian architects devised for Saint Peter's in Rome (see FIGS. 22-29 and 24-2) to solve the problem of the relationship between the facade and dome. Certainly, the upper levels and lanterns of the towers are Borrominesque (FIG. 24-12), the lower levels are Palladian, and the superposed paired columnar porticos recall the Louvre facade (FIG. 24-66). Wren's skillful eclecticism brought all these foreign features into a monumental unity.

Wren's designs for the city churches were masterpieces of careful planning and ingenuity. His task was never easy, for the churches often had to be fitted into small, irregular areas. Wren worked out a rich variety of schemes to meet awkward circumstances. When designing the church exteriors, he concentrated his attention on the towers, the one element that would set the building apart from its crowding neighbors. The skyline of London, as Wren left it, is punctuated with such towers, which served as prototypes for later buildings both in England and in colonial America.

LATE BAROQUE ART OF THE EARLY 18TH CENTURY

Late Baroque Architecture in England

A SPLENDID COUNTRY HOUSE In 1705, while Saint Paul's was being completed, the British government commissioned a monumental palace in Oxfordshire, Blenheim (FIG. **24-75**), for John Churchill, duke of Marlborough. The palace was a reward for Churchill's military exploits; people throughout the country acclaimed his victory over the French in 1704 at the Battle of Blenheim during the War of the Spanish Succession. Designed by JOHN VANBRUGH (1664–1726), Blenheim was one of the largest of the splendid country houses built during the period of prosperity resulting from Great Britain's expansion into the New World. At that time, a small group of architects associated with the aging Sir Christopher Wren was responsible for briefly returning Italian Baroque complexity to favor over the streamlined Palladian classicism of Inigo Jones. Vanbrugh was the best known of this group. The picturesque silhouette he created for Blenheim,

24-75 JOHN VANBRUGH, Blenheim Palace, Oxfordshire, England, 1705–1722.

Indian Miniature Painting

Although India had a tradition of mural painting going back to ancient times (see "The Painted Caves of Ajanta," Chapter 6, page 177, and FIG. 6-14), the most popular form of painting under the Mughal emperors (FIGS. 25-3 and 25-4) and Rajput kings (FIG. 25-6) was *miniature painting*. Art historians call these paintings "miniatures" because of their small size (about the size of a page in this book) compared to that of paintings on walls, wooden panels, or canvas. Indian miniatures were designed to be held in the hands, either as illustrations in books or as loose-leaf pages in albums. Owners did not place Indian miniatures in frames and only very rarely hung them on walls.

Indian artists used opaque watercolors and paper (occasionally cotton cloth) to produce their miniatures. The manufacturing and painting of miniatures was a complicated process and required years of training as an apprentice in a workshop. The painters' assistants created pigments by grinding natural materials—minerals such as malachite for green and lapis lazuli for blue; earth ochers for red and yellow; and metallic foil for gold, silver, and copper. They fashioned brushes from bird quills and kitten or baby squirrel hairs.

The artist began the painting process by making a full-size sketch of the composition. The artist then transferred the sketch onto paper by *pouncing,* or tracing, using thin, transparent gazelle skin placed on top of the drawing and pricking the contours of the design with a pin. Then, with the skin laid on a fresh sheet of fine paper, the painter forced black pigment through the tiny holes, reproducing the outlines of the composition. Painting proper started with the darkening of the outlines with black or reddish brown ink. Painters of miniatures sat on the ground, resting their painting boards on one raised knee. The paintings usually required several layers of color, with gold always applied last. The final step was to burnish the painted surface. The artists accomplished this by placing the miniature, painted side down, on a hard, smooth surface and stroking the paper with polished agate or crystal.

25-3 BASAWAN and CHATAR MUNI, *Akbar and the Elephant Hawai,* folio 22 from the *Akbarnama (History of Akbar)* by Abul Fazl, ca. 1590. Opaque watercolor on paper, $1' 1\frac{7}{8}'' \times 8\frac{3}{4}''$. Victoria and Albert Museum, London.

emperor's personal copy of the *Akbarnama* was a collaborative effort between the painter BASAWAN, who designed and drew the composition, and CHATAR MUNI, who colored it. The painting depicts the episode of Akbar and Hawai (FIG. **25-3**), a wild elephant that the 19-year-old ruler mounted and pitted against another ferocious elephant. When the second animal fled in defeat, Hawai, still carrying Akbar, chased it to a pontoon bridge. The enormous weight of the elephants capsized the boats, but Akbar managed to bring Hawai under control and dismount safely. The young ruler viewed the episode as an allegory of his ability to govern— that is, to take charge of an unruly state.

For his pictorial record of that frightening day, Basawan chose the moment of maximum chaos and danger—when the elephants crossed the pontoon bridge, sending boatmen flying into the water. The composition is a bold one, with a very high horizon and two strong diagonal lines formed by the bridge and the shore. Together these devices tend to flatten out the vista, yet at the same time Basawan created a sense of depth by diminishing the size of the figures in the background. He was also a master of vivid gestures and anecdotal detail. Note especially the bare-chested figure in the foreground clinging to the end of a boat, the figure near the lower right corner with outstretched arms sliding into the water as the bridge becomes submerged, and the oarsman just beyond the bridge who strains to steady his vessel while his three passengers stand up or lean overboard in reaction to the commotion all around them.

THE EMPEROR ABOVE TIME That the names Basawan and Chatar Muni are known is significant in itself. In contrast to the anonymity of artists in the Hindu and Buddhist traditions, many artists working for the Islamic Mughal emperors signed their work. Another of these was BICHITR, whom Akbar's son and successor, Jahangir (r. 1605–1627), employed in the imperial workshop. The Mughals presided over a cosmopolitan court with refined tastes. After the establishment of the East India Company in 1600 (see page 755), British ambassadors and merchants were frequent visitors to the Mughal capital, and Jahangir, like his father, acquired many luxury goods from Europe, including globes, hourglasses, prints, and portraits.

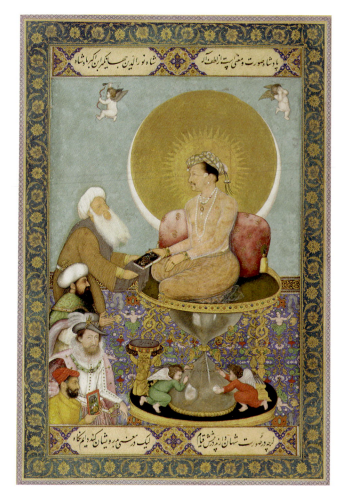

25-4 BICHITR, *Jahangir Preferring a Sufi Shaykh to Kings*, ca. 1615–1618. Opaque watercolor on paper, 1′ 6⅞″ × 1′ 1″. Freer Gallery of Art, Washington, D.C.

The impact of European as well as Persian styles on Mughal painting under Jahangir is evident in Bichitr's allegorical portrait of Jahangir seated on an hourglass throne (FIG. 25-4), a miniature from an album made for the emperor around 1615–1618. As the

sands of time run out, two Cupids (clothed, unlike their European models more closely copied at the top of the painting) inscribe the throne with the wish that Jahangir would live a thousand years. Bichitr portrayed his patron as an emperor above time and also placed behind Jahangir's head a radiant halo combining a golden sun and a white crescent moon, indicating that Jahangir is the center of the universe and its light source. One of the inscriptions on the painting gives the emperor's title as "Light of the Faith."

At the left are four figures. The lowest, both spatially and in the social hierarchy, is the Hindu painter Bichitr himself, wearing a red turban. He holds a miniature representing two horses and an elephant, costly gifts from Jahangir, and another self-portrait. In the miniature-within-the-miniature, Bichitr bows deeply before the emperor. In the larger painting, the artist signed his name across the top of the footstool Jahangir uses to step up to his hourglass throne. Thus, the ruler steps on Bichitr's name, further indicating the painter's inferior status.

Above Bichitr is a portrait in full European style (compare FIGS. 23-10 and 23-11) of King James I of England (r. 1603–1625), copied from a painting by John de Critz that the English ambassador to the Mughal court had given as a gift to Jahangir. Above the king is a Turkish sultan, a convincing study of physiognomy, but probably not a specific portrait. The highest member of the foursome is an elderly Muslim Sufi *shaykh* (mystic saint). Jahangir's father, Akbar, had gone to the mystic to pray for an heir. The current emperor, the answer to Akbar's prayers, presents the holy man with a sumptuous book as a gift. An inscription explains that "although to all appearances kings stand before him, Jahangir looks inwardly toward the dervishes [Islamic holy men]" for guidance. Bichitr's allegorical painting portrays his emperor in both words and pictures as favoring spiritual over worldly power.

A MAUSOLEUM IN PARADISE Monumental tombs were not part of either the Hindu or Buddhist traditions, but had a long history in Islamic architecture. The Delhi sultans had erected tombs in India, but none could compare in grandeur to the fabled Taj Mahal at Agra (FIG. 25-5). Shah Jahan (r. 1628–1658), Jahangir's son, built the immense mausoleum as a memorial to

25-5 Taj Mahal, Agra, India, 1632–1647.

26-6 Wangshi Yuan (Garden of the Master of the Fishing Nets), Suzhou, Jiangsu Province, China, Ming dynasty, 16th century and later.

26-7 Liu Yuan (Lingering Garden), Suzhou, Jiangsu Province, China, Ming dynasty, 16th century and later.

More gates and a series of courtyards and imposing buildings, all erected using the traditional Chinese bracketing system (see "Chinese Wooden Construction," Chapter 7, page 200), led eventually to the Hall of Supreme Harmony, perched on an immense platform above marble staircases, the climax of a long north-south axis. Within the hall, the emperor sat on his throne on another high stepped platform.

THE GARDENS OF SUZHOU At the opposite architectural pole from the formality and rigid axiality of palace architecture is the Chinese pleasure garden. Several Ming gardens at Suzhou have been meticulously restored, including the huge (almost 54,000 square feet) Wangshi Yuan (Garden of the Master of the Fishing Nets; FIG. **26-6**). Designing a Ming garden was not a matter of cultivating plants in rows or of laying out terraces, flower beds, and avenues in geometric fashion, as was the case in many other cultures (compare, for example, the 17th-century French gardens at Versailles, FIGS. 24-67 and 24-68). Instead, the gardens are often scenic arrangements of natural and artificial elements intended to reproduce the irregularities of uncultivated nature. Verandas and pavilions rise on pillars above the water, and stone bridges, paths, and causeways encourage wandering through ever-changing vistas of trees, flowers, rocks, and their reflections in the ponds. The typical design is a sequence of carefully contrived visual surprises.

A favorite garden element, fantastic rockwork, may be seen at Liu Yuan (Lingering Garden; FIG. 26-7) in Suzhou. The stones were dredged from nearby Lake Tai and then shaped by sculptors to create an even more natural look. The Ming gardens of Suzhou were the pleasure retreats of high officials and the landed gentry,

Lacquered Wood

acquer is produced from the sap of the Asiatic sumac tree, native to central and southern China. From ancient times it was used to cover wood, because when it dries, it cures to great hardness and prevents the wood from decaying. Often colored with mineral pigments, lacquered objects have a lustrous surface that transforms the appearance of natural wood. The earliest examples of lacquered wood to survive in quantity date to the Eastern Zhou period (770–256 BCE).

The first step in producing a lacquered object is to heat and purify the sap. Then the lacquer worker mixes the minerals—carbon black and cinnabar red are the most common—into the sap. To apply the lacquer, the artisan uses a hair brush similar to a calligrapher's or painter's brush. The lacquer goes on one layer at a time. Then it must dry and be sanded before another coat can be applied. If a sufficient number of layers is built up, the lacquer can be carved as if it were the wood itself (FIG. 26-8).

Other techniques for decorating lacquer include inlaying metals and lustrous materials, such as mother-of-pearl, and sprinkling gold powder into the still-wet lacquer. Such techniques also flourished in both Korea and Japan (see FIG. 27-9).

sanctuaries where the wealthy could commune with nature in all its representative forms and as an ever-changing and boundless presence. Chinese poets never cease to sing of the restorative effect of gardens on mind and spirit.

THE ART OF LACQUER The Ming court's lavish appetite for luxury goods gave new impetus to brilliant technical achievement in the decorative arts. Like the Yuan rulers, the Ming emperors turned to the Jingdezhen kilns for fine porcelains. For objects in lacquered wood (see "Lacquered Wood," above), their patronage went to a large workshop known today as the Orchard Factory. One of its masterpieces is a table with drawers (FIG. **26-8**)

made between 1426 and 1435. The artist carved floral motifs, along with the dragon and phoenix imperial emblems, into the thick cinnabar-colored lacquer, which had to be built up in numerous layers.

MING COURT PAINTING At the Ming court, the official painters were housed in the Forbidden City itself, and portraiture of the imperial family was their major subject. The court artists also depicted historical figures as exemplars of virtue, wisdom, or heroism. An exceptionally large example of Ming history painting is a hanging scroll that SHANG XI (active in the second quarter of the 15th century) painted around 1430. *Guan Yu Captures*

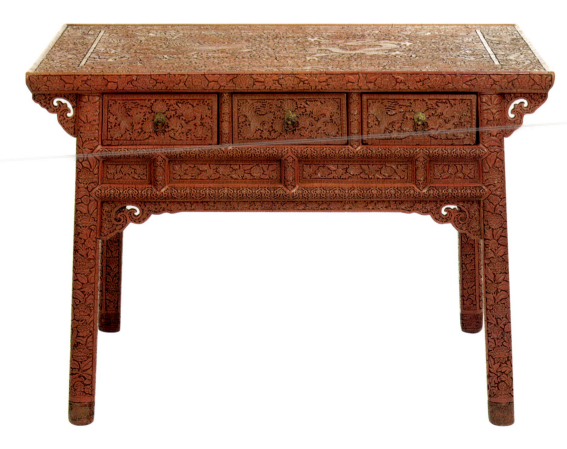

26-8 Table with drawers, Ming dynasty, ca. 1426–1435. Carved red lacquer on a wood core, 3′ 11″ long. Victoria and Albert Museum, London.

26-9 SHANG XI, *Guan Yu Captures General Pang De,* Ming dynasty, ca. 1430. Hanging scroll, ink and colors on silk, 6′ 5″ × 7′ 7″. Palace Museum, Beijing.

General Pang De (FIG. **26-9**) represents an episode from the tumultuous third century (Period of Disunity; see Chapter 7), whose wars inspired one of the first great Chinese novels, *The Romance of the Three Kingdoms.* Guan Yu was a famed general of the Wei dynasty (220–280) and a fictional hero in the novel. The painting depicts the historical Guan Yu, renowned for his loyalty to his emperor and his military valor, being presented with the captured enemy general Pang De. In his painting, Shang Xi uses color to focus attention on Guan Yu and his attendants, who stand out sharply from the ink landscape. He also contrasts the victors' armor and bright garments with the vulnerability of the captive, who has been stripped almost naked, further heightening his humiliation.

MING LITERATI The work of Shang Xi and other professional court painters, designed to promote the official Ming ideology, is far removed from the venerable tradition of literati painting, which also flourished during the Ming dynasty, but, as under the Yuan emperors, was largely independent of court patronage. One of the leading figures was SHEN ZHOU (1427–1509), a master of the Wu School of painting, so called because of the ancient name (Wu) of the city of Suzhou. Shen Zhou came from a family of scholars and painters and turned down an offer to serve in the Ming bureaucracy in order to devote himself to poetry and painting. His hanging scroll, *Lofty Mount Lu* (FIG. **26-10**), a birthday gift to one of his teachers, bears a long poem he wrote in the teacher's honor. Shen Zhou had never seen Mount Lu, but he chose the subject because he wished the lofty mountain peaks to

express the grandeur of his teacher's virtue and character. The artist suggested the immense scale of Mount Lu by placing a tiny figure at the bottom center of the painting, sketched in lightly and partly obscured by a rocky outcropping. The composition owes a great deal to early masters like Fan Kuan (see FIG. 7-18). But, characteristic of literati painting in general, the scroll is in the end a very personal conversation—in pictures and words—between the painter and the teacher for whom it was created.

DONG QICHANG One of the most intriguing and influential literati of the late Ming dynasty was DONG QICHANG (1555–1636), a wealthy landowner and high official who was a poet, calligrapher, and painter. He also amassed a vast collection of Chinese art and achieved great fame as an art critic. In Dong Qichang's view, most Chinese landscape painters could be classified as belonging to either the Northern School of precise, academic painting or the Southern School of more subjective, freer painting. "Northern" and "Southern" were therefore not geographic but stylistic labels. Dong Qichang chose these names for the two schools because he determined that their characteristic styles had parallels in the northern and southern schools of Chan Buddhism (see "Chan Buddhism," Chapter 7, page 212). Northern Chan Buddhists were "gradualists" and believed that enlightenment could be achieved only after long training. The Southern Chan Buddhists believed that enlightenment could come suddenly. The professional, highly trained court painters belonged to the Northern School. The leading painters of the Southern School

26-10 SHEN ZHOU, *Lofty Mount Lu*, Ming dynasty, 1467. Hanging scroll, ink and color on paper, 6′ 4¼″ × 3′ 2⅝″. National Palace Museum, Taiwan.

were the literati, whose freer and more expressive style Dong Qichang judged to be far superior.

Dong Qichang's own work—for example, *Dwelling in the Qingbian Mountains* (FIG. 26-11), painted in 1617—belongs to the Southern School he admired so much. His debt to earlier literati painters can readily be seen in both subject and style as well as in the incorporation of a long inscription at the top. But Dong Qichang was also an innovator, especially in his treatment of the towering mountains, where shaded masses of rocks alternate with flat, blank bands, flattening the composition and creating highly expressive and abstract patterns. Some critics have even called Dong Qichang the first modernist painter, foreshadowing developments in 19th-century European landscape painting (see Chapter 29).

26-11 DONG QICHANG, *Dwelling in the Qingbian Mountains*, Ming dynasty, 1617. Hanging scroll, ink on paper, 7′ 3½″ × 2′ 2½″. Cleveland Museum of Art (Leonard C. Hanna, Jr. bequest).

CHINA 771

Élisabeth Louise Vigée-Lebrun, *Self-Portrait*, 1790. Oil on canvas, 8′ 4″ × 6′ 9″. Galleria degli Uffizi, Florence.

28

THE ENLIGHTENMENT
AND ITS LEGACY

ART OF THE LATE 18TH THROUGH
THE MID-19TH CENTURY

The death of Louis XIV in 1715 brought many changes in French high society. The court of Versailles was at once abandoned for the pleasures of town life. Although French citizens still owed their allegiance to a monarch, the early 18th century saw a resurgence in aristocratic social, political, and economic power. Appropriately, some historians refer to the 18th century as the great age of the aristocracy. The nobility not only exercised their traditional privileges (for example, exemption from certain taxes and from forced labor on public works) but also sought to expand their power.

ROCOCO: THE FRENCH TASTE

In the cultural realm, aristocrats reestablished their predominance as art patrons. The *hôtels* (town houses) of Paris soon became the centers of a new, softer style called *Rococo*. The sparkling gaiety cultivated in the new age (see "Of Knowledge, Taste, and Refinement: Salon Culture," page 799), associated with the regency that followed the death of Louis XIV and with the reign of Louis XV, found perfectly harmonious expression in this new style. Rococo appeared in France in about 1700, primarily as a style of interior design. The French Rococo exterior was most often simple, or even plain, but Rococo exuberance took over the interior. The term derived from the French word *rocaille*, which literally means "pebble," but it referred especially to the small stones and shells used to decorate grotto interiors. Such shells or shell forms were the principal motifs in Rococo ornament.

A PERMANENTLY "FESTIVE" ROOM A typical French Rococo room is the Salon de la Princesse (FIG. 28-1) in the Hôtel de Soubise in Paris, designed by GERMAIN BOFFRAND (1667–1754). Comparing this room to the Galerie des Glaces at Versailles (see FIG. 24-69) reveals how Boffrand softened the strong architectural lines and

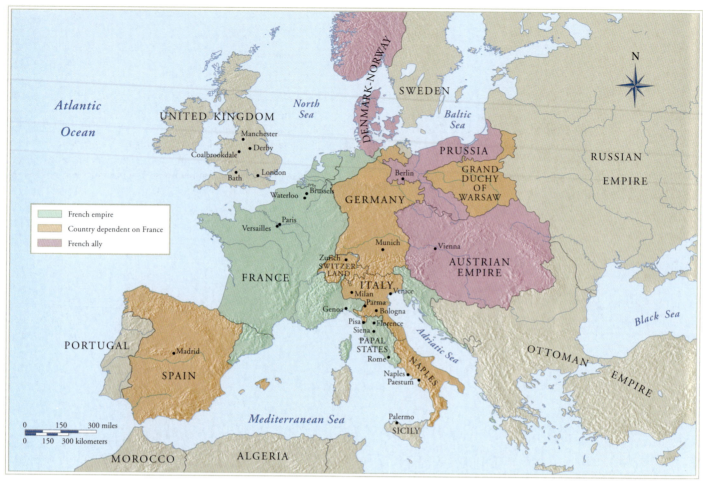

MAP 28-1 Napoleonic Europe 1800–1815.

28-1 GERMAIN BOFFRAND, *Salon de la Princesse*, with painting by CHARLES-JOSEPH NATOIRE and sculpture by J. B. LEMOINE, Hôtel de Soubise, Paris, France, 1737–1740.

Of Knowledge, Taste, and Refinement
Salon Culture

The feminine look of the Rococo style suggests that the age was dominated by the taste and social initiative of women—and, to a large extent, it was. Women—Madame de Pompadour in France, Maria Theresa in Austria, and Elizabeth and Catherine in Russia—held some of the highest positions in Europe, and female influence was felt in numerous smaller courts. The Rococo salon was the center of early-18th-century Parisian society, and Paris was the social capital of Europe. Wealthy, ambitious, and clever society hostesses competed to attract the most famous and the most accomplished people to their salons. The medium of social intercourse was conversation spiced with wit, repartee as quick and deft as a fencing match. Artifice reigned supreme, and participants considered enthusiasm or sincerity in bad taste.

These salon women referred to themselves as *femmes savantes*, or learned women. Among these learned women was Julie de Lespinasse (1732–1776), one of the most articulate, urbane, and intelligent French women of the time. She held daily salons from five o'clock until nine in the evening. *Memoirs of Marmontel* documents the liveliness of these gatherings and the remarkable nature of this hostess:

> The circle was formed of persons who were not bound together. She had taken them here and there in society, but so well assorted were they that once there they fell into harmony like the strings of an instrument touched by an able hand. Following out that comparison, I may say that she played the instrument with an art that came of genius; she seemed to know what tone each string would yield before she touched it; I mean to say that our minds and our natures were so well known to her that in order to bring them into play she had but to say a word. Nowhere was conversation more lively, more brilliant, or better regulated than at her house. It was a rare phenomenon indeed, the degree of tempered, equable heat which she knew so well how to maintain, sometimes by moderating it, sometimes by quickening it. The continual activity of her soul was communicated to our souls, but measurably; her imagination was the mainspring, her reason the regulator. Remark that the brains she stirred at will were neither feeble nor frivolous. . . . Her talent for casting out a thought and giving it for discussion to men of that class, her own talent in discussing it with precision, sometimes with eloquence, her talent for bringing forward new ideas and varying the topic—always with the facility and ease of a fairy . . . these talents, I say, were not those of an ordinary woman. It was not with the follies of fashion and vanity that daily, during four hours of conversation, without languor and without vacuum, she knew how to make herself interesting to a wide circle of strong minds.[1]

[1] Jean François Marmontel, *Memoirs of Marmontel*, translated by Brigit Patmore (London: Routledge, 1930), 270.

panels of the earlier style into flexible, sinuous curves luxuriantly multiplied in mirror reflections. The walls melt into the vault. Irregular painted shapes, surmounted by sculpture and separated by the typical rocaille shells, replace the hall's cornices. Painting, architecture, and sculpture combine to form a single ensemble. The profusion of curving tendrils and sprays of foliage blend with the shell forms to give an effect of freely growing nature, suggesting that the designer permanently decked the Rococo room for a festival.

Rococo was a style preeminently evident in small works. Artists exquisitely wrought furniture, utensils, and accessories of all sorts in the characteristically delicate, undulating Rococo line. French Rococo interiors were designed as lively total works of art with elegant furniture, enchanting small sculptures, ornamented mirror frames, delightful ceramics and silver, a few "easel" paintings, and decorative tapestry complementing the architecture, relief sculptures, and wall paintings. As seen today, French Rococo interiors, such as the Salon de la Princesse, have lost most of the moveable "accessories" that once adorned them. Viewers can imagine, however, how such rooms—with their alternating gilded moldings, vivacious relief sculptures, and daintily colored ornament of flowers and garlands—must have harmonized with the chamber music played in them, with the elaborate costumes of satin and brocade, and with the equally elegant etiquette and sparkling wit of the people who graced them.

FRENCH ROCOCO IN GERMANY A good example of French Rococo in Germany is the Amalienburg, a small lodge FRANÇOIS DE CUVILLIÉS (1695–1768) built in the park of the Nymphenburg Palace in Munich. Although Rococo was essentially a style of interior design, the Amalienburg beautifully harmonizes the interior and exterior elevations through the curving flow of lines and planes that cohere in a sculptural unity of great elegance. The most spectacular interior room in the lodge is the circular Hall of Mirrors (FIG. **28-2**), a silver-and-blue ensemble of architecture, stucco relief, silvered bronze mirrors, and crystal. It dazzles the eye with myriad scintillating motifs, forms, and figurations the designer borrowed from the full Rococo ornamental repertoire. This room displays the style at its zenith. The room is bathed in silvery light, which is amplified by windows and mirrors. The reflections of light create shapes and contours that weave rhythmically around the upper walls and the ceiling coves. Everything seems organic, growing, and in motion, an ultimate refinement of illusion that the architect, artists, and artisans, all magically in command of their varied media, created with virtuoso flourishes.

A DELICATE DANCER The painter whom scholars most associate with French Rococo is ANTOINE WATTEAU (1684–1721). The differences between the Baroque age in France and the Rococo age can be seen clearly by contrasting Rigaud's portrait of

28-2 FRANÇOIS DE CUVILLIÉS, Hall of Mirrors, the Amalienburg, Nymphenburg Palace park, Munich, Germany, early 18th century.

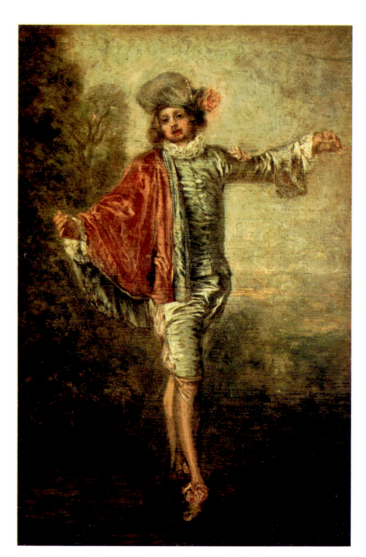

28-3 ANTOINE WATTEAU, *L'Indifférent*, ca. 1716. Oil on canvas, approx. 10″ × 7″. Louvre, Paris.

Louis XIV (see FIG. 24-65) with one of Watteau's paintings, *L'Indifférent* (The indifferent one; FIG. 28-3). Rigaud portrayed pompous majesty in supreme glory, as if the French monarch were reviewing throngs of bowing courtiers at Versailles. Watteau's painting, in contrast, is not as heavy or staid and is more delicate. The artist presented a languid, gliding dancer whose mincing minuet might be seen as mimicking the monarch's solemnity if the paintings were hung together. In Rigaud's portrait, stout architecture, bannerlike curtains, flowing ermine, and fleur-de-lis exalt the king. In Watteau's painting, the dancer moves in a rainbow shimmer of color, emerging onto the stage of the intimate comic opera to the silken sounds of strings. This contrast also highlights the different patronage of the eras; whereas the French Baroque period was dominated by royal patronage (particularly that of Louis XIV), Rococo was the culture of a wider aristocracy and high society.

CELEBRATING THE GOOD LIFE Watteau was largely responsible for creating a specific type of Rococo painting, called a *fête galante* painting. These paintings depicted the outdoor entertainment or amusements of upper-class society. An example of a fête galante painting is Watteau's masterpiece (painted in two versions), *Return from Cythera* (FIG. 28-4), completed between 1717 and 1719 as the artist's acceptance piece for admission to the Royal Academy. Watteau was Flemish, and his work, influenced by Rubens's style, contributed to the popularity of an emphasis on color in painting.

At the turn of the century, the French Royal Academy was divided rather sharply between two doctrines. One doctrine upheld the ideas of Le Brun (the major proponent of French Baroque under Louis XIV), who followed Nicolas Poussin in teaching that form was the most important element in painting, whereas "colors in painting are as allurements for persuading the eyes," additions for effect and not really essential.[1] The other doctrine, with Rubens as its model, proclaimed the natural supremacy of color

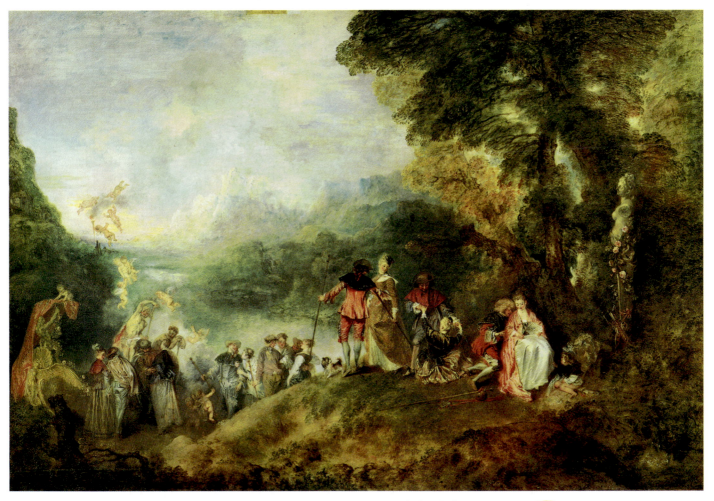

28-4 Antoine Watteau, *Return from Cythera*, 1717–1719. Oil on canvas, approx. 4′ 3″ × 6′ 4″. Louvre, Paris.

and the coloristic style as the artist's proper guide. Depending on which side they took, academy members were called "Poussinistes" or "Rubénistes." With Watteau in their ranks, the Rubénistes carried the day, and they established the Rococo style in painting on the colorism of Rubens and the Venetians.

Watteau's *Return from Cythera* (FIG. 28-4) represents a group of lovers preparing to depart from the island of eternal youth and love, sacred to Aphrodite. Young and luxuriously costumed, they move gracefully from the protective shade of a woodland park, filled with amorous cupids and voluptuous statuary, down a grassy slope to an awaiting golden barge. Watteau's figural poses, which combine elegance and sweetness, are unparalleled. He composed his generally quite small paintings from albums of superb drawings that have been preserved and are still in fine condition. These show that he observed slow movement from difficult and unusual angles, obviously intending to find the smoothest, most poised, and most refined attitudes. As he sought nuances of bodily poise and movement, Watteau also strove for the most exquisite shades of color difference, defining in a single stroke the shimmer of silk at a bent knee or the iridescence that touches a glossy surface as it emerges from shadow.

Art historians have noted that the theme of love and Arcadian happiness (seen in the work of Giorgione [see FIG. 22-33] and which Watteau may have seen in works by Rubens) in Watteau's pictures is slightly shadowed with wistfulness, or even melancholy. Perhaps Watteau, during his own short life, meditated on the swift passage of youth and pleasure. The haze of

color, the subtly modeled shapes, the gliding motion, and the air of suave gentility were all to the taste of the Rococo artist's wealthy patrons.

A PLAYFUL ROCOCO FANTASY Watteau's successors never quite matched his taste and subtlety. Their themes were about love, artfully and archly pursued through erotic frivolity and playful intrigue. After Watteau's early death at age 37, his follower, FRANÇOIS BOUCHER (1703–1770), painter for Madame de Pompadour (the influential mistress of Louis XV), rose to the dominant position in French painting. Although he was an excellent portraitist, Boucher's fame rested primarily on his graceful allegories, with Arcadian shepherds, nymphs, and goddesses cavorting in shady glens engulfed in pink and sky blue light. *Cupid a Captive* (FIG. 28-5) presents the viewer with a rosy pyramid of infant and female flesh set off against a cool, leafy background, with fluttering draperies both hiding and revealing the nudity of the figures. Boucher used the full range of Italian and French Baroque devices—the dynamic play of crisscrossing diagonals, curvilinear forms, and slanting recessions—to create his masterly composition. But in his work he dissected powerful Baroque curves into a multiplicity of decorative arabesques, dissipating Baroque drama into sensual playfulness. Lively and lighthearted, Boucher's artful Rococo fantasies became mirrors for his patrons, the wealthy French, to behold the ornamental reflections of their cherished pastimes.

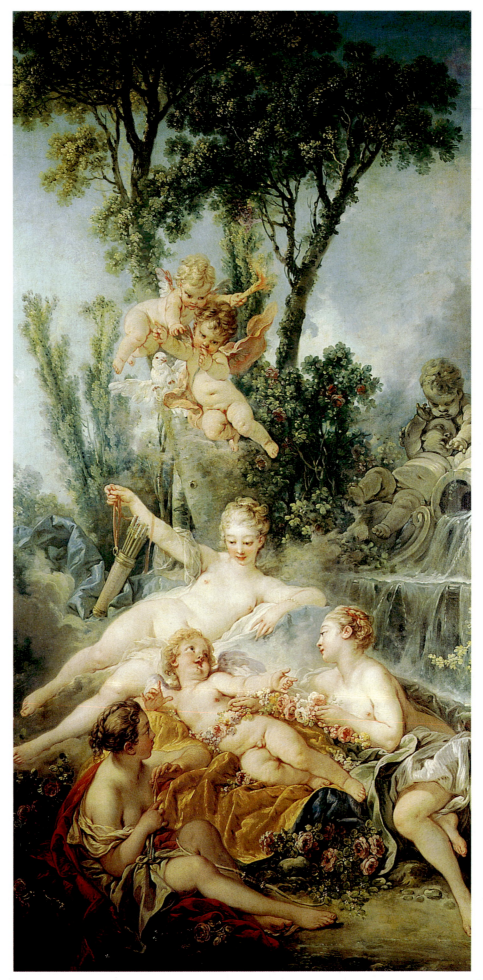

28-5 FRANÇOIS BOUCHER, *Cupid a Captive*, 1754. Oil on canvas, approx. 5′ 6″ × 2′ 10″. The Wallace Collection, London.

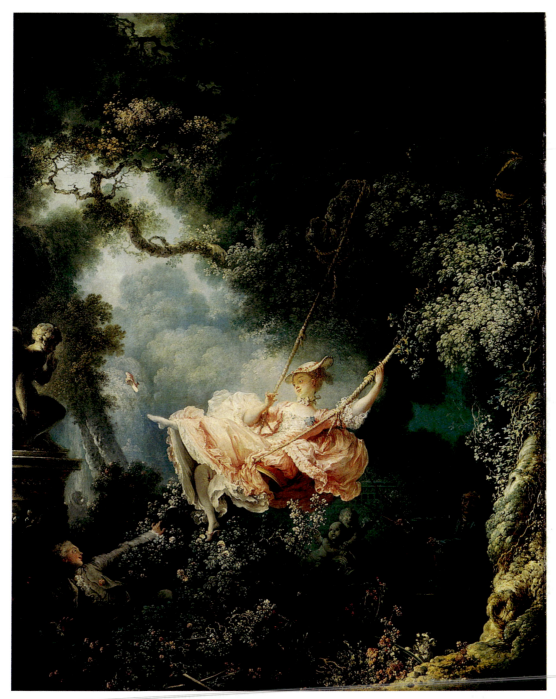

28-6 Jean-Honoré Fragonard, *The Swing*, 1766. Oil on canvas, approx. 2′ 11″ × 2′ 8″. The Wallace Collection, London.

AN INTRIGUING FLIRTATION Jean-Honoré Fragonard (1732–1806), Boucher's student, was a first-rate colorist whose decorative skill almost surpassed his master's. An example of his manner can stand as characteristic not only of his work but also of the later Rococo in general. *The Swing* (FIG. **28-6**) is a typical "intrigue" picture. A young gentleman has managed an arrangement whereby an unsuspecting old bishop swings the young man's pretty sweetheart higher and higher, while her lover (and the work's patron), in the lower left corner, stretches out to admire her ardently from a strategic position on the ground. The young lady flirtatiously and boldly kicks off her shoe at the little statue of Cupid, who holds his finger to his lips. The landscape setting is out of Watteau — a luxuriant perfumed bower in a park that very much resembles a stage scene for the comic opera. The

glowing pastel colors and soft light convey, almost by themselves, the theme's sensuality.

ECHOES OF BERNINI IN ROCOCO The Rococo mood of sensual intimacy also permeated many of the small sculptures designed for the 18th-century salons. Artists such as Claude Michel, called CLODION (1738–1814), specialized in small, lively sculptures that combined the sensuous Rococo fantasies with lightened echoes of Bernini's dynamic figures. Perhaps historians should expect such influence in Clodion's works. He lived and worked in Rome for some years after discovering the city's charms during his tenure as the recipient of the cherished Prix de Rome. The Royal Academy annually gave the Prix de Rome (Rome Prize) to the artist who produced the best history

Kauffmann replaced the modern setting and character of their works. She clothed her actors in ancient Roman garb and posed them in classicizing Roman attitudes within Roman interiors. The theme in this painting is the virtue of Cornelia, mother of the future political leaders Tiberius and Gaius Gracchus, who, in the second century BCE, attempted to reform the Roman Republic. Cornelia's character is revealed in this scene, which takes place after a lady visitor had shown off her fine jewelry and then haughtily requested that Cornelia show hers. Instead of rushing to get her own precious adornments, Cornelia brings her sons forward, presenting them as her jewels. The architectural setting is severely Roman, with no Rococo motif in evidence, and the composition and drawing have the simplicity and firmness of low-relief carving. The only Rococo elements still lingering are charm and grace—in the arrangement of the figures, in the soft lighting, and in Kauffmann's own tranquil manner.

Neoclassicism in France

PLANTING THE SEEDS OF GLORY The lingering echoes of Rococo disappeared in the work of JACQUES-LOUIS DAVID (1748–1825), the Neoclassical painter-ideologist of the French Revolution and the Napoleonic empire (MAP 28-1). The revolt against the French monarchy in 1789 was prompted, in part, by the Enlightenment idea of a participatory and knowledgeable citizenry. The immediate causes of the French Revolution were France's economic crisis and the clash between the Third Estate

(bourgeoisie, peasantry, and urban and rural workers) and the First and Second Estates (the clergy and nobility, respectively). They fought over the issue of representation in the legislative body, the Estates-General, which had been convened to discuss taxation as a possible solution to the economic problem. However, the ensuing revolution revealed the instability of the monarchy and of French society's traditional structure and resulted in a succession of republics and empires as France struggled to find a way to adjust to these decisive changes.

David was a distant relative of Boucher and followed Boucher's style until a period of study in Rome won the younger man over to the classical art tradition. David favored the academic teachings about using the art of the ancients and of the great Renaissance masters as models. In his individual style, David reworked the classical and academic traditions. He rebelled against the Rococo as an "artificial taste" and exalted classical art as the imitation of nature in her most beautiful and perfect form.

David concurred with the Enlightenment belief that subject matter should have a moral and should be presented so that the "marks of heroism and civic virtue offered the eyes of the people [will] electrify its soul, and plant the seeds of glory and devotion to the fatherland."[5] A milestone painting in David's career, *Oath of the Horatii* (FIG. 28-21), depicts a story from pre-Republican Rome, the heroic phase of Roman history. The topic was not an arcane one for David's audience. This story of conflict between love and patriotism, first recounted by the ancient Roman historian Livy, had been retold in a play by Pierre Corneille performed in Paris several years earlier, making it familiar to David's viewing

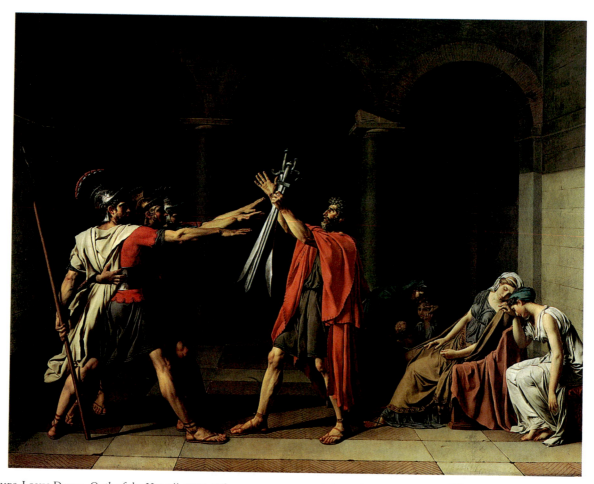

28-21 JACQUES-LOUIS DAVID, *Oath of the Horatii*, 1784. Oil on canvas, approx. 11′ × 14′. Louvre, Paris.

public. According to the story, the leaders of the warring cities of Rome and Alba decided to resolve their conflicts in a series of encounters waged by three representatives from each side. The Roman champions, the three Horatius brothers, were sent to face the three sons of the Curatius family from Alba. A sister of the Horatii, Camilla, was the bride-to-be of one of the Curatius sons, and the wife of the youngest Horatius was the sister of the Curatii.

David's painting shows the Horatii as they swear on their swords, held high by their father, to win or die for Rome, oblivious to the anguish and sorrow of their female relatives. In its form, *Oath of the Horatii* is a paragon of the Neoclassical style. Not only does the subject matter deal with a narrative of patriotism and sacrifice excerpted from Roman history, but the image is also presented with admirable force and clarity. David depicted the scene in a shallow space much like a stage setting, defined by a severely simple architectural framework. The statuesque and carefully modeled figures are deployed across the space, close to the foreground, in a manner reminiscent of ancient relief sculpture. The rigid, angular, and virile forms of the men on the left effectively contrast with the soft curvilinear shapes of the distraught women on the right. This visually pits virtues the Enlightenment leaders ascribed to men (such as courage, patriotism, and unwavering loyalty to a cause) against the emotions of love, sorrow, and despair that the women in the painting express. The French viewing audience perceived such emotionalism as characteristic of the female nature. The message was clear and of a type readily identifiable to the prerevolutionary French public. The picture created a sensation when it was exhibited in Paris in 1785, and although it had been painted under royal patronage and was not intended as a revolutionary statement, its Neoclassical style soon became the semiofficial voice of the revolution. David may have painted in the academic tradition, but he made something new of it. He created a program for arousing his audience to patriotic zeal.

IN THE SERVICE OF REVOLUTION When the French Revolution broke out in 1789, David was thrust amid this momentous upheaval. He became increasingly involved with the revolution and threw in his lot with the Jacobins, the radical and militant faction. He accepted the role of de facto minister of propaganda, organizing political pageants and ceremonies that included floats, costumes, and sculptural props. He believed that "the arts must . . . contribute forcefully to the education of the public,"[6] and he realized that the emphasis on patriotism and civic virtue perceived as integral to classicism would prove effective in dramatic, instructive paintings. However, rather than continuing to create artworks that focused on scenes from antiquity, David began to portray scenes from the French Revolution itself.

A MARTYRED REVOLUTIONARY *The Death of Marat* (FIG. 28-22) is one such work and served not only to record an important event in the revolution but also to provide inspiration and encouragement to the revolutionary forces. Jean-Paul Marat, a revolutionary radical, a writer, and David's personal friend, was tragically assassinated in 1793. David depicted the martyred revolutionary after he was stabbed to death in his medicinal bath by Charlotte Corday, a member of a rival political faction. The artist ensured proper identification of this hero. The makeshift writing surface, the inscription on the writing stand, and the medicinal bath (Marat was afflicted with a painful skin disease) all provide specific references to Marat. David presented the scene with

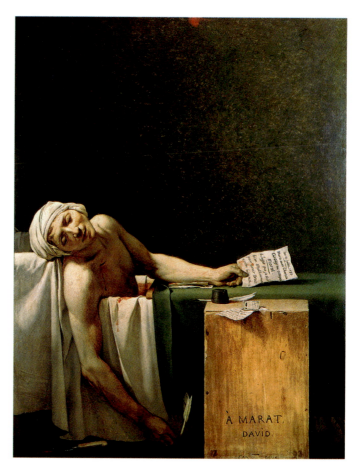

28-22 JACQUES-LOUIS DAVID, *The Death of Marat*, 1793. Oil on canvas, approx. 5′ 3″ × 4′ 1″. Musées Royaux des Beaux-Arts de Belgique, Brussels.

directness and clarity. The cold neutral space above Marat's figure slumped in the tub makes for a chilling oppressiveness. The painter vividly placed narrative details—the knife, the wound, the blood, the letter with which the young woman gained entrance—to sharpen the sense of pain and outrage and to confront viewers with the scene itself. Although David's depiction was based on historical events, his composition reveals his close study of Michelangelo, especially the Renaissance artist's Christ in the *Pietà* (not illustrated) in Saint Peter's in Rome. *The Death of Marat* is convincingly real, yet it was masterfully composed to present Marat to the French people as a tragic martyr who died in the service of their state. In this way, the painting was meant to function as an "altarpiece" for the new civic "religion"; it was designed to inspire viewers with the saintly dedication of their slain leader. Rather than the grandiosity of spectacle characteristic of West's *The Death of General Wolfe* (FIG. 28-17), a severe Neoclassical spareness pervades David's *Marat*, yet it retains its drama and ability to move spectators.

NAPOLEON'S ASCENDANCE At the fall of the French revolutionist Robespierre (1758–1794) and his party in 1794, David barely escaped with his life. He was tried and imprisoned, and after his release in 1795 he worked hard to resurrect his career. When Napoleon Bonaparte (1769–1821)—who had exploited the revolutionary disarray and ascended to power—approached David and offered him the position of First Painter of the Empire, David seized the opportunity. One of the major paintings David produced for

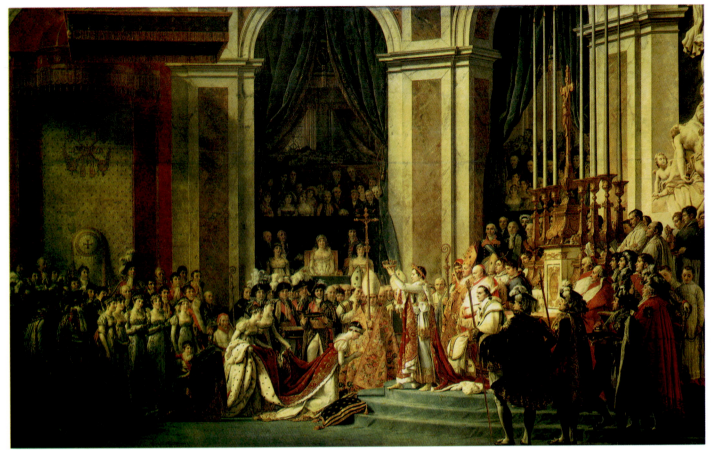

28-23 JACQUES-LOUIS DAVID, *The Coronation of Napoleon*, 1805–1808. Oil on canvas, 20' 4½" × 32' 1¾". Louvre, Paris.

Napoleon was *The Coronation of Napoleon* (FIG. **28-23**), a large-scale work that documents the pomp and pageantry of Napoleon's coronation in December of 1804.

The Coronation of Napoleon is a monumental painting (20 × 32 feet) that reveals the interests of both patron and artist. Napoleon was well aware of the utility of art for constructing a public image and of David's skill in producing inspiring, powerful images. To a large extent, David adhered to historical fact regarding the coronation. He was present at this momentous event and recorded his presence in the painting (he appears in one of the tribunes, or loges, constructed for spectators). The ceremony was held in Notre-Dame Cathedral, whose majestic interior David faithfully reproduced. The artist also duly recorded those in attendance. In addition to Napoleon, his wife Josephine (being crowned), and Pope Pius VII (seated behind Napoleon), others present included Joseph and Louis Bonaparte, Napoleon's ministers, the retinues of the emperor and empress, and a representative group of the clergy. Despite the artist's apparent fidelity to historical accuracy, preliminary studies and drawings reveal that David made changes at Napoleon's request. For example, Napoleon insisted that the painter depict the pope with his hand raised in blessing. Further, Napoleon's mother appears prominently in the center background, yet she had refused to attend the coronation and apparently was included in the painting at the emperor's insistence.

Despite the numerous figures and the lavish pageantry involved in this event, David retained the structured composition central to the Neoclassical style. As in David's *Oath of the Horatii*, the action here was presented as if on a theater stage. In addition,

as he did in his arrangement of the men and women in *Oath*, David conceptually divided the painting to reveal polarities. In this case, the pope, prelates, and priests representing the Catholic Church appear on the right, contrasting with members of Napoleon's imperial court on the left. The relationship between church and state was one of this period's most contentious issues. Napoleon's decision to crown himself, rather than to allow the pope to perform the coronation, as was traditional, revealed Napoleon's concern about the power relationship between church and state. Napoleon's insistence on emphasizing his authority is evidenced by his selection of the moment depicted; having already crowned himself, Napoleon places a crown on his wife's head. Thus, although this painting represents an important visual document in the tradition of history painting, it also represents a more complex statement about the changing politics in Napoleonic France.

It was not just David's individual skill but Neoclassicism in general that appealed to Napoleon. When Napoleon Bonaparte ascended to power, he embraced all links with the classical past as sources of symbolic authority for his short-lived imperial state. Such associations, particularly connections to the Roman Empire, served Napoleon well and were invoked in architecture and sculpture as well as painting.

ROMAN GRANDEUR IN FRANCE Architecture served as an excellent vehicle for consolidating authority because of its public presence. Napoleon was not the first to rely on classical models, however. Fairly early in the 18th century, architects began to turn away from the theatricality and ostentation of Baroque and

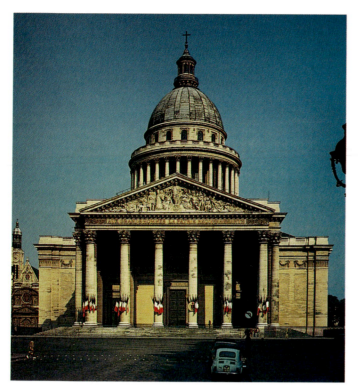

28-24 JACQUES-GERMAIN SOUFFLOT, the Panthéon (Sainte-Geneviève), Paris, France, 1755–1792.

Roman grandeur in France. The walls are severely blank, except for a repeated garland motif near the top. The colonnaded dome, a Neoclassical version of the domes of Saint Peter's in Rome (see FIG. 22-29), the Church of the Invalides in Paris (see FIG. 24-72), and Saint Paul's in London (see FIG. 24-74), rises above a Greek-cross plan. Both the dome and vaults rest on an interior grid of splendid freestanding Corinthian columns, as if the portico's colonnade were continued within. Although the whole effect, inside and out, is Roman, the structural principles employed are essentially Gothic. Soufflot was one of the first 18th-century builders to suggest that Gothic engineering was highly functional structurally and could be applied to modern buildings. In his work, the curious, but not unreasonable, conjunction of Gothic and classical has a structural integration that laid the foundation for a 19th-century admiration of Gothic engineering.

A NAPOLEONIC "TEMPLE OF GLORY" La Madeleine (FIG. 28-25) was briefly intended as a "temple of glory" for Napoleon's armies and as a monument to the newly won glories of France. Begun as a church in 1807, at the height of Napoleon's power (some three years after he proclaimed himself emperor), the structure reverted again to a church after his defeat and long before its completion in 1842. Designed by PIERRE VIGNON (1763–1828), this grandiose temple includes a high podium and broad flight of stairs leading to a deep porch in the front. These architectural features, coupled with the Corinthian columns, recall Roman imperial temples (such as the Maison Carrée, FIG. 10-30, in Nîmes, France), making La Madeleine a symbolic link between the Napoleonic and Roman empires. Curiously, the building's classical shell surrounds an interior covered by a sequence of three domes, a feature found in Byzantine and Romanesque churches. It is as though Vignon clothed this church in the costume of pagan Rome.

THE EMPEROR'S SISTER AS GODDESS Under Napoleon, classical models were prevalent in sculpture as well. The emperor's favorite sculptor was ANTONIO CANOVA (1757–1822), who somewhat reluctantly left a successful career in Italy to settle

Rococo design and embraced a more streamlined classicism. The Neoclassical portico of the Parisian church of Sainte-Geneviève (FIG. 28-24), now the Panthéon, was designed by JACQUES-GERMAIN SOUFFLOT (1713–1780). It stands as testament to the revived interest in Greek and Roman cultures. The Roman ruins at Baalbek in Syria, especially a titanic colonnade, provided much of the inspiration for this portico. The columns, reproduced with studied archaeological exactitude, are the first revelation of

28-25 PIERRE VIGNON, La Madeleine, Paris, France, 1807–1842.

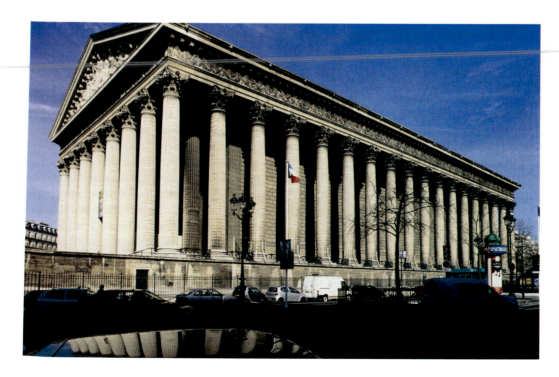

Dramatic Action, Emotion, and Color

In the early 19th century, Romantic artists increasingly incorporated dramatic action, all the while extending their exploration of the exotic, erotic, fictional, or fantastic. One artist whose works reveal these compelling dimensions is the Spaniard Francisco José de Goya y Lucientes (1746–1828). Goya was David's contemporary, but one scarcely could find two artists living at the same time and in adjacent countries who were so completely unlike each other.

RECONSIDERING REASON Goya did not arrive at his general dismissal of Neoclassicism without considerable thought about the Enlightenment and the Neoclassical penchant for rationality and order. This reflection emerges in such works as *The Sleep of Reason Produces Monsters* (FIG. **28-41**), an etching and aquatint from a series titled *Los Caprichos (The Caprices)*. In this print, Goya depicted himself asleep, slumped onto a table or writing stand, while threatening creatures converge on him. Seemingly poised to attack the artist are owls (symbols of folly) and bats (symbols of ignorance). The viewer might read this as a portrayal of what emerges when reason is suppressed and, therefore, as advocating Enlightenment ideals. However, it also can be interpreted as Goya's commitment to the creative process and the Romantic spirit—the unleashing of imagination, emotions, and even nightmares.

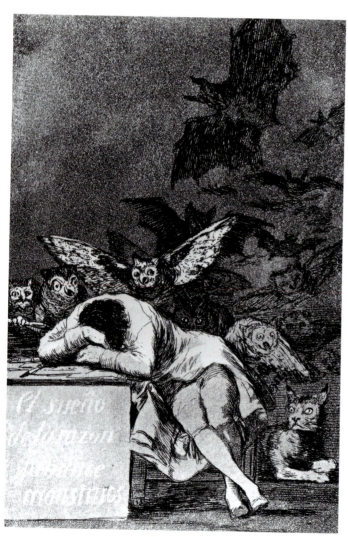

28-41 Francisco Goya, *The Sleep of Reason Produces Monsters*, from *Los Caprichos*, ca. 1798. Etching and aquatint, $8\frac{7}{16}'' \times 5\frac{7}{8}''$. Metropolitan Museum of Art, New York (gift of M. Knoedler & Co., 1918).

PORTRAIT OF SPANISH ROYALTY The emotional art Goya produced during his long career stands as testimony not only to the allure of the Romantic vision but also to the turmoil in Spain and to the conflicts in Goya's own life. Goya's skills as a painter were recognized early on, and in 1786 he was appointed Pintor del Rey (Painter to the King). In this capacity (he was promoted to First Court Painter in 1799) Goya produced such works as *The Family of Charles IV* (FIG. **28-42**). Here King Charles IV and Queen Maria Luisa are surrounded by their children. As a court painter and artist enamored with the achievements of his predecessor Diego Velázquez, Goya appropriately used Velázquez's *Las Meninas* (see FIG. 24-33) as his inspiration for this image. As in *Las Meninas*, the royal family appears facing the viewer in an interior space while the artist included himself on the left, dimly visible, in the act of painting on a large canvas. Goya's portrait of the royal family has been subjected to intense scholarly scrutiny, resulting in a variety of interpretations. Some scholars see this painting as a naturalistic depiction of Spanish royalty; others believe it to be a pointed commentary in a time of Spanish turmoil. It is clear that his patrons authorized the painting's basic elements—the royal family members, their attire, and Goya's inclusion. Little evidence exists as to how this painting was received. Although some scholars have argued that the royal family was dissatisfied with the portrait, others have suggested that the painting confirmed the Spanish monarchy's continuing presence and strength and thus elicited a positive response from the patrons.

TURMOIL IN SPAIN As dissatisfaction with the rule of Charles IV and Maria Luisa increased, the political situation grew more tenuous. The Spanish people eventually threw their support behind Ferdinand VII, son of Charles IV and Maria Luisa, in the hope that he would initiate reform. To overthrow his father and mother, Ferdinand VII enlisted the aid of Napoleon Bonaparte, whose authority and military expertise in France at that time were uncontested. Napoleon had designs on the Spanish throne and thus willingly sent French troops to Spain. Not surprisingly, once Charles IV and Maria Luisa were ousted, Napoleon revealed his plan to rule Spain himself by installing his brother Joseph Bonaparte on the Spanish throne.

THE MASSACRE OF MAY 3, 1808 The Spanish people, finally recognizing the French as invaders, sought a way to expel the foreign troops. On May 2, 1808, in frustration, the Spanish attacked the Napoleonic soldiers in a chaotic and violent clash. In retaliation and as a show of force, the French responded the next day by executing numerous Spanish citizens. This tragic event is the subject of Goya's most famous painting, *The Third of May, 1808* (FIG. **28-43**).

In emotional fashion, Goya depicted the anonymous murderous wall of Napoleonic soldiers ruthlessly executing the unarmed and terrified Spanish peasants. The artist encouraged empathy for the Spanish by portraying horrified expressions and anguish on their faces, endowing them with a humanity absent from the firing squad. Further, the peasant about to be shot throws his arms out in a cruciform gesture reminiscent of Christ's position on the cross.

Goya enhanced the drama of this event through his stark use of darks and lights. In addition, Goya's choice of imagery extended the time frame and thus heightened the emotion of the tragedy. Although the artist captured a specific moment when one man is about to be executed, others lie dead at his feet, their

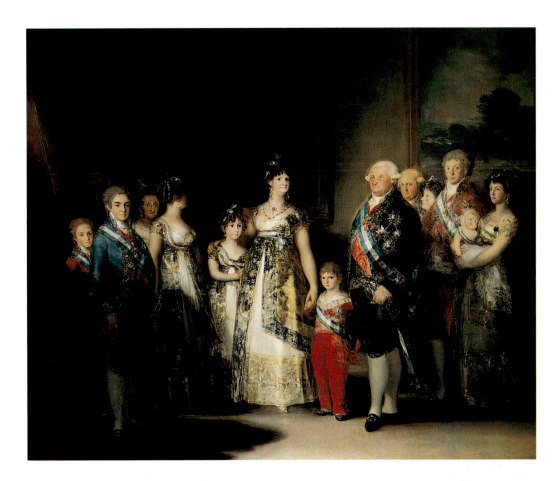

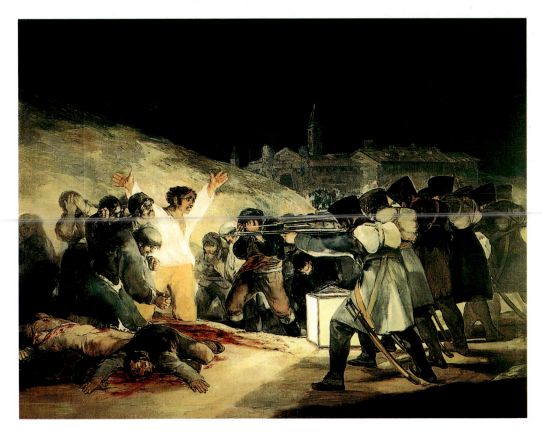

28-43 FRANCISCO GOYA, *The Third of May, 1808*, 1814. Oil on canvas, approx. 8′ 8″ × 11′ 3″. Museo del Prado, Madrid.

blood staining the soil of Príncipe Pío hill, and many others have been herded together to be subsequently shot.

Its depiction of the resistance and patriotism of the Spanish people notwithstanding, *The Third of May, 1808* was painted in 1814 for Ferdinand VII, who had been restored to the throne after the ouster of the French. Although the Spanish citizens had placed great faith in Ferdinand to install more democratic policies than were in place during the reign of his father, Charles IV, Ferdinand VII increasingly emulated his father, resulting in the restoration of an authoritarian monarchy.

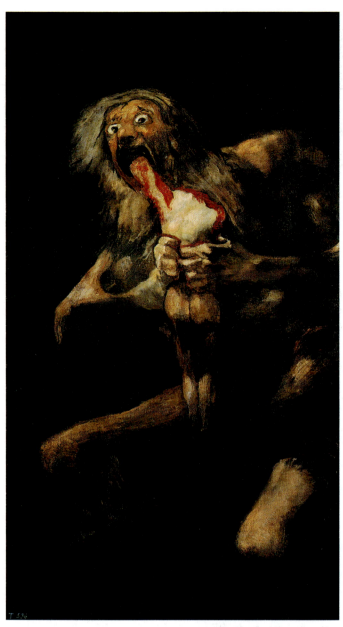

28-44 FRANCISCO GOYA, *Saturn Devouring One of His Children*, 1819–1823. Detail of a detached fresco on canvas, full size approx. 4′ 9″ × 2′ 8″. Museo del Prado, Madrid.

Goya's work, rooted both in a personal and a national history, presents darkly emotional images well in keeping with Romanticism. The demons that haunted Goya emerged in his art. As historian Gwyn Williams nicely sums up: "As for the grotesque, the maniacal, the occult, the witchery, they are precisely the product of the sleep of *human* reason; they are *human* nightmares. *That these monsters are human is, indeed, the point.*"[9]

DEATH AND DESPAIR ON A RAFT In France, Théodore Géricault and Eugène Delacroix were the artists most closely associated with the Romantic movement. THÉODORE GÉRICAULT (1791–1824) studied with an admirer of David, P. N. Guérin (1774–1833). Although Géricault retained an interest in the heroic and the epic and was well trained in classical drawing, he chafed at the rigidity of the Neoclassical style, eventually producing works that captivate the viewer with their drama, visual complexity, and emotional force.

Géricault's most ambitious project was a large-scale painting (approximately 16 × 23 feet) titled *Raft of the Medusa* (FIG. **28-45**). In this depiction of an actual historical event, the artist abandoned the idealism of Neoclassicism and instead invoked the theatricality of Romanticism. The painting's subject is a shipwreck that took place in 1816 off the African coast. The French frigate *Medusa* ran aground on a reef due to the incompetence of the captain, a political appointee. As a last-ditch effort to survive, 150 of those remaining built a makeshift raft from the disintegrating ship. The raft drifted for 12 days, and the number of survivors dwindled to 15. Finally, the raft was spotted, and the emaciated survivors were rescued. This horrendous event was political dynamite once it became public knowledge.

In Géricault's huge painting, which took him eight months to complete, he sought to confront viewers with the horror, chaos, and emotion of the tragedy while invoking the grandeur and impact of large-scale history painting. He depicted the few weak, despairing survivors as they summon what little strength they have left to flag down the passing ship far on the horizon. Géricault departed from the straightforward organization of Neoclassical compositions and instead presented a jumble of writhing bodies. The survivors and several corpses are piled onto one another in every attitude of suffering, despair, and death (recalling Gros's *Napoleon*, FIG. 28-34) and are arranged in a powerful X-shaped composition. One light-filled diagonal axis stretches from bodies at the lower left up to the black man raised on his comrades' shoulders and waving a piece of cloth toward the horizon. The cross axis descends from the storm clouds and the dark, billowing sail at the upper left to the shadowed upper torso of the body trailing in the open sea. Géricault's decision to place the raft at a diagonal so that a corner juts out toward viewers further compels their participation in this scene. Indeed, it seems as though some of the corpses are sliding off the raft into the viewing space. The subdued palette and prominent shadows lend an ominous pall to the scene.

Despite the theatricality and dramatic action that imbues this work with a Romantic spirit, Géricault did in fact go to great lengths to ensure a degree of accuracy. He visited hospitals and morgues to examine corpses, interviewed the survivors, and had a model of the raft constructed in his studio.

Géricault also took this opportunity to insert a comment on the practice of slavery. The artist was a member of an abolitionist group that sought ways to end the slave trade in the colonies. Given Géricault's antipathy to slavery, it is appropriate that he placed Jean Charles, a black soldier and one of the few survivors, at the top of the pyramidal heap of bodies.

PAINTINGS OF DARK EMOTIONS Over time, Goya became increasingly disillusioned and pessimistic; his declining health only contributed to this state of mind. Among his later works is a series of frescoes called the Black Paintings. Goya painted these frescoes on the walls of his farmhouse in Quinta del Sordo, outside Madrid. Because Goya created these works solely on his terms and for his viewing, one could argue that they provide great insight into the artist's outlook. If so, the vision is terrifying and disturbing. One of these Black Paintings, *Saturn Devouring One of His Children* (FIG. **28-44**), depicts the raw carnage and violence of Saturn (the Greek god Kronos; see "The Gods and Goddesses of Mount Olympus," Chapter 5, page 107, or page xiii in Volume II), wild-eyed and monstrous, as he consumes one of his children. Because of the similarity of Kronos and Khronos (the Greek word for "time"), Saturn has come to be associated with time. This has led some to interpret Goya's painting as an expression of the artist's despair over the passage of time. Despite the simplicity of the image, it conveys a wildness, boldness, and brutality that cannot help but evoke an elemental response from any viewer.

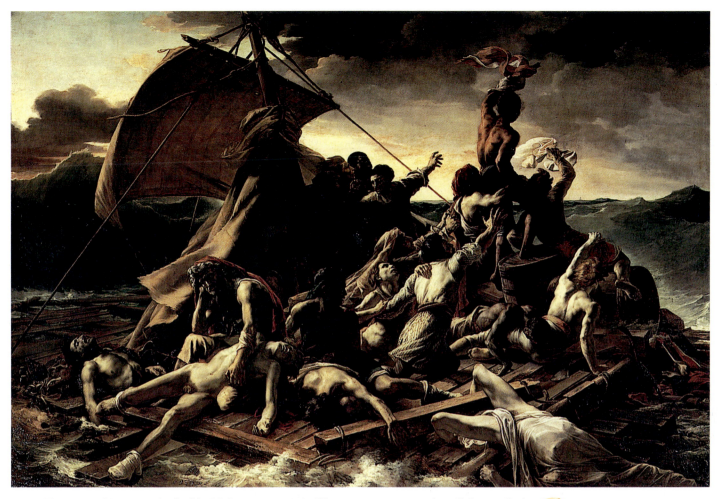

28-45 Théodore Géricault, *Raft of the Medusa,* 1818–1819. Oil on canvas, approx. 16′ × 23′. Louvre, Paris.

PICTURING INSANITY Mental aberration and irrational states of mind hardly could have failed to interest the rebels against Enlightenment rationality. Géricault, like many of his contemporaries, examined the influence of mental states on the human face and believed, as others did, that a face accurately revealed character, especially in madness and at the moment of death. He made many studies of the inmates of hospitals and institutions for the criminally insane, and he studied the severed heads of guillotine victims. Scientific and artistic curiosity was not easily separated from the morbidity of the Romantic interest in derangement and death. Géricault's *Insane Woman (Envy),* FIG. **28-46**—her mouth tense, her eyes red-rimmed with suffering— is one of several of his portraits of insane subjects that have a peculiar hypnotic power. These portraits present the psychic facts with astonishing authenticity, especially in contrast to earlier idealized commissioned portraiture. The more the Romantics became involved with nature, sane or mad, the more they hoped to reach the truth.

LINE VERSUS COLOR Like Géricault, Delacroix is consistently invoked in discussions of Romanticism. The history of 19th-century painting in its first 60 years often has been interpreted as a contest between two major artists—Ingres the draftsman and EUGÈNE DELACROIX (1798–1863) the colorist. Their dialogue harked back to the quarrel between the Poussinistes and the Rubénistes at the end of the 17th century. As discussed earlier, the Poussinistes were conservative defenders of academism who held drawing as superior to color, whereas the Rubénistes proclaimed the importance of color over line (line quality being

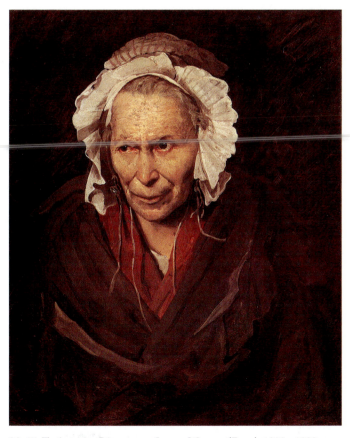

28-46 Théodore Géricault, *Insane Woman (Envy),* 1822–1823. Oil on canvas, approx. 2′ 4″ × 1′ 9″. Musée des Beaux-Arts, Lyon.

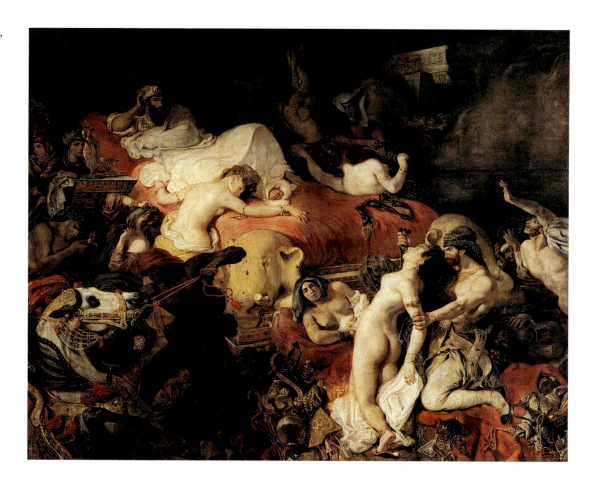

28-47 Eugène Delacroix, *Death of Sardanapalus,* 1826. Oil on canvas, approx. 12′ 1″ × 16′ 3″. Louvre, Paris.

more intellectual and thus more restrictive than color). Although the differences between Ingres and Delacroix are clear, it is impossible to make categorical statements about any artist. As shown, Ingres's work, though steeped in Neoclassical tradition, does incorporate elements of Romanticism. In the end, Ingres and his great rival Delacroix complemented rather than contradicted each other. Their works stand as visual expressions of the great Neoclassical and Romantic dialogue.

INSPIRING FICTION AND VERSE Delacroix's works were products of his view that the artist's powers of imagination would in turn capture and inflame the viewer's imagination. Literature of imaginative power served Delacroix (and many of his contemporaries) as a useful source of subject matter. Théophile Gautier, the prominent Romantic critic and novelist, recalled:

> In those days painting and poetry fraternized. The artists read the
> poets, and the poets visited the artists. We found Shakespeare, Dante,
> Goethe, Lord Byron and Walter Scott in the studio as well as in the
> study. There were as many splashes of color as there were blots of ink
> in the margins of those beautiful books which we endlessly perused.
> Imagination, already excited, was further fired by reading those for-
> eign works, so rich in color, so free and powerful in fantasy.[10]

ORGIASTIC DESTRUCTION Delacroix's *Death of Sardana- palus* (FIG. **28-47**) is an example of pictorial grand drama. Undoubtedly, Delacroix was inspired by Lord Byron's 1821 narrative poem *Sardanapalus,* but the painting does not illustrate that text (see "The Romantic Spirit in Music and Literature," page 835). Instead, Delacroix depicted the last hour of the Assyrian king (who received news of his armies' defeat and the enemies' entry into his city) in a much more tempestuous and crowded setting than Byron described. Here, orgiastic destruction replaces the sacrificial suicide found in the poem. In the painting, the king watches

gloomily from his funeral pyre, soon to be set alight, as all of his most precious possessions—his women, slaves, horses, and treasure—are destroyed in his sight. Sardanapalus's favorite concubine throws herself on the bed, determined to go up in flames with her master. The king presides like a genius of evil over the panorama of destruction. Most conspicuous are the tortured and dying bodies of the harem women. In the foreground, a muscular slave plunges his knife into the neck of one woman. This spectacle of suffering and death is heightened by the most daringly difficult and tortuous poses and by the richest intensities of hue. With its exotic and erotic overtones, *Death of Sardanapalus* taps into the fantasies of both the artist and some viewers.

LEADING THE MASSES IN UPRISING Although *Death of Sardanapalus* reveals Delacroix's fertile imagination, like Géricault he also turned to current events, particularly tragic or sensational ones, for his subject matter. For example, he produced several images based on the Greek War for Independence (1821–1829). Certainly, the French perception of the Greeks locked in a brutal struggle for freedom from the cruel and exotic Ottoman Turks generated great interest. Closer to home, Delacroix captured the passion and energy of the Revolution of 1830 in his painting *Liberty Leading the People* (FIG. **28-48**). Based on the Parisian uprising against the rule of Charles X at the end of July 1830, it depicts the allegorical personification of Liberty defiantly thrusting forth the republic's tricolor banner as she urges the masses to fight on. The urgency of this struggle is reinforced by the scarlet Phrygian cap (the symbol of a freed slave in antiquity) she wears. Arrayed around her are bold Parisian types—the street boy brandishing his pistols, the menacing worker with a cutlass, and the intellectual dandy in top hat with sawed-off musket. As in Géricault's *Raft of the Medusa,* dead bodies are strewn about. In the background, the towers of Notre-Dame rise through

The Romantic Spirit in Music and Literature

The appeal of Romanticism, with its emphasis on freedom and feeling, extended well beyond the realm of the visual arts. In European music, literature, and poetry, the Romantic spirit was a dominant presence during the late 18th and early 19th centuries. These artistic endeavors rejected classicism's structured order in favor of the emotive and expressive. In music, the compositions of Franz Schubert (1797–1828), Franz Liszt (1811–1886), Frédéric Chopin (1810–1849), and Johannes Brahms (1833–1897) all emphasized the melodic or lyrical. These composers believed that music had the power to express the unspeakable and to communicate the subtlest and most powerful human emotions.

In literature, Romantic poets such as John Keats (1795–1821), William Wordsworth (1770–1850), and Samuel Taylor Coleridge (1772–1834) published volumes of poetry that serve as manifestations of the Romantic interest in lyrical drama. *Ozymandias,* by Percy Bysshe Shelley (1792–1822), speaks of faraway, exotic locales. Lord Byron's poem of 1821, *Sardanapalus,* is set in the kingdom of Assyria in the seventh century BCE. It conjures images of eroticism and fury unleashed—images that appear in

Delacroix's painting *Death of Sardanapalus* (FIG. 28-47). One of the best examples of the Romantic spirit is the engrossing novel *Frankenstein,* written in 1818 by Mary Wollstonecraft Shelley (1797–1851), who was married to Romantic poet Percy Bysshe Shelley. This fantastic tale of a monstrous creature run amok is filled with drama and remains popular to the present. As was true of many Romantic artworks, this novel not only embraces the emotional but also rejects the rationalism that underlay Enlightenment thought. Dr. Frankenstein's monster was a product of science, and this novel easily could have been interpreted as an indictment of the tenacious belief in science promoted by Enlightenment thinkers such as Voltaire. *Frankenstein* thus served as a cautionary tale of the havoc that could result from unrestrained scientific experimentation and from the arrogance of scientists like Dr. Frankenstein.

The imagination and vision that characterized Romantic paintings and sculptures were equally moving and riveting in musical or written form. The sustained energy of Romanticism is proof of the captivating nature of this movement and spirit.

the smoke and haze. The painter's inclusion of this recognizable Parisian landmark announces the specificity of locale and event. It also reveals Delacroix's attempt, like that of Géricault in *Raft,* to balance contemporary historical fact with poetic allegory (*Liberty*). This desire for balance is further revealed in the Salon title of this work, *The 28th of July: Liberty Leading the People.*

THE ALLURE OF MOROCCO An enormously influential event in Delacroix's life that affected his art in both subject and form was his visit to North Africa in 1832. Things he saw there shocked his imagination with fresh impressions that lasted throughout his life. He discovered, in the sun-drenched landscape and in the hardy and colorful Moroccans dressed in robes reminiscent of the Roman

28-48 EUGÈNE DELACROIX, *Liberty Leading the People,* 1830. Oil on canvas, approx. 8′ 6″ × 10′ 8″. Louvre, Paris.

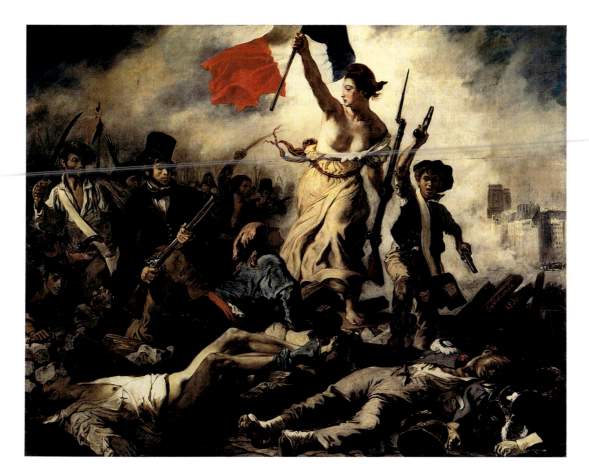

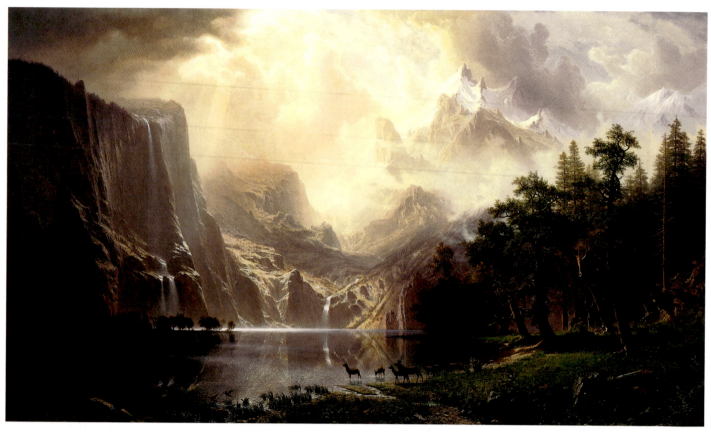

28-56 ALBERT BIERSTADT, *Among the Sierra Nevada Mountains, California,* 1868. Oil on canvas, 6′ × 10′. National Museum of American Art, Smithsonian Institution, Washington.

displacement of the Native Americans, and the exploitation of the environment. It should come as no surprise that among those most eager to purchase Bierstadt's work were mail-service magnates and railroad builders—entrepreneurs and financiers involved in westward expansion.

REAFFIRMING RIGHTEOUSNESS FREDERIC EDWIN CHURCH (1826–1900) also has been associated with the Hudson River School. His interest in landscape scenes was not limited to America;

during his life he traveled to South America, Mexico, Europe, the Middle East, Newfoundland, and Labrador. Church's paintings are instructive because, like the works of Cole and Bierstadt, they are firmly entrenched in the idiom of the Romantic sublime. Yet they also reveal contradictions and conflicts in the constructed mythology of American providence and character. *Twilight in the Wilderness* (FIG. **28-57**) presents an awe-inspiring panoramic view of the sun setting over the majestic landscape. Beyond Church's precise depiction of the spectacle of nature, the painting

28-57 FREDERIC EDWIN CHURCH, *Twilight in the Wilderness,* 1860s. Oil on canvas, 3′ 4″ × 5′ 4″. Cleveland Museum of Art, Cleveland (Mr. and Mrs. William H. Marlatt Fund, 1965.233).

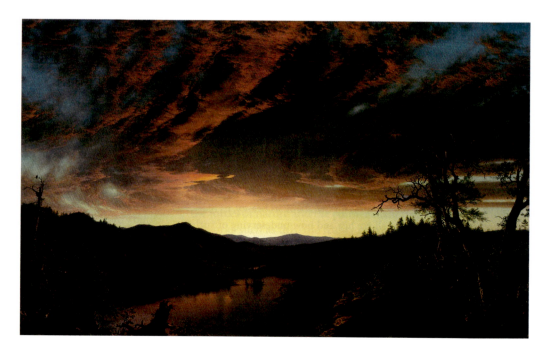

is remarkable for what it does not depict. Like John Constable, Church and the other Hudson River School painters worked in a time of great upheaval. *Twilight in the Wilderness* was created in 1860, when the Civil War was decimating the country. Yet this painting does not display evidence of turbulence or discord; indeed, it does not include even a trace of humanity. By constructing such an idealistic and comforting view, Church contributed to the national mythology of righteousness and divine providence—a mythology that had become increasingly difficult to maintain in the face of conflict.

Landscape painting was immensely popular in the late 18th and early 19th centuries, in large part because it provided viewers with breathtaking and sublime spectacles of nature. Artists also could allegorize nature, and it was rare for a landscape painting not to touch on spiritual, moral, historical, or philosophical issues. Landscape painting became the perfect vehicle for artists (and the viewing public) to "naturalize" conditions, rendering debate about contentious issues moot and eliminating any hint of conflict.

Various Revivalist Styles in Architecture

RECONSIDERING THE PAST As 19th-century scholars gathered the documentary materials of European history in extensive historiographic enterprises, each nation came to value its past as evidence of the validity of its ambitions and claims to greatness. Intellectuals appreciated the art of the remote past as a product of cultural and national genius. In 1773, Goethe, praising the Gothic cathedral of Strasbourg in *Of German Architecture,* announced the theme by declaring that the German art scholar "should thank God to be able to proclaim aloud that it is German Architecture, our architecture." He also bid the observer, "approach and recognize the deepest feeling of truth and beauty of proportion emanating from a strong, vigorous German soul."[16] In 1802, the eminent French writer Chateaubriand published his influential *Genius of Christianity,* which defended religion on the grounds of its beauty and mystery rather than on the grounds of truth. Gothic cathedrals, according to Chateaubriand, were translations of the sacred groves of the Druidical Gauls into stone and must be cherished as manifestations of France's holy history. In his view, the history of Christianity and of France merged in the Middle Ages.

RESTORING MEDIEVAL ARTISANSHIP Modern nationalism thus prompted a new evaluation of the art in each country's past. In London, when the old Houses of Parliament burned in 1834, the Parliamentary Commission decreed that designs for the new building be either Gothic or Elizabethan. CHARLES BARRY (1795–1860), with the assistance of A.W.N. PUGIN (1812–1852), submitted the winning design (FIG. **28-58**) in 1835. By this time, style had become a matter of selection from the historical past. Barry had traveled widely in Europe, Greece, Turkey, Egypt, and Palestine, studying the architecture in each place. He preferred the classical Renaissance styles, but he had designed some earlier Neo-Gothic buildings, and Pugin successfully influenced him in the direction of English Late Gothic. Pugin was one of a group of English artists and critics who saw moral purity and spiritual authenticity in the religious architecture of the Middle Ages. They glorified the careful medieval artisans who had produced it. The Industrial Revolution was flooding the market with cheaply made and ill-designed commodities. Machine work was replacing handicraft. Many, such as Pugin, believed in the necessity of restoring the old artisanship, which had honesty and quality. The design of the Houses of Parliament, however, is not genuinely Gothic, despite its picturesque tower groupings (the Clock Tower, containing Big Ben, at one end, and the Victoria Tower at the other). The building has a formal axial plan and a kind of Palladian regularity beneath its Tudor detail (an early-16th-century style of English domestic architecture characterized by expansive living spaces—parlors, studies, and bedrooms—often with oak paneling and ornamented walls and ceilings). Pugin himself is reported to have said of it, "All Grecian, Sir. Tudor details on a classical body."[17]

28-58 CHARLES BARRY and A. W. N. PUGIN, Houses of Parliament, London, England, designed 1835.

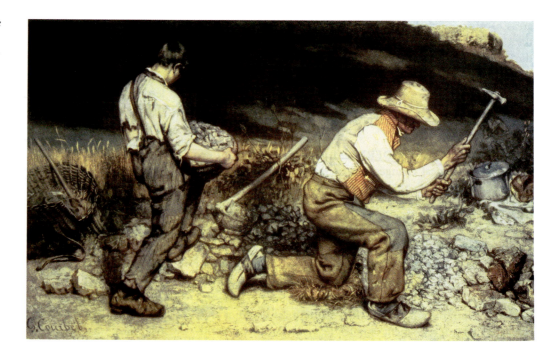

29-1 GUSTAVE COURBET, *The Stone Breakers*, 1849. Oil on canvas, 5′ 3″ × 8′ 6″. Formerly at Gemäldegalerie, Dresden (destroyed in 1945).

PEASANT LIFE AND DEATH Also representative of Courbet's work is *Burial at Ornans* (FIG. **29-2**), which depicts a funeral in a bleak provincial landscape attended by "common, trivial" persons, the type of people Honoré de Balzac and Gustave Flaubert presented in their novels.[5] While an officious clergyman reads the Office of the Dead, those attending cluster around the excavated gravesite, their faces registering all degrees of response to the situation.

Although the painting has the monumental scale of a traditional history painting, the subject's ordinariness and the starkly antiheroic composition horrified contemporary critics. Arranged in a wavering line extending across the broad horizontal width of the canvas, the figures are portrayed in groups—the somberly clad women at the back right, a semicircle of similarly clad men by the open grave, and assorted churchmen at the left. This wall of figures, seen at eye level in person, blocks any view into deep space. The faces are portraits; some of the models were Courbet's sisters (three of the women in the front row, toward the right) and friends. Behind and above the figures are bands of overcast sky and barren cliffs. The dark pit of the grave opens into the viewer's space in the center foreground. Despite the unposed look of the figures, the artist controlled the composition in a masterful way by his sparing use of bright color. The heroic, the sublime, and the dramatic are not found here—only the mundane realities of daily life and death. In 1857, Champfleury wrote of *Burial at Ornans*, ". . . it represents a small-town funeral and yet reproduces the funerals of *all* small towns."[6] Unlike the theatricality of Romanticism, Realism captured the ordinary rhythms of contemporaneous life.

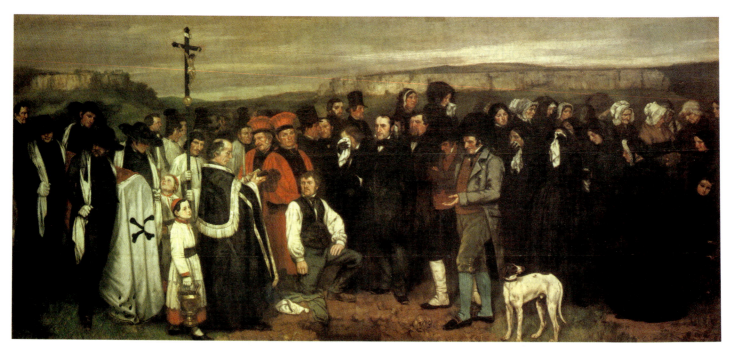

29-2 GUSTAVE COURBET, *Burial at Ornans*, 1849. Oil on canvas, approx. 10′ × 22′. Louvre, Paris.

EMPHASIZING THE PAINTED SURFACE Viewed as the first modernist movement by many scholars and critics, Realism also involved a reconsideration of the painter's primary goals and departed from the established priority on illusionism. Accordingly, Realists called attention to painting as a pictorial construction by their pigment application or composition manipulation. Courbet's intentionally simple and direct methods of expression in composition and technique seemed unbearably crude to many of his more traditional contemporaries, and he was called a primitive. Although his bold, somber palette was essentially traditional, Courbet often used the palette knife for quickly placing and unifying large daubs of paint, producing a roughly wrought surface. His example inspired the young artists who worked for him (and later Impressionists such as Claude Monet and Auguste Renoir), but the public accused him of carelessness and critics wrote of his "brutalities."

Because of both the style and content of Courbet's paintings, they were not well received. The jury selecting work for the 1855 Salon (part of the Exposition Universelle in that year) rejected two of his paintings on the grounds that his subjects and figures were too coarsely depicted (so much so as to be plainly "socialistic") and too large. In response, Courbet set up his own exhibition outside the grounds, calling it the Pavilion of Realism. Courbet's pavilion and his statements amounted to the new movement's manifestos. Although he maintained he founded no school and was of no school, he did, as the name of his pavilion suggests, accept the term *realism* as descriptive of his art.

A PAINTER OF COUNTRY LIFE Like Courbet, JEAN-FRANÇOIS MILLET (1814–1878) found his subjects in the people and occupations of the everyday world. Millet was one of a group of French painters of country life who, to be close to their rural subjects, settled near the village of Barbizon in the forest of Fontainebleau. This Barbizon school specialized in detailed pictures of forest and countryside. Millet, perhaps their most prominent member, was of peasant stock and identified with the hard lot of the country poor. In *The Gleaners* (FIG. **29-3**), he depicted three peasant women performing the back-breaking task of gleaning the last wheat scraps. These women were members of the lowest level of peasant society, and such impoverished people were permitted to glean—to pick up the remainders left in the field after the harvest. This feudal right was traditionally granted to the peasantry by landowning nobles. Millet characteristically placed his monumental figures in the foreground, against a broad sky. Although the field stretches back to a rim of haystacks, cottages, trees, and distant workers and a flat horizon, the viewer's attention is drawn to the gleaners quietly doing their tedious and time-consuming work.

Although Millet's works have a sentimentality absent from those of Courbet, the French public reacted to paintings such as *The Gleaners* with disdain and suspicion. In the aftermath of the Revolution of 1848, Millet's investing the poor with solemn grandeur did not meet with the approval of the prosperous classes. In particular, middle-class landowners resisted granting the traditional gleaning rights, and thus such relatively dignified depictions of gleaning did not sit well with them. Further, the middle class linked the poor with the dangerous, newly defined working class, which was finding outspoken champions in men such as Karl Marx, Friedrich Engels, and the novelists Émile Zola (1840–1902) and Charles Dickens (1812–1870). Socialism was a growing movement, and both its views on property and its call for social justice, even economic equality, frightened the bourgeoisie. Millet's sympathetic depiction of the poor seemed to many like a political manifesto.

CHAMPIONING THE WORKING CLASS Because people widely recognized the power of art to serve political means, the political and social agitation accompanying the violent revolutions in France and the rest of Europe in the later 18th and early 19th centuries prompted the French people to suspect artists of subversive intention. A person could be jailed for too bold a statement in the press, in literature, in art—even in music and drama. Realist artist

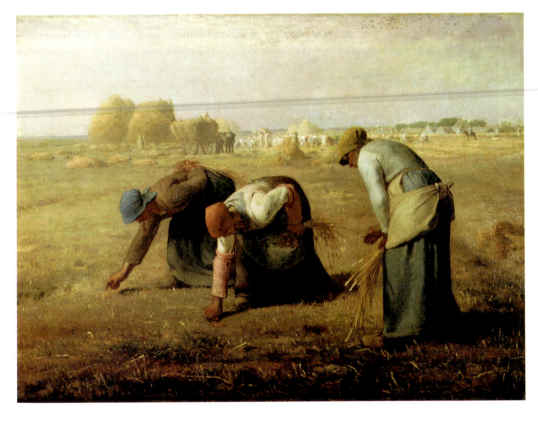

29-3 JEAN-FRANÇOIS MILLET, *The Gleaners*, 1857. Oil on canvas, approx. 2′ 9″ × 3′ 8″. Louvre, Paris.

from war to peace. Indeed, one could suggest that the veteran turned from harvesting men (see FIG. 28-68) to harvesting wheat. This transition to work after the end of the Civil War and the fate of disbanded soldiers were of national concern. The *New York Weekly Tribune* commented: "Rome took her great man from the plow, and made him a dictator—we must now take our soldiers from the camp and make them farmers."[10] America's ability to effect a smooth transition was seen as evidence of its national strength. "The peaceful and harmonious disbanding of the armies in the summer of 1865," poet Walt Whitman wrote, was one of the "immortal proofs of democracy, unequall'd in all the history of the past."[11] Homer's painting thus reinforced the perception of the country's greatness.

The Veteran in a New Field also comments symbolically about death—both the deaths of the soldiers and the death of Abraham Lincoln. By the 1860s, farmers used cradled scythes to harvest wheat. However, Homer chose not to insist on this historical reality and painted a single-bladed scythe. This transforms the veteran into a symbol of Death—the Grim Reaper himself—and the painting into an elegy to the thousands of soldiers who died in the Civil War and into a lamentation on the death of the recently assassinated president.

NOT FOR THE SQUEAMISH A dedicated appetite for showing the realities of the human experience made THOMAS EAKINS (1844–1916) a master Realist portrait and genre painter in the United States. He studied both painting and medical anatomy in Philadelphia before undertaking further study under French artist Jean-Léon Gérôme (1824–1904). Eakins was resolutely a Realist; his ambition was to paint things as he saw them rather than as the public might wish them portrayed. This attitude was very much in tune with 19th-century American taste, combining an admiration for accurate depiction with a hunger for truth.

The too-brutal Realism of Eakins's early masterpiece, *The Gross Clinic* (FIG. **29-12**), prompted the art jury to reject it for the Philadelphia exhibition that celebrated the American independence centennial. The work presents the renowned surgeon Dr. Samuel Gross in the operating amphitheater of the Jefferson Medical College in Philadelphia, where the painting now hangs. That Eakins chose to depict such an event testifies to the public's increasing faith in scientific and medical progress. Dr. Gross, with bloody fingers and scalpel, lectures about his surgery on a young man's leg. The patient suffered from osteomyelitis, a bone infection. The surgeon, acclaimed for his skill in this particular operation, is accompanied by colleagues, all of whom historians have identified, and by the patient's mother, who covers her face. Indicative of the contemporaneity of this scene is the anesthetist's presence in the background, holding the cloth over the patient's face. Anesthetics had been introduced in 1846, and their development eliminated a major obstacle to extensive surgery. The painting is, indeed, an unsparing description of a contemporaneous event, with a good deal more reality than many viewers could endure. "It is a picture," one critic said, "that even strong men find difficult to look at long, if they can look at it at all."[12] It was true to the artistic program of "scenes from modern life," as Southworth and Hawes had been in their daguerreotype of a similar setting (see FIG. 28-65). Both images recorded a particular event at a particular time.

Eakins believed that knowledge—and where relevant, scientific knowledge—was a prerequisite to his art. As a scientist (in his anatomical studies), Eakins preferred a slow, deliberate method of careful invention based on his observations of the perspective, the anatomy, and the actual details of his subject. This insistence on

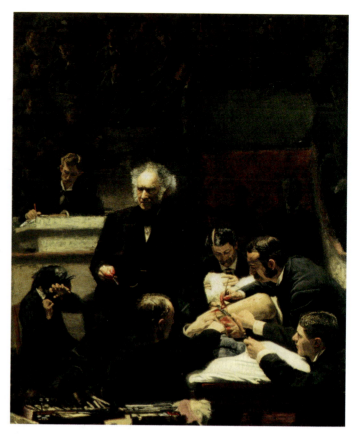

29-12 THOMAS EAKINS, *The Gross Clinic*, 1875. Oil on canvas, 8′ × 6′ 6″. Jefferson Medical College of Thomas Jefferson University, Philadelphia.

scientific fact corresponded to the dominance of empiricism during the latter half of the 19th century. Eakins's concern for anatomical correctness led him to investigate the human form and humans in motion, both with regular photographic apparatuses and with a special camera that the French kinesiologist (a person who studies the physiology of body movement) Étienne-Jules Marey devised. Eakins's later collaboration with Eadweard Muybridge in the photographic study of animal and human action of all types drew favorable attention in France, especially from Degas, and anticipated the motion picture.

THE ILLUSION OF MOTION The Realist photographer and scientist EADWEARD MUYBRIDGE (1830–1904) came to the United States from England in the 1850s and settled in San Francisco, where he established a prominent international reputation for his photographs of the western United States. (His large-plate landscape images of the Yosemite region won him a gold medal at the Vienna Exposition of 1873.) In 1872, the governor of California, Leland Stanford, sought Muybridge's assistance in settling a bet about whether, at any point in a stride, all four feet of a horse galloping at top speed are off the ground. Through his sequential photography, as seen in *Horse Galloping* (FIG. **29-13**), Muybridge proved they were. This experience was the beginning of Muybridge's photographic studies of the successive stages in human and animal motion—details too quick for the human eye to capture. These investigations culminated in 1885 at the University of Pennsylvania with a series of multiple-camera motion studies that recorded separate photographs of progressive moments in a single action. His discoveries received extensive publicity through the book *Animal Locomotion*, which Muybridge published in

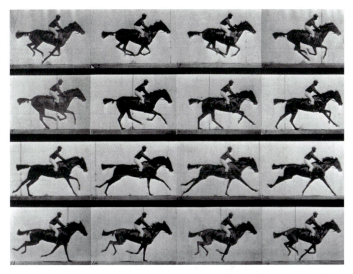

29-13 EADWEARD MUYBRIDGE, *Horse Galloping*, 1878. Collotype print. George Eastman House, Rochester, New York.

1887. Muybridge's motion photographs earned him a place in the history of science, as well as art. His sequential motion studies, along with those of Eakins and Marey, influenced many other artists, including their contemporary, the painter and sculptor Edgar Degas (FIGS. 29-27 and 29-30), and 20th-century artists such as Marcel Duchamp (see FIGS. 33-23, 33-24, and 33-29).

Muybridge presented his work to scientists and general audiences with a device called the zoopraxiscope, which he invented to project his sequences of images (mounted on special glass plates) onto a screen. The result was so lifelike that one viewer said it "threw upon the screen apparently the living, moving animals. Nothing was wanting but the clatter of hoofs upon the turf."[13] The illusion of motion here was created by a physical fact of human eyesight called "persistence of vision." Stated simply, it means that the brain holds whatever the eye sees for a fraction of a second after the eye stops seeing it. Thus, viewers saw a rapid succession of different images merging one into the next, producing the illusion of continuous change. This illusion lies at the heart of the "realism" of all cinema.

AMERICAN REALIST PORTRAITURE The expatriate American artist JOHN SINGER SARGENT (1856–1925) was a younger contemporary of Eakins and Muybridge. Sargent developed a looser, more dashing Realist portrait style, in contrast to Eakins's carefully rendered details. Sargent studied art in Paris before settling in London, where he was renowned both as a cultivated and cosmopolitan gentleman and as a facile and fashionable portrait painter. He learned his fluent brushing of paint in thin layers and his effortless achievement of quick and lively illusion from his study of Velázquez, whose masterpiece, *Las Meninas* (see FIG. 24-33), may have influenced Sargent's family portrait *The Daughters of Edward Darley Boit* (FIG. **29-14**). The four girls (the children of one of Sargent's close friends) appear in a hall and small

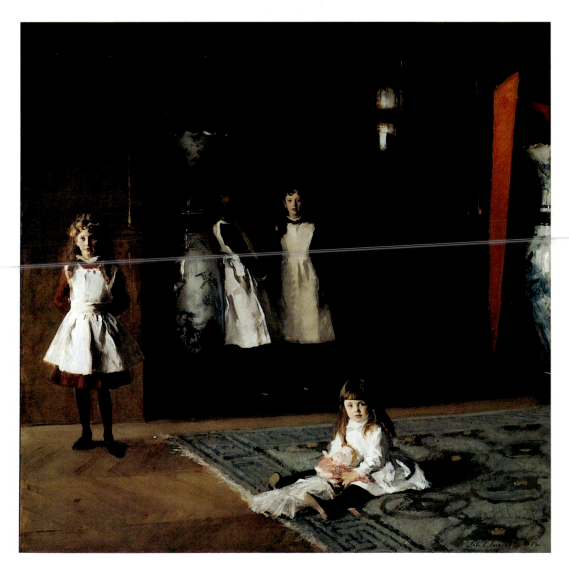

29-14 JOHN SINGER SARGENT, *The Daughters of Edward Darley Boit*, 1882. Oil on canvas, 7′ 3 3/8″ × 7′ 3 5/8″. Museum of Fine Arts, Boston (gift of Mary Louisa Boit, Florence D. Boit, Jane Hubbard Boit, and Julia Overing Boit, in memory of their father, Edward Darley Boit).

remarkably similar to his *La Place du Théâtre Français.* With a special twin-lensed camera, HIPPOLYTE JOUVIN (active mid-1800s) made the stereograph, viewed with an apparatus called a stereoscope, to re-create the illusion of three dimensions. In this double image, the viewer's vantage point is from the upper story of a building along the roadway of the "New Bridge," which stretches diagonally from lower left to upper right. Hurrying pedestrians are dark silhouettes, and the scene moves from sharp focus in the foreground to soft focus in the distance. Because of the familiarity Pissarro and the other Impressionists had with photography, scholars have been quick to point out the visual parallels between Impressionist paintings and photographs. These parallels include, here, the arbitrary cutting off of figures at the frame's edge and the curious flattening spatial effect the high viewpoint caused.

LEISURE AND RECREATION Another facet of the new, industrialized Paris that drew the Impressionists' attention was the leisure activities of its inhabitants. Scenes of dining, dancing, the café-concerts, the opera, the ballet, and other forms of enjoyable recreation were mainstays of Impressionism. Although seemingly unrelated to industrialization, these activities were facilitated by it. With the advent of set working hours, people's schedules became more regimented, allowing them to plan their favorite pastimes.

A LIVELY PARISIAN DANCE HALL *Le Moulin de la Galette* (FIG. **29-25**) by PIERRE-AUGUSTE RENOIR (1841–1919) depicts a popular Parisian dance hall. Throngs of people have gathered; some people crowd the tables and chatter, while others dance energetically. So lively is the atmosphere that the viewer can virtually hear the sounds of music, laughter, and tinkling glasses. The whole scene is dappled by sunlight and shade, artfully blurred into the figures to produce just the effect of floating and fleeting light the Impressionists so cultivated. Renoir's casual unposed placement of the figures and the suggested continuity of space, spreading in all directions and only accidentally limited by the frame, position the viewer as a participant, rather than as an outsider. Whereas classical art sought to express universal and timeless qualities, Impressionism attempted to depict just the opposite—the incidental, momentary, and passing aspects of reality.

A REFLECTION ON CAFÉ LIFE Édouard Manet's famous work, *A Bar at the Folies-Bergère* (FIG. **29-26**), was painted in 1882. The Folies-Bergère was a popular Parisian café-concert (a café with music-hall performances). These cafés were fashionable gathering places for throngs of revelers, and many of the Impressionists frequented these establishments. In *Folies-Bergère,* the viewer is confronted by a barmaid, centrally placed, who looks back but who seems disinterested or lost in thought. This woman appears divorced from the patrons as well as from the viewer.

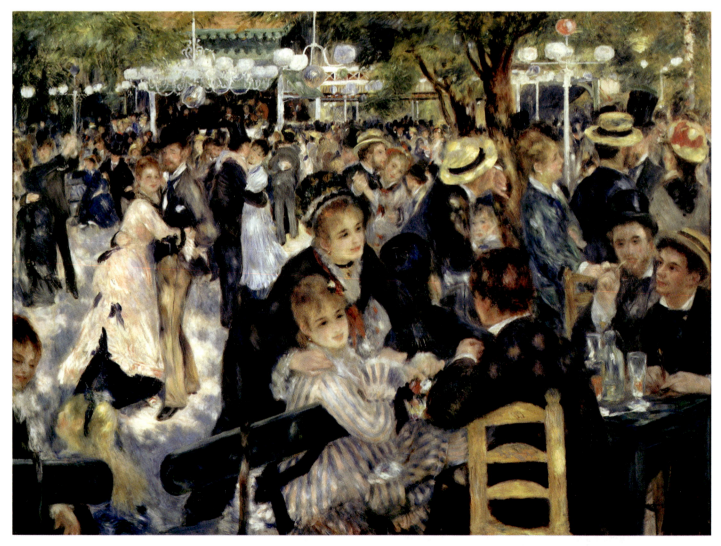

29-25 PIERRE-AUGUSTE RENOIR, *Le Moulin de la Galette,* 1876. Oil on canvas, approx. 4′ 3″ × 5′ 8″. Réunion des Musées Nationaux.

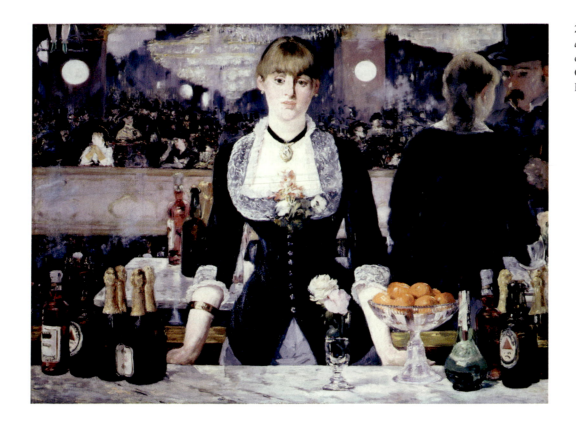

29-26 ÉDOUARD MANET, *A Bar at the Folies-Bergère,* 1882. Oil on canvas, approx. 3′ 1″ × 4′ 3″. Courtauld Institute of Art Gallery, London.

Manet blurred and roughly applied the brush strokes, particularly those in the background, and the effects of modeling and perspective are minimal. This painting method further calls attention to the surface by forcing the viewer to scrutinize the work to make sense of the scene. On such scrutiny, visual discrepancies seem to emerge. For example, what initially seems easily recognizable as a mirror behind the barmaid creates confusion throughout the rest of the painting. Is the woman on the right the barmaid's reflection? If so, it is impossible to reconcile the spatial relationship between the barmaid, the mirror, the bar's frontal horizontality, and the barmaid's seemingly displaced reflection. These visual contradictions reveal Manet's insistence on calling attention to the pictorial structure of this painting, in keeping with his modernist interest in examining the basic premises of the medium. This radical break with tradition and redefinition of the function of the picture surface explains why many scholars position Manet as the first modernist artist.

OF MUSIC AND DANCE: THE BALLET Impressionists also depicted more formal leisure activities. The fascination EDGAR DEGAS (1834–1917) had with patterns of motion brought him to the Paris Opéra and its ballet school. There, his great observational power took in the formalized movements of classical ballet, one of his favorite subjects. In *Ballet Rehearsal* (FIG. **29-27**), Degas used

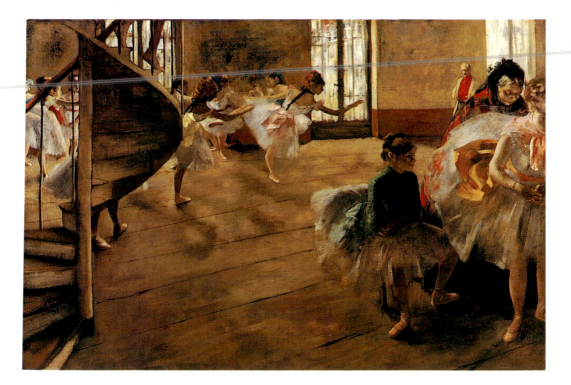

29-27 EDGAR DEGAS, *Ballet Rehearsal,* 1874. Oil on canvas, 1′ 11″ × 2′ 9″. Glasgow Art Galleries and Museum, Glasgow (The Burrell Collection).

29-55 Antonio Gaudi, Casa Milá, Barcelona, 1907.

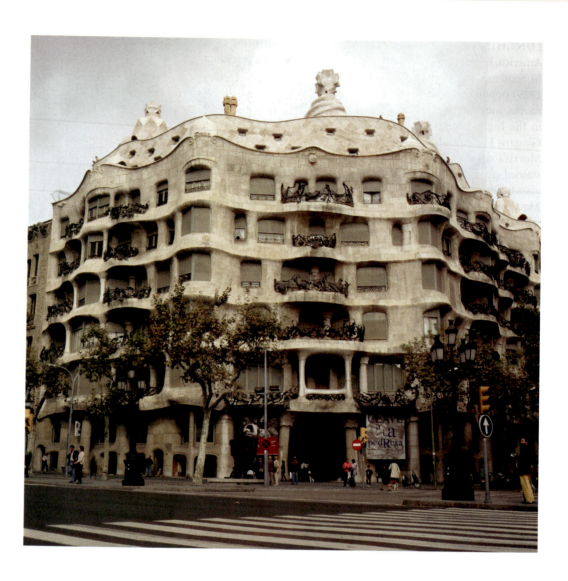

unfailing sense of linear rhythms and harmonies supports his mastery of calligraphic line. In his short lifetime—he died at age 26—he expressed in both his life and art the aesthete's ideal of "art for art's sake."

SCULPTING A BUILDING Art Nouveau achieved its most personal expression in the work of the Spanish architect ANTONIO GAUDI (1852–1926). Before becoming an architect, Gaudi had trained as an ironworker. Like many young artists of his time, he longed to create a style that was both modern and appropriate to his country. Taking inspiration from Moorish-Spanish architecture and from the simple architecture of his native Catalonia, Gaudi developed a personal aesthetic. He conceived a building as a whole and molded it almost as a sculptor might shape a figure from clay. Although work on his designs proceeded slowly under the guidance of his intuition and imagination, Gaudi was a master who invented many new structural techniques that facilitated the actual construction of his visions. His apartment house, Casa Milá (FIG. **29-55**), is a wondrously free-form mass wrapped around a street corner. Lacy iron railings enliven the swelling curves of the cut-stone facade. Dormer windows peep from the undulating tiled roof, which is capped by fantastically writhing chimneys that poke energetically into the air above. The rough surfaces of the stone walls suggest naturally worn rock. The entrance portals look like eroded sea caves, but their design also may reflect the excitement that swept Spain following the 1879 discovery of Paleolithic cave paintings at Altamira. Gaudi felt that each

of his buildings was symbolically a living thing, and the passionate naturalism of his Casa Milá is the spiritual kin of early-20th-century Expressionist painting and sculpture.

FIN DE SIÈCLE CULTURE

As the end of the 19th century neared, the momentous changes to which the Realists and Impressionists responded had become familiar and ordinary. As noted earlier, the term *fin de siècle*, which literally means "end of the century," is used to describe this period. This designation is not merely chronological but also refers to a certain sensibility. The cultures to which this term applies experienced a significant degree of political upheaval toward the end of the 19th century. Moreover, prosperous wealthy middle classes dominated these societies—middle classes that aspired to the advantages the aristocracy already enjoyed. These people were determined to live "the good life," which evolved into a culture of decadence and indulgence. Characteristic of the fin de siècle period was an intense preoccupation with sexual drives, powers, and perversions; the femme fatale was a particularly resonant figure. People at the end of the century also immersed themselves in an exploration of the unconscious. This culture was unrestrained and freewheeling, but the determination to enjoy life masked an anxiety prompted by the fluctuating political situation and uncertain future. The country most closely associated with fin de siècle culture was Austria.

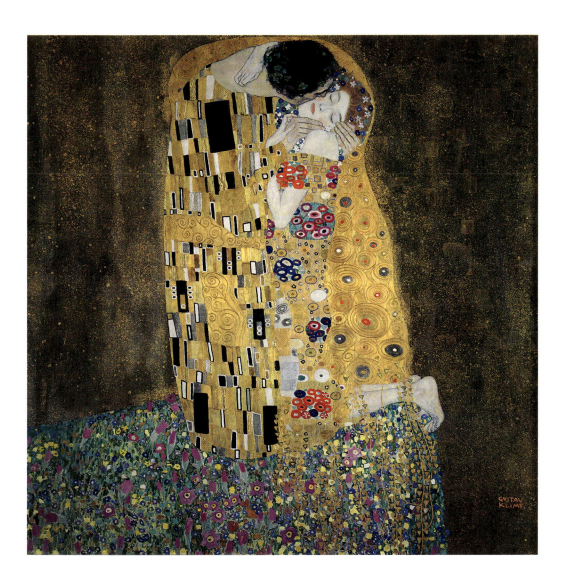

29-56 Gustav Klimt, *The Kiss*, 1907–1908. Oil on canvas, 5′ 10$\frac{3}{4}$″ × 5′ 10$\frac{3}{4}$″. Austrian Gallery, Vienna.

FIN DE SIÈCLE SENSUALITY One Viennese artist whose works capture this period's flamboyance but temper it with unsettling undertones was Gustav Klimt (1863–1918). In *The Kiss* (FIG. **29-56**), Klimt depicted a couple locked in an embrace. All that is visible of the couple, however, is a segment of each person's head. The rest of the painting dissolves into shimmering, extravagant flat patterning. This patterning has clear ties to Art Nouveau and to the Arts and Crafts movement. Such a depiction is also reminiscent of the conflict between two- and three-dimensionality intrinsic to the work of Degas and other modernists. Paintings such as *The Kiss* were visual manifestations of fin de siècle spirit because they captured a decadence conveyed by opulent and sensuous images.

OTHER ARCHITECTURE IN THE LATER 19TH CENTURY

The Beginnings of a New Style

In the later 19th century, new technology and the changing needs of urbanized, industrialized society affected architecture throughout the Western world. Since the 18th century, bridges had been built of cast iron (see FIG. 28-10), which permitted engineering advancements in the construction of larger, stronger, and more fire-resistant structures. Steel, available after 1860, allowed architects to enclose ever larger spaces, such as those found in railroad stations and exposition halls.

A SOARING METAL SKELETON The Realist impulse encouraged an architecture that honestly expressed a building's purpose, rather than elaborately disguising a building's function. The elegant metal skeleton structures of the French engineer-architect Alexandre-Gustave Eiffel (1832–1923) can be seen as responses to this idea, and they constituted an important contribution to the development of the 20th-century skyscraper. A native of Burgundy, Eiffel trained in Paris before beginning a distinguished career designing exhibition halls, bridges, and the interior armature for France's anniversary gift to the United States—Frédéric Auguste Bartholdi's Statue of Liberty. Eiffel designed his best-known work, the Eiffel Tower (FIG. **29-57**), for a great exhibition in Paris in 1889. Originally seen as a symbol of modern Paris and still considered a symbol of 19th-century civilization, the elegant metal tower thrusts its needle shaft 984 feet above the city, making it at the time of its construction (and for some time to come) the world's highest structure. The tower's well-known configuration rests on four giant supports connected by gracefully arching open-frame skirts that provide a pleasing mask for the heavy horizontal girders needed to strengthen the legs. Visitors can take two elevators to the top, or they can use the internal staircase. Architectural historian

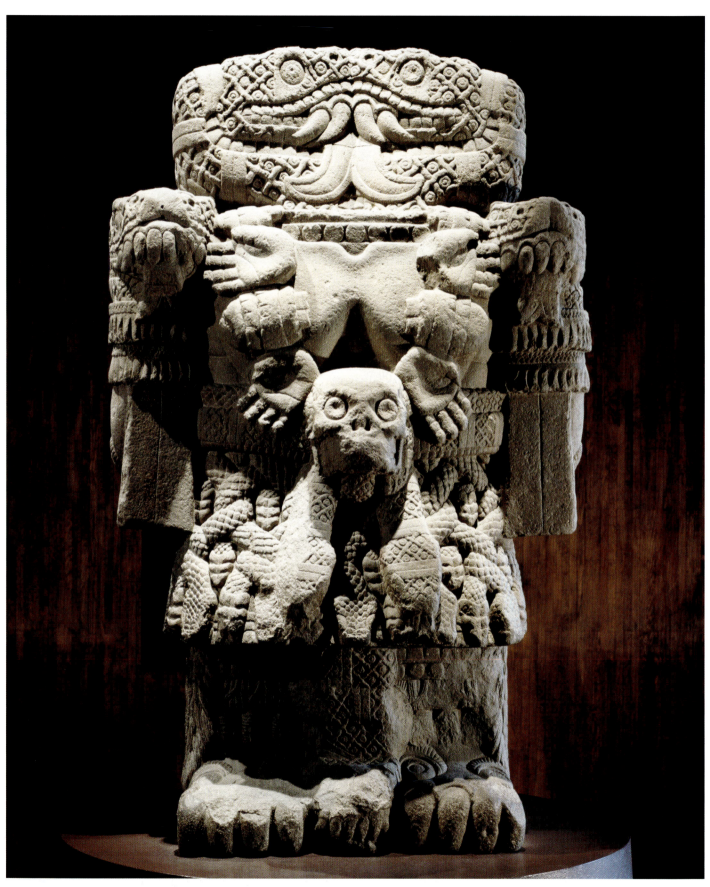

Coatlicue (She of the Serpent Skirt), Aztec, from Tenochtitlán, Mexico City, ca. 1487–1520. Andesite, 11′ 6″ high. Museo Nacional de Antropología, Mexico City.

30

BEFORE AND AFTER
THE CONQUISTADORS

NATIVE ARTS OF THE AMERICAS AFTER 1300

In the years following Christopher Columbus's arrival in the "New World" in 1492, the Spanish monarchs poured money into expeditions that probed the coasts of North and South America (MAP 30-1), but had little luck in finding the wealth they sought. When brief stops on the coast of Yucatán, Mexico, yielded a small but still impressive amount of gold and other precious artifacts, the Spanish governor of Cuba outfitted yet another expedition. Headed by Hernán Cortés, this contingent of Spanish explorers was the first to make contact with the great Aztec emperor Moctezuma (r. 1502–1521). In only two years, with the help of guns, horses, and native allies revolting against their Aztec overlords, Cortés managed to overthrow the vast and rich Aztec Empire. His victory in 1521 opened the door to hordes of Spanish conquistadors seeking their fortunes, to missionaries eager for new converts to Christianity, and to a host of new diseases for which the native Americans had no immunity. The ensuing clash of cultures led to a century of turmoil and an enormous population decline throughout the Spanish king's new domains.

The Aztec Empire that the Spanish encountered and defeated was but the latest of a series of highly sophisticated indigenous art-producing cultures in the Americas. Their predecessors have been treated in Chapter 14. This chapter examines in turn the artistic achievements of the native peoples of Mesoamerica, South America, and North America after 1300.

MESOAMERICA

After the fall and destruction of the great central Mexican city of Teotihuacán in the eighth century and the abandonment of the southern Maya sites around 900, new cities arose to take their places (MAP 30-2). Notable were the Maya city of Chichén Itzá in Yucatán and Tula, the Toltec capital not far from modern Mexico City (see Chapter 14). Their dominance was relatively short-lived, however, and neither city left extensive

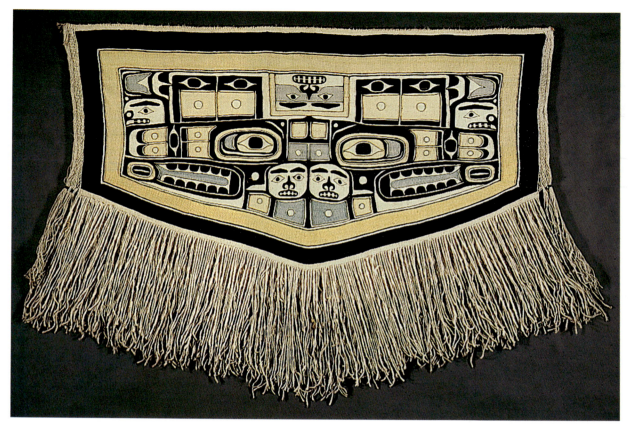

30-13 Chilkat blanket with stylized animal motifs, Tlingit, early 20th century. Mountain goat's wool and cedar bark, 6' × 2' 11". Southwest Museum, Los Angeles.

Additional crests could also be obtained through marriage and trade. The right to own and display such crests was so jealously guarded that even warfare could break out over the disputed ownership of a valued crest. In the poles shown, the crests represented include an upside-down dogfish (a small shark), an eagle with a downturned beak, and a killer whale with a crouching human between its snout and its upturned tail flukes. During the 19th century, the Haida erected more poles and made them larger in response to greater competitiveness and the availability of metal tools. The artists carved poles up to 60 feet tall from the trunks of single cedar trees. Because of the damp coastal climate, however, most of the poles decayed in a century or less. Nonetheless, many well-preserved 19th-century poles exist in museum collections. The Haida continue to carve totem poles in large numbers today.

ALASKAN CEREMONIAL BLANKETS Another characteristic Northwest Coast art form is the Chilkat blanket (FIG. **30-13**), named for an Alaskan Tlingit village where the blankets were woven. Male designers provided the templates for these blankets in the form of wooden pattern boards for the female weavers. Woven of shredded cedar bark and mountain goat wool on an upright loom, the Tlingit blankets took at least six months to complete. Actually robes worn over the shoulders, these became widespread prestige items of ceremonial dress during the 19th century. They display several characteristics of the Northwest Coast style recurrent in all media: symmetry and rhythmic repetition, schematic abstraction of animal motifs (in the robe illustrated, a bear), eye designs, a regularly swelling and thinning line, and a tendency to round off corners.

The devastating effects of 19th-century epidemics, coupled with government and missionary repression of Northwest Coast

ritual and social activities, threatened to wipe out the traditional arts entirely. Nevertheless, outstanding Northwest Coast artists continue to produce art objects today, some for the nonnative trade. The last half century has seen an impressive revival of traditional art forms, as well as the development of new ones, such as printmaking.

Eskimo

THE NORTH WIND The 19th-century Yupik Eskimos living around the Bering Strait of Alaska also had a highly developed ceremonial life focused on game animals, particularly seal. Their religious specialists wore highly imaginative masks with moving parts. The Yupik generally made these masks for single occasions and then abandoned them. Consequently, many masks have ended up in museums and private collections. Our example (FIG. **30-14**) represents the spirit of the north wind, its face surrounded by a hoop representing the universe, its voice re-created by the rattling appendages. The paired human hands commonly found on such masks refer to the wearer's power to attract animals for hunting. The painted white spots represent snowflakes.

In more recent years, Canadian Eskimos, known as the Inuit, have set up cooperatives to produce and market stone carvings and prints. With these new media, artists generally depict themes from the rapidly vanishing traditional Inuit way of life.

Great Plains

After colonial governments disrupted settled indigenous communities on the East Coast and the Europeans introduced the horse to North America, a new mobile Native American culture

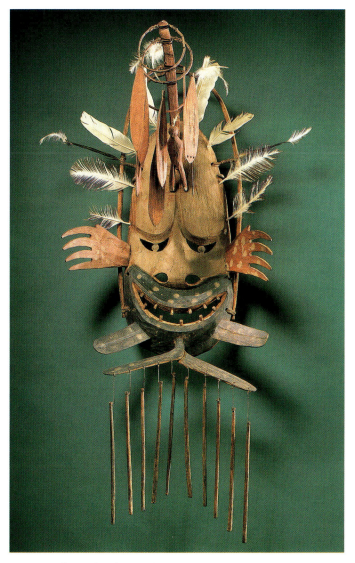

may be called his biography—a composite artistic statement in several media that neighboring Native Americans could have "read" easily. The concentric circle design over his left shoulder, for example, is an abstract rendering of an eagle-feather warbonnet.

Plains peoples also made shields and shield covers that were both artworks and "power images." Shield paintings often derived from personal religious visions. The owners believed that the symbolism, the pigments themselves, and added materials, such as feathers, provided them with magical protection and supernatural power.

Plains warriors battled incursions into their territory throughout the 19th century, but they were finally defeated by a combination of broken treaties, the rapid depletion of the buffalo, and military defeats at the hands of the U.S. Army. The pursuit of Plains natives culminated in the 1890 slaughter of Lakota participants who had gathered for a ritual known as the Ghost Dance at Wounded Knee Creek, South Dakota. Indeed, from the 1830s on, U.S. troops forcibly removed Native Americans from their homelands and resettled them in other parts of the country. Toward the end of the century, governments confined them to reservations in both the United States and Canada.

LEDGER PAINTINGS During the reservation period, some Plains arts continued to flourish, notably beadwork for the women and painting in ledger books for the men. Traders, the army, and Indian agents had for years provided Plains peoples with pencils

30-14 Mask, Yupik Eskimo, Alaska, early 20th century. Wood and feathers, approx. 3′ 9″ high. Metropolitan Museum of Art, New York (The Michael C. Rockefeller Memorial Collection, gift of Nelson Rockefeller).

flourished for a short time on the Great Plains. Artists of the Great Plains worked in materials and styles quite different from those of the Northwest Coast and Eskimo peoples. Much artistic energy went into the decoration of leather garments, pouches, and horse trappings, first with compactly sewn quill designs and later with beadwork patterns. Artists painted tipis, tipi linings, and buffalo-skin robes with geometric and stiff figural designs prior to about 1830. After that, they gradually introduced naturalistic scenes, often of war exploits, in styles adapted from those of visiting European artists.

HIDATSA REGALIA Because, at least in later periods, most Plains peoples were nomadic, they focused their aesthetic attention largely on their clothing and bodies and on other portable objects, such as shields, clubs, pipes, tomahawks, and various containers. Transient but important Plains art forms can sometimes be found in the paintings and drawings of visiting American and European artists. The Swiss KARL BODMER (1809–1893), for example, portrayed the personal decoration of Two Ravens, a Hidatsa warrior, in an 1833 watercolor (FIG. **30-15**). The painting depicts his pipe, painted buffalo robe, bear-claw necklace, and feather decorations, all symbolic of his affiliations and military accomplishments. They

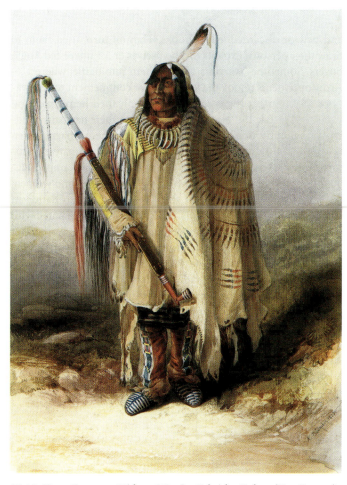

30-15 KARL BODMER, *Hidatsa Warrior Pehriska-Ruhpa (Two Ravens)*, 1833. Watercolor, 1′ 3⅞″ × 11½″. Joslyn Art Museum, Omaha (gift of the Enron Art Foundation).

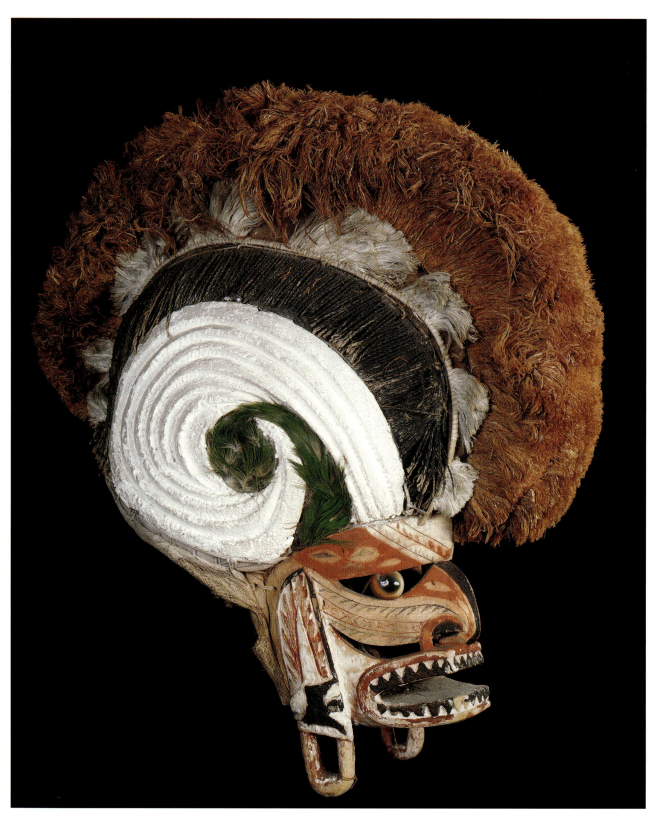

Tatanua mask, from New Ireland. Wood, shell, lime, and fiber, 1′ 5$\frac{3}{4}$″ high. Otago Museum, New Zealand.

31

THE FLOURISHING
OF ISLAND CULTURES
THE ART OF OCEANIA

Although the term *South Pacific* may well call to mind images of balmy tropical is-
lands, the Pacific Ocean actually encompasses a truly diverse range of habitats
and cultures. Environments range from the arid deserts of the Australian outback to
the tropical rainforests of inland New Guinea and the coral atolls of the Marshall Is-
lands. Oceanic cultures are not only geographically varied but also politically, linguis-
tically, culturally, and artistically diverse.

WAVES ACROSS THE PACIFIC Oceania (MAP **31-1**) consists of over 25,000 islands
(less than 1,500 inhabitable), including the island continent of Australia. Although
documentary evidence does not exist for Oceanic cultures until the arrival of seafar-
ing Europeans in the early 16th century, archaeologists have determined that the is-
lands have been inhabited for tens of thousands of years. Their research has revealed
that different parts of the Pacific were populated during distinct migratory waves. The
first group arrived in the Pacific during the last Ice Age, approximately 40,000 years
ago, when a large continental shelf extended from Southeast Asia and allowed human
access to Australia and New Guinea. After the end of the Ice Age, descendants of these
first settlers dispersed to other islands. The most recent migratory wave to areas of
Micronesia and Polynesia involved people of Asian ancestry; this migration probably
took place sometime after 3000 BCE. Knowledge of this movement into Micronesia
and western Polynesia is based in part on a type of pottery (known as Lapita) that is
common to much of this area. Named after a site on New Caledonia in Melanesia,
Lapita pottery (ceramic vessels elaborately decorated with incised, geometric designs)
has been found in a geographical region stretching from the straits between New
Guinea and New Britain in the west, to Tonga and Samoa in the east. The last Pacific
islands colonized were those of Polynesia; its most far-flung islands—Hawaii, New
Zealand, and Rapa Nui (Easter Island)—were inhabited by about 500–1000 CE.

Because of the expansive chronological span of these migrations, Pacific cultures
vary widely. For example, the Aboriginal peoples of Australia speak a language unre-
lated to those of New Guinea, whose diverse languages fall into a family often referred

These figures symbolize female clan ancestors in a birthing position. The Iatmul also keep various types of portable art in their ceremonial houses. These include ancestors' skulls overmodeled with clay in a likeness of the deceased, ceremonial chairs, sacred flutes, hooks for hanging sacred items and food, and several types of masks.

The Abelam (Papua New Guinea)

A COMPLEX YAM CULT That Oceanic art relates not only to fundamental spiritual beliefs but also to basic subsistence is highlighted by the yam masks produced by the Abelam people, agriculturists living in the hilly regions north of the Sepik River. The Abelam's principal cultivar is the yam. Such has been the case throughout recent Abelam history and continues to the present day. Relatively isolated, the Abelam received only sporadic visits from foreigners until the 1930s, so little is known about early Abelam history. Because of the importance of yams to the survival of Abelam society, those who can grow the largest yams are endowed with power and prestige. Indeed, the Abelam developed

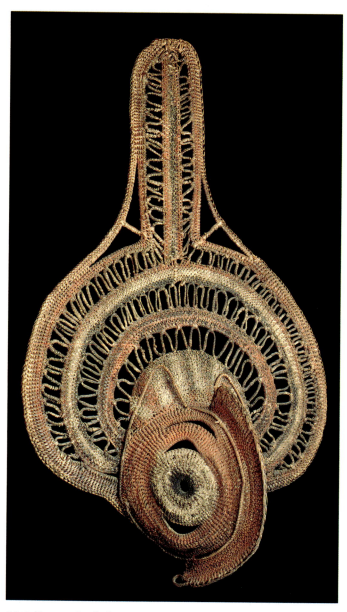

31-2 Yam mask, Abelam, Maprik district, Papua New Guinea, 1′ 6 9/10″ high.

a complex yam cult, which involves a series of rites and activities intended to promote the growth of yams. Special plantations are devoted to yam cultivation; only initiated men who observe strict rules of conduct, including sexual abstinence, can work these fields. The Abelam believe that ancestors aid in the growth of yams, and they hold ceremonies to honor these ancestors. Special long yams (distinct from the short yams cultivated for consumption) are placed on display during these festivities, and the largest of the yams are named after important ancestors. Yam masks are an integral part of the ceremonies. These cane or wood frame masks (FIG. **31-2**) are usually painted red, white, yellow, and black. Further, the Abelam incorporate sculpted faces, cassowary feathers, and shell ornaments into the yam masks. The Abelam use the same designs to decorate their bodies for dances, revealing how closely they identify with their principal food source.

The Asmat (Irian Jaya)

THE ART OF WARFARE In contrast with the Abelam, with their relatively peaceful agricultural pursuits, the Asmat face a much harsher life. Living along the coast of southwestern New Guinea, the Asmat eke out their existence by hunting and gathering the varied flora and fauna found in the mangrove swamps, rivers, and tropical forests where they live. Because resources are limited, each Asmat community is in constant competition for these resources. Historically, the Asmat extended this competitive spirit beyond food and materials to energy and power as well. To increase one's personal energy or spiritual power, one had to take it forcibly from someone else. As a result, warfare and head-hunting became central to Asmat culture and art. The Asmat did not believe that any death was natural; it could only be the result of a direct assault (head-hunting or warfare) or sorcery, and it diminished ancestral power. Thus, to restore a balance of spirit power, an enemy's head had to be taken to avenge a death and to add to one's communal spirit power. Head-hunting was common in the 1930s when Europeans established an administrative and missionary presence among the Asmat. As a result of European efforts, head-hunting was effectively abandoned by the 1960s.

AVENGING A DEATH When they still practiced head-hunting, the Asmat erected *bisj* poles (FIG. **31-3**) that served as a pledge to avenge a relative's death. Such poles were constructed when a man could command the support of enough men to undertake a head-hunting raid. Carved from the trunk of the mangrove tree, bisj poles included superimposed figures of individuals who had died. At the top, extending flangelike from the bisj pole, was one of the tree's buttress roots carved into an openwork pattern. All of the decorative elements on the pole were related to head-hunting and foretold a successful raid. The many animals that appeared on bisj poles (and in Asmat art in general) are symbols of head-hunting. The Asmat see the human body as a tree—the feet as the roots, the arms as the branches, and the head as the fruit. Thus any fruit-eating animal (such as the black king cockatoo, the hornbill, or the flying fox) is symbolic of the headhunter and appeared frequently on bisj poles. Asmat art also often includes representations of the praying mantis; the Asmat consider the female praying mantis's practice of beheading her mate after copulation and then eating him as another form of head-hunting. The curvilinear or spiral patterns that filled the pierced openwork at the top of the pole can be related to the characteristic curved tail of the *cuscus* (a fruit-eating mammal) or the tusk of a boar (related to hunting and virility). Once carved, bisj poles were placed on a

rack near the men's house, in public view. After the success of the head-hunting expedition, the bisj poles were discarded and allowed to rot, having served their purpose.

The Elema (Papua New Guinea)

VISITING WATER SPIRITS Central to the culture of the Elema people of Orokolo Bay in the Papuan Gulf was Hevehe, an elaborate cycle of ceremonial activities. Conceptualized as the mythical visitation of the water spirits (*ma-hevehe*), the Hevehe cycle involved the production and presentation of large, ornate masks (also called *hevehe*). The Elema last practiced Hevehe in the 1950s. Primarily organized by the male elders of the village, the cycle was a communal undertaking, and normally took from 10 to 20 years to complete. The duration of the Hevehe and the resources and human labor required reveal the role of Hevehe as a social glue—it reinforced cultural and economic relations and maintained the social structure in which elder male authority dominated.

Throughout the cycle, the Elema held ceremonies to initiate male youths into higher ranks. These ceremonies involved the exchange of wealth (such as pigs and shell ornaments), thereby

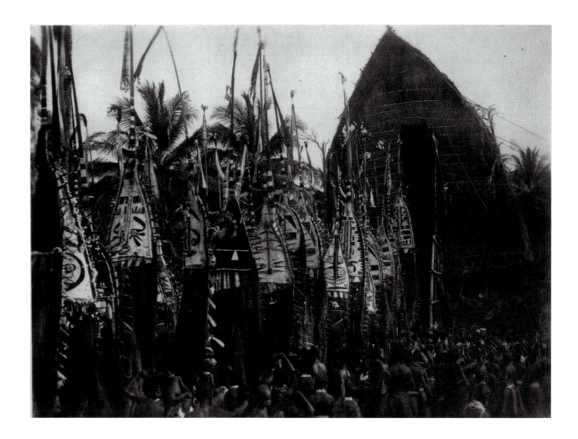

31-4 *Hevehe* masks retreating into the men's house *(eravo)*, Elema, Orokolo Bay, Papua New Guinea.

serving an economic purpose as well. The cycle culminated in the display of the finished hevehe masks. Each mask was constructed of painted barkcloth (see pages 930–931) wrapped around a cane-and-wood frame that fit over the wearer's body. A hevehe mask was normally 9 to 10 feet in height, although extensions often raised the height to as much as 25 feet. Because of its size and intricate design, a hevehe mask required great skill to construct, and only trained men would participate in mask-making. Designs were specific to particular clans and were passed down by elder men from memory. Each mask represented a female sea spirit, but the overall decoration of the mask often incorporated designs from local flora and fauna as well.

The final stage of the cycle focused on the dramatic appearance of the masks from the *eravo* (men's house; FIG. **31-4**). After a procession, men wearing the hevehe mingled with relatives. Upon conclusion of related dancing (often lasting about one month), the masks were ritually killed and then dumped in piles and burned. This destruction allowed the sea spirits to return to their mythic domain and provided a pretext for commencing the cycle again.

The Trobriand Islands (Papua New Guinea)

TRADING PLACES The various rituals of Oceanic cultures discussed thus far often involve exchanges that cement social relationships and reinforce or stimulate the economy. Further, these rituals usually have a spiritual dimension. All of these aspects apply to the practices of the Trobriand Islanders, who live off the coast of the southeastern corner of New Guinea (part of Papua New Guinea). The Trobriand Islanders are well known for *kula*—an exchange of white conus-shell arm ornaments for red chama-shell necklaces. Kula, possibly originating some 500 years ago, came to Western attention through the extensive documentation of anthropologist Bronislaw Malinowski (1884–1942),

published in 1920 and 1922. Kula exchanges can be complex, and there is great competition for valuable shell ornaments (determined by aesthetic appeal and exchange history). Because of the isolation imposed by their island existence, the Trobriand Islanders had to undertake potentially dangerous voyages to participate in kula trading. Appropriately, the Trobrianders lavish a great deal of effort on decorating their large canoes, which are elaborately carved and include ornate prows and splashboards (FIG. **31-5**). These prows and splashboards are carved by artists who have acquired both the necessary carving skill and the knowledge of the symbolism of the kula images. Human, bird, and serpent motifs, as references to sea spirits, ancestors, and totemic animals, appear on prows. These motifs are highly stylized, making specific identification difficult. The curvilinear, intertwined designs are fluidly presented; this intricate style is characteristic of Trobriand art. To ensure a successful kula expedition, the Trobrianders invoked spells when attaching these prows to the canoes. In recent years, Trobrianders have adapted kula to modern circumstances; by the 1970s, they largely abandoned canoes for motorboats, and the exchanges now facilitate contemporary business and political networking.

New Ireland (Papua New Guinea)

HONORING THE DEAD Mortuary rites and memorial festivals are a central concern of the Austronesian-speaking peoples who live in the northern section of the island of New Ireland in Papua New Guinea. The term *malanggan* refers to both the festivals held in honor of the deceased and the carvings and objects produced for these festivals. Malanggan practices have enjoyed longevity; one of the first references to malanggan appears in an 1883 publication, and these rituals continue to be practiced today. Malanggan rites are critical in facilitating the transition of the soul from the world of the

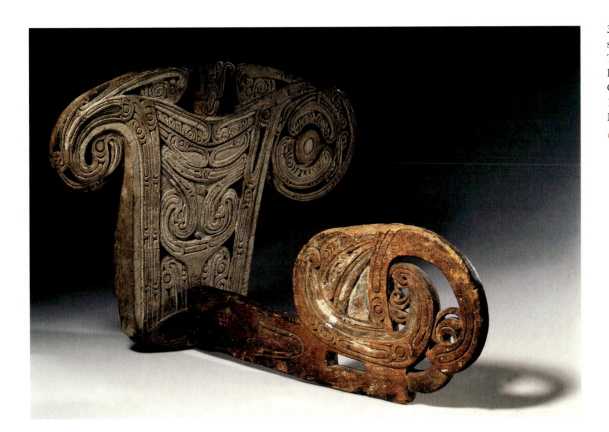

31-5 Canoe prow and splashboard, from Trobriand Islands, Milne Bay Province, Papua New Guinea. Wood and paint, 1′ 3½″ high, 1′ 11″ long. Musée de l'Homme, Paris.

living to the realm of the dead. Because of the ultimate destination of the soul, these rituals are part of an ancestor cult. In addition to the religious function of malanggan, the extended ceremonies also promote social solidarity and stimulate the economy (as a result of the resources necessary to mount impressive festivities). To educate the younger generation about these practices, malanggan also includes the initiation of young men.

Among the many malanggan carvings produced—masks, figures, poles, friezes, and ornaments—are *tatanua* masks (FIG. **31-6**). Although some masks are simply displayed, most of them are worn by dancers. Tatanua represent the spirits of specific deceased people and are constructed of soft wood, vegetable fiber, and rattan. The crested hair, made of fiber, duplicates a hairstyle formerly common among the men. Sea snail opercula (the operculum is the plate that closes the shell when the animal is retracted) are embedded as eyes. Traditionally, the masks are painted black, white, yellow, and red— colors the people of New Ireland associate with warfare, magic spells, and violence. Rather than being destroyed after the conclusion of the many ceremonies, tatanua are stored for future use.

MICRONESIA

THE ART OF SEAFARING CULTURES The Austronesian-speaking cultures of Micronesia tend to be more socially stratified than those found in New Guinea and other Melanesian areas. Such cultures are frequently organized around chieftainships with craft and ritual specializations, and their religions include named deities as well as honored ancestors. Life in virtually all Micronesian cultures centers around seafaring activities—fishing, trading, and long-distance travel in large oceangoing vessels. For this reason, much of their artistic imagery relates to the sea. Micronesian arts include carved canoes, charms, and images of spirits used to protect travelers at sea and for fishing and fertility magic. Micronesian artists also tend to simplify and to abstract geometrically the natural forms of animals, humans, and plants. This characteristic often differentiates Micronesian art from the arts of Melanesia, Polynesia, and Australia.

31-6 *Tatanua* mask, from New Ireland. Wood, shell, lime, and fiber, 1′ 5¾″ high. Otago Museum, New Zealand.

Belau (Caroline Islands)

HOUSES THAT TELL STORIES On Belau (formerly Palau) in the Caroline Islands, the islanders put much effort into creating and maintaining elaborately painted men's ceremonial clubhouses called *bai*. These bai (FIG. **31-7**) have steep overhanging roofs decorated with geometric patterns along the roof boards. Belau artists carve the gable in low relief and paint it with narrative scenes, as well as various abstracted forms of the shell money used traditionally on Belau as currency. These decorated storyboards illustrate important historical events and myths related to the clan who built the bai. In the illustration, the rooster images along the base of the house symbolize the rising sun, while the multiple frontal human faces carved and painted above the entrance and on the vertical elements above the rooster images represent a deity called Blellek. He warns women to stay away from the ocean and the *bai* or he will molest them. In so doing, the god serves as a social control mechanism within Belau society.

Artists also carve and paint the crossbeams on the inside of the house with similar narratives recounting clan histories and myths. The shell-like abstract patterns found on the exterior roof beams and lower sections of the house all refer to the shell-money wealth of the clan and its chief. While the Iatmul make their ceremonial houses, discussed earlier (FIG. 31-1), by elaborate tying, lashing, and weaving of different-size posts, trees, saplings, and grasses, the Belau people make the main structure of the bai entirely of worked, fitted, joined, and pegged wooden elements, which allows them to assemble it easily.

A PROTECTIVE FEMALE FIGURE Although the bai was the domain of men, women figured prominently in the imagery that covered it. This reality reveals the important symbolic and social positions that women held in this culture (see "The Many Roles of Women in Oceania," page 929). A common element surmounting the main bai entrance was a simple, symmetrical wooden sculpture (on occasion, a painting) of a splayed female figure, known as Dilukai (FIGS. 31-8 and 31-7). Serving as a symbol of both protection and fertility, the Dilukai was also a moralistic reminder to women to be chaste. According to legend, Dilukai's brother, Bagei, was embarrassed by his sister's promiscuity and carved her image on the bai to shame her. The Dilukai figure demonstrates the ability of an image to control a group (here, women) while at the same time celebrating women's power.

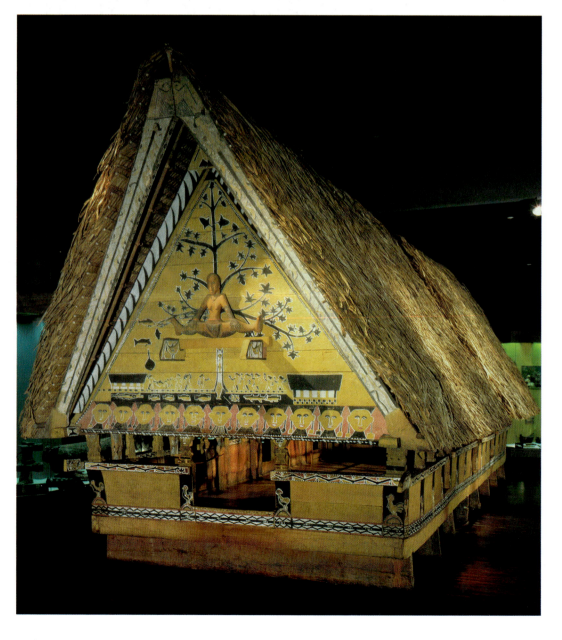

31-7 Men's ceremonial house *(bai),* from Belau (Palau), Republic of Belau. Staatliche Museen zu Berlin Preussischer Kulturbesitz. Ethnologisches Museum.

The Many Roles of Women in Oceania

Given the prominence of men's houses and the importance of male initiation in so many Oceanic societies, one might conclude that women are peripheral members of these cultures. Much of the extant material culture—ancestor masks, shields, clubs—seems to corroborate this. In reality, however, women play crucial roles in most Pacific cultures, although those roles may be less ostentatious or public than those of men. In addition to their significant contributions through exchange and ritual activities to the maintenance and perpetuation of the social network upon which the stability of village life depends, women are important producers of art.

For the most part, women's artistic production was historically restricted to forms such as barkcloth, weaving, and pottery. Throughout much of Polynesia, women produced barkcloth (see page 930), which was often dyed and stenciled, and sometimes even perfumed. Women in the Trobriand Islands continue to make brilliantly dyed skirts of shredded banana fiber that not only are aesthetically beautiful but also serve as a form of wealth and are presented symbolically during mortuary rituals. In some cultures in New Guinea, potters were primarily female.

In general, women were largely proscribed from working in hard materials (such as wood, stone, bone, or ivory) or using specialized tools. Further, in most Oceanic cultures, women were rarely allowed to produce images that had religious or spiritual powers or that conferred status on their users. Scholars investigating the role of the artist in Oceania have concluded that these restrictions were due to the perceived difference in innate power. Because women have the natural power to create and control life, male-dominated societies developed elaborate ritual practices that served to counteract this female power. By excluding women from participating in these rituals and denying them access to knowledge about specific practices, men derived a political authority that could be perpetuated. It is important to note,

however, that even in rituals or activities restricted to men, women often participate; for example, in the now-defunct Hevehe ceremonial cycle in Papua New Guinea (see pages 925–926), women helped to construct the hevehe masks, but feigned ignorance about these sacred objects, knowledge of which was limited to initiated men.

Pacific cultures often acknowledged women's innate power in the depictions of women in Oceanic art. For example, the splayed Dilukai female sculpture (FIG. 31-8) that appears regularly on Palauan bai (men's houses) celebrates women's procreative powers. Yet it simultaneously reinforces male authority by moralistically reminding women to limit their sexual activity. The Dilukai figure also confers protection upon visitors to the bai, another symbolic acknowledgment of female power. Similar concepts underlie the design of the Iatmul men's house (FIG. 31-1). Conceived as a giant female ancestor, the men's house incorporates women's natural power into the conceptualization of what is normally the most important architectural structure of an Iatmul village. In addition, the Iatmul associate entrance and departure from the men's house with death and rebirth, thereby reinforcing the primacy of fertility and the perception of the men's house as representing a woman's body.

Women were active participants in all aspects of Oceanic life, and their contributions in various arenas, such as art, are often overlooked. The general perception of Oceania as male dominated is due in part to the fact that the objects collected by visitors to the Pacific in earlier centuries tended to be those that suggest aggressive, warring societies. That the majority of these Western travelers (and collectors) were men and therefore had contact predominantly with men no doubt accounts for this pattern of collecting. Recent scholarship has done a great deal to rectify this misperception, thereby revealing the richness of social, artistic, and political activity in the Pacific.

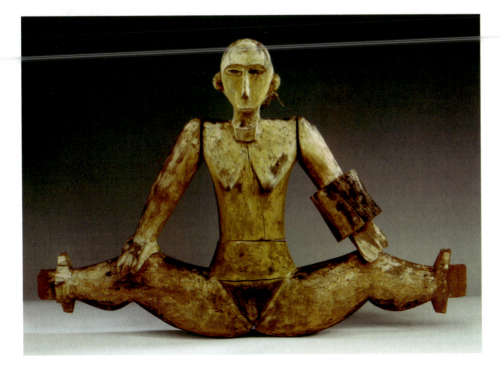

31-8 Dilukai, from Belau (Palau). Wood, pigment, and fiber, 1′ 11⅝″ high. Linden Museum, Stuttgart.

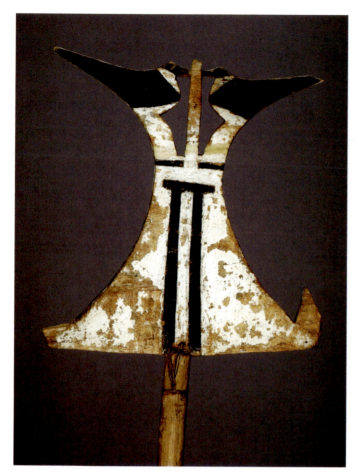

31-9 Canoe prow ornament, from Chuuk, Caroline Islands. Wood and paint. British Museum, London.

SEAFARING PROTECTION Given the importance of seafaring and long-distance ocean travel in Micronesia, canoe building acquired a prominent position in Micronesian art and culture. This canoe prow ornament (FIG. 31-9), from Chuuk in the Caroline Islands, was carved by a master canoe builder from a single plank of wood. Fastened to a large, paddled war canoe, a prow ornament such as this was intended to provide protection on arduous or long voyages. Appropriately, the prow ornament design, while seemingly abstract, actually represents two symmetrically placed sea swallows—creatures capable of navigating long distances. The form may also represent a stylized human figure. That these canoe prow ornaments were not permanently attached to the canoe was a matter of function; when approaching another vessel, these ornaments were lowered to signal peaceful intentions, and they were removed from the canoe when not in use.

POLYNESIA

OF CHIEFS AND KINGS Polynesia was one of the last areas in the world that humans colonized. It was not settled until about the end of the first millennium BCE in the west and the first millennium CE in the south. Its inhabitants brought complex sociopolitical and religious institutions with them. Whereas Melanesian societies are fairly egalitarian and advancement in rank is possible, Polynesian societies typically are highly stratified, with power determined by heredity. Indeed, rulers often trace their genealogies directly to the gods of creation. Most

Polynesian societies possess elaborate political organizations headed by chiefs and ritual specialists. By the 1800s, some Polynesian cultures (Hawaii and the Society Islands, for example) evolved into kingdoms. Because of this social hierarchy, much of Polynesian art is made for high-ranking persons of noble or high religious background and serves to reinforce their power and prestige. These objects, like their chiefly owners, are often invested with *mana,* or spiritual power.

BEATEN CLOTH Despite the prominence of art for high-ranking individuals, art in Polynesia is not solely the purview of rulers. For example, women throughout Polynesia traditionally produced decorated barkcloth using the inner bark of the paper mulberry tree *(Broussonetia papyrifera).* The finished product goes by various names in Polynesia, including *ahu* (Tahiti), *autea* (Cook Islands), *aute* (New Zealand), *kapa* (Hawaii), *hiapo* (Marquesas Islands), *siapo* (Samoa), and *masi* (Fiji). During the 19th century, when the production of barkcloth reached its zenith, *tapa* became a widely used reference word for such Polynesian barkcloth and still is today. Although tapa was utilized extensively for clothing and bedding, its uses extended beyond mere functionality. For example, in some Polynesian cultures, such as that of Tonga, large sheets (FIG. **31-10**) were (and still are) produced for exchange. Barkcloth can also have a spiritual dimension and can serve to confer sanctity upon the object wrapped. Appropriately, the bodies of high-ranking deceased chiefs were traditionally wrapped in barkcloth.

The use and decoration of tapa have varied over the years. In the 19th century, tapa used for everyday clothing was normally unadorned, whereas tapa used for ceremonial or ritual purposes was dyed, painted, stenciled, and sometimes even perfumed. The designs applied to the tapa differed depending upon the particular island group producing it and the function of the cloth. The production process was complex and time-consuming (see "The Production of Barkcloth," page 931). Indeed, some Oceanic cultures, such as those of Tahiti and Hawaii, constructed buildings specifically for the beating stage in the production of barkcloth.

The production of tapa reached its peak in the early 19th century, partly as a result of the interest expressed by visiting Westerners, such as whalers and missionaries. By the late 19th century, the use of tapa for cloth had been abandoned throughout much of eastern Polynesia, although its use in rituals (for example, as a wrap for corpses of deceased chiefs or as a marker of tabooed sites) continued. Even today, tapa exchanges are still an integral part of funerals and marriage ceremonies, and there is a considerable tourist market for tapa as well.

Rarotonga (Cook Islands)

Even though the Polynesians were skillful navigators, various island groups remained isolated from one another for centuries by the vast distances they would have had to cover in open outriggers. This allowed distinct regional styles to develop within a recognizable general Polynesian style. For example, deity images with multiple figures attached to their bodies surfaced in the material culture of Rarotonga and Mangaia in the Cook Islands and Rurutu in the Austral Islands. These carvings probably represented clan and district ancestors, revered for their protective and procreative powers. All such images refer ultimately to the creator deities the Polynesians revere for their central role in human fertility.

The Production of Barkcloth

Tongan barkcloth provides an instructive example of the labor-intensive process of tapa production. At the time of early contact between Europeans and Polynesians in the late 18th and early 19th centuries, ranking women in Tonga (western Polynesia) made decorated barkcloth *(ngatu)*. Today, women's organizations called *kautaha* produce it. The kautaha may have the honorary patronage of ranking women. In Tonga, men plant the paper mulberry tree and harvest it in two to three years. They cut the trees into about 10-foot lengths and allow them to dry for several days. Then the women strip off the outer bark and soak the inner bark in water to prepare it for further processing. They place these soaked inner bark strips over a wooden anvil and repeatedly strike them with a wooden beater until they spread out and flatten. Folding and layering the strips while beating them, a felting process, results in a wider piece of ngatu than the original strips. Afterward, the beaten barkcloth dries and bleaches in the sun.

The next stage of ngatu production involves the placement of the thin, beaten sheets over semicircular boards. The women then fasten embroidered design tablets *(kupesi)* of low-relief leaf,

coconut leaf midribs, and string patterns to the boards. They transfer the patterns on the design tablets to the outer barkcloth by rubbing. Then the women fill in the lines and patterns by painting, covering the large white spaces with painted figures. The Tongans use brown, red, and black pigments derived from various types of bark, clay, fruits, and soot to create the colored patterns on ngatu. Sheets, rolls, and strips of ngatu are made for use on special occasions, such as weddings, funerals, and ceremonial presentations for ranking persons.

A traditionally patterned ngatu (FIG. 31-10) made in 1967 for the coronation of King Tupou IV of Tonga clearly shows the richness of pattern, subtlety of theme, and variation of geometric forms that characterize Tongan royal barkcloths. One of the women barkcloth specialists—MELE SITANI, who made this presentation piece—kneels in the middle of the ngatu covered in triangular patterns known as *manulua*. This pattern is made from the intersection of three or four triangular points. *Manulua* means "two birds," and the design gives the illusion of two birds flying together. The motif symbolizes chiefly status derived from both parents.

31-10 MELE SITANI, decorated barkcloth *(ngatu)* with two-bird *(manulua)* designs, Tonga, 1967.

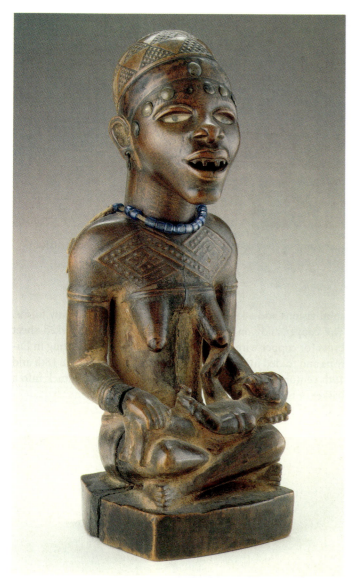

32-4 Mother and child, Kongo, from Mayombe region, Democratic Republic of Congo, 19th or early 20th century. Wood, glass, glass beads, brass tacks, and pigment, $10\frac{1}{8}''$ high. National Museum of African Art, Smithsonian Institution, Washington. 💿

Kongo Art (Democratic Republic of Congo)

KONGO POWER IMAGES Ancestral and power images of the Kongo peoples of the lower reaches of the Congo River show varieties of conventionalized naturalism. They served several purposes—commemoration, healing, divination, and social regulation. The woman-and-child carving we illustrate (FIG. 32-4) represents Kongo royalty, indicated by the woman's cap (recalling royal examples of woven banana fiber), chest scarification, and jewelry. The image may commemorate an ancestor or more probably a legendary founding clan mother, a *genetrix*. The Kongo called some of these figures "white chalk," a reference to the medicinal power of white kaolin clay. Diviners owned some of them, and others were used in women's organizations concerned with fertility and the treatment of infertility.

The large, standing male carving (FIG. 32-5), bristling with nails and blades, is a Kongo power figure (*nkisi n'kondi*) that a trained priest consecrated using precise ritual formulas. Such images embodied spirits believed to heal and give life, or sometimes capable of inflicting harm, disease, or even death. Each figure had its own

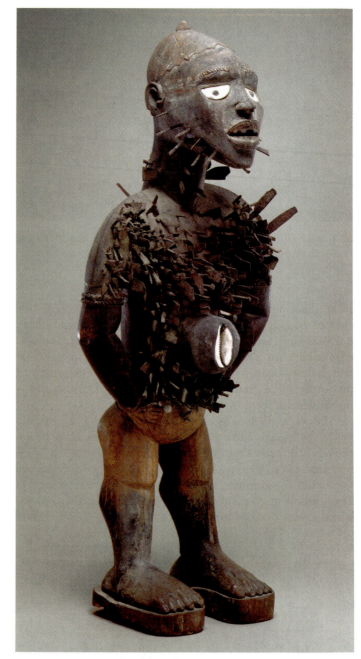

32-5 Nail figure (*nkisi n'kondi*), Kongo, from Shiloango River area, Democratic Republic of Congo, ca. 1875–1900. Wood, nails, blades, medicinal materials, and cowrie shell, 3′ $10\frac{3}{4}''$ high. Detroit Institute of Arts, Detroit. 💿

specific role, just as it wore particular medicines—here protruding from the abdomen and featuring a large cowrie shell. The Kongo also activated every image differently. Owners appealed to a figure's forces every time they inserted a nail or blade, as if to prod the spirit to do its work. People invoked other spirits by a certain chant, by rubbing them, or by applying special powders. The roles of power figures varied enormously, from curing minor ailments to stimulating crop growth, from punishing thieves to weakening an enemy. Very large Kongo figures, such as this one, had exceptional ascribed powers and aided entire communities. Although benevolent for their owners, the figures stood at the boundary between life and death, and most villagers held them in awe. As is true of the woman-and-child group (FIG. 32-4), this Kongo figure is relatively naturalistic, although the facial features are simplified and the head is magnified in size and thus emphasis. The carvers of both images, though, rendered surfaces as skin over muscled volume.

Dogon Art (Mali)

A STYLIZED COUPLE In contrast to the organic, relatively realistic treatment of the human body in Kongo art is a strongly stylized Dogon carving of a male and female couple (FIG. **32-6**) that dates to the 19th century or perhaps earlier. The Dogon live in Mali near the bend of the great Niger River, not far from the inland Niger Delta region where many terracotta images (see FIG. 15-5) have been excavated. This carving of a linked man and woman—probably a shrine or altar, although contextual information is lacking—cogently documents primary gender roles in traditional African society. The man wears a quiver on his back; the woman carries a child on hers. Thus a protective role as hunter or warrior is implied for the man, a nurturing one for the woman. The slightly larger man reaches behind his mate's neck and touches her breast, as if to protect her. His left hand points to his own genitalia. Four stylized figures support the stool upon which they sit. They are probably either spirits or ancestors, but the identity of the larger figures is not known.

The highly conventionalized style of this group makes it a *conceptual* image rather than a *perceptual* one. That is, it is based more on the idea or concept of human forms than on the imitative portrayal of heads, torsos, and limbs as perceived in life. Here, the linked body parts are tubes and columns articulated inorganically. The almost abstract geometry of the overall composition is reinforced by incised rectilinear and diagonal patterns on the surfaces. The sculptor also understood the importance of space, and charged the voids, as well as the sculptural forms, with rhythm and tension. The artist was not at all concerned with naturalism or realism, yet produced a refined and complex image that is very successful as sculpture.

Baule Art (Central Côte d'Ivoire)

BUSH SPIRITS In striking contrast to the Dogon sculptor of the seated man and woman (FIG. 32-6), the artist who created the matched pair of Baule male and female images (FIG. **32-7**) consciously perceived many naturalistic aspects of human anatomy,

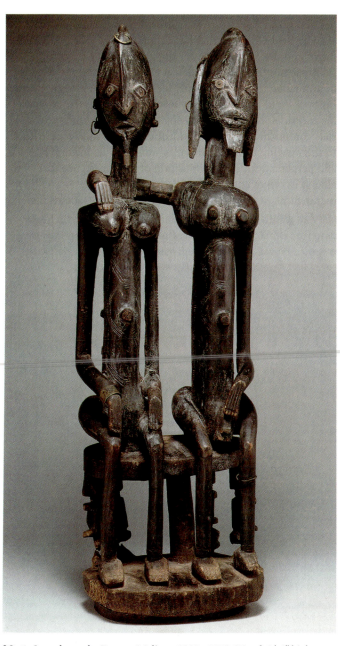

32-6 Seated couple, Dogon, Mali, ca. 1800–1850. Wood, 2′ 4″ high. Metropolitan Museum of Art, New York (gift of Lester Wunderman).

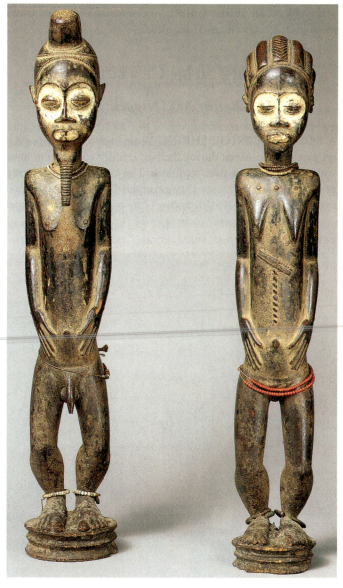

32-7 Male and female figures, probably bush spirits *(asye usu)*, Baule, Côte d'Ivoire, late 19th or early 20th century. Wood, beads, and kaolin, man 1′ 9¾″ high, woman 1′ 8⅝″ high. Metropolitan Museum of Art, New York (Michael C. Rockefeller Memorial Collection, gift of Nelson A. Rockefeller).

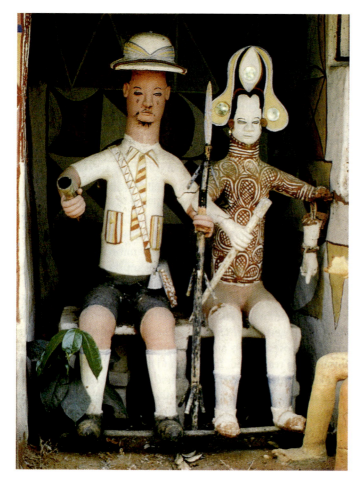

32-21 The thunder god Amadioha and his wife, painted clay sculptures in an *mbari*, Igbo, Umugote Orishaeze, Nigeria, photographed in 1966.

house. Our illustration (FIG. **32-21**) shows the thunder god Amadioha and his wife in an mbari house at Umugote Orishaeze. The god wears modern clothing, whereas his consort appears with traditional body paint and a fancy hairstyle. These differing modes of dress relate to Igbo concepts of modernity and tradition, both viewed as positive by the men who control the ritual and art. They allow themselves modern things but want their women to remain traditional. The artist enlarged and extended both figures' torsos, necks, and heads to express their aloofness, dignity, and power. More informally posed figures and groups appear on the other sides of the house, including beautiful, amusing, or frightening figures of animals, humans, and spirits taken from mythology, history, dreams, and everyday life—a kaleidoscope of subjects and meanings.

The mbari construction process, veiled in secrecy behind a fence, is a stylized world-renewal ritual. After the ritual opening, the completed monument shows off that world, the cosmos renewed. Ceremonies for unveiling the house to public view indicate that the god accepted the sacrificial offering (of the mbari) and, for a time at least, will be benevolent. An mbari house never undergoes repair. Instead, it is allowed to disintegrate and return to its source, the earth. The Igbo today rarely make mbari complexes for ritual purposes. Two recent ones, sponsored by the Nigerian government essentially as museums—secular variations on the earlier sacred theme—were constructed of cement. In this way the arts of the past have been preserved to educate future generations.

BODY ADORNMENT People in many rural areas of eastern Africa continue to embellish their own bodies, not only for occasional ceremonies, but every day. Samburu men and women in northern Kenya, shown in FIG. **32-22** at a spontaneous dance, each have distinct styles of personal decoration (see "Gender Roles in African Art Production," page 955). Men, particularly warriors who are not yet married, expend hours creating elaborate hairstyles for one another. They paint their bodies with red ocher, and wear bracelets, necklaces, and other bands of beaded jewelry young women make for them. For themselves, women make more lavish constellations of beaded collars, which they mass around their necks. As if to help separate the genders, women shave their heads and adorn them with beaded headbands. Personal decoration begins in childhood, increasing to become lavish and highly self-conscious in young adulthood, and diminishing as people get older. Much of it is coded to reveal information—age, marital or initiation status, parentage of a warrior son—that can be read by those who know the codes. Dress ensembles have evolved over

32-22 Samburu men and women dancing, northern Kenya, photographed by Herbert Cole in 1973.

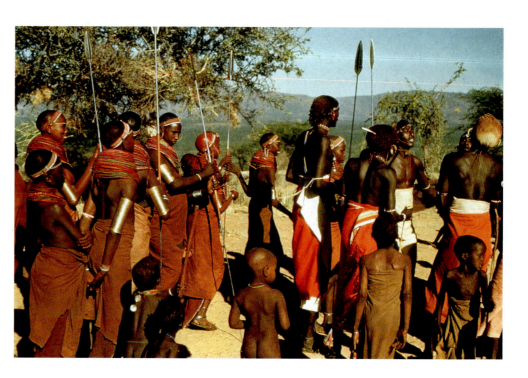

Gender Roles in African Art Production

Until the past decade or two, art production in Africa has been quite rigidly gender specific. Men have been, and largely still are, iron smiths and gold and copper-alloy casters. Men were architects, builders, and carvers of both wood and ivory. Women were, and for the most part remain, wall and body painters, calabash decorators, potters, and often clay sculptors (FIG. 32-9), although men make clay figures in some areas. Both men and women work with beads and weave baskets and textiles, men executing narrow strips (later sewn together) on horizontal looms and women working wider pieces of cloth on vertical looms.

Much African art, however, is collaborative. Men may build a clay wall, for example, but women will normally be called in to decorate it. Igbo mbari houses (FIG. 32-21) are truly collaborative despite the fact that their figures are modeled by professional male artists. Festivals, invoking virtually all the arts, are also collaborative. Masquerades are largely the province of men, yet in some cases women are asked to contribute costume elements such as skirts, wrappers, and scarves. And even though women dance masks among the Mende and related peoples, the masks themselves have always been carved by men.

Until recently in most regions, Africans did not greatly emphasize artists' individuality, even when personal styles were clearly recognizable. This does not mean art is anonymous or that artists are not honored locally. Many artists, like Osei Bonsu (FIGS. 32-10 and 32-11) and Olowe of Ise (FIG. 32-12), were highly appreciated in their own time as they are today. Still, Africans have tended not to exalt artistic individuality as much as Westerners have. All that has been changing over the past few decades, however. Increasingly, even artists in villages want to be recognized for their skills and rewarded for the works they create.

In late colonial and especially in postcolonial times, earlier gender distinctions in art production have been breaking down. Women, as well as men, now weave kente cloth, and a number of women are now sculptors in wood, metal, stone, and composite materials. Men are making pottery, once the exclusive prerogative of women. Both women and men make international art forms in urban and university settings, although male artists are more numerous. One well-known Nigerian woman artist, Sokari Douglas Camp, produces welded metal sculptures, sometimes of masqueraders. Douglas Camp is thus doubly unusual. She might find it difficult to do this work in her traditional home in the Niger River delta, but as she lives and works in London, she encounters no adverse response. In the future there will undoubtedly be a further breaking down of restrictive barriers and greater mobility for artists.

time. Different colors and sizes of beads became available, plastics and aluminum were introduced, and specific fashions have changed, but the overall concept of fine personal adornment — that is, dress raised to the level of art — remains much the same today as it was centuries ago.

MAMY WATA Around 1900 in the Niger River delta there appeared a color lithograph of a light-skinned, straight-haired woman controlling large snakes. This print, seen on the wall in FIG. 32-23, was imported from Europe in great numbers and seems to have stimulated the growth of the Mamy Wata ("mother of water") cult as a vehicle for the assimilation and expression of contemporary spiritual values grafted onto traditional ones. Snakes, for example, figure as messengers of many African deities. Mamy Wata came from across the sea, as white people did, bringing riches as well as problems. She is charismatic and beautiful, yet she offers help to those in need, at the price of becoming her devotee. Her priests and priestesses consult her as an oracle. Her special province is modern life — passing exams, for example, or finding enough money to buy a moped or a new suit. She appears in peoples' dreams as an exotic temptress offering glamorous products, often imports of the sort she likes herself.

Mamy Wata's shrines (FIG. 32-23) usually feature one or more brightly colored paintings or sculptures of the snake-entwined woman, the original lithograph, powders, soaps, perfumes, glittery jewelry, dolls, candles, medicines, and a mirror. The mirror is present both because the goddess is vain, and because it serves as a symbolic membrane, an illusory water surface, a kind of "Alice's looking glass" within which wondrous things can happen to those who give Mamy Wata the presents and sacrifices she demands. She can bring wealth or poverty, insanity or health, children or barrenness, depending on how she is treated. One becomes a devotee of Mamy

32-23 Mamy Wata shrine with priestess, Igbo, near Owerri town, Nigeria, photographed by Henry J. Drewal in 1978.

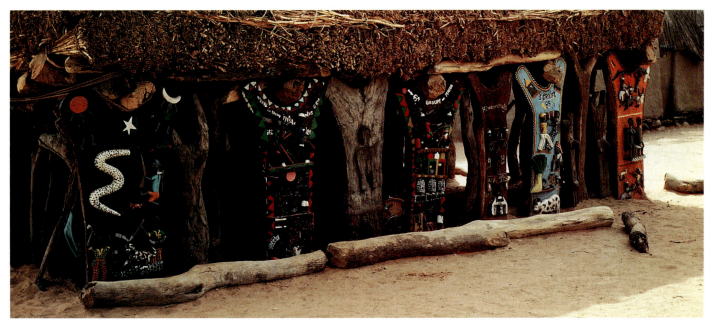

32-24 *Togu na* ("men's house of words"), Dogon, Mali, photographed in 1989. Wood and pigment.

Wata when one dreams of her or has problems that a diviner feels she may be able to help with. Today there are many thousands of Mamy Wata shrines and worshipers across the breadth of West Africa. As in other shrines, the presence of art heightens the mystique and helps to focus the attention of disciples.

DOGON HOUSES OF WORDS Traditionalism and modernism are united in contemporary Dogon *togu na*, or "men's house of words." The togu na is so called because men's deliberations vital to community welfare take place under its sheltering roof. It is considered the "head" and the most important part of the community, which the Dogon characterize with human attributes. The men's houses were built over time. Earlier posts, such as the central one in the togu na we illustrate (FIG. **32-24**), show schematic renderings of legendary female ancestors, similar to stylized ancestral couples (FIG. 32-6) or masked figures (FIG. 32-16). Recent replacement posts feature narrative and topical scenes of varied subjects, such as horsemen or hunters or women preparing food, a lot of descriptive detail, bright polychrome painting in enamels, and even some writing. Unlike earlier traditional sculptors, the contemporary artists who made these posts want to be recognized for their work. Their names are known, and they are eager to sell their work (other than these posts) to tourists.

GA CASKETS Today's African artists also tend to use new forms, techniques, and materials within older functional categories. Carved wooden caskets, created by KANE KWEI (1924–1991) and his sons of the Ga people in urban coastal Ghana, exemplify this type of art. Beginning around 1970, Kwei created figurative coffins intended to reflect the deceased's life, occupation, or major accomplishments. On commission he made such diverse shapes as a cow, a whale, and a bird; various local food crops, such as onions and cocoa pods; airplanes; a Mercedes Benz; and a modern villa. These coffins were not carved, but rather pieced together using nails and glue. The artists are carpenters rather than woodcarvers. Kwei also created coffins in traditional leaders' forms, such as an eagle, an elephant, a leopard, and a stool. The coffin illustrated here (FIG. **32-25**), a hen with chicks, was created for a respected woman with a huge family. Kwei died in 1991, but his sons and

former apprentices continue his legacy. Their own commissions—a tiger, a crab, a lobster, a Mercedes, and a fishing canoe—accompanied his coffin from the church to the cemetery.

A CONGOLESE INTERNATIONALIST TRIGO PIULA (b. ca. 1950), a contemporary painter of the international school (trained in Western artistic techniques and styles) from the Democratic Republic of Congo, creates works that fuse Western and Congolese images and objects in a pictorial blend that provides social commentary on present-day Congolese culture. *Ta Tele Gabon* (FIG. **32-26**) depicts a group of Congolese citizens staring transfixed at colorful pictures of life beyond Africa displayed on 14 television screens. The TV images include references to travel to exotic places (such as Paris with the Eiffel Tower), sports events, love, the earth seen from a satellite, and Western worldly goods. A traditional Kongo power figure associated with warfare and divination stands at the composition's center as a visual mediator between the anonymous foreground viewers and the multiple TV images. In traditional Kongo contexts (FIG. 32-5), this figure's feather headdress associates it with supernatural and magical powers from the sky, such as lightning and storms. In Piula's rendition, the headdress perhaps refers to the power of airborne televised pictures. In the stomach area, where Kongo power figures often have glass in front of a medicine packet, Piula painted a television screen showing a second power figure, as if to double the figure's power. The artist shows most of the television viewers with a small, white image of a foreign object—car, shoe, heart (signifying love), bottle, or knife and fork—on the backs of their heads.

One meaning of this picture appears to be that television messages have deadened Congolese peoples' minds to anything but modern thoughts or commodities. The power figure stands squarely on brown earth. Two speaker cabinets set against the back wall beneath the TV screens are wired to the figure, which in the past could inflict harm. In traditional Kongo thinking and color symbolism, the color white and earth tones are associated with spirits and the land of the dead. Perhaps Piula suggests that like earlier power figures, the contemporary world's new television-induced consumerism is poisoning the minds and souls of Congolese people as if by magic or sorcery.

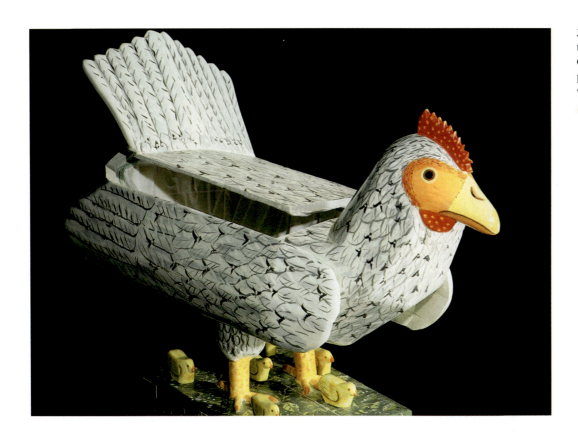

32-25 KANE KWEI, coffin in the shape of a hen with chicks, Ga, Ghana, 1989. Wood and pigment, 7′ 6½′ long. Museum voor Volkenkunde, Rotterdam.

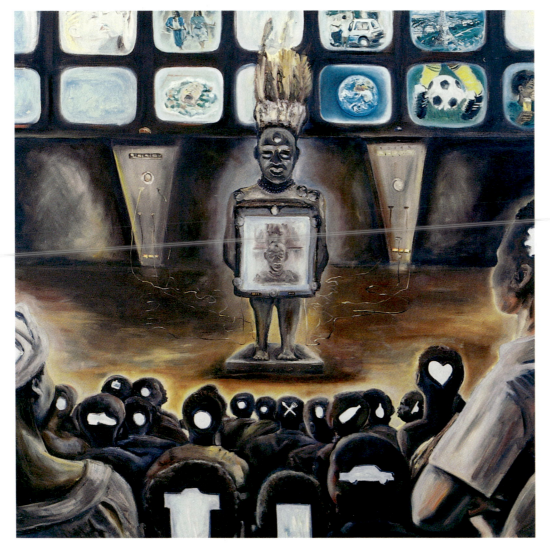

32-26 TRIGO PIULA, *Ta Tele Gabon,* Democratic Republic of Congo, 1988. Oil on canvas, 3′ 3⅜″ × 3′ 4⅜″. National Museum of African Art, Smithsonian Institution, Washington.

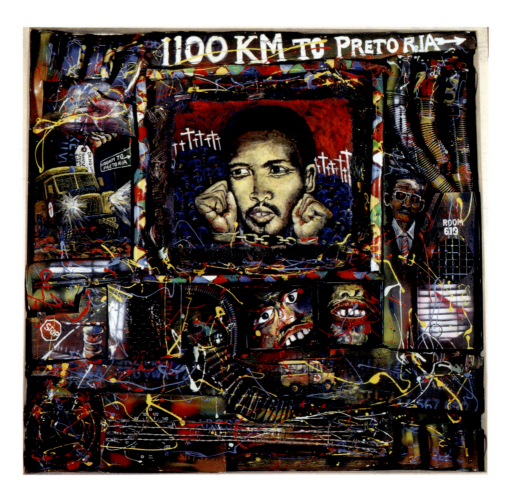

ART AND SOCIAL PROTEST Many contemporary African art forms are formally vibrant, as well as concerned with social and political issues. Art in South Africa, for example, first helped protest against *apartheid* (government-sponsored racial separation), then celebrated its demise and the subsequent democratically elected government under the first president, Nelson Mandela. The contemporary artist WILLIE BESTER, in his 1992 *Homage to Steve Biko* (FIG. **32-27**), was among the critics of the apartheid system. Biko, a gentle and heroic leader of the Black Liberation Movement, was killed by white authorities while in detention. The two white doctors in charge of him were exonerated at Biko's inquest, setting off protests around the world. Bester packs his layered picture with references to death and injustice. Biko's portrait, at the center, is near another of the police minister, Kruger, who had him transported 1100 miles to Pretoria in the yellow Land Rover ambulance seen left of center and again beneath Biko's portrait. Bester shows Biko with his chained fists raised in the recurrent protest gesture. This portrait memorializes both Biko and the many others—indicated by the white graveyard crosses above a blue sea of skulls beside Biko's head. The crosses stand out against a red background that recalls the inferno of burned townships. The stop sign (lower left) seems to mean "stop Kruger," or perhaps "stop apartheid." Biko's death is referenced also by the tagged foot, as if in a morgue, above the ambulance (to the left). The red crosses on this vehicle's door and on Kruger's reflective dark glasses repeat, with sad irony, the graveyard crosses.

Blood red and ambulance yellow are in fact unifying colors dripped or painted on many parts of the work. Writing and numbers, found fragments and signs, both stenciled and painted, also appear throughout the composition. Numbers refer to dehumanized life under apartheid. Found objects—wire, sticks, cardboard, sheet metal, cans, and other discards—from which fragile,

impermanent township dwellings are created, remind viewers of the degraded, impoverished lives of most South African people of color. The oilcan guitar (bottom center), another recurrent Bester symbol, refers both to the social harmony and joy provided by music and to the control imposed by apartheid policies. The whole composition is richly textured and dense in its collage combinations of objects, photographs, signs, symbols, and painting. *Homage to Steve Biko* is a radical and powerful critique of an oppressive sociopolitical system, and it exemplifies the extent to which art can be invoked in the political process.

CONCLUSION

African art has always changed and developed in response to the continent's evolving history, both before and after the arrival of Europeans in Africa. During the past two centuries, the encroachments of Christianity, Islam, Western education, market economies, and other colonial imports have led to increasing secularization in all the arts of Africa. Many figures and masks earlier commissioned for shrines or as incarnations of ancestors or spirits are now made mostly for sale to outsiders, essentially as tourist arts. Dogon masks are regularly danced briefly for tourists, after which some of the masks are sold. In towns and cities, painted murals and cement sculptures appear frequently, often making implicit comments about modern life. Nonetheless, despite the growing importance of urbanism (pre-European in a few areas), most African people still live in rural communities. Traditional values, although under pressure, hold considerable force in villages especially, and some people adhere to spiritual beliefs that uphold traditional art forms. African art remains as varied as the vast continent itself and continues to change.

1800

■ ACTIVE CHRISTIAN MISSIONIZING, 19TH CENTURY

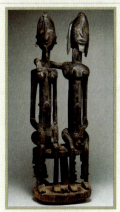

1 Seated couple, Dogon, Mali, ca. 1800-1850

1850

■ BERLIN CONFERENCE DIVIDING CONTINENT AMONG COLONIAL POWERS, 1884-1885

■ EUROPEAN COUNTRIES COLONIZE MOST OF AFRICA, CA. 1885–1924

■ BRITISH PUNITIVE EXPEDITION SACKS BENIN, 1897

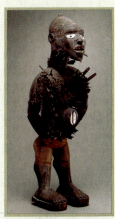

1900

■ FIRST WORLD WAR, 1914-1918

■ SECOND WORLD WAR, 1939-1945

2 Nail figure, Kongo, Democratic Republic of Congo, ca. 1875–1900

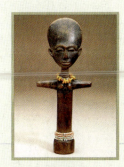

1950

■ MOST AFRICAN COUNTRIES ACHIEVE INDEPENDENCE, BEGINNING CA. 1960

3 Osei Bonsu, *akua'ba,* Asante, Ghana, ca. 1935

2000

4 Willie Bester, *Homage to Steve Biko,* South Africa, 1992

HANNAH HÖCH, *Cut with the Kitchen Knife Dada through the Last Weimar Beer Belly Cultural Epoch of Germany*, 1919–1920. Photomontage, 3′ 9″ × 2′ 11½″. Neue Nationalgalerie, Staatliche Museen, Berlin.

33

THE DEVELOPMENT OF MODERNIST ART

THE EARLY 20TH CENTURY

The decisive changes that marked the 19th century—industrialization, urbanization, and the growth of nationalism and imperialism—are chronicled in Chapter 29. During the first half of the 20th century, rampant industrialization matured into international industrial capitalism, which fueled the rise of consumer economies.

REVOLUTION AND WORLD WAR

As in the 19th century, these developments presented societies with great promise, as well as significant problems. Appropriately, these changes prompted both elation and anxiety. The combination of euphoria and alienation that was the hallmark of fin de siècle culture in Europe (see Chapter 29, page 896) carried through the next decades. Momentous historical events—World War I, the Great Depression, the rise of totalitarianism, and World War II—exacerbated this rather schizophrenic attitude. The arts manifested the same conflicted mind-set through the stark contrast of, on the one hand, the lofty utopian visions of artistic groups such as the Bauhaus and De Stijl, and, on the other, the scathing social commentary of the Dada artists.

20th-Century Intellectual Developments

In the early 20th century, societies worldwide contended with discoveries and new ways of thinking in a wide variety of fields, including science, technology, economics, and politics. These new ideas forced people to revise radically how they understood their worlds. In particular, the values and ideals that were the legacy of the Scientific Revolution (during the Age of Newton) and the Enlightenment began to yield to innovative views. Thus, intellectuals countered 18th- and 19th-century assumptions about progress and reason with ideas challenging traditional notions about the physical universe, the structure of society, and human nature. Artists participated in this reassessment.

33-2 Henri Matisse, *Red Room (Harmony in Red)*, 1908–1909. Oil on canvas, approx. 5′ 11″ × 8′ 1″. State Hermitage Museum, Saint Petersburg.

flattened out the forms—for example, he eliminated the front edge of the table, making the table, with its identical patterning, as flat as the wall behind it. The colors, however, contrast richly and intensely. Matisse's process of overpainting reveals color's importance for striking the right chord in the viewer. Initially, this work was predominantly green, and then he repainted it blue. Neither color seemed appropriate to Matisse, and not until he repainted this work red did he feel he had struck the proper chord. Like van Gogh and Gauguin, Matisse expected color to provoke an emotional resonance in the viewer. He declared: "Color was not given to us in order that we should imitate Nature. It was given to us so that we can express our own emotions."[3]

EXPRESSING CONTENT WITH COLOR André Derain (1880–1954), also a Fauve group member, worked closely with Matisse. Like Matisse, Derain worked to use color to its fullest potential—for aesthetic and compositional coherence, to increase luminosity, and to elicit emotional responses from the viewer. *The Dance* (FIG. **33-3**) is typical of Derain's art. The perspective is flattened out, and color delineates space. In addition, the artist indicated light and shadow not by differences in value, but by contrasts of hue. Finally, color does not describe the local tones of objects; instead, it expresses the picture's content.

German Expressionism: Die Brücke

The immediacy and boldness of the Fauve images appealed to many artists, including the German Expressionists. However, although color plays a prominent role in the work of the German Expressionists, the expressiveness of their images is due as much to the wrenching distortions of form, ragged outline, and agitated brush strokes. This resulted in savagely powerful, emotional canvases in the years leading to World War I.

The first group of German artists to explore expressionist ideas gathered in Dresden in 1905 under the leadership of Ernst Ludwig Kirchner (1880–1938). The group members thought of themselves as paving the way for a more perfect age by bridging the old age and the new. They derived their name, Die Brücke (The Bridge), from this concept. Kirchner's early studies in architecture, painting, and the graphic arts had instilled in him a deep admiration for German medieval art. Like the British artists associated with the Arts and Crafts movement, such as William Morris (see FIG. 29-51), members of this group modeled themselves on their ideas of medieval craft guilds by living together and practicing all the arts equally. Kirchner described their lofty goals in a ringing statement:

33-3 ANDRÉ DERAIN, *The Dance,* 1906. Oil on canvas, 6' $\frac{7}{8}''$ × 6' $10\frac{1}{4}''$. Fridart Foundation, London.

With faith in development and in a new generation of creators and appreciators we call together all youth. As youth, we carry the future and want to create for ourselves freedom of life and of movement against the long-established older forces. Everyone who with directness and authenticity conveys that which drives him to creation, belongs to us.[4]

These artists protested the hypocrisy and materialistic decadence of those in power. Kirchner, in particular, focused much of his attention on the detrimental effects of industrialization, such as the alienation of individuals in cities, which he felt fostered a mechanized and impersonal society. This perception was reinforced when most of the group, including Kirchner, moved to Berlin, a teeming metropolis. The tensions leading to World War I further exacerbated the discomfort and anxiety evidenced in the works of Die Brücke.

URBAN LIFE IN PREWAR DRESDEN Kirchner's *Street, Dresden* (FIG. **33-4**) provides the viewer with a glimpse into the frenzied urban activity of a bustling German city before World War I. Rather than offering the distant, panoramic urban view of the Impressionists, this street scene is jarring and dissonant. The women in the foreground loom large, approaching the viewer somewhat menacingly. The steep perspective of the street, which threatens to push the women directly into the viewing space, increases their confrontational nature. Harshly rendered, the women's features make them appear zombielike and ghoulish, and the garish, clashing colors—juxtapositions of bright orange, emerald green, acrid chartreuse, and pink—add to the expressive impact of the image. Kirchner's perspectival distortions, disquieting figures, and color choices reflect the influence of the work of Edvard Munch, who made similar expressive use of formal elements in *The Cry* (see FIG. 29-46).

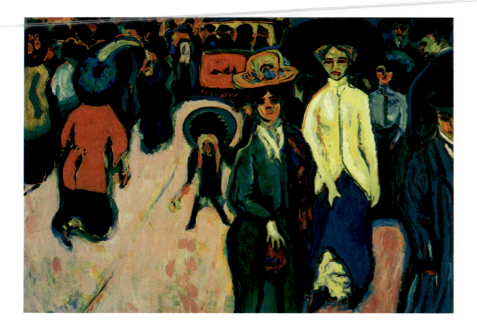

33-4 ERNST LUDWIG KIRCHNER, *Street, Dresden,* 1908 (dated 1907). Oil on canvas, 4' $11\frac{1}{4}''$ × 6' $6\frac{7}{8}''$. Museum of Modern Art, New York.

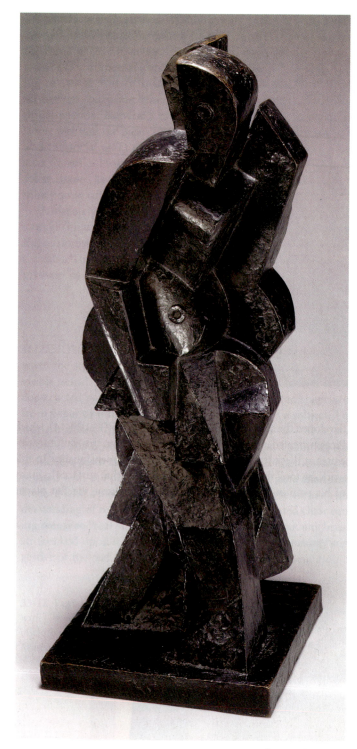

33-15 JACQUES LIPCHITZ, *Bather,* 1917. Bronze, 2′ 10¾″ × 1′ 1¼″ × 1′ 1″. Nelson-Atkins Museum of Art, Kansas City (gift of the Friends of Art). Copyright © Estate of Jacques Lipchitz/Licensed by VAGA, New York/Marlborough Gallery, New York.

cardboard surfaces (we illustrate the maquette, or model; the finished sculpture was to be made of sheet metal). By presenting what is essentially a cutaway view of a guitar, Picasso allowed the viewer to examine both surface and interior space, both mass and void. This, of course, is completely in keeping with the Cubist program. Some scholars have suggested that Picasso derived the cylindrical form that serves as the sound hole on the guitar from the eyes on masks from the Ivory Coast of Africa. African masks were a

continuing and persistent source of inspiration for the artist, and such references appear in both *Portrait of Gertrude Stein* (FIG. 33-8) and *Les Demoiselles d'Avignon* (FIG. 33-9). Here, however, Picasso seems to have transformed the anatomical features of African masks into a part of a musical instrument—dramatic evidence of his unique, innovative artistic vision.

DYNAMIC FORM IN SPACE One of the most successful sculptors to adapt into three dimensions the planar, fragmented dissolution of form central to Analytic Cubist painting was JACQUES LIPCHITZ (1891–1973). Born in Latvia, Lipchitz resided for many years in France and the United States. He worked out his ideas for many of his sculptures in clay before creating them in bronze or in stone. *Bather* (FIG. **33-15**) is typical of his Cubist style. Lipchitz broke the continuous form in this work into cubic volumes and planes. The interlocking and gracefully intersecting irregular facets and curves recall the paintings of Picasso and Braque and represent a parallel analysis of dynamic form in space. Lipchitz later produced less volumetric sculptures that included empty spaces outlined by metal shapes. In these sculptures, Lipchitz pursued even further the Cubist notion of spatial ambiguity and the relationship between solid forms and space.

THE INTERPLAY OF MASS AND SPACE The Russian sculptor ALEKSANDR ARCHIPENKO (1887–1964) explored similar ideas, as seen in *Woman Combing Her Hair* (FIG. 33-16). This statuette introduces, in place of the head, a void with a shape of its own that figures importantly in the whole design. Enclosed spaces have always existed in figurative sculpture—for example, the space between the arm and the body when the hand rests on the hip, as in Verrocchio's *David* (see FIG. 21-24). But here the space penetrates the figure's continuous mass and is a defined form equal in importance to the mass of the bronze. It is not simply the negative counterpart to the volume. Archipenko's figure shows the same fluid intersecting planes seen in Cubist painting, and the relation of the planes to each other is similarly complex. Thus, in painting and sculpture, the Cubists broke through traditional limits and transformed the medium. Archipenko's figure is still somewhat representational, but sculpture (like painting) executed within the Cubist idiom tended to cast off the last vestiges of representation.

WELDED METAL SCULPTURES A friend of Picasso, JULIO GONZÁLEZ (1876–1942) shared his interest in the artistic possibilities of new materials and new methods borrowed from both industrial technology and traditional metalworking. Born into a family of metalworkers in Barcelona, Spain, González helped Picasso construct a number of welded sculptures. This contact with Picasso, in turn, allowed González to refine his own sculptural vocabulary. Using ready-made bars, sheets, or rods of welded or wrought iron and bronze, González created dynamic sculptures with both linear elements and volumetric forms. In his *Woman Combing Her Hair* (FIG. 33-17; compare with Archipenko's version of the same subject), the figure is reduced to an interplay of curves, lines, and planes—virtually a complete abstraction. Although González's sculpture received limited exposure during his lifetime, it became particularly important for sculptors in subsequent decades who focused their attention on the capabilities of welded metal.

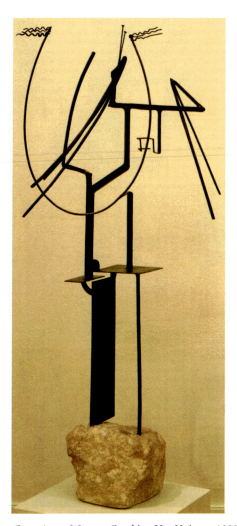

33-17 JULIO GONZÁLEZ, *Woman Combing Her Hair*, ca. 1930–1933. Iron, 4′ 9″ high. Moderna Museet, Stockholm.

Purism

THE MACHINE AESTHETIC Charles Edouard Jeanneret, known as Le Corbusier, is today best known as one of the most important modernist architects (see later discussion, pages 1012–1014). Also a painter, he founded in 1918 a movement called Purism, which opposed Synthetic Cubism on the grounds that it was becoming merely an esoteric, decorative art out of touch with the machine age. Purists maintained that machinery's clean functional lines and the pure forms of its parts should direct the artist's experiments in design, whether in painting, architecture, or industrially produced objects. This "machine esthetic" inspired FERNAND LÉGER (1881–1955), a French painter who had early on painted with the Cubists. He devised an effective compromise of tastes, bringing together meticulous Cubist analysis of form with the Purist's broad simplification and machinelike finish of the design components. He retained from his Cubist practice a preference for cylindrical and tube-shaped motifs, suggestive of machined parts such as pistons and cylinders.

Léger's works have the sharp precision of the machine, whose beauty and quality he was one of the first artists to discover. His contemporary, modern composer George Antheil, wrote a score for a Léger film, *Ballet Mécanique* (1924). The film contrasted inanimate objects such as functioning machines with humans in dancelike variations. Preeminently the painter of modern urban

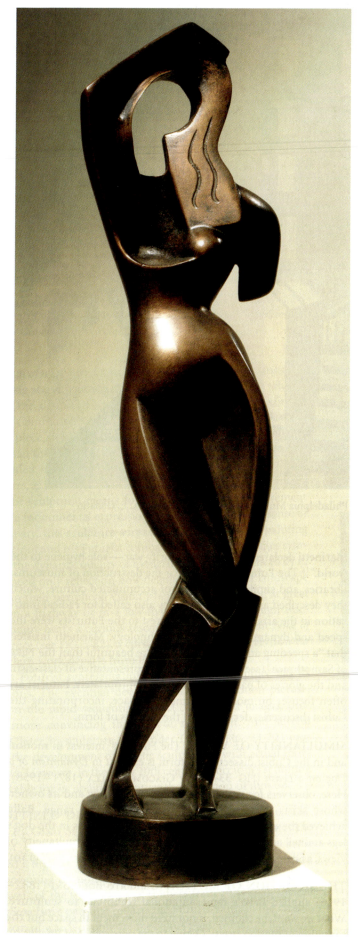

33-16 ALEKSANDR ARCHIPENKO, *Woman Combing Her Hair*, 1915. Bronze, approx. 1′ 1¾″ high. Tate Gallery, London.

A HARLEM RENAISSANCE ARTIST Also deriving his personal style from Synthetic Cubism was African American artist AARON DOUGLAS (1898–1979), who used the style to represent symbolically the historical and cultural memories of African Americans. Born in Kansas, Douglas studied in Nebraska and Paris before settling in New York City, where he became part of the flowering of art and literature in the 1920s known as the *Harlem Renaissance.* Spearheaded by writers and editors Alain Locke and Charles Johnson, the Harlem Renaissance was a manifestation of the desire of African Americans to promote their cultural accomplishments. They also aimed to cultivate pride among fellow African Americans and racial tolerance across the United States. Expansive and diverse, the cultural products associated with the Harlem Renaissance included the writing of authors such as Langston Hughes, Countee Cullen, and Zora Neale Hurston; the jazz and blues of Duke Ellington, Bessie Smith, Eubie Blake, Fats Waller, and Louis Armstrong; the photographs of James Van-DerZee and Prentice H. Polk; and the paintings and sculptures of Meta Warrick Fuller and Augusta Savage. Aaron Douglas arrived in New York City in 1924 and became one of the most sought-after graphic artists in the African American community. Encouraged to create art that would express the cultural history of his race, Douglas incorporated motifs from African sculpture into compositions painted in a version of Synthetic Cubism that stressed transparent angular planes. *Noah's Ark* (FIG. **33-35**) was one of seven paintings based on a book of poems by James Weldon Johnson called *God's Trombones: Seven Negro Sermons in Verse.* Douglas used flat planes to evoke a sense of mystical space and miraculous happenings. In *Noah's Ark,* lightning strikes and rays of light crisscross the pairs of animals entering the ark, while men load supplies in preparation for departure. The artist suggested deep space by differentiating the size of the large human head and shoulders of the worker at the bottom and the small person at work on the far deck of the ship. Yet the composition's unmodulated color shapes create a pattern on the Masonite surface that cancels any illusion of three-dimensional depth. Here, Douglas used Cubism's formal language to express a powerful religious vision.

Precisionism

It is obvious from viewing American art in the period immediately after the Armory Show that American artists were intrigued by the latest European avant-garde art, from Cubism to Dada. However, these artists did not just passively absorb the ideas transported across the Atlantic. For many American artists, the challenge was to understand the ideas this modernist European art presented and then filter them through an American sensibility. Ultimately, many American artists set as their goal the development of a uniquely American art.

ART OF THE MACHINE AGE One group of such artists became known as *Precisionists.* This was not an organized movement, and these artists rarely exhibited together (although once the similarities in their work were revealed, they were grouped together in shows), but they did share certain thematic and stylistic traits in their art. Precisionism developed in the 1920s out of a fascination with the machine's precision and importance in modern life. Although many European artists (for example, the Futurists) had demonstrated interest in burgeoning technology, Americans generally seemed more enamored by the prospects of a mechanized society than did Europeans. Even French artist Francis Picabia (associated with both Cubism and Dada) noted: "Since machinery is the soul of the modern world, and since the genius of machinery attains its highest expression in America, why is it not reasonable to believe that in America the art of the future will flower most brilliantly?"[30] The efforts of others in the art world also supported this observation. Alfred Stieglitz's 291 gallery was instrumental in exhibiting mechanistically oriented works, thereby championing the "age of the machine."

Precisionism, however, expanded beyond the exploration of machine imagery. Many artists associated with this group gravitated toward Synthetic Cubism's flat, sharply delineated planes as an appropriate visual idiom for their imagery, adding to the clarity and precision of their work. Eventually, Precisionism came to be characterized by a merging of a familiar native style in American architecture and artifacts with a modernist vocabulary derived largely from Synthetic Cubism.

AMERICAN PYRAMIDS? CHARLES DEMUTH (1883–1935) spent the years 1912–1914 in Paris and thus had firsthand exposure to Cubism and other avant-garde directions in art. He incorporated the spatial discontinuities characteristic of Cubism into his work, focusing much of it on industrial sites near his native Lancaster, Pennsylvania. *My Egypt* (FIG. **33-36**) is a prime example of Precisionist painting. Demuth depicted the John W. Eshelman and Sons grain elevators, which he reduced to simple geometric forms. The grain elevators remain insistently recognizable and solid. However, the painting is disrupted by the "beams" of transparent planes and the diagonal force lines that threaten to

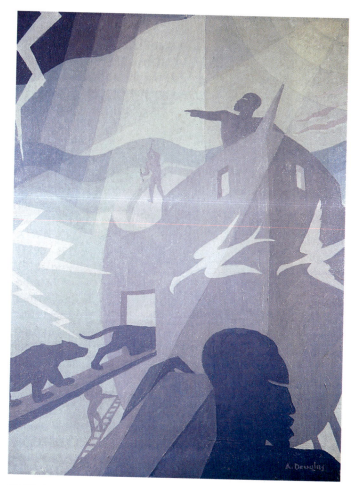

33-35 AARON DOUGLAS, *Noah's Ark,* ca. 1927. Oil on Masonite, 4′ × 3′. Fisk University Galleries, Nashville, Tennessee.

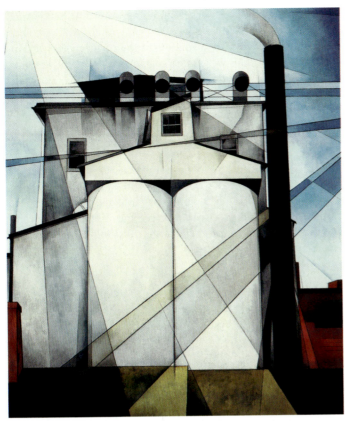

33-36 CHARLES DEMUTH, *My Egypt,* 1927. Oil on composition board, 2′ 11¾″ × 2′ 6″. Collection of Whitney Museum of American Art, New York (purchase with funds from Gertrude Vanderbilt Whitney).

destabilize the image and that correspond to Cubist fragmentation of space. Not only does this adaptation of Cubist vocabulary place Demuth in the more progressive ranks of American artists of the time, but it also reveals his sensitivity to the effects of expanding technology.

The degree to which Demuth intended to extol the American industrial scene is unclear. The title, *My Egypt,* is sufficiently ambiguous in tone to accommodate differing readings. On the one hand, Demuth could have been suggesting a favorable comparison between the Egyptian pyramids and American grain elevators as cultural icons. On the other hand, the title could be read cynically, as a negative comment on the limitations of American culture.

THE RHYTHM OF CITY LIFE The work of GEORGIA O'KEEFFE (1887–1986), like that of many artists, changed stylistically throughout her career. During the 1920s, O'Keeffe was affiliated with Precisionism. She had moved from the tiny town of Canyon, Texas, to New York City in 1918 (she had visited the city on occasion previously), and what she found there both overwhelmed and excited her. "You have to live in today," she told a friend. "Today the city is something bigger, more complex than ever before in history. And nothing can be gained from running away. I couldn't even if I could."[31] While in New York, O'Keeffe met Alfred Stieglitz, who had seen and exhibited some of her earlier work, and she was drawn into the circle of painters and photographers surrounding Stieglitz and his gallery. Stieglitz became one of O'Keeffe's staunchest supporters and, eventually, her husband. The interest of Stieglitz and his circle in capturing the sensibility of the machine age intersected with O'Keeffe's fascination with the fast pace of city life, and she produced paintings during this period, such as *New York, Night* (FIG. **33-37**), that depict the soaring

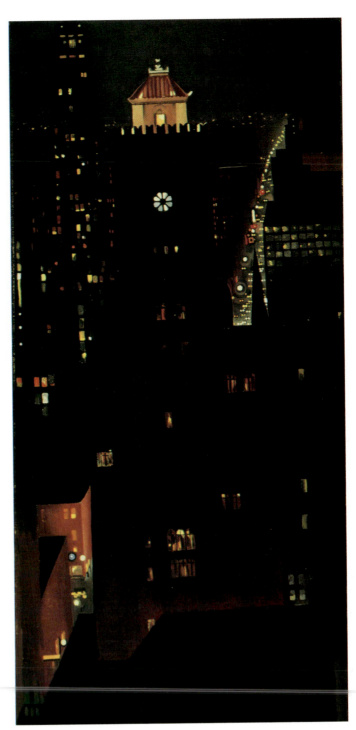

33-37 GEORGIA O'KEEFFE, *New York, Night,* 1929. Oil on canvas, 3′ 4⅛″ × 1′ 7⅛″. The Georgia O'Keeffe Foundation.

skyscrapers dominating the city. Like other Precisionists, O'Keeffe reduced her images to flat planes, here punctuated by small rectangular windows that add rhythm and energy to the image, countering the monolithic darkness of the looming buildings.

THE PURITY OF FLORAL FORM Despite O'Keeffe's affiliation with the Precisionist movement, she is probably best known for her paintings of cow skulls and of flowers. One such painting, *Jack in the Pulpit No. 4* (see FIG. Intro-4), reveals the artist's interest in stripping her subjects to their purest forms and colors to heighten their expressive power. In this work, O'Keeffe reduced the incredible details of her subject to a symphony of basic colors, shapes, textures, and vital rhythms. Exhibiting the natural flow of

curved planes and contour, O'Keeffe simplified the form almost to the point of complete abstraction. The fluid planes unfold like undulant petals from a subtly placed axis—the white jetlike streak—in a vision of the slow, controlled motion of growing life. O'Keeffe's painting, in its graceful, quiet poetry, reveals the organic reality (Brancusi would say "essence") of the object by strengthening its characteristic features, in striking contrast with either Kandinsky's explosions (FIG. 33-6) or Mondrian's rectilinear absolutes (FIG. 33-55). O'Keeffe enjoyed a long career; in 1946, she moved permanently to New Mexico and continued to paint for decades, until her death in 1986.

EUROPEAN ART IN THE WAKE OF WORLD WAR I

That American artists could focus on these modernist artistic endeavors with such commitment was due to the fact that World War I was fought entirely on European soil. Thus, its effects were not as devastating as they were both on Europe's geopolitical terrain and on individual and national psyches. After the war concluded, many European artists were drawn to the expressionist idiom (as developed by the Fauves and the German Expressionists) both to express and to deal with the trauma of world war.

Neue Sachlichkeit

As shown earlier, the war severely impacted many artists, notably those associated with German Expressionism and Dada. *Neue Sachlichkeit (New Objectivity)* grew directly out of the war experiences of a group of German artists. All of the artists associated

with Neue Sachlichkeit served, at some point, in the German army and thus had firsthand involvement with the military. Their military experiences deeply influenced their world views and informed their art. This was not an organized movement, and museum director G. F. Hartlaub coined its label in 1923. That label does, however, capture their aim—to present a clear-eyed, direct, and honest image of the war and its effects. As George Grosz, one of the Neue Sachlichkeit artists, explained: "I am trying to give an absolutely realistic picture of the world."[32]

MILITARY HORRORS GEORGE GROSZ (1893–1958) was, for a time, associated with the Dada group in Berlin, but his work, with its harsh and bitter tone, seems more appropriately linked with Neue Sachlichkeit. Grosz observed the onset of World War I with horrified fascination, but that feeling soon turned to anger and frustration. He reported:

> Of course, there was a kind of mass enthusiasm at the start. But this intoxication soon evaporated, leaving a huge vacuum. . . . And then after a few years when everything bogged down, when we were defeated, when everything went to pieces, all that remained, at least for me and most of my friends, were disgust and horror.[33]

Grosz produced numerous paintings and drawings, such as *Fit for Active Service* (FIG. **33-38**), that were caustic indictments of the military. In these works, he often depicted military officers as heartless or incompetent. This particular drawing may relate to Grosz's personal experience. On the verge of a nervous breakdown in 1917, he was sent to a sanatorium where doctors examined him and, much to his horror, declared him "fit for service." In this biting and sarcastic drawing, an army doctor proclaims the skeleton before him "fit for service." None of the other military officers or doctors attending seem to dispute this evaluation. The

33-38 GEORGE GROSZ, *Fit for Active Service*, 1916–1917. Pen and brush and ink on paper, 1′ 8″ × 1′ 2⅜″. Museum of Modern Art, New York (A. Conger Goodyear Fund). Copyright © Estate of George Grosz/Licensed by VAGA, New York, New York.

spectacles perched on the skeleton's face, very similar to the gold-rimmed glasses Grosz wore, further suggest he based this scene on his experiences. Grosz's searing wit is all the more evident upon comparing *Fit for Active Service* with Marsden Hartley's *Portrait of a German Officer* (FIG. 33-33). Although Hartley's painting deals with the death of a friend in battle, the incorporation of colorful German military insignia and emblems imbues the painting with a more heroic, celebratory tone. In contrast, the simplicity of Grosz's line drawing contributes to the directness and immediacy of the work, which scathingly portrays the German army.

DEPICTING WORLD VIOLENCE MAX BECKMANN (1884–1950), like Grosz, enlisted in the German army and initially rationalized the war. He believed the chaos would lead to a better society, but over time the mass destruction increasingly disillusioned him. Soon his work began to emphasize the horrors of war and of a society he saw descending into madness. His disturbing view of society is evident in *Night* (FIG. **33-39**). *Night* depicts a cramped room three intruders have forcefully invaded. A bound woman,

apparently raped, is splayed across the foreground of the painting. Her husband appears on the left; one of the intruders hangs him, while another one twists his left arm out of its socket. An unidentified woman cowers in the background. On the far right, the third intruder prepares to flee with the child.

Although this image does not depict a war scene, the wrenching brutality and violence pervading the home is a searing and horrifying comment on society's condition. Beckmann also injected a personal reference by using himself, his wife, and his son as the models for the three family members. The stilted angularity of the figures and the roughness of the paint surface contribute to the image's savageness. In addition, the artist's treatment of forms and space reflects the world's violence. Objects seem dislocated and contorted, and the space appears buckled and illogical. For example, the woman's hands are bound to the window that opens from the room's back wall, but her body appears to hang vertically, rather than lying across the plane of the intervening table. Despite the fact that images such as *Night* do not directly depict war's carnage or violence, Beckmann's art is undeniably powerful and honest.

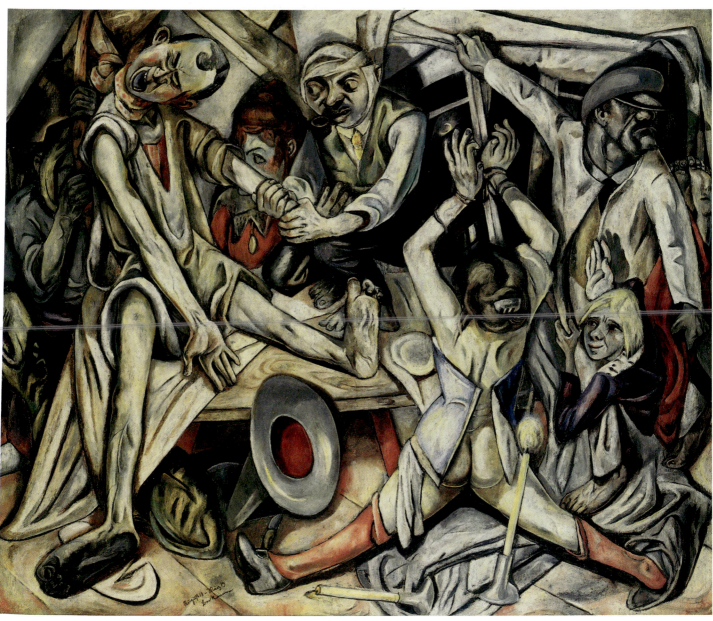

33-39 MAX BECKMANN, *Night*, 1918–1919. Oil on canvas, 4' 4⅜" × 5' 1¼". Kunstsammlung Nordrhein-Westfalen, Düsseldorf.

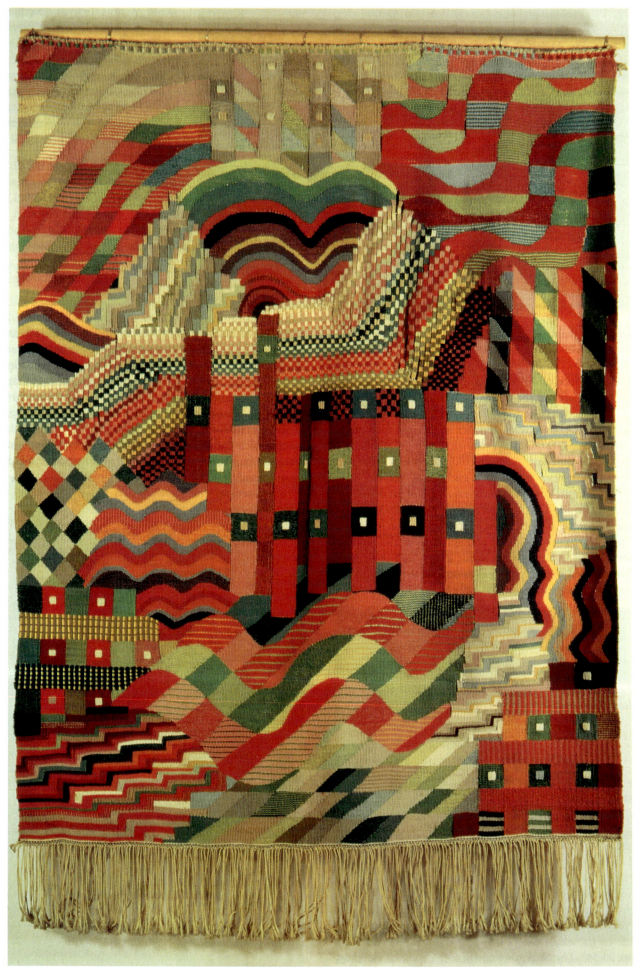

33-61 Gunta Stölzl, Gobelin tapestry, 1926–1927. Linen and cotton.

BREUER (1902–1981). Breuer supposedly was inspired to use tubular steel while riding his bicycle and admiring the handlebars. In keeping with Bauhaus aesthetics, his chairs have a simplified, geometric look, and the leather or cloth supports add to the furniture's comfort and functionality. These chairs were also easily mass produced and thus stand as epitomes of the Bauhaus program.

This reductive, spare geometric aesthetic served many purposes—artistic, practical, and social. Bauhaus and De Stijl artists alike championed this style. Theo van Doesburg, an important De Stijl member, promoted this simplified artistic vocabulary, in part accepted because of its association with the avant-garde and progressive thought. Such an aesthetic also evoked the machine. Appropriately, it easily could be applied to all art forms, from stage design to advertising to architecture, and therefore was perfect for mass production. Even further, this aesthetic fit in well with Gropius's directive that artists, architects, and designers restrict their visual vocabulary "to what is typical and universally intelligible," revealing the social dimension of the Bauhaus agenda in its adherence to socialist principles.

BAUHAUS FIBER CRAFTS The universal intelligibility of this aesthetic is seen in a tapestry (FIG. **33-61**) designed by GUNTA STÖLZL (1897–1983), the only woman on the Bauhaus staff. More lively than many of the other Bauhaus-produced designs, this intricate and colorful work retains the emphasis on geometric patterns and clear intersection of verticals and horizontals. Stölzl was largely responsible for the vitality of the weaving workshop at the Bauhaus, creating numerous handwoven carpets, curtains, and runners. In accordance with Bauhaus principles, she also designed weavings for machine production. In terms of establishing production links with outside businesses, her department was one of the most successful at the school.

"LESS IS MORE" In 1928, Gropius left the Bauhaus, and architect LUDWIG MIES VAN DER ROHE (1886–1969) eventually took over the directorship, moving the school to Berlin. In his architecture and furniture, he made such a clear and elegant statement of the International Style (FIGS. 33-63 and 33-64) that his work had enormous influence on modern architecture. Taking as his motto "less is more" and calling his architecture "skin and bones," he had already fully formed his aesthetic when he conceived the model for a glass skyscraper building in 1921 (FIG. **33-62**). This model received extensive publicity when it was shown at the first Bauhaus exhibition in 1923. Working with glass provided Mies van der Rohe with new freedom and many expressive possibilities.

In the glass model, three irregularly shaped towers flow outward from a central court designed to hold a lobby, a porter's room, and a community center. Two cylindrical entrance shafts rise at the ends of the court, each containing elevators, stairways, and toilets. Wholly transparent, the perimeter walls reveal the regular horizontal patterning of the cantilevered floor planes and their thin vertical supporting elements. The bold use of glass sheathing and inset supports was, at the time, technically and aesthetically adventurous. A few years later, Gropius pursued it in his design for the Bauhaus building in Dessau. The weblike delicacy of the lines of the glass model, its radiance, and the illusion of movement created by reflection and by light changes seen

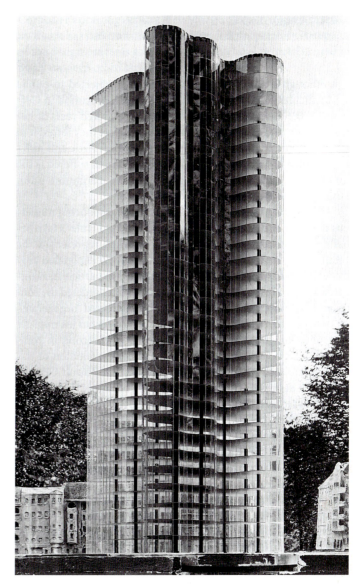

33-62 LUDWIG MIES VAN DER ROHE, model for a glass skyscraper, Berlin, Germany, 1922 (no longer extant).

through it prefigured the design of many of the glass skyscrapers found in major cities throughout the world today.

THE DEMISE OF THE BAUHAUS In 1933, the Nazis finally occupied the Bauhaus and closed the school for good, one of Hitler's first acts after coming to power (see "'Degenerate Art,'" page 1012). During its 14-year existence, the beleaguered school graduated fewer than 500 students, yet it achieved legendary status. Its phenomenal impact extended beyond painting, sculpture, and architecture to interior design, graphic design, and advertising. Even further, the Bauhaus greatly influenced art education, and art schools everywhere structured their curricula in line with that the Bauhaus pioneered. The Bauhaus philosophy and aesthetic were disseminated widely, in large part by the numerous instructors who fled Nazi Germany, many to the United States. Walter Gropius and Marcel Breuer ended up at Harvard University, and Mies van der Rohe and László Moholy-Nagy moved to Chicago and taught there. Josef Albers moved to the United States in 1933, teaching at Black Mountain College in North Carolina and later at Yale University.

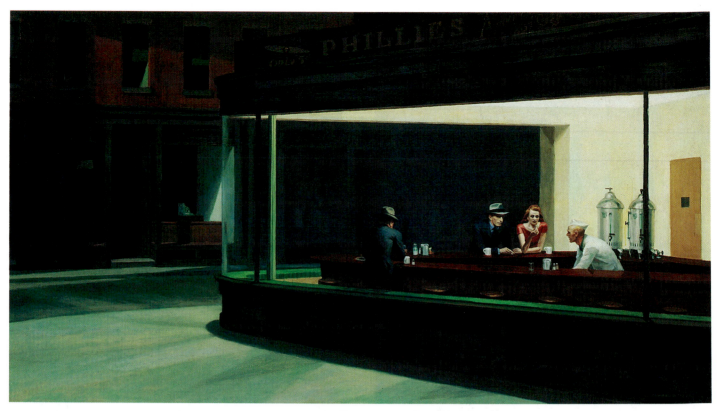

33-76 EDWARD HOPPER, *Nighthawks*, 1942. Oil on canvas, 2′ 6″ × 4′ 8 11/16″. The Art Institute of Chicago, Chicago (Friends of American Art Collection).

The response to this photo indicates the ability of *Migrant Mother, Nipomo Valley* to strike a sympathetic chord in viewers. Within days after this image was printed in a San Francisco newspaper, people rushed food to Nipomo to feed the hungry workers.

DEPRESSION-ERA LONELINESS EDWARD HOPPER (1882–1967) produced paintings during the Depression era evoking the national mindset. However, rather than depict historically specific scenes, he took as his subject the more generalized theme of the overwhelming loneliness and echoing isolation of modern life in the United States. Trained as a commercial artist, Hopper studied painting and printmaking in New York and Paris before returning to the United States. He then concentrated on scenes of contemporary American city and country life, painting buildings, streets, and landscapes that are curiously muted, still, and filled with empty spaces. Motion is stopped and time suspended, as if the artist recorded the major details of a poignant personal memory. From the darkened streets outside a restaurant in *Nighthawks* (FIG. **33-76**), the viewer glimpses the lighted interior through huge plate-glass windows, which lend the inner space the paradoxical sense of being both a safe refuge and a vulnerable place for the three customers and the counterman. The seeming indifference of Hopper's characters to one another and the echoing spaces that surround them evoke the pervasive loneliness of modern humans. Although Hopper invested works such as *Nighthawks* with the straightforward mode of representation, creating a kind of realist vision recalling that of 19th-century artists such as Thomas Eakins (see FIG. 29-12) and Henry Ossawa Tanner (see FIG. 29-15), he simplified the shapes in the painting, moving toward abstraction, in order to heighten the mood of the scene.

AFRICAN AMERICAN MIGRATION African American artist JACOB LAWRENCE (1917–2000) found his subjects in modern history, concentrating on the culture and history of African Americans. Lawrence moved to Harlem, New York, in 1927 at about age 10. There, he came under the spell of the African art and the African American history he found in lectures and exhibitions and in the special programs sponsored by the 135th Street New York Public Library, which had outstanding collections of African American art and archival data. Inspired by the politically oriented art of Goya (see FIG. 28-43), Daumier (see FIG. 29-6), and Orozco (FIG. 33-80), and influenced by the many artists and writers (such as Alain Locke, Aaron Douglas [FIG. 33-35], Claude McKay, and Countee Cullen) of the Harlem Renaissance whom he met, Lawrence found his subjects in the everyday life of Harlem and his people's history. He defined his own vision of the continuing African American struggle against discrimination.

In 1941, Lawrence began a 60-painting series titled *The Migration of the Negro*. Unlike his earlier historical paintings depicting important figures in American history, such as Frederick Douglass, Toussaint L'Ouverture, and Harriet Tubman, this series called attention to a contemporaneous event—the ongoing exodus of black labor from the southern United States. Disillusioned with their lives in the South, hundreds of thousands of African Americans migrated north in the years following World War I, seeking improved economic opportunities and more hospitable political and social conditions. This subject had personal relevance to Lawrence. He explained: "I was part of the migration, as was my family, my mother, my sister, and my brother. . . . I grew up hearing tales about people 'coming up,' another family arriving. . . . I didn't realize what was happening until about the middle of the 1930s, and that's when the *Migration* series began to take form in my mind."[79]

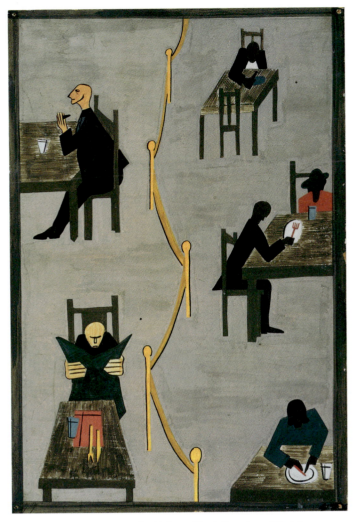

33-77 JACOB LAWRENCE, *No. 49* from *The Migration of the Negro,* 1940–1941. Tempera on Masonite, 1′ 6″ × 1′. The Phillips Collection, Washington.

The "documentation" of the period, such as the RA program, ignored African Americans, and thus this major demographic shift remained largely invisible to most Americans. Of course, the conditions African Americans encountered both during their migration and in the North were often as difficult and discriminatory as those they had left behind in the South.

Lawrence's series provides numerous vignettes capturing the experiences of these migrating people. Often, a sense of bleakness and of the degradation of African American life dominates the images. *No. 49* of this series (FIG. **33-77**) bears the caption "They also found discrimination in the North although it was much different from that which they had known in the South." The artist depicted a blatantly segregated dining room with a barrier running down the room's center separating the whites on the left from the African Americans on the right. To ensure a continuity and visual integrity among all 60 paintings, Lawrence interpreted his themes systematically in rhythmic arrangements of bold, flat, and strongly colored shapes. His style drew equally from his interest in the push-pull effects of Cubist space and his memories of the patterns made by the colored scatter rugs brightening the floors of his childhood homes. Further, he unified the narrative with a consistent palette of bluish green, orange, yellow, and grayish brown throughout the entire series. Lawrence believed that this story, like every subject he painted during his long career, had important lessons to teach viewers.

Regionalism

Although many American artists, such as the Precisionists (FIGS. 33-36 and 33-37), were enamored of the city or of rapidly developing technological advances, others chose not to depict these aspects of modern life. The Regionalists, sometimes referred to as the American Scene Painters, turned their attention to rural life as America's cultural backbone. One of the Regionalists, GRANT WOOD (1891–1942), for example, published an essay titled "Revolt against the City" in 1935. Although this movement was not formally organized, Wood acknowledged its existence in 1931, when he spoke at a conference. In his address, he announced a new movement developing in the Midwest, known as *Regionalism,* which he described as focused on American subjects and as standing in reaction to "the abstraction of the modernists" in Europe and New York.[80]

THE APPEAL OF RURAL IOWA Grant Wood's paintings focus on rural scenes from Iowa, where he was born and raised. The work that catapulted Wood to national prominence was *American Gothic* (FIG. **33-78**), which became an American icon. The artist depicted a farmer and his spinster daughter standing in front of a neat house with a small lancet window, typically found on Gothic cathedrals. The man and woman wear traditional attire—he appears in worn overalls and she in an apron trimmed with rickrack. The dour expression on both of their faces gives the painting a severe quality, which Wood enhanced with his meticulous brushwork. When *American Gothic* was exhibited, many people praised the work, which they perceived as "quaint, humorous, and AMERICAN," in the words of one

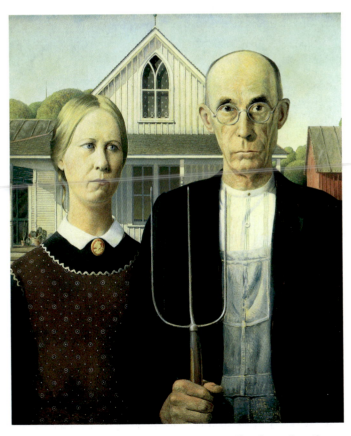

33-78 GRANT WOOD, *American Gothic,* 1930. Oil on beaverboard, 2′ 5⅞″ × 2′ ⅞″. Art Institute of Chicago, Chicago (Friends of American Art Collection).

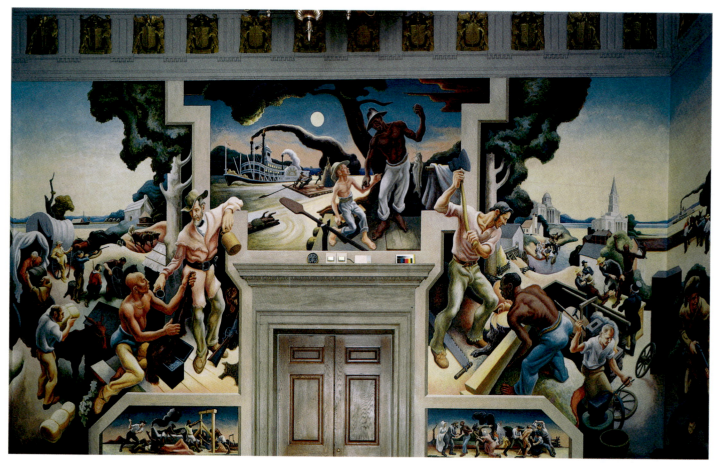

33-79 THOMAS HART BENTON, *Pioneer Days and Early Settlers,* State Capitol, Jefferson City, 1936. Mural. Copyright © T. H. Benton and R. P. Benton Testamentary Trusts/Licensed by VAGA, New York, New York.

critic.[81] Many saw the couple as embodying "strength, dignity, fortitude, resoluteness, integrity," and were convinced that Wood had captured the true spirit of America.[82]

Wood's Regionalist vision involved more than his subjects, extending to a rejection of avant-garde styles in favor of a clearly readable, realist style. Surely this approach appealed to many people alienated by the increasing presence of abstraction in art. Interestingly enough, despite the accolades this painting received, it was also criticized. Not everyone saw the painting as a sympathetic portrayal of midwestern life; indeed, some in Iowa felt insulted by the depiction. In addition, despite the seemingly reportorial nature of *American Gothic,* some viewed it as a political statement—one of staunch nationalism. In light of the problematic nationalism in Germany at the time, this perceived nationalistic attitude was all the more disturbing. Ultimately, Regionalism had both stylistic and political implications.

CONSTRUCTING A STATE'S HISTORY THOMAS HART BENTON (1889–1975) was another of the major Regionalist artists. Whereas Wood focused his attention on Iowa, Benton turned to scenes from his native Missouri. He produced one of his major works, a series of murals titled *A Social History of the State of Missouri,* in 1936 for the Missouri State Capitol. The murals depict a collection of images from the state's true and legendary history, such as primitive agriculture, horse trading, a vigilante lynching, and an old-fashioned political meeting. Other scenes portray the mining industry, grain elevators, Native Americans, and family life. One segment, *Pioneer Days and Early Settlers* (FIG. 33-79), shows a white man using whisky as a bartering tool with a Native American (at left), along with scenes documenting the building

of Missouri. Part documentary and part imaginative, Benton's images include both positive and negative aspects of Missouri's history, as these examples illustrate. Although Regionalists were popularly perceived as dedicated to glorifying midwestern life, that belief distorted their aims. Indeed, Grant Wood observed, "your true regionalist is not a mere eulogist; he may even be a severe critic."[83] Benton, like Wood, was committed to a visually accessible style, but he developed a highly personal aesthetic that included complex compositions, a fluidity of imagery, and simplified figures depicted with a rubbery distortion.

Not surprisingly, during the Great Depression of the 1930s, Regionalist paintings had a popular appeal because they often projected a reassuring image of America's heartland. The public saw Regionalism as a means of coping with the national crisis through a search for cultural roots. Thus, people deemed acceptable any nostalgia implicit in Regionalist paintings or mythologies these works perpetuated because they served a larger purpose.

Mexican Muralists

VALIDATING MEXICAN HISTORY JOSÉ CLEMENTE OROZCO (1883–1949) was one of a group of Mexican artists determined to base their art on the indigenous history and culture existing in Mexico before Europeans arrived. The movement these artists formed was part of the idealistic rethinking of society that occurred in conjunction with the Mexican Revolution (1910–1920) and the lingering political turmoil of the 1920s. Among the projects these politically motivated artists undertook were vast mural cycles placed in public buildings to dramatize and validate the history of

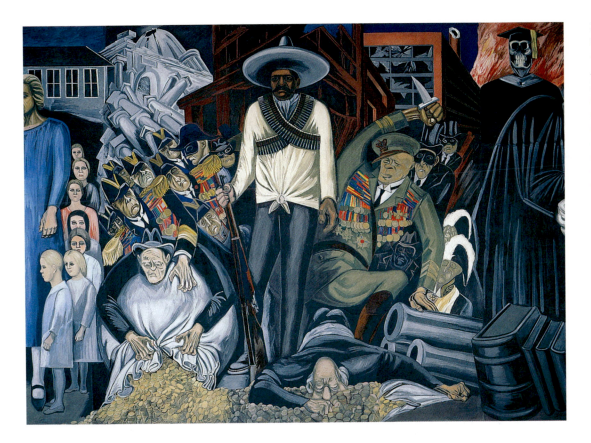

Mexico's native peoples. Orozco worked on one of the first major cycles, painted in 1922 on the walls of the National Training School in Mexico City. He carried the ideas of this mural revolution to the United States, completing many commissions for wall paintings between 1927 and 1934. From 1932 to 1934, he worked on one of his finest mural cycles in the Baker Library at Dartmouth College in New Hampshire, partly in honor of its superb collection of books in Spanish. The college let him choose the subject. Orozco depicted, in 14 large panels and 10 smaller ones, a panoramic and symbolic history of ancient and modern Mexico, from the early mythic days of the feathered-serpent god Quetzalcoatl to a contemporary and bitterly satiric vision of modern education.

The imagery in the illustrated detail, *Epic of American Civilization: Hispano-America* (panel 16; FIG. 33-80), revolves around the monumental figure of a heroic Mexican peasant armed to participate in the Mexican Revolution. Looming on either side of him are mounds crammed with symbolic figures of his oppressors—bankers, government soldiers, officials, gangsters, and the rich. Money-grubbers pour hoards of gold at the incorruptible peon's feet, cannons threaten him, and a bemedaled general raises a dagger to stab him in the back. Orozco's training as an architect gave him a sense of the framed wall surface, which he easily commanded, projecting his clearly defined figures onto the solid mural plane in monumental scale.

In addition, Orozco's early training as a maker of political prints and as a newspaper artist had taught him the rhetorical strength of graphic brevity, which he used here to assure that his allegory was easily read. His special merging of the graphic and mural media effects gives his work an originality and force rarely seen in mural painting after the Renaissance and Baroque periods.

THE POWER OF PUBLIC ART DIEGO RIVERA (1886–1957), like his countryman Orozco, achieved great renown for his murals, both in Mexico and in the United States. A staunch Marxist, Rivera was committed to developing an art that served his people's needs.

Toward that end, he sought to create a national Mexican style focusing on Mexico's history and also incorporating a popular, generally accessible aesthetic (in keeping with the Socialist spirit of the Mexican Revolution). Rivera produced numerous large murals in public buildings, among them a series lining the staircase of the National Palace in Mexico City. In these images, painted between 1929 and 1935, he depicted scenes from Mexico's history; we depict here *Ancient Mexico* (FIG. 33-81) from this series. These scenes represent the conflicts between the indigenous people and the Spanish colonizers. Rivera included portraits of important figures in Mexican history and, in particular, in the struggle for Mexican independence. Although complex, the decorative, animated murals retain the legibility of folklore—the figures consist of simple monumental shapes and areas of bold color.

ÉMIGRÉS AND EXILES: ENERGIZING AMERICAN ART AT MIDCENTURY

The Armory Show in 1913 in New York City, discussed earlier (page 986), was an important vehicle for disseminating information about developments in European art. Equally significant was the emigration of European artists around the European continent and across the Atlantic Ocean to America. The havoc Hitler and the National Socialists wreaked in the early 1930s forced artists to flee. The United States, among other countries, offered both survival and a more hospitable environment for producing their art.

Many artists gravitated to Paris and London, but when the threat of war expanded, the United States became an attractive alternative. Several artists and architects associated with the Bauhaus—Gropius, Moholy-Nagy, Albers, Breuer, and Mies van der Rohe—came to the United States. Many accepted teaching positions, providing them a means of disseminating their ideas. Artists associated with other avant-garde movements—Neue Sachlichkeit (Beckmann and

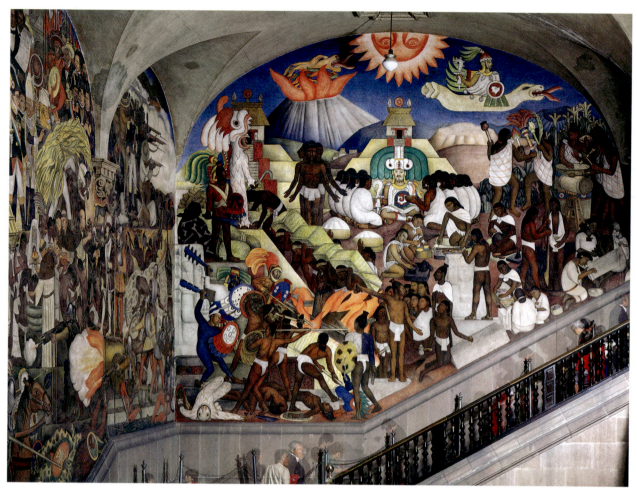

33-81 DIEGO RIVERA, *Ancient Mexico,* from the *History of Mexico* fresco murals, National Palace, Mexico City, 1929–1935. Fresco.

Grosz), Surrealism (Ernst, Dalí, and Breton), and Cubism (Léger and Lipchitz)—all made their way to American cities.

Museums in the United States, wanting to demonstrate their familiarity and connection with the most progressive European art, mounted exhibitions centered on the latest European artistic developments. In 1938 alone, the City Art Museum of Saint Louis in Missouri presented an exhibition of Beckmann's work, the Art Institute of Chicago organized *George Grosz: A Survey of His Art from 1918–1938,* and the Museum of Modern Art in New York offered *Bauhaus, 1919–1928.* This interest in exhibiting the work of artists persecuted and driven from their homelands also had political overtones. In the highly charged atmosphere of the late 1930s leading to the onset of World War II, people often perceived support for these artists and their work as support for freedom and democracy. In 1942, Alfred H. Barr Jr., director of the Museum of Modern Art, stated:

> Among the freedoms which the Nazis have destroyed, none has been more cynically perverted, more brutally stamped upon, than the Freedom of Art. For not only must the artist of Nazi Germany bow to political tyranny, he must also conform to the personal taste of that great art connoisseur, Adolf Hitler. . . . But German artists of spirit and integrity have refused to conform. They have gone into exile or slipped into anxious obscurity. . . . Their paintings and sculptures, too, have been hidden or exiled. . . . But in free countries they can still be seen, can still bear witness to the survival of a free German culture.[84]

Despite this moral support for exiled artists, once the United States formally entered the war, Germany officially became the enemy. Then it was much more difficult for the art world to promote German artists, however persecuted. Many émigré artists (for example, Ernst, Dalí, Léger, and Grosz) returned to Europe after the war ended. Their collective presence in the United States until then, however, was critical for the development of American art and contributed to the burgeoning interest in the avant-garde among American artists. In addition, the artistic vitality that resulted from the confluence of artists in the United States during the first half of the 20th century propelled that country into an increasingly prominent position in the art world (including the sale, exhibition, and criticism of art).

CONCLUSION

The upheaval during the early 20th century, evidenced by the prominence of war and economic instability, was a catalyst for significant change in art. Artists explored in depth various elements of artistic expression, such as color (the Fauves), form (the Cubists), and time and space (the Constructivists). They also challenged the processes by which art was created—for example, the Surrealists delved into the subconscious realm to produce works prompted by intuition. The early 20th century was also characterized by increased dialogue between American and European artists. The Armory Show in 1913 and the emigration of European artists to the United States were both important catalysts for the momentum and energy in the art world that carried on into the later 20th century.

1900

▎ SIGMUND FREUD, 1856–1939; *The Interpretation of Dreams*, 1900

▎ MAX PLANCK, 1858–1947; QUANTUM THEORY, 1900

▎ QUEEN VICTORIA'S REIGN ENDS, 1901

▎ FIRST TRANSATLANTIC RADIO SIGNAL, 1901

1 ▎ WRIGHT BROTHERS' FIRST FLIGHT, 1903

▎ ALBERT EINSTEIN, 1879–1955; THEORY OF RELATIVITY, 1905–1915

▎ DIE BRÜCKE, FORMED 1905

▎ LES FAUVES, FORMED 1905

▎ FUTURIST MANIFESTO, 1909

▎ DIE BLAUE REITER, FORMED 1911

▎ NIELS BOHR, 1885–1962; ATOMIC THEORY, 1913

▎ WORLD WAR I, 1914–1918

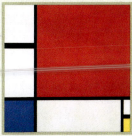

1 Henri Matisse, *Woman with the Hat*, 1905

1915

▎ ESTABLISHMENT OF CABARET VOLTAIRE IN ZURICH, 1916

2 ▎ RUSSIAN REVOLUTION, ESTABLISHMENT OF COMMUNIST REGIME, 1917–1921

▎ BAUHAUS FOUNDED, 1919

▎ TREATY OF VERSAILLES, 1919

▎ COMMERCIAL TELEVISION, 1920S

▎ LEAGUE OF NATIONS, 1921–1939

▎ U.S.S.R. OFFICIALLY ESTABLISHED, 1923

▎ SURREALIST MANIFESTO, 1924

▎ MEXICAN REVOLUTION ENDS, 1924

2 Marcel Duchamp, *Fountain* (second version), 1950 (original version produced 1917)

1925

▎ ADDITION OF SOUND TECHNOLOGY TO FILMS, 1927

▎ CARL JUNG, 1875–1961 (ANALYTICAL PSYCHOLOGY)

▎ FASCISM IN ITALY, 1920–1945

▎ STOCK MARKET CRASHES, 1929

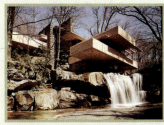

3 Piet Mondrian, *Composition in Red, Blue, and Yellow*, 1930

1930

3 ▎ THE GREAT DEPRESSION, 1930S

▎ RISE OF NAZISM IN GERMANY, 1930S

▎ ROOSEVELT'S "NEW DEAL" IN UNITED STATES, 1933–1939

1936

▎ SPANISH CIVIL WAR, 1936–1939

4 ▎ JAPAN INVADES CHINA, 1937

▎ WORLD WAR II, 1939–1945

4 Frank Lloyd Wright, Kaufmann House (Fallingwater), 1936–1939

1940

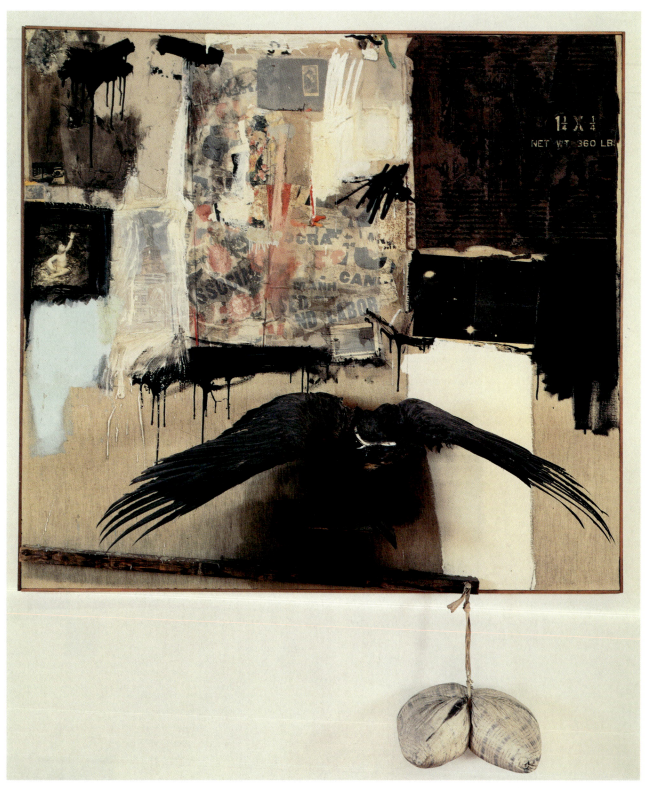

ROBERT RAUSCHENBERG, *Canyon,* 1959. Oil, pencil, paper, fabric, metal, cardboard box, printed paper, printed reproductions, photograph, wood, paint tube, and mirror on canvas, with oil on bald eagle, string, and pillow, 6′ 9¾″ × 5′ 10″ × 2′. Sonnabend Collection. Copyright © Untitled Press, Inc./Licensed by VAGA, New York, New York.

34

FROM THE MODERN TO THE POSTMODERN AND BEYOND

ART OF THE LATER 20TH CENTURY

World War II, with the global devastation it unleashed on all dimensions of life—psychological, political, physical, and economic—set the stage for the second half of the 20th century. The dropping of atomic bombs by the United States on Hiroshima and Nagasaki in 1945 signaled a turning point not just in the war itself, but in the geopolitical balance and the nature of international conflict (MAP **34-1**). As a result, the history of the later 20th century became one of upheaval, change, and conflict. For the rest of the century, nuclear war became a very real threat. Indeed, the two nuclear superpowers, the United States and the Soviet Union, divided the post–World War II world into spheres of influence, and each regularly intervened politically, economically, and militarily wherever and whenever it considered its interests to be at stake.

Disruption and Upheaval

The consistent presence of conflict throughout the world in the later 20th century resulted in widespread disruption and dislocation. In 1947, the British left India, which erupted in a murderous Hindu-Muslim war that divided the subcontinent into the new, still hostile nations of India and Pakistan. After a catastrophic war, Communists came to power in China in 1949. North Korea challenged the authority of the fledgling United Nations, founded after the war, by invading South Korea in 1950 and fighting a grim war with the United States and its UN allies that ended in 1953. The Soviets brutally suppressed uprisings in their subject nations—East Germany, Poland, Hungary, and Czechoslovakia. The United States intervened in disputes in Central and South America. Hardly had the previously colonized nations of Africa—Kenya, Uganda, Nigeria, Angola, Mozambique, the Sudan, Rwanda, and the Congo—won their independence

prominence of the American Clement Greenberg (1909–1994). As an art critic who wielded considerable influence from the 1940s through the 1970s, Greenberg was instrumental in redefining the parameters of modernism.

For Greenberg, late-20th-century modernist artists were those who refined the critical stance of the late-19th- and early-20th-century modernists. This critical stance involved rejecting illusionism and exploring the properties of each artistic medium. So dominant was Greenberg that scholars often refer to the general modernist tenets during this period as Greenbergian formalism. Although he modified his complex ideas about art over the years, certain basic concepts are associated with Greenbergian formalism. In particular, Greenberg promoted the idea of purity in art. He explained, "Purity in art consists in the acceptance, willing acceptance, of the limitations of the medium of the specific art."[1] In other words, he believed artists should strive for a more explicit focus on the properties exclusive to each medium—for example, two-dimensionality or flatness in painting, and three-dimensionality in sculpture. To achieve this, artists had to eliminate illusion and embrace abstraction. Greenberg elaborated:

> It follows that a modernist work of art must try, in principle, to avoid communication with any order of experience not inherent in the most literally and essentially construed nature of its medium. Among other things, this means renouncing illusion and explicit subject matter. The arts are to achieve concreteness, "purity," by dealing solely with their respective selves—that is, by becoming "abstract" or nonfigurative.[2]

Greenberg avidly promoted the avant-garde, which he viewed as synonymous with modernism in the postwar years. Generally speaking, the spirit of rebellion and disdain for convention central to the historical avant-garde flourished in the sociopolitical upheaval and counterculture of the 1960s and 1970s. However, the acute sociopolitical dimension inherent in the avant-garde's early development had evaporated by this time (although many of the artists considered avant-garde aligned themselves with the Left). Thus the avant-garde (and modernism) became primarily an artistic endeavor. Still, the distance between progressive artists and the public widened. In his landmark 1939 article "Avant-Garde and Kitsch," Greenberg insisted on the separation of the avant-garde from kitsch (which Greenberg defined as "ersatz," or artificial, culture, such as popular commercial art and literature), thereby advocating the continued alienation of the public from avant-garde art.

The Emergence of Postmodernism

The intense criticism of the discipline and the unrelenting challenges to artistic convention that were central to modernism eventually led to its demise in the 1970s. To many, it seemed artistic traditions had been so completely undermined that modernism simply played itself out. From this situation emerged *postmodernism,* one of the most dramatic developments during the century. Postmodernism cannot be described as a style; it is a widespread cultural phenomenon. Many people view it as a rejection of modernist principles. Accordingly, postmodernism is far more encompassing and accepting than the more rigid confines of modernist practice. Postmodernism's ability to accommodate seemingly everything in art makes it extremely difficult to provide a clear and concrete definition of the term. In response to the

elitist, uncompromising stance of modernism, postmodernism grew out of a naive and optimistic populism.

Whereas the obscure meaning of abstract work limited the audience for modernist art, postmodern artists offer something for everyone. For example, in architecture, postmodernism's eclectic nature often surfaces in a whimsical mixture of styles and architectural elements (such as Greek columns juxtaposed with ornate Baroque decor). In other artistic media, postmodernism accommodates a wide range of styles, subjects, and formats, from traditional easel painting to video and *installation* (artwork creating an artistic environment in a room or gallery), and from the spare abstraction associated with modernism to carefully rendered illusionistic scenes.

The emergence of postmodernism was also driven by theoretical concerns, such as exploring the relationship between art and mass culture, and examining the tendency to privilege the artist's voice in the search for meaning in art. Various investigations have been identified as particularly postmodern, including critiquing modernist tenets, reassessing the nature of representation, and questioning the ways in which meaning is generated. Despite the prevalence of theory in postmodernism, much of the art produced during the postmodern period is resolutely grounded in specific historical conditions. Thus, later in this chapter, we discuss art addressing issues of race, class, gender, sexual orientation, and ethnicity.

POSTWAR EXPRESSIONISM IN EUROPE

The end of World War II in 1945 left devastated cities, ruptured economies, and governments in chaos throughout Europe. These factors, coupled with the massive loss of life and the indelible horror of the Holocaust and of Hiroshima and Nagasaki, resulted in a pervasive sense of despair, disillusionment, and skepticism. Although many (for example, the Futurists in Italy) had tried to find redemptive value in World War I, it was virtually impossible to do the same with World War II, coming as it did so closely on the heels of the war that was supposed to "end all wars." Additionally, World War I was largely a European conflict that left roughly 10 million people dead, while World War II was a truly global catastrophe, leaving 35 million dead in its wake.

Existentialism: The Absurdity of Human Existence

The cynicism emerging across Europe was reflected in the popularity of existentialism, a philosophy asserting the absurdity of human existence and the impossibility of achieving certitude. Many existentialists also promoted atheism and questioned the possibility of situating God within a systematic philosophy. The roots of existentialism are often traced to the Danish theologian Søren Kierkegaard (1813–1855), and the writings of philosophers and novelists such as Friedrich Nietzsche (see Chapter 33, page 963), Martin Heidegger (1889–1976), Fyodor Dostoyevsky (1821–1881), and Franz Kafka (1883–1924) disseminated its ideas. In the postwar period, the writings of the French author Jean-Paul Sartre (1905–1980) most clearly captured the existentialist spirit. According to Sartre, people must consider seriously the implications of atheism. If God does not exist, then individuals must constantly struggle in isolation

with the anguish of making decisions in a world without absolutes or traditional values.

This spirit of pessimism and despair emerged frequently in the European art of the immediate postwar period. A brutality or roughness appropriately expressing both the artist's state of mind and the larger cultural sensibility characterized much of this art.

AN INDICTMENT OF HUMANITY *Painting* (FIG. **34-1**) by British artist Francis Bacon (1910–1992) is a compelling and revolting image of a powerful figure who presides over a scene of slaughter. Painted in the year after World War II ended, this work can be read as an indictment of humanity and a reflection of war's butchery. The central figure is a stocky man with a gaping mouth and a vivid red stain on his upper lip, as if he were a carnivore devouring the raw meat sitting on the railing surrounding him. Bacon may have based his depiction of this central figure on news photos of Nazi leaders Joseph Goebbels and Heinrich Himmler, Benito Mussolini, or Franklin Roosevelt, which were an important part of media coverage during World War II and very familiar to the artist. The umbrella recalls wartime images of Neville Chamberlain, the British prime minister who so disastrously misjudged Hitler and was frequently photographed with an umbrella. Bacon suspended the flayed carcass hanging behind the central figure like a crucified human form, adding to the visceral impact of the

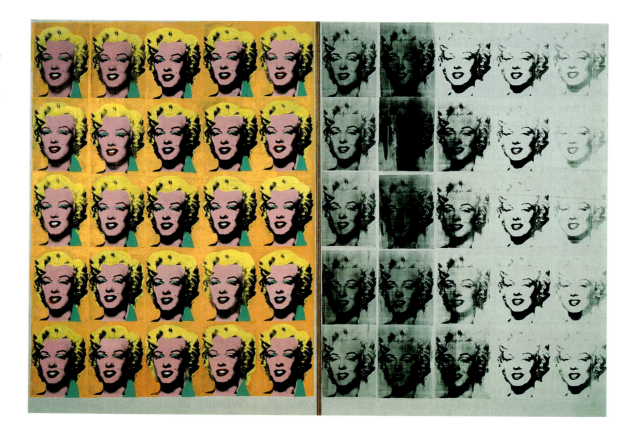

34-32 ANDY WARHOL, *Marilyn Diptych,* 1962. Oil, acrylic, and silk-screen enamel on canvas, each panel 6′ 8″ × 4′ 9″. Tate Gallery, London.

A MYTHIC CELEBRITY Warhol often produced images of Hollywood celebrities, such as Marilyn Monroe. Like his other paintings, these works emphasize the commodity status of the subjects depicted. Warhol created *Marilyn Diptych* (FIG. **34-32**) in the weeks following the tragic suicide of the movie star in August 1962, capitalizing on the media frenzy that her death prompted. Warhol selected a publicity photo of Monroe, one that provides no insight into the real Norma Jean Baker. Rather, all the viewer sees is a mask—a persona the Hollywood myth machine generated. The garish colors and the flat application of paint contribute to the image's masklike quality. Like that of the Coke bottles, the repetition of Monroe's face reinforces her status as a consumer product, her glamorous, haunting visage seemingly confronting the viewer endlessly, as it did the American public in the aftermath of her death. The right half of this work, with its poor registration of pigment, suggests a sequence of film stills, referencing the realm from which Monroe derived her fame.

Warhol's own ascendance to the realm of celebrity underscored his remarkable and astute understanding of the dynamics and visual language of mass culture. He predicted that the age of mass media would enable everyone to become famous for 15 minutes. His own celebrity lasted much longer, long after his death at age 58 in 1987.

SUPERSIZING SCULPTURE Pop artist CLAES OLDENBURG (b. 1929) has produced sculptures that incisively comment on American consumer culture. His early works consisted of plaster reliefs of food and clothing items. Oldenburg constructed these sculptures of plaster layered on chicken wire and muslin, painting them with cheap commercial house enamel. In later works, focused on the same subjects, he shifted to large-scale stuffed sculptures of sewn vinyl or canvas. Examples of both types of sculptures can be seen in the photograph of a one-person show

(FIG. **34-33**) that Oldenburg held at the Green Gallery in New York in 1962. He had included many of the works in this exhibition in an earlier show he mounted titled *The Store*. An installation of Oldenburg's sculptures of consumer products, *The Store* was an appropriate comment on the function of art as a commodity in a consumer society. Over the years, Oldenburg's sculpture has become increasingly monumental. In recent decades, he and his wife and collaborator, COOSJE VAN BRUGGEN (b. 1942), have become particularly well known for their mammoth outdoor sculptures of familiar, commonplace objects, such as cue balls, shuttlecocks, clothespins, and torn notebooks.

Superrealism

Like the Pop artists, the artists associated with *Superrealism* were interested in finding a form of artistic communication that was more accessible to the public than the remote, unfamiliar visual language of the Abstract Expressionists or the Post-Painterly Abstractionists. The Superrealists expanded Pop's iconography in both painting and sculpture by making images in the late 1960s and 1970s involving scrupulous fidelity to optical fact. Because many Superrealists used photographs as sources for their imagery, people also referred to the Superrealist painters as Photorealists. These artists reproduced in minute and unsparing detail the commonplace facts and artifacts that Pop art addressed.

EXPLORING "PHOTO-VISION" American artist AUDREY FLACK (b. 1931) was one of the movement's pioneers. Her paintings, such as *Marilyn* (FIG. **34-34**), were not simply technical exercises but were also conceptual inquiries into the nature of photography and the extent to which photography constructs an understanding of reality. Flack noted, "[Photography is] my whole

34-33 CLAES OLDENBURG, photo of one-person show at the Green Gallery, New York, 1962. © Estate of Rudolph Burkhardt/ Licensed by VAGA, New York, New York.

34-34 AUDREY FLACK, *Marilyn,* 1977. Oil over acrylic on canvas, 8′ × 8′. Collection of the University of Arizona Museum, Tucson (museum purchase with funds provided by the Edward J. Gallagher Jr. Memorial Fund).

life, I studied art history, it was always photographs, I never saw the paintings, they were in Europe. . . . Look at TV and at magazines and reproductions, they're all influenced by photo-vision."[33] The photograph's formal qualities also intrigued her, and she used photographic techniques by first projecting an image in slide form onto the canvas. By next using an airbrush (a device originally designed as a photo-retouching tool), Flack could duplicate the smooth gradations of tone and color found in photographs. Her attention to detail and careful preparation resulted in paintings (mostly still lifes) that present the viewer with a collection of familiar objects painted with great optical fidelity. *Marilyn* provides a different comment on the tragic death of Marilyn Monroe than does Warhol's *Marilyn Diptych* (FIG. 34-32). In Flack's still-life painting, she alludes to the traditional vanitas painting (see FIGS. 24-55 and 24-56). Like a Dutch vanitas painting, *Marilyn* is replete with references to death. In addition to the black-and-white photographs of a youthful, smiling Monroe, fresh fruit (some of it cut), an hourglass, a burning candle, a watch, and a calendar all refer to the passage of time and the transience of life on earth.

LARGE-SCALE PORTRAITS American artist CHUCK CLOSE (b. 1940), best known for his large-scale portraits, is another artist whose work has been associated with the Superrealist movement. However, Close felt his connection to the Photorealists was tenuous, because for him realism, rather than an end in itself, was actually the result of an intellectually rigorous, systematic approach to painting. He based his paintings of the late 1960s and early 1970s, such as his *Big Self-Portrait* (FIG. **34-35**), on photographs, and his main goal was to translate photographic information into painted information. Because he aimed simply to record visual information about his subject's appearance, he deliberately avoided creative compositions, flattering lighting effects, and revealing facial expressions. Close, not interested in providing great insight into the personalities of those portrayed, painted anonymous and generic people, mostly friends. By reducing the variables in his paintings (even their canvas size is a constant nine feet by seven feet), Close could focus on employing his methodical presentations of faces, thereby encouraging the viewer to deal with the formal aspects of his works. Indeed, because of the large scale of Close paintings, close scrutiny causes the images to dissolve into abstract patterns.

CASTS OF STEREOTYPICAL AMERICANS Superrealist sculpture has been best articulated in the work of DUANE HANSON (1925–1996). Like many of the other Superrealists, Hanson was interested in finding a visual vocabulary the public would understand. Once he perfected his casting technique, he created numerous life-size figurative sculptures. Hanson first made plaster molds from live models. He then filled the molds with polyester resin. After the resin hardened, the artist removed the outer molds and cleaned, painted with an airbrush, and decorated the sculptures with wigs, clothes, and other accessories. These works, such as *Supermarket Shopper* (FIG. **34-36**), depict stereotypical average Americans, striking chords with the viewer specifically because of their familiarity. Hanson explained his choice of imagery: "The subject matter that I like best deals with the familiar lower and middle-class American types of today. To me, the resignation, emptiness and loneliness of their existence captures the true reality of life for these people. . . . I want to achieve a certain tough realism which speaks of the fascinating idiosyncrasies of our time."[34] Due to Hanson's choice of imagery and careful production process, the viewer often initially mistakes his sculptures, when on display, for real people, accounting for his association with the Superrealist movement.

34-35 CHUCK CLOSE, *Big Self-Portrait,* 1967–1968. Acrylic on canvas, 8′ 11″ × 6′ 11″ × 2″. Collection of Walker Art Center, Minneapolis (Art Center Acquisition Fund, 1969).

34-36 DUANE HANSON, *Supermarket Shopper,* 1970. Polyester resin and fiberglass polychromed in oil, with clothing, steel cart, and groceries, life-size. Nachfolgeinstitut, Neue Galerie, Sammlung Ludwig, Aachen. © Estate of Duane Hanson/Licensed by VAGA, New York, New York.

Site-Specific Art and Environmental Art

Environmental art, sometimes called *Earth art* or *earthworks,* emerged in the 1960s and included a wide range of artworks, most site-specific and existing outdoors. Many artists associated with these sculptural projects also used natural or organic materials, including the land itself. This art form developed during a period of increased concern for the American environment. The ecology movement of the 1960s and 1970s aimed to publicize and combat escalating pollution, depletion of natural resources, and the dangers of toxic waste. The problems of public aesthetics (for example, litter, urban sprawl, and compromised scenic areas) were also at issue. Widespread concern about the environment led to the passage of the National Environmental Policy Act in 1969 and the creation of the federal Environmental Protection Agency. Environmental artists used their art to call attention to the landscape and, in so doing, were part of this national dialogue.

As an innovative art form that challenged traditional assumptions about art making and artistic models, Environmental art clearly had an avant-garde, progressive dimension. It is discussed here with the more populist art movements such as Pop and Superrealism, however, because these artists insisted on moving art out of the rarefied atmosphere of museums and galleries and into the public sphere. Most Environmental artists encouraged spectator interaction with the works. Environmental artists such as Christo and Jeanne-Claude, whose work matured in the context of Nouveau Réalisme, a European version of Pop art, made audience participation an integral part of their works. Thus these artists, like the Pop artists and Superrealists, intended their works to connect with a larger public. Ironically, the remote locations of many earthworks have limited public access.

THE ENDURING POWER OF NATURE A leading American Environmental artist was ROBERT SMITHSON (1938–1973), who used industrial construction equipment to manipulate vast quantities of earth and rock on isolated sites. One of Smithson's best-known pieces is *Spiral Jetty* (FIG. **34-37**), a mammoth coil of black basalt, limestone rocks, and earth that extends out into the Great Salt Lake in Utah. Driving by the lake one day, Smithson came across some abandoned mining equipment, left there by a company that had tried and failed to extract oil from the site. Smithson saw this as a testament to the enduring power of nature and to humankind's inability to conquer nature. He decided to create an artwork in the lake that ultimately became a monumental spiral curving out from the shoreline and running 1,500 linear feet into the water. Smithson insisted on designing his work in response to the location itself; he wanted to avoid the arrogance of an artist merely imposing an unrelated concept on the site. The spiral idea grew from Smithson's first impression of the location:

> As I looked at the site, it reverberated out to the horizons only to suggest an immobile cyclone while flickering light made the entire landscape appear to quake. A dormant earthquake spread into the fluttering stillness, into a spinning sensation without movement. The site was a rotary that enclosed itself in an immense roundness. From that gyrating space emerged the possibility of the Spiral Jetty.[35]

The appropriateness of the spiral forms was reinforced when, while researching the Great Salt Lake, Smithson discovered that the molecular structure of the salt crystals that coat the rocks at the water's edge is spiral in form. Smithson not only recorded *Spiral Jetty* in photographs, but also filmed its construction in a movie that describes the forms and life of the whole site. The photographs and film have become increasingly important, because fluctuations in the Great Salt Lake's water level often place *Spiral Jetty* underwater.

CAPTIVATING ENVIRONMENTAL INTERVENTIONS CHRISTO and JEANNE-CLAUDE (both b. 1935) intensify the viewer's awareness of the space and features of rural and urban sites. However, rather than physically alter the land itself, as Smithson often did, Christo and Jeanne-Claude prompt this awareness by temporarily modifying the landscape with cloth. Their pieces also incorporate the relationships among human sociopolitical action,

34-37 ROBERT SMITHSON, *Spiral Jetty,* 1970. Black rock, salt crystals, earth, red water (algae) at Great Salt Lake, Utah. 1,500′ × 15′ × $3\frac{1}{2}$′. © Estate of Robert Smithson/Licensed by VAGA, New York, New York.

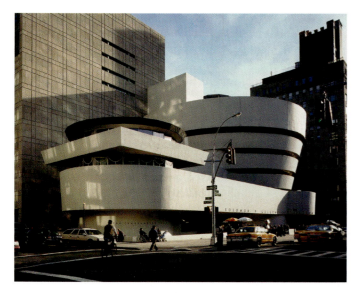

34-40 FRANK LLOYD WRIGHT, Solomon R. Guggenheim Museum (exterior view from the north), New York, 1943–1959.

(FIGS. **34-40** and **34-41**), built in New York City between 1943 and 1959. Using reinforced concrete almost as a sculptor might use resilient clay, Wright designed a structure inspired by the spiral of a snail's shell.

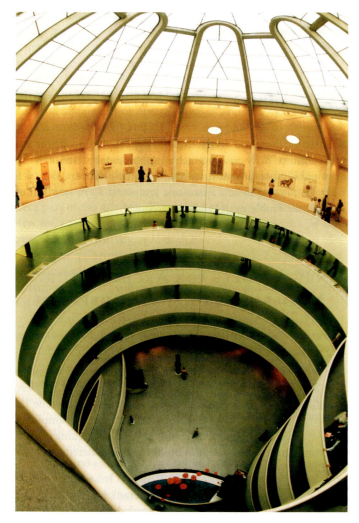

34-41 FRANK LLOYD WRIGHT, Interior of the Solomon R. Guggenheim Museum, New York, 1943–1959.

Wright had introduced curves and circles into some of his plans in the 1930s, and, as the architectural historian Peter Blake noted, "The spiral was the next logical step; it is the circle brought into the third and fourth dimensions."[37] Inside the building (FIG. 34-41), the shape of the shell expands toward the top, and a winding interior ramp spirals to connect the gallery bays, which are illuminated by a skylight strip embedded in the museum's outer wall. Visitors can stroll up the ramp or take an elevator to the top of the building and proceed down the gently inclined walkway, viewing the artworks displayed along the path. Thick walls and the solid organic shape give the building, outside and inside, the sense of turning in on itself. Moreover, the long interior viewing area opening onto a 90-foot central well of space seems a sheltered environment, secure from the bustling city outside.

SCULPTURAL ARCHITECTURE The startling organic forms of Le Corbusier's Notre-Dame-du-Haut (FIGS. **34-42** and **34-43**), completed in 1955 at Ronchamp, France, present viewers with a fusion of architecture and sculpture in a single expression. The architect designed this small chapel on a pilgrimage site in the Vosges Mountains to replace a building destroyed in World War II. The monumental impression of Notre-Dame-du-Haut seen from afar is somewhat deceptive. Although one massive exterior wall contains a pulpit facing a spacious outdoor area for large-scale open-air services on holy days, the interior holds at most 200 people. The intimate scale, stark and heavy walls, and mysterious illumination (jewel tones cast from the deeply recessed stained-glass windows) give this space (FIG. 34-43) an aura reminiscent of a sacred cave or a medieval monastery.

Notre-Dame-du-Haut's structure may look free-form to the untrained eye, but Le Corbusier actually based it, like the medieval cathedral, on an underlying mathematical system. The fabric was formed from a frame of steel and metal mesh, which was sprayed with concrete and painted white, except for two interior private chapel niches with colored walls and the roof, left unpainted to darken naturally with the passage of time. The roof appears to float freely above the sanctuary, intensifying the quality of mystery in the interior space. In reality, the roof is elevated above the walls on a series of nearly invisible blocks. Le Corbusier's preliminary

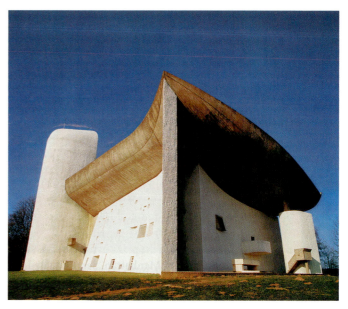

34-42 LE CORBUSIER, Notre-Dame-du-Haut, Ronchamp, France, 1950–1955.

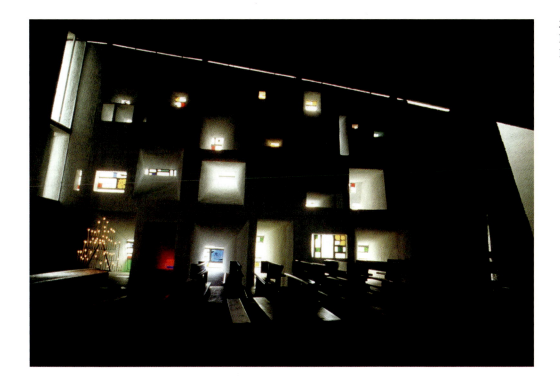

34-43 LE CORBUSIER, Interior of Notre-Dame-du-Haut, Ronchamp, France, 1950–1955.

sketches for the building indicate he linked the design with the shape of praying hands, with the wings of a dove (representing both peace and the Holy Spirit), and with the prow of a ship (a reminder that the Latin word used for the main gathering place in Christian churches is *nave*, meaning "ship"). The artist envisioned that in these powerful sculptural solids and voids, human beings could find new values—new interpretations of their sacred beliefs and of their natural environments.

A METAPHORICAL BUILDING The opera house in Sydney, Australia (FIG. **34-44**), designed by the Danish architect JOERN UTZON (b. 1918) in 1959, is a bold composition of organic forms on a colossal scale. Utzon worked briefly with Frank Lloyd Wright at Taliesin (Wright's Wisconsin residence), and the style of the Sydney Opera House resonates distantly with the graceful curvature of the Guggenheim Museum. Two clusters of immense concrete shells rise from massive platforms and soar to delicate peaks. Utzon was especially taken with the platform architecture of Mesoamerica (see FIG. 14-14). Recalling at first the ogival shapes of Gothic vaults, the shells also suggest both the buoyancy of seabird wings and the sails of the tall ships that brought European settlers to Australia in the 18th and 19th centuries. These architectural metaphors are appropriate to the harbor surrounding Bennelong Point, whose bedrock foundations support the building. Utzon's matching of the structure with its site and atmosphere adds to the organic nature of this construction.

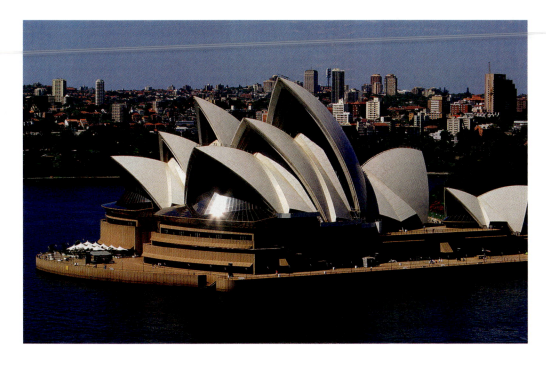

34-44 JOERN UTZON, Sydney Opera House, Sydney, Australia, 1959–1972. Reinforced concrete; height of highest shell, 200′.

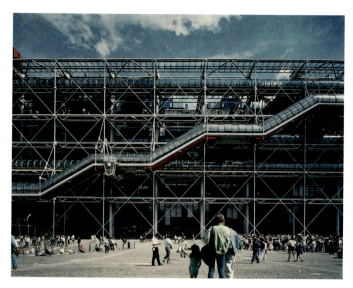

34-52 RICHARD ROGERS and RENZO PIANO, Georges Pompidou National Center of Art and Culture (the "Beaubourg"), Paris, 1977.

MAKING "METABOLISM" VISIBLE In Paris, the short-lived partnership of British architect RICHARD ROGERS (b. 1933) and Italian architect RENZO PIANO (b. 1937) involved using motifs and techniques from ordinary industrial buildings in their design for the Georges Pompidou National Center of Art and Culture, known popularly as the "Beaubourg" (FIG. **34-52**), in Paris. The anatomy of this six-level building, which opened in 1977, is fully exposed, rather like an updated version of the Crystal Palace (see FIG. 28-62). However, the architects also made visible the Pompidou Center's "metabolism." They color-coded pipes, ducts, tubes, and corridors according to function (red for the movement of people, green for water, blue for air-conditioning, and yellow for electricity), much as in a sophisticated factory.

Critics who deplore the Beaubourg's vernacular qualities disparagingly refer to the complex as a "cultural supermarket" and point out that its exposed entrails require excessive maintenance to protect them from the elements. Nevertheless, the building has been popular with visitors since it opened. The flexible interior spaces and the colorful structural body provide a festive environment for the crowds flowing through the building and enjoying its art galleries, industrial design center, library, science and music centers, conference rooms, research and archival facilities, movie theaters, rest areas, and restaurant (which looks down and through the building to the terraces outside). The sloping plaza in front of the main entrance has become part of the local scene. Peddlers, street performers, Parisians, and tourists fill this square at almost all hours of the day and night. The kind of secular activity that once occurred in the open spaces in front of cathedral entrances interestingly now takes place next to a center for culture and popular entertainment—perhaps today's most commonly shared experiences.

Deconstructivist Architecture

In the later decades of the 20th century, art critics (such as Clement Greenberg and Harold Rosenberg) assumed a commanding role. Indeed, their categorization of movements and their interpretation and evaluation of monuments became a kind of monitoring, gatekeeping activity that determined, as well as described, what was going on in the art world. The voluminous

and influential writing these critics (along with artists and art historians) produced prompted scholars to examine the basic premises of criticism. This examination has generated a field of study known as critical theory. Critical theorists view art and architecture, as well as literature and the other humanities, as a culture's intellectual products or "constructs." These constructs unconsciously suppress or conceal the actual premises that inform the culture, primarily the values of those politically in control. Thus, cultural products function in an ideological capacity, obscuring, for example, racist or sexist attitudes. When revealed by analysis, the facts behind these constructs, according to critical theorists, contribute to a more substantial understanding of artworks, buildings, books, and the overall culture.

As straightforward as such analysis may seem, it is actually exceedingly challenging, and such undertakings often reveal contradictions rather than provide seamless resolution. Many critical theorists use an analytical strategy called *deconstruction,* after a method developed by French intellectuals, notably Michel Foucault and Jacques Derrida, in the 1960s and 1970s. For those employing deconstruction, all cultural constructs are "texts." Acknowledging the lack of fixed or uniform meanings in such texts, critical theorists accept a variety of interpretations as valid. Further, as cultural products, how texts signify and what they signify are entirely conventional. They can refer to nothing outside of themselves, only to other texts. Thus, no extratextual reality exists that people can reference. The enterprise of deconstruction is to reveal the contradictions and instabilities of these texts, or cultural language (written or visual).

With primarily political and social aims, deconstructive analysis has the ultimate goal of effecting political and social change. Accordingly, critical theorists who employ this approach seek to uncover, to deconstruct, the facts of power, privilege, and prejudice underlying the practices and institutions of any given culture. In so doing, deconstruction reveals the precariousness of structures and systems, such as language and cultural practices, along with the assumptions underlying them. Yet because of the lack of fixed meaning in texts, many politically committed thinkers assert that deconstruction does not provide a sufficiently stable basis for dissent.

Critical theorists are not unified about any philosophy or analytical method, because in principle they oppose firm definitions. They do share a healthy suspicion of all traditional truth claims and value standards, all hierarchical authority and institutions. For them, deconstruction means destabilizing established meanings, definitions, and interpretations while encouraging subjectivity and individual differences.

In architecture, deconstruction as an analytical strategy emerged in the 1970s (some scholars refer to this development as *Deconstructivist architecture*). It proposes, above all, to disorient the observer. To this end, Deconstructivist architects attempt to disrupt the conventional categories of architecture and to rupture the viewer's expectations based on them. Destabilization plays a major role in Deconstructivist architecture. Disorder, dissonance, imbalance, asymmetry, unconformity, and irregularity replace their opposites—order, consistency, balance, symmetry, regularity, and clarity, as well as harmony, continuity, and completeness. The haphazard presentation of volumes, masses, planes, borders, lighting, locations, directions, spatial relations, as well as the disguised structural facts, challenge the viewer's assumptions about architectural form as it relates to function. According to Deconstructivist principles, the very absence of the stability of traditional categories of architecture in a structure announces a "deconstructed" building.

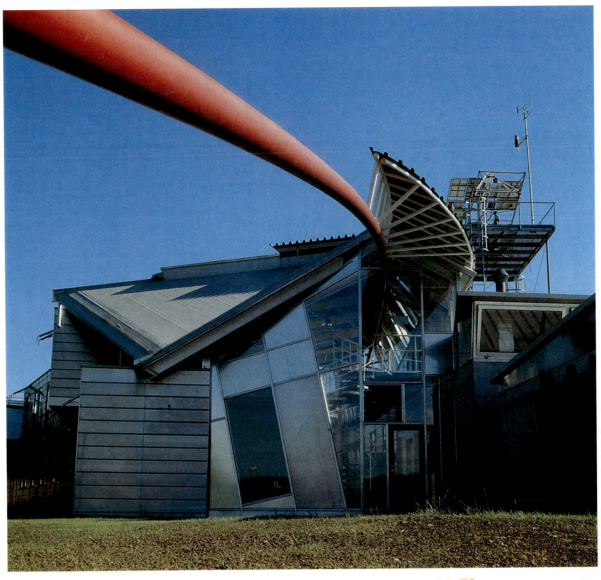

34-53 GÜNTER BEHNISCH, Hysolar Institute Building, University of Stuttgart, Stuttgart, Germany, 1987.

AN ARCHITECTURE OF CHAOS Audacious in its dissolution of form, and well along on the path of deconstruction, is a building in Stuttgart, the Hysolar Institute Building at the University of Stuttgart (FIG. 34-53). GÜNTER BEHNISCH (b. 1922) designed it as part of a joint German–Saudi Arabian research project on the technology of solar energy. The architect intended to deny here the possibility of spatial enclosure altogether, and his apparently chaotic arrangement of the units defies easy analysis. The shapes of the Hysolar Institute's roof, walls, and windows seem to explode, avoiding any suggestion of clear, stable masses. Behnisch aggressively played with the whole concept of architecture and the viewer's relationship to it. The disordered architectural elements that seem precariously perched and visually threaten to collapse frustrate the observer's expectations of buildings.

DISORDER AND DISEQUILIBRIUM The architect whom scholars perhaps have most identified with Deconstructivist architecture is the Canadian-born FRANK GEHRY (b. 1929). Trained in sculpture, and at different times a collaborator with Claes Oldenburg and Donald Judd, Gehry works up his designs by constructing models and then cutting them up and arranging them until he has a satisfying composition. Among Gehry's most notable projects is the Guggenheim Museum (FIG. 34-54) in Bilbao,

Spain. The immensely dramatic building appears as a mass of asymmetrical and imbalanced forms, and the irregularity of the main masses—whose profiles change dramatically with every shift of a visitor's position—seems like a collapsed or collapsing aggregate of units. The scaled limestone- and titanium-clad exterior lends a space-age character to the building and highlights further the unique cluster effect of the many forms. A group of organic forms that Gehry refers to as a "metallic flower" tops the museum. Gehry was inspired to create the offbeat design by what he called the "surprising hardness" of the heavily industrialized city of Bilbao. His fascination with Fritz Lang's 1926 film *Metropolis* also contributed to this industrial severity. The film, now considered a classic by film historians, reveals a futuristic urban vision of a cold, mechanical industrial world in 2026. In the center of the museum, an enormous glass-walled atrium soars to 165 feet in height, serving as the focal point for the three levels of galleries (see FIG. Intro-1) radiating from it. The seemingly weightless screens, vaults, and volumes of the interior float and flow into one another, guided only by light and dark cues. Overall, the Guggenheim in Bilbao is a profoundly compelling structure. Its disorder, its seeming randomness of design, and the disequilibrium it prompts in viewers fit nicely into postmodern and Deconstructivist agendas.

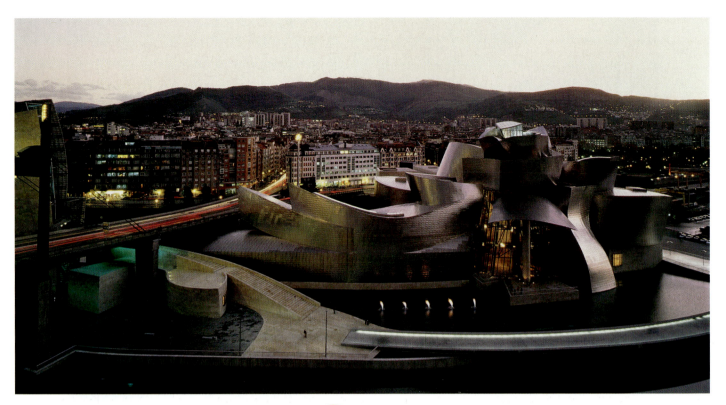

34-54 Frank Gehry, Guggenheim Bilbao Museo, Spain, 1997.

Postmodernism in Painting, Sculpture, and New Media

The challenges to modernist doctrine that emerged in architecture have their own resolutions in other artistic media. As with architecture, arriving at a concrete definition of postmodernism in other media is difficult. Historically, by the 1970s, the range of art—from abstraction to performance to figuration—was so broad that the inclusiveness central to postmodern architecture characterizes postmodern art as well. Just as postmodern architects incorporate traditional elements or historical references, many postmodern artists reveal a self-consciousness about their place in the historical continuum of art. They resurrect artistic traditions to comment on and reinterpret those styles or idioms. Writings about postmodern art refer to Neo-Minimalism, Neo-Pop, and Neo-Romanticism, among others, evidencing the prevalence of this reevaluation of earlier art forms.

Beyond that, however, artists, critics, dealers, and art historians do not agree on the elements comprising the vague realm of postmodern art. Many people view postmodernism as a critique of modernism. For example, numerous postmodern artists have undertaken the task of challenging modernist principles such as the avant-garde's claim to originality. In avant-garde artists' zeal to undermine traditional notions about art and to produce ever more innovative art forms, they placed a premium on originality and creativity. Postmodern artists challenge this claim by addressing issues of the copy or reproduction (already explored by the Pop artists) and the appropriation of images or ideas from others.

Other scholars, such as Frederic Jameson, assert that a major characteristic of postmodernism is the erosion of the boundaries between high culture and popular culture—a separation Clement Greenberg and the modernists had staunchly defended. With the appearance of Pop art, that separation became more difficult to maintain. Jameson argues that the intersection of high and mass culture is, in fact, a defining feature of the new postmodernism. He attributes the emergence of postmodernism to "a new type of social life and a new economic order—what is often euphemistically called modernization, postindustrial or consumer society, the society of the media or the spectacle, or multinational capitalism."[39]

Further, the intellectual inquiries of critical theorists serving as the basis for Deconstructivist architecture also impacted the other media. For many recent artists, postmodernism involves examining the process by which meaning is generated and the negotiation or dialogue that transpires between viewers and artworks. Like the theorists using deconstructive methods to analyze "texts," or cultural products, many postmodern artists reject the notion that each artwork contains a single fixed meaning. Their work, in part, explores how viewers derive meaning from visual material.

Postmodern art, then, comprises a dizzying array of artworks. While some involve critiques of the modernist program, others present critiques of the art world, and still others incorporate elements of and provide commentary on previous art. A sampling of postmodern art in various media follows.

New Expressionist Explorations

One of the first coherent movements to emerge during the postmodern era was *Neo-Expressionism*. This movement's name reflects postmodern artists' interest in reexamining earlier art production and connects this art to the powerful, intense works of the German Expressionists (see Chapter 33, page 966) and the Abstract Expressionists, among other artists.

EXTENDING PAINT'S PHYSICALITY The art of American artist Julian Schnabel (b. 1951), in effect, forcefully restates the premises of Abstract Expressionism. When executing his works in the 1980s, however, Schnabel experimented widely with materials and supports—from fragmented china plates bonded to wood, to paint on velvet and tarpaulin. He was particularly interested in

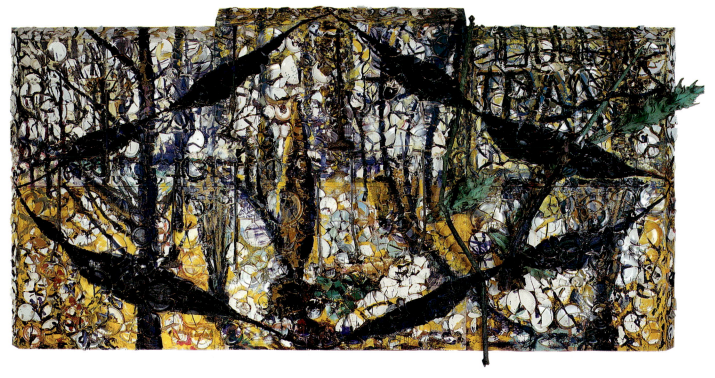

34-55 Julian Schnabel, *The Walk Home*, 1984–1985. Oil, plates, copper, bronze, fiberglass, and Bondo on wood, 9′ 3″ × 19′ 4″. Broad Art Foundation and the Pace Gallery, New York.

the physicality of the objects, and by attaching broken crockery, as evident in *The Walk Home* (FIG. **34-55**), he found an extension of what paint could do. Superficially, the painting recalls the work of the gestural abstractionists—the spontaneous drips of Jackson Pollock (FIG. 34-4) and the energetic brush strokes of Willem de Kooning (FIG. 34-6). The large scale of Schnabel's works is also reminiscent of Abstract Expressionism. The thick, mosaiclike texture, an amalgamation of media, brings together painting, mosaic, and low-relief sculpture. In effect, Schnabel reclaimed older media for his expressionistic method, which considerably amplifies his bold and distinctive statement.

HORSES AS METAPHORS In the 1970s, American Susan Rothenberg (b. 1945) produced a major series of large paintings with the horse as the central image. The horse theme resonates with history and metaphor—from Roman equestrian sculpture to the paintings of German Expressionist Franz Marc. Like Marc, Rothenberg saw horses as metaphors for humanity. She stated, "The horse was a way of not doing people, yet it was a symbol of people, a self-portrait, really."[40] Rothenberg, however, distilled the image down to a ghostly outline or hazy depiction that is more poetic than descriptive. As such, her works fall in the nebulous area between representation and abstraction. In paintings such as *Tattoo* (FIG. **34-56**), the loose brushwork and agitated surface contribute to the expressiveness of the image and account for Rothenberg's categorization as a Neo-Expressionist. The title, *Tattoo,* refers to the horse's head drawn within the outline of its leg—"a tattoo or memory image," according to the artist.[41]

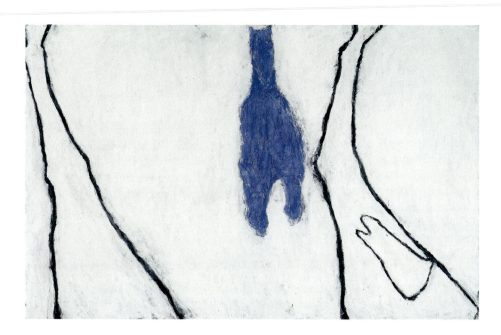

34-56 Susan Rothenberg, *Tattoo*, 1979. Acrylic, flashe on canvas, 5′ 7″ × 8′ 7″. Collection Walker Art Center, Minneapolis (purchased with the aid of funds from Mr. and Mrs. Edmond R. Ruben, Mr. and Mrs. Julius E. Davis, the Art Center Acquisition Fund, and the National Endowment for the Arts, 1979).

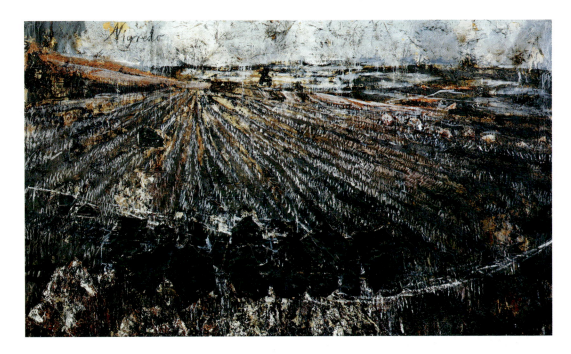

34-57 Anselm Kiefer, *Nigredo*, 1984. Oil paint on photosensitized fabric, acrylic emulsion, straw, shellac, relief paint on paper pulled from painted wood, 11′ × 18′. Philadelphia Museum of Art, Philadelphia (gift of Friends of the Philadelphia Museum of Art).

CONFRONTING GERMAN HISTORY Neo-Expressionism was by no means a solely American movement. The number of artists who pursued this direction in their art indicates the compelling nature of this style. German artist ANSELM KIEFER (b. 1945) has produced some of the most lyrical and engaging works of the contemporary period. His paintings, such as *Nigredo* (FIG. **34-57**), are monumental in scale, thereby commanding immediate attention. On further inspection, the works draw the viewer to the textured surface, made more complex by the addition of materials such as straw and lead. Kiefer's paintings, like those of Schnabel, have thickly encrusted surfaces. It is not just the impressive physicality of Kiefer's paintings that accounts for impact of his work, however. His images function on a mythological or metaphorical level, as well as on a historically specific one. Kiefer's works of the 1970s and 1980s often involve a reexamination of German history, particularly the painful Nazi era of 1933–1945, and evoke the feeling of despair. Kiefer believes that Germany's participation in World War II and the Holocaust left permanent scars on the souls of the German people and on the souls of all humanity.

Nigredo (the Latin word for "blackening") pulls the viewer into an expansive landscape depicted using Renaissance perspectival principles. This landscape, however, is far from pastoral or carefully cultivated. Rather, it appears bleak and charred. Although it does not make specific reference to the Holocaust, this incinerated landscape does indirectly allude to the horrors of that historical event. More generally, the blackness of the landscape may refer to the notion of alchemical change or transformation, a concept of great interest to Kiefer. Black is one of the four symbolic colors of the alchemist—a color that refers both to death and to the molten, chaotic state of substances broken down by fire. The alchemist, however, focuses on the transformation of substances, and thus the emphasis on blackness is not absolute, but can also be perceived as part of a process of renewal and redemption. Kiefer thus imbued his work with a deep symbolic meaning that, when combined with the intriguing visual quality of his parched, congealed surfaces, results in paintings of enduring impact.

RE-PRESENTING THE VIRGIN MARY Although not affiliated with the Neo-Expressionists of the 1970s and 1980s, CHRIS OFILI (b. 1968) has produced work that is emphatically expressionistic in nature. In his art, Ofili explores themes such as religion (he was raised as a Catholic), reinterpreted through the eyes of a British-born male of Nigerian descent. Ofili's *The Holy Virgin Mary* (FIG. **34-58**) depicts Mary in a manner that departs

34-58 CHRIS OFILI, *The Holy Virgin Mary,* 1996. Paper collage, oil paint, glitter, polyester resin, map pins, elephant dung on linen, 7′ 11″ × 5′ 11$\frac{5}{16}$″. The Saatchi Collection, London.

Contesting Culture
Controversies in Art

Although there is much in art that inspires and moves us, beauty and uplift are not art's only raisons d'être. Throughout its history, art has also challenged and offended. In recent years, a number of heated controversies about art have surfaced in the United States. That attempts were made in each of these controversies to remove the offending works from public view brought charges of censorship from many outraged art supporters. Ultimately, the question has been raised time and again: Are there limits to what art can appropriately be exhibited, and do authorities (for instance, the federal government) have the right to monitor and pass judgment on creative endeavors? Further, should the acceptability of art be a criterion in determining the federal funding of art?

Two exhibits in 1989 placed the National Endowment for the Arts (NEA), a federal agency charged with supporting the arts (particularly through the distribution of federal funds), squarely in the hot seat of this debate. One of the exhibitions, which was devoted to recipients of the Awards for the Visual Arts (AVA), was held at the Southeastern Center for Contemporary Art in North Carolina. Among the award winners was Andres Serrano, whose *Piss Christ,* a photograph of a crucifix submerged in urine, sparked an uproar. Responding to this artwork, Reverend Donald Wildmon, an evangelical minister from Mississippi and head of the American Family Association, was outraged both that such a work was being exhibited and that the exhibition was funded by the NEA and the Equitable Life Assurance Society (a sponsor of the AVA). He demanded that the work be removed and launched a letter-writing campaign that led Equitable Life to cancel its sponsorship of the awards. To Wildmon and other staunch conservatives, this exhibition, along with the *Robert Mapplethorpe: The Perfect Moment* show, served as evidence of cultural depravity and immorality, which they insisted should not be funded by government agencies such as the NEA. Mapplethorpe was a photographer well known for his elegant, spare photographs of flowers and vegetables as well as his erotic, homosexually oriented images. As a result of media furor over *The Perfect Moment,* the director of the Corcoran Museum of Art decided to cancel the scheduled exhibition of this traveling show. This led to charges of censorship; the real showdown, however, came in Cincinnati, where the director of the Contemporary Arts Center decided to mount the show and was indicted on charges of obscenity; he and the center were acquitted six months later.

These controversies intensified public criticism of the NEA and its funding practices. The following year, in 1990, the head of the NEA, John Frohnmayer, vetoed grants for four lesbian, gay, or feminist performance artists—Karen Finley, John Fleck, Holly Hughes, and Tim Miller—who became known as the "NEA Four." Infuriated by what they perceived as overt censorship, the artists filed suit, eventually settling the case and winning reinstatement of their grants.

As a result of these incidents, however, the funding and future of the NEA have become more precarious. Congress has dramatically reduced its budget, and it no longer awards grants or fellowships to individual artists.

In more recent years, controversies have continued to surface. In 1999, a furor erupted over the exhibition *Sensation: Young British Artists from the Saatchi Collection.* Led by Rudy Giuliani, the mayor of New York at that time, a number of individuals and groups expressed their outrage over artworks, especially Chris Ofili's *The Holy Virgin Mary* (FIG. 34-58), a collage of Mary incorporating cutouts from pornographic magazines and shellacked clumps of elephant dung. Denouncing the show as "sick stuff," the mayor threatened to cut off all city subsidies to the Brooklyn Museum, where *Sensation* was on view. Such oratory polarized the community and no doubt fueled interest in the show (and in Ofili's work in particular).

Art that seeks to unsettle and challenge is critical to the cultural, political, and psychological life of a society. The regularity with which such art raises controversy suggests that it operates at the intersection of two competing principles: free speech and artistic expression on the one hand and a reluctance to impose images upon an audience that finds them repugnant or offensive on the other. What these controversies do demonstrate, beyond doubt, is the impact and power of art.

radically from staid, conventional Renaissance representations (see FIGS. 19-6, 19-7, 19-10, and 20-11). Ofili's work presents the Virgin in simplified form, and she appears to float in an indeterminate space. The artist employed brightly colored pigments, applied to the canvas in multiple layers of beadlike dots (inspired by images from ancient caves in Zimbabwe). The Virgin Mary is surrounded by tiny images of genitalia and buttocks cut out from pornographic magazines, which, to the artist, parallel the putti that often surround Mary in Renaissance paintings. Another reference to Ofili's African heritage surfaces in the clumps of elephant dung—one attached to the Virgin's breast, and two more on which the canvas rests, serving as supports. The dung allowed Ofili to incorporate Africa into his work in a literal way; still, he wants the viewer to move beyond the cultural associations of the materials and see them in new ways.

Not surprisingly, *The Holy Virgin Mary* elicited strong reactions when it was exhibited. Its inclusion in the show *Sensation: Young British Artists from the Saatchi Collection* in Brooklyn, New York, in 1999 prompted indignant demands for cancellation of the show and countercharges of censorship (see "Contesting Culture: Controversies in Art," above).

Art as a Political Weapon

With the renewed interest in representation ushered in by the Pop artists and Superrealists in the 1960s and 1970s, artists once again began to embrace the persuasive powers of art to communicate with a wide audience. In recent decades, artists have investigated more insistently the dynamics of power and privilege,

especially in relation to issues of race, ethnicity, gender, and class. This section introduces artists addressing these issues, beginning with feminism.

In the 1970s, the feminist movement focused public attention on the history of women and their place in society. In art, two women—Judy Chicago and Miriam Schapiro—largely spearheaded the American feminist movement under the auspices of the Feminist Art Program. Chicago and a group of students at California State University, Fresno, founded this program, and Chicago and Schapiro coordinated it at the California Institute of the Arts in Valencia, California. In 1972, as part of this program, teachers and students joined to create projects such as Womanhouse, an abandoned house in Los Angeles they completely converted into a suite of "environments," each based on a different aspect of women's lives and fantasies.

A DINNER PARTY CELEBRATING WOMEN In her own work in the 1970s, JUDY CHICAGO (born Judy Cohen in 1939) wanted to educate viewers about women's role in history and the fine arts. She aimed to establish a respect for women and their art, to forge a new kind of art expressing women's experiences, and to find a way to make that art accessible to a large audience. Inspired early in her career by the work of Barbara Hepworth (see FIG. 33-70), Georgia O'Keeffe (see FIGS. 33-37 and Intro-4), and Louise Nevelson (FIG. 34-17), Chicago developed a personal painting style that consciously included abstract organic vaginal images. In the early 1970s, Chicago began planning an ambitious piece, *The Dinner Party* (FIG. 34-59), using craft techniques (such as china painting and stitchery) traditionally practiced by women, to celebrate the achievements and contributions women made throughout history. She originally conceived the work as a feminist Last Supper attended by 13 women (the "honored guests"). The number 13 also refers to the number of women in a witches' coven. This acknowledges a religion (witchcraft) founded to encourage the worship of a female— the Mother Goddess. In the course of her research, Chicago uncovered so many worthy women that she expanded the number of guests threefold to 39 and placed them around a triangular table 48 feet long on each side. The triangular form refers to the ancient symbol for both woman and the Goddess. The notion of a dinner party also alludes to women's traditional role as homemakers. A team of nearly 400 workers under Chicago's supervision assisted in the creation and assembly of the artwork to her design specifications.

The Dinner Party rests on a white tile floor inscribed with the names of 999 additional women of achievement to signify that

34-59 JUDY CHICAGO, *The Dinner Party*, 1979. Multimedia, including ceramics and stitchery, 48′ × 48′ × 48′ installed.

34-60 Miriam Schapiro, *Anatomy of a Kimono* (section), 1976. Fabric and acrylic on canvas, 6' 8" × 8' 6". Collection of Bruno Bishofberger, Zurich.

the accomplishments of the 39 honored guests rest on a foundation other women laid. Among the "invited" women at the table are O'Keeffe, the Egyptian pharaoh Hatshepsut (see "Hatshepsut: The Woman Who Would Be King," Chapter 3, page 71), the British writer Virginia Woolf, the Native American guide Sacagawea, and the American suffragist Susan B. Anthony. Chicago acknowledged each guest with a place setting of identical eating utensils and a goblet. Each also has a unique oversized porcelain plate and a long place mat or table runner covered with imagery that reflects significant facts about her life and culture. The plates range from simple concave shapes with china-painted imagery to dishes whose sculptured three-dimensional designs almost seem to struggle to free themselves. The unique designs on each plate incorporate both butterfly and vulval motifs—the butterfly as the ancient symbol of liberation and the vulva as the symbol of female sexuality. Each table runner combines traditional needlework techniques, including needlepoint, embroidery, crochet, beading, patchwork, and appliqué.

The rigorous arrangement of *The Dinner Party* and its sacramental qualities draw visitors in and let them experience the importance of forgotten details in the history of women. While the individual place settings with their carefully constructed tributes to the 39 women are impressive, the entire work—both in conception and presentation—provides viewers with a powerful launching point for considering feminist concerns. This work was exhibited in the United States, Canada, Australia, and Europe for nearly a decade after its completion. It has recently found a permanent home; it will go on view as part of the Brooklyn Museum's collection in 2004.

"FEMMAGE" AND COLLAGE Pursuing a somewhat different path than the one Chicago undertook, Miriam Schapiro (b. 1923) has tried in her work since the 1970s to rouse viewers to a new appreciation of the beauty in materials and techniques that women artists used throughout history. Schapiro enjoyed a thriving career as a hard-edge painter when she moved to California in the late 1960s and became fascinated with the hidden metaphors for womanhood she then saw in her abstract paintings. Intrigued by the materials she had used to create a doll's house for her part in Womanhouse, Schapiro began to make huge sewn collages, assembled from fabrics, quilts, buttons, sequins, lace trim, and rickrack collected at antique shows and fairs. She called these works

"femmages" to make the point that women had been doing so-called collages long before Pablo Picasso introduced them to the art world. *Anatomy of a Kimono* (FIG. **34-60**) is one of a series of monumental femmages based on the patterns of Japanese kimonos, fans, and robes. This vast composition repeats the kimono shape in a sumptuous array of fabric fragments.

CHALLENGING THE "MALE GAZE" Early attempts at dealing with feminist issues in art tended toward essentialism, emphasizing universal differences—either biological or experiential—between women and men. More recent discussions have gravitated toward the notion of gender as a socially constructed concept, and an extremely unstable one at that. Identity is multifaceted and changeable, making the discussion of feminist issues more challenging. Consideration of the many variables, however, results in a more complex understanding of gender roles. American artist Cindy Sherman (b. 1954) addresses in her work the way much of Western art has been constructed to present female beauty for the enjoyment of the "male gaze," a primary focus of contemporary feminist theory. She produced a series of more than 80 black-and-white photographs titled *Untitled Film Stills,* which she began in 1977. Sherman considered how representation constructs reality, and this led her to rethink how her own image was conveyed. She got the idea for the *Untitled Film Stills* series when she was shown some soft-core pornography magazines and was struck by the stereotypical ways they depicted women. Sherman decided to produce her own series of photographs, designing, acting in, directing, and photographing the works. In so doing, she took control of her own image and constructed her own identity. In works from the series, such as *Untitled Film Still #35* (FIG. **34-61**), Sherman appears, often in costume and wig, in a photograph that seems to be a film still. Most of the images in this series recall popular film genres but are sufficiently generic so that the viewer cannot relate them to specific movies. Sherman often reveals the constructed nature of these images with the shutter release cable she holds in her hand to take the pictures. (The cord runs across the floor in our illustration.) Although she is still the object of the viewer's gaze in these images, the identity is one she has chosen to assume.

TEXT AND IMAGE Another artist who has also explored the male gaze and the culturally constructed notion of gender in her art is Barbara Kruger (b. 1945), whose best-known subject has been her exploration of the strategies and techniques of contemporary

In these 10 black-and-white photographs documenting a performance, Wilke appears topless in a variety of poses, some seductive and others more confrontational. In each, her body is decorated with pieces of chewed gum shaped into small vulvas. While these tiny vaginal sculptures allude to female pleasure, they also appear as scars, suggesting pain. Ultimately, Wilke hoped that women would "take control of and have pride in the sensuality of their own bodies and create a sexuality in their own terms, without deferring to concepts degenerated by culture."[44]

WHO CONTROLS THE BODY? As we have seen thus far, much of the art dealing with gender issues focuses on the objectification of women and, in particular, of the human body. American KIKI SMITH (b. 1954), for example, is very interested in the issue of who controls the body. Her early work consisted of sculptures referring to bodily organs and bodily fluids. This seemingly clinical approach was due, in part, to Smith's training as an Emergency Medical Service technician in New York. Smith, however, also wants to reveal the socially constructed nature of the body, and, in her more recent art, she encourages the viewer to consider how external forces shape people's perceptions of their bodies. In works such as *Untitled* (FIG. **34-65**), the artist

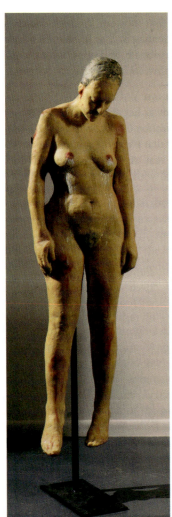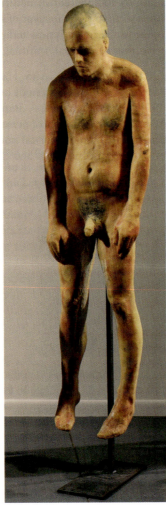

34-65 KIKI SMITH, *Untitled,* 1990. Beeswax and microcrystalline wax figures on metal stands, female figure installed height 6′ 1½″ and male figure installed height 6′ 4¹⁵⁄₁₆″. Collection of Whitney Museum of American Art, New York (purchase with funds from the Painting and Sculpture Committee).

presents the viewer with depictions of the body that dramatically depart from conventional representations of the body, both in art and in the media. *Untitled* consists of two life-size wax figures, one male and one female. Both are nude and appear suspended from metal stands. Smith marked each of the sculptures with long white drips—bodily fluids running from the woman's breasts and down the man's leg. She commented:

> Most of the functions of the body are hidden . . . from society. . . . [W]e separate our bodies from our lives. But, when people are dying, they are losing control of their bodies. That loss of function can seem humiliating and frightening. But, on the other hand, you can look at it as a kind of liberation of the body. It seems like a nice metaphor—a way to think about the social—that people lose control despite the many agendas of different ideologies in society, which are trying to control the body(ies) . . . medicine, religion, law, etc. Just thinking about control—who has control of the body? . . . Does the mind have control of the body? Does the social?[45]

BOTH PERSONAL AND POLITICAL Faith Ringgold and Adrian Piper both use their art to explore issues associated with being African American women in contemporary America. Inspired by the civil rights movement, FAITH RINGGOLD (b. 1930) produced numerous works in the 1960s that provided pointed and incisive commentary on the realities of racial prejudice. She increasingly incorporated references to gender as well and, in the 1970s, turned to fabric as the predominant material in her art. Using fabric allowed her to make more specific reference to the domestic sphere, traditionally associated with women, and to collaborate with her mother, Willi Posey, a fashion designer. After her mother's death in 1981, Ringgold created *Who's Afraid of Aunt Jemima?* (FIG. **34-66**), a quilt composed of dyed, painted, and pieced fabric. A moving tribute to her mother, this work combines the personal and the political. The quilt includes a narrative—the witty story of the family of Aunt Jemima, most familiar as the stereotypical black "mammy" but here a successful African American businesswoman. Ringgold conveyed this narrative through both a text, written in black dialect, and embroidered portraits, all interspersed with traditional patterned squares. This work, while resonating with personal, autobiographical references, also speaks to the larger issues of the history of African American culture and the struggles of women to overcome oppression.

COMBATING RACISM ADRIAN PIPER (b. 1948) is committed to using her art to effect social change—in particular, to combat pervasive racism. Appropriately, her art, such as the installation *Cornered* (FIG. **34-67**), is provocative and confrontational. This piece included a video monitor placed behind an overturned table. Piper appeared on the video monitor, literally cornered behind the table, as she spoke to viewers. Her comments sprang from her experiences as a light-skinned African American woman and from her belief that although overt racism had diminished, subtle and equally damaging forms of bigotry were still rampant. "I'm black," she announces on the 16-minute videotape. "Now let's deal with this social fact and the fact of my stating it together. . . . If you feel that my letting people know that I'm not white is making an unnecessary fuss, you must feel that the right and proper course of action for me to take is to pass for white. Now this kind of thinking presupposes a belief that it's inherently better to be identified as white," she continues. The directness of Piper's art forces viewers to examine their own behaviors and values.

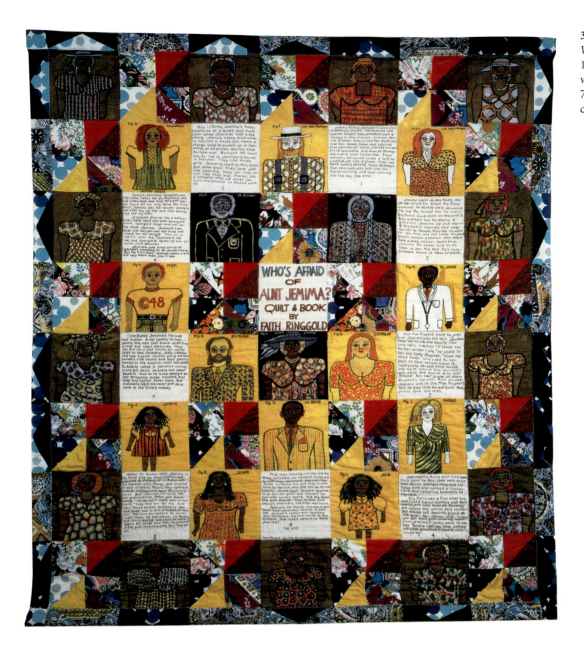

34-66 FAITH RINGGOLD, *Who's Afraid of Aunt Jemima?* 1983. Acrylic on canvas with fabric borders, quilted, 7′ 6″ × 6′ 8″. Private collection.

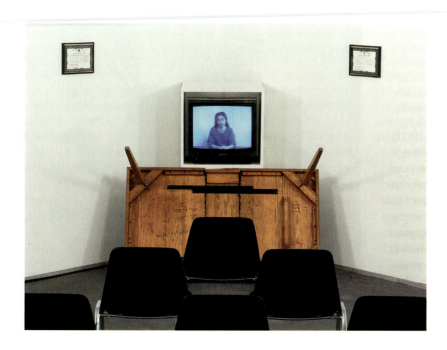

34-67 ADRIAN PIPER, *Cornered,* 1988. Mixed-media installation of variable size; video monitor, table, and birth certificates. Collection of Museum of Contemporary Art, Chicago.

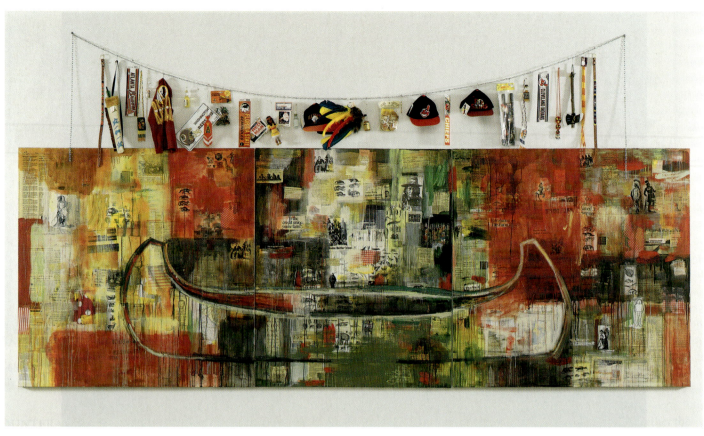

34-71 Jaune Quick-to-See Smith, *Trade (Gifts for Trading Land with White People),* 1992. Oil and mixed media on canvas, 5′ × 14′ 2″. Chrysler Museum of Art, Norfolk, Virginia (museum purchase 93.2).

FIG. **34-71**, is a large-scale painting with collage elements and attached objects, reminiscent of a Rauschenberg combine (FIG. 34-29). The painting's central image, a canoe, appears in an expansive field painted in loose Abstract Expressionist fashion and covered with clippings from Native American newspapers. Above the painting, as if hung from a clothesline, is an array of objects. These include Native American artifacts, such as beaded belts and feather headdresses, and contemporary sports memorabilia from teams with American Indian–derived names—the Cleveland Indians, Atlanta Braves, and Washington Redskins. The inclusion of these contemporary objects immediately recalls the vocal opposition to such names and to acts such as the Braves' "tomahawk chop." Like Edwards, Quick-to-See Smith uses the past—cultural heritage and historical references—to comment on the present.

BRUTAL VISIONS OF VIOLENT TIMES Other artists have used their art to speak out about pressing social and political issues, sometimes in universal terms and other times with searing specificity. In his art, American artist LEON GOLUB (b. 1923) has expressed a seemingly brutal vision of contemporary life through a sophisticated reading of the news media's raw data. The work he is best known for deals with violent events of recent decades—the narratives people have learned to extract from news photos of anonymous characters participating in atrocious street violence, terrorism, and torture. Paintings in Golub's *Assassins* and *Mercenaries* series suggest not specific stories but a condition of being. As the artist said,

> Through media we are under constant, invasive bombardment of images—from all over—and we often have to take evasive action

to avoid discomforting recognitions. . . . The work [of art] should have an edge, veering between what is visually and cognitively acceptable and what might stretch these limits as we encounter or try to visualize the real products of the uses of power.[50]

Mercenaries (IV), FIG. **34-72**, a huge canvas, represents a mysterious tableau of five mercenaries (tough freelance military professionals willing to fight, for a price, for any political cause). The three clustering at the right side of the canvas react with tense physical gestures to something one of the two other mercenaries standing at the far left is saying. The dark uniforms and skin tones of the four black fighters flatten their figures and make them stand out against the searing dark red background. The slightly modulated background seems to push their forms forward up against the picture plane and becomes an echoing void in the space between the two groups. The menacing figures loom over viewers standing in front of the work. Golub painted the mercenaries so that the viewer's eye is level with the mercenaries' knees, placing the men so close to the front plane of the work that their feet are cut off by the lower edge of the painting, thereby trapping the viewer with them in the painting's compressed space. Golub emphasized both the scarred light tones of the white mercenary's skin and the weapons. Modeled with shadow and gleaming highlights, the guns contrast with the harshly scraped, flattened surfaces of the figures. The rawness of the canvas reinforces the rawness of the imagery. Golub often dissolved certain areas with solvent after applying pigment and scraped off applied paint with, among other tools, a meat cleaver. The feeling of peril confronts viewers mercilessly. They become one with all the victims caught in today's political battles.

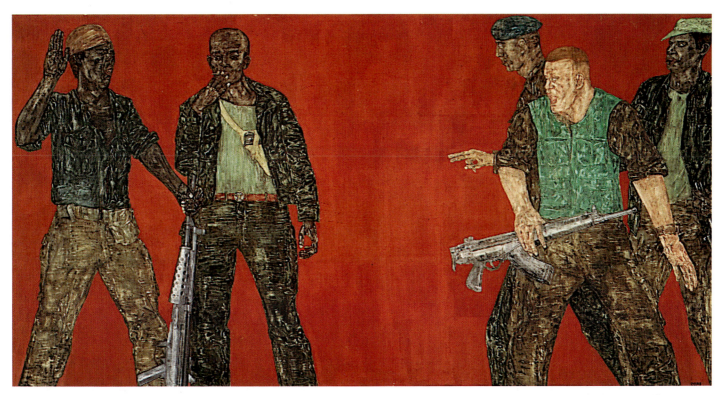

34-72 Leon Golub, *Mercenaries (IV)*, 1980. Acrylic on linen, 10′ × 19′ 2″. Courtesy Ronald Feldman Fine Arts. © Leon Golub/Licensed by VAGA, New York, New York.

FABRIC AS A RECORD OF THE SOUL The stoic, everyday toughness of the human spirit has been the subject of figurative works by the Polish fiber artist Magdalena Abakanowicz (b. 1930). A leader in the recent exploration in sculpture of the expressive powers of weaving techniques, Abakanowicz gained fame with experimental freestanding pieces in both abstract and figurative modes. For Abakanowicz, fiber materials are deeply symbolic: "I see fiber as the basic element constructing the organic world on our planet, as the greatest mystery of our environment. It is from fiber that all living organisms are built—the tissues of plants and ourselves. . . . Fabric is our covering and our attire. Made with our hands, it is a record of our souls."[51]

To all of her work, this artist brought the experiences of her early life as a member of an aristocratic family disturbed by the dislocations of World War II and its aftermath. Initially attracted to weaving as a medium that would adapt well to the small studio space she had available, Abakanowicz gradually developed huge abstract hangings she called Abakans that suggest organic spaces as well as giant pieces of clothing. She returned to a smaller scale with works based on human forms—*Heads, Seated Figures,* and *Back*s—multiplying each type for exhibition in groups as symbols for the individual in society lost in the crowd yet retaining some distinctiveness. This impression is especially powerful in an installation of *Backs* (FIG. **34-73**). Abakanowicz made each piece by pressing layers of natural organic fibers into a plaster mold. Every sculpture depicts the slumping shoulders, back, and arms of a figure of indeterminate sex and rests legless directly on the floor. The repeated pose of the figures in *Backs* suggests meditation, submission, and anticipation. Although made from a single mold, the figures achieve a touching sense of individuality because each assumed a slightly different posture as the material dried and because the artist imprinted a different pattern of fiber texture on each.

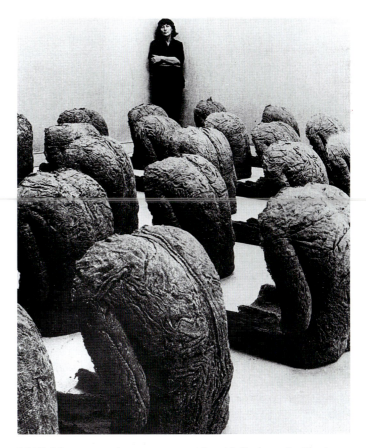

34-73 Magdalena Abakanowicz, artist with *Backs,* at the Musée d'Art Moderne de la Ville de Paris, Paris, France, 1982. Copyright © Magdalena Abakanowicz/Licensed by VAGA, New York, N.Y./ Marlborough Gallery, New York.

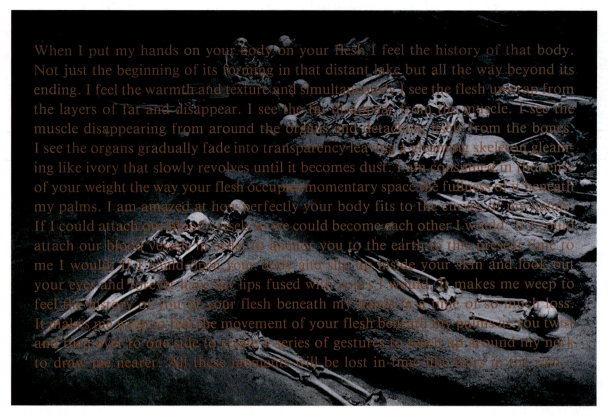

When I put my hands on your body on your flesh I feel the history of that body. Not just the beginning of its forming in that distant lake but all the way beyond its ending. I feel the warmth and texture and simultaneously I see the flesh unwrap from the layers of fat and disappear. I see the fat disappear from the muscle. I see the muscle disappearing from around the organs and detaching itself from the bones. I see the organs gradually fade into transparency leaving a gleaming skeleton gleaming like ivory that slowly revolves until it becomes dust. I am consumed in the sense of your weight the way your flesh occupies momentary space the fullness of it beneath my palms. I am amazed at how perfectly your body fits to the curves of my hands. If I could attach our blood vessels so we could become each other I would. If I could attach our blood vessels in order to anchor you to the earth to this present time to me I would. If I could open up your body and slip up inside your skin and look out your eyes and forever have my lips fused with yours I would. It makes me weep to feel the history of you of your flesh beneath my hands in a time of so much loss. It makes me weep to feel the movement of your flesh beneath my palms as you twist and turn over to one side to create a series of gestures to reach up around my neck to draw me nearer. All these moments will be lost in time like tears in the rain.

34-74 DAVID WOJNAROWICZ, *"When I put my hands on your body,"* 1990. Gelatin-silver print and silk-screened text on museum board, 2′ 2″ × 3′ 2″.

DEALING WITH AIDS DAVID WOJNAROWICZ (1955–1992) devoted the latter part of his artistic career to producing images dealing with issues of homophobia and acquired immune deficiency syndrome (AIDS). As a gay activist and as someone who had seen many friends die of AIDS, Wojnarowicz created disturbing yet eloquent works about the tragedy of this disease, such as *"When I put my hands on your body"* (FIG. **34-74**). In this image, the artist overlaid a photograph of a pile of skeletal remains with evenly spaced typed commentary that communicates his feelings about watching a loved one dying of AIDS. He movingly describes the effects of AIDS on the human body and soul. Wojnarowicz juxtaposed text with imagery, which, like the works of Barbara Kruger (FIG. 34-62) and Lorna Simpson (FIG. 34-68), paralleled the use of both words and images in advertising. The public's familiarity with this format ensured greater receptivity to the artist's message. Wojnarowicz's career was cut short when he also died of AIDS in 1992.

EXPOSING THE NEXUS OF POWER When working in Canada in 1980, Polish-born artist KRZYSZTOF WODICZKO (b. 1943) developed artworks involving outdoor slide images. He projected photographs on specific buildings to expose how civic buildings embody, legitimize, and perpetuate power. When Wodiczko moved to New York City in 1983, the pervasive homelessness troubled him, and he resolved to use his art to publicize this problem. In 1987, he produced *The Homeless Projection* (FIG. **34-75**) as part of a New Year's celebration in Boston. The artist projected images of homeless people on all four sides of the Soldiers' and Sailors' Civil War Memorial on the Boston Common. In these photos, plastic bags filled with their possessions flanked those depicted. At the top of the monument, Wodiczko projected a local condominium construction site, which helped viewers make a connection between urban development and homelessness.

New Technologies: Video and Digital Imagery

Initially, video was available only in commercial television studios and was only occasionally accessible to artists. In the 1960s, with the development of relatively inexpensive portable video recording equipment and of electronic devices allowing manipulation of recorded video material, artists began to explore in earnest the expressive possibilities of this new medium. In its basic form, video technology involves a special motion-picture camera that captures visible images and translates them into electronic data that can be displayed on a video monitor or television screen. Video pictures resemble photographs in the amount of detail they contain, but, like computer graphics, a video image is displayed as a series of points of light on a grid, giving the impression of soft focus. Viewers looking at television or video art are not aware of the monitor's surface. Instead, fulfilling the Renaissance ideal, they concentrate on the image and look through the glass surface, as through a window, into the "space" beyond. Video images combine the optical realism of photography with the sense that the subjects move in real time in a deep space "inside" the monitor.

FROM VIDEO TO COMPUTER IMAGES When video introduced the possibility of manipulating subjects in real time, artists such as the Korean-born, New York–based videographer NAM JUNE PAIK (b. 1932) were eager to work with the medium. Inspired by the ideas of American composer John Cage and after studying music performance, art history, and Eastern philosophy in Korea and Japan, Paik worked with electronic music in Germany in the late 1950s. He then turned to performances using modified television sets. In 1965, after relocating to New York City, Paik acquired the first inexpensive video recorder sold in Manhattan (the Sony Porta-Pak) and immediately recorded everything he saw out the window of his taxi on the return trip to his studio downtown.

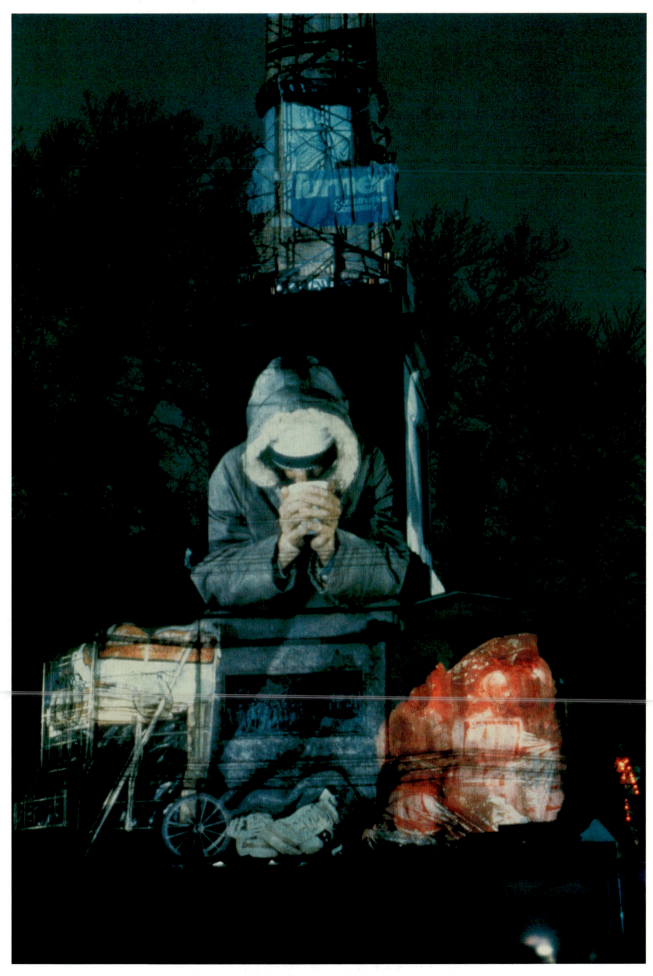

34-75 Krzysztof Wodiczko, *The Homeless Projection*, 1986–1987. Outdoor slide projection at the Soldiers and Sailors Civil War Memorial, Boston, organized by First Night, Boston.

34-76 Nam June Paik, Video still from *Global Groove*, 1973. 3/4″ videotape, color, sound, 30 minutes. Collection of the artist.

Experience acquired as artist-in-residence at television stations WGBH in Boston and WNET in New York allowed him to experiment with the most advanced broadcast video technology.

A grant permitted Paik to collaborate with the gifted Japanese engineer-inventor Shuya Abe in developing a video synthesizer. This instrument allows artists to manipulate and change the electronic video information in various ways, causing images or parts of images to stretch, shrink, change color, or break up. With the synthesizer, artists can also layer images, inset one image into another, or merge images from various cameras with those from video recorders to make a single visual kaleidoscopic "time-collage." This kind of compositional freedom permitted Paik to combine his interests in the ideas of Cage, painting, music, Eastern philosophy, global politics for survival, humanized technology, and cybernetics. Paik called his video works "physical music"

and said that his musical background enabled him to understand time better than video artists trained in painting or sculpture.

Paik's best-known video work, *Global Groove* (FIG. **34-76**), combines in quick succession fragmented sequences of female tap dancers, poet Allen Ginsberg reading his work, a performance of cellist Charlotte Moorman using a man's back as her instrument, Pepsi commercials from Japanese television, Korean drummers, and a shot of the Living Theatre group performing a controversial piece called *Paradise Now*. Commissioned originally for broadcast over the United Nations satellite, the cascade of imagery in *Global Groove* was intended to give viewers a glimpse of the rich worldwide television menu Paik predicted would be available in the future.

While some new technologies were revolutionizing the way artists could work with pictorial space, other technologies, especially those of computer graphics, were transforming how artists could create and manipulate illusionistic three-dimensional forms. Computer graphics as a medium uses light to make images and, like photography, can incorporate specially recorded camera images. Computer graphics allows artists to work with wholly invented forms, as painters can.

Developed during the 1960s and 1970s, computer graphics opened up new possibilities for both abstract and figurative art. It involves electronic programs dividing the surface of the computer monitor's cathode-ray tube into a grid of tiny boxes called "picture elements" (pixels). Artists can electronically address these picture elements individually to create a design, much as knitting or weaving patterns have a grid matrix as a guide for making a design in fabric. Once created, parts of a computer graphic design can be changed quickly through an electronic program, allowing artists to revise or duplicate shapes in the design and to manipulate at will the color, texture, size, number, and position of any desired detail. A computer graphics picture is displayed in luminous color on the cathode-ray tube. The effect suggests a view into a vast world existing inside the tube.

34-77 David Em, *Nora*, 1979. Computer-generated color photograph, 1′ 5″ × 1′ 11″. Private collection.

COMPUTER-GENERATED LANDSCAPES One of the best-known artists working in this electronic painting mode, DAVID EM (b. 1952), uses what he terms "computer imaging" to fashion fantastic imaginary landscapes. These have an eerily believable existence within the "window" of the computer monitor. When he was artist-in-residence at the California Institute of Technology's Jet Propulsion Laboratory, Em created brilliantly colored scenes of alien worlds using the laboratory's advanced computer graphics equipment. He also had access to software programs developed to create computer graphics simulations of the NASA's missions in outer space. Creating images with the computer allows Em great flexibility in manipulating simple geometric shapes—shrinking or enlarging them, stretching or reversing them, repeating them, adding texture to their surfaces, and creating the illusion of light and shadow. In images such as *Nora* (FIG. **34-77**), Em created futuristic geometric versions of Surrealistic dreamscapes whose forms seem familiar and strange at the same time. The illusion of space in these works is immensely vivid and seductive. It almost seems possible to wander through the tube-like foreground "frame" and up the inclined foreground plane or to hop aboard the hovering globe at the lower left for a journey through the strange patterns and textures of this mysterious labyrinthine setting.

THE AUTHORITY OF SIGNS In conjunction with the growing popularity of digital imagery and the expanding interest in video technology, many artists have appropriated the mechanisms and strategies of these media. JENNY HOLZER (b. 1950) is interested in reaching a wide audience with her art. Realizing the efficiency of signs, she created several series using electronic signs, most involving light-emitting diode (LED) technology. In 1989, Holzer did a major installation at the Guggenheim Museum in New York that included elements from her previous series and consisted of a large continuous LED display spiraling around the museum's interior ramp (FIG. **34-78**). Holzer's art focused specifically on text, and she invented sayings with an authoritative tone

for her LED displays. Statements included "Protect me from what I want," "Abuse of power comes as no surprise," and "Romantic love was invented to manipulate women." The statements, which people could read from a distance, were purposefully vague and ambiguous and, in some cases, contradictory.

DIGITAL SENSORY EXPERIENCE BILL VIOLA (b. 1951) has spent much of his artistic career exploring the capabilities of digitized imagery, producing many video installations and single-channel works. Often focusing on sensory perception, the pieces not only heighten viewer awareness of the senses but also suggest an exploration into the spiritual realm. Viola, an American, spent years seriously studying Buddhist, Christian, Sufi, and Zen mysticism. Because he fervently believes in art's transformative power and in a spiritual view of human nature, Viola designs works encouraging spectator introspection. His recent video projects involve using such techniques as extreme slow motion, contrasts in scale, shifts in focus, mirrored reflections, staccato editing, and multiple or layered screens to achieve dramatic effects.

The power of Viola's work is evident in *The Crossing* (FIG. **34-79**), an installation piece involving two color video channels projected on 16-foot-high screens. The artist either shows the two projections on the front and back of the same screen or on two separate screens in the same installation. In these two companion videos, shown simultaneously on the two screens, a man surrounded in darkness appears, moving closer until he fills the screen. On one screen, drops of water fall from above onto the

34-78 JENNY HOLZER, *Untitled* (selections from *Truisms, Inflammatory Essays, The Living Series, The Survival Series, Under a Rock, Laments,* and *Child Text*), 1989. Extended helical tricolor LED electronic display signboard, 16″ × 162′ × 6″. Solomon R. Guggenheim Foundation, New York, December 1989–February 1990 (partial gift of the artist, 1989).

34-79 BILL VIOLA, *The Crossing*, 1996. Video/sound installation with two channels of color video projection onto screens 16′ high.

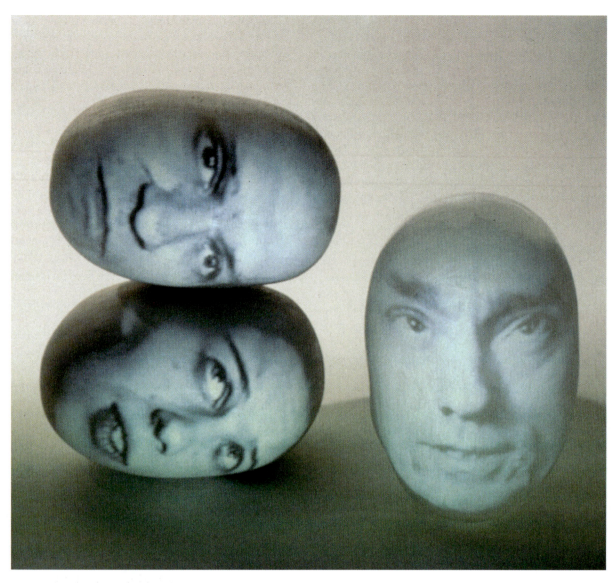

34-80 Tony Oursler, *Mansheshe,* 1997. Ceramic, glass, video player, videocassette, CPJ-200 video projector, sound, 11″ × 7″ × 8″ each. Courtesy of the artist and Metro Pictures, New York.

man's head, while on the other screen, a small fire breaks out at the man's feet. Over the next few minutes, the water and fire increase in intensity until the man disappears in a torrent of water on one screen and flames consume the man on the other screen. The deafening roar of a raging fire and a torrential downpour accompany these visual images. Eventually, everything subsides and fades into darkness. This installation's elemental nature and its presentation in a dark space immerse viewers in a pure sensory experience very much rooted in tangible reality.

SCULPTURAL VIDEO PROJECTIONS While many artists present video and digital imagery to the audience on familiar flat screens, thus reproducing the format in which we most often come into contact with such images, TONY OURSLER (b. 1957) manipulates his images, projecting them onto sculptural objects. This has the effect of taking such images out of the digital world and insinuating them into the "real" world. Accompanied by sound tapes, Oursler's installations, such as *Mansheshe* (FIG. **34-80**), not only engage but often challenge the viewer. In this example, talking heads are projected onto egg-shaped oval forms suspended from poles. Because the projected images of people look directly at the viewer, the statements they make about religious beliefs, sexual identity, and interpersonal relationships cannot be easily dismissed.

Postmodernism and Commodity Culture

SYMBOLS OF WHAT'S WRONG TODAY? In keeping with Fredric Jameson's evaluation of postmodern culture as inextricably linked to consumer society and mass culture, several postmodern artists have delved into the issues associated with commodity culture. American JEFF KOONS (b. 1955) first became prominent in the art world for a series of works in the early 1980s that involved exhibiting common purchased objects such as vacuum cleaners. Clearly following in the footsteps of artists such as Marcel Duchamp and Andy Warhol, Koons made no attempt to manipulate or alter the objects. Critics and other art world participants perceived them as representing the commodity basis of both the art world and society at large. Koons's experience as a commodities broker before turning to art and his blatant self-promotion have led to accusations that his art is market driven.

More recently, Koons has produced porcelain sculptures, such as *Pink Panther* (FIG. **34-81**). Here, Koons continued his immersion in contemporary mass culture by intertwining a magazine centerfold nude with a well-known cartoon character. He reinforced the trite and kitschy nature of this imagery by titling the exhibition of which this work was a part *The Banality Show.* Some

art critics have argued that Koons and his work instruct viewers because both artist and work serve as the most visible symbols of everything that is wrong with contemporary American society. Whether or not this is true, people must acknowledge that, at the very least, Koons's prominence in the art world indicates that he, like Warhol before him, has developed an acute understanding of the dynamics of consumer culture.

Postmodernism and the Critique of Art History

Postmodern architecture often incorporates historical forms and styles. Members of the art world have frequently cited this awareness of the past as a defining characteristic of postmodernism, in both architecture and art. Such awareness, however, extends beyond mere citation. People have described it as a self-consciousness on the part of artists about their place in the continuum of art history. Not only do artists demonstrate their knowledge about past art, but they also express awareness of the mechanisms and institutions of the art world. For many postmodern artists, then, referencing the past moves beyond simple quotation from earlier works and styles and involves a critique of or commentary on fundamental art historical premises. In short, their art is about making art.

THE HISTORY OF ART IN ART In his humorous *A Short History of Modernist Painting* (FIG. **34-82**), American artist MARK TANSEY (b. 1949) provides viewers with a tongue-in-cheek summary of the various approaches to painting artists have embraced over the years. Tansey presents a sequence of three images, each visualizing a way of looking at art. At the far left, a glass window encapsulates the Renaissance ideal of viewing art as though one were looking through a window. In the center image, a man pushing his head against a solid wall represents the thesis central to much of modernist formalism—that the painting should be

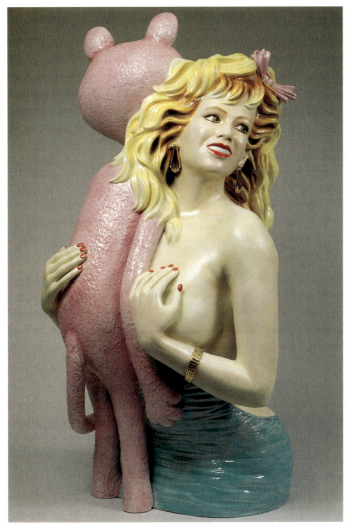

34-81 JEFF KOONS, *Pink Panther*, 1988. Porcelain, $3' 5'' \times 1' 8\frac{1}{2}'' \times 1' 7''$. Collection of Museum of Contemporary Art, Chicago (Gerald S. Elliot Collection).

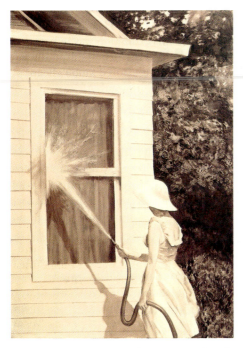 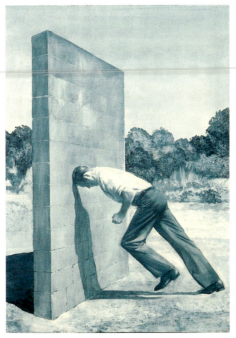

34-82 MARK TANSEY, *A Short History of Modernist Painting*, 1982. Oil on canvas, three panels, each $4' 10'' \times 3' 4''$. Courtesy Curt Marcus Gallery.

34-86 Matthew Barney, *Cremaster* cycle, installation at the Solomon R. Guggenheim Museum, 2003.

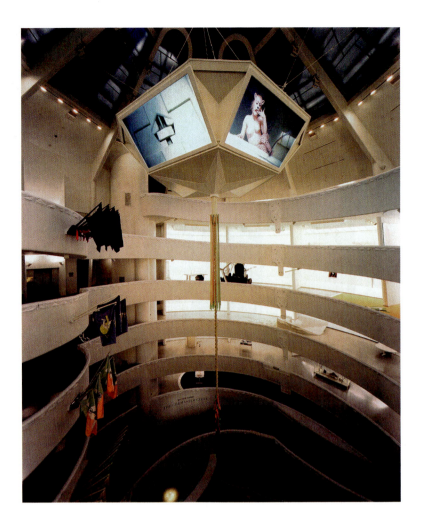

Into the 21st Century:
The Future of Art and Art History

At the end of the 19th century, a unique fin de siècle culture emerged, followed by the emergence in the early 20th century of prodigious artistic talents such as Matisse, Duchamp, and Picasso. What will the 21st century bring? Will a similarly fertile period in art and culture arise as the new century and the new millennium progress, as some people anticipate? It is, of course, impossible to predict anything with any certainty. Further, with the expansive scope of postmodernism, no single approach or style dominates. Indeed, as we move into the 21st century, it seems that one of the major trends is a relaxation of the traditional boundaries between artistic media. Following in the footsteps of artists such as Duchamp, Rauschenberg, Piper, and Hammons, many artists today are creating multimedia installations that are often site-specific.

AN EPIC CREATION CYCLE One such artist is MATTHEW BARNEY (b. 1967). The 2003 installation (FIG. **34-86**) of his epic *Cremaster* cycle (1994–2002) at the Solomon R. Guggenheim Museum in New York typifies the expansive scale upon which many contemporary works are conceptualized. A multimedia extravaganza involving drawings, photographs, sculptures, videos, films, and performances (presented in videos), the *Cremaster* cycle is a lengthy narrative that takes place in a self-enclosed universe created by Barney. The title of the work refers to the cremaster muscle, which controls testicular contractions in response to external stimuli. Barney uses the development of this muscle in the embryonic process of sexual differentiation as the conceptual springboard for this entire project, in which he explores the notion of creation in expansive and complicated ways. The cycle's narrative, revealed in the five 35-mm feature-length films and the artworks, makes reference to, among other things, a musical revue in Boise, Idaho (Barney's hometown), the life cycle of bees, the execution of convicted murderer Gary Gilmore, the construction of the Chrysler Building (see FIG. 33-65), Celtic mythology, Masonic rituals, a motorcycle race, and a lyric opera set in late-19th-century Budapest. In the installation, the artworks are tied together conceptually by a five-channel video piece that is projected on screens hanging in the Guggenheim's rotunda. Immersion in Barney's constructed world is disorienting and overwhelming and has a force that competes with the immense scale and often frenzied pace of contemporary life.

Conclusion

In the later 20th century, the domination of modernist formalism in art gave way to an eclectic postmodernism. The emergence of postmodern thought not only encouraged a wider range of styles and approaches but also prompted commentary (often ironic) about the nature of art production and dissemination. In recent decades, many artists have produced works prompted by sociopolitical concerns, dealing with aspects of race, gender, class, and other facets of identity. The universally expanding presence of computers, digital technology, and the Internet will surely have an effect on the art world. It may well erode remaining conceptual and geographical boundaries, and make art and information about art available to virtually everyone, thereby creating a truly global artistic community.

| Existentialism, 1930–1950s

1945

| United Nations organized, 1945
| Atomic bomb devastates Hiroshima and Nagasaki, 1945
| Independence of India and Pakistan, 1947
| Transistor invented, 1948
| State of Israel created, 1948
| People's Republic of China established, 1949

1950

1 Alberto Giacometti, *Man Pointing*, 1947

| Korean conflict, 1950–1953
| Crick and Watson, Discovery of Structure of DNA, 1954
| *Sputnik I* launched, 1957
| Computer chip invented, 1959

1960

| Lasers invented, 1960
| First manned space flight, 1961
| John F. Kennedy assassinated, 1963
| Corporation for Public Broadcasting formed, 1967
| Martin Luther King and Robert Kennedy assassinated, 1968
| Moon landing, 1969

2 Andy Warhol, *Green Coca-Cola Bottles*, 1962

1970

| Postmodernism in art, literature, 1970s–
| Watergate, 1972
| War in Vietnam ends, 1975
| Personal computers introduced, 1975
| Islamic Revolution in Iran, 1978–1979

3 Richard Rogers and Renzo Piano, Georges Pompidou National Center of Art and Culture, 1977

1980

| Gorbachev comes to power in Soviet Union, 1985
| Opening of Berlin Wall, 1989
| Collapse of Soviet Union, 1989
| Tiananmen Square massacre, 1989

1990

4 Jenny Holzer, *Untitled*, 1989

| First Gulf War, 1990
| US intervention, Somalia, Haiti, 1990s
| Breakup of Yugoslavia, 1990
| Expansion of World Wide Web, 1990s
| Terrorist attack on New York City and Washington, D.C., 2001

NOTES

Chapter 20

1. Quoted in Henry Dussart, ed., *Fragments inédits de Romboudt de Doppere: Chronique brugeoise de 1491 à 1498* (Bruges: L. de Plancke, 1892), 49.

Chapter 21

1. Quoted in Elizabeth Gilmore Holt, ed., *Literary Sources of Art History* (Princeton, N.J.: Princeton University Press, 1947), 87–88.
2. Giorgio Vasari, *Lives of the Painters, Sculptors and Architects,* translated by Gaston du C. de Vere (New York: Knopf, 1996), 1: 304.
3. Quoted in Holt, *Literary Sources,* 90–91.
4. Vasari, *Lives of the Painters, Sculptors and Architects,* 1: 318.
5. Quoted in H. W. Janson, *The Sculpture of Donatello* (Princeton, N.J.: Princeton University Press, 1965), 154.

Chapter 22

1. Da Vinci to Ludovico Sforza, ca. 1480–81, in Elizabeth Gilmore Holt, ed., *Literary Sources of Art History* (Princeton: Princeton University Press, 1947), 170.
2. Quoted in Anthony Blunt, *Artistic Theory in Italy, 1450–1600* (London: Oxford University Press, 1964), 34.
3. Quoted in Bruce Boucher, *Andrea Palladio: The Architect in His Time* (New York: Abbeville Press, 1998), 229.
4. Quoted in James M. Saslow, *The Poetry of Michelangelo: An Annotated Translation* (New Haven, Conn.: Yale University Press, 1991), 407.
5. Giorgio Vasari, *Lives of the Painters, Sculptors and Architects,* translated by Gaston du C. de Vere (New York: Knopf, 1996), 2: 736.
6. Quoted in A. Richard Turner, *Renaissance Florence: The Invention of a New Art* (New York: Abrams, 1997), 163.
7. Quoted in Robert J. Clements, *Michelangelo's Theory of Art* (New York: New York University Press, 1961), 320.
8. Quoted in Francesco Valcanover, "An Introduction to Titian," in *Titian: Prince of Painters* (Venice: Marsilio Editori, 1990), 23–24.
9. Quoted in Holt, ed., *Literary Sources of Art History,* 229.

Chapter 23

1. Quoted in Wolfgang Stechow, *Northern Renaissance Art 1400–1600: Sources and Documents* (Evanston, Ill.: Northwestern University Press, 1989), 111.
2. Ibid., 118.
3. Ibid., 123.
4. Giorgio Vasari, *Lives of the Painters, Sculptors and Architects,* translated by Gaston du C. de Vere (New York: Knopf, 1996), 2: 863.

Chapter 24

1. John Milton, *Il Penseroso* (1631, published 1645), 166.
2. Quoted in Wolfgang Stechow, *Rubens and the Classical Tradition* (Cambridge: Harvard University Press, 1968), 26.
3. Quoted in David G. Wilkins, Bernard Schultz, and Katheryn M. Linduff, *Art Past, Art Present,* 3rd ed. (New York: Abrams, 1997), 365.
4. Quoted in Bob Haak, *The Golden Age: Dutch Painters of the Seventeenth Century* (New York: Abrams, 1984), 75.
5. Ibid., 450.
6. Quoted in Robert Goldwater and Marco Treves (eds.), *Artists on Art,* 3rd ed. (New York: Pantheon Books, 1958), 155.
7. Ibid., 155.
8. Ibid., 151–53.

Chapter 27

1. Quoted in Junichi Shiota, *Kimio Tsuchiya, Sculpture 1984–1988* (Tokyo: Morris Gallery, 1988), 3.

Chapter 28

1. Robert Goldwater and Marco Treves (eds.), *Artists on Art,* 3rd ed. (New York: Pantheon Books, 1958), 157.

2. Quoted in Thomas A. Bailey, *The American Pageant: A History of the Republic,* 2nd ed. (Boston: Heath, 1961), 280.
3. *The Indispensable Rousseau,* compiled and presented by John Hope Mason (London: Quartet Books, 1979), 39.
4. Quoted in Elizabeth Gilmore Holt, ed., *Literary Sources of Art History* (Princeton, N.J.: Princeton University Press, 1947), 532.
5. Quoted in Goldwater and Treves, *Artists on Art,* 205.
6. Ibid., 205.
7. Edgar Allen Poe, "To Helen" (1831).
8. Quoted in Marcus Whiffen and Fredrick Koeper, *American Architecture 1607–1976* (Cambridge: MIT Press, 1981), 130.
9. Gwyn A. Williams, *Goya and the Impossible Revolution* (London: Allen Lane, 1976), 175–77.
10. Théophile Gautier, *Histoire de Romantisme* (Paris: Charpentier, 1874), 204.
11. Delacroix to Auguste Jal, 4 June 1832, in Charles Harrison and Paul Wood, eds., with Jason Gaiger, *Art in Theory 1815–1900: An Anthology of Changing Ideas* (Oxford: Blackwell, 1998), 88.
12. Quoted in Helmut Borsch-Supan, *Caspar David Friedrich* (New York: Braziller, 1974), 7.
13. Quoted in Harrison and Wood, eds., with Gaiger, *Art in Theory,* 54.
14. Quoted in Brian Lukacher, "Nature Historicized: Constable, Turner, and Romantic Landscape Painting," in Stephen F. Eisenman, ed., *Nineteenth Century Art: A Critical History* (New York: Thames & Hudson, 1994), 121.
15. Quoted in John W. McCoubrey, *American Art 1700–1960: Sources and Documents* (Upper Saddle River, N.J.: Prentice Hall, 1965), 98.
16. Quoted in Holt, *Literary Sources,* 547, 548.
17. Nicholas Pevsner, *An Outline of European Architecture* (Baltimore: Penguin, 1960), 627.
18. Letter from Delaroche to François Arao, in Helmut Gernsheim, *Creative Photography* (New York: Bonanza Books, 1962), 24.
19. Quoted in Naomi Rosenblum, *A World History of Photography* (New York: Abbeville Press, 1984), 69.

Chapter 29

1. Clement Greenberg, "Modernist Painting," *Art and Literature,* no. 4 (Spring 1965): 193.
2. Ibid., 194.
3. Quoted in Linda Nochlin, *Realism and Tradition in Art 1848–1900* (Upper Saddle River, N.J.: Prentice Hall, 1966), 39, 38, 42.
4. Quoted in Robert Goldwater and Marco Treves, eds., *Artists on Art,* 3rd ed. (New York: Pantheon Books, 1958), 295–97.
5. Comment by French critic Enault in Linda Nochlin, *The Nature of Realism* (New York: Penguin Books, 1971), 34.
6. Quoted in Nochlin, *Realism and Tradition in Art,* 42.
7. George Heard Hamilton, *Manet and His Critics* (New Haven: Yale University Press, 1954), 45.
8. Stephen F. Eisenman, *Nineteenth Century Art: A Critical History* (London: Thames & Hudson, 1994), 242.
9. "On the Heroism of Modern Life" (the closing section of Baudelaire's *Salon of 1846,* published as a brochure in Paris in 1846).
10. *New York Weekly Tribune,* 30 September 1865.
11. Quoted in Nikolai Cikovsky Jr. and Franklin Kelly, *Winslow Homer* (Washington, D.C.: National Gallery of Art, 1995), 26.
12. Lloyd Goodrich, *Thomas Eakins, His Life and Work* (New York: Whitney Museum of American Art, 1933), 51–52.
13. Kenneth MacGowan, *Behind the Screen* (New York: Delta, 1965), 49.
14. Quoted in Linda Nochlin, *Realism* (Harmondsworth: Penguin Books, 1971), 28.
15. Quoted in Linda Nochlin, *Impressionism and Post-Impressionism 1874–1904* (Upper Saddle River, N.J.: Prentice Hall, 1966), 35.
16. Quoted in Roy McMullan, *Degas: His Life, Times, and Work* (Boston: Houghton Mifflin, 1984), 293.

17. Quoted in John McCoubrey, *American Art 1700–1960: Sources and Documents* (Upper Saddle River, N.J.: Prentice Hall, 1965), 184.
18. Quoted in Laurie Schneider Adams, *A History of Western Art,* 2nd ed. (Madison, Wis.: Brown & Benchmark, 1997), 443.
19. Quoted in Goldwater and Treves, eds., *Artists on Art,* 322.
20. Van Gogh to Theo van Gogh, 3 September 1888, *Van Gogh: A Self-Portrait; Letters Revealing His Life as a Painter,* selected by W. H. Auden (New York: Dutton, 1963), 319.
21. Van Gogh to Theo van Gogh, 11 August 1888, *Van Gogh: A Self-Portrait,* 313.
22. Ibid., 321.
23. Van Gogh to Theo van Gogh, September 1888, in J. van Gogh–Bonger and V. W. van Gogh, eds., *The Complete Letters of Vincent van Gogh* (Greenwich, Conn.: 1979), 3: 534.
24. Van Gogh to Theo van Gogh, 8 September 1888, *Van Gogh: A Self-Portrait,* 320.
25. Van Gogh to Theo van Gogh, 16 July 1888, *Van Gogh: A Self-Portrait,* 299.
26. Quoted in Belinda Thompson, ed., *Gauguin by Himself* (Boston: Little, Brown, 1993), 270–71.
27. Quoted in Herschel B. Chipp, *Theories of Modern Art* (Berkeley: University of California Press, 1968), 72.
28. Quoted in Goldwater and Treves, eds., *Artists on Art,* 375.
29. Quoted in Richard W. Murphy, *The World of Cézanne 1839–1906* (New York: Time-Life Books, 1968), 70.
30. Quoted in Goldwater and Treves, eds., *Artists on Art,* 363.
31. Cézanne to Émile Bernard, 15 April 1904, in Chipp, *Theories of Modern Art,* 19.
32. Quoted in Goldwater and Treves, eds., *Artists on Art,* 361.
33. Quoted in George Heard Hamilton, *Painting and Sculpture in Europe, 1880–1940,* 6th ed. (New Haven: Yale University Press, 1993), 124.
34. Quoted in V. Frisch and J. T. Shipley, *Auguste Rodin* (New York: Stokes, 1939), 203.
35. Quoted in Eileen Boris, *Art and Labor: Ruskin, Morris, and the Craftsman Ideal in America* (Philadelphia: Temple University Press, 1986), 7.
36. Siegfried Giedion, *Space, Time, and Architecture* (Cambridge: Harvard University Press, 1965), 282.

Chapter 30

1. Alfred M. Tozzer, ed., *Landa's Relación de las cosas de Yucatán: A Translation* (Cambridge, Mass.: Peabody Museum Papers, 1941), 18.
2. Bernal Díaz del Castillo, *The Discovery and Conquest of Mexico,* translated by A. P. Maudslay (New York: Farrar, Straus, Giroux, 1956), 218–19.

Chapter 32

1. Pieter de Marees, *A Description and Historical Declaration of the Golden Kingdom of Guinea* (1604), translated by Samuel Purchas. Quoted in Herbert M. Cole and Doran H. Ross, *The Arts of Ghana* (Los Angeles: Museum of Cultural History, 1977), 119.

Chapter 33

1. "Kunst und Leben," *Der Sturm* 10 (1919): 2.
2. Quoted in John Elderfield, *The "Wild Beasts": Fauvism and Its Affinities* (New York: Museum of Modern Art, 1976), 29.
3. Quoted in John Russell and the editors of Time-Life Books, *The World of Matisse 1869–1954* (New York: Time-Life Books, 1969), 98.
4. Quoted in Peter Selz, *German Expressionist Painting* (Berkeley: University of California Press, 1957), 95.
5. Quoted in Herschel B. Chipp, *Theories of Modern Art* (Berkeley: University of California Press, 1968), 182.
6. Quoted in Frederick S. Levine, *The Apocalyptic Vision: The Art of Franz Marc as German Expressionism* (New York: Harper & Row, 1979), 57.
7. Quoted in Sam Hunter and John Jacobus, *Modern Art,* 3rd ed. (New York: Abrams, 1992), 121.
8. Quoted in Roland Penrose, *Picasso: His Life and Work,* rev. ed. (New York: Harper & Row, 1971), 122.
9. Quoted in George Heard Hamilton, *Painting and Sculpture in Europe, 1880–1940,* 6th ed. (New Haven: Yale University Press, 1993), 246.
10. Quoted in Edward Fry, ed., *Cubism* (London: Thames & Hudson, 1966), 112–13.
11. Hamilton, *Painting and Sculpture,* 238.
12. Quoted in Michael Hoog, *R. Delaunay* (New York: Crown, 1976), 49.
13. Quoted in Françoise Gilot and Carlton Lake, *Life with Picasso* (New York: McGraw-Hill, 1964), 77.
14. From the *Initial Manifesto of Futurism,* first published 20 February 1909.
15. Ibid.
16. Umberto Boccioni, Carlo Carrà, Luigi Russolo, Giacomo Balla, and Gino Severini, "Futurist Painting: Technical Manifesto," *Poesia,* 10 April 1910.
17. Hans Richter, *Dada: Art and Anti-Art* (London: Thames & Hudson, 1961), 25.
18. Quoted in Robert Short, *Dada and Surrealism* (London: Octopus Books, 1980), 18.
19. Quoted in Robert Motherwell, ed., *The Dada Painters and Poets: An Anthology,* 2nd ed. (Cambridge, Mass.: Belknap Press of Harvard University, 1989).
20. Richter, *Dada,* 64–65.
21. Ibid., 57.

22. Tristan Tzara, "Chronique Zurichoise," translated by Ralph Manheim, in Motherwell, ed., *The Dada Painters and Poets,* 236.
23. Quoted in Arturo Schwarz, *The Complete Works of Marcel Duchamp* (London: Thames & Hudson, 1965), 466.
24. Quoted in Sam Hunter, *American Art of the 20th Century* (New York: Abrams, 1972), 30.
25. Ibid., 37.
26. Charles C. Eldredge, "The Arrival of European Modernism," *Art in America* 61 (July–August 1973): 35.
27. Dorothy Norman, *Alfred Stieglitz: An American Seer* (Millerton, N.Y.: Aperture, 1973).
28. Ibid., 161.
29. Ibid., 9–10, 161.
30. Quoted in Gail Stavitsky, "Reordering Reality: Precisionist Directions in American Art, 1915–1941," in *Precisionism in America 1915–1941: Reordering Reality* (New York: Abrams, 1994), 12.
31. Quoted in Karen Tsujimoto, *Images of America: Precisionist Painting and Modern Photography* (Seattle: University of Washington Press, 1982), 70.
32. Quoted in Matthias Eberle, *World War I and the Weimar Artists: Dix, Grosz, Beckmann, Schlemmer* (New Haven: Yale University Press, 1985), 65.
33. Ibid., 54.
34. Ibid., 22.
35. Ibid., 42.
36. Quoted in William S. Rubin, *Dada, Surrealism, and Their Heritage* (New York: Museum of Modern Art, 1968), 64.
37. Quoted in Hamilton, *Painting and Sculpture,* 392.
38. Quoted in Richter, *Dada,* 155.
39. Ibid., 159.
40. Quoted in Rubin, *Dada, Surrealism, and Their Heritage,* 111.
41. Quoted in Hunter and Jacobus, *Modern Art,* 179.
42. Quoted in William S. Rubin, *Miró in the Collection of the Museum of Modern Art* (New York: Museum of Modern Art, 1973), 32.
43. Quoted in Chipp, *Theories of Modern Art,* 182–86.
44. Ibid., 341, 345.
45. Quoted in Robert L. Herbert, ed., *Modern Artists on Art* (Upper Saddle River, N.J.: Prentice Hall, 1965), 140–41, 145–46.
46. Quoted in Chipp, *Theories of Modern Art,* 328, 334, 336.
47. Ibid., 332, 335.
48. Quoted in Camilla Gray, *The Russian Experiment in Art* 1863–1922 (New York: Abrams, 1970), 216.
49. Kenneth Frampton, *Modern Architecture: A Critical History* (London: Thames & Hudson, 1985), 142.
50. Ibid., 147.
51. Quoted in Michel Seuphor, *Piet Mondrian: Life and Work* (New York: Abrams, 1956), 117.
52. Quoted in Hamilton, *Painting and Sculpture,* 319.
53. Quoted in Chipp, *Theories of Modern Art,* 349.
54. Ibid., 350.
55. Quoted in Hans L. Jaffé, comp., *De Stijl* (New York: Abrams, 1971), 185–188.
56. Piet Mondrian, "Dialogue on the New Plastic," in Charles Harrison and Paul Wood, eds., *Art in Theory 1900–1990: An Anthology of Changing Ideas* (Oxford: Blackwell, 1992), 285.
57. Walter Gropius, from *The Manifesto of the Bauhaus,* April 1919.
58. Ibid.
59. Ibid.
60. László Moholy-Nagy, *Vision in Motion* (Chicago: Paul Theobald, 1969), 268.
61. Quoted in Hamilton, *Painting and Sculpture,* 345.
62. Ibid.
63. Quoted in *Josef Albers: Homage to the Square* (New York: Museum of Modern Art, 1964), n.p.
64. Quoted in John Willett, *Art and Politics in the Weimar Period: The New Sobriety, 1917–1933* (New York: Da Capo Press, 1978), 119.
65. Quoted in Wayne Craven, *American Art: History and Culture* (Madison, Wis.: Brown & Benchmark, 1994), 403.
66. Quoted in Vincent Scully Jr., *Frank Lloyd Wright* (New York: Braziller, 1960), 18.
67. Quoted in Edgar Kauffmann, ed., *Frank Lloyd Wright, An American Architect* (New York: Horizon, 1955), 205, 208.
68. Quoted in Philip Johnson, *Mies van der Rohe,* rev. ed. (New York: Museum of Modern Art, 1954), 200–01.
69. Quoted in Hamilton, *Painting and Sculpture,* 462.
70. Quoted in H. H. Arnason and Marla F. Prather, *History of Modern Art,* 4th ed. (Upper Saddle River, N.J.: Prentice Hall, 1998), 180.
71. Barbara Hepworth, *A Pictorial Autobiography* (London: Tate Gallery, 1978), 9, 53.
72. Quoted in Herbert, *Modern Artists on Art,* 139.
73. Ibid., 140–41, 145–46.
74. Ibid., 143.
75. Quoted in Frances K. Pohl, *Ben Shahn: New Deal Artist in a Cold War Climate, 1947–1954* (Austin: University of Texas Press, 1989), 159.

and inscribed book on long sheets of bark paper or deerskin coated with fine white plaster and folded into accordionlike pleats.

coffer—A sunken panel, often ornamental, in a *vault* or a ceiling.

collage—(kō-ˈlazh) A composition made by attaching to a flat surface various materials, such as newspaper, wallpaper, printed text and illustrations, photographs, and cloth.

colonnade—A series or row of *columns,* usually spanned by *lintels.*

colophon—(ˈka-lŭ-fan) An inscription, usually on the last page, giving information about a book's manufacture. In Chinese painting, written texts on attached pieces of paper or silk.

color field painting—A variant of *Post-Painterly Abstraction* whose artists sought to reduce painting to its physical essence by pouring diluted paint onto unprimed canvas, allowing these pigments to soak into the fabric.

colorito—(ko-lo-ˈrē-tō) Italian, "colored" or "painted." A term used to describe the application of paint. Characteristic of the work of 16th-century Venetian artists who emphasized the application of paint as an important element of the creative process. Central Italian artists, in contrast, largely emphasized *disegno*—the careful design preparation based on preliminary drawing.

column—A vertical, weight-carrying architectural member, circular in cross-*section* and consisting of a base (sometimes omitted), a *shaft,* and a *capital.*

Composite capital—A capital combining *Ionic* volutes and *Corinthian* acanthus leaves, first used by the ancient Romans.

Conceptual art—An American avant-garde art movement of the 1960s that asserted that the "artfulness" of art lay in the artist's idea rather than its final expression.

condottiere—(kon-da-ˈtyer-ē) A professional military leader employed by the Italian city-states in the early Renaissance.

confraternity—(kon-frŭ-ˈtŭr-nŭ-tē) In late antiquity, an association of Christian families pooling funds to purchase property for burial. In late medieval Europe, an organization founded by laypersons who dedicated themselves to strict religious observances.

Constructivism—An early-20th-century Russian art movement in art formulated by Naum Gabo, who built up his sculptures piece by piece in space instead of carving or *modeling* them in the traditional way. In this way the sculptor worked with "volume of mass" and "volume of space" as different materials.

contrapposto—(kon-trŭ-ˈpas-tō) The disposition of the human figure in which one part is turned in opposition to another part (usually hips and legs one way, shoulders and chest another), creating a counterpositioning of the body about its central axis. Sometimes called "weight shift" because the weight of the body tends to be thrown to one foot, creating tension on one side and relaxation on the other.

Corinthian capital—A more ornate form than *Doric* or *Ionic;* it consists of a double row of acanthus leaves from which tendrils and flowers grow, wrapped around a bell-shaped *echinus.* Although this *capital* form is often cited as the distinguishing feature of the Corinthian *order,* there is, strictly speaking, no Corinthian order, but only this style of capital used in the *Ionic* order.

cornice—The projecting, crowning member of the *entablature* framing the *pediment;* also, any crowning projection.

Cosmato work—(kos-ˈma-tō) Marble or mosaic work characterized by inlays of gold and precious or semiprecious stones and finely cut marble in geometric patterns.

Cubism—An early-20th-century art movement that rejected naturalistic depictions, preferring compositions of shapes and forms abstracted from the con-

ventionally perceived world. See also *Analytic Cubism* and *Synthetic Cubism.*

cutaway—An architectural drawing that combines an exterior view with an interior view of part of a building.

Dada—(ˈda-da) An art movement prompted by a revulsion against the horror of World War I. Dada embraced political anarchy, the irrational, and the intuitive, and the art produced by the Dadaists was characterized by a disdain for convention, often enlivened by humor or whimsy.

daguerreotype—(da-ˈger-ō-tip) A photograph made by an early method on a plate of chemically treated metal; developed by Louis J. M. Daguerre.

De Stijl—(du stēl) Dutch, "the style." An early-20th-century art movement (and magazine) founded by Piet Mondrian and Theo van Doesburg, whose members promoted utopian ideals and developed a simplified geometric style.

deconstruction—An analytical strategy developed in the late 20th century according to which all cultural "constructs" (art, architecture, literature) are "texts." People can read these texts in a variety of ways, but they cannot arrive at fixed or uniform meanings. Any interpretation can be valid, and readings differ from time to time, place to place, and person to person. For those employing this approach, deconstruction means destabilizing established meanings and interpretations while encouraging subjectivity and individual differences.

Deconstructivist architecture—Using *deconstruction* as an analytical strategy, Deconstructivist architects attempt to disorient the observer by disrupting the conventional categories of architecture. The haphazard presentation of volumes, masses, planes, lighting, and so forth challenges the viewer's assumptions about form as it relates to function.

di sotto in sù — (dē ˈsot-tō in ˈsū) Italian, "from below upwards." A technique of representing *perspective* in ceiling painting.

diptych—(ˈdip-tik) A two-paneled painting or *altarpiece;* also, an ancient Roman, Early Christian, or Byzantine hinged writing tablet, often of ivory and carved on the external sides.

disegno—(dē-ˈzā-nyō) Italian, "drawing" and "design." Renaissance artists considered drawing to be the external physical manifestation (*disegno esterno*) of an internal intellectual idea of design (*disegno interno*).

dome—A hemispheric *vault;* theoretically, an *arch* rotated on its vertical axis.

Doric—(ˈdor-ik) One of the two systems (or *orders*) evolved for articulating the three units of the *elevation* of an ancient Greek temple—the platform, the *colonnade,* and the superstructure (*entablature*). The Doric order is characterized by, among other features, *capitals* with funnel-shaped *echinuses, columns* without bases, and a frieze of *triglyphs* and *metopes.* See also *Ionic.*

drypoint—An engraving in which the design, instead of being cut into the plate with a *burin,* is scratched into the surface with a hard steel "pencil." See also *engraving, etching, intaglio.*

echinus—(ŭ-ˈkīn-ŭs) In architecture, the convex element of a *capital* directly below the *abacus.*

écorché—(ā-ˈko-zhā) A figure painted or sculpted to show the muscles of the body as if without skin.

edition—A set of impressions taken from a single print surface.

elevation—In architecture, a head-on view of an external or internal wall, showing its features and often other elements that would be visible beyond or before the wall.

enamel—A decorative coating, usually colored, fused onto the surface of metal, glass, or ceramics.

engaged column—A half-round *column* attached to a wall. See also *pilaster.*

engraving—The process of *incising* a design in hard material, often a metal plate (usually copper); also, the print or impression made from such a plate.

entablature—(in-ˈtăb-lŭ-chŭr) The part of a building above the *columns* and below the roof. The entablature has three parts: *architrave* or epistyle, *frieze,* and *pediment.*

Environmental art—An American art form that emerged in the 1960s. Often using the land itself as their material, Environmental artists construct monuments of great scale and minimal form. Permanent or impermanent, these works transform some section of the environment, calling attention both to the land itself and to the hand of the artist. Sometimes referred to as Earth art or earthworks.

eravo—(ŭ-ˈra-vō) A men's meeting house constructed by the Elema people in New Guinea.

escutcheon—(ŭ-ˈskŭt-chŭn) An emblem bearing a coat of arms.

etching—A kind of *engraving* in which the design is *incised* in a layer of wax or varnish on a metal plate. The parts of the plate left exposed are then etched (slightly eaten away) by the acid in which the plate is immersed after incising. See also *drypoint, engraving, intaglio.*

expressionism—Twentieth-century *modernist* art that is the result of the artist's unique inner or personal vision and that often has an emotional dimension. Expressionism contrasts with art focused on visually describing the empirical world.

Fauvism—(ˈfō-viz-ŭm) From the French word *fauve,* "wild beast." An early-20th-century art movement led by Henri Matisse, for whom color became the formal element most responsible for pictorial coherence and the primary conveyor of meaning.

fête galante—(fet ga-ˈlaⁿ) A type of *Rococo* painting depicting the outdoor amusements of upper-class society.

figura serpentinata—(fi-ˈgŭ-ra ser-pen-ti-ˈna-ta) In Renaissance art, a contortion or twisting of the body in contrary directions, especially characteristic of the sculpture and paintings of Michelangelo and the Mannerists.

fin de siècle—(făⁿ-dŭ-sē-ˈek-lŭ) French, "end of the century." A period in Western cultural history from the end of the 19th century until just before World War I, when decadence and indulgence masked anxiety about an uncertain future.

finial—A crowning ornament.

flute or **fluting**—Vertical channeling, roughly semicircular in cross-*section* and used principally on *columns* and *pilasters.*

Fluxus—A group of American, European, and Japanese artists of the 1960s who created *Performance art.* Their performances often focused on single actions, such as turning a light on and off or watching falling snow, and were more theatrical than *Happenings.*

formalism—Strict adherence to, or dependence on, stylized shapes and methods of composition. An emphasis on an artwork's visual elements rather than its subject.

found objects—Images, materials, or objects as found in the everyday environment that are incorporated into works of art.

fresco—(ˈfres-kō) Painting on lime plaster, either dry (dry fresco or fresco secco) or wet (true or buon fresco). In the latter method, the pigments are mixed with water and become chemically bound to the freshly laid lime plaster. Also, a painting executed in either method.

fresco secco—(ˈfres-kō ˈsek-ō) See *fresco.*

frieze—(frēz) The part of the *entablature* between the *architrave* and the *cornice;* also, any sculptured or painted band in a building. See *register.*

frottage—(frō-ˈtazh) A process of rubbing a crayon or other medium across paper placed over surfaces with a strong and evocative texture pattern to combine patterns.

Futurism—An early-20th-century movement involving a militant group of Italian poets, painters, and sculptors. These artists published numerous manifestos

declaring revolution in art against all traditional tastes, values, and styles and championing the modern age of steel and speed and the cleansing virtues of violence and war.

garbha griha—(ˈgarb-ha ˈgrē-ha) Hindi, "womb chamber." In Hindu temples, the *cella,* the holy inner sanctum, for the cult image or symbol.

genetrix—A legendary founding clan mother.

genre—(ˈzhäⁿ-rŭ) A style or category of art; also, a kind of painting that realistically depicts scenes from everyday life.

German Expressionism—An early-20th-century art movement; German Expressionist works are characterized by bold, vigorous brushwork, emphatic line, and bright color. Two important groups of German Expressionists were Die Brÿcke, in Dresden, and Der Blaue Reiter, in Munich.

gestural abstraction—Also known as *action painting.* A kind of abstract painting in which the gesture, or act of painting, is seen as the subject of art. Its most renowned proponent was Jackson Pollock. See also *Abstract Expressionism.*

glaze—A vitreous coating applied to pottery to seal and decorate the surface; it may be colored, transparent, or opaque, and glossy or *matte.* In oil painting, a thin, transparent, or semitransparent layer put over a color to alter it slightly.

gopuras—(ˈgō-pū-rŭz) The massive, ornamented entrance gateway towers of South Indian temple compounds.

Gothic—Originally a derogatory term named after the Goths, used to describe the history, culture, and art of medieval western Europe in the 12th to 14th centuries.

graver—An *incising* tool used by engravers and sculptors.

Greek cross—A cross with four arms of equal length and at right angles.

grisaille—(grŭ-ˈzīy) A monochrome painting done mainly in neutral grays to simulate sculpture.

groin or **cross vault**—Formed by the intersection at right angles of two barrel vaults of equal size. Lighter in appearance than the barrel vault, the groin vault requires less *buttressing.* See *vault.*

Happenings—A term coined by American artist Allan Kaprow in the 1960s to describe loosely structured performances, whose creators were trying to suggest the aesthetic and dynamic qualities of everyday life; as actions, rather than objects, Happenings incorporate the fourth dimension (time).

hard-edge painting—A variant of *Post-Painterly Abstraction* that rigidly excluded all reference to gesture, and incorporated smooth knife-edge geometric forms to express the notion that painting should be reduced to its visual components.

Harlem Renaissance—A particularly fertile period of cultural production for African Americans. During the 1920s and 1930s, African American artists, writers, and musicians celebrated their heritage and culture and redefined artistic forms of expression.

hatching—A technique used in drawing and in printmaking methods such as *engraving* and *woodcut,* in which fine lines are cut or drawn close together to achieve an effect of shading.

heiau—(hī-yau) A Hawaiian temple structure.

Hevehe—(he-ve-he) An elaborate cycle of ceremonial activities performed by the Elema people of the Papuan Gulf region of New Guinea. Also the large, ornate masks that were produced for and presented during these ceremonies.

hieroglyphic—(hī-rō-ˈglif-ik) A system of writing using symbols or pictures.

humanism—In the Renaissance, an emphasis on education and on expanding knowledge (especially of classical antiquity), the exploration of individual potential and a desire to excel, and a commitment to civic responsibility and moral duty.

Impressionism—A late-19th-century art movement that sought to capture a fleeting moment, thereby conveying the illusiveness and impermanence of images and conditions.

incise—(in-ˈsīz) To cut into a surface with a sharp instrument; also, a method of decoration, especially on metal and pottery.

inscriptions—Texts written on the same surface as the picture (as in Chinese paintings) or *incised* in stone (as in ancient art). See also *colophon.*

installation—An artwork that creates an artistic environment in a room or gallery.

intaglio—(in-ˈta-lē-ō) A graphic technique in which the design is *incised,* or scratched, on a metal plate, either manually *(engraving, drypoint)* or chemically *(etching).* The incised lines of the design take the ink, making this the reverse of the *woodcut* technique.

intarsia—(in-ˈtar-sē-ŭ) Inlay work in wood of design elements made from such materials as mother-of-pearl, marble, and ivory.

International Style—A style of 14th- and 15th-century painting begun by Simone Martini, who adapted the French *Gothic* manner to Sienese art fused with influences from the North. This style appealed to the aristocracy because of its brilliant color, lavish costume, intricate ornament, and themes involving splendid processions of knights and ladies. Also a style of 20th-century architecture associated with Le Corbusier, whose elegance of design came to influence the look of modern office buildings and skyscrapers.

Ionic—(ī-ˈan-ik) One of the two systems (or *orders*) evolved for articulating the three units of the *elevation* of a Greek temple: the platform, the *colonnade,* and the superstructure *(entablature).* The Ionic order is characterized by, among other features, *volutes, capitals, columns* with *bases,* and an uninterrupted *frieze.*

Japonisme—(zhă-pŭ-ˈnēz-mŭ) The French fascination with all things Japanese. Japonisme emerged in the second half of the 19th century.

katsina—(kŭ-ˈchē-nŭ) An art form of Native Americans of the Southwest, the katsina doll represents benevolent supernatural spirits (katsinas) living in mountains and water sources.

kiva—(ˈkē-vŭ) A large circular underground structure that is the spiritual and ceremonial center of Pueblo Indian life.

koru—(ˈka-rū) An unrolled spiral design used by the Maori in their tattoos.

kula—(ˈkū-lŭ) An exchange of white conus-shell arm ornaments and red chama-shell necklaces that takes place among the Trobriand Islanders. These exchanges serve to stimulate the economy and cement social relationships.

lacquer—(ˈläk-ŭr) A varnishlike substance made from the sap of the Asiatic sumac, used to decorate wood and other organic materials. Often colored with mineral pigments, lacquer cures to great hardness and has a lustrous surface.

landscape—A picture showing natural scenery, without narrative content.

Lapita pottery—(ˈlă-pĭ-tŭ) Ceramic vessels elaborately decorated with incised, geometric designs. Found in a geographical region roughly bounded by New Guinea in the west and Tonga and Samoa in the east.

letterpress—The technique of printing with movable type invented in Germany in the 15th century.

linear perspective—See *perspective.*

lintel—(ˈlĭn-tŭl) A beam used to span an opening.

literati—(lĭt-ŭ-ˈra-tē) In China, talented amateur painters and scholars from the landed gentry.

local color—An object's actual color in white light.

loggia—(ˈlo-jŭ) A gallery with an open *arcade* or a *colonnade* on one or both sides.

logogram—(ˈla-gŭ-gram) One of the thousands of characters in the Chinese writing system, corresponding to one meaningful language unit. See also *pictograph.*

ma-hevehe—(ma-he-ve-hŭ) Mythical water spirits; the Elema people of New Guinea believed that these spirits visited their villages.

malanggan—(ma-lang-gan) Both the festivals held in honor of the deceased in New Ireland (Papua New Guinea) and the carvings and objects produced for these festivals.

mandapa—(man-ˈda-pa) *Pillared* hall of a Hindu temple.

Mannerism—A style of later Renaissance art that emphasized "artifice," often involving contrived imagery not derived directly from nature. Such artworks showed a self-conscious stylization involving complexity, caprice, fantasy, and polish. Mannerist architecture tended to flout the classical rules of order, stability, and symmetry, sometimes to the point of parody.

manulua—(ma-nu-lu-a) Tongan, "two birds." A Tongan design motif that symbolizes chiefly status derived from both parents.

masquerade—Among some African groups, a ritualized drama performed by several masked dancers, embodying ancestors or nature spirits.

matte (also **mat**)—(măt) In painting, pottery, and photography, a dull finish.

mbari house—(ŭm-ˈba-rĭ) An Igbo renewal house, constructed from mud every 50 years as a sacrifice to a major deity, often Ala, goddess of the earth.

medium—The material (for example, marble, bronze, clay, fresco) in which an artist works; also, in painting, the vehicle (usually liquid) that carries the pigment.

memento mori—(mi-ˈment-ō ˈmo-rē) A reminder of human mortality, usually represented by a skull.

mendicants—In medieval Europe, friars belonging to the Franciscan and Dominican orders, who renounced all worldly goods, lived by contributions of laypersons (the word *mendicant* literally means "beggar"), and devoted themselves to preaching, teaching, and doing good works.

Mesoamerica—The region that comprises Mexico, Guatemala, Belize, Honduras, and the Pacific coast of El Salvador.

metope—(ˈmet-ŭ-pē) The panel between the *triglyphs* in a *Doric frieze,* often sculpted in *relief.*

Mexica—The name used by a group of initially migratory invaders from northern Mexico to identify themselves. Settling on an island in Lake Texcoco in central Mexico, they are known today as the Aztecs.

miniatures—Small individual paintings intended by Indian painters to be held in the hand and viewed by one or two individuals at one time.

Minimalism (Minimal art)—A predominantly sculptural American trend of the 1960s whose works consist of a severe reduction of form, oftentimes to single, homogeneous units.

moai—(mō-ī) A large, blocky figural stone sculpture found on Rapa Nui (Easter Island).

modeling—The shaping or fashioning of three-dimensional forms in a soft material, such as clay; also, the gradations of light and shade reflected from the surfaces of matter in space, or the illusion of such gradations produced by alterations of value in a drawing, painting, or print.

modernism—A movement in Western art that developed in the second half of the 19th century and sought to capture the images and sensibilities of the age. Modernist art goes beyond simply dealing with the present and involves the artist's critical examination of the premises of art itself.

moko—The form of tattooing practiced by the Maori of New Zealand (Aotearoa).

Nabis—(ˈnă-bĭs) Hebrew, "prophet." A group of *Symbolist* painters influenced by Paul Gauguin.

nave—The central area of an ancient Roman *basilica* or of a church, demarcated from *aisles* by *piers* or *columns.*

Neoclassicism—A style of art and architecture that emerged in the later 18th century. Part of a general

revival of interest in classical cultures, Neoclassicism was characterized by the utilization of themes and styles from ancient Greece and Rome.

Neo-Expressionism—An art movement that emerged in the 1970s and that reflects the artists' interest in the expressive capability of art, seen earlier in *German Expressionism* and *Abstract Expressionism.*

Neoplasticism—A theory of art developed by Piet Mondrian to create a pure plastic art composed of the simplest, least subjective, elements, *primary colors,* primary values, and primary directions (horizontal and vertical).

Neue Sachlichkeit (New Objectivity)—('noi-ŭ 'sak-lĭk-kīt) An art movement that grew directly out of the World War I experiences of a group of German artists who sought to show the horrors of the war and its effects.

ngatu—((n)ga-tu) *Tapa* made by women in Tonga.

nihonga—(nē-hong-ga) A 19th-century Japanese painting style that incorporated some Western techniques in basically Japanese-style painting, as opposed to *yoga* (Western painting).

nishiki-e—(ni-shi-ki-e) Japanese, "brocade pictures." Japanese polychrome woodblock prints valued for their sumptuous quality.

nkisi n'kondi—((n)kē-sē (n)kan-dē) A power figure carved by the Kongo people of the Democratic Republic of Congo. Such images embodied spirits believed to heal and give life or capable of inflicting harm or death.

oculus (pl., **oculi**)—(a-kyū-lus/a-kyū-lē) The round central opening or "eye" of a dome. Also, small round windows in *Gothic cathedrals.*

ogive (adj., **ogival**)—(ō-'jī-vŭl) The diagonal *rib* of a *Gothic vault;* a pointed, or Gothic, *arch.*

order—In classical architecture, a style represented by a characteristic design of the *columns* and *entablature.* See also *superimposed orders.*

orthogonal—(or-'thag-ŭn-ŭl) A line imagined to be behind and perpendicular to the picture plane; the orthogonals in a painting appear to recede toward a vanishing point on the horizon.

overglaze—In *porcelain* decoration, the technique of applying mineral colors over the *glaze* after the work has been fired. The overglaze colors, or *enamels,* fuse to the glazed surface in a second firing at a much lower temperature than the main firing. See also *underglaze.*

pagoda—(pŭ-'gō-dŭ) A Chinese tower, usually associated with a Buddhist temple, having a multiplicity of winged *eaves;* thought to be derived from the Indian *stupa.*

parchment—Lambskin prepared as a surface for painting or writing.

pediment—In classical architecture, the triangular space (gable) at the end of a building, formed by the ends of the sloping roof above the *colonnade;* also, an ornamental feature having this shape.

pendentive—A concave, triangular section of a hemisphere, four of which provide the transition from a square area to the circular base of a covering *dome.* Although pendentives appear to be hanging (pendant) from the dome, they in fact support it.

Performance art—An American avant-garde art trend of the 1960s that made time an integral element of art. It produced works in which movements, gestures, and sounds of persons communicating with an audience replace physical objects. Documentary photographs are generally the only evidence remaining after these events. See also *Happenings.*

perspective—A formula for projecting an illusion of the three-dimensional world onto a two-dimensional surface. In linear perspective, the most common type, all parallel lines or lines of projection seem to converge on one, two, or three points located with reference to the eye level of the viewer (the horizon line of the picture), known as vanishing points, and associated objects are rendered smaller the farther from

the viewer they are intended to seem. Atmospheric, or aerial, perspective creates the illusion of distance by the greater diminution of color intensity, the shift in color toward an almost neutral blue, and the blurring of contours as the intended distance between eye and object increases.

photomontage—(fō-tō-mon-'taj) A composition made by pasting together pictures or parts of pictures, especially photographs. See also *collage.*

Photorealists—See *Superrealism.*

pictograph—('pik-tō-grăf) A picture, usually stylized, that represents an idea; also, writing using such means; also painting on rock. See also *hieroglyphic.*

pier—A vertical, freestanding masonry support.

pilaster—A flat, rectangular, vertical member projecting from a wall of which it forms a part. It usually has a *base* and a *capital* and is often *fluted.*

pillar—Usually a weight-carrying member, such as a *pier* or a *column;* sometimes an isolated, freestanding structure used for commemorative purposes.

Pittura Metafisica—(pē-'tū-ra me-ta-'fē-sē-ka) Italian, "metaphysical painting." An early-20th-century Italian art movement led by Giorgio de Chirico, whose work conveys an eerie mood and visionary quality.

Plateresque—(plă-tŭr-'esk) A 15th- and 16th-century style of Spanish architecture characterized by elaborate decoration based on *Gothic,* Italian Renaissance, and Islamic sources; derived from the Spanish word *platero,* meaning "silversmith."

plein air—('plen-ār) An approach to painting much favored by the *Impressionists,* in which artists sketch outdoors to achieve a quick impression of light, air, and color. The sketches were then taken to the studio for reworking into more finished works of art.

poesia—(pō-e-zē-ŭ) A term describing "poetic" art, notably Venetian Renaissance paintings, which emphasizes the lyrical and sensual.

pointillism—('poin-tŭ-liz-ŭm) A system of painting devised by the 19th-century French painter Georges Seurat. The artist separates color into its component parts and then applies the component colors to the canvas in tiny dots (points). The image becomes comprehensible only from a distance, when the viewer's eyes optically blend the pigment dots. Sometimes referred to as divisionism.

polyptych—('pa-lŭp-tĭk) An *altarpiece* made up of more than three sections.

Pop art—A term coined by British art critic Lawrence Alloway to refer to art, first appearing in the 1950s, that incorporated elements from consumer culture, the mass media, and popular culture, such as images from motion pictures and advertising.

porcelain—('por-sŭ-lŭn) Extremely fine, hard, white ceramic. Unlike stoneware, porcelain is made from a fine white clay called kaolin mixed with ground petuntse, a type of feldspar. True porcelain is translucent and rings when struck.

postmodernism—A reaction against *modernist formalism,* seen as elitist. Far more encompassing and accepting than the more rigid confines of modernist practice, postmodernism offers something for everyone by accommodating a wide range of styles, subjects, and formats, from traditional easel painting to *installation* and from abstraction to illusionistic scenes. Postmodern art often includes irony or reveals a self-conscious awareness on the part of the artist of the processes of art making or the workings of the art world.

Post-Painterly Abstraction—An American art movement that emerged in the 1960s and was characterized by a cool, detached rationality emphasizing tighter pictorial control. See also *color field painting* and *hard-edge painting.*

pou tokomanawa—('po-ŭ 'to-ko-ma-na-wa) A sculpture of an ancestor that supports a ridge pole of a Maori meetinghouse.

pouncing—The method of transferring a sketch onto paper by tracing, using thin, transparent gazelle skin placed on top of the sketch, pricking the contours of the design with a pin, placing the skin on paper, and forcing black pigment through the holes.

poupou—('po-ŭ-po-ŭ) A decorated wall panel in a Maori meetinghouse.

Precisionists—A group of American painters, active in the 1920s and 1930s, whose work concentrated on portraying man-made environments in a clear and concise manner to express the beauty of perfect and precise machine forms.

predella—(prŭ-'del-lŭ) The narrow ledge on which an *altarpiece* rests on an altar.

Pre-Raphaelite Brotherhood—A group of 19th-century artists who refused to be limited to contemporary scenes and chose instead to represent fictional, historical, and fanciful subjects in a style influenced by Italian artists before Raphael.

primary colors—Red, yellow, and blue—the colors from which all other colors may be derived.

Productivism—An art movement that emerged in the Soviet Union after the Revolution; its members believed that artists must direct art toward creating products for the new society.

pueblo—('pwe-blō) A communal multistoried dwelling made of stone or *adobe* brick by the Native Americans of the Southwest; with cap. also used to refer to various groups that occupied such dwellings.

pukao—('pu-ka-ō) A small red scoria cylinder that appears as a hat on *moai.*

quadro riportato—('kwa-drō re-por-'ta-tō) A ceiling design in which painted scenes are arranged in panels that resemble framed pictures transferred to the surface of a shallow, curved *vault.*

quatrefoil—('ka-trŭ-foil) A shape or plan in which the parts assume the form of a cloverleaf.

quipu—('kē-pū) Andean record-keeping device made of fibers in which numerous knotted strings hung from a main cord were used to record, by position and color, numbers and categories of things.

quoins—(kwoins) The large, sometimes *rusticated,* usually slightly projecting stones that often form the corners of the exterior walls of masonry buildings.

Realism—A movement that emerged in mid-19th-century France. Realist artists represented the subject matter of everyday life (especially that which up until then had been considered inappropriate for depiction) in a relatively naturalistic mode.

Regionalism—A 20th-century American movement that portrayed American rural life in a clearly readable, realist style. Major Regionalists include Grant Wood and Thomas Hart Benton.

register—One of a series of superimposed bands or *friezes* in a pictorial narrative, or the particular levels on which motifs are placed.

relief—In sculpture, figures projecting from a background of which they are part. The degree of relief is designated high, low (bas), or sunken. In the last, the artist cuts the design into the surface so that the highest projecting parts of the image are no higher than the surface itself. See also *repoussé.*

repoussé—(rŭ-pū-'sā) Formed in *relief* by beating a metal plate from the back, leaving the impression on the face. The metal is hammered into a hollow mold of wood or some other pliable material and finished with a *graver.* See also *relief.*

retable—(rē-'tā-bŭl) An architectural screen or wall above and behind an altar, usually containing painting, sculpture, carving, or other decorations. See also *altarpiece.*

rib—A relatively slender, molded masonry *arch* that projects from a surface. In *Gothic* architecture, the ribs form the framework of the *vaulting.* A diagonal rib is one of the ribs that form the X of a *groin vault.* A transverse rib crosses the nave or aisle at a 90-degree angle.

Rococo—(rō-kō-'kō) A style, primarily of interior

design, that appeared in France around 1700. Rococo interiors were extensively decorated and included elegant furniture, small sculpture, ornamental mirrors, easel paintings, *tapestries,* reliefs, and wall painting.

Romanticism—A Western cultural phenomenon, beginning around 1750 and ending about 1850, that gave precedence to feeling and imagination over reason and thought. More narrowly, the art movement that flourished from about 1800 to 1840.

rotulus—('rat-yū-lŭs) The manuscript scroll used by Egyptians, Greeks, Etrus-cans, and Romans; predecessor of the *codex.*

rotunda—(rō-'tŭnd-ŭ) The circular area under a *dome;* also a domed round building.

rusticate—To give a rustic appearance by roughening the surfaces and beveling the edges of stone blocks to emphasize the joints between them. Rustication is a technique employed in ancient Roman architecture and popular during the Renaissance, especially for stone courses at the ground-floor level.

sabi—('sa-bī) The value found in the old and weathered, suggesting the tranquility reached in old age.

sacra conversazione—('sa-kra kno-ver-sa-tsē-o-nā) Italian, "holy conversation"; a style of *altarpiece* painting popular after the middle of the 15th century, in which saints from different epochs are joined in a unified space and seem to be conversing either with each other or with the audience.

saint—From the Latin word *sanctus,* meaning "made holy by God." Persons who suffered and died for their Christian faith or who merited reverence for their Christian devotion while alive. In the Roman Catholic Church, a worthy deceased Catholic who is canonized by the pope.

samurai—('sam-ŭ-rī) Medieval Japanese warriors.

section—In architecture, a diagram or representation of a part of a structure or building along an imaginary plane that passes through it vertically. Drawings showing a theoretical slice across a structure's width are lateral sections. Those cutting through a building's length are longitudinal sections. See also *elevation* and *cutaway.*

sfumato—(sfū-'ma-tō) A smokelike haziness that subtly softens outlines in painting; particularly applied to the painting of Leonardo and Correggio.

shaft—The tall, cylindrical part of a *column* between the *capital* and the *base.*

shogun—('shō-gŭn) In 14th- through 19th-century Japan, a military governor who managed the country on behalf of a figurehead emperor.

silverpoint—A *stylus* made of silver, used in drawing in the 14th and 15th centuries because of the fine line it produced and the sharp point it maintained.

stanza (pl. **stanze**)—('stan-zā/'stan-zē) Italian, "room."

stigmata—(stĭ g-'ma-tŭ) In Christian art, the wounds that Christ received at his crucifixion that miraculously appear on the body of a saint.

stylus—A needlelike tool used in *engraving* and *incising;* also, an ancient writing instrument used to inscribe clay or wax tablets.

superimposed orders—*Orders* of architecture that are placed one above another in an *arcaded* or *colonnaded* building, usually in the following sequence: *Doric* (the first story), *Ionic,* and *Corinthian.* Superimposed orders are found in later Greek architecture

and were used widely by Roman and Renaissance builders.

superimposition—The nesting of earlier structures within later ones, a common *Mesoamerican* building trait.

Superrealism—A school of painting and sculpture of the 1960s and 1970s that emphasized producing artworks based on scrupulous fidelity to optical fact. The Superrealist painters were also called Photorealists because many used photographs as sources for their imagery.

Suprematism—A type of art formulated by Kazimir Malevich to convey his belief that the supreme reality in the world is pure feeling, which attaches to no object and thus calls for new, nonobjective forms in art—shapes not related to objects in the visible world.

Surrealism—A successor to *Dada,* Surrealism incorporated the improvisational nature of its predecessor into its exploration of the ways to express in art the world of dreams and the unconscious. Biomorphic Surrealists, such as Joan Miró, produced largely abstract compositions. Naturalistic Surrealists, notably Salvador Dalí, presented recognizable scenes transformed into a dream or nightmare image.

Symbolism—A late-19th-century movement based on the idea that the artist was not an imitator of nature but a creator who transformed the facts of nature into a symbol of the inner experience of that fact.

Synthetic Cubism—A later phase of *Cubism,* in which paintings and drawings were constructed from objects and shapes cut from paper or other materials to represent parts of a subject, in order to engage the viewer with pictorial issues, such as figuration, realism, and abstraction.

tapa—(ta-pa) Barkcloth made particularly in Polynesia. Tapa is often dyed, painted, stenciled, and sometimes perfumed.

tapestry—A weaving technique in which the *weft* threads are packed densely over the *warp* threads so that the designs are woven directly into the fabric.

tarashikomi—(ta-ra-shi-ko-mē) In Japanese art, a painting technique involving the dropping of ink and pigments onto surfaces still wet with previously applied ink and pigments.

tatami—(ta-ta-mē) The traditional woven straw mat used for floor covering in Japanese architecture.

tempera—('tem-pŭ-rŭ) A technique of painting using pigment mixed with egg yolk, glue, or casein; also the *medium* itself.

tenebrism—('ten-ŭ-briz(-ŭ)m) Painting in the "dark manner," using violent contrasts of light and dark, as in the work of Caravaggio.

tholos (pl. **tholoi**)—('thō-los/'thō-loi) A temple with a circular plan.

thrust—The outward force exerted by an *arch* or a *vault* that must be counterbalanced by *buttresses.*

tiki—A Marquesan three-dimensional carving of an exalted, deified ancestor figure.

togu na—(tō-gū na) "House of words." The Dogon (Mali) men's house, where deliberations vital to community welfare take place.

tokonoma—(to-ko-no-ma) A shallow alcove in a Japanese room, which is used for decoration, such as a painting or stylized flower arrangement.

tondo—('ton-dō) A circular painting or *relief* sculpture.

triglyph—('tri-glif) A triple projecting, grooved member of a *Doric frieze* that alternates with *metopes.*

triptych—('trip-tik) A three-paneled painting or *altarpiece.*

trompe l'oeil—(troⁿp 'loi) French, "fools the eye." A form of illusionistic painting that aims to deceive viewers into believing that they are seeing real objects rather than a representation of those objects.

tukutuku—('tu-ku-tu-ku) A stitched lattice panel found in a Maori meetinghouse.

ukiyo-e—(ū-kē-yō-ā) Japanese, "pictures of the floating world." A style of Japanese *genre* painting that influenced 19th-century Western art.

underglaze—In *porcelain* decoration, the technique of applying of mineral colors to the surface before the main firing, followed by an application of clear *glaze.* See also *overglaze.*

vanitas—('va-nē-tas) A term describing paintings (particularly 17th-century Dutch still lifes) that include references to death.

vault—A masonry roof or ceiling constructed on the *arch* principle. A barrel or tunnel vault, semicylindrical in cross-*section,* is in effect a deep arch or an uninterrupted series of arches, one behind the other, over an oblong space. A quadrant vault is a half-barrel vault. A *groin* or cross vault is formed at the point at which two barrel vaults intersect at right angles. In a ribbed vault, there is a framework of *ribs* or arches under the intersections of the vaulting sections. A sexpartite vault is a rib vault with six panels. A fan vault is a vault characteristic of English Perpendicular *Gothic,* in which radiating ribs form a fanlike pattern.

veduta—(ve-'dū-ta) Italian, "view." A type of naturalistic landscape and cityscape painting popular in 18th-century Venice.

vellum—Calfskin prepared as a surface for writing or painting.

vimana—(vĭ-'ma-na) A pyramidal tower over the *garbha griha* of a Hindu temple of the southern, or Dravida, style.

volute—(vŭ-'lūt) A spiral, scroll-like form characteristic of the ancient Greek *Ionic* and the Roman *Composite capital.*

voussoir—(vū-'swar) A wedge-shaped block used in the construction of a true *arch.* The central voussoir, which sets the arch, is the keystone.

wabi—(wa-bē) A 16th-century Japanese art style characterized by refined rusticity and an appreciation of simplicity and austerity.

waka sran—(wa-ka sran) "People of wood." Baule (Côte d'Ivoire) wooden figural sculptures.

warp—The vertical threads of a loom or cloth.

weft—The horizontal threads of a loom or cloth.

woodcut—A wooden block on the surface of which those parts not intended to print are cut away to a slight depth, leaving the design raised; also, the printed impression made with such a block.

yang—In Chinese cosmology, the principle of active masculine energy, which permeates the universe in varying proportions with yin, the principle of passive feminine energy.

yin—See *yang.*

yoga—See *nihonga.*

Zen—A Japanese Buddhist sect and its doctrine, emphasizing enlightenment through intuition and introspection rather than the study of scripture. In Chinese, *Chan.*

BIBLIOGRAPHY

This list of books is intended to be comprehensive enough to satisfy the reading interests of the beginning art history student and general reader, as well as those of more advanced readers who wish to become acquainted with fields other than their own. The resources listed range from works that are valuable primarily for their reproductions to those that are scholarly surveys of schools and periods. No entries for periodical articles appear, but some of the major periodicals that publish art-historical scholarship in English are noted.

SELECTED PERIODICALS

The following list is by no means exhaustive. Students wishing to pursue research in journals should contact their instructor, their college or university's reference librarian, or the online catalogue for additional titles.

African Arts
American Indian Art
American Journal of Archaeology
Archaeology
Archives of Asian Art
Ars Orientalis
The Art Bulletin
Art History
The Art Journal
The Burlington Magazine
Journal of the Society of Architectural Historians
Journal of the Warburg and Courtauld Institutes
Latin American Antiquity
Oxford Art Journal

GENERAL STUDIES

Arntzen, Etta, and Robert Rainwater. *Guide to the Literature of Art History.* Chicago: American Library Association, 1981.

Bator, Paul M. *The International Trade in Art.* Chicago: University of Chicago Press, 1988.

Baxandall, Michael. *Patterns of Intention: On the Historical Explanation of Pictures.* New Haven: Yale University Press, 1985.

Bindman, David, ed. *The Thames & Hudson Encyclopedia of British Art.* London: Thames & Hudson, 1988.

Broude, Norma, and Mary D. Garrard, eds. *The Expanding Discourse: Feminism and Art History.* New York: Harper Collins, 1992.

———. *Feminism and Art History: Questioning the Litany.* New York: Harper & Row, 1982.

Bryson, Norman. *Vision and Painting: The Logic of the Gaze.* New Haven: Yale University Press, 1983.

Bryson, Norman, Michael Ann Holly, and Keith Moxey. *Visual Theory: Painting and Interpretation.* New York: Cambridge University Press, 1991.

Cahn, Walter. *Masterpieces: Chapters on the History of an Idea.* Princeton, N.J.: Princeton University Press, 1979.

Chadwick, Whitney. *Women, Art, and Society.* New York: Thames & Hudson, 1990.

Cheetham, Mark A., Michael Ann Holly, and Keith Moxey, eds. *The Subjects of Art History: Historical Objects in Contemporary Perspective.* New York: Cambridge University Press, 1998.

Chilvers, Ian, and Harold Osborne, eds. *The Oxford Dictionary of Art.* Rev. ed. New York: Oxford University Press, 1997.

Cummings, P. *Dictionary of Contemporary American Artists.* 6th ed. New York: St. Martin's Press, 1994.

Deepwell, K., ed. *New Feminist Art.* Manchester: Manchester University Press, 1994.

Derrida, Jacques. *The Truth in Painting.* Chicago: University of Chicago Press, 1987.

Encyclopedia of World Art. 15 vols. New York: Publisher's Guild, 1959–1968. Supplementary vols. 16, 1983; 17, 1987.

Fielding, Mantle. *Dictionary of American Painters, Sculptors, and Engravers.* 2nd rev. and enl. ed. Poughkeepsie, N.Y.: Apollo, 1986.

Fleming, John, Hugh Honour, and Nikolaus Pevsner. *Penguin Dictionary of Architecture.* 4th ed. New York: Penguin, 1991.

Frazier, Nancy. *The Penguin Concise Dictionary of Art History.* New York: Penguin, 2000.

Freedberg, David. *The Power of Images: Studies in the History and Theory of Response.* Chicago: University of Chicago Press, 1989.

Giedion, Siegfried. *Space, Time and Architecture: The Growth of a New Tradition.* 5th ed. Cambridge, Mass.: Harvard University Press, 1982.

Gombrich, Ernst Hans Josef. *Art and Illusion.* 5th ed. London: Phaidon, 1977.

Haggar, Reginald G. *A Dictionary of Art Terms: Architecture, Sculpture, Painting, and the Graphic Arts.* Poole: New Orchard Editions, 1984.

Hall, James. *Dictionary of Subjects and Symbols in Art.* 2nd rev. ed. London: J. Murray, 1979.

Harris, Anne Sutherland, and Linda Nochlin. *Women Artists: 1550–1950.* Los Angeles: Los Angeles County Museum of Art; New York: Knopf, 1977.

Hauser, Arnold. *The Sociology of Art.* Chicago: University of Chicago Press, 1982.

Hind, Arthur M. *A History of Engraving and Etching from the Fifteenth Century to the Year 1914.* 3rd rev. ed. New York: Dover, 1963.

Holt, Elizabeth Gilmore, ed. *A Documentary History of Art.* 2nd ed. 2 vols. Princeton, N.J.: Princeton University Press, 1981.

Hults, Linda C. *The Print in the Western World: An Introductory History.* Madison: University of Wisconsin Press, 1996.

Kostof, Spiro. *A History of Architecture: Settings and Rituals.* 2nd ed. Oxford: Oxford University Press, 1995.

Kronenberger, Louis. *Atlantic Brief Lives: A Biographical Companion to the Arts.* Boston: Little, Brown, 1971.

Kultermann, Udo. *The History of Art History.* New York: Abaris, 1993.

Lucie-Smith, Edward. *The Thames & Hudson Dictionary of Art Terms.* London: Thames & Hudson, 1984.

Murray, Peter, and Linda Murray. *A Dictionary of Art and Artists.* 5th ed. New York: Penguin, 1988.

Myers, Bernard S., ed. *Encyclopedia of Painting: Painters and Painting of the World from Prehistoric Times to the Present Day.* 4th rev. ed. New York: Crown, 1979.

Myers, Bernard S., and Myers, Shirley D., eds. *Dictionary of 20th-Century Art.* New York: McGraw-Hill, 1974.

Nelson, Robert S., and Richard Shiff, eds. *Critical Terms for Art History.* Chicago: University of Chicago Press, 1996.

Osborne, Harold, ed. *The Oxford Companion to 20th Century Art.* New York: Oxford University Press, 1981.

Parker, Rozsika, and Griselda Pollock. *Old Mistresses: Women, Art, and Ideology.* London: Routledge & Kegan Paul, 1981.

Penny, Nicholas. *The Materials of Sculpture.* New Haven: Yale University Press, 1993.

Pevsner, Nikolaus. *A History of Building Types.* London: Thames & Hudson, 1987. Reprint of 1979 ed.

———. *An Outline of European Architecture.* 8th ed. Baltimore: Penguin, 1974.

———. *The Buildings of England.* 46 vols. Harmondsworth: Penguin, 1951–1974.

Pierce, James Smith. *From Abacus to Zeus: A Handbook of Art History.* 7th ed. Upper Saddle River, N.J.: Pearson Prentice Hall, 1998.

Placzek, Adolf K., ed. *Macmillan Encyclopedia of Architects.* 4 vols. New York: Macmillan, 1982.

Podro, Michael. *The Critical Historians of Art.* New Haven: Yale University Press, 1982.

Pollock, Griselda. *Vision and Difference: Femininity, Feminism and Histories of Art.* London: Routledge, 1988.

Preziosi, Donald, ed. *The Art of Art History: A Critical Anthology.* New York: Oxford University Press, 1998.

Reid, Jane D. *The Oxford Guide to Classical Mythology in the Arts 1300–1990s.* 2 vols. New York: Oxford University Press, 1993.

Rosenblum, Naomi. *A World History of Photography.* New York: Abbeville, 1984.

Roth, Leland M. *Understanding Architecture: Its Elements, History, and Meaning.* New York: Harper & Row, 1993.

Rubenstein, Charlotte Streifer. *American Women Artists from Early Indian Times to the Present.* Boston: G. K. Hall/Avon Books, 1982.

Slatkin, Wendy. *Women Artists in History: From Antiquity to the 20th Century.* 2nd ed. Upper Saddle River, N.J.: Prentice Hall, 1985.

Smith, Alistair, ed. *The Larousse Dictionary of Painters.* New York: Larousse, 1981.

Smith, G. E. Kidder. *The Architecture of the United States: An Illustrated Guide to Buildings Open to the Public.* 3 vols. Garden City, N.J.: Doubleday/Anchor, 1981.

Stangos, Nikos. *The Thames & Hudson Dictionary of Art and Artists.* Rev. ed. New York: Thames & Hudson, 1994.

Steer, John, and Antony White. *Atlas of Western Art History: Artists, Sites and Monuments from Ancient Greece to the Modern Age.* New York: Facts on File, 1994.

Stratton, Arthur. *The Orders of Architecture: Greek, Roman and Renaissance.* London: Studio, 1986.

Sutton, Ian. *Western Architecture: From Ancient Greece to the Present.* New York: Thames & Hudson, 1999.

Trachtenberg, Marvin, and Isabelle Hyman. *Architecture, from Prehistory to Post-Modernism.* New York: Abrams, 1986.

Tufts, Eleanor. *American Women Artists, Past and Present: A Selected Bibliographic Guide.* New York: Garland Publishers, 1984.

———. *Our Hidden Heritage: Five Centuries of Women Artists.* London: Paddington Press, 1974.

Turner, Jane, ed. *The Dictionary of Art.* 34 vols. New York: Grove Dictionaries, 1996.

Van Pelt, R., and Carroll William Westfall. *Architectural Principles in the Age of Historicism.* New Haven: Yale University Press, 1991.

Waterhouse, Ellis. *The Dictionary of British 18th Century Painters in Oils and Crayons.* Woodbridge, England: Antique Collectors' Club, 1981.

Wittkower, Rudolf. *Sculpture Processes and Principles.* New York: Harper & Row, 1977.

Wölfflin, Heinrich. *The Sense of Form in Art.* New York: Chelsea, 1958.

Young, William, ed. *A Dictionary of American Artists, Sculptors, and Engravers.* Cambridge, Mass.: W. Young, 1968.

CHAPTER 19
FROM GOTHIC TO RENAISSANCE: 14TH-CENTURY ITALIAN ART

Andrés, Glenn M., John M. Hunisak, and Richard Turner. *The Art of Florence.* 2 vols. New York: Abbeville Press, 1988.

Antal, Frederick. *Florentine Painting and Its Social Background.* London: Kegan Paul, 1948.

Bomford, David. *Art in the Making: Italian Painting before 1400.* London: National Gallery, 1989.

Borsook, Eve, and Fiorelli Superbi Gioffredi. *Italian Altarpieces 1250–1550: Function and Design.* Oxford: Clarendon Press, 1994.

Cennini, Cennino. *The Craftsman's Handbook (Il Libro dell'Arte).* Translated by Daniel V. Thompson Jr. New York: Dover, 1954.

Cole, Bruce. *Sienese Painting: From Its Origins to the Fifteenth Century*. New York: HarperCollins, 1987.

———. *Italian Art, 1250–1550: The Relation of Renaissance Art to Life and Society*. New York: Harper & Row, 1987.

Hills, Paul. *The Light of Early Italian Painting*. New Haven: Yale University Press, 1987.

Maginnis, Hayden B. J. *Painting in the Age of Giotto: A Historical Reevaluation*. University Park: Pennsylvania State University Press, 1997.

———. *The World of the Early Sienese Painter*. University Park: Pennsylvania State University Press, 2001.

Meiss, Millard. *Painting in Florence and Siena after the Black Death*. Princeton, N.J.: Princeton University Press, 1976.

Moskowitz, Anita Fiderer. *Italian Gothic Sculpture: c. 1250–c. 1400*. Cambridge: Cambridge University Press, 2001.

Norman, Diana, ed. *Siena, Florence, and Padua: Art, Society, and Religion 1280–1400*. New Haven: Yale University Press, 1995.

Panofsky, Erwin. *Renaissance and Renascences in Western Art*. New York: HarperCollins, 1972.

Pope-Hennessy, John. *Introduction to Italian Sculpture*. 3rd. ed. 3 vols. New York: Phaidon, 1986.

———. *Italian Gothic Sculpture*. 3rd ed. Oxford: Phaidon, 1986.

Smart, Alastair. *The Dawn of Italian Painting*. Ithaca, N.Y.: Cornell University Press, 1978.

White, John. *Art and Architecture in Italy: 1250–1400*. 3rd ed. New Haven: Yale University Press, 1993.

CHAPTER 20
PIETY, PASSION, AND POLITICS:
15TH-CENTURY ART IN NORTHEN
EUROPE AND SPAIN

Baxandall, Michael. *The Limewood Sculptors of Renaissance Germany*. New Haven: Yale University Press, 1980.

Blum, Shirley Neilsen. *Early Netherlandish Triptychs: A Study in Patronage*. Berkeley: University of California Press, 1969.

Campbell, Lorne. *The Fifteenth Century Netherlandish Schools*. London: National Gallery Publications, 1998.

Chatelet, Albert. *Early Dutch Painting*. New York: Konecky, 1988.

Cuttler, Charles P. *Northern Painting from Pucelle to Bruegel*. New York: Holt, Rinehart & Winston, 1968.

De Hamel, Christopher. *A History of Illuminated Manuscripts*. Oxford: Phaidon, 1986.

Friedlander, Max J. *Early Netherlandish Painting*. 14 vols. New York: Praeger/Phaidon, 1967–1976.

———. *From Van Eyck to Bruegel*. 3rd ed. Ithaca, N.Y.: Cornell University Press, 1981.

Harbison, Craig. *The Mirror of the Artist: Northern Renaissance Art in Its Historical Context*. New York: Abrams, 1995.

Huizinga, Johan. *The Autumn of the Middle Ages*. Translated by Rodney J. Payton and Ulrich Mammitzsch. Chicago: University of Chicago Press, 1996.

Jacobs, Lynn F. *Early Netherlandish Carved Altarpieces, 1380–1550: Medieval Tastes and Mass Marketing*. Cambridge: Cambridge University Press, 1998.

Lane, Barbara G. *The Altar and the Altarpiece: Sacramental Themes in Early Netherlandish Painting*. New York: Harper & Row, 1984.

Meiss, Millard. *French Painting in the Time of Jean de Berry: The Limbourgs and Their Contemporaries*. New York: Braziller, 1974.

Müller, Theodor. *Sculpture in the Netherlands, Germany, France and Spain: 1400–1500*. New Haven: Yale University Press, 1986.

Panofsky, Erwin. *Early Netherlandish Painting: Its Origins and Character*. 2 vols. Cambridge, Mass: Harvard University Press, 1966.

Prevenier, Walter, and Wim Blockmans. *The Burgundian Netherlands*. Cambridge: Cambridge University Press, 1986.

Snyder, James. *Northern Renaissance Art: Painting, Sculpture, the Graphic Arts from 1350 to 1575*. New York: Abrams, 1985.

Wolfthal, Diane. *The Beginnings of Netherlandish Canvas Painting, 1400–1530*. New York: Cambridge University Press, 1989.

CHAPTER 21
HUMANISM AND THE ALLURE
OF ANTIQUITY:
15TH-CENTURY ITALIAN ART

Adams, Laurie Schneider. *Key Monuments of the Italian Renaissance*. Denver, Colo.: Westview Press, 1999.

Alberti, Leon Battista. *On Painting*. Translated by John R. Spencer. Rev. ed. New Haven: Yale University Press, 1966. (Written 1435/36; originally published 1540)

———. *Ten Books on Architecture*. Edited by J. Rykwert; translated by J. Leoni. London: Tiranti, 1955. (Written ca. 1450; originally published 1486)

Ames-Lewis, Francis. *Drawing in Early Renaissance Italy*. New Haven: Yale University Press, 1981.

Baxandall, Michael. *Painting and Experience in Fifteenth Century Italy: A Primer in the Social History of Pictorial Style*. 2nd ed. New York: Oxford University Press, 1988.

Beck, James. *Italian Renaissance Painting*. New York: HarperCollins, 1981.

Bober, Phyllis Pray, and Ruth Rubinstein. *Renaissance Artists and Antique Sculpture: A Handbook of Sources*. Oxford: Oxford University Press, 1986.

Borsook, Eve. *The Mural Painters of Tuscany*. New York: Oxford University Press, 1981.

Burckhardt, Jacob. *The Architecture of the Italian Renaissance*. Chicago: University of Chicago Press, 1987. (Originally published 1868)

———. *The Civilization of the Renaissance in Italy*. London: Phaidon, 1960. (Originally published 1867)

Christiansen, Keith, Laurence B. Kanter, and Carl B. Strehle, eds. *Painting in Renaissance Siena, 1420–1500*. New York: Metropolitan Museum of Art, 1988.

Cole, Alison. *Virtue and Magnificence: Art of the Italian Renaissance Courts*. New York: Abrams, 1995.

Cole, Bruce. *Masaccio and the Art of Early Renaissance Florence*. Bloomington: Indiana University Press, 1980.

Dempsey, Charles. *The Portrayal of Love: Botticelli's Primavera and Humanist Culture at the Time of Lorenzo the Magnificent*. Princeton, N.J.: Princeton University Press, 1992.

Edgerton, Samuel Y., Jr. *The Heritage of Giotto's Geometry: Art and Science on the Eve of the Scientific Revolution*. Ithaca, N.Y.: Cornell University Press, 1991.

———. *The Renaissance Rediscovery of Linear Perspective*. New York: Harper & Row, 1976.

Gilbert, Creighton, ed. *Italian Art 1400–1500: Sources and Documents*. Evanston, Ill.: Northwestern University Press, 1992.

Goldthwaite, Richard A. *The Building of Renaissance Florence: An Economic and Social History*. Baltimore: Johns Hopkins University Press, 1980.

Gombrich, E. H. *Norm and Form: Studies in the Art of the Renaissance*. 4th ed. Oxford: Phaidon, 1985.

Hall, Marcia B. *Color and Meaning: Practice and Theory in Renaissance Painting*. Cambridge: Cambridge University Press, 1992.

Hartt, Frederick. *History of Italian Renaissance Art: Painting, Sculpture, Architecture*. 4th ed. Revised by David G. Wilkins. Upper Saddle River, N.J.: Prentice Hall, 1994.

Heydenreich, Ludwig H., and Wolfgang Lotz. *Architecture in Italy, 1400–1600*. Harmondsworth: Penguin, 1974.

Hollingsworth, Mary. *Patronage in Renaissance Italy: From 1400 to the Early Sixteenth Century*. Baltimore: Johns Hopkins University Press, 1994.

Kemp, Martin. *Behind the Picture: Art and Evidence in the Italian Renaissance*. New Haven: Yale University Press, 1997.

Kempers, Bram. *Painting, Power, and Patronage: The Rise of the Professional Artist in the Italian Renaissance*. London: Penguin, 1992.

Kent, F. W., and Patricia Simons, eds. *Patronage, Art, and Society in Renaissance Italy*. Canberra: Humanities Research Centre and Clarendon Press, 1987.

Lieberman, Ralph. *Renaissance Architecture in Venice*. New York: Abbeville Press, 1982.

McAndrew, John. *Venetian Architecture of the Early Renaissance*. Cambridge, Mass: MIT Press, 1980.

Meiss, Millard. *The Painter's Choice: Problems in the Interpretation of Renaissance Art*. New York: HarperCollins, 1977.

Murray, Peter. *The Architecture of the Italian Renaissance*. Rev. ed. New York: Schocken, 1986.

———. *Renaissance Architecture*. New York: Electa/Rizzoli, 1985.

Murray, Peter, and Linda Murray. *The Art of the Renaissance*. London: Thames & Hudson, 1985.

Olson, Roberta J. M. *Italian Renaissance Sculpture*. London: Thames & Hudson, 1992.

Panofsky, Erwin. *Renaissance and Renascences in Western Art*. New York: HarperCollins, 1972.

Pater, Walter. *The Renaissance: Studies in Art and Poetry*. Edited by D. L. Hill. Berkeley: University of California Press, 1980.

Pope-Hennessy, John. *An Introduction to Italian Sculpture*. 3rd ed. 3 vols. New York: Phaidon, 1986.

Seymour, Charles. *Sculpture in Italy: 1400–1500*. New Haven: Yale University Press, 1966.

Thomson, David. *Renaissance Architecture: Critics, Patrons, and Luxury*. Manchester: Manchester University Press, 1993.

Turner, A. Richard. *Renaissance Florence: The Invention of a New Art*. New York: Abrams, 1997.

Vasari, Giorgio. *Lives of the Painters, Sculptors and Architects*. Translated by Gaston du C. de Vere. New York: Knopf, 1996. (Originally published 1550)

Wackernagel, Martin. *The World of the Florentine Renaissance Artist: Projects and Patrons, Workshops and Art Market*. Princeton, N.J.: Princeton University Press, 1981.

Welch, Evelyn. *Art and Society in Italy 1350–1500*. Oxford: Oxford University Press, 1997.

White, John. *The Birth and Rebirth of Pictorial Space*. 3rd ed. Boston: Faber & Faber, 1987.

Wilde, Johannes. *Venetian Art from Bellini to Titian*. Oxford: Clarendon Press, 1981.

Wittkower, Rudolf. *Architectural Principles in the Age of Humanism*. 4th ed. London: Academy, 1988.

CHAPTER 22
BEAUTY, SCIENCE, AND SPIRIT
IN ITALIAN ART:
THE HIGH RENAISSANCE
AND MANNERISM

Blunt, Anthony. *Artistic Theory in Italy, 1450–1600*. London: Oxford University Press, 1975.

Brown, Patricia Fortini. *Art and Life in Renaissance Venice*. New York: Abrams, 1997.

Castiglione, Baldassare. *Book of the Courtier*. New York: Viking Penguin, 1976. (Originally published 1528)

Farago, Claire, ed. *Reframing the Renaissance: Visual Culture in Europe and Latin America, 1450–1650*. New Haven: Yale University Press, 1995.

Freedberg, Sydney J. *Painting in Italy: 1500–1600*. 3rd ed. New Haven: Yale University Press, 1993.

Friedlaender, Walter. *Mannerism and Anti-Mannerism in Italian Painting*. New York: Schocken, 1965.

Goffen, Rona. *Piety and Patronage in Renaissance Venice: Bellini, Titian, and the Franciscans*. New Haven: Yale University Press, 1986.

Hall, Marcia B. *After Raphael: Painting in Central Italy in the Sixteenth Century*. Cambridge: Cambridge University Press, 1999.

Haskell, Francis, and Nicholas Penny. *Taste and the Antique: The Lure of Classical Sculpture, 1500–1900*. New Haven: Yale University Press, 1981.

Holt, Elizabeth Gilmore, ed. *A Documentary History of Art. Vol. 2, Michelangelo and the Mannerists*. Rev. ed. Princeton, N.J.: Princeton University Press, 1982.

Humfry, Peter. *Painting in Renaissance Venice*. New Haven: Yale University Press, 1995.

Huse, Norbert, and Wolfgang Wolters. *The Art of Renaissance Venice: Architecture, Sculpture, and Painting.* Chicago: University of Chicago Press, 1990.

Levey, Michael. *High Renaissance.* New York: Viking Penguin, 1978.

Murray, Linda. *The High Renaissance and Mannerism.* New York: Oxford University Press, 1977.

Partner, Peter. *Renaissance Rome, 1500–1559: A Portrait of a Society.* Berkeley: University of California Press, 1977.

Partridge, Loren. *The Art of Renaissance Rome.* New York: Abrams, 1996.

Pietrangeli, Carlo, André Chastel, John Shearman, John O'Malley, S.J., Pierluigi de Vecchi, Michael Hirst, Fabrizio Mancinelli, Gianluigi Colalucci, and Franco Bernbei. *The Sistine Chapel: The Art, the History, and the Restoration.* New York: Harmony Books, 1986.

Pope-Hennessy, John. *Italian High Renaissance and Baroque Sculpture.* 3rd ed. 3 vols. Oxford: Phaidon, 1986.

Rosand, David. *Painting in Cinquecento Venice: Titian, Veronese, Tintoretto.* New Haven: Yale University Press, 1982.

Shearman, John K. G. *Mannerism.* Baltimore: Penguin, 1978.

———. *Only Connect . . . Art and the Spectator in the Italian Renaissance.* Princeton, N.J.: Princeton University Press, 1990.

Summers, David. *Michelangelo and the Language of Art.* Princeton, N.J.: Princeton University Press, 1981.

Venturi, Lionello. *The Sixteenth Century: From Leonardo to El Greco.* New York: Skira, 1956.

Wölfflin, Heinrich. *The Art of the Italian Renaissance.* New York: Schocken, 1963.

———. *Classic Art: An Introduction to the Italian Renaissance.* 4th ed. Oxford: Phaidon, 1980.

CHAPTER 23
THE AGE OF REFORMATION:
16TH-CENTURY ART IN NORTHERN EUROPE AND SPAIN

Benesch, Otto. *Art of the Renaissance in Northern Europe.* Rev. ed. London: Phaidon, 1965.

———. *German Painting from Dürer to Holbein.* Geneva: Skira, 1966.

Blunt, Anthony. *Art and Architecture in France, 1500–1700.* Rev. ed. New Haven: Yale University Press, 1999.

Gibson, W. S. *"Mirror of the Earth": The World Landscape in Sixteenth Century Flemish Painting.* Princeton, N.J.: Princeton University Press, 1989.

Harbison, Craig. *The Mirror of the Artist: Northern Renaissance Art in Its Historical Context.* New York: Abrams, 1995.

Hitchcock, Henry-Russell. *German Renaissance Architecture.* Princeton, N.J.: Princeton University Press, 1981.

Koerner, Joseph Leo. *The Moment of Self-Portraiture in German Renaissance Art.* Chicago: University of Chicago Press, 1993.

Landau, David, and Peter Parshall. *The Renaissance Print: 1470–1550.* New Haven: Yale University Press, 1994.

Smith, Jeffrey C. *German Sculpture of the Later Renaissance, c. 1520–1580: Art in an Age of Uncertainty.* Princeton, N.J.: Princeton University Press, 1993.

Stechow, Wolfgang. *Northern Renaissance Art, 1400–1600: Sources and Documents.* Upper Saddle River, N.J.: Prentice Hall, 1966.

BOOKS SPANNING THE
14TH THROUGH 17TH CENTURIES

Campbell, Lorne. *Renaissance Portraits: European Portrait-Painting in the Fourteenth, Fifteenth, and Sixteenth Centuries.* New Haven: Yale University Press, 1990.

Dunkerton, Jill, Susan Foister, Dillian Gordon, and Nicholas Penny. *Giotto to Dürer: Early Renaissance Painting in the National Gallery.* New Haven: Yale University Press, 1991.

Gilbert, Creighton. *History of Renaissance Art throughout Europe.* New York: Abrams, 1973.

Haskell, Francis, and Nicholas Penny. *Taste and the Antique: The Lure of Classical Sculpture 1500–1900.* New Haven: Yale University Press, 1981.

Huyghe, René. *Larousse Encyclopedia of Renaissance and Baroque Art.* See Reference Books.

Kemp, Martin. *The Science of Art: Optical Themes in Western Art From Brunelleschi to Seurat.* New Haven: Yale University Press, 1990.

Paoletti, John T,. and Gary M. Radke. *Art in Renaissance Italy.* Upper Saddle River: Prentice Hall, 1997.

CHAPTER 24
POPES, PEASANTS, MONARCHS,
AND MERCHANTS:
BAROQUE ART

The Age of Caravaggio. New York: Metropolitan Museum of Art, 1985.

Alpers, Svetlana. *The Art of Describing: Dutch Art in the Seventeenth Century.* Chicago: University of Chicago Press, 1984.

———. *Rembrandt's Enterprise: The Studio and the Market.* Chicago: University of Chicago Press, 1988.

Blunt, Anthony. *Art and Architecture in France, 1500–1700.* Rev. ed. New Haven: Yale University Press, 1999.

———, ed. *Baroque and Rococo: Architecture and Decoration.* Cambridge: Harper & Row, 1982.

Brown, Christopher. *Scenes of Everyday Life: Dutch Genre Painting of the Seventeenth Century.* London: Faber & Faber, 1984.

Brown, Jonathan. *The Golden Age of Painting in Spain.* New Haven: Yale University Press, 1991.

———. *Kings and Connoisseurs: Collecting Art in Seventeenth-Century Europe.* Princeton, N.J.: Princeton University Press, 1994.

Bryson, Norman. *Word and Image: French Painting of the Ancien Régime.* Cambridge: Cambridge University Press, 1981.

Chastel, André. *French Art: The Ancien Regime, 1620-1775.* New York: Flammarion, 1996.

Enggass, Robert, and Jonathan Brown. *Italy and Spain, 1600–1750: Sources and Documents.* Upper Saddle River, N.J.: Prentice Hall, 1970.

Franits, Wayne. *Looking at Seventeenth-Century Dutch Art: Realism Reconsidered.* Cambridge: Cambridge University Press, 1997.

Freedberg, Sydney J. *Circa 1600: A Revolution of Style in Italian Painting.* Cambridge, Mass.: Harvard University Press, 1983.

Haak, Bob. *The Golden Age: Dutch Painters of the Seventeenth Century.* New York: Abrams, 1984.

Haskell, Francis. *Patrons and Painters: A Study in the Relations between Italian Art and Society in the Age of the Baroque.* Rev. ed. New Haven: Yale University Press, 1980.

Held, Julius, and Donald Posner. *17th and 18th Century Art: Baroque Painting, Sculpture, Architecture.* New York: Abrams, 1971.

Hempel, Eberhard. *Baroque Art and Architecture in Central Europe.* New York: Viking Penguin, 1977.

Hibbard, Howard. *Carlo Maderno and Roman Architecture, 1580–1630.* London: Zwemmer, 1971.

Howard, Deborah. *The Architectural History of Venice.* London: Batsford, 1981.

Huyghe, René, ed. *Larousse Encyclopedia of Renaissance and Baroque Art.* New York: Prometheus Press, 1963.

Kahr, Madlyn Millner. *Dutch Painting in the Seventeenth Century.* New York: Harper & Row, 1978.

Kitson, Michael. *The Age of Baroque.* London: Hamlyn, 1976.

Krautheimer, Richard. *The Rome of Alexander VII, 1655–1677.* Princeton, N.J.: Princeton University Press, 1985.

Lagerlöf, Margaretha R. *Ideal Landscape: Annibale Carracci, Nicolas Poussin and Claude Lorrain.* New Haven: Yale University Press, 1990.

Lees-Milne, James. *Baroque in Italy.* New York: Macmillan, 1960.

Martin, John R. *Baroque.* New York: Harper & Row, 1977.

Mérot, Alain. *French Painting in the Seventeenth Century.* New Haven: Yale University Press, 1995.

Millon, Henry A. *Baroque and Rococo Architecture.* New York: Braziller, 1965.

Montagu, Jennifer. *Roman Baroque Sculpture: The Industry of Art.* New Haven: Yale University Press, 1989.

Muller, Sheila D., ed. *Dutch Art: An Encyclopedia.* New York: Garland Publishers, 1997.

Norberg-Schulz, Christian. *Baroque Architecture.* New York: Rizzoli, 1986.

———. *Late Baroque and Rococo Architecture.* New York: Electa/Rizzoli, 1985.

North, Michael. *Art and Commerce in the Dutch Golden Age.* New Haven: Yale University Press, 1997.

Rosenberg, Jakob, Seymour Slive, and E. H. ter Kuile. *Dutch Art and Architecture, 1600–1800.* New Haven: Yale University Press, 1979.

Schama, Simon. *The Embarrassment of Riches: An Interpretation of Dutch Culture in the Golden Age.* Berkeley: University of California Press, 1988.

Stechow, Wolfgang. *Dutch Landscape Painting of the 17th Century.* 3rd ed. Oxford: Phaidon, 1981.

Summerson, Sir John. *Architecture in Britain: 1530–1830.* 9th ed. New Haven: Yale University Press, 1989.

Varriano, John. *Italian Baroque and Rococo Architecture.* New York: Oxford University Press, 1986.

Vlieghe, Hans. *Flemish Art and Architecture, 1586–1700.* New Haven: Yale University Press, 1999.

Waterhouse, Ellis Kirkham. *Baroque Painting in Rome.* London: Phaidon, 1976.

———. *Italian Baroque Painting.* 2nd ed. London: Phaidon, 1969.

———. *Painting in Britain: 1530–1790.* 4th ed. New Haven: Yale University Press, 1979.

Wittkower, Rudolf. *Art and Architecture in Italy 1600–1750.* 3rd ed. Harmondsworth: Penguin, 1982.

Wölfflin, Heinrich. *Principles of Art History: The Problem of the Development of Style in Later Art.* 7th ed. New York: Dover, 1950.

———. *Renaissance and Baroque.* London: Collins, 1984.

Wright, Christopher. *The French Painters of the 17th Century.* New York: New York Graphic Society, 1986.

CHAPTER 25
SULTANS, KINGS, EMPERORS,
AND COLONISTS:
THE ART OF SOUTH AND SOUTHEAST ASIA
AFTER 1200

Asher, Catherine B. *Architecture of Mughal India.* New York: Cambridge University Press, 1992.

Beach, Milo Cleveland. *Mughal and Rajput Painting.* Cambridge: Cambridge University Press, 1992.

Blurton, T. Richard. *Hindu Art.* Cambridge, Mass: Harvard University Press, 1993.

Chaturachinda, Gwyneth, Sunanda Krishnamurty, and Pauline W. Tabtiang. *Dictionary of South and Southeast Asian Art.* Chiang Mai: Silkworm Books, 2000.

Craven, Roy C. *Indian Art: A Concise History.* Rev. ed. London: Thames & Hudson, 1997.

Dallapiccola, Anna Libera, ed. *Vijayanagara: City and Empire.* 2 vols. Stuttgart: Steiner, 1985.

Dehejia, Vidya. *Indian Art.* London: Phaidon, 1997.

Encyclopedia of Indian Temple Architecture. 8 vols. New Delhi: American Institute of Indian Studies, and Philadelphia: University of Pennsylvania Press, 1983–1996.

Girard-Geslan, Maud, ed. *Art of Southeast Asia.* New York: Abrams, 1998.

Harle, James C. *The Art and Architecture of the Indian Subcontinent.* 2nd ed. New Haven: Yale University Press, 1994.

Huntington, Susan L., and John C. Huntington. *The Art of Ancient India: Buddhist, Hindu, Jain.* New York: Weatherhill, 1985.

Michell, George. *Architecture and Art of Southern India: Vijayanagara and the Successor States, 1350–1750.* Cambridge: Cambridge University Press, 1995.

———. *Hindu Art and Architecture.* New York: Thames & Hudson, 2000.

———. *The Hindu Temple: An Introduction to Its Meaning and Forms.* Chicago: University of Chicago Press, 1988.

Mitter, Partha. *Indian Art.* New York: Oxford University Press, 2001.

Narula, Karen Schur. *Voyage of the Emerald Buddha.* Kuala Lumpur: Oxford University Press, 1994.

Pal, Pratapaditya, ed. *Master Artists of the Imperial Mughal Court.* Mumbai: Marg, 1991.

Rawson, Phillip. *The Art of Southeast Asia.* New York: Thames & Hudson, 1990.

Stadtner, Donald M. *The Art of Burma: New Studies.* Mumbai: Marg, 1999.

Stevenson, John, and John Guy, eds. *Vietnamese Ceramics: A Separate Tradition.* Chicago: Art Media Resources, 1997.

Stierlin, Henri. *Hindu India from Khajuraho to the Temple City of Madurai.* Cologne: Taschen, 1998.

Welch, Stuart Cary. *Imperial Mughal Painting.* New York: Braziller, 1978.

———. *India: Art and Culture 1300–1900.* New York: Metropolitan Museum of Art, 1985.

CHAPTER 26
FROM THE MONGOLS TO THE MODERN: THE ART OF LATER CHINA AND KOREA

Andrews, Julia Frances, and Kuiyi Shen. *A Century in Crisis: Modernity and Tradition in the Art of Twentieth-Century China.* New York: Guggenheim Museum, 1998.

Barnhart, Richard M. *Painters of the Great Ming: The Imperial Court and the Zhe School.* Dallas: Dallas Museum of Art, 1993.

Cahill, James. *Chinese Painting.* New York: Rizzoli, 1960.

———. *The Painter's Practice: How Artists Lived and Worked in Traditional China.* New York: Columbia University Press, 1994.

Clunas, Craig. *Art in China.* New York: Oxford University Press, 1997.

Fahr-Becker, Gabriele, ed. *The Art of East Asia.* Cologne: Könemann, 1999.

Fisher, Robert E. *Buddhist Art and Architecture.* New York: Thames & Hudson, 1993.

Fong, Wen C., and James C. Y. Watt. *Preserving the Past: Treasures from the National Palace Museum, Taipei.* New York: Metropolitan Museum of Art, 1996.

Laing, Ellen Johnston. *The Winking Owl: Art in the People's Republic of China.* Berkeley: University of California Press, 1989.

Lee, Sherman E., and Wai-Kam Ho. *Chinese Art under the Mongols: The Yuan Dynasty (1279–1368).* Cleveland: Cleveland Museum of Art, 1969.

Li, Chu-tsing, ed. *Artists and Patrons: Some Social and Economic Aspects of Chinese Painting.* Lawrence: Kress Department of Art History in cooperation with Indiana University Press, 1989.

Nakata, Yujiro, ed. *Chinese Calligraphy.* New York: Weatherhill, 1983.

Portal, Jane. *Korea: Art and Archaeology.* New York: Thames & Hudson, 2000.

Rawson, Jessica, ed. *The British Museum Book of Chinese Art.* New York: Thames & Hudson, 1992.

Silbergeld, Jerome. *Chinese Painting Style: Media, Methods, and Principles of Form.* Seattle: University of Washington Press, 1982.

Steinhardt, Nancy S., ed. *Chinese Architecture.* New Haven: Yale University Press, 2002.

Sullivan, Michael. *Art and Artists of Twentieth-Century China.* Berkeley: University of California Press, 1996.

———. *The Arts of China.* 4th ed. Berkeley: University of California Press, 1999.

Thorp, Robert L. *Son of Heaven: Imperial Arts of China.* Seattle: Son of Heaven Press, 1988.

Thorp, Robert L., and Richard Ellis Vinograd. *Chinese Art and Culture.* New York: Abrams, 2001.

Vainker, S. J. *Chinese Pottery and Porcelain: From Prehistory to the Present.* London: Braziller, 1991.

Watson, William. *The Arts of China 900–1260.* New Haven: Yale University Press, 2000.

Weidner, Marsha, ed. *Flowering in the Shadows: Women in the History of Chinese and Japanese Painting.* Honolulu: University of Hawaii Press, 1990.

———. *Views from Jade Terrace: Chinese Women Artists 1300–1912.* Indianapolis: Indianapolis Museum of Art, 1988.

Xin, Yang, Nie Chongzheng, Lang Shaojun, Richard M. Barnhart, James Cahill, and Wu Hung. *Three Thousand Years of Chinese Painting.* New Haven: Yale University Press, 1997.

CHAPTER 27
FROM THE SHOGUNS TO THE PRESENT: THE ART OF LATER JAPAN

Addiss, Stephen. *The Art of Zen.* New York: Abrams, 1989.

Akiyama, Terukazu. *Japanese Painting.* Geneva: Skira; New York: Rizzoli, 1977.

Baekeland, Frederick. *Imperial Japan: The Art of the Meiji Era (1868–1912).* Ithaca, N.Y.: Herbert F. Johnson Museum of Art, 1980.

Brown, Kendall. *The Politics of Reclusion: Painting and Power in Muromachi Japan.* Honolulu: University of Hawaii Press, 1997.

Cahill, James. *Scholar Painters of Japan.* New York: Asia Society, 1972.

Coaldrake, William H. *Architecture and Authority in Japan.* London: Routledge, 1996.

Drexler, Arthur. *The Architecture of Japan.* New York: Museum of Modern Art, 1966.

Fontein, Jan, and Money L. Hickman. *Zen Painting and Calligraphy.* Greenwich, Conn.: New York Graphic Society, 1970.

Guth, Christine. *Art of Edo Japan: The Artist and the City, 1615–1868.* New York: Abrams, 1996.

Hickman, Money L., John T. Carpenter, Bruce A. Coats, Christine Guth, Andrew J. Pekarik, John M. Rosenfield, and Nicole C. Rousmaniere. *Japan's Golden Age: Momoyama.* New Haven: Yale University Press, 1996.

Kawakita, Michiaki. *Modern Currents in Japanese Art.* Translated by Charles E. Terry. New York: Weatherhill, 1974.

Kidder, J. Edward, Jr. *The Art of Japan.* New York: Park Lane, 1985.

Lane, Richard. *Images from the Floating World: The Japanese Print.* New York: Dorset, 1978.

Mason, Penelope. *History of Japanese Art.* New York: Abrams, 1993.

Meech-Pekarik, Julia. *The World of the Meiji Print: Impressions of a New Civilization.* New York: Weatherhill, 1986.

Munroe, Alexandra. *Japanese Art after 1945: Scream against the Sky.* New York: Abrams, 1994.

Nishi, Kazuo, and Kazuo Hozumi. *What Is Japanese Architecture?* Translated by H. Mack Horton. New York: Kodansha International, 1985.

Rosenfield, John M., and Elizabeth ten Grotenhuis. *Journey of the Three Jewels.* New York: Asia Society, 1979.

Sanford, James H., William R. LaFleur, and Masatoshi Nagatomi. *Flowing Traces: Buddhism in the Literary and Visual Arts of Japan.* Princeton, N.J.: Princeton University Press, 1992.

Shimizu, Yoshiaki, ed. *Japan: The Shaping of Daimyo Culture, 1185–1868.* Washington, D.C.: National Gallery of Art, 1988.

Singer, Robert T. *Edo: Art in Japan 1615–1868.* Washington, D.C.: National Gallery of Art, 1998.

Stewart, David B. *The Making of a Modern Japanese Architecture, 1868 to the Present.* New York: Kodansha International, 1988.

Watson, William, ed. *The Great Japan Exhibition: Art of the Edo Period, 1600–1868.* London: Royal Academy of Arts, 1981.

Weidner, Marsha, ed. *Flowering in the Shadows: Women in the History of Chinese and Japanese Painting.* Honolulu: University of Hawaii Press, 1990.

CHAPTER 28
THE ENLIGHTENMENT AND ITS LEGACY: ART OF THE LATE 18TH THROUGH THE MID-19TH CENTURY

Bermingham, Ann. *Landscape and Ideology: The English Rustic Tradition, 1740–1850.* Berkeley: University of California Press, 1986.

Boime, A. *Art in the Age of Bonapartism, 1800–1815.* Chicago: University of Chicago Press, 1990.

———. *Art in the Age of Revolution, 1750–1800.* Chicago: University of Chicago Press, 1987.

Braham, Allan. *The Architecture of the French Enlightenment.* Berkeley: University of California Press, 1980.

Brion, Marcel. *Art of the Romantic Era: Romanticism, Classicism, Realism.* New York: Praeger, 1966.

Bryson, Norman. *Tradition and Desire: From David to Delacroix.* New York: Cambridge University Press, 1984.

Burchard, John, and Albert Bush-Brown. *The Architecture of America: A Social and Cultural History.* Boston: Little, Brown/The American Institute of Architects, 1965.

Clark, Kenneth. *The Romantic Rebellion: Romantic versus Classic Art.* New York: Harper & Row, 1973.

Clay, Jean. *Romanticism.* New York: Phaidon, 1981.

Conisbee, Philip. *Painting in Eighteenth-Century France.* Ithaca, N.Y.: Phaidon/Cornell University Press, 1981.

Cooper, Wendy A. *Classical Taste in America, 1800–1840.* Baltimore: Baltimore Museum of Art, 1993.

Crow, Thomas E. *Painters and Public Life in Eighteenth-Century Paris.* New Haven: Yale University Press, 1985.

Eitner, Lorenz. *Neoclassicism and Romanticism, 1750–1850: An Anthology of Sources and Documents.* New York: Harper & Row, 1989.

Gaunt, W. *The Great Century of British Painting: Hogarth to Turner.* New York: Phaidon, 1971.

Herrmann, Luke. *British Landscape Painting of the Eighteenth Century.* New York: Oxford University Press, 1974.

Holt, Elizabeth Gilmore, ed. *From the Classicists to the Impressionists: A Documentary History of Art and Architecture in the Nineteenth Century.* Garden City, N.J.: Anchor Books/Doubleday, 1966.

Honour, Hugh. *Neo-Classicism.* Harmondsworth: Penguin, 1968.

———. *Romanticism.* New York: Harper & Row, 1979.

Kalnein, Wend Graf, and Michael Levey. *Art and Architecture of the Eighteenth Century in France.* New York: Viking/Pelican, 1973.

Kroeber, Karl. *British Romantic Art.* Berkeley: University of California Press, 1986.

Levey, Michael. *Painting in Eighteenth-Century Venice.* Ithaca, N.Y.: Phaidon/Cornell University Press, 1980.

———. *Rococo to Revolution: Major Trends in Eighteenth-Century Painting.* London: Thames & Hudson, 1966.

Mendelowitz, Daniel M. *A History of American Art.* 2nd ed. New York: Holt, Rinehart & Winston, 1970.

Middleton, Robin, and David Watkin. *Neoclassical and 19th-Century Architecture.* 2 vols. New York: Electa/Rizzoli, 1987.

Novotny, Fritz. *Painting and Sculpture in Europe, 1780–1880.* 3rd ed. New Haven: Yale University Press, 1988.

Pierson, William. *American Buildings and Their Architects.* Vol. 1, The Colonial and Neo-Classical Style. Garden City, N.J.: Doubleday, 1970.

Porterfield, Todd. *The Allure of Empire: Art in the Service of French Imperialism 1798–1836.* Princeton, N.J.: Princeton University Press, 1998.

Rosenblum, Robert. *Transformations in Late Eighteenth Century Art.* Princeton, N.J.: Princeton University Press, 1970.

Roston, Murray. *Changing Perspectives in Literature and the Visual Arts, 1650–1820.* Princeton, N.J.: Princeton University Press, 1990.

Rykwert, Joseph. *The First Moderns: Architects of the Eighteenth Century.* Cambridge: MIT Press, 1983.

Stillman, Damie. *English Neo-Classical Architecture.* 2 vols. London: Zwemmer, 1988.

Vaughn, William. *German Romantic Painting.* New Haven: Yale University Press, 1980.

Wilton, Andrew. *The Swagger Portrait: Grand Manner Portraiture in Britain from Van Dyck to Augustus John, 1630–1930.* London: Tate Gallery, 1992.

Wolf, Bryan Jay. *Romantic Revision: Culture and Consciousness in Nineteenth-Century American Painting and Literature.* Chicago: University of Chicago Press, 1986.

CHAPTER 29
THE RISE OF MODERNISM:
ART OF THE LATER 19TH CENTURY

Adams, Steven. *The Barbizon School and the Origins of Impressionism.* London: Phaidon, 1994.

Baudelaire, Charles. *The Mirror of Art, Critical Studies.* Translated by Jonathan Mayne. Garden City: Doubleday, 1956.

———. *The Painter of Modern Life, and Other Essays.* Translated and edited by Jonathan Mayne. London: Phaidon, 1964.

Benjamin, Roger. *Orientalist Aesthetics: Art, Colonialism, and French North Africa, 1880–1930.* Berkeley: University of California Press, 2003.

Boime, Albert. *The Academy and French Painting in the 19th Century.* London: Phaidon, 1971.

Broude, Norma. *Impressionism: A Feminist Reading.* New York: Rizzoli, 1991.

Chu, Petra ten-Doesschate. *Nineteenth-Century European Art.* New York: Abrams, 2003.

Clark, Kenneth. *The Gothic Revival: An Essay in the History of Taste.* New York: Humanities Press, 1970.

Clark, T. J. *The Absolute Bourgeois: Artists and Politics in France, 1848–1851.* London: Thames & Hudson, 1973.

———. *Image of the People: Gustave Courbet and the 1848 Revolution.* London: Thames & Hudson, 1973.

———. *The Painting of Modern Life: Paris in the Art of Manet and His Followers.* Princeton, N.J.: Princeton University Press, 1984.

Crary, Jonathan. *Suspensions of Perception: Attention, Spectacle, and Modern Culture.* Cambridge, Mass: MIT Press, 1999.

Duncan, Alastair. *Art Nouveau.* New York: Thames & Hudson, 1994.

Eisenmann, Stephen F. *19th-Century Art: A Critical History.* 2nd ed. New York: Thames & Hudson, 2002.

Farwell, Beatrice. *Manet and the Nude: A Study in the Iconology of the Second Empire.* New York: Garland Publishers, 1981.

Fried, Michael. *Courbet's Realism.* Chicago: University of Chicago Press, 1982.

———. *Manet's Modernism, or, The Face of Painting in the 1860s.* Chicago: University of Chicago Press, 1996.

Garb, Tamar. *Bodies of Modernity: Figure and Flesh in Fin-de-Siècle France.* New York: Thames & Hudson, 1998.

Gerdts, William H. *American Impressionism.* New York: Abbeville Press, 1984.

Hamilton, George H. *Painting and Sculpture in Europe, 1880–1940.* 6th ed. New Haven: Yale University Press, 1993.

Herbert, Robert L. *Impressionism: Art, Leisure, and Parisian Society.* New Haven: Yale University Press, 1988.

Hilton, Timothy. *The Pre-Raphaelites.* New York: Oxford University Press, 1970.

Holt, Elizabeth Gilmore. *From the Classicists to the Impressionists: Art and Architecture in the Nineteenth Century.* Garden City: Doubleday/Anchor, 1966.

———, ed. *The Expanding World of Art, 1874–1902.* New Haven: Yale University Press, 1988.

Janson, Horst W. *19th-Century Sculpture.* New York: Abrams, 1985.

Jensen, Robert. *Marketing Modernism in Fin-de-Siècle Europe.* Princeton, N.J.: Princeton University Press, 1994.

Krell, Alain. *Manet and the Painters of Contemporary Life.* London: Thames & Hudson, 1996.

Leymarie, Jean. *French Painting in the Nineteenth Century.* Geneva: Skira, 1962.

Mainardi, Patricia. *Art and Politics of the Second Empire: The Universal Expositions of 1855 and 1867.* New Haven: Yale University Press, 1987.

———. *The End of the Salon: Art and the State in the Early Third Republic.* Cambridge: Cambridge University Press, 1993.

Middleton, Robin, ed. *The Beaux-Arts and Nineteenth-Century French Architecture.* Cambridge, Mass: MIT Press, 1982.

Needham, Gerald. *19th-Century Realist Art.* New York: Harper & Row, 1988.

Nochlin, Linda. *Impressionism and Post-Impressionism, 1874–1904: Sources and Documents.* Upper Saddle River, N.J.: Prentice Hall, 1966.

———. *Realism and Tradition in Art, 1848–1900: Sources and Documents.* Upper Saddle River, N.J.: Prentice Hall, 1966.

Novak, Barbara. *American Painting of the Nineteenth Century: Realism and the American Experience.* New York: Harper & Row, 1979.

Novotny, Fritz. *Painting and Sculpture in Europe, 1780–1880.* 3rd ed. New Haven: Yale University Press, 1988.

Pevsner, Nikolaus. *Pioneers of Modern Design.* Harmondsworth: Penguin, 1964.

Pollock, Griselda. Vision and Difference: *Femininity, Feminism, and Histories of Art.* New York: Routledge, 1988.

Rewald, John. *The History of Impressionism.* New York: Museum of Modern Art, 1973.

———. *Post-Impressionism: From Van Gogh to Gauguin.* New York: Museum of Modern Art, 1956.

Rosen, Charles, and Henri Zerner. *Romanticism and Realism: The Mythology of Nineteenth-Century Art.* New York: Viking Press, 1984.

Rosenblum, Robert, and Horst W. Janson. *19th-Century Art.* New York: Abrams, 1984.

Schapiro, Meyer. *Modern Art: 19th and 20th Centuries.* New York: Braziller, 1978.

Schorske, Carl E. *Fin-de-Siècle Vienna: Politics and Culture.* New York: Knopf, 1980.

Shiff, Richard. *Cézanne and the End of Impressionism: A Study of the Theory, Technique, and Critical Evaluation of Modern Art.* Chicago: University of Chicago Press, 1984.

Silverman, Debora L. *Art Nouveau in Fin-de-Siècle France: Politics, Psychology, and Style.* Berkeley: University of California Press, 1989.

Sloane, Joseph C. French *Painting between the Past and the Present: Artists, Critics, and Traditions from 1848 to 1870.* Princeton, N.J.: Princeton University Press, 1973.

Smith, Paul. *Impressionism: Beneath the Surface.* New York: Abrams, 1995.

Sullivan, Louis. *The Autobiography of an Idea.* New York: Dover, 1956.

Taylor, Joshua, ed. *Nineteenth-Century Theories of Art.* Berkeley: University of California Press, 1987.

Van Gogh: A Self-Portrait; Letters Revealing His Life as a Painter. Selected by W. H. Auden. New York: Dutton, 1963.

Weisberg, Gabriel P. *The European Realist Tradition.* Bloomington: Indiana University Press, 1982.

White, Harrison C., and Cynthia A. Harrison. *Canvases and Careers: Institutional Change in the French Painting World.* New York: Wiley, 1965.

Wood, Christopher. *The Pre-Raphaelites.* New York: Viking Press, 1981.

CHAPTER 30
BEFORE AND AFTER THE CONQUISTADORS:
NATIVE ARTS OF THE AMERICAS AFTER 1300

Anderson, Richard, and Karen L. Field, eds. *Art in Small-Scale Societies: Contemporary Readings.* Upper Saddle River, N.J.: Prentice Hall, 1993.

Berlo, Janet Catherine, ed. *Plains Indian Drawings 1865–1935.* New York: Abrams, 1996.

Berlo, Janet Catherine, and Ruth B. Phillips. *Native North American Art.* New York: Oxford University Press, 1998.

Berlo, Janet Catherine, and Lee Anne Wilson, eds. *Arts of Africa, Oceania, and the Americas: Selected Readings.* Upper Saddle River, N.J.: Prentice Hall, 1993.

Boone, Elizabeth. *The Aztec World.* Washington, D.C.: Smithsonian Institution Press, 1994.

———, ed. *Andean Art at Dumbarton Oaks.* 2 vols. Washington, D.C.: Dumbarton Oaks, 1996.

Bruhns, Karen O. *Ancient South America.* New York: Cambridge University Press, 1994.

Coe, Michael D. *The Maya.* 6th ed. New York: Thames & Hudson, 1999.

———. *Mexico.* 4th ed. New York: Thames & Hudson, 1994.

Coe, Michael D., and Justin Kerr. *The Art of the Maya Scribe.* New York: Abrams, 1998.

Diaz, Gisele, and Alan Rodgers. *The Codex Borgia.* New York: Dover, 1993.

Donnan, Christopher. *Ceramics of Ancient Peru.* Los Angeles: Fowler Museum of Cultural History, 1992.

Feest, Christian F. *Native Arts of North America.* 2nd ed. New York: Thames & Hudson, 1992.

Fienup-Riordan, Ann. *The Living Tradition of Yup`ik Masks.* Seattle: University of Washington Press, 1996.

Fitzhugh, William W., and Aron Crowell, eds. *Crossroads of Continents: Cultures of Siberia and Alaska.* Washington, D.C.: Smithsonian Institution Press, 1988.

Gasparini, Graziano, and Luise Margolies. *Inca Architecture.* Bloomington: Indiana University Press, 1980.

Hill, Tom, and Richard W. Hill Sr., eds. *Creation's Journey: Native American Identity and Belief.* Washington, D.C.: Smithsonian Institution Press, 1994.

Jonaitis, Aldona. *From the Land of the Totem Poles: The Northwest Coast Indian Art Collection at the American Museum of Natural History.* Seattle: University of Washington Press, 1988.

Kubler, George. *The Art and Architecture of Ancient America: The Mexican, Maya, and Andean Peoples.* 3rd ed. New Haven: Yale University Press, 1992.

Malpass, Michael A. *Daily Life in the Inca Empire.* Westport, Conn.: Greenwood Press, 1996.

Mathews, Zena, and Aldona Jonaitis, eds. *Native North American Art History.* Palo Alto, Calif.: Peek Publications, 1982.

Matos, Eduardo M. *The Great Temple of the Aztecs: Treasures of Tenochtitlan.* New York: Thames & Hudson, 1988.

Maurer, Evan M. *Visions of the People: A Pictorial History of Plains Indian Life.* Seattle: University of Washington Press, 1992.

Miller, Mary E. *The Art of Mesoamerica, from Olmec to Aztec.* 2nd ed. New York: Thames & Hudson, 1996.

Miller, Mary E., and Karl Taube. *The Gods and Symbols of Ancient Mexico and the Maya: An Illustrated Dictionary of Mesoamerican Religion.* New York: Thames & Hudson, 1993.

Morris, Craig, and Adriana von Hagen. *The Inka Empire and its Andean Origins.* New York: Abbeville, 1993.

Nabokov, Peter, and Robert Easton. *Native American Architecture.* New York: Oxford University Press, 1989.

Pasztory, Esther. *Aztec Art.* New York: Abrams, 1983.

———. *Pre-Columbian Art.* New York: Cambridge University Press, 1998.

Penney, David. *Art of the American Indian Frontier.* Seattle: University of Washington Press, 1992.

Penney, David, and George C. Longfish. *Native American Art.* Hong Kong: Hugh Lauter Levin & Associates, 1994.

Peterson, Susan. *The Living Tradition of Maria Martinez.* Tokyo: Kodansha International, 1977.

Phillips, Ruth B. *Trading Identities: The Souvenir in Native North American Art.* Seattle: University of Washington Press, 1998.

Plazas, Clemencia, Ana Maria Falchetti, and Armand J. Labbé. *Tribute to the Gods: Treasures of the Museo del Oro.* Santa Ana, Calif.: Bowers Museum of Cultural Art, 1992.

Samuel, Cheryl. *The Chilkat Dancing Blanket.* Norman: University of Oklahoma Press, 1982.

Schaafsma, Polly, ed. *Kachinas in the Pueblo World.* Albuquerque: University of New Mexico Press, 1994.

Stewart, Hilary. *Looking at Totem Poles.* Seattle: University of Washington Press, 1993.

Townsend, Richard F., ed. *Art from Sacred Landscapes.* Chicago: Art Institute of Chicago, 1992.

Wardwell, Allen. *Tangible Visions: Northwest Coast Indian Shamanism and Its Art.* New York: Monacelli Press, 1996.

Washburn, Dorothy. *Living in Balance: The Universe of the Hopi, Zuni, Navajo, and Apache.* Philadelphia: University Museum, 1995.

Weaver, Muriel Porter. *The Aztecs, Mayas, and Their Predecessors.* 3rd ed. San Diego: Academic Press, 1993.

Whiteford, Andrew H., Stewart Peckham, and Kate Peck Kent. *I Am Here: Two Thousand Years of Southwest Indian Arts and Crafts.* Santa Fe: Museum of New Mexico Press, 1989.

Wright, Robin K. *Northern Haida Master Carvers.* Seattle: University of Washington Press, 2001.

Wyman, Leland C. *Southwest Indian Drypainting.* Albuquerque: University of New Mexico Press, 1983.

CHAPTER 31
THE FLOURISHING OF ISLAND CULTURES:
THE ART OF OCEANIA

Barrow, Terence. *The Art of Tahiti and the Neighboring Society, Austral and Cook Islands.* London: Thames & Hudson, 1979.

Berndt, Ronald M., ed. *Australian Aboriginal Art.* New York: Macmillan, 1964.

Corbin, George A. *Native Arts of North America, Africa, and the South Pacific: An Introduction.* New York: HarperCollins, 1988.

Cox, J. Halley, and William H. Davenport. *Hawaiian Sculpture.* Rev. ed. Honolulu: University of Hawaii Press, 1988.

D'Alleva, Anne. *Arts of the Pacific Islands.* New York: Abrams, 1998.

Feldman, Jerome, and Donald H. Rubinstein. *The Art of Micronesia.* Honolulu: University of Hawaii Art Gallery, 1986.

Greub, Suzanne, ed. *Authority and Ornament: Art of the Sepik River, Papua New Guinea.* Basel: Tribal Art Centre, 1985.

Guiart, Jean. *Arts of the South Pacific.* New York: Golden Press, 1963.

Hanson, Allan, and Louise Hanson, eds. *Art and Identity in Oceania.* Honolulu: University of Hawaii Press, 1990.

Kaeppler, Adrienne L., Christian Kaufmann, and Douglas Newton. *Oceanic Art.* New York: Abrams, 1997.

Kooijman, Simon. *Tapa in Polynesia.* Honolulu: Bishop Museum Press, 1972.

Lincoln, Louise, ed. *Assemblage of Spirits: Idea and Image in New Ireland.* New York: Braziller in association with the Minneapolis Institute of Arts, 1987.

Mead, Sidney Moko, ed. *Te Maori: Maori Art from New Zealand Collections.* New York: Abrams in association with the American Federation of Arts, 1984.

Morphy, Howard. *Aboriginal Art.* London: Phaidon Press, 1998.

Rockefeller, Michael C. *The Asmat of New Guinea: The Journal of Michael Clark Rockefeller.* Greenwich, Conn.: New York Graphic Society, 1967.

Schneebaum, Tobias. *Embodied Spirits: Ritual Carvings of the Asmat.* Salem, Mass.: Peabody Museum of Salem, 1990.

Simons, S. C., and H. Stevenson, eds. *Luk Luk Gen! Contemporary Art from Papua New Guinea.* Townsville: Perc Tucker Regional Gallery, 1990.

Smidt, Dirk, ed. *Asmat Art: Woodcarvings of Southwest New Guinea.* New York: Braziller in association with Rijksmuseum voor Volkenkunde, Leiden, 1993.

Starzecka, Dorota, ed. *Maori Art and Culture.* Chicago: Art Media Resources, 1996.

Sutton, Peter, ed. *Dreamings: The Art of Aboriginal Australia.* New York: Braziller in association with the Asia Society Galleries, 1988.

Thomas, Nicholas. *Oceanic Art.* London: Thames & Hudson, 1995.

CHAPTER 32
TRADITIONALISM AND INTERNATIONALISM:
19TH- AND 20TH-CENTURY AFRICAN ARTS

Abiodun, Roland, Henry J. Drewal, and John Pemberton III, eds. *The Yoruba Artist: New Theoretical Perspectives on African Arts.* Washington, D.C.: Smithsonian Institution Press, 1994.

Blier, Suzanne P. *The Royal Arts of Africa.* New York: Abrams, 1998.

Cole, Herbert M. *Icons: Ideals and Power in the Art of Africa.* Washington, D.C.: National Museum of African Art, Smithsonian Institution, 1989.

————. *Mbari: Art and Life among the Owerri Igbo.* Bloomington: Indiana University Press, 1982.

————, ed. *I Am Not Myself: The Art of African Masquerade.* Los Angeles: UCLA Fowler Museum of Cultural History, 1985.

Cole, Herbert M., and Chike C. Aniakor. *Igbo Art: Community and Cosmos.* Los Angeles: UCLA Fowler Museum of Cultural History, 1984.

Cole, Herbert M., and Doran H. Ross. *The Arts of Ghana.* Los Angeles: UCLA Fowler Museum of Cultural History, 1977.

Cornet, Joseph. *Art Royal Kuba.* Milan: Edizioni Sipiel, 1982.

Enwezor, Okwui, ed. *The Short Century: Independence and Liberation Movements in Africa, 1945–1994.* Munich: Prestel, 2001.

Ezra, Kate. *The Art of the Dogon: Selections from the Lester Wunderman Collection.* New York: Metropolitan Museum of Art, 1988.

Fischer, Eberhard, and Hans Himmelheber. *The Arts of the Dan in West Africa.* Translated by Anne Biddle. Zurich: Museum Reitberg, 1984.

Fraser, Douglas F., and Herbert M. Cole, eds. *African Art and Leadership.* Madison: University of Wisconsin Press, 1972.

Geary, Christraud M. *Things of the Palace: A Catalogue of the Bamum Palace Museum in Foumban (Cameroon).* Weisbaden: Franz Steiner Verlag, 1983.

Glaze, Anita J. *Art and Death in a Senufo Village.* Bloomington: Indiana University Press, 1981.

In/sight: African Photographers, 1940 to the Present. New York: Guggenheim Museum, 1996.

Kasfir, Sidney L. *Contemporary African Art.* London: Thames & Hudson, 1999.

————. *West African Masks and Cultural Systems.* Tervuren: Musée Royal de l'Afrique Centrale, 1988.

Kennedy, Jean. *New Currents, Ancient Rivers: Contemporary African Artists in a Generation of Change.* Washington, D.C.: Smithsonian Institution Press, 1992.

Magnin, Andre, with Jacques Soulillou. *Contemporary Art of Africa.* New York: Abrams, 1996.

McGaffey, Wyatt, and Michael Harris. *Astonishment and Power (Kongo Art).* Washington, D.C.: Smithsonian Institution Press, 1993.

Nooter, Mary H. *Secrecy: African Art That Conceals and Reveals.* New York: Museum for African Art, 1993.

Oguibe, Olu, and Okwui Enwezor, eds. *Reading the Contemporary: African Art from Theory to the Marketplace.* London: Institute of International Visual Arts, 1999.

Perrois, Louis. *Ancestral Art of Gabon from the Collections of the Barbier-Mueller Museum.* Translated by Francine Farr. Geneva: Musée Barbier-Mueller, 1985.

Phillips, Ruth B. *Representing Women: Sande Masquerades of the Mende of Sierra Leone.* Los Angeles: UCLA Fowler Museum of Cultural History, 1995.

Roy, Christopher D. *Art and Life in Africa: Selections from the Stanley Collection.* Iowa City: University of Iowa Museum of Art, 1992.

Sieber, Roy, and Roslyn A. Walker. *African Art in the Cycle of Life.* Washington, D.C.: Smithsonian Institution Press, 1987.

Thompson, Robert F., and Joseph Cornet. *The Four Moments of the Sun: Kongo Art in Two Worlds.* Washington, D.C.: National Gallery of Art, 1981.

Vansina, Jan. *The Children of Woot: A History of the Kuba Peoples.* Madison: University of Wisconsin Press, 1978.

Vinnicombe, Patricia. *People of the Eland: Rock Paintings of the Drakensberg Bushmen as a Reflection of Their Life and Thought.* Pietermaritzburg: University of Natal Press, 1976.

Vogel, Susan M. *Baule: African Art, Western Eyes.* New Haven: Yale University Press, 1997.

————, ed. *Africa Explores: Twentieth-Century African Art.* New York: Te Neues, 1990.

————, ed. *Art/Artifact: African Art in Anthropology Collections.* New York: Te Neues, 1988.

————, ed. *For Spirits and Kings: African Art from the Tishman Collection.* New York: Metropolitan Museum of Art, 1981.

Walker, Roslyn A. *Olowe of Ise: A Yoruba Sculptor to Kings.* Washington, D.C.: National Museum of African Art, 1998.

CHAPTER 33
THE DEVELOPMENT OF MODERNIST ART:
THE EARLY 20TH CENTURY

Ades, Dawn. *Photomontage.* London: Thames & Hudson, 1976.

Antliff, Mark. *Cultural Politics and the Parisian Avant-Garde.* Princeton, N.J.: Princeton University Press, 1993.

Baigell, Matthew. *The American Scene: American Painting of the 1930s.* New York: Praeger, 1974.

Balakian, Anna Elizabeth. *Surrealism: The Road to the Absolute.* New York: Dutton, 1970.

Barr, Alfred H., Jr. *Cubism and Abstract Art: Painting, Sculpture, Constructions, Photography, Architecture, Industrial Arts, Theatre, Films, Posters, Typography.* Cambridge: Belknap, 1986.

————, ed. *Fantastic Art, Dada, Surrealism.* New York: Arno Press, 1969. (Originally published 1936 by the Museum of Modern Art)

Barron, Stephanie. *Exiles and Emigrés: The Flight of European Artists from Hitler.* Los Angeles: Los Angeles County Museum of Art, 1997.

————, ed. *Degenerate Art: The Fate of the Avant-Garde in Nazi Germany.* Los Angeles: Los Angeles County Museum of Art, 1991.

Bayer, Herbert, Walter Gropius, and Ise Gropius. *Bauhaus, 1919–1928.* New York: Museum of Modern Art, 1975.

Bearden, Romare, and Harry Henderson. *A History of African-American Artists from 1792 to the Present.* New York: Pantheon Books, 1993.

Breton, André. *Surrealism and Painting.* New York: Harper & Row, 1972.

Brown, Milton. *Story of the Armory Show: The 1913 Exhibition That Changed American Art.* 2nd ed. New York: Abbeville, 1988.

Campbell, Mary Schmidt, David C. Driskell, David Lewis Levering, and Deborah Willis Ryan. *Harlem Renaissance: Art of Black America.* New York: Studio Museum in Harlem; Abrams, 1987.

Curtis, William J. R. *Modern Architecture Since 1900.* Upper Saddle River, N.J.: Prentice Hall, 1996.

Davidson, Abraham A. *Early American Modernist Painting, 1910–1935.* New York: Harper & Row, 1981.

Eberle, Matthias. *World War I and the Weimar Artists: Dix, Grosz, Beckmann, Schlemmer.* New Haven: Yale University Press, 1985.

Elderfield, John. *The "Wild Beasts": Fauvism and Its Affinities.* New York: Museum of Modern Art, 1976.

Elsen, Albert. *Origins of Modern Sculpture.* New York: Braziller, 1974.

Fer, Briony, David Batchelor, and Paul Wood. *Realism, Rationalism, Surrealism: Art between the Wars.* New Haven: Yale University Press, 1993.

Frampton, Kenneth. *A Critical History of Modern Architecture.* London: Thames & Hudson, 1985.

Friedman, Mildred, ed. *De Stijl, 1917–1931: Visions of Utopia.* Minneapolis: Walker Art Center; New York: Abbeville Press, 1982.

Fry, Edward, ed. *Cubism.* London: Thames & Hudson, 1966.

Goldberg, RoseLee. *Performance: Live Art 1909 to the Present.* New York: Abrams, 1979.

CREDITS

The authors and publisher are grateful to the proprietors and custodians of various works of art for photographs
of these works and permission to reproduce them in this book. Sources not included in the captions are listed here.

NOTE: *All references in the following credits are to figure numbers unless otherwise indicated.*

Introduction—© Guggenheim Museum Bilbao: 1; Aerofilms Limited: 2; akg-images/Rabatti-Domingie: 3; © 2001 The Georgia O'Keefe Foundation/Artist Rights Society (ARS), NY: 4; © 2001 Ben Shahn/Licensed by VAGA, NY, NY: 5; www.bednorz-photo.de: 6; DY/Art Resource, NY: 07; Photograph © M.M.A.: 8; Saskia: 9; © National Gallery, London: 11; MOA Art Museum, Shizuoka-ken, Japan: 12; Joachim Blauel/Arthothek: 13; Jürgen Liepe, Berlin: 14; Nimatallah/Art Resource, NY: 15; Photograph © 1983 M.M.A.: 16; Scala: 17

Chapter 19-AL: 1, 17, 18, 21; Canali: 2, 5, 12, 14; © Alinari Archives/Corbis: 3; Scala: opener, 4, 6, 8, 9, 10, 11, 13, 15, 16, 20: Summerfield Press, Ltd.: 7; Photo by Ralph Lieberman: 19.

Chapter 20-R.M.N.: 1, 2; Scala: opener, 4a, 4b, 5, 10; Lessing: 3, 11, 14, 20, 23; Artothek: 6; Copyright © Museo del Prado: 7, 18; Gir: 8; Paul Laes: 9; Photo Copyright © 1981 M.M.A. All rights reserved: 12, 15, 25; Copyright © National Gallery, London: 13, 16; Copyright © 1999 Board of Trustees, National Gallery of Art, Washington, D.C.: 17; Staatliche Museen zu Berlin, Preussicscher Kulturbesiz, Gemäldegalier: 19a; Koninklijk Museum voor Schone Kunsten, Antwerp, Belgium: 19b; Photo copyright © Musee d'Art et d'Histoire, Geneva: 21; © Christopher Rennie/Robert Harding Picture Library, London: 22; Luarine Tansey: 24; © Intsitut Amatller D'art Hispànic: 26.

Chapter 21-© Arte & Immagini srl/Corbis: 1, 2; Scala: opener, 3, 4, 6, 7, 13, 19, 20, 21, 24, 25, 32, 33, 37, 46, 49, 50, 51; © The Art Archive/Dagli Orti (A): 5; Lessing: 8, 9, 22, 30, 48; © The Art Archive/Sta Maria del Carmine Florence/Dagli Orti (A): 10; Canali: 11, 12, 36, 38, 39, 43; AL: 15, 41, 47; © Angelo Hornak/Corbis: 17; Ralph Lieberman: 23, 34; Photo Copyright © 1982 M.M.A. All rights reserved: 26, © Summerfield Press Ltd.: 27; © Board of Trustees, National Gallery of Art, Washington, D.C./Art Resource, NY: 28; © Saskia: 29; Bridgeman Art Library: 31; © 1987 M. Sarri/Photo Vatican Museums: 40; G. Giovetti: 45

Chapter 22-Scala: 1, 18, 20, 22, 23, 24, 29, 31, 34, 35, 36, 50, 53, 55; © National Gallery Collection, by kind permission of the Trustees of the National Gallery, London/Corbis: 2; © AFP/Corbis: 3a; © Edimedia/Corbis: 3b; R.M.N.: 4, 11, 21, 33, 47; The Royal Collection © 2003 Her Majesty Queen Elizabeth II: 5; British Museum: 7; Canali: 8, 42, 54; © Michael S. Yamashita/Corbis: 9; © Gianni Dagli Orti/Corbis: 10; © Nippon Television Network Corporation, Tokyo: opener, 12, 15, 16, 25; Photo Vatican Museums: 13; © Bracchietti-Zigrosi/Photo Vatican Museums: 14; Photo copyright © Victor Boswell, National Geographic Image Collection: 15; © 1983 M. Sarri/Photo Vatican Museums: 17; Lessing: 19, 37, 39, 49, 58; Pubbli Aer Foto: 26; © SEF/Art Resource, NY: 27; Photo copyright © 1990 M.M.A. All rights reserved: 30, 45 © 1999 Board of Trustees, National Gallery of Art, Washington, D.C.: 32; AL: 38, 40, 41, 48; Summerfield Press, Ltd.: 43; National Gallery, London: 44; © Cameraphoto/Art Resource, NY: 52; © Sandro Vannini/Corbis: 56; © John Heseltine/Corbis: 59.

Chapter 23-© British Museum: 1, 4; Gir: 2; © Musée d'Unterlinden, -F68000 Colmar, photo O. Zimmerman: 3; Scala: opener, 5, 9, 13, 26; © 1999 Museum of Fine Arts, Boston. All rights reserved: 6; Bridgeman Art Library: 7; Photo © 1998 M.M.A. All Rights reserved: 8, National Gallery, London: 10; R.M.N.: 11, 17; Lessing: 12, 14, 16; Uppsala University Art Collection: 18; Oeffentliche Kunstsammlung Basel, photo Martin Bühler: 19; The Royal Collection © 2003, Her Majesty Queen Elizabeth II: 20; © Museo del Prado, Madrid: 21; Kunsthistorisches Museum, Vienna: 22; © BPK, Bildarchiv Preussischer/Art Resource, NY: 23; © Institut Amatller D'art Hispànic: 24, 25.

Chapter 24-Saskia: 1, 12, 72; © Ruggero Vanni/Corbis: 2; Pubbli Aer Foto: 4; © Saskia Ltd./Art Resource, NY: 5; Canali: 6, 10, 18, 23, 24; Scala: 7, 9, 15, 17, 19, 20, 21, 22, 25, 26, 39, 46, 59, 79; Gabinetto Fotographico Nazionale, ICCD, Rome: 8; Lessing: opener, 14, 33, 36, 53; © Enzo & Paolo Ragazzini/Corbis: 16; Summerfield Press, Ltd.: 27, 41; Museo del Prado, Madrid: 28; © Victoria & Albert Museum, London/Art Resource, NY: 30; Gir: 31, 70; © The Frick Collection, New York: 32; Royal Institute for the Study and Conservation of Belgium's Artistic Heritage: 34; Ambrosiana Library: 35; © Nimatallah/Art Resource, NY: 37; R.M.N.: 38, 58, 62, 65, 67; Iv. #5088, Ernst Moritz, The Hague: 40; Photo Tom Haartsen: 42; Frans Halsmuseum, Haarlem: 43; © Rijksmuseum, Amsterdam: 45, 52, 54; © English Heritage Photographic Library: 47; © Pierpont Morgan Library/Art Resource, NY: 48; © 2004 Board of Trustees, National Gallery of Art Washington, D.C.: 49; © National Gallery, London: 50; © Mauritshuis, The Hague: 51; Indianapolis Museum of Art, Gift in commemoration of the 60th anniversary of the Art Association of Indianapolis, in memory of Daniel W. and Elizabeth C. Marmon: 56; Ernst Wrba Foto-Design: 61; © Hulton Archive/Getty Images: 63; © Gala/Superstock: 66; © New York Public Library/Art Resource, NY: 68; Ancient Art and Architecture Collection.: 69; © Archivo Iconografiopener, S.A./Corbis: 71; © Angelo Hornak/Corbis: 73; A. F. Kersting: 74, 76; © Yann Arthus-Bertrans/Corbis: 75; Hirmer Verlag, Munich: 78

Chapter 25-Sheldan Collins/Corbis: 1; Geoffrey Taunton, Cordaiy Photo Library Ltd./Corbis: 2; Victoria & Albert Museum, London/Art Resource, NY: 3; Freer Gallery of Art, Smithsonian Institution, Washington, D.C., Purchase, F1942.15: opener, 4; Henry Stierlin: 5; Spectrum Colour Library: 8; The Brooklyn Museum of Art, 87.234.6: 9; Robert L. Brown: 10; Luca Tettoni Photography: 11; Alain Mahuzier: 12; Benoy K. Behl: 14.

Chapter 26-Collection of the National Palace Museum, Taiwan, Republic of China: 1, 2, 3, 10; Percival David Foundation of Chinese Art, B614: 4; photos12.com, Panorama Stock: 5; Laurence G. Liu: 6, 7; Victoria & Albert Museum, London/Art Resource, NY, 8; Cultural Relics Publishing House, Beijing: 9, 14; Dong Qichang, Chinese, 1555–1636, Ming Dynasty. The Quingbian Mountains. Hanging scroll, ink on paper, 224.5 x 67.2 cm. © The Cleveland Museum of Art, 2003. Leonard C Hanna, Jr., Bequest, 1980: 10, 11; Honolulu Academy of Arts, gift of Mr. Robert Allerton, 1957 (2306.1): 12; John Taylor Photography: 13; Percival David Foundation of Chinese Art, A821: 15; Audrey R. Topping: 16; Copyright © Elvehjem Museum of Art, University of Wisconsin-Madison. Artist Xu Bing: 17; Photo copyright © Korea National Tourism Organisation: 18; Heritage Images/British Museum: 20

Chapter 27-Patricia Graham: 1; Tokyo National Museum. Image TNM Image Archives. Source: http://TnmArchives.jp: 2, 3, 5, 9; Sakamoto Photo Research Laboratory/Corbis: 4; © The Hatakeyama Memorial Museum of Fine Art: 6; TRIP photographic library, photographer: F. Good/Art Directors: 7; Photo courtesy of The Art Institute of Chicago 1925.2043. All rights reserved: 11; Photograph © 2003 Museum of Fine Art, Boston, "Katsushika Hokusai," Japanese, 1760–1849. In the Hollow of a Wave off the Coast at Kanagawa. Japanese, Edo Period, about 1830–1831. Object Place: Japan. Woodblock print; ink and color on paper. 25.2 x 37.3 cm (9 15/16 x 14 11/16 in.) Museum of Fine Arts, Boston. William Sturgis Bigelow Collection: 12; Tokyo National University of Fine Arts and Music, 13; Copyright © Shokodo Co., Ltd.: 14; Tokyo Tourist Office, 15; Association de la Jeune Sculpture 1987/2: 17.

Chapter 28-Saskia: 1; Scala: 2, 4, 34; Lessing: 3, 23, 35, 60; Reproduced by permission of the Trustees of The Wallace Collection: 5, 6, 19; By permission of the British Library: 8; Derby Museums and Art Gallery, Derby, Derbyshire: 9; © Robert Estall/Corbis: 10; R.M.N.: 11, 12, 21, 36, 37, 45, 47, 48, 49, 51; Summerfield Press, Ltd.: opener, 13; National Gallery, London: 14, 53; © 1999 Board of Trustees, National Gallery of Art, Washington, D.C.: 15; © National Gallery Collection, by kind permission of the Trustees of the National Gallery, London /Corbis: 16; National Gallery of Canada: 17; Courtesy, Museum of Fine Arts, Boston. All rights reserved: 18, 54; © Virginia Museum of Fine Arts: 20; Gir: 22, 46, 50; Lessing: 23, 35, 60; J. E. Bulloz, Paris: 24; © Arthur Thevenart/Corbis: 25; © The Art Archive/Galleria Gorghese Rome/Dagli Orti: 26, © Eric Crichton/Corbis: 27; © Adam Wolfitt/Corbis: 28; Bildarchiv Monheim: 29; © Courtesy of the Victoria & Albert Museum/Art Resource, NY: 30, 41,62; Monticello/Thomas Jefferson Foundation, Inc.: 31; Reproduced from the Collections of the Library of Congress: 32; Photo © The Detroit Institute of Arts: 39; Whitworth Art Gallery: 40; © Museo del Prado: 42, 43, 44; Staatliche Museen au Berlin-Preussischer Kulturbesitz, Nationalgalerie, photo Jorg P. Anders, BPK: 52; photo © 1995 M.M.A. All rights reserved: 55; © Art Resource, NY: 56, 68; © The Cleveland Museum of Art: 57; © Nik Wheeler/Corbis: 58; © Roger Antrobus/Corbis: 59; J. Paul Getty Museum, Los Angeles: 63; Collection Société Francaise de Photographie, Paris: 64; Massachusetts General Hospital Archives and Special Collections, Boston: 65; Bibliothèque Nationale, Paris: 66; Courtesy George Eastman House: 67

Chapter 29-Bridgeman Art Library: 1; Lessing: 2, 21, 56; Scala: 3; Philadelphia Museum of Art, Philadelphia: 4, 40; Photo, Schecter Lee © 1986 M.M.A. All rights reserved: 6; R.M.N.: 7, 8, 25, 43; © Sterling and Francine Clark Art Institute, Williamstown, MA, USA: 9; Photo © 1985 M.M.A. All rights reserved: 10, 11, 29, 47; Jefferson Medical College of Thomas Jefferson University, Philadelphia: opener, 12; Courtesy George Eastman House: 13, 24; Museum of Fine Arts, Boston: 14, 37; Art Resource Technical Services, Hyattsville, MD: 15; © BPK, Bildarchiv Preussischer/Art Resource, NY: 16; © Tate Gallery/Art Resource, NY: 17, 18; © 2004 The Museum of Modern Art, New York /Art Resource, NY: 19, 35, 45; Gir: 20, 30; Photo courtesy of The Art Institute of Chicago: 22, 31, 32, 38, 39, 41, 42; Los Angeles County Museum of Art, Los Angeles: 23; Glasgow Art Galleries and Museum: 27, 52; Norton Simon Art Foundation, Los Angeles: 28; Photo © The Detroit Institute of Arts: 33; Yale University Art Gallery, New Haven, Connecticut: 34; National Gallery of Scotland, Edinburgh: 36; © The Kröller-Müller Foundation: 44; © 2001 The Munch Museum/The Munch-Ellingsen Group/Scala/Art Resource, NY: 46; © Smithsonian American Art Museum, Washington, D.C./Art Resource, NY: 48; Hirshhorn

Museum and Sculpture Garden, Smithsonian Institution, Washington, D.C.: 49, 50; © Massimo Listri/Corbis: 51; © Stephanie Colasanti/Corbis: 55; © Hulton-Deutsch Collection/Corbis: 57; Chicago Architectural Photographing Company: 58; Ralph Lieberman: 59; Chicago Historical Society/Photo Hedrich-Blessing HB-19321-E: 60; The Preservation Society of Newport County: 61

Chapter 30–Biblioteca Apostolica Vaticana, Rome: 1; adapted from an image by Ned Seidler/National Geographic Society: 2; Gianni Dagli Orti/Corbis: 3, 4; photo courtesy the Library, American Museum of Natural History: 5; Michael Freeman/Corbis: 6; Museum of New Mexico, Santa Fe: 7; Arizona State Museum, University of Arizona, photographer W. McLennan: 8; National Museum of Women in the Arts: 9; American Museum of Natural History, New York: 10, 11; Museum of Anthropology at the University of British Columbia/photo W. McLennan: 12; courtesy of the Southwest Museum, Los Angeles, photo # Ct.37/Larry Reynolds, photographer: 13; M.M.A., The Michael C. Rockefeller Memorial Collection, gift of Nelson A. Rockefeller, 1961 (1978.412.76). Photographed © M.M.A.: 14; Joslyn Art Museum: 15; Mr. and Mrs. Charles Diker Collection: 16

Chapter 31- courtesy of Library Services, American Museum of Natural History: 1; © abm-archives barbier mueller, photographer Wolfgang Pulfer: 2; Tobias Schneebaum: 3; South Australian Museum Archives: 4; D. Destable/Collection Musee de l'homme, Paris: 5; Copyright Otago Museum, Dunedin, New Zealand, D45.179: 6; Staatliche Museen zu Berlin Preussischer Kulturbesitz, Ethnologisches Museum, photo by Dietrich Graf: 7; Linden Museum, Stuttgart: 8; Heritage Images/British Museum: 9, 15; Adrienne Kaeppler: 10; Robert and Lisa Sainsbury Collection, University of East Anglia, Norwich, photo by James Austin: 11; University of Pennsylvania Museum/T4-3195: 12; Ann Ronan Picture Library, 13; Bishop Museum, Honolulu, Hawaii: 14; copyright Otago Museum, Dunedin, New Zealand: 16; Lessing: 17; Reproduced courtesy of Museum Victoria: 18; Meteorological Service of New Zealand Ltd. Collection, Wellington: 19

Chapter 32-Natal Museum, Pietermaritzburg: 1; National Museum of African Art, Smithsonian Institution, Washington, D.C.: 2, 4, 26; copyright abm-Archives Barbier-Mueller, photographer Roger Asselberghs: 3; Detroit Institute of Arts: 5; M.M.A., gift of Lester Wunderman, 1977 (1977.394.15), photograph © 1993 M.M.A.: 6; M.M.A., The Michael C. Rockefeller Memorial Collection, gift of Nelson A. Rockefeller, 1969 (1978.412.390,.391), photograph © 1999 M.M.A.: 7; National Museum of African Art Smithsonian Institution/Eliot Elisofon Photographic Archives: 8, 13; photo Roy Sieber, 1964: 9; Private Collection: 10; Skip Cole: 11; Denver Art Museum, Denver: 12; © abm-Archives Barbier-Mueller, photographer Pierre-Alain Ferrazzini: 14; © Anita Glaze: 15; Fowler Museum of Cultural History, University of California, Los Angeles, gift of the Wellcome Trust: 17; Edizioni Sipiel/Joseph Cornet: 18; Peabody Museum, Harvard University, Cambridge: 19; © Herbert M Cole: 20, 21, 22; photo: Henry J. Drewal: 23; photo: Philip Ravenhill: 24; Museum voor Volkendunde, Rotterdam: 25; © Willie Bester: 26

Chapter 33-© 2006 Succession H. Matisse, Paris/ Artists Rights Society (ARS), New York: 1, 2; Scala: 2; Gir: 3; © 2006 Artists Rights Society (ARS), New York/ADAGP, Paris: 3, 6, 10, 17, 18, 21, 45, 63, 64; © MOMA/Art Resource, NY: 4, 9, 22, 34, 38, 45, 46, 48, 50, 52; © Hamburger Kunsthalle/BPK, Berlin. Photo Elke Walford/Art Resource, NY: 5; Photo David Heald © The Solomon R. Guggenheim Foundation, New York: 6; Öffentliche Kunstsammlung Basel, Martin Bühler: 7; © 2006 Estate of Pablo Picasso/Artists Rights Society (ARS), New York: 8, 9, 12, 14, 73, Photo courtesy of The Art Institute of Chicago, Chicago: 11, 57, 76, 78; R.M.N.: 12; © The Bridgeman Art Library: 13, 19, 21, 44, 54, 55; © Digital Image © The Museum of Modern Art/Licensed by Scala/Art Resource, NY: 14, 20, 32, 51; © Tate Gallery, London/Art Resource, NY: 16; © 2006 Estate of Alexander Archipenko/ Artists Rights Society (ARS), New York: 16; © 2006 Artists Rights Society (ARS), New York/SIAE, Rome: 19, 44; © 2006 Artists Rights Society (ARS), New York/VG Bild-Kunst, Bonn: 22, 26, 39, 40, 41, 51, 57, 62; © Photo Graydon Wood, 1992: 23; © 2006 Artists Rights Society (ARS), New York/ADAGP, Paris/Succession Marcel Duchamp: 23, 24, 29; © BPK, Bildarchiv Preussischer/Art Resource, NY: opener, 25; Photo by Walter Pach © MOMA/Art Resource, NY: 28; © 2006 The Georgia O'Keeffe Foundation/Artists Rights Society (ARS), New York: 30, 37; © 1981 Center for Creative Photography, Arizona Board of Regents: 31; © 2006 Man Ray Trust/Artists Rights Society (ARS), NY/ADAGP, Paris: 32; © Estate of Stuart Davis/Licensed by VAGA, New York, NY: 34; © 2003 Whitney Museum of American Art: 36; © Estate of George Grosz /Licensed by VAGA, New York, NY: 38; Photo by Walter Klein: 39; Photo Sachsesche Landesbibliothek/Art Resource: 40; © Burstein Collection/Corbis: 42; Lessing: 43; © 2006 Salvador Dali, Gala-Salvador Dali Foundation/ Artists Rights Society (ARS), New York: 46; © 1993 Museum Associates, Los Angeles County Museum of Art. All rights reserved. © 2006 C. Herscovici, Brussels/Artists Rights Society (ARS), New York: 47; Bridgeman Art Library © 2006 Artists Rights Society (ARS), New York/DACS, London: 48; © Schalkwijk/Art Resource, NY: 49; © 2006 Succession Miro/ Artists Rights Society (ARS), New York/ADAGP, Paris: 50; © Estate of Vladimir Tatlin/Licensed by VAGA, NY: 54; © 2006 Mondrian Holtzman Trust/c/o Artists Rights Society (ARS), New York: 55; © 2006 Artists Rights Society (ARS), New York/Beeldrecht, Amsterdam: 56; Photo © Whitney Museum of American Art/© 2006 The Josef and Anni Albers Foundation/Artists Rights Society (ARS), New York: 58; © Vanni/Art Resource, NY: 59; © The Museum of Modern Art/Licensed by SCALA/Art Resource, NY: 60; Bauhaus Archive © 2006 Artists Rights Society (ARS), New York/Beeldrecht, Amsterdam: 61; Photo courtesy The Mies van der Rohe Archive, The Museum of Modern Art, New York/Art Resource, NY: 62; Photo by Ralph Lieberman: 64; © Bluestone Productions/Superstock: 65; © Ray F. Hillstrom Jr./ The 11th Hour Pictures: 66; Ezra Stoller © Esto, All rights reserved © 2006 Frank Lloyd Wright Foundation, Scottsdale, AZ: 68; © Philadelphia Museum of Art/Corbis: 69; © Tate Gallery, London /Art Resource, NY: 70; © Henry Moore Foundation: 71; Institut Amatller D'art Hispànic © Museo del Prado: 73; © Gregor Schmid/Corbis: 74; Courtesy The Dorothea Lange Collection, The Oakland Museum of California: 75; The Phillips Collection, Washington, D. C.: 77; © T. H. Benton and R. P. Benton Testamentary Trusts/Licensed by VAGA, New York, NY: 78, 79; Photo © Lloyd Grotjan/Full Spectrum Photo, Jefferson City: 79; Commissioned by the Trustees of Dartmouth College, Hanover, New Hampshire. © Orozco Valladares Family/SOMAAP, Mexico/Licensed by VAGA, NY: 80; Photo © 1986 The Detroit Institute of the Arts/Dirk Bakker © INBA Mexico: 81

Chapter 34-© Digital Image © The Museum of Modern Art/Licensed by Scala/Art Resource, NY: 1, 6, 14, 25; © Tate Gallery, London/Art Resource, NY © 2003 ADAGP, Paris/ARS, NY: 2; Center for Creative Photography: 5; © MOMA, NY/Art Resource, NY: 7, 28; © 2003 Barnett Newman Foundation/ARS, NY: 7; © Kate Rothko Prizel & Christopher Rothko/ARS, NY: 8; © VAGA, NY/Art Resource, NY: 9, 28; © Estate of David Smith / Licensed by VAGA, New York, NY: 9, Photo Philipp Scholz Ritterman © Ellsworth Kelly 1963: 10; © 2003 Helen Frankenthaler: 12; Photo David Heald © The Solomon R. Guggenheim Foundation, New York: 13, 78; Art © Donald Judd Foundation/Licensed by VAGA, New York, NY: 15; © Frank Fournier/Contact Press Images/PictureQuest: 16; © RMN, Paris/Art Resource, NY © 2006 Estate of Louise Nevelson/Artists Rights Society (ARS), New York: 17; © CNAC/MNAM/Dist. R.M.N. © Estate of Louise Bourgeois/Licensed by VAGA, New York, NY: 18; Photo © Al Geise: 22; © 2006 Artists Rights Society (ARS), New York/VG Bild-Kunst, Bonn: 23, 46, 84; © 2006 Artists Rights Society (ARS), New York/ADAGP, Paris: 24, 42, 43; © 2006 Joseph Kosuth/ Artists Rights Society (ARS), New York: 25; © 2006 Bruce Nauman/ Artists Rights Society (ARS), New York : 26; Bridgeman Art Library © 2006 Artists Rights Society (ARS), New York/DACS, London: 27; © Jasper Johns/Licensed by VAGA, New York, NY: 28; © Robert Rauschenberg/Licensed by VAGA, New York, NY: opener, 29; Offentliche Kunstsammlung Basel/Photo Martin Bühler. © Estate of Roy Lichtenstein: 30; © 2004 The Whitney Museum of American Art © 2006 Andy Warhol Foundation for the Visual Arts/ARS, NY: 31; © Tate Gallery, London/Art Resources, NY © 2006 Andy Warhol Foundation for the Visual Arts/ARS, NY: 32; © Estate of Rudolph Burkhardt/Licensed by VAGA, New York, NY: 33; Photo by Anne Gold. Art © Estate of Duane Hanson/Licensed by VAGA, New York, NY: 36; © Estate of Robert Smithson/Licensed by VAGA, New York, NY: 37; © 1983 Christo photo Wolfgang Volz. Christo & Jeanne-Claude: 38; © 2006 Richard Serra/ Artists Rights Society (ARS), New York: 39; © Angelo Hornak/Corbis:40; © 2006 Frank Lloyd Wright Foundation, Scottsdale, AZ: 40, 41; © Paolo Koch/Photo Researchers: 41; © Archivo Iconografiopener, S.A./Corbis: 42; © Artur/Archipress/Marc Loiseau, www.bildarchiv-monheim.de: 43; © Paul A. Souders/Corbis: 44; © Bettmann/Corbis: 45; © Ezra Stoller/ESTO/Arcaid: 46; Peter Aaron © Esto: 50; Richard Bryant © Esto /Arcaid: 52; Courtesy Behnisch and Partner, Stuttgart: 53; © FMGB Guggenheim Bilbao Museoa © 1997 Erica Barahona Ede, photographer. All rights reserved. Partial or total reproduction prohibited: 54; © 2006 Succession Susan Rothenberg/ Artists Rights Society (ARS), New York: 56; Courtesy Sperone Westwater: 57; Courtesy Chris Ofili: 58; © Judy Chicago/ARS, NY, photo © Donald Woodman © 2006 Judy Chicago/ Artists Rights Society (ARS), New York: 59; © Miriam Schapiro, photo courtesy Bernice Steinbaum Gallery, Miami: 60; Courtesy of the artist and Metro Pictures: 61; © Copyright 2003 Marsie, Emanuelle, Damon and Andrew scharlatt. Courtesy Ronald Feldman Fine Arts, New York. Photo; Ziindman/Fremont: 64; Pace Wildenstein Gallery: 65; © 1983 Faith Ringgold: 66; Adrian Piper Research Archives: 67; Courtesy, Sean Kelly Gallery: 68; Smithsonian American Art Museum, Washington, D.C./Art Resource, NY: 69; Scott Frances © Esto. All rights reserved: 70; Jaune Quick-to-See Smith: 71; Courtesy Ronald Feldman Fine Arts. © Leon Golub/Licensed by VAGA, New York, NY: 72; Courtesy of P.P.O.W.: 74; © 1979 David Em: 77; © 2006 Jenny Holzer/Artists Rights Society (ARS), New York: 78; photo © Benny Chan/Fotoworks, courtesy of the artist: 79; courtesy the artist and Metro Pictures, New York: 80; Photo Michael Tropea, Chicago: 81; courtesy Curt Marcus Gallery: 82; © Estate of Robert Arneson/Licensed by VAGA, NY: 83; © Georges Pompidou, Paris/Art resource, NY: 84; Courtesy Guerrilla Girls: 85

ILLUSTRATION CREDITS

Fig. 21-35 From Marvin Trachtenberg and Isabelle Hyman, Architecture from Prehistoric to Post-Modernism/The Western Tradition, Saddle Ridge, NJ: Prentice-Hall, 1986, p. 86, p. 293. Used by permission; **Fig. 21-42** From Nikolaus Pevsner, An Outline of European Architecture, 6th Ed., 1960, Penguin Books Ltd., Copyright © Nikolaus Pevsner, 1943, 1960, 1963.

INDEX

Boldface names refer to artists. Pages in italics refer to illustrations